D0519174

A Genius for Failure

The Life of Benjamin Robert Haydon

A Genius for Failure

The Life of Benjamin Robert Haydon

PAUL O'KEEFFE

THE BODLEY HEAD

LONDON

Published by The Bodley Head 2009

2 4 6 8 10 9 7 5 3 1

Copyright © Paul O'Keeffe 2009

Paul O'Keeffe has asserted his right under the Copyright, Designs
and Patents Act 1988 to be identified as the author of this work

This book is sold subject to the condition that it shall not,
by way of trade or otherwise, be lent, resold, hired out,
or otherwise circulated without the publisher's prior
consent in any form of binding or cover other than that
in which it is published and without a similar condition,
including this condition, being imposed
on the subsequent purchaser.

First published in Great Britain in 2009 by
The Bodley Head
Random House, 20 Vauxhall Bridge Road,
London SW1V 2SA

www.bodleyhead.co.uk
www.rbooks.co.uk

Addresses for companies within The Random House Group Limited can be
found at: www.randomhouse.co.uk/offices.htm

The Random House Group Limited Reg. No. 954009

A CIP catalogue record for this book
is available from the British Library

ISBN 9780224062473 (HBK)

The Random House Group Limited supports The Forest Stewardship
Council (FSC), the leading international forest certification organisation. All our
titles that are printed on Greenpeace-approved FSC-certified paper carry the FSC
logo. Our paper procurement policy can be found at
www.rbooks.co.uk/environment

Mixed Sources
Product group from well-managed
forests and other controlled sources
www.fsc.org Cert no. TT-COC-2139
© 1996 Forest Stewardship Council
FSC

Typeset by Palimpsest Book Production Limited,
Grangemouth, Stirlingshire

Printed and bound in Great Britain by
Clays Ltd, St Ives PLC

To Sian Hughes

Contents

A CATALOGUE

OF THE

VALUABLE EFFECTS

OF THE LATE

B. R. HAYDON, Esq.,

Historical Painter,

Comprising A NOBLE GALLERY PAINTING OF

ALFRED and the FIRST BRITISH JURY,

Being One of the Series of Six Paintings originally intended for the HOUSE OF LORDS.

A FINE GALLERY PAINTING of SATAN and URIEL,

Several Valuable SKETCHES for the Paintings of NAPOLEON and WELLINGTON. Finished and Unfinished Paintings and Designs of Historical and Emblematical Subjects, and Portraits of Eminent Characters.

The Valuable SKETCH BOOKS for the large Paintings of

ARISTIDES, THE REFORM BANQUET,

And others of his well-known Paintings & Drawings in Chalk, Crayons, &c.

A Select Collection of Casts and Busts,

Of the APOLLO de BELVIDERA, the VENUS de MEDICI, ILYSSUS;

SPECIMENS FROM THE ELGIN MARBLES,

Colossal Casts and others. A Portfolio of Choice Engravings and Framed Presentation Prints.

400 VOLUMES OF BOOKS,

Many of which are considered rare, and generally interspersed with his MS. Remarks.

CONTENTS OF THE LAMENTED ARTIST'S STUDIO,

CONSISTING OF

The Colour Stone and Mullers of the late JOHN BARRY, Esq., R.A.; Pallets, Maul-Sticks, 20 Dozen Sable, Hair, and other Brushes, Ground and Unground Colours, &c. Curious Items of Taste and Vertu, and a variety of Interesting Objects of Art. Also the whole of the

HOUSEHOLD FURNITURE,

OF THE USUAL DESCRIPTION;

Which will be Sold by Auction, by

MR. NUTTER,

ON THE PREMISES,

14, BURWOOD PLACE, NORFOLK CRESCENT, HYDE PARK,

On WEDNESDAY, 5th August, and Following Day, at 12.

May be Viewed the day preceding and Mornings of Sale, and Catalogues obtained (at 6d. each) on the Premises, and of the Auctioneer, No. 8, Upper Berkeley Street West, Hyde Park Square.

LOT 343

As Mr Nutter cracked his hammer down and declared the nine-foot-by-twelve expanse of painted canvas sold, the auction of 'Valuable Effects of the late B.R. Haydon, Esq., Historical Painter' was all but at an end. It was nearly seven o'clock in the evening of Thursday 6 August 1846 and only five lots remained to be disposed of. However, the total of four pounds eleven shillings confirmed by those five subsequent hammer blows was a negligible sum compared with the single bid of £200 that had just secured Lot 343 for an absentee buyer, understood to be the former Prime Minister, Sir Robert Peel. The catalogue declared this 'Noble Gallery Painting', unfinished though it was, to be 'in an exceedingly forward state', and it was 'the general opinion that this would have been the lamented Artist's chef d'oeuvre'.[1] Neither the auctioneer nor the catalogue mentioned the rumour that a portion of this canvas – *The Blessings of Justice or King Alfred and the First Trial by Jury* – had been spattered with the dying painter's blood.[2]

<center>*</center>

The sale had begun at noon the previous day, on the premises in Burwood Place[3] so recently visited by tragedy, Mr Nutter inviting bids for the contents of the back attic. A half-tester bedstead, two japanned tables and a deal table fetched sixteen shillings; seven chairs, a basin stand and fittings, fender and fire-guard, just five. There were eleven lots in the front attic. These included a variety of furniture, japanned, mahogany and deal, two more bedsteads – one of them painted and of French design – sundry mattresses, blankets, counterpanes and a feather bolster. The bedroom at the rear of the second floor yielded more of the same, while the second-floor front offered buyers a five-

foot mahogany four-poster with 'carved pillars, green furniture and straw palliasse' and a 'high japanned shower bath with curtains'. Lot succeeded lot, down through the house: fender and fire-irons in the second-floor anteroom; nineteen yards of Brussels carpet on the staircase, along with seven yards of Wilton, and twenty-nine brass stair-rods; the 'capital 8-day clock in high mahogany case' made by Tyler's of the Strand, in the hall; six cane-seat chairs and cushions, a circular mahogany table, two ranges of bookshelves either side of the fireplace in the back parlour. Clearly, the most desirable furniture was in the dining room, where a set of ten mahogany-framed and two elbow-chairs attracted a successful bid of eight pounds, 'a mahogany framed reclining chair, spring stuffed, and covered with leather' three pounds. More bedding, dressing and shaving mirrors, chamber pots and a 'night convenience' in the butler's room and the assorted copper, tin, iron and china contents of the front kitchen – the mundane paraphernalia of pans, gridirons, tureens, buckets, bowls, kettles, candlesticks, clothes horses and dinner services – brought to an end the auction of domestic furniture. Sale of the seventy-five lots had raised a little over sixty pounds to meet the substantial demands of the deceased's creditors.

The contents of a private library can reveal much about its owner, and the 400 or so books that Mr Nutter next set about selling provided numerous insights into the tastes and preoccupations of the sixty-year-old man who had destroyed himself at this address.

A Greek lexicon, a Latin dictionary, volumes of Pliny, Cicero, Tacitus, Horace, Xenophon, Virgil, Livy and Ovid might have been found on the shelves of any classically educated gentleman of the period, as might Apollonius Rhodius, Justinian, Martial, Thucydides and Theocritus, not to mention Theophrastus, Suetonius, Juvenal, Pausanias and Plutarch. But for an 'Historical Painter', the creator of *Alexander Taming Bucephalus*, *The Assassination of Dentatus*, *Xenophon and the Ten Thousand*, *Curtius Leaping into the Gulf*, *The Burning of Rome by Nero* and *The Banishment of Aristides*, they had constituted essential research material.

Lest it be thought that his subject matter had been drawn entirely from pagan sources, the painter of *Christ's Triumphant Entry into Jerusalem*, *The Judgement of Solomon*, *The Raising of Lazarus*, *Christ's Agony in the Garden* and *Christ Blessing Little Children* also numbered among his possessions an Italian translation of the Gospels, *Sacra Biblia*, John Brown's *Dictionary of the Bible*, anonymous works on scriptural narrative and the

land of Israel, John Collinson's *Observations on the History of the Preparation for the Gospel* and *Compositions from Morning and Evening Prayers*, by the Reverend Andrew Bell, 'presented by the author'.[4] At the Coroner's inquest the deceased had been described as 'a very pious man',[5] and it was remarked that his diary entries towards the end of his life frequently began with prayer: 'O God, bless me through the evils of this day.'

There were books that would have rested as easily upon the shelves of a medical man as upon those of a painter: John Bell's *Anatomy of the Bones, Muscles and Joints*; Thomas Nunneley's *Anatomical Tables* containing concise descriptions of the muscles, ligaments, fasciae, blood vessels and nerves; the *Myographiae Comparative Specimen* by James Douglas, MD, was subtitled 'a comparative description of all the muscles in a man and in a quadruped', to which was added, with admirable thoroughness, 'an account of the muscles peculiar to a woman'. There was also a volume that no occasional painter of quadrupeds could afford to be without: George Stubbs's *The Anatomy of the Horse*.

The creator of more than thirty canvases of Napoleon Bonaparte had devoted part of his library to the late Emperor of France: ten volumes of the *Code Napoléon*, seven volumes of the *Correspondence de Napoléon, Inédite, Officielle, et Confidentielle*, a two-volume *Histoire de Napoléon* by the Comte de Ségur, together with related works such as *Considérations sur la Révolution Française*, by De Staël, and *Discours sur les Révolutions*, by Cuvier. In a spirit of historical even-handedness, if not of opportunism, Haydon had also painted half a dozen versions of Napoleon's nemesis 'musing on the Field of Waterloo'. *The Duke of Wellington's General Orders* formed part of a lot that was knocked down for eleven shillings.

Many of the books being sold that Wednesday afternoon were concerned with a subject their owner had always referred to as 'the Art', definite article and capital letter giving his chosen calling due weight and stature. Works included Giovanni Battista Armenini on *Painting*, Callcott on *Painting*, a *Critical Essay on Oil Painting* by Raspe, Shee's *Elements of Art*, Hoare's *Epoch of the Arts*. There were Lives of Michelangelo, Rubens, Fuseli, Lawrence, Northcote and West. There was an unbound ten-volume set of Vasari's *Lives of the Painters, Sculptors and Architects*. Lot 122, which sold for one pound seven shillings,

comprised: 'Walpole's Anecdotes of Painting; Webb's Beauties of Ditto; Buchanan's Memoirs of Ditto; Idea of Ditto'.

The first day's sale concluded with a collection of thirty-seven lots, described in the catalogue as 'Portfolios of Engravings, Etchings, &c.'[6] Among these were four engravings of Napoleon, two of the Duke of Wellington and one of Lord Nelson. There were engravings after famous masterpieces by Michelangelo, Raphael and Rubens, and a number of etchings, engravings and lithographs intended to disseminate, in a popular and inexpensive form, the works of Benjamin Robert Haydon himself.

<p style="text-align:center">*</p>

The second day's sale was advertised to begin at noon, but did not actually start until one o'clock. It was held in the 'principal saloon' on the first floor, used by the late artist as his painting room. It was here, in front of the 'Noble Gallery Painting', the sale of which would constitute a fitting climax to the day's proceedings, that his body had been discovered, face-down in a wide pool of his own gore.

As the auction got under way again, the room was 'densely crowded', *The Times* reported, 'principally by artists',[7] and it was to these gentlemen that the first thirty or so lots would be expected to appeal. There were 'bottles of linseed oil and sundry bottles of turps', more than 200 artist's brushes, a 'quantity of ground and unground colours, in jars and loose', twenty or so prepared canvases of various sizes ranging from kit-cat to whole length, and a 'large roll of well seasoned canvas, about 76 yards'. Of the three easels, one was designed to accommodate large 'gallery paintings', and there was 'a pair of high steps' upon which to work at it. Mr Nutter attempted especially to talk up Lot 217. It was an 'excellent octagon colour stone and two mullers',[8] used for grinding paints. Originally the property of James Barry, RA, it had then been owned by another Academician, John Hoppner, from whose sale it had been bought for the considerable sum of thirty-five pounds.

It might, at this point, have occurred to the more censorious elements of the audience to speculate on the course of Haydon's career, had he not been so profligate with his resources. Four incarcerations for debt in the King's Bench Prison would not have blighted

that less-tragic span governed by thrift; nor would it have ended in death by his own hand, with the wreckage of his life now falling under Mr Nutter's hammer.

For all the auctioneer's efforts, the colour stone and mullers sold for just one pound thirteen shillings. Lot 214 had fared even worse. The palette, maulstick and crayon holder, 'used by the late Mr Haydon on the morning of his death',[9] as Mr Nutter informed the crowd, sold for only a guinea.

Lots 220 to 255 consisted of casts: three legs; eighteen hands and feet; eighteen children's hands, legs and feet; twelve female hands and feet; 'sundry casts of youth's legs, arms, &c' and 'four cast legs of horses'. In addition there were three 'colossal casts of feet', two 'colossal casts of arms' and a 'cast of colossal limbs'. There were casts from the Elgin Marbles, including 'a fine cast of Ilissos, the first cast ever made, 1815'. A seven-foot-high *Apollo Belvedere* sold for a guinea, the more modestly proportioned 'Venus de Medici, life size' for fourteen shillings. One notable item in this section of the sale was a bronze cast of the hand of Napoleon's sister, Pauline, Princess Borghese, by Antonio Canova, which went for one pound fifteen shillings.

The next ten lots were described in the catalogue as 'Curious Items' and included a pair of Persian boots, a stuffed peacock and a 'pair of swan's and duck's wings for study'. There were two pieces of 'curiously inlaid armour' and 'two antique shields and [a] roman sword'[10] – the last-named weapon was that depicted bouncing on the thigh of Marcus Curtius riding his terrified horse into the ravine. Also offered was a saddle purporting to be Henry VIII's, presented by Lord Audley to the artist, and a steward's staff, a relic of Haydon's vast portrayal of the Reform Banquet in the Guildhall, 11 July 1832. A coat worn on the same occasion by Earl Grey, 'with ribbon and the garter', was withdrawn from the sale when no advance was made beyond a bid of seven shillings. A frock coat and waistcoat employed for the portrait of the Duke of Wellington sold for eleven shillings, and the much-used facsimile of Napoleon's coat for six.

As the sale proceeded into the late afternoon, there were a number of items considered by the *Times* correspondent as 'deserving of notice'.[11] Lot 281 was a small framed print of George IV, inscribed by Haydon with the words 'The only Monarch that felt for me'.[12] This was a reference to the solitary instance of royal patronage that the

artist had enjoyed, his late Majesty's purchase of *The Mock Election* in 1828. Lot 291, an unfinished painting of Copenhagen, 'the charger rode by the Duke of Wellington at the Battle of Waterloo', was purchased by the Iron Duke himself for seventeen guineas. A painting of his Grace's sword sold for two and a half guineas, a study of his hat for ten shillings, while a companion study, of Napoleon's hat, went for nineteen shillings. Lot 305 was an oil sketch showing the interior of a Nelson mausoleum, which – had Haydon's submission to the competition for monumental designs, held in 1839, been favourably received – would have been erected on the Trafalgar Square site in place of William Railton's column.

There were drawings derived from another ill-fated application, to the committee inviting fresco designs for the new Houses of Parliament. Having ignominiously failed to be considered for this immense scheme of state-subsidised decoration, Haydon recklessly set about executing a series of six compositions regardless. They were intended to dramatise the vices and virtues of governance: 'The Horrors of Anarchy', 'The Horrors of Despotism', 'The Horrors of Democracy' and 'The Horrors of Revolution' were to be opposed by two 'Blessings': of Justice, and of 'Freedom under Limited Monarchy'. Only 'Despotism', represented by the Emperor Nero playing on his lyre while Rome burned, and 'Democracy', by the banishment of Aristides from Athens, were actually completed. It was the exhibition of these two huge canvases, desolate and disregarded, in an upper room of Mr Bullock's Egyptian Hall in Piccadilly that provided Haydon's final, insupportable and ruinous humiliation, worsted by the tremendous box-office receipts of an American midget appearing in the same building.

Only one more of the projected series was ever begun. Lot 343, showing King Alfred instructing the first British jury in its duties, formed a theatrical backdrop when, a little after half-past ten on the morning of Monday 22 June, the artist committed suicide. The small pocket pistol with which he had failed to kill himself did not appear in the sale catalogue, nor did the razor he employed to finish the job.

In the same first-floor room of the house, not seven weeks later, the day's business was drawing to a close, and Mr Nutter was nearing the end of his labours. The hammer fell at five pounds ten shillings for Lot 342, a large unfinished painting of a subject from Milton – *Satan and*

Uriel – in which the face of the noble, muscular Guardian of the Sun, directing the fallen Archangel to Earth, might have been recognised, by those who had known the painter, as an idealised self-portrait. But before any offers could be made for the long-awaited Lot 343, a man handed the auctioneer a written note and declared, in a voice loud enough for the *Times* correspondent to quote it verbatim: 'I give you notice not to sell the large picture, for if you do you will do it on your own respon- sibility.'[13] Mr Nutter paid no heed to the mysterious intervention, or to the note, but announced that he already had a commission to purchase the picture for £200. There being no further advance on this extraordin- ary sum, and no further interruption from the man who imagined himself to have a prior claim upon *The Blessings of Justice*, the hammer fell again.

PART ONE

NO STRANGER TO THE MUSES

1786–1807

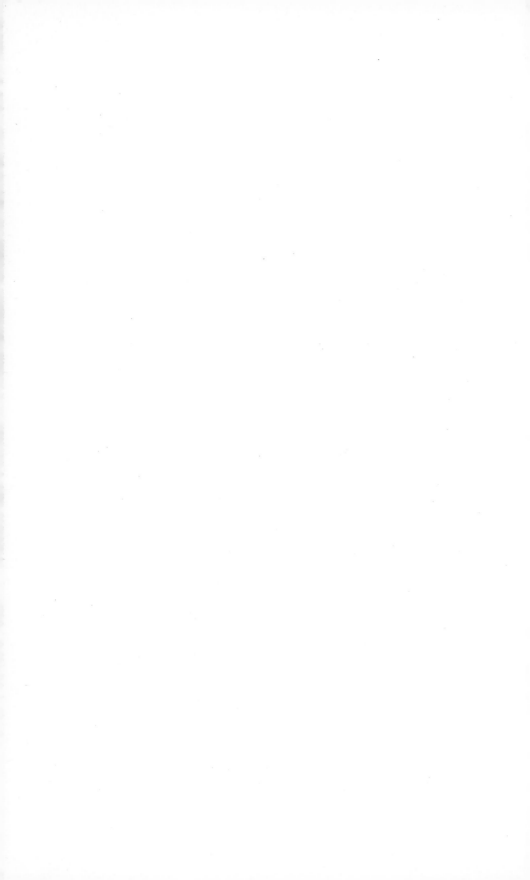

Very Dirty Weather. Wind West-South-West.

Folk living in a seaport pay closer attention to the weather than do those whose homes lie further inland. Even men pursuing relatively sheltered trades on the coast must have a sympathetic feeling for the more daring souls making a living upon the sea. That a Plymouth bookseller, stationer and printer should daily consult the weathervane is not therefore surprising. On Tuesday 24 January 1786 Benjamin Robert Haydon senior recorded in his diary 'Sally taken Bad' and expressed the hope 'it will end Well with her'. The seriousness of the crisis seemed reflected by climatic conditions: 'Very Dirty Weather,' he wrote, 'Wind W.S.W.' Four months later, a health scare would be accompanied by an easterly wind: 'My dear Sally & little one Very poorly . . . Wind at E.N.E.' Bereavement in a neighbouring household was also recounted: 'Poor Mrs Burgess died in Child Bed to the great Affliction of poor Tom Burgess who is much Distressed . . . Wind W.N.W.'[1] Many years later, after reading his father's diary, the painter remarked: 'There was a consolation in finding that the course of nature went on . . . Poor Tom Burgess had lost his wife, but yet he ought to be comforted, for the wind was not a south-wester.' But no mention was made of the weather on Wednesday 25 January 1786, when, at half-past nine at night, Sarah Haydon was taken in labour, delivered of 'a fine Boy' and reported to be 'as well as could be expected'.[2] The painter was left in ignorance of the prevailing wind, auspicious or otherwise, that fanned his own nativity.

Benjamin Robert Haydon senior had more than the common Plymouth citizen's passing interest in maritime matters. He contributed

three instalments of a history of the town to the *Naval Chronicle*.[3] The doorway of his shop – nearly opposite the Guildhall – was 'the lounge of the more noted individuals of the town and garrison . . . news-mongers of all grades, civil, naval and military'.[4] Being at the centre of this information network, he took it upon himself to act as an Admiralty 'special correspondent' to the *Bristol Journal*. 'Warmly attached to his King and Country,' his obituary noted, 'he was zealous in announcing to his friends and to the world the earliest intelligence of the valorous exploits of British heroes in various parts of the globe. The columns of the Bristol Journal have repeatedly borne testimony to the accuracy and importance of his valuable correspondence [and] regular intelligence from the West.'[5] This bookseller, printer and stationer no doubt regarded his vicarious participation in 'valorous exploits' as a measure of compensation for renouncing the military career that his own father had originally intended for him, because when his father died suddenly, 'from disease of the heart', the fifteen-year-old youth had been ordered by his mother to take over the family business.

The painter's grandfather, Robert Haydon, had begun his working life aged nine, apprenticed to a sign and fillet painter, one Waltham Savery of Slade Hall, Ivy Bridge, ten miles east of Plymouth. From apprentice he graduated to steward. He prospered, saved, married the daughter of a local printing family, Mary Baskerville, and, on the death of Mr Savery, established – with the financial assistance of his wife – the book shop, stationery and printing business at 75 Market Place that he would leave so precipitately to his son. He possessed some talent as a painter, and the grandson remembered a portrait, 'an old head of a brown complexion with a white beard', by his hand. He had been, for the last twenty-odd years of his life, parish clerk of Charles Church in the centre of Plymouth, and it was there that he was laid to rest by a grateful community in 1773. His widow survived him by eighteen years and her grandson wrote admiringly of Mary Haydon as a woman 'of great energy and violent prejudices', recounting a characteristic incident that occurred during the American War of Independence:

She hated the French and she hated the Americans; and once, when an American prisoner, who had escaped, crept into her house [and]

appealed to her for protection until pursuit was over, though alone in
the house, she told him 'she hated all Americans', and turned the poor
fellow out into the street.

Back beyond his grandparents, the painter's ancestral line blurs into
unreliability. Not surprisingly, in one possessing a lifelong, unshake-
able sense of self-worth, he claimed descent from an old and illus-
trious Devon family, the Haydons of Cadhay.[6] The last scion of that
house and fortune, Gideon, dying intestate after a hunting accident,
the birthright of his heirs was swallowed up in a Chancery suit. This
served to explain grandfather Robert Haydon's lowly start in life,
bound to Mr Savery, although it overlooked the fact that this appren-
ticeship began six years before the Chancery suit that was supposed
to have ruined the family.[7] Nevertheless, imagining his forebears as
masters of a great estate allowed Gideon's supposed descendant the
dubious comfort of holding an ancient wrong responsible for all his
troubles. 'This is the way Property and Ancestral seats change
Proprietors!' declared the painter:

> This is the way Families are ruined, children innocent of the faults of
> their Fathers, sent into the World degraded & without fortune, and a
> century afterwards look back with desponding gaze on their lost &
> decayed prospects! This is the way my own family Property has gone
> into other hands and I am compelled to slave for my existence, from
> the folly of my great Grandfather.

This stream of folly clearly ran in the genes, because the painter's
father had been 'a great rake in youth'[8] and was said to have brought
his family to the brink of catastrophe for a second time. His son left
the following account of the circumstances:

> In early life [my father] had been most basely treated by a man whom
> he had assisted in every possible way, and who returned this lavish
> generosity by a blow from which my father never recovered. Disgusted
> with the world, he plunged into dissipation to forget himself. The society
> of the educated and virtuous was not stimulating enough, and from
> one class to another he gradually sunk till nothing pleased or gratified
> him but the company of players. This neglect of his duties soon led

to embarrassment, embarrassment to law costs, and law costs, as a matter of course, to ruin and bankruptcy.

<center>★</center>

The maternal side of the painter's family comprised clergy, adventurers of both sexes, and at least one prodigal whose fiscal incompetence also flowed into the gene pool.

The wife who gave Benjamin Robert Haydon senior his only son was christened Sarah Cobley. She was the second daughter of the Reverend Benjamin Cobley, curate of Shillingford, later rector of Dodbrook, who was said to have been killed while preaching when the sounding board above his pulpit fell down on his head.[9] He left a wife and eight children. Undaunted by the perils of his late father's calling, one son, John Cobley, also entered the Church, as curate of Over Stowey near Bridgewater, then as curate of Shepton Mallet and eventually attaining to the living of Cheddar, and Prebendary of Wells Cathedral. The eldest daughter followed commerce, marrying a merchant named Partridge and taking two of her brothers and a sister, Harriet, to live with her in the Italian port of Leghorn. It was there that Harriet met and married Nicolay S. Mordvinov, a captain in the Russian navy who eventually rose to the rank of Admiral and the title of Count. One of the brothers, Thomas Cobley, gained a commission in the Russian army, distinguishing himself during the Turkish War of 1787–91 at the sieges of Izmayil and Ochakiv.[10] He became a General, then Governor of Odessa, and had the rare distinction of having a Russian village, Coblifka, named after him. The other brother, Benjamin Cobley, stayed in Italy acquiring a taste for art and indolence. He returned to Devonshire, took possession of the estate his mother had left him, sold it and, without bothering to invest the considerable sum realised, kept it in a portmanteau for years, taking it out, 'guinea by guinea', until it was exhausted. Then he went to Plymouth on a six-week visit to his sister Sarah, and, in his nephew's jaundiced words, 'never had energy to remove, got imbedded in the family, stayed thirty years and died'. He died in sole possession of the business – Haydon senior, whom he outlived, having made him a partner.

Sarah Haydon, the painter's mother, was 'a vivacious woman, of

handsome presence, rapid apprehension, and many accomplishments. She was imperious, quick tempered, tender hearted to a degree, passionately attached to her children, not very judicious in their management, and of unbounded benevolence to all in distress. She [was] known, on her walks in winter, to go up a dark passage, strip herself of her quilted petticoat and give it to some poor shivering wretch who had begged her charity.'[11] Such a character would have acted as a steadying influence on her husband.

She was to bear him only one more child, three years after her son: a girl, christened Harriet Cobley Haydon. A previous daughter, and namesake, Sarah, had died in infancy.

<p style="text-align:center">★</p>

The commercial scope and nature of the business at 75 Market Place was described in a newspaper advertisement in July 1788 as 'Booksellers and Printers to his ROYAL HIGHNESS PRINCE WILLIAM HENRY'. The notice gave thanks to customers for 'distinguished patronage . . . received for near half a century', offering them a remarkable line of merchandise, following a recent commercial expedition to the metropolis:

> Solicitous and ambitious to please . . . they are lately arrived from London, and having had an opportunity of visiting all the capital print-shops in town, they have selected the most beautiful and elegant variety of ENGLISH and FOREIGN ENGRAVINGS . . . The collection consists of historical subjects, shipping, portraits, landscapes, groups of figures, cattle, caricatures, medallions, coloured and plain, at the lowest price marked on each print, from which no abatement can be made.[12]

While the painter professed to remember nothing of his early childhood up until the age of five, a story told him by his mother may date from the year that his father flooded the shop with pictures:

> As I was one day in a fury of rage which nothing could pacify, my mother entering the room with a book of engravings in her hand, as a last resource showed me the 'pretty pictures', at which, she used to

declare, I became very silent and interested, and would not part with
the book for the rest of the day.

He remembered 'a servant maid, in a passion, putting [him] to the
parlour table, and to keep [him] quiet giving [him] a common half-
penny Picture & a brush to paint it, ([his] father selling these things
they were always lying about the house)'.[13]

Further artistic education was used as a cloak for domestic sexual
intrigue:

> Among my father's apprentices was one (George, I called him) who
> made love to my nurse, and under pretence of showing me prints and
> teaching me to draw from them, visited the nursery very frequently.
> In fact George became so very fond of teaching 'little master Benjamin
> – the little dear', to draw, that my nurse was obliged to be sent away.

In another version, the apprentice was also dismissed for neglecting
the business:

> [He] went to London, entered the Academy and came back full of all
> the Wonders of the Art to teach Drawing, he brought casts the first I
> had ever seen . . . He told me there was a cast of the Hercules in the
> Academy ten feet high![14]

A severe bout of fever, for a month and a half, threatened the child's
life. He was taken to recuperate in Underwood near Plympton St
Mary, where his father owned a cottage, and another early memory
was from this time:

> I remember sitting, propped up with pillows, on a little pony, watching
> some gentlemen throwing the fly on the bridge opposite the church
> in the valley. The delight of this day, with its beautiful landscape and
> village church, I have never forgotten.

Then he was six years old and running to school,[15] his mother standing
at the door watching and waving. This was in 1792, and he remem-
bered inscribing those numbers alongside his first, middle and surname
in a parchment copy-book. The school's location is not known, but,

according to the painter, it was during the year he was attending this establishment that he learned his first rudimentary lesson in facial anatomy:

> While I was [drawing] a schoolfellow, my father came behind me and said, 'What are you about, sir? You are putting the eyes in the forehead!' As I went to school, I observed people's eyes were not in the middle of their foreheads, as I had drawn them. To this day and hour I hardly ever paint a head without thinking of my father's remark.

He learned the power of satire, its rewards and potential consequences. He recalled that his first attempt at 'original thinking' was the caricature of a classmate who was always crying:

> I drew him with a stream of tears running over his cheeks, and a hand at the corner holding a cup to catch them . . . It excited the uproar of the whole school; the usher took it and pasted it against the ceiling, and whenever the boy cried, all fingers were pointed up.

He got a reputation among his schoolfellows, 'and Haydon draw this, Haydon draw that were perpetually stunning [his] ears'.[16]

<p style="text-align:center">*</p>

Following the execution of Louis XVI, on 21 January 1793, England went to war with France. The boy was seven years old and remembered Plymouth being crowded with French prisoners. Perhaps his father gave him one of the miniature guillotines carved by these unwilling visitors from mutton bones and sold at the prison gates. The deadly instrument certainly exerted a fascination on him and added a new subject to his artistic repertoire: '"Louis taking leave of the People" in his shirt sleeves . . . copied from a print of the day'. Later, in October, he remembered his mother sitting in tears on the sofa and, when he asked her why, being told: 'They have cut off the Queen of France's head, my dear.' Pros and cons of the Revolutionary War became confused in children's play. 'On half-holidays [he would lead] out ten or a dozen boys to the cornfields to cut off Frenchman's heads, which meant slicing every poppy

they met, shouting as each head fell, "There goes a Frenchman!
Huzza!"'

Later in that first year of war he was sent to the Grammar School,
a substantial stone building in St Catherine Street, close to the Public
Dispensary and the Workhouse. A guide book published more than
twenty years after his attendance describes the school room as 'a
narrow, gloomy apartment, contain[ing] forms for seven classes'.[17] As
master, the Reverend Dr Bidlake had accommodation in the building
and a garden next to the playground at his disposal. Bidlake was 'a
man of some taste', Haydon recalled:

> He painted and played on the organ, patronised talent, was fond of
> country excursions, wrote poems, which nobody ever read, one on 'the
> Sea', another on 'the Year'. I remember him with his rhyming dictionary,
> composing his verses and scanning with his fingers. He was not a deep
> classic, but rather encouraged a sort of idle country-excursion habit in
> the school; perhaps, however, he thus fostered a love of nature.

He further extended the boy's artistic instruction:

> Finding that I had a taste for art, he always took me with another boy
> from our studies to attend his caprices in painting. Here his odd and
> peculiar figure, for his back was bent from fever, induced us to play
> him tricks. As he was obliged to turn round and walk away to study
> the effect of his touches, we used to rub out what he had done before
> he returned, when his perplexity and simplicity were delightful to
> mischievous boys.

Haydon did not name his co-conspirator, but a likely candidate would
be the future topographical watercolourist Samuel Prout. Born in
Treville Street, barely a hundred yards from the Market Place, and
also the son of a shopkeeper, Prout was a little over two years older
than Haydon. In the late 1840s he told John Ruskin of his time at
Bidlake's school, and of his early friendship. It was information that
enabled the celebrated author of Modern Painters to arrive at an eval-
uation of Haydon's disastrous career, based on the comparative
temperaments of the two children:

[Prout's] first beginnings in landscape study were made in happy truant excursions . . . with the painter Haydon, then also a youth . . . The two boys were directly opposed in their habits of application and modes of study. Prout unremitting in diligences, patient in observation, devoted in copying what he loved in nature, never working except with his model before him; Haydon restless, ambitious, and fiery; exceedingly imaginative, never captivated with simple truth, nor using his pencil on the spot, but trusting always to his powers of memory. The fates of the two youths were inevitably fixed by their opposite characters. The humble student became the originator of a new School of Art, and one of the most popular painters of his age. The self-trust of the wanderer in the wildnesses of his fancy betrayed him into the extravagances, and deserted him in the sufferings, with which his name must remain sadly, but not unjustly associated.[18]

There is, however, one piece of evidence that shows the eight- or nine-year-old Haydon copying what he saw with a diligence and patience of observation that would have been close to Ruskin's heart. Sitting in a garret window at the top of the family home and shop in Market Place, he drew the roofscape to the west: the domed cupola and clock of the Guildhall, and the bristling of masts and spars in the dock beyond. He made notes in the outlines of the conical, ridged and domed structures in front of him, as though intending a more detailed rendition of the scene at a later date. Most surfaces were labelled 'Slate', while a chimneystack to the left was of 'Brick' and the cupola 'Lead'.[19]

While Dr Bidlake took his pupils on excursions from school west to the Ridgeway and Plympton St Mary, and north to Bickleigh Vale, encouraging them to draw from the natural landscape around them, a mentor closer to home exerted a contrary influence over Haydon. In charge of the binding office on the publishing side of his father's business was a Neapolitan called Fenzi, 'a fine, muscular, lazzaroni-like fellow', who liked to talk about his native country, the treasures of the Vatican and about Raphael and Michelangelo. 'Do not draw de landscape; draw de feegoore, Master Benjamin,' he would say. And he would bare his arm to the boy as though presenting himself as a prime specimen of de feegoore.

William Hazlitt said of Haydon that he 'should have been the boatswain of a man-of-war' and that he had 'no other ideas of glory than those which belong to a naval victory, or to vulgar noise and insolence'.[20] Such ideas were absorbed at an early age and during particularly stirring times. In 1794 news came of Admiral Howe's routing of the French fleet in the Atlantic on what became known as 'The Glorious First of June'. It was the beginning of a series of English maritime victories culminating in that of October 1805 off Cape Trafalgar. Two years after Howe's success, in February 1797, the eleven-year-old Haydon was in bed with measles when his father brought glorious news. 'My dear, Jervis has beaten the Spanish fleet and taken four sail of the line. This will cure ye!' Although Admiral Sir John Jervis, on board the flagship *Victory*, was commander-in-chief of the British fleet, it had been the man commanding HMS *Captain* who played the most decisive part in the action. It would be a further ten days after the first reports before disclosure of Commodore Horatio Nelson's deeds in the battle of Cape St Vincent made him a national hero. The following year his destruction of a French fleet, as it lay at anchor in Aboukir Bay to the west of the Nile Delta, made him an object of worship. Haydon claimed to have caught his first sight of the legendary figure at about this time:

> I remember, that after the battle of the Nile . . . I was walking with a schoolfellow, near Stonehouse, when a little diminutive man, with a green shade over his eye, a shabby well-worn cocked hat, and buttoned-up undress coat, approached us. He was leaning on the arm of a taller man in a black coat and round hat . . . [A]s he came up, my companion said, 'There's NELSON!' 'Let us take off our hats,' said I. We did so, and held them out so far that he could not avoid seeing us, and as he passed he touched his own hat, and smiled. We boasted of this for months.

The taller man, Haydon surmised, was 'poor Scott', Nelson's secretary, who would be cut in half by a cannon round on the quarterdeck of the *Victory* less than an hour before his master fell to sniper fire on the same spot.[21]

In addition to the possibility of meeting naval heroes on any street corner, the results of their exploits were evident offshore:

[T]he Sound was filled with fighting-fleets preparing for sea, or triumphantly returning, battered and blackened, with shattered spars and torn sails, but with the captured ships of the enemy in tow; and the gallant frigates, amidst the cheers of thousands of people, were to be seen rounding the point into the inner harbour, with the Union Jack floating proudly above the Tricolour or the Spanish flag, while the guns of the batteries thundered out salutes in honour of the victors.[22]

Haydon remembered running along the waterfront, 'cheering till [his] throat was parched'. Once he was taken aboard an English frigate docked for repairs after action and was shown 'the trace of a shot which had passed fore and aft, taking off the heads of the captains of several guns, scattering blood and brains along the beams'.[23] On another occasion he witnessed the destruction of an East Indiaman by more natural forces. During a violent storm on 26 January 1796, the troopship *Dutton* ran aground on rocks below the Plymouth Citadel. 'So melancholy and distressing a scene has not been witnessed in this place for many years past,' declared *The Times*. Miraculously, only five or six men perished, crushed by falling masts and spars, while the crew and some 300 soldiers of the 10th Regiment were winched ashore, 'many of them . . . in a state of nakedness, and so bruised as to be unable to stand when landed'.[24] Haydon and Prout watched the abandoned and battered hulk, enthralled. As recounted by Ruskin, the spectacle again prompted scornful reflection on the taste for melo-drama of the future 'Historical Painter' in contrast to his more studious companion:

The wreck held together for many hours under the cliff, rolling to and fro as the surges struck her. Haydon and Prout sat on the crags together and watched her vanish fragment by fragment into the gnashing foam. Both were equally awestruck at the time; both, on the morrow, resolved to paint their first pictures; both failed; but Haydon, always incapable of acknowledging and remaining loyal to the majesty of what he had seen, lost himself in vulgar thunder and lightning. Prout struggled to some resemblance of the actual scene, and the effect upon his mind was not effaced.[25]

Although the event remained fresh in Prout's mind even fifty years later, Haydon never alluded to it.

<center>*</center>

'Colonel Hawker, my dear', said Haydon senior to his wife, 'likes Benjamin's drawings.'

John Hawker was a valued customer, a fellow merchant and a prominent figure in Plymouth; 'a very worthy but pompous man, exceedingly vain, very fond of talking French before people that could not speak a word, and quoting Italian sayings of which he knew little'. He had also taken it upon himself to defend his city from invasion by the ravening hordes of blood-soaked Republicanism. On 22 February 1797 three French frigates had landed 1,500 troops near Fishguard, on the south Wales coast. The force largely comprised liberated convicts under the command of a seventy-year-old American adventurer, Colonel William Tate. Following a two-day looting spree, the invaders surrendered to a local militia led by Lord Cawdor. The incident caused widespread panic and a run on the banks. The suspension of convertibility of paper currency kept the country off the gold standard for the next twenty-four years. It also highlighted the need for more such local volunteer forces as that raised so usefully by Lord Cawdor. 'Colonel' John Hawker was commander of the Plymouth militia and would throw the town into periodic uproar by marching his grenadiers through its narrow streets with trumpet and drum, to the great excitement of small boys, barking dogs and impressionable young women. This man would be responsible for introducing the young Haydon to William Seguier, picture restorer, connoisseur and future power in the art world, who was to become Superintendent of the British Institution, Curator of the Royal Collection under George IV and the first Keeper of the National Gallery. When her husband told Sarah Haydon that Colonel Hawker liked their son's drawings, she was unimpressed and, 'with that . . . love of tearing off disguises which belongs to all women', responded: 'What does *he* know of drawings?'

'What does *he* know?' replied her husband and, harbouring his own doubts about the Colonel, but unwilling to voice them in the hearing of his children, concluded: 'You know, my dear, he *must* know.'

<center>*</center>

The boy who doffed his cap to the Hero of the Nile was no longer a pupil of Dr Bidlake. In 1798, at the age of twelve, he had been taken out of Plymouth Grammar School and sent as a boarder to All Hallows School in Honiton, about sixty miles away to the north-east.[26] He remembered painting his name on the wall in vermilion, along with the names of two classmates. Because one boy had ambitions to join the navy and the other the army, Haydon painted a blue jacket and a red jacket respectively, above each of their names. If the adult Haydon is to be believed, it was to remove him from the artistic influences of Bidlake, and of Fenzi – from injunctions to draw landscape and *de feegoore* – that his father placed his further education in the hands of the master of All Hallows, the Reverend William Hayne, with instructions that he 'check, as far as possible, every inclination he might perceive [in the boy] for drawing'.[27] There are numerous stories of the headmaster's failure to do so. One has Haydon establishing a small academy of drawing among his classmates. Using the better-shaped boys as models, he first drew eyes, noses, mouths and arms, which the others endeavoured to copy, he himself 'marching about and correcting as [he] went'. Another story has him executing a large impromptu mural of a hare-coursing event with charcoal in the school hall, the other boys keeping him supplied with burnt twigs. This even succeeded in gaining the approval of the headmaster, who 'was so pleased . . . that he kept it from being rubbed out for some time, and used daily to bring in his friends to see it; and when Haydon returned home for the holidays, advised his father not to check any longer what appeared to him an irresistible inclination'.[28]

In 1800 the Reverend Hayne accepted a new teaching post and took his family and his boys with him. Plympton St Maurice, or Plympton Earle, lies just south of Plympton St Mary. For the fourteen-year-old Haydon it was a return to an area that figured among his earliest childhood memories, as a convalescent, propped up with pillows on top of a pony. It had also been the scene of his first attempts at sketching from nature with Dr Bidlake. The Grammar School was 'a handsome edifice in the Gothic style, with large antique windows. Below the schoolroom [was] a spacious piazza, with nine arches supported by granite pillars, intended and excellently adapted for school boy sports in rainy weather.'[29] Coincidentally, his new school

had a former association that could only augur well for Haydon's future occupation. An earlier master's son, the late President of the Royal Academy, had been born and educated there, and the Reverend Hayne would tell visitors that when he first came to the school there was a drawing on one of the walls, 'one of the early efforts of Sir Joshua Reynolds, [w]hen a boy'. He would also ruefully recount that during his own absence at a watering place – having neglected to leave instructions for the precious relic to be preserved – the workmen employed redecorating the school had painted over it 'and nothing . . . remained to be seen'.[30]

After nearly three years under the tutelage of the Reverend Hayne – two at Honiton, and six months at Plympton, as head boy – Haydon's schooldays came to an end. Although 'just . . . beginning to under-stand and relish the beauties of Virgil & Homer', he was, at fifteen years of age, 'with idle habits and abandoned inclinations, stumbling with difficulty and without a clear perception of what [he] wanted to do'. But there was no mistaking what his father wanted him to do. 'Merchant's accounts' – to prepare him for taking over, in time, the family business – now displaced study of the classics, and Haydon was sent to Exeter to be perfected in the dry, but useful mysteries of balancing profit and loss. He spent half a year being so instructed, but by his own account did little apart from learn crayon-drawing and achieve a certain notoriety 'for electrifying the cat, killing flies by sparks, and doing everything and anything but [his] duty'.

He returned to Plymouth, to be indentured as apprentice to his father for a legally binding term of seven years. His day-to-day exis-tence became an extended sulk. He rose early and walked alone by the sea. He sat up late and brooded. He hated Plymouth and its people. He hated serving behind the counter, despised the customers and sneered at the faulty proportions in prints that his father offered for sale. He hated the stultifying library of merchant's accounts: 'day-books, ledgers, bill-books, and cash books'. At length, things came to a head when a gentleman attempted to haggle him down from the legitimate cost of a Latin dictionary. The appren-tice slammed the book back on its shelf and stormed out of the shop, leaving his father to smooth the ruffled customer 'by explaining to him the impropriety of expecting a respectable tradesman to take less than the market price'. The gentleman took

the book at the full price, but the apprentice never served behind the counter again.

Arguments followed.

He wanted to be an artist.

Yes, but his father and grandfather had felt just the same way at his age and the desire had passed. 'When you know yourself better, my dear boy,' his father told him, 'you will laugh at these delusions.'

Still, he wanted to be an artist.

Reason was brought to bear:

'Wouldn't it be a sin and a shame to allow so fine a business to pass out of the hands of its founders for the mere want of a little self-denial? to let such a fine property go to ruin because you had no younger brother?'

'I can't help it.'

'Why?'

'Because I want to be an artist.'

'Who has put this stuff in your head? Fenzi? He shall be discharged!'

'Nobody: I always have had it.'

'You will live to repent.'

'Never, my dear father; I would rather die in the trial.'

Silence followed, 'at dinner, tea, at bedtime'.

Then, perhaps as a result of the strains occasioned by this family conflict, he fell ill. The most alarming symptom was a 'chronic inflammation of the eyes' and for a period he became entirely blind. After six weeks, the faint glimmer of a silver spoon signalled a recovery of his sight, but it came gradually – interrupted and reversed by recurrent inflammation – and 'never perfectly'. It must have seemed to Haydon senior that this illness had settled the question of his son's artistic ambitions once and for all, and without further domestic disruption and argument. Not so. When it became clear that his son's mind had not changed, he voiced the obvious, exasperated objection: 'How can *you* think of being a painter? Why, you can't *see*!'

'I can see enough! And, see or not see, a painter I'll be, and if I am a great one without seeing, I shall be the first.' And in years to come his own son would hear Haydon boasting that he was 'the first blind man who ever successfully painted pictures'.[31]

It was a chance discovery, among the books of another of his

father's apprentices, that offered a more solid base and eminent authority for young Haydon's arguments. 'Labour is the only price of solid fame,' Sir Joshua Reynolds had declared in his first discourse, delivered at the opening of the Royal Academy of Arts on 2 January 1769, 'and that whatever their force of genius may be, there is no easy method of becoming a good painter.'[32] Application could overcome the greatest of obstacles – even that seemingly insurmountable one, for a visual artist, of poor eyesight. The *Discourses* 'placed so much reliance on honest industry', Haydon recalled, 'expressed so strong a conviction that all men were equal . . . that I fired at once. I took them . . . and read them through before breakfast the next morning.' He arrived at table with the book under his arm, and that first meal of the day must have been a stormy one. 'I demolished all arguments. My mother, regarding my looks, which probably were more those of a maniac than of a rational being, burst into tears. My father was in a passion and the whole house was in an uproar. Everybody that called during the day was had up to bait me, but I attacked them so fiercely that they were glad to leave me to my own reflections.'

One of his father's customers, however, gave practical advice – not entirely unrelated to Signor Fenzi's 'draw *de feegoore*'. Samuel Northcote advised Haydon to study anatomy. Later, Samuel's brother, the Academician James Northcote, would provide precisely contrary advice.

In June 1803 the library of the late Dr Farr was put up for auction at Plymouth Naval Hospital. A particular volume listed in the catalogue caught Haydon's eye: Bernard Siegfried Albinus's *Tables of the Skeleton and Muscles of the Human Body*, translated from the Latin and published in 1749. The would-be student of anatomy attended the sale and bid for the large folio volume, and it was knocked down to him for two pounds ten shillings, a sum that he did not possess. It was the first, but not the last, occasion in his life when he would purchase goods without the means to pay for them. He went home and convinced his mother to intercede with his father, who settled the liability with ill grace. Haydon retreated to his room with his prize.

He opened the book, and a smiling cherub frozen in the act of whipping away a billow of drapery – as though at the climax of a

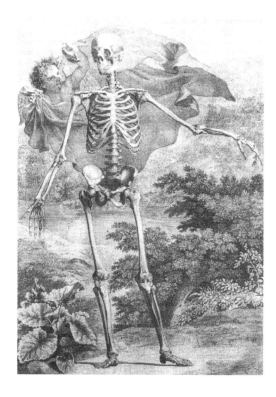

conjuring trick – revealed a standing male skeletal figure, seen from the front. Other plates showed the same figure from the back and the side. Nine more presented the figure stripped of skin, then stripped of successive layers of musculature: four viewed from the front, four from the rear and one from the side. Finally, a further sixteen plates presented composites of individual bones, muscles, internal organs and veinous, arterial and nervous systems. Each bony or flayed figure displayed his miraculous intricacy with mournful elegance against varying backgrounds of romantic landscape: rocks and blasted trees, lush wooded valleys, precipitous ravines, with here and there a cracked urn, a mausoleum or a corner of masonry. A couple of plates incorporated a large, and entirely gratuitous, two-and-a-half-year-old female rhinoceros, occupying most of the background. It was included, Albinus explained, in the belief that 'the rarity of the beast would render these figures . . . more agreeable than any other ornament, resulting from mere fancy'.[33]

The student set himself to learn, recruiting his little sister, Harriet, to test him:

'How many heads to the deltoid?'

'Three.'

'Where does it rise?'

'From the clavicle, and from the acromium and spine of the scapula.'

'Where is it inserted?'

'The humerus.'

'How many heads to the levator scapulae?'

'Four.'

'Where does it rise?'

From the atlas, from the – now, don't tell me – the epistrophaeus[34] and from the third and fourth cervical vertebrae.'

'Where is it inserted?'

'The scapula . . .'

Within a fortnight, Haydon claimed to know every muscle and bone by heart.

His father's opposition having gradually been worn down, and his tearful mother painfully reconciled to the fact that her son's resolve would not be shaken, it was finally agreed that he be given twenty pounds to begin with and allowed to go to London to study at the Royal Academy of Arts for two years 'on trial'. Lodgings were secured for him in the Strand, close to what would be the centre of his activities, Somerset House. Although tuition at the Royal Academy Schools was entirely free of charge, admission was not straightforward and needed to be eased by personal connection with an Academician. Haydon's uncle, Benjamin Cobley, furnished him with a letter of introduction to an old friend: Prince Hoare.

Haydon would need to leave Plymouth by late spring if he was to reach London in time to see the great extravaganza of fine art, mounted each year by the Royal Academy at Somerset House, and which was known to Society, in the absence of any other comparable spectacle, simply as: The Exhibition.

On a Monday in May 1804, he reserved his place on the mail coach. In the afternoon, with his trunks on top of the vehicle, he took his seat inside. '[T]he whip cracked, the horses pranced and started off – [his] career for life had begun!' Haydon senior noted in his diary: '14th May. – Ben started for London. Weather fine. Wind east.'[35]

He was advised, by a fellow passenger, not to break his journey in Exeter and, instead, to travel on overnight. Accordingly it was at dawn, on the Tuesday, somewhere past Maidstone, when the dome of St Paul's was pointed out to him in the distance. He strained his eyes and said 'Is it really?', but could see nothing 'but some spots in the cold grey light of the breaking morning'. The coach rattled through the village of Kensington – affording views to the north of the pastured and meadowed slopes of Notting Hill – and along Knightsbridge, but it was not until they had passed the toll-collectors' lodges and gates of the Hyde Park turnpike that his fellow passengers pronounced him to be truly in London.

The coachman pulled up at the White Horse Cellar in Piccadilly, where the majority of passengers alighted, but since the lodging house booked for Haydon lay a considerable distance further on, he was advised to stay on board until St Clement's Coffee House at the eastern end of the Strand. As they approached this final stage, they passed Somerset House, home of the Royal Academy of Arts, on their right. However, it was a large ornate building on the left that caught Haydon's eye, standing on its own island and taking up fully half the width of the thoroughfare. He leaned out of the window and shouted up to the guard: 'What building is that?' But the guard, assuming the young man to be enquiring about the edifice they had just passed on the right, shouted back: 'Somerset House'.

'Ah!' thought Haydon, 'there's the Exhibition, where I'll be soon!'

So, having deposited his luggage at his lodgings, washed, changed and breakfasted, it was to the church of St Mary-le-Strand that he hurried for his first sight of High Art. His acceptance, without question, of a church as housing the Royal Academy he explained many years later. 'Our churches in Devonshire are all Gothic,' he declared, and very different from the 'flimsy style' and 'gaudy exterior' of James Gibbs's neoclassical structure. It was the beadle, guarding the steps of St Mary's with staff, cocked hat and cloak, who gently turned away the young acolyte proffering his shilling and directed him across the street. Had the acolyte looked up to the top of the building that the beadle pointed out to him, and had his eyesight been stronger, he might have discerned the two winged figures perched on the roof, flanking the arms of the British Empire. They represented Fame and the Genius of England.

Fame blew a trumpet while the finger of Genius pointed at the base of the quartered escutcheon and, beyond it, towards the crowded Strand below, as though singling out for her approval the young man from Devonshire hurrying across from St Mary's church. Reaching the pavement and passing through one of the three open archways of Somerset House, he entered a lofty, Doric-columned Vestibule, four bays in depth and disclosing, at its far end, the immense courtyard beyond, dominated by the bronze monument to the reigning, but ailing, monarch, George III. A bust of Sir Isaac Newton presided to the left of the Vestibule, where the Royal Society and Society of Antiquaries had their accommodation. Haydon turned the other way, towards the craggy features of Michelangelo, and walked through a door on the right.

In the small Entrance Hall he was at last parted from his shilling by an attendant and received in return a catalogue and admission to the thirty-sixth Exhibition of the Royal Academy. Sculpture and architectural drawings were to be found on the ground floor to the right, but no one, save those with a special interest in viewing statues, busts and miniature domes, poorly lit, would bother with this gloomy chamber – the Model (or Life) Academy during term time – until they were on their way out of the building, if at all. Important watercolours and drawings were displayed in the Council Room on the first floor. Other drawings, engravings and paintings jostled for attention in the Library, or in the Antique (or Plaister) Academy, where they had to compete with the permanent collection of Roman and Greek casts. Copied by generations of students before and since, the *Apollo Belvedere*, the *Belvedere Torso*, the *Borghese Gladiator*, the *Dying Gladiator*, the *Dancing Faun*, the *Discobolus*, the writhing complexity of *Laocoön* and his sons wrestling serpents, formed the plaster bedrock of the art education that Haydon had arrived in London to acquire.

Casts were the first objects to meet his eyes as he crossed the threshold of the Entrance Hall. The *Furietti Centaurs* occupied plinths on either side of a short flight of stone steps leading up to the central pair of Doric pillars. Beyond these, a gigantic nude figure, known as the *Farnese Hercules* – which George, the apprentice, had spoken of – with lion-skin and a club like a tree trunk, loomed in the stairwell.

But to inspect what might ultimately be accomplished, through an education that began by copying such casts – High Art, as it was under-

stood by the Royal Academy and by the country at large – Haydon had to climb.

Mounting the semicircular spiral of the staircase, he was intended by the architect of Somerset House, Sir William Chambers, to be aware of hard-won architectural progress: leaving behind, in the Vestibule and Entrance Hall, the solid Doric order and ascending, by intermediate stages, to the pre-eminent sophistication of the Corinthian, bathed in the glow of the great circular skylight at the top.

With the first curving flight of stair, skirting the muscular buttocks and shoulders of Hercules, and reaching the mezzanine landing, the ram's-horn Ionic order was attained. A panel by Cipriani represented 'several Genii employed in the study of Painting, Sculpture, Architecture, Geometry, and Mechanicks'. At the first-floor level, the Composite or Roman order ruled. Between this and the Corinthian climax of the ascent, there was a half-space landing, thoughtfully placed by Chambers on this particularly precipitous section of stair to enable the climber to catch his breath. Here was displayed another Cipriani panel: *Minerva Visiting the Muses on Mount Parnassus*. The mythical theme was continued as the visitor, having reached the summit, crossed the top landing and entered the small square Ante-Room: a *Sacrifice to Minerva* on one side, the *Marriage of Cupid and Psyche* on the other, both by Rigaud. Cupid and Psyche were, a guide book to the Academy pointed out, emblematic 'of the mental and executive faculties requisite to constitute a perfect Artist'.[36] The Ante-Room itself, however, was a far-from-perfect place for that Artist to exhibit. Ill lit and congested, it could be a grave disappointment for those unfortunate enough to have their work consigned to its walls, and the public, as if sensing it to be a harbour for the second rank, generally moved eagerly through this chamber, looking barely to right or left, and into the Great Room.

The admission charge paid in the Entrance Hall had been enforced since 1780, its rationale being explained by the Catalogue of that year: 'to prevent the Rooms from being filled by improper Persons, to the entire Exclusion of those for whom the Exhibition is apparently intended'.[37] And lest there were any doubt as to the type of person for whom the Exhibition was intended and the 'improper Persons' for whom it was proscribed, the legend on the lintel of the door giving

access to the Great Room was in Greek – ΟΥΔΕΙΣ ΑΜΟΥΣΟΣ ΕΙΣΙΤΩ – an injunction which the properly educated might loosely translate as 'Let no Stranger to the Muses enter'.

Haydon entered.

Light came from high above, seemingly from the blue, cloud-puffed sky painted to create the illusion of a large, round hole cut in the ceiling. In reality the light came from four broad, semicircular Diocletian windows set into the clerestory just below the painted surface. As if to show the full extent of the climb from the street, the north-facing window afforded a rear view of Fame and the Genius of England outside on the roof. In the corners of the square ceiling left by the circle of sky, groups of chubby putti played at Painting and Sculpture, Architecture and Geometry.

The paintings were hung tightly packed together, from floor to the coving below the windows. Frame abutted frame, tops to bottoms, sides to sides, in a complex assemblage for which Messrs Farington, Dance, Loutherbourg and Smirke, that year's Committee of Arrangement, were responsible. Small and medium-sized paintings were hung at eye level or lower. Larger canvases rested on 'the line', a dado rail running

at door-height around all four walls. In order to cram as many works into the Great Room as possible, a number served merely to plug gaps high up in the arrangement, but such woefully 'skied' works generally went unnoticed by the crowds milling twenty feet below. All paintings on and above 'the line' were mounted on a temporary framework of wooden laths inclined at an angle of thirty degrees or so from the vertical, and they swept out over Haydon as he craned his neck and gaped up at them. It must have looked as though each patchwork wall of painted canvas and gold-leaved moulding had been erected so high that it was teetering over at the top and could come crashing down on the spectator at any moment.

Despite the best efforts of Joseph Farington and his colleagues, the positioning of work was not to everyone's taste. 'The general arrangement of the pictures is extremely injudicious and defective,' reported the *Times* correspondent. 'They are disposed without a sufficient regard to that harmony of colour and *unity of effect*, which are so essential to please a correct and experienced eye.'[38]

That year there were 229 paintings displayed in the Great Room, not counting the 142 miniatures clustered, barnacle-like, around the fireplace in the east wall.[39] Works were numbered in the Catalogue according to the order of their placing, clockwise about the room. Number 1, the portrait of a *Mr and Mrs Rolls*,[40] was above the door at which the visitor entered, in the west wall. Number 229, a view of Bishopsgate Bridge in Norfolk,[41] fetched up to the left of the door. Views and portraits, as in previous years, accounted for well over half the number of works on show. There were 106 portraits in the Great Room alone, ranging from Sir Thomas Lawrence's 'brown and dusky' whole length of Mrs Siddons, dominating the south wall, 'considerably larger than nature,'[42] according to *The Times*, to umpteen indeterminate portraits 'of a gentleman' or 'of a lady'. There were also several portraits of dogs, the most noteworthy being *Trim*, 'a favourite terrier', the Catalogue entry explained, 'who accompanied his master, an officer in the army, through the Egyptian campaign'.[43]

Haydon looked about him for historical pictures: those works executed in what Sir Joshua had called 'the great style'[44] where the noble protagonists of the past, of scripture, of myth, of literature or other edifying themes, were presented in more than human scale and

physique, gesturing in a manner befitting their dignity and heroism, and clothed, where appropriate, not in the workaday fabrics of muslin, wool, cotton or silk, but in the heightened stuff of 'drapery'. Had he experienced any prior misgivings as to the quality of the historical paintings he would be setting himself to compete with and surpass, he might have drawn some comfort from *The Times* a fortnight earlier:

> A few historical works are thinly scattered through the rooms; but these are not of such a character as to lead us very deeply to regret that they constitute so inconsiderable a proportion of the whole collection.

Occupying a central position, thirty canvases to the right of the door, was an apocalyptic composition by the President of the Academy himself, the American painter Benjamin West. *The Destruction of the beast and the false prophet* had prancing forces of light to one side, the snarling chaos of routed evil to the other and was accompanied in the Catalogue by verses from the Book of Revelation. On the same wall were other works inspired by the same source – John Francis Rigaud's *St John in the Island of Patmos* and Henry Howard's *The Sixth trumpet soundeth* – each accompanied by relevant verses.

The *Times* critic had been particularly scathing about Benjamin West's offerings this year. His *Cicero and the Magistrates of Syracuse ordering the tomb of Archimedes to be freed from the bushes that obscured it* was singled out as a work 'totally destitute of what the Artists technically term *atmosphere*'. Sly reference was also made to *Hagar and Ishmael*, notoriously rejected by the previous year's Committee of Arrangement, on the grounds that it had already been shown twenty-eight years before in the 1776 Exhibition, despite the artist's assurances that he had completely reworked the picture since then. West had come close to resigning his presidency over the issue, but this year he had won the argument and the large canvas occupied a prominent position to the left of the door. The critic from *The Times* archly assured his readers: 'This, *of course*, is not the same performance which was excluded from the Exhibition of the last year.'[45]

West being the most eminent exponent of historical painting contributing to the 'thinly scattered' showing of such works, Haydon would also have scrutinised his *Last Supper*, the *Tobias received by his blind father* in the middle of the north wall, and his *Venus lamenting*

the death of Adonis to the left of the fireplace. But decades later, recalling this first visit to the Exhibition in his *Autobiography*, Haydon made mention of neither West nor any of the nine canvases bearing his name in the Catalogue. And if he experienced any enjoyment or excitement at his first sight of High Art in the Great Room of Somerset House, his memoir gave no flavour of it. The only two works he remembered making any impression upon him at all were John Opie's illustration of a scene from *Gil Blas* and the forlorn *Shipwrecked Mariner* by Henry Thomson, which 'was the wonder of the crowd'.

Having viewed the best that the Genius of England had to offer in that year of 1804, the eighteen-year-old Haydon marched away from the Exhibition undaunted, even defiant, inwardly addressing the Academy: 'I do not fear you.'

<div align="center">★</div>

Each student, who offers himself for Admission into the Royal Schools shall present a Drawing . . . from some Plaister Cast to the Keeper, and if he thinks him properly qualified, he shall be permitted to make a Drawing . . . from some Casts in the Royal Academy, which if approved of by the Keeper . . . shall be laid before the Council for their confirmation, which obtained he shall receive his Letter of Admission as a Student in the Royal Academy.[46]

It was to comply with the first stage of this admission procedure that Haydon went directly from his reconnoitre of Somerset House to a purveyor of plaster casts in Drury Lane. Here he purchased a cast of *Laocoön*'s head, together with 'some arms, hands and feet' and, back in his room, unpacked his copy of *Albinus* and set himself to work. He saw practically no one for the next three months:

I rose when I woke, at three, four, or five; drew at anatomy until eight, in chalk from my casts from nine to one and from half-one until five – then walked, dined, and to anatomy again from seven to ten and eleven.

He did not leave his room for a fortnight at a time, 'and the people of the house used to send up and beg he would not kill himself'.[47]

Once, having gone without speaking for a particularly long period of sustained concentration, he discovered that the grinding, clenched tension of his teeth had painfully inflamed his gums.

His studies were soon augmented by the acquisition of *Anatomy of the Bones, Muscles and Joints* by John Bell, Surgeon, which he carried home, hugged to his chest, from Cawthorne's bookshop in the Strand. It provided a startling contrast to the nobility of Albinus's Arcadian visions of the dissected human form. A student opening Bell's *Anatomy* would be admirably prepared for the degraded horrors, the gruesome excavations of flesh, everything but the stench, of the dissecting room. The macabre tone was set by a plate showing muscles of the face, neck, throat, shoulder and breast. The body was slung on a rope passing across its chest, under both armpits and hoisted from above, so that the right shoulder was grotesquely higher than the left. The entire face had been skinned, as had the neck, left shoulder and part of the chest. The scalp had been pulled well back over the crown of the head, while a ragged sheath of skin pulled down to the midpoint of the upper arm looked like a half-discarded sock. The position of the head against the high right shoulder was explained by the surgeon's commentary: 'drawn from a subject that had been hanged, and the neck being broken, the head lies flatter upon one shoulder, than it should do even in the dead body; for the Atlas and Dentatus, the two first Vertebrae of the Neck, were fairly broken loose from each other'.[48]

Another corpse, of unspecified but no doubt sinister provenance, lay prone on a table, a rope lashed round the ankles, suspending the lower legs in a vertical position from the knees. At the other end of the table, a head was concealed somewhere under the ragged blanket of skin flayed and thrown forwards from buttocks to neck. Skin from the body's flank hanging down over the edge seemed to serve as a tablecloth. The lobed and knotted muscular structure of the entire back was exposed like peeled fruit.

Haydon was delighted with his purchase. It became, in time, the textbook of his own students. Forty years later, an embittered and thwarted man, he would write in a margin of the battered, worn, heavily scored and annotated volume a list of those beneficiaries and of their dishonoured obligations to him.[49]

His regime of study during those first months in London did not extend to the Sabbath. On the Sunday following his arrival he returned

to St Mary-le-Strand, establishing the habit of special pleading with the Almighty that he would retain for the rest of his life:

> I [humbly] begged for the protection of the Great Spirit, to guide, assist and bless my endeavours, to open my mind and enlighten my under-standing. I prayed for health of body and mind, and on rising from my knees felt a breathing assurance of spiritual aid which nothing can describe. I was calm, cool, illuminated as if crystal circulated through my veins. I returned home and spent the day in mute seclusion.

On the rare occasions he ventured out in public for purposes other than feeding and worship, he went in search of history paintings. Having found the Academy's Exhibition wanting, his favoured resort was the Shakespeare Gallery, Alderman John Boydell's ill-starred enterprise at 52 Pall Mall. The engraver and print publisher had hoped his collection of 162 commissioned paintings of Shakespearean subjects would inspire a great national school of history painting, and intended to leave it to the nation for that purpose. Instead, they were all sold by lottery to settle debts later in 1804, the year of his death. It was an ominous moment for Haydon to embark on his career, one established on similar ambitions of founding a school of history painting and doomed likewise to end in ruin.

Towards the end of the year he set about gaining access to the more formal, supervised art education that the Royal Academy offered, and made use of his uncle Cobley's letter of introduction to Prince Hoare. A failed painter and a writer of farces and libretti, Hoare was 'a delicate, feeble-looking man, with a timid expression on his face, and when he laughed heartily, he almost seemed to be crying'. He held the honorary post, previously held by James Boswell, of the Royal Academy's Secretary for Foreign Correspondence. Haydon showed Hoare his drawings and explained the principles governing his course of anatomical study. The older man was 'much interested', told him that he was right and urged him not to be 'dissuaded from [his] plan'. Haydon flushed at the very idea of dissuasion.

Hoare furnished him with letters of introduction to two painters who might offer more practical advice, and Haydon made his way first to a house at 39 Argyll Street, in Soho. He would have seen works by James Northcote in the Great Room at the Exhibition, all of them

portraits and, had he lingered in the Ante-Room, a tiger-hunting scene. Northcote was a direct link with Sir Joshua Reynolds, having been the great man's assistant for a number of years, and would soon write the first biography of him. Haydon was shown upstairs and into a filthy painting room, where Northcote greeted him. He was about fifty-eight, bald and grey, 'a diminutive wizened figure in an old blue-striped dressing gown, his spectacles pushed up on his forehead'. Like his young visitor, he hailed from Plymouth, and Haydon's account of their conversation suggests that six years' residence in Italy and nearly thirty in London had done nothing to eradicate his Devonshire accent:

'Zo, you mayne tu bee a peinter, doo-ee? What zort of peinter?'

'Historical painter, sir.'

'Heestoricaul peinter! Why, yee'll starve with a bundle of straw under yeer head!'

Then:

'I remember yeer vather, and yeer granvather tu; he used tu peint.'

'So I have heard, sir.'

'Ees; he peinted an elephant once for a tiger, and he asked my vather what colour the indzide of's ears was, and my vather told-un reddish, and your grandvather went home and painted un a vine vermillion.'

Receiving no response from the young man to this curious anec-dote about old Robert Haydon, Northcote glanced again through Hoare's letter:

'I see Mr Hoare zays you're studying anatomy; that's no use – Sir Joshua didn't know it; why should you want to know what he didn't?'

It may have occurred to Haydon to cite Northcote's own brother, Samuel, as the man who first advised that direction of study. Instead, he reminded the Academician of the anatomical studies of a much earlier authority.

'But Michel Angelo did, sir.'

'Michel Angelo! What's he tu du here? You must peint portraits here!'

'But I won't.'

'Won't? but you *must*! Your vather isn't a monied man, is he?'

'No, sir; but he has a good income, and will maintain me for three years.'[50]

'Will he? He'd better make'ee mentein yeezelf.'

Haydon took his leave: 'Shall I bring you my drawings, sir?'

'Ees, you may.'

Walking to the end of Argyll Street, he turned right onto Oxford Street, then left into Berners Street, the corner distinguished by a golden lion. His next appointment was with one of the two painters whose work had attracted his attention at the Exhibition. John Opie was forty-four years old and soon to become the Academy's Professor of Painting, an office he would hold until his premature and harrowing death[51] only two years later. His initial comment after reading Hoare's letter of introduction was considerably more encouraging than the interview in Argyll Street had been. Opie, known as 'The Cornish Wonder' on his first appearance at the Academy in 1782, was another West Countryman, but if he had any pronounced accent, Haydon made no allusion to it:

'You are studying anatomy. Master it. Were I your age, I would do the same.'

'I have just come from Mr Northcote, and he says I am wrong, sir.'

'Never mind what *he* says, he doesn't know it himself, and would be very glad to keep you as ignorant.'

It was a promising start, but Opie's response to the next question aroused Haydon's suspicions:

'My father, sir, wishes me to ask you if you think I ought to be a pupil to any particular man.'

There was an eagerness in the reply: 'Certainly; it will shorten your road. It is the only way.'

Haydon left and 'mused the whole day on what Northcote said of anatomy, and Opie of being a pupil'.

The following day he returned, as arranged, to Argyll Street with his drawings. The reaction to his work was predictably discouraging. Having recovered from his bout of cackling, Northcote conceded that the would-be historical painter had the makings of a sufficiently good engraver. Haydon ignored the slight and enquired: 'Do you think, sir, that I ought to be pupil to anybody?'

The answer came, blunt and to Haydon's liking: 'No, who is to teach'ee here? It'll be throwing your vather's money away.'

'Mr Opie, sir, says I ought to be.'

'Hee zays zo, does he? Ha, ha, ha, he wants your vather's money!'

On reflection, Haydon trusted Opie's opinion over Northcote's on the subject of anatomy, and Northcote's over Opie's on the subject

of pupilage. He decided that 'on these points both were wrong' and resolved to continue as he was.

Prince Hoare next introduced Haydon to the most powerful and intimidating of mentors. On Christmas Eve 1804, the Academy's Professor of Painting, John Henry Fuseli – 'The Wild Swiss' – had been made Keeper, Robert Smirke's election to that post having been overruled by George III on account of Smirke's outspoken democratic political opinions. But when Hoare's protégé visited him, in the first week of 1805, Fuseli had not yet occupied the Keeper's lodgings in the basement of Somerset House and was still a close neighbour of Opie's, in Berners Street. Carrying his sketchbooks and crossing Soho by way of Wardour Street, Haydon considered the man he was about to meet. Fuseli 'had a great reputation for the terrible'. It was a reputation established a little over twenty years previously with a painting that has proved a source of fascination ever since to surrealist and psychologist alike. *The Nightmare* showed a sleeping woman, her body arched backwards over the side of a bed, with a grinning, spike-eared homuncule squatting on her chest, while a demonic horse's head – blank, white, bulbous eyes and flaring nostrils – appeared through the curtains behind. Haydon had 'relished and brooded' on a print of Fuseli's *Uriel and Satan*[52] in his father's shop window, and still had 'a mysterious awe' of the celebrated painter. His apprehension of the coming encounter was shared by Prince Hoare, who was concerned that Fuseli might injure Haydon's taste and even his morals. Haydon senior was also familiar with the new Keeper's reputation: 'God speed you,' he had written to his son, 'with the terrible Fuseli.'

So nervous was he that, finding himself at last in front of number 13 Berners Street, Haydon swung the knocker with such force that it rebounded from the door and stuck out at an angle. Struggling to replace it in its proper position, he accidentally drove it down with as much force as before and produced a second violent report. The startled maid looked, 'as if the house was burning' but in response to his stammered request, she led Haydon into the room in which her master showed off his work to prospective clients and left him there. On every wall there were images 'enough to frighten anybody at twilight', he recalled. 'Galvanised devils – malicious witches brewing their incantations – Satan bridging Chaos, and springing upwards like a pyramid of fire – Lady Macbeth – Paolo and Francesca – Falstaff

and Mrs Quickly – humour, pathos, terror, blood, and murder, met one at every look!' At length he heard a footstep, and, as if stage-managed in keeping with the room's macabre decorations, a skeletal hand slid round the edge of the door. The hand was followed by, 'a little white-headed lion-faced man in an old flannel dressing-gown tied round his waist with a piece of rope and upon his head the bottom of Mrs Fuseli's work-basket'. His eccentric garb and sinister reputation notwithstanding, Fuseli breezily dispelled his visitor's apprehensions, made him welcome and asked to see his drawings.

Instead of handing over his studies from the Antique – essential if the Keeper was to judge him fit for the Academy – Haydon inadvertently proffered his sketchbook, and Fuseli opened it at the drawing of a man pushing a sugar barrel into a grocer's shop. Whether referring to the subject or to the draughtsman, Fuseli's amused comment revealed his strong Swiss accent: 'By Gode, de fellow does his business at least with eneargy.'

Like Opie, like Hoare, but unlike Northcote, Fuseli approved of the direction of Haydon's labours: 'You are studying anatomy – you are right.' And then: 'I am Keeper of de Academy, and hope to see you dere de first nights.'

<center>★</center>

The invitation granted Haydon admission, as a Probationer, to the first floor of Somerset House and there, among the plaster casts, he renewed his acquaintance with the 'terrible' Fuseli. It was the evening of 21 January 1805 and the Winter Academy was resuming, after the Christmas vacation. 'I know enough of you,' the Keeper roared, pointing a finger at Haydon. The implication was that he knew enough of the young man to realise his worth, but the statement, delivered in a voice of thunder, sounded so much like an accusation that the other students whispered to Haydon: 'Why, what does he know of you?' And he himself had the disconcerting feeling he had 'unconsciously been guilty of murder'.

That Monday night he made an alarming discovery. Instructed to draw one of the plaster casts, and being seated some distance away, he found that he could not see it. He had not been so aware of the defect in his vision while working closely, for the past seven months,

in the small space of his lodgings. But now, fifteen feet away from the object, in the Antique Academy, he could barely distinguish a feature. He would soon find a corrective to this undeniable handicap for a painter, in the purchase of his first pair of spectacles.

The following day he made a friend. John Jackson was 'a little good-natured looking man in black with his hair powdered, whom [he first] took for a clergyman'. He was from Whitby in Yorkshire and a protégé of Lord Mulgrave and Sir George Beaumont, two men who were to play their parts in the development of Haydon's own career.

Another early friend, his identity disguised by the initial L in Haydon's *Autobiography* because of the unflattering description it contained, was John Bryant Lane, a Cornishman:

> a pompous little fellow who was always saying, 'God bless my soul.' He was patronised by Lord D[e Dunstanvill]e, looked down on me for not drawing with spirit – thought lightly of Jackson because he studied effect – and meant himself to be a grand painter, because – he had a noble patron! He had an awful feeling for the grand style – Oh, the grand style! – and marched about us like a tutor.

And it was probably Lane, 'a student gifted with more self-conceit than genius', who fell victim to the Keeper's sarcasm on one occasion. At this time, and, indeed, well into the twentieth century, art students used pieces of bread as erasers to correct their drawings, and the young man – handing his finished work to Fuseli – asked if 'it wanted any bread'. The Keeper, perceiving false modesty, 'thundered out: "Yeas, gate a loaffe and youse it all."'[53]

Haydon's dogged application, by contrast, impressed the old man. 'Why, when de devil *do* you dine?' he demanded one evening, noticing the Probationer still at work when all his fellows had departed, and invited him down to the Keeper's apartment for dinner. Haydon's industry even enabled Fuseli to look with indulgence upon occasional bouts of high spirits. '[We] were all making a great row in the hall of the Academy', he recalled:

> I was standing with my back to the Academy stairs fighting them with my umbrella. Of a sudden they ran away. I turned and saw Fuseli's

fiery face behind me. Out I scampered. The next day, quite ashamed of my boyish noise, I called on him. He received me with the greatest kindness, but said, 'don't make such a damn noise. I like fun myself, but I don't like to feel as if the ceiling were coming down.'

It was probably Fuseli who affectionately dubbed them 'hell hounds'.[54]

To qualify for Letters of Admission as Students of the Academy – their 'tickets', as these were generally known – each Probationer was set by the Keeper to execute a single drawing from the *Discobolus*. Haydon approached the task as he might a full-scale composition and, compensating for his poor eyesight, ensured that he had mastered every detail of the athlete's figure, by producing preliminary sketches, of the hands and feet, and making studies of the way light fell across different parts of the body. The Academy Council sat on the evening of 9 March 1805. It comprised the President and John Inigo Richards, the Secretary, John Hoppner, Robert Smirke, Thomas Stothard and Henry Thomson. The Keeper presented his Probationers' work for inspection. The President himself praised Haydon's drawing of the *Discobolus*, telling Fuseli 'that it had the exact leap and action of the figure'. Haydon, Jackson, Lane and fifteen other Probationers all received their 'tickets' as Students of Painting.[55]

Haydon continued his studies after the end of term – twelve to fourteen hours a day – fully intending to remain in London throughout the vacation. But a letter from home, informing him that his father was dying, interrupted his plans. He packed immediately and boarded a west-bound coach, resigning himself to the possibility of missing the Exhibition, which was to open on 29 April. In the event, it proved to be as uninspiring as the one he had seen twelve months previously. 'You won't lose much by not seeing this year's exhibition,' Jackson told him later. 'It is an —— of wretchedness.'[56] He could not even bring himself to supply the elision.

Haydon arrived in Plymouth, after two days' travel, to find his father out of danger, but much exhausted. Mrs Haydon, shaking her head when she saw her son's spectacles, by turns laughing, weeping, imploring, 'Don't leave us again – don't leave us again', clasped him to her, murmuring over and over, 'Don't leave me, don't leave me.'

In the hurry to leave London, he had fortunately taken the precaution of packing his drawing materials, and on the day following his

arrival he visited Plymouth Naval Hospital: 'got bones and muscles from the surgeon . . . and was hard at work that very night'.

Jackson wrote at the end of May. There was no urgency for Haydon's return to London because, when the Exhibition closed in June, 'the Academy [would] not be fit for the reception of the "hell-hounds" before July'.[57] The beginning of the summer term may also have been delayed by the necessary recuperation of the Keeper, who was 'laid up in consequence of bruises occasioned by being thrown down by a Coach'[58] on his way home from the theatre. 'Poor dear Mr Fuseli' had been in the country ever since, but 'he [was] doing well again', according to Jackson, who did not allow the delayed resumption of the Academy to hold his studies back:

> I have had the pleasure of meeting an old acquaintance and schoolfellow a Surgeon thro' whom I have seen many curious and valuable preparations, dissections and Anatomical theatres, Museums . . . I purpose having a subject myself in order to dissect in the Autumn, will you join me?[59]

Meanwhile, Haydon continued to make correct copies of the 'dry bones and drier muscles', from Plymouth Naval Hospital. In July, at the beginning of the new term, Jackson wrote again to inform his friend of an interesting addition to the 'hell hounds' number: 'Make haste back; there is a queer, tall, pale, keen-looking Scotchman come into the Academy to draw . . . There is something in him! He is called Wilkie.'[60] As Haydon prepared to leave his family to resume his artistic studies, he reflected on the newcomer: 'Hang the fellow, I hope with his "something", he is not going to be a historical painter.' His concern on this point was increased when he reached town and was told by Jackson that Wilkie had already painted a scene from *Macbeth*, 'the murder of Macduff's wife and children',[61] before leaving Edinburgh. Jackson said the Scot 'drew too square' for his taste, but that he did so with 'great truth'. Lane thought his style vulgar. 'What does Fuseli say?' asked Haydon. 'Oh,' Jackson replied, 'he think's dere's something in de fellow!'

Haydon had not renewed his tenancy in the Strand, but had taken an upper room at 47 Carey Street, a dogleg running from Portugal Street to Chancery Lane. Twenty years later he recalled himself here,

at the age of nineteen in 1805, unable to draw or paint because of a recurrence of his eye infection, lying back in a chair and mentally working out a composition for *The Judgement of Solomon*. Later still, in 1840, he would climb the stairs and, surrounded by ghosts, stand again in his old lodgings, musing on the companions assembled in that room 'when I was ill in my eyes . . . 34 years ago'.

He told two versions of his first encounter at the Royal Academy with David Wilkie. One has his rival 'most punctual of mankind',[62] in the class before him. In the other, Wilkie arrived 'an hour after'. Both accounts agreed on the way the two young men sized one another up:

> We sat and drew in silence for some time: at length Wilkie rose, came and looked over my shoulder, said nothing, and resumed his seat. I rose, went and looked over his shoulder, said nothing, and resumed my seat. We saw enough to satisfy us as to each other's skill.[63]

Nevertheless, as Haydon was delighted to point out in later life, Wilkie 'moved first'.[64]

It must have been a slight disappointment to Haydon that on the next day, when he brought in the anatomical drawings he had completed in Plymouth during the summer, and the other students crowded round him, as the centre of admiration and attention, the Scotsman was not present. Wilkie's first impression of his fellows at the Royal Academy was 'that they seemed to think nothing good but what was 300 years old'. Haydon conceded, in retrospect, that he and Jackson 'maintain[ed] the old Masters against the Moderns'. It might have been upon this contentious subject that Wilkie and Haydon argued a day or two after their mutual appraisal. Neither party to the dispute gave ground, and afterwards they went and dined together. By the end of term they did so habitually:

> We used to dine at an ordinary in Poland Street, in a house on the right. You passed through the passage and came to the dining-room with a skylight in it. Many French came there . . . Sometimes we used to dine at a chop-house at the back of Slaughter's Coffee House, in St Martin's Court; and very often at John O'Groat's in Rupert Street.

There was also 'a second rate French Coffee House' in Gerrard Street, called the 'Nassau'. Another dinner companion, at Slaughter's, was a landscape painter ten years older than Haydon, John Constable.

Haydon did not stay long in Carey Street, moving to second-floor rooms 'more to the West End, as better for health', at 3 Broad Street[65] in Soho. Wilkie had a front parlour, even further west, on the edge of fields that would soon become the Regent's Park, at 8 Norton Street.[66] Invited to breakfast one morning and arriving early, Haydon found the lanky, red-haired Scot sitting stark-naked on his bed, drawing himself in a full-length mirror. It was 'copital practice', he drawled, and the embarrassed guest strolled in the fields for an hour until his friend was ready and decent for breakfast. After eating, Wilkie showed him a painting he had done at the age of nineteen, of a village fair. 'The colour was bad, but the grouping beautiful, and the figures full of expression.' It might have comforted Haydon to see that, far from being a rival historical painter, the young man was a painter of genre, owing more to Teniers than to Rubens.

For those students who had not considered Wilkie's canny use of

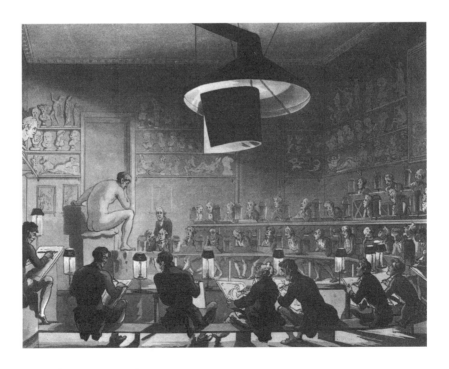

his own body as a pictorial resource, there was the Model Academy. After being given their 'tickets' – proof that they had mastered the art of drawing from plaster – they had to submit a further drawing from the Antique to qualify them for permission to draw from the living flesh. In the lofty, square room to the right of the Entrance Hall, a flaring chandelier was heavily shaded in order to direct light, and whatever heat was not escaping upwards through the enormous conical flue, upon the nude model. This individual posed at the focus of two curving tiered benches, each student's place being lit by his own shaded candle. Unlike the Antique Academy, which was solely governed by the Keeper, the Model Academy was supervised by a different Academician rotating as 'Visitor' every month. One month an historical painter might be in charge, the next a painter of portraits, then a landscape painter, each with an entirely different set of criteria as to what the students were to gain from the exercise. Many years later an eminent landscape painter, as Visitor, attempted to create a Garden of Eden on the central dais: 'brought down a large quantity of plants in pots, orange and great lemon trees, and put them all round a naked figure in which he wanted to set off the flesh of the model and make an Eve of it'.[67]

Perhaps because of the lack of continuity in its supervision, there was considerable apathy among the student body. On a Monday evening in early 1805, when Hoppner was Visitor, only one student attended, and the following evening '*not one* had appeared at 7 o'clock – on which he told the model to go away'. This, according to Joseph Farington, showed 'to what a state of indifference the Students have arrived'.[68] Towards the end of that year the President himself 'looked in . . . & found the students in general very backward'. In the Antique Academy, on the other hand, 'there was very great improvement which did Fuseli's administration of the Office of Keeper great credit'.[69]

Only a few drawings have survived testifying to Haydon's attendance. A page of three rough studies of a naked man, posing with a walking stick for support, is dated 30 January 1806.[70] A larger, more finished, undated drawing shows the same model in an energetic pose: leaning forward, right leg stretched back, left bent and braced high on a box, grasping with both hands a long pole angled at forty-five degrees to the ground. The drawing is labelled – perhaps because it

suggested to Haydon a future subject for a narrative painting, or because the pose was deliberately arranged as such by a Visitor with a literary bent – 'Robinson Crusoe on the Raft'.[71] The maritime theme was apt. The model, one Borwood, 'little Borwood' or the 'pocket Hercules' as he was called by the students, had fought the French under Admiral Rodney at the battle of the Saintes, twenty-five years earlier. No drawings by Haydon's hand have survived of the Academy's female model, said by Farington to be 'very modest in her deportment, notwithstanding Her habit of exposure & . . . lately married to a Shoemaker'.[72]

★

In early September, Haydon caught his second and last glimpse of the man he had saluted, when a schoolboy, near Stonehouse. The Hero of the Nile was again accompanied by his secretary, 'poor Scott', walking past Northumberland House at the bottom of the Strand. This time Haydon offered no salutation, but, calling at Dollond's the optician shortly afterwards, saw on the counter the night-glass that his Lordship had just purchased and the address for delivery, 'written by his own hand'.[73]

When news of the victory at Trafalgar and the death of Nelson arrived in London, Haydon was 'affected . . . for days'. He stood in the hushed, bareheaded crowd and watched the funeral cortège pass on 9 January 1806. The carriage that bore the coffin was a masterpiece of ostentation: fashioned in the form of a ship, a figurehead of Fame at its prow, *Victory* in yellow letters at the stern and, above the quarterdeck, an immense black plumed canopy embroidered with the names of naval triumphs, NILE foremost, and appropriately supported by four palm trees entwined with laurel and cypress. It showed – as a foreign correspondent suggested, and Haydon readily agreed – 'the nation's generosity and its utter want of taste'. At the end of the service in St Paul's, seamen from the *Victory* were to have placed two battle-torn Union flags and a St George's Ensign into the grave of their commander. At the last minute they tore away most of the largest flag and distributed fragments among themselves. Lascelles Hoppner, who had a seat in the cathedral through his father's court connections,[74] and somehow managed to secure one of the pieces, afterwards

gave it to Haydon: a relic 'religiously kept until it was irretrievably lost in the confusion of [his] ruin'.

Towards the end of 1805 Jackson proved true to his word in obtaining and sharing a cadaver for dissection. Characteristically, Haydon's *Autobiography* made no mention of his friend's initiative in the arrangement.

No ropes or pullies figured in the drawings that Haydon made at a private surgical establishment in Hatton Garden. The entire top of the dissecting table was hinged along one side, enabling the surface to be raised and propped at a steep angle. The subject was arranged chest-down – head and arms hanging over the raised edge at armpit level, the trunk inclined and anchored by its own weight, the buttocks and legs hanging over the lower edge of the table in a roughly standing position. With the upper body at an angle of thirty degrees, the dorsal tissues could be slit, opened and studied, with the ready convenience of a book on a lectern. One drawing showed this arrangement from the side, another from above, with half the skin of the back peeled away and hanging in long strips down the arm and side of the head.[75] The body next appeared laid on its back, arms hooked over the table-edge, a position serving to stretch the exposed pectoral muscle into a broad, red fan shape.[76] Another drawing showed the muscles and tendons of the throat, pulled taut by the weight of the backward-hanging head.[77]

The practical experience he gained in Hatton Garden enabled him to revise the anatomical studies he had completed at Plymouth. Alongside a meticulous drawing of the thighs and buttocks viewed from the side, he made the following admission: 'This was done before I saw a dissection, so that the tensor virginis femorus ends too suddenly, its fascia ought to be continued down to the knee.'[78]

Early in 1806 there was an opportunity for more formal tuition. 'At this time, a Scotchman . . . came to town, and Wilkie, taking a considerable interest in his success, asked [Haydon] if [he] would attend a class, were one to be got up, for a course of lectures on anatomy.' In addition to being a skilled but squeamish surgeon, Charles Bell was an artist. Later he travelled, on his own initiative, to Brussels, following the battle of Waterloo, to treat gunshot and shrapnel wounds, painting the more noteworthy injuries in delicate watercolours and oils. He was also responsible for the gruesome illustrations to his elder brother

John's *Anatomy of the Human Body*, the first volume of which remained
Haydon's principal textbook.

The anatomy course for artists began on Wednesday 5 February
1806 in a large first-floor room off Leicester Square. Each student paid
two guineas. The first lecture, 'Comparison of Ancient and Modern
Art – Studies of the Italian Masters', was an introduction, read from
the book that Bell was preparing for publication: *The Anatomy and
Philosophy of Expression as connected with the Fine Arts*.[79] 'They stand
with open mouth,' he told his brother George in Edinburgh, 'seeming
greatly delighted.'[80] The following week each student sat at a little
table drawing bones. Haydon was set to copy 'the skull of a Roman,
with an obolus in his mouth',[81] a relic recently acquired by Bell.

Wilkie created his first sensation at the Exhibition of 1806, with a
genre scene: *The Village Politicians*. At the Private View it attracted a
crowd, and at the Academy Dinner on the Saturday night the Prince
of Wales was taken to see it. The following morning Haydon found
it praised in the newspaper. In his *Autobiography* he was to stress his
own unselfish pleasure at his friend's good fortune, serving as a contrast
to the future parsimony that he would feel himself served in return:

> Jackson [and I] bolted into Wilkie's room. I roared out: 'Wilkie, my
> boy, your name's in the paper!' 'Is it rea-al-ly,' said David. I read the
> puff – we huzzaed, and taking hands all three danced round the table
> until we were tired! [Ours] was the joy of three friends, pure from all
> base passions; one of whom had proved a great genius, and we felt as
> if it reflected honour on our choice of each other.

The next day, when the Exhibition opened to the public, it was impos-
sible to get near the picture for the press of bodies. When Wilkie
returned home, he found his hall table covered with visiting cards:
'cards of people of fashion, people of no fashion, and people of every
fashion'.

Reflected glory could not long satisfy Haydon and towards the end
of his second year at the Academy, in the autumn of 1806, he began
painting his first picture.[82] It was not before time, as far as his friends
were concerned. As early as May of the previous year Jackson had
chided him for drawing in Indian ink: 'why not use the tools by which
your reputation is to be acquired? Depend upon it, my dear fellow,

there is more real difficulty in successfully handling the brush than some people are aware of; therefore the sooner we begin to use it the better.' But by the summer of 1806 Haydon was not entirely without practice, having, by his own account, begun experimenting with paint earlier in the year.

Through the good offices of Sir George Beaumont, Wilkie, Jackson and Haydon were granted access to the collection of the 2nd Marquess of Stafford,[83] who, between May and August 1806, opened his London home to artists and connoisseurs every Wednesday from twelve o'clock until five. Haydon took full advantage and would try out different mixtures of paint, carrying them down on pieces of pasteboard to compare them with the four great Titians: *Diana and Actaeon*, *Diana and Callisto*, *The Three Ages of Man* and *Venus Rising from the Sea*. 'By these means,' Haydon explained, 'I had not neglected the study of the brush, and thus, when I commenced painting I was not ignorant of the theory of practice.'

Before he left for the summer vacation he had decided on the subject for his first major composition – the Holy Family's flight into Egypt – but had not begun painting it. Wilkie, who was staying for part of the summer as the guest of Lord Mulgrave in North Yorkshire, was somewhat premature when he told his host of the picture his friend was 'at present engaged with'. However, his 'curiosity and expectations' having been raised, concerning the young man of whom he had already heard much from Jackson, Mulgrave instructed Wilkie to inform Haydon of his desire to commission another painting once the present one was finished. The subject that he had in mind was an episode from Nathaniel Hooke's *Roman History*, a subject 'seldom or never . . . painted', which his Lordship thought 'an advantage to it'.[84]

Haydon, meanwhile, was somewhere by the coast, and 'furiously in love'. The precise location is not known, nor the object's name, but the experience was sufficiently intense to put out of his mind, for a time, all thoughts of art and the Academy:

> to ride about the delicious neighbourhood, to read Milton and Tasso and Shakespeare in grassy nooks by the rippling sea, to bind her hair, and watch her fastening it back with her ivory arms bent back over her head, to hear her thrilling laugh at [his] passionate oaths of fidelity.

Wilkie's letter, sent from Mulgrave Castle at his host's instigation, containing a commission to paint his second picture before he had even started his first, interrupted Haydon's seaside idyll. He hurried back to London. Later he would confess to shedding tears for his 'ladye-love' on the first twenty miles by mail coach. Then, at about the thirtieth mile, he was distracted by a pretty dimpled face at an inn where they changed horses, and dozed, thinking of her, until he smelled the London smoke, 'when all these rustic whims and fancies gave way to deep reflection on High Art and a fearless confidence in [his] own ambition'.

Back in his lodgings he ordered a canvas, six feet high and seven feet wide. On 1 October, after praying to God to bless his career, to grant him the energy 'to create a new era in art, and to rouse the people and patrons to a just estimate of the moral value of historical painting', he began work on *Joseph and Mary Resting on the Road to Egypt*. Throughout the six months it took him to finish, he prayed for guidance when rising each morning, before retiring at night and occasionally, 'in the fervour of conception', during the day. He admitted also, from the outset, to the guidance of a more experienced painter. Haydon had spent a whole morning 'rubbing in' the picture, when Wilkie stopped him:

'That's jest too dark for rubbing in.'

'Why?'

'Because what can ye do darker? Ye must jest never lose your ground at first.'

Haydon obediently scraped away the morning's work until he had exposed the ground colour, and then, under his friend's direction, 'rubbed in' the main lines of the composition again with a thin, transparent layer more like a watercolour wash than oil paint. Later, he complained to Wilkie that his colours were drying too quickly.

'What d'ye paint in?'

'Drying oil and varnish.'

'Use raw oil!'

'What is raw oil?'

'Why, oil not boiled.'

After nine days Wilkie reported that his friend was 'going on vigorously with his picture'.[85]

The model for Mary was a girl called Lizzie – 'of masculine under-

standing, not regularly beautiful, but approaching it' – who lodged in the same house as some friends of Wilkie's. The Academy model Sam Strowger sat for the figure of Joseph, even though Haydon was unable to pay him. Strowger was the first, and by no means the last, of Haydon's many models to exercise immense patience with his painting technique. 'The difficulties of a first attempt were enormous,' Haydon confessed. 'I wanted to make Joseph's head looking down so as to leave the eyes out of sight, and I did it so badly that people said: "Why, he's asleep!"'

Unusually, in this composition, it was Joseph, not Mary, who was holding the Infant Saviour, and the increased responsibility of care necessitated alertness. 'So out came that head several times, but at last [he] hit the look from the model after a long, long morning's trial of some eight hours.' Another misjudgement was painting the white drapery across Joseph's knee with a recently invented substance marketed as 'Rembrandt Paste'. It was 'trash', cracked badly and later had to be restored.

Haydon had been hard at work for a full month when Sir George and Lady Beaumont arrived in town from the country and, with 'a thundering knock and trampling horses, a rattling down of steps and flinging open of doors', came to call at Broad Street. Wilkie had given his friend advance warning and arrived with them to make the introductions. 'The picture was set in a good light, the room neat, the chairs old, the carpet worn.'

Sir George studied the work in progress.

'Well, very poetical,' he declared, 'and quite large enough for anything.' It was a harmless remark, but size of canvas was to become an acrimonious issue between the two men a few years later, when Sir George, in his turn, commissioned a picture from Haydon.

That night, over dinner with Wilkie, Haydon learned that he had made an impression on Lady Beaumont, who had said on leaving: 'I like him very much; for he has an antique head.'

Sir George invited them both to dinner the following Sunday. The architect George Dance was there with his son Charles and his brother Sir Nathanial, as was the scientist Humphry Davy, 'a little slender youth . . . his hair combed over his forehead, speaking very dandily and drawlingly'. Haydon sat between Sir Nathanial and Joseph Farington. At one point Lady Beaumont enquired from her end of

the table: 'When do you begin Lord Mulgrave's picture, Mr Haydon?'
As heads turned, he felt himself 'the new man of the night'.

During the ensuing months, as Haydon laboured over *Joseph and
Mary*, Sir George offered sound advice and encouragement:

> I am not surprised, and indeed very little sorry, to hear of your diffi-
> culties, for you must remember the more elevated your goal the greater
> must be the exertion of every nerve and sinew to reach it; had you
> been easily satisfied, I should have formed no interesting hopes of your
> progress . . . the present pains and troubles are distressing, yet, when
> once achieved . . . your reward [will] be the approbation of every man
> of real taste.[86]

In February, Wilkie observed that Haydon was 'proceeding on care-
fully with his picture; but although he works constantly at it, it will
take him a considerable time to finish'.[87] But by March, Haydon's first
historical painting was rapidly nearing completion:

> In the centre was Joseph holding the child asleep; the ass on the other
> side; above were two angels regarding the group, and in the extreme
> distance the Pyramids at the break of day. The whole was silently
> tender. The scenery divided interest with the actors. The colour was
> toned and harmonious – the drawing correct . . . It had colour, light
> and shadow, impasto, handling, drawing, form and expression.

The sending-in date for the Royal Academy Exhibition of 1807 was
in early April. It then became apparent that Sir George – 'although
admitting it was a wonderful first picture' – strongly advised against
exhibiting it *because* it was a first picture. Perhaps he believed it to
be too easy an attainment, and 'the man who fancies attainment easy,'
he had told the novice in February, 'has a circumscribed mind, ill
calculated to reach any point approaching excellence'.[88] Whatever his
motive, the advice put Haydon in a difficult position. To ignore Sir
George's advice would give offence, but to follow it would 'keep
[him] from the world another year'. However, at the urging of Jackson
and other friends, he decided to send his picture to the Academy.
Even so, the crisis had shaken his faith in two men. The first was Sir
George Beaumont, who, despite professing every care for his progress

in 'the Art', seemed intent for his own reasons upon holding him back. The second was David Wilkie, of all his friends the only one to side with 'the man of rank' and advise him against exhibiting. 'Wilkie,' said one friend, 'does not wish to differ from Sir George.' And Haydon agreed:

> There was something so cold in Wilkie's thus withdrawing his support from a devoted friend, that I really date my loss of confidence from the hour he thus refused me his countenance and denied his first opinions.

On 7 April the Committee of Arrangement began its deliberations, and Haydon haunted the Keeper's residence – at the bottom of the dark staircase below the *Farnese Hercules* – for news of each day's proceedings. Finally, Fuseli had information for him:

'For your comfort den, you are hung by Gode, and damned well too, though not in chains yet.'

'Where, sir, for God's sake?'

'Ah! Dat is a sacrate, but you are in the great room. Dey were all pleased.' The old man then told him of one Committee member who had not been so pleased.

'Northcote tried to hurt you, but dey would not listen.'

Northcote, it seems, had suggested that the work was not entirely Haydon's own and that he saw Wilkie's hand in it.

The portrait painter Richard Westall had spoken up in defence:

'Come, come!' he said to Northcote, 'that's too bad, even for you!'

Then Fuseli brought his own authority, as Keeper, to bear on behalf of his protégé: 'Wale, wale, you are his townsman,' he told Northcote, 'hang him wale.'

Despite this, when Fuseli next entered the Great Room, he found that Northcote had 'skied' the picture high above the whole lengths and smaller works.

'Why, you are sending him to heaven before his time,' Fuseli protested. 'Take him down, take him down; dat is shameful!'

At the Keeper's insistence, *Joseph and Mary* was at last hung just above the doorway whose outer lintel was defended, by Greek proscription, from every stranger to the Muses.

When the Exhibition opened to the public on 4 May, Wilkie's *Blind*

Fiddler created an even greater sensation than his *Village Politicians* had the previous year. But Haydon enjoyed his own, more modest triumph. His picture, number 252 in the Catalogue, was considered 'highly creditable to a young Artist',[89] and even Sir George Beaumont conceded that Haydon had been right to ignore the advice not to exhibit.

It was purchased by Thomas Hope, the immensely wealthy connoisseur who liked to play down the size of his fortune, claiming it to be 'not so large as supposed', and explaining that he was able to 'do a good deal in art' only because 'He had not the expense of dogs & horses.'[90] Hope paid Haydon 100 guineas for the picture and considered it 'display[ed] in an eminent degree those highest and rarest excellencies of art – sublimity of conception and correctness of design'. He compared it with the year's crowd-pleasing favourite:

> While the perfections of familiar subjects, like Wilkie's, strike every eye, come home to every intellect and become a general topic of conversation, the merits of more elevated subjects are as yet felt by few only, require being pointed out to the many, and do not spontaneously excite that enthusiasm indicative of a strong and universal sense of the higher branches of art.[91]

This, from a man of Hope's distinction and influence, was praise indeed. At last Haydon could send palpable proof of success in his chosen calling to Plymouth, and his mother leafed through the Catalogue and read his name, printed for the first time. She lovingly copied out his first press notice:

> Though this piece is the production of a young student in the Academy, it well bears the test of criticism. His powers are active, and feelingly alive to the fire and impulse of genius. A luxuriant harvest may justly be expected from the promising Spring of genius ... There is Raphaelian judgement and simplicity in the [picture] ... We augur well from a young painter who exhibits such purity of judgement undazzled by the meretriciousness of Art.[92]

His career had begun, and he felt secure in his destiny to do greater things. Looking up at his painting, he could relish the moment. 'Fame had at last placed her trumpet to her mouth,' he would declare in an

early essay at autobiography, 'and it was not my fault if I never suffered her again to drop it.'[93] But his next contribution to the Exhibition, two years later, was to be displaced from that same position above the door in the Great Room by the painting of a little girl, in a white frock, red sash and red slippers.

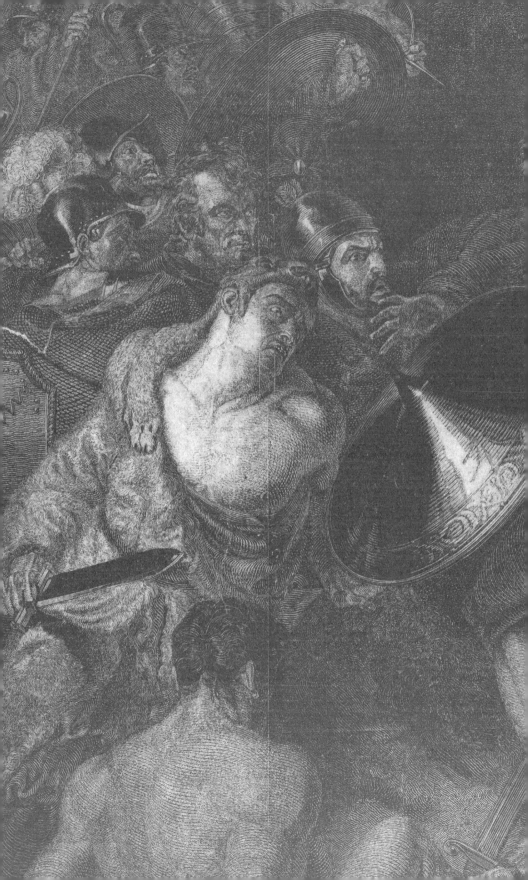

PART TWO

STRUGGLES

1807–14

According to legend, during the fifth century before Christ, the tribune and warrior, Lucius Siccius Dentatus, having fallen foul of the Decemvirate governing the early Roman republic, was sent out in command of a hundred soldiers who were under covert orders to assassinate him. Nathaniel Hooke's *Roman History: from the Building of Rome to the Ruin of the Commonwealth* provides an account of the hero's last desperate struggle against overwhelming odds:

> [Dentatus] having led them into the narrow passages of some moun-
> tains, they took that opportunity to fall upon him. He no sooner
> perceived their base design, but setting his back against a rock, that he
> might not be attacked behind, he received them with a courage that
> struck terror into the boldest of them. Calling up all his ancient valour,
> he slew several of the assailants, and wounded others: And now not
> one durst venture near him: They stood at a distance and threw their
> darts at him. But as even this did not effect their purpose, the villains
> climbed up to the top of the rock, and thence knocked him on the
> head with stones.[1]

It was a transcription of this passage, and news of a commission from Lord Mulgrave to make a painting of the subject, that David Wilkie sent to Haydon on 7 September 1806, three weeks before a brush had been laid on the canvas that was to become *Joseph and Mary Resting on the Road to Egypt*. Nine months later, with his first painting finished, respectably hung in the Great Room and sold to one of the foremost connoisseurs in London, Haydon could begin work on his second.

Perhaps recognising inadequacies in the features of *Joseph and Mary*, Wilkie suggested that he practise portraiture during the summer,

before beginning *Dentatus*. Called back to Plymouth by another crisis in his father's health, and finding him ill but out of danger, Haydon settled back into the parental home and pursued his friend's advice. Sitting succeeded sitting and commission followed commission and, at fifteen guineas a head, he had soon accumulated a large sum. The portraits were, by his own admission, 'execrable' and in later life he hoped that none had survived. Nevertheless Wilkie wrote to congratulate him on the success of his enterprise, professed himself 'a little surprised at the rapid accumulation of such a sum of money' and urged Haydon 'to go on at the same trade for a little longer', because he would 'not have either time or inclination to return to it on any future occasion'.[2] But although practice had given him a facility, and more people were coming to sit, Haydon was impatient to return to London. As he painted his mother's portrait he saw 'a tear now and then fill her eye and slowly trickle down her cheek'. While his father's health improved, hers had deteriorated. Exacerbated by anxiety for her husband and the prospect of her son's departure, her condition took an alarming turn and the slightest physical exertion or emotional strain convulsed her frail body with a vice-like grip across the chest, the suffocating agony of *angina pectoris*. She grew weak and deranged. Obsessed with the vain hope that advice from an eminent surgeon might save her, she determined to travel to London, and Haydon and his sister agreed to accompany her. They stopped at Wells to visit her brother, the Reverend John Cobley. Here, Haydon was witness to a pitiful encounter between his mother and a disappointed suitor of thirty years before.

In about 1778, John Cobley's brother-in-law, Richard Crosse – a deaf-mute from birth – had proposed to Sarah Cobley, unaware that she was already engaged. Deeply affected by her refusal, Crosse had left Devonshire and settled in London to pursue a lucrative artistic career, as a painter of miniatures. He never married and, by 1807, in his mid-sixties, he was living in retirement at Wells, in the care of his sister, under the Reverend Cobley's roof. And there he was when the love of his life, dying, came to call. Haydon encountered the apparition in a corridor outside his mother's room:

> . . . a tall, handsome old man; . . . muttering hasty unintelligible sounds
> he opened the door, saw my mother, and rushed over to her as if

inspired of a sudden with youthful vigour. Then, pressing her to his heart, he wept, uttering sounds of joy not human! . . . We came so suddenly to my uncle's, they had never thought of getting him out of the way . . . He was . . . smoothing her hair and pointing first to her cheek and then to his own, as if to say, 'How altered!' . . . My sister, hanging over my poor mother, wept painfully. She, Cross[e], my uncle and aunt, were all sobbing and much touched; for my part, my chest hove up and down and I struggled with emotions at this singular and affecting meeting.

For Crosse, it was as if thirty-year-old wounds had reopened and he was losing her all over again:

He saw her before him, broken and dying; he felt all his affection return, and flinging himself forward on the table he burst into a paroxysm of tears as if his very heartstrings would crack. By degrees we calmed him . . . and they parted in a few moments for the last time.

Inevitably, the strain brought on further attacks of angina before mother and children could continue their journey. They travelled on by post-chaise, determined to reach London as quickly as possible. The end came at the Windmill Inn, a coach stop at Salt Hill, just west of Slough, on the night of 21 November.

Eleven years later, while travelling to the West Country, Haydon revisited the inn. He climbed the white stone staircase that he and his sister had climbed supporting their mother. He remembered that they had had to pause and rest on every step of the ascent, the silence broken only by the loud tick of a clock above their heads and the laboured breathing of the invalid. It had taken a long time to reach the second floor and the room on the left-hand passage that had been prepared for her. He remembered the furnishings of the room. The bed was a different one, but, as he sat in the 'great, rich, ponderous chair . . . with the very same coloured covering', he fancied he felt his mother's cold hands embrace him. She had spent the night wrapped up in the chair so as to be nearer the fire, her son and daughter keeping vigil. Haydon had woken up around half-past two in the morning to find the fire sunk to a few glowing embers and his mother staring into them: 'her nose was sharp – her cheek fallen, – she looked as if

she saw the grave and pondered its wonders'. Then his sister, still asleep in her chair, had stirred and the shawl covering her dropped away. It was the exertion of trying to rise and replace the shawl around her daughter's shoulders that brought on Sarah Haydon's last and most violent attack. She died while her son was away fetching a surgeon.

She had expressed a wish to be buried next to her father in the village of Ide, near Exeter, and the recent success of Haydon's portrait-painting career enabled him to meet the cost of transporting the body there, together with the funeral expenses. She was laid to rest in her family's crypt in the south aisle of the church of St Ida. That evening, having bribed the sexton, Haydon took solitary leave of his mother:

> [I] descended into the vault, and stretching myself upon the coffin for the last time lay long and late, musing on every action of her hard devoted life: on my knees, by her side, I prayed God for his blessing on all my actions.

Grief indulged, purged, thereby fortified and 'prepared for the battle of life', he returned to London and *The Assassination of Dentatus*.

<p style="text-align:center">*</p>

Fuseli, hearing of his protégé's commission from Lord Mulgrave, had told him he might '*vainture* now upon a first floor', and it was probably in January of the new year, 1808, that Haydon changed his lodgings, moving from Carey Street to 41 Great Marlborough Street. For the following decade Henry Perkins, whose tea wholesaling business flourished next door at number 40, would be a patient and generous landlord, offering 'fatherly protection' and 'kindness . . . in trouble and want'. The first-floor accommodation comprised a painting room, an outer room and a small bedchamber. It was spacious enough for his current needs, although increasingly crammed with plaster casts and would become cramped to the point of suffocation over the coming years.

Between his return to London and beginning work in earnest on *Dentatus*, Haydon was one of a number of students who resolved to

present Fuseli with a silver cup in gratitude to him as a teacher. Committee meetings, over oysters at the Garrick's Head in Bow Street, were so enjoyable and the fellowship so invigorating that discussions of the cup, inscription and formalities of the presentation might have gone on for ever, for all any of them cared. As treasurer, Haydon was given charge of the fifty guineas raised in half-guinea subscriptions, guarding it at night with a French cavalry sabre laid beside his bed while he slept. He also made the principal speech when the cup was presented to the Keeper, and the jealous indignation of the Academy's Council was roused against him and the other 'impudent puppies' for their presumption. He claimed that his prominence in the unauthorised honour 'first sowed the seeds of enmity . . . in the minds of many of the Academicians'.

At last he began work on *Dentatus*, but struggled to reconcile the heroism of his subject with a realism that would make it convincing. If he painted his figures from life they looked mean, if from the antique casts at Somerset House they looked like stone. An encounter with the contents of a large shed in the grounds of a house at the corner of Park Lane and Piccadilly, to which Wilkie first took him, resolved this problem once and for all. The dank interior, some fifty foot square and illuminated by skylights in the pitched roof, disclosed a collection of battered sculptural fragments placed – a rough attempt at symmetry – in an ox-bow arrangement. The central component of the bow was a caryatid that had once, with five others, supported the roof of a temple porch on the Acropolis at Athens, the so-called 'Porch of the Maidens'. On either side were sculptures from the east and west pediments of the Parthenon: standing figures, seated figures, reclining figures. Some were naked, others draped; all but one decapitated, most dismembered, not a hand or foot among them. At the extremities of the bow – between which visitors entered the central arena to view the collection – a horse's head on a pillar confronted a similarly mounted male torso.

The first detail that Haydon noticed was the wrist of a female figure, 'in which were visible, though in a feminine form, the radius and ulna'. He observed in the elbow of the figure 'the outer condyle visibly affecting the shape as in nature'. Turning to the semi-recumbent male figure, then known as the *Theseus*, to the right of the caryatid, he saw that 'every form was altered by action or repose'. He walked behind

it and found that 'the two sides of [the figure's] back varied, one side stretched from the shoulder-blade being pulled forward, and the other side compressed from the shoulder-blade being pushed close to the spine as he rested on his elbow, with the belly flat because the bowels fell into the pelvis as he sat'. By contrast, opposite the *Theseus*, the belly of the *Ilissos* protruded because the figure lay on its side. Here was the 'combination of nature and idea' that Haydon had been trying to reconcile. His way forward with *The Assassination of Dentatus* was clear.

Beyond the periphery of the free-standing sculptures, the great series of 'metopes' – rectangular slabs, carved in high relief, from the Parthenon frieze – showing the death struggles of naked Lapiths with Centaurs in defence of their women, were propped against the shed walls. Haydon compared one figure with the rest and 'saw the muscle shown under the one arm-pit in that instantaneous action of darting out, and left out in the other arm-pits because not wanted'. It was 'the most heroic style of art combined with all the essential detail of actual life'. Such was Haydon's first sight of the Elgin Marbles. He would think, speak and write of them until his death.

Rescued, allegedly, from the target practice of the occupying Turks, the Athenian sculptures, loaded into fifty packing cases, had arrived in England four years previously in January 1804. They preceded the unfortunate Lord Elgin, who – deeply in debt, his marriage in ruins and his nose disintegrated by disease – arrived two years later, having been captured and imprisoned by the French on his way home from Constantinople. The makeshift museum in the garden of Gloucester House had opened to visitors in June 1807. The sculptor Joseph Nollekens saw them then and 'did not find anything fine among them', but reserved his final judgement until 'they were all arranged, and put into such situations as to be properly seen, & the broken parts united'.[3] However, Farington saw the collection in February 1808 and declared 'That it was highest quality of Art, a Union of greatness & nature'.[4] West called them 'sublime specimens of the purest sculpture' and wished, in his seventieth year, that he could be twenty again, 'that He might labour to profit by them'. Nevertheless he determined, in the summer, 'to devote much time to study from them'.[5] The twenty-two-year-old Haydon, however, seems to have made an earlier start, one of his chalk drawings being dated March 1808.

West would later lay claim to be the first artist 'in modern times' to have 'availed [himself] of the rare advantage of forming compositions from [the Marbles], by adapting their excellencies to poetic fictions and historical facts'.[6] It was a claim that Haydon would reject, pointing to his own canvas, completed and exhibited two years before West's compositions. There, in the lower right foreground, at Dentatus's feet, a wounded figure struggled to raise himself on his elbows, displaying just that contrasting play of muscles across the back that Haydon had observed in the *Theseus*.

The first impression of Haydon's new picture in its early state was not encouraging. Wilkie called to see it in May, noting in his diary: 'thought the head he had done too large in proportion'.[7] This was not surprising, because Haydon was conceiving each of his figures from several disparate sources, some living, some antique, and he admitted that 'by doing the parts separately they did not hang together'. The figure of Dentatus, for instance, was based on the *Belvedere Torso* and on Samuel Strowger the Academy model, with casts of legs and thighs from another model called Boswell; and the hands were John Salmon's, a Horse Guardsman whose services Lord Mulgrave had procured for him. A dying figure, lying at Dentatus's feet, owed its pose to a Lapith in one of the metopes, its chest and hand to plaster casts from a model by the name of Rogers. An early version showing the agonised features of this figure was based on a young man whose family Haydon had known in Plymouth. 'I found poor W[illiam] Eastlake in a fit of asthma gasping for Breath,' he recalled. 'I said, "You are the very model for my dying man." I got a coach, took him out in a blanket, & painted the dying soldier!'

William's brother, Charles Lock Eastlake, was fifteen when he left Charterhouse school at the end of 1808 determined to be an historical painter, after taking tea with Haydon and seeing *Dentatus*. He became Haydon's first pupil and more than thirty years later recalled visiting Westminster Hall with his teacher, who mimed 'drawing a gigantic limb on the wall with the end of [his] umbrella . . . jumping up to reach and saying "This is the place for art!"' Haydon had high hopes the young man would 'be eminent' one day. 'If before I die,' he wrote, 'I can but see the Art generally improved and all in the right road, I shall die happily.' Eastlake did indeed achieve eminence and a position of considerable influence, but he was unable to repay

the early kindness of his old teacher, and Haydon would die believing him a traitor.

<div align="center">★</div>

The first dated entry in the twenty-six volumes of Haydon's manuscript journal was the drawing of a fist: 'July 3rd, 1808 – my own hand'.[8] It would appear to anticipate the chronicles of struggle to come. Three weeks later[9] he was in Dover, walking on top of the chalk cliffs at twilight and musing upon King Lear. There, he fancied, Shakespeare had been inspired; there his protagonist 'defied the Storm'; and there, at the castle, 'Cordelia died'. With the last gleam of the setting sun, he thought he saw France and imagined the baleful presence, less than thirty miles away, of Napoleon Bonaparte, 'the wonder and detestation of the World'. Although the threat of invasion had lessened since Trafalgar, people were still vigilant, and the little stranger – bearing, it might be thought, a passing resemblance to the foreign tyrant – was viewed with suspicion during his stay: 'Everybody stared on the beach, no person knew my name or where I came from, I was always wet, alone on some solitary shore or silent meadow.' Walking at night on the beach, he was repeatedly challenged at bayonet point by sentries guarding the coast of England against the French.

He thought of pictures, planning his future career and compiling a list of thirty-eight 'Subjects Suitable for Painting'. Number 26 he had already accomplished, *Joseph and Mary Resting on the Road to Egypt*, and number 25, *Dentatus*, awaited him back in London. Numbers 35 and 36 were variants on *Macbeth*, his next picture, while later works, *The Judgement of Solomon* and *The Raising of Lazarus*, were numbered 15 and 24 respectively. Eight more subjects from the list would be attempted over the following years, culminating in number 37, *The Maid of Saragossa*, exhibited at the Royal Academy in 1843.

As he came down from his evening walk, Haydon looked back up at the cliff and mentally sketched the plan for a colossal statue of Britannia 'with her Lion at her feet, surveying France with a lofty air'. It would be visible from miles out to sea. Later, he mentioned the idea to an unimaginative companion, who objected:

'Why, it [would have to] be twenty feet high.'

'Twenty feet!!' snorted Haydon, 'One hundred and fifty!'

'Who would you get to undertake such a thing?' came the response.

'Who would I get?' For Haydon the objection summed up every-thing that was wrong with the artistic taste of his country. 'Is this a question that an Athenian would have asked?' Large-scale undertak-ings were greeted with bewilderment or ridicule by his small-minded contemporaries, while a grubby little Dutch genre scene by Jan Mieris excited admiration merely for its imitative detail: 'a Woman and a Boy, with cabbages, Potatoes, & red herrings, a cat, a brass pan, and some carrots, – then all are in raptures, "what an exquisite imitation, look at the carrots, look at the herrings" . . . all crowd round this inimitable carrot Picture, lost in rapture & delight'. The rapture and delight in genre painting and the virtuoso representation of the tiniest detail had ensured Wilkie's popular success. Haydon's determination to reform the taste of his countrymen with heroic subjects and giant conceptions could only end in failure. The carrots would always be preferred to the Colossus.

By early August he was back in London, dividing his time between working on *Dentatus* and copying from the Elgin Marbles. Lord Mulgrave had secured him permission for this privilege and Haydon was taking full advantage of it, drawing from ten o'clock until six. In September he finished 'the best drawing [he had] made yet', before one of the revered lumps of stone fell and cut his leg. For the next ten days he was confined to his rooms, a virtual invalid, unable to walk or paint, the efficacies of Turlington's Balsam notwithstanding. Towards the end of this recuperative period, his injured leg stretched out on a chair, he was spending as much as thirteen hours a day reading, and reported his 'right eye a little strained' in consequence.

★

John Sheldon had been insane for twenty years when his death in October 1808 necessitated his replacement as the Royal Academy's Professor of Anatomy.

There were only two candidates for the post: Charles Bell, the students' preferred choice, and Anthony Carlisle. Haydon and Wilkie canvassed for Bell. They called on the portrait painter Sir William Beechey, who insisted that Wilkie 'sit for his head', while Haydon

went off to secure Smirke's vote for their man. Notwithstanding Wilkie's persuasive arguments while he sat, Sir William would eventually support Carlisle, as would Smirke. Haydon suspected Carlisle of lobbying on his own account; 'he knows the effect good dinners have on half starved Academicians'. Predictably, Carlisle eventually succeeded Sheldon as Professor, with twenty-seven votes to Bell's four.

Haydon would always hold it against the Academy that they had elected a man who 'denied . . . the Greeks knew Anatomy'. If Carlisle was correct, the implication was that the Greeks had achieved perfection in art while 'ignorant of the science'. Such a conviction, declared Haydon, was both injurious to art education and, when examined logically, frankly absurd: 'a Professor is . . . established in a national Institution to teach the uses of Anatomy; the doubts he contrives to instil into the students' mind of the Utility of his own efforts, renders his lectures an endurance rather [than] an instruction . . . since what can he do . . . but teach a Science to Students that they may excel in the Art, at the same time inferring it's of no use by telling them the Greeks, the greatest Artists, did excel without it!'

Fully recovered from his leg injury, Haydon was back at work on *Dentatus* by the middle of October, but on the 18th of that month he decided to obliterate his main figure and begin it again. The next day he sketched it back in from Sam Strowger, 'much better'. The following day he improved it further, but feared it was 'too large'. He put in the head the next day, but was 'not at all satisfied', and must have taken it out because by mid-November he was putting it back in again. On 16 November he painted the arm and shoulders and altered the head, but two days later was still not satisfied: 'My Hero's head, tho' nearly done, I see is not as it ought. I have made up my mind and out it comes again to-morrow.' He was determined that it had to be 'such as the greatest Painter that ever existed could have made it'.

He had intended to stop copying from the Elgin Marbles until the weather grew warmer, but he worked on to the end of October and throughout the first week of November: 'not at all fatigued, not at all sore, [but] rather damp & cold'.

On the last day of November he reported his picture 'advanced', but remarked that he was unable to recollect a month 'of more vice and wickedness'. Some years later he would remember 'tremendous struggles against vice at this period . . . totally unable to remit my

burning appetites in spite of all my efforts'. Between the journal entries of 20 September and 9 October a page was torn out, after the painter's death, by his son and a note of explanation appended: 'Unchastity – Broke his oath "never to touch another woman" in two days!' 9 October was a Sunday and Haydon's entry was short and intriguing: 'Was more pious but not recovered from yesterday's shock.' On 26 October he prayed: 'O God Accept my unfeigned gratitude that I have by thy assistance kept clear of vice for these last 18 days.' There are, however, other gaps: two pages cut out between 28 and 31 October, and a further six between 5 and 15 November. Following those moral lapses, Haydon made another resolution and left a journal note: 'Remember this night ½ past ten Nov 16th, 1808.' But, as before, and after a similar interval of struggle, he yielded to temptation. 'This night I remember *swearing* an oath I would never touch another Woman,' he noted ruefully. 'I broke it with agonising pangs in two days.' Again, the relevant page was removed by the son in deference, presumably, to his father's posthumous reputation.

<div align="center">★</div>

Despite his intention to avoid the freezing conditions of Lord Elgin's shed until the weather improved, in mid-December – encountering further problems in his painting – Haydon ventured back 'down among the Ruins of Athens, to consult about legs & feet . . . so cold [he] became benumbed in spite of [his] abstraction'. Close study of the metopes taught him that 'the end of the toes are the parts that are press[ed] down, the upper joints not, consequently the flesh must rise all up about the nail and the top and the upper joint still keep its form'. Back in his painting room, he drew in the left leg and foot of Dentatus, but took them out again. He was still putting in and taking out the legs and feet, painting and repainting, a month later. Below the feet, the dying figure made equally tortured progress, only to be obliterated by drapery, with just one hand showing. The face 'in the agonies of Death', had 'distracted attention', he decided. So he covered the face with the robe, 'as the Romans generally did'. This created 'a solemn feeling, a repose to all the bustle, and room for reflections which silent Death always excites'. Poor William Eastlake's asthmatic attack had been in vain.

The painting was exciting considerable discussion from those who had watched its development. Later it was said that Sir George Beaumont's championship had created such high expectations that disappointment was inevitable. Fuseli spoke of it with 'decided approbation'.[10] Wilkie saw it when nearly finished and 'was much pleased with it' and hoped 'the public will not be insensible to its merits'.[11] Lord Mulgrave urged Haydon to exhibit it at the British Institution, where it would compete for the 100-guinea premium for best 'picture of historical or poetical composition'.

With premises at 52 Pall Mall, former home of Boydell's Shakespeare Gallery, the British Institution had, since its foundation in January 1806, been holding annual exhibitions of contemporary painting and alternating these with displays of old masters on loan from private collections. 'The avowed purpose of this excellent institution was to give to the painters a facility in selling their works, and to form a school of painting for the rising generation, by furnishing exemplars . . . from the collections of the nobility and gentry who formed and supported the plan.'[12] Despite the fact that his other friend and mentor, Sir George Beaumont, was a director of that 'excellent institution', Haydon had doubts about the standards of competition prevailing there and rejected Lord Mulgrave's suggestion:

If Mr West and all the Academicians were to be my competitors, nothing would give me greater delight, even if I lost it – less glory would be lost, and more won if I gained it. But to contend with a parcel of mannered, ignorant, illiterate boys, without science or principle [at the British Institution], if I were successful would be no honour, and if unsuccessful, I should never hold up my head again. Besides, what do I care for prizes? I want public approbation and fame – this is the only prize I esteem.

Such 'public approbation and fame' were to be had, he believed, in only one arena: the Great Room of the Royal Academy's Exhibition. Had he acceded to Lord Mulgrave's suggestion, Haydon's subsequent relations with the Academy might have been very different.

One day, in the first week of April 1809, Haydon could have been seen anxiously guiding his six-foot by eight stretched canvas up the Strand, a man at each corner. Leigh Hunt – poet and inflammatory

editor of the *Examiner* – had come along for the lark, teasing the painter mercilessly: 'Wouldn't it be a delicious thing now for a lamp-lighter to come round the corner and put the two ends of his ladder right into Dentatus's eye? or suppose we meet a couple of dray-horses playing tricks with a barrel of beer, knocking your men down and trampling your poor Dentatus to a mummy!' Haydon was so agitated that, dodging ahead of the party to see that all was clear, he tripped up one of the corner men and almost pitched the picture into the gutter. Arriving safely without further incident at Somerset House, and labelled with its full title – *The Celebrated Old Roman Tribune, Dentatus, Making his Last Desperate Effort against his own Soldiers, who Attacked and Murdered him in a Narrow Pass* – it was left to the mercy of the Committee of Arrangement.

Martin Archer Shee, Thomas Phillips and Henry Howard, together with Fuseli – who, as Keeper, was an *ex officio* Committee member – made their selection from that year's submissions over the next couple of days and set about hanging the Exhibition. Fuseli placed *Dentatus* in the same position that *Joseph and Mary Resting on the Road to Egypt* had occupied two years before. Then, two days later, Benjamin West intervened, telling Fuseli that he had done neither the picture nor the painter justice. 'Get him a better place yourself,' the Keeper replied, walking away. Moved, on the President's orders, a little more than ten feet from the place Fuseli had given it, Haydon's picture was finally listed in the Catalogue as number 259. The difference in position, however, between catalogue number 252 in 1807 and 259 two years later was immense. The one had put *Joseph and Mary* above the door in the Great Room, the next had bundled *Dentatus* through that door into the dark of the Ante-Room. That, at least, was how Haydon would describe its treatment until the end of his life, although another witness, Charles Robert Leslie, recalled that the Ante-Room was excellently illuminated, having the benefit of a skylight, 'the best of all windows for pictures'.[13] And it was in this way that West justified his action to Sir George Beaumont: that the picture had originally been hung in a place 'where he could not bear to see it', and that he had moved it into 'the best light in all the Academy'.

Another version recounted by Haydon had West justifying his action to Lady Beaumont and telling her, 'We have hung it in the best place in the Academy.'

'The best place,' Lady Beaumont repeated at dinner the same evening, 'in the whole Academy.'

'And where may that be?' asked Lord Mulgrave.

'In the centre, I think of the Ante-Room,' she replied.

Mulgrave's rejoinder brought an uncomfortable silence to the company at table: 'Did West ever hang any of his own pictures there?'

It is entirely possible that the President had acted with complete sincerity, moving an important picture from a marginal place in one room to the most prominent in another. He was, however, not entirely consistent in his conversation about the matter. 'What a pity it is not in the Great Room,' he told another friend of Haydon's, 'but, Sir, the Academicians will have their Pictures there.'

Haydon pointed out that the picture occupying *Dentatus*'s original position – 'the miserable portrait of a little girl in a white frock and red slippers'[14] – was not the work of an Academician, either.

The question, however, as to the advantage or disadvantage, the light or darkness, of the Ante-Room as a space for displaying a painting is not material. The suspicion lingers that what really rankled with Haydon was that his work had been expelled from that charmed paradise of the Great Room reserved for friends of the Muses.

As time passed, Haydon's account of the affair would assign a less prominent role to West. Even by the end of the year he was laying the blame entirely on the Committee, albeit expanded to include Flaxman among its miscreants. Eventually it would be simply 'the Academicians' or 'the Academy' who put *Dentatus* 'in the dark'. Twenty-five years later he would attribute to that 'ill treatment of the Academy' all his subsequent misfortunes: 'I lost my Patrons – & sunk into a species of despair & embarrassment from which I have had occasional gleams of Sunshine but never permanent fortune . . . [It] threw a cloud on the whole of my life – embarrassments, exasperations followed . . . I lost all employment & sunk to a Prison.'

Lord Mulgrave had been supportive. He took Haydon by the hand and gave him 'a look as if to say "don't be discouraged"'. He paid for the picture immediately with 160 guineas, followed by a further fifty. But something had changed and it was most marked at dinner:

Wilkie, who two months ago was neglected, was now smiled on, spoken to, praised, flattered, while I, who when there was a prospect of success,

was treated in a similar manner, was now unnoticed. Not a word about my Picture, no person but Lady Mulgrave who sat next me & Lady Beaumont . . . said any thing to me . . . my observations were drowned in clamour, every ear and eye . . . were directed to Wilkie. He that is successful is always welcome.

Haydon's personal behaviour during this crisis in his life may also have cooled friendships. Mulgrave recommended Wilkie to advise his friend 'to leave off His habit of swearing'. Sir George Beaumont did the same and 'wished Him not to put Himself forward in such a manner as to give offence to artists His Seniors'.[15] Sir George had also heard that Haydon's 'manners are objected to by some of the younger Artists, & . . . ought to be regulated'.[16] Haydon's friendship with Wilkie was placed under additional strain. When Robert Hunt wrote in the *Examiner* that he had 'added dignity to the Historical art of his country', Haydon read the review to Wilkie and was offended at his 'want of warmth'.

About this time Haydon severed relations with another early friend, his former dining companion at Slaughter's, John Constable. The land-scape painter had been irritated by him for some time. Joseph Farington reported a conversation with Constable about 'Haydon having great influence over the mind of Wilkie, that the latter after a day's work is desirous to have Haydon's opinion of his proceeding & is affected by it accordingly as it is approval or the reverse. Constable remon-strated against it & justly observed to Wilkie that "if He continued to do so He would at last come to paint from Haydon's mind rather than from his own."'[17] Matters came to a head when Constable took Haydon to task for making slighting remarks about another old friend, the amiable Jackson, and for disregarding his part in Lord Mulgrave's commission for *Dentatus*. Constable warned Haydon 'not to ridicule the ladder by which *He had ascended*'. He also recounted the conver-sation to Northcote. Haydon wrote him a furious letter saying 'That He was *Mad* at having allowed Constable to have wound himself into his acquaintance.'[18] Thereafter Constable was to be Farington's main source of malicious gossip concerning Haydon.

*

Sir George Beaumont had commissioned his own painting while Haydon was still working on Lord Mulgrave's, and at one stage even suggested that he begin it before his Lordship's was finished. The choice of subject was left entirely to the artist. The previous October, Haydon had walked out of a performance of *Macbeth* at the Opera House before Act III, 'enraged & disgusted'. Mrs Siddons 'acted with very little spirit' during a scene that ought to have had her 'in a blaze'. Distracted by indifferent acting and the slamming of box doors, from a play that he usually read at home with a tingling of the scalp, he vowed never to see another Shakespeare play presented in the theatre.[19] Haydon was convinced that his own mental image of Act II, Scene 2 was superior to anything that could be produced on stage. He had the subject for his next picture:

> Macbeth approaching to murder Duncan . . . In the centre stands Macbeth; the victim of imagination and terror; he has just slid in between the grooms and the King; his chest is heaved up with gasping agony; his eye glaring and bending on a vacancy; his hands fixed, and grasping the daggers with supernatural clutch; behind lies Duncan in innocent and unconscious slumber; in front are the grooms buried in the drowsy sleep of heated intoxication; and in dim obscurity without, leans Macbeth's furious and terrific wife.[20]

Haydon's offence at Wilkie's 'lack of warmth' did not last long. Within a week his friend had lent him a piece of 'Scotch plaid for his picture of Macbeth',[21] and the following month the two men set out on holiday together. They left London for Portsmouth on 22 June with a letter of introduction from Lord Mulgrave's brother to Sir Roger Curtis, the Port Admiral, and the promise of transportation to Plymouth on board a man-of-war. Sir Roger invited them to dine and explained that a vast combined military and naval expedition to occupy the island of Walcheren and take Antwerp was in preparation and that ships were consequently coming from, rather than going to, Plymouth. Instead of a man-of-war, they might have to content themselves with a cutter.

While waiting for transport to Plymouth they witnessed a scene of carnage more terrible, in its way, than the disaster awaiting the fleet at Walcheren. Lord Chatham's ill-fated campaign would result in the

deaths of more than 4,000 men, but mostly from malaria and with only 106 killed in action. What happened on the quayside at Portsmouth, when an old woman tapped out her pipe close to a broken barrel of gunpowder, was the more appalling for its domesticity.

Haydon and Wilkie heard the roar of an explosion and the alarm bell as they were eating breakfast, and rushed out. The first thing they saw was a charred body lying across the roof of a cottage. As they approached the waterfront, the scale of destruction became apparent:

> The glass in the windows was shivered to atoms; here lay one poor Soldier, blown completely in two; there another lacerated, his jaw fixed and rolling on his back in excruciating agony, [mothers were with supernatural strength pulling aside the fragments in search of their children, and children were screaming and looking for their mothers,] while the crowd were thunderstruck, as if the whole was enchantment.[22]

According to a report in the *Sussex Weekly*, about thirty men, women and children were killed. Only the action of a company of the Worcester militia and some sailors, who managed to clear burning fragments of debris from sixteen other powder barrels, saved the town from general destruction.

They were two nights at sea, aboard a cutter escorting empty troopships westward, with Wilkie confined below by sickness, and Haydon relishing the salt beef and biscuit of the naval life. Anchored in Plymouth Sound on the afternoon of 28 June 1809, they were 'frankly received' by Haydon's father. For the next four weeks Haydon introduced his friend to the Devonshire scenery and society. They were invited to dine in a large party where everyone knew everyone else, 'stories of them & their families . . . the only subject of conversation, and what they wanted in wit . . . made up by laughter'. They dined with William Elford, amateur painter and banker, who would become a patron of Haydon's five years later, and listened to his anecdotes of Joshua Reynolds.

They visited Plympton St Maurice, and Wilkie was shown the house where Reynolds was born, the schoolroom where Reynolds and Haydon were educated. The dour Scot 'felt himself inwardly cheered, but exhibited no rapture',[23] and that lack of demonstrable enthusiasm extended to everything else he was shown. The two men rode to the top of Mount Edgecombe to watch a Devonshire sunset, but Haydon

was unable to persuade his companion to sit up there all night and watch the Devonshire sunrise.

Wilkie learned to swim, first on the Haydons' drawing-room table, 'face downwards, moving his limbs like an awkward frog', and then in more authentic conditions at Two Coves, below the headland of Mount Batten. Haydon, who 'loved to have fathoms of water under him', had himself rowed out with a Plymouth acquaintance into the Sound, leaving the novice to 'dabble about in shallow water until [they] swam in'. The two swimmers came ashore to find Wilkie practising his table-top strokes 'spread out in a few inches of water, and sputtering over the sand'. Haydon shouted encouragement: 'Hold up your head, Wilkie! Go in deeper.'[24]

They left Plymouth towards the end of July, making stops at Exeter, Wells and Bath on their way back to London. At Wells, Haydon saw his uncle John Cobley for the first time since his mother's death. They made an excursion to Cheddar Gorge and Cave and watched the lighting effects, in the half-mile subterranean vault, of candles in paper boats floating down the stream:

> Nothing could be more exquisitely poetical, the way they floated on, illumining the immense cavern, suspended as it were in the air, for the water was so clear its surface could not be seen. Then they would be lost behind some projection, and their effect only was seen. Then they would be again seen glimmering in the distance, and . . . float away into obscurity. This looked like spirits, on the Styx.

As ever a stranger to the sublime, and with the instincts of a genre painter to the fore, Wilkie talked only of what a grand picture it would make 'to have a number of people & children setting off those things and some of their lights frizzing & spitting in the water!'

They reached London on 3 August, but less than a fortnight later they were off again, this time travelling north to Ashby de la Zouch and from there to Coleorton, Sir George Beaumont's home, where they spent a fortnight:

> We dined with the Claude and Rembrandt before us, breakfasted with the Rubens landscape, and did nothing, morning, noon or night, but think of painting, talk of painting, dream of painting, and wake to paint again.

The two young rivals tried to outdo one another in impressing Sir George: Haydon with the sketch of a horse's head, Wilkie with 'an exquisite study of an old woman of the village, in his best style'. The competition was judged a draw, Haydon admitted, 'but they all allowed that nothing could exceed the eye of my horse'.

One evening, he had Lady Beaumont's maid stand on the stairs with a candle behind her to throw a large shadow on the wall and painted 'an excellent study for Lady Macbeth'. It was during this fortnight that important details of his commission were discussed and its first confusions originated. According to Haydon, while they were out riding, his host asked him what size he proposed painting *Macbeth*.

'Any size you please, Sir George,' Haydon replied.

'Would a whole length be large enough?'

'Certainly,' said Haydon, 'it is larger than I had contemplated, and I should be highly gratified at being allowed to paint the picture such a size.'

For his part, Sir George claimed he had originally commissioned a picture in which 'the figures might be of the size of West's *Pylades & Orestes*' – a canvas about three foot by four and in which the figures were half the size of life – but that 'Haydon afterwards expressed a [wish to] paint the picture on a whole length Canvass', to which his patron agreed.

Back in London, Haydon ordered his 'whole length' and began work on this scale in earnest. Early in October, Wilkie came to see it and reported that 'he had laid it on in a very clear and brilliant manner, and had begun another sketch, which he had touched in with the general effect in a style that gave me a much higher idea of his powers for colouring and handling than any thing I had yet seen of his . . . [and] his sketchings in of the Duncan and the youths are admirable.' Wilkie had only one reservation: 'He has not yet succeeded with the figure of Macbeth.'[25]

By the end of the month Haydon had run into serious difficulties and told Wilkie 'that in consequence of alterations he had made in his Macbeth, he intended to begin it anew, and had ordered a canvas for the purpose'.[26] He wrote and explained to Sir George, who replied that he should by all means proceed as he saw fit and that the picture would be all the better for the delay and care he was taking over it. Encouraged, Haydon worked on the new canvas for the next two

months. Then, in January 1810, Sir George came to town and called to see the progress of his picture.

'This is the full size of life?' he asked when he stood in front of it.

'No, Sir George, it is a little less,' replied Haydon.

'This is larger than Lord Mulgrave's,' said Sir George. Haydon told him it was 'a whole length in length', as discussed at Coleorton the previous August, 'and a little broader'. Sir George muttered something about it promising great things and went away apparently satisfied. But he returned two days later with Lord Mulgrave's brother, General Edmund Phipps, as if for support. He told Haydon that he would prefer to have something smaller. Sir George appears to have had two main objections: the picture was too big, and the figures were not big enough. His original specification – half-size figures in a picture the scale of *Pylades and Orestes* – would have been entirely acceptable. But Haydon was painting a big picture in which the figures were slightly less than life-size. They were, as Sir George explained the matter to Farington, '*dwarfish* approaching too near the height of men without being it . . . a size which He particularly disliked, something less than life & looking like a race of little men'.[27] Haydon retorted that if his figures were dwarfish, 'Poussin's [were] puppets.'[28]

Finding it impossible to negotiate directly with the artist, Sir George asked his other former house-guest to mediate and persuade Haydon to paint a smaller picture. Wilkie, who had just been elected an Associate of the Royal Academy, was an exemplar of diplomacy and common sense. He urged his friend to comply with the patron's wishes, not least because 'it would be a great advantage to Haydon to paint small, from the much greater demand there would be for his pictures.'[29] Looking at the picture in Haydon's painting room, Wilkie also thought 'the Macbeth's head too large for the body'.[30]

Haydon vacillated. One Sunday 'he had partly undertaken to make his picture smaller',[31] but by Friday 'he could not and would not paint the picture smaller than he had begun it'.[32] Three days later, 'he had, after all, begun his picture on a small scale from policy rather than principle'.[33] But a month later he was still 'much at a loss whether to begin his picture anew . . . or go on with the old plan'.[34] He wrote to Sir George suggesting a compromise: 'He was to finish the picture thus begun & should not Sir George then like it, He was to paint another the size which Sir George preferred.'[35]

That February a lioness died, from natural causes, on the second floor of a building in the Strand. Mr Gilbert Pidcock, proprietor of the Exeter Change Menagerie, sold the carcase to Charles Bell, who invited Haydon to participate in its dissection. It was a welcome distraction from the troublesome commission for Sir George Beaumont. For a fortnight Haydon dissected the specimen at Bell's Leicester Street rooms during the day, and was able to relate the complexities of bone, sinew and muscle to the movements of surviving beasts in Mr Pidcock's establishment during the evening.

About the middle of March, Sir George and Lady Beaumont called to see him and Haydon was amazed that a subject that had caused him so much anguish, and had been for so long in the forefront of his mind, was not even touched upon in their conversation. His visitors 'talked and chattered as usual', did not mention *Macbeth* and appeared to have forgotten there had ever been a commission to dispute. The way matters had previously been left – decidedly advantageous to Sir George – that the picture be finished and offered to him on approval, and with no obligation to accept it – was not alluded to.

Piqued, and determined to prove a point, the following day Haydon sent the canvas to be enlarged. By so doing he meant to dispel 'all suspicion that [he] had any intentions of forcing them to take it . . . and to please [him]self entirely, in every respect to prove to the World too the thorough contempt [he] entertained for them, and how little [he] cared for their patronage'. The canvas, which Sir George had considered too large in January at a 'whole length . . . and a little broader', was now extended to ten feet high and twelve feet wide.

<center>*</center>

Haydon sent two works to the Academy Exhibition that year. One was the study of a lioness, the other a modestly sized canvas: *Romeo Leaving Juliet at the Break of Day*: 'Juliet sinking, hanging on his neck . . . her hair carelessly diffused about her heavenly neck, her delicate form appearing through her mantle. Romeo, a fine erect, heroic limbed youth, pressing her gently to his bosom, with a look of trembling tenderness, pointing to the east, unable to tell her what is really the truth, that day is beginning to break.' He had made a sketch for it twelve months earlier as mental relief from a gruesome fantasy of

Lady Macbeth thrusting her hand into Duncan's gaping, still-warm wound and smearing the grooms' faces with his blood.

Romeo Leaving Juliet was first given a place in the Great Room and then, a pattern seeming to establish itself, was taken down and hung in the Ante-Room. Where the lioness was placed is not known, because when told the position of his main picture, Haydon withdrew both from the Exhibition.[36] He could, however, take comfort from the prominent place given to *Dentatus* at the British Institution, where he had sent it with Lord Mulgrave's permission and hopes that it would win the premium of 100 guineas for 'best picture of historical or poetical composition'.

<p style="text-align:center">★</p>

On Good Friday, 20 April 1810, Haydon took Holy Communion for the first time in his life. He trembled as he approached the altar, fearing that his thoughts might wander as he received the sacrament and

invalidate the ritual. But he remained absorbed, '[ate] the bread in awe, and drank the wine with firmness'. He staggered back to his seat, imagining Christ's agonised cry from the cross: 'it is finished'. On his way home he was startled at the significance of what he had done: 'drank wine & [ate] bread as our Saviour himself did 1800 years ago, and commanded us to do in remembrance of him . . . I have indeed done it . . . I am now a Christian.' Two days later, Easter Sunday, he received the Sacrament again, resolving 'to struggle with all my might to do all a Christian who has obeyed his blessed Saviour's commands ought to do, to render himself worthy of his protection and blessing'.

Some time during the same year, 'in the midst of melancholy reflections', he believed himself in receipt of divine instruction: 'an awful voice said within my breast "GO ON"'. He opened his Bible at random and the words of Isaiah, Chapter 41, verses 10–13, must have leaped off the page at him, every line weighted with significance bearing on his struggles:

> Fear thou not, for I am with thee; be not dismayed, for I am thy God; I will strengthen thee; yea, I will help thee; yea, I will uphold thee with the right hand of my righteousness.
>
> Behold, all they that were incensed against thee shall be ashamed and confounded; they shall be as nothing, and they that strive with thee shall perish.
>
> Thou shalt seek them, and shalt not find them, even them that contended with thee; they that war against thee shall be as nothing, and as a thing of nought.
>
> For I the Lord thy God will hold thy right hand, saying unto thee, Fear not; I will help thee!

More than thirty years later the same treacherous inner voice would urge him on to further struggle, to failure and to death.

<p align="center">*</p>

Haydon was not the only artist to withdraw his work from that year's Academy Exhibition. Wilkie had sent in a humorous picture of an elderly man teasing a little girl by pretending to promenade in her

favourite bonnet and shawl.[37] It was felt, by Sir George Beaumont and a number of Academicians, to be not up to his usual standard and that a picture sent in by Edward Bird, a rising star of genre painting, might overshadow it. Bowing to the argument that, as a new Associate of the Academy, the competition might do him harm, Wilkie withdrew the painting. But, as he later admitted to Haydon, had he seen the rival's effort, he would have allowed his own picture to stand and bear comparison with Bird's.

When Haydon met Sir George and Lady Beaumont at the Private View, the tension underlying their conversation probably had less to do with its ostensible subject than with the unresolved business of his commission.

'What do you think of Bird's Picture?' Sir George asked.

Haydon said he 'thought it a very inefficient Picture and by no means as good as his last'. Furthermore, he declared Wilkie to be by far the superior painter.

Lady Beaumont said that, all the same, she approved of Wilkie withdrawing his picture.

Haydon said he did not, and that 'it was a rascally thing to advise him to do so'.

Taken aback by such bluntness, and the imputation of rascality to her husband, she urged that 'docility in early life was a great requisite'.

'It certainly is,' Haydon replied, 'but one does not like to be trampled on.'

Three days later, Sir George and his Lady came to visit him in his painting room. This time it was impossible to avoid reference to *Macbeth* towering on its easel.

'What, you have enlarged the canvas?'

Haydon had doubtless rehearsed the conversation in his mind many times since the enlargement. 'Yes, sir, you never came near me for six weeks, and I concluded you had given up the commission, and I added the canvas to please myself.' He was now determined to have the matter settled. 'Am I to paint this picture for you, Sir George, or not?' he demanded.

'I can answer that,' Lady Beaumont broke in. 'We have not room for such a Picture.'

Haydon chose to ignore this. There was a silence, while Sir George attempted to collect his thoughts. Then:

'Ah – oh yes indeed – ah, ah – I thought it was to be as you mentioned in the Letter – that you were to go on with it, but if I did not like it when done I was not to have it . . .'

'Certainly, I thought so too, Sir George, but when You & Lady Beaumont called on me on your arrival in London and never even hinted I had ever been painting for you – I thought . . . that you wished to consider the engagement at an end.'

'Oh no, we meant nothing – nothing – yes indeed – oh no – oh no . . .' He looked at the canvas again. 'But then you have had it enlarged . . .'

'Certainly, Sir George. When I considered there was no prospect of your having the picture, I determined to please myself entirely.' His tone became more conciliatory. 'I should feel my mind greatly relieved if you would tell me decidedly whether you would have it or not – I should then begin it with energy – it would be a great stimulus.'

Sir George steered back towards their earlier agreement. 'Would it not be as great a stimulus if you were to paint it for me – but if when it is done I should not like it – I should not be obliged to take it?'

Haydon replied that in that case he should consider himself engaged to paint Sir George a smaller picture, the size of *Joseph and Mary*. He had one further stipulation regarding *Macbeth*.

'What's that?'

'Why, that neither you or Lady Beaumont shall see it till it is completely finished & in the frame.'

They agreed. Haydon was careful to recapitulate the arrangement, so there should be no misunderstanding, that *'the enlarged Picture was to be the one'* that he would be offering them. Again they agreed, and departed.

During the next few days Sir George received letters from Haydon 'such as seemed to show Him to be deranged in mind'. Haydon also wrote a long letter reporting the matter to Lord Mulgrave and referring to him as *'His real Patron'*. His Lordship showed this to Sir George over dinner, observing that 'Haydon wrote like a man in a state of madness.' Sir George voiced the fear that 'Haydon might commit some desperate act upon himself.'[38]

★

Associates of the Royal Academy were elected every year on the first Monday in November, candidates having first made their ambitions known on a large sheet of paper underneath the following lines of copperplate script:

> Exhibitors, being Artists by Profession, viz. Painters, Sculptors, or Architects, and not under Twenty-four Years of Age, nor Members of any other Society of Artists established in London, are eligible as Associates of the Royal Academy, and may become Candidates, by subscribing their Names to this List, which will be placed in the Academy for that Purpose, *during the month of May and no longer.*[39]

In 1810 there were thirty-two candidates comprising twenty-six painters, two sculptors and four architects. Having reached his twenty-fourth birthday that January, Haydon added his name, and designation of painter, to the list. He was entitled to apply, despite having no picture in the current Exhibition, because he had been an exhibitor the previous year. However, the bad grace with which he had endured the treatment of *Dentatus* on that occasion, the 'swearing' and 'offence to artists His Seniors', would not make him the most popular of candidates with the Academy's Council. His more recent behaviour, withdrawing his pictures in protest at their not being hung as he wished, would not endear him, either.

During the same month that he hazarded his name on the Academy list, and invited almost certain rejection the following November, another body of men voted to honour him. The Directors of the British Institution met on 17 May and awarded *Dentatus* the 100-guinea premium. Lord Mulgrave wrote warning against over-complacency in his success, and Haydon replied that he considered this 'as one step only of the fifty I had yet to make before I can approach the great object of my being'. In an alternate draft of the letter he modestly told his Lordship: 'I rejoice more that I have not dishonoured *your* taste in selecting *me*, than from my own particular gratification, that I have obtained the great premium.'[40]

Relations with 'His real Patron' were to deteriorate, however. *Dentatus*, when returned to his Lordship's London home following the Exhibition, was not taken out of its case, let alone hung, for another two years. Constable told Farington how: 'Haydon being

desirous to see where His picture was placed in Lord Mulgrave's House, called on his Lordship, but though He had long been received as a favourite guest, He was now refused admittance . . . & it is now known that the much admired picture of Dentatus, is now in its *Case* placed in his Lordship's stable. So much for capricious patronage.'[41]

The 100 guineas he received from the British Institution may have been the cause of more regular income, from another source, drying up completely. Haydon's father, when he heard of his son's good fortune, wrote him a letter 'full of heart'. He had, Haydon admitted, 'done his duty and never complained, and . . . lived to see my talents honoured and rewarded'. However, it must also have occurred to the old man that, with his son's talents honoured and rewarded so munificently, he had thereby achieved a measure of financial independence. Payments of Haydon's allowance had been increasingly erratic, but he now received another letter from his father saying that he could maintain him no longer. 'It was natural a father's patience should wear out at last,' Haydon reflected. 'It was right my sister should not be forgotten.' But he felt resentful nonetheless: 'It was not quite just to deprive me of necessaries when my father and his [business] partner were indulging in the luxuries of life. I was a virtuous and diligent youth. I had no expensive habits of self-indulgence. I never touched wine, dined at reasonable chophouses, lived principally, indeed always, in my study, worked, thought, painted, drew and cleaned my own brushes, like the humblest student.'

His greatest fear at this turn in his fortunes was that Sir George Beaumont would refuse to pay for *Macbeth*. But he comforted himself that it was a fine picture, which 'surely . . . could not be refused'. Even if it was, he had already won the 100-guinea prize with *Dentatus*, and saw no reason why *Macbeth* should not win him the 300 guineas being offered by the British Institution the following year. In the meantime, he borrowed. '*And here began debt and obligation,*' he commented later, '*out of which I never have been, and never shall be, extricated, as long as I live.*'

★ .

In June, Haydon stood in the gallery of John Julius Angerstein's London house looking closely at a large and very expensive picture. At twelve and a half feet high by nine and a half, Sebastiano del Piombo's *The Raising of Lazarus* was the largest in the banker's collection, and he had bought it in 1798 for 3,500 guineas, but considered he had got it cheap. Fuseli thought that the figure of Lazarus alone 'was worth the money' and that his expression was 'like one who had been looking into a warm place (Hell) & cd. Hardly believe himself secure from it'.[42] Painted on the same scale as Raphael's *Transfiguration*, and intended to rival that masterpiece, many – including Fuseli and Beaumont – considered it superior. In 1824 the House of Commons would vote £60,000 to purchase it, together with thirty-seven other works from Angerstein, to form the nucleus of a national art collection. The picture that Haydon was so carefully examining would have the rare distinction of numbering 'one' in the National Gallery's catalogue.

He thought the Christ 'a mean affected figure'. Having heard the casualness of the Saviour's gesture defended 'as if the painter wished to make it appear as an easy matter to him . . . to raise the dead', Haydon was not convinced:

> As the Painter's object is to excite the greatest possible interest . . . if you make [the principal figure] uninterested . . . the Spectator will be equally uninterested while looking at it.

Next he looked at the figure of Lazarus. Despite Fuseli's assertion that no less a master than Michelangelo himself had 'gone over it',[43] Haydon thought 'the chest [was] meagre, the Shoulder really badly drawn . . . and the leg poorly understood and not at all defined'. Following his study of the Elgin Marbles, he found the foot of Christ also deficient: 'nothing of that exquisite system of reasoning that you perceive in every grecian foot – the fleshy parts pressing up round the bones . . . it looks as if there was no weight above it – no pressure'.

For all its failings, he felt it to be 'a grand Picture; a great acquisition to the country – and an honour to Mr Angerstein's spirit and taste, in purchasing it'. Nevertheless, he believed he could do better. The title had figured in his list of 'Subjects Suitable for Painting'

compiled at Dover two years previously. Having examined the faults of this *Lazarus*, he declared that 'if God prolongs my life . . . I hope I shall leave one behind me that will do more honour to my country'. Thirteen years later he would complete his own version of the subject, twice the size of Sebastiano's.

<p style="text-align:center">★</p>

Just as Haydon's conception of *Dentatus* had been altered by his encounter with the Elgin Marbles, so, in September 1810, his introduction to a naked six-foot-tall black sailor from Boston left him 'disgusted' with his current picture, 'after contemplating that exquisite form . . . [H]e had that perfect suppleness that one felt but never before saw – his joints were exquisitely clear – every head of bone, having insertion of tendon – but marked by delicacy & feeling – in repose they became undulating beauties & in action vehicles of energy and refined activity – his body bent at the loins like whalebone.' The Royal Academy was also agog. The new Professor of Anatomy had discovered 'the Negro' Wilson 'in an Hospital [where he] attended him for some slight injury He had sustained'. Carlisle reported him to be 'an extraordinary fine figure' and took him to show Thomas Lawrence and Benjamin West. They considered him the finest figure they had ever seen, 'combining the character & perfection of many of the Antique Statues'. Lawrence made a sketch on canvas. 'When His arm was suspended,' he told Farington, 'it appeared like that of the Antinous, when contracted for exertion it was like the Farnese Hercules.'[44] George Dawe engaged Wilson as a model at two guineas a week[45] to pose for *A Negro Overpowering a Buffalo*, a six-foot-square canvas that he intended entering for the following year's British Institution premium.

Haydon had in mind a more substantial record of that wonderful physique when he hired the sailor for a month with thirty pounds borrowed from Leigh Hunt's brother John. He had had casts made of Boswell's leg and thigh for *Dentatus*, and now he systematically set about having 'all [Wilson's] joints moulded in every stage, from their greatest possible flexion to their greatest possible extension'. When he and the moulders had taken casts of what amounted to two whole figures, piece by piece, Haydon felt confident that a mould of the

entire body, front and back, could be made and worked out a method of doing so, a method that seemed perfectly simple. First they built a wall round the naked man, then they poured in fifty-six gallons of wet plaster up to his chin. It was only when the plaster set that the flaw in Haydon's method became apparent. Encased as he was in solid plaster, Wilson could not expand his chest sufficiently to take in air. Incapable of breathing, it is remarkable that he was able to utter the single phrase Haydon credited him: 'I – I – I die.' Then his head fell forward and he lost consciousness. Panic-stricken, Haydon and his workmen grabbed the front of the mould and pulled it down, bricks and all, breaking the plaster into three large pieces. Wilson fell forward, senseless, to the floor, where he lay gasping for breath and pouring sweat.

Although nearly fatal, the operation proved successful. Looking at the back part of the mould, which had not been injured, Haydon saw 'the most beautiful sight on earth'. It had taken the impression of Wilson's figure 'with all the purity of a shell', and when joined to the three broken front pieces, there appeared a perfect cast, one that he defied anyone in the world to equal without killing the man in the process.

<div align="center">★</div>

Courtesy dictated that a candidate for Associateship, after putting his name forward for election, should call on prominent members of the Royal Academy to lobby for their support.[46] Farington recorded Haydon's visit: 'He much wished me to express what my opinion was as to the strength of His claim, but I declined saying anything respecting it.'[47] The sculptor John Rossi, Haydon claimed, 'received me . . . with great vulgarity and almost pushed me from the door.' There is no record of the other calls he made, only the dispiriting lesson he learned from them: 'that the advance or improvement of Art was of the most trifling importance, in comparison with paltry intrigues or petty cabals for superiority'.

It was to be expected, when the eighteen members of the Council – Benjamin West presiding – met on 5 November 1810 to fill that year's single vacant Associateship, that Haydon would not be elected. He took satisfaction – as one who had anticipated nothing else – in the

fact that he received 'not a single vote'. This was indeed the case, but neither did the majority of the other twenty-five candidates. In the first ballot the still-life and animal painter George Arnald received fifteen votes and John James Halls the next-highest number of votes: two. In the second ballot, the single stray vote attached itself to Halls, giving him three, while Arnald held his fifteen and was duly elected.

That year John Constable also stood for the first time and also received 'not a single vote'. Unlike Haydon, however, Constable persevered. He stood again the following year, and again was rejected. He put his name forward every May for the next six years, and every November he was passed over until 1819, when an unusually small turnout of Council members resulted in his election with just eight votes.

<div align="center">★</div>

Haydon described the first six months of 1811 as 'one scene with few exceptions, of Idleness and vice', but conceded that he had been 'at times energetically employed'. He had resumed drawing from the Elgin Marbles, now occupying a different shed, at the rear of Burlington House, a temporary accommodation given to them by Lord Devonshire. In February Haydon drew there for as long as seven hours a day until 'benumbed with cold'.

He had worked steadily at his picture. One day he painted for five hours, concentrating on the head of Macbeth. He made studies of the ear, wanting 'to give it a motion as if starting forward to catch the sound, like a horse's'. At one stage, having finished painting the main protagonist to his satisfaction, and deciding that the composition would be improved if the figure were higher up the canvas, he scraped it out and repainted it in the required position. 'My Friends tell [this] as a wonderful instance of my perseverance,' he wrote later, adding, '. . . the wonder in Ancient Athens would have been if I had suffered it to remain'. He felt his friends' reaction epitomised the English acceptance of mediocrity. 'In such a state is Art in this Country!!!'

In August, news of 'the brig *Traveller*, lately arrived at Liverpool from Sierra Leone . . . perhaps the first vessel that ever reached Europe, entirely owned and navigated by Negroes', inspired Leigh Hunt to

devote his editorial remarks in the *Examiner* to the proposition that, although 'it is not to be denied that the negro, *at present* . . . exhibits an inferior animal character to the white man', thanks to the recent abolition of the traffic in slaves Captain Paul Cuffee could be welcomed as 'one of the forerunners of an equal race of beings'.[48] Hunt argued that racial inequality was due not to any intellectual or physical inferiority of the black to the white, but to his social condition and his servitude.

The editorial drew fire from two directions. Under the sobriquet 'Niger', one correspondent took issue with the phrase 'inferior animal condition'. He denied that the black race was in any way inferior to the white and argued that the very reason they were so highly valued as slaves was that 'they have been found infinitely superior in hardihood and robustness of constitution . . . can live and undergo great toils in climates where White men cannot labour, and can hardly live'.[49]

From the opposite direction, Haydon, signing himself 'An English Student', challenged the editor's questioning of 'the Negro's inferiority . . . in his bodily and intellectual conformation'. Bringing to the debate his study of the Elgin Marbles, dissection of a lioness, observations at Pidcock's menagerie and his acquaintance with the awesome physique of Wilson, the 'English Student' formulated a dubious thesis of comparative anatomy:

> In . . . the divine works of Greece . . . their standard of high form for an intellectual being was totally the reverse of all . . . brutal characteristics: – their feet were arched . . . the *inner* ankle *higher* than the outer, the pelvis wide, the calf low, full, and vigorous . . . These are the characteristics . . . of an intellectual European. In examining negroes, I soon perceived them to sink from these characteristics . . . and approach those of the brute. I perceived their ankles approached inversion, their feet flatness, their calf height, their heels projection, their pelvises narrowness . . . [T]he ankles of a monkey were nearly horizontal, his feet still flatter, and still more incapable to stand erectly; his pelvis still narrower, his hands still flatter . . . till a lion's ankles were completely *inverted*, his feet *perfectly* flat, his heel projecting immensely, and having completely those characteristics . . . belonging to brutality.[50]

Argument between the editor, the 'English Student', 'Niger' and, in its latter stages, 'A Friend of Human Improvement' continued for six weeks, with no party conceding ground to another. Haydon's was the last word in the exhausted correspondence. Responding to the views of the 'Friend of Human Improvement', he declared: 'I deny the negro that power of conquering his brutality . . . because I suspect . . . he is without the intellectual power.'[51] It would be thirty years before he published a retraction of this opinion.

<div align="center">★</div>

By the end of the year, *Macbeth* was finished.[52] The scene was viewed through the open doorway of Duncan's bedchamber. In the foreground were the two sleeping grooms, one collapsed on his knees, the other on his back, 'hands resting on the ground on each side, his face flushed, his jaw dropped, his hair dishevelled . . . and everything about him denoting deep, drowsy, intoxicating slumber'. Just behind the grooms, between them and Duncan's bed, was the main protagonist:

> Macbeth, the victim of imagination and terror . . . his chest heaved up with agony, his mouth gasping for breath with spasmatic effort, his nostril open, his eyes glaring, and bending on vacancy, his lips blue, his cheeks pallid and sunk – and his hands fixed & grasping the daggers with supernatural clutching energy.

Beyond lay the supine Duncan, vulnerable in sleep, his chest bared, the crown beside him on a velvet cushion, 'the terror [of the scene] . . . greatly encreased by the Shadow of Macbeth englooming across the royal bed'. While the main action was confined within the chamber, the other participant in the plot could be seen to one side of the composition:

> In dim obscurity without . . . in an enthusiastic elevated fury, with a face heated by fancy, a bosom heavy with anxiety, and an eye glittering with delight at the anticipation of the crown, with a hand uplifted as if listening and the deep shadow of her form trembling on the wall . . . is seen [Macbeth's] dreadful wife.

Haydon had given much excited thought to his erotically charged conception of this 'bold, full, vigorously lovely form flushed with wine . . . naked Shoulders half concealed by her jet black hair . . . tumble[d] in wild disordered luxuriance over her fine bosom heaving with anxiety for murder and a crown'.

He wrote to inform Sir George Beaumont that the painting he had commissioned was finished. He also asked his patron's permission to send it to the British Institution in competition for the 300-guinea premium. Sir George replied that 'He might do as He liked as the picture was not his',[53] since, according to their arrangement, 'he has no concern with it until he has seen & approved of the picture'.[54] Several abusive letters came from Haydon in return.[55] When he eventually saw *Macbeth* at the British Institution, Sir George, predictably, declined it and wrote to the painter with alternative propositions:

> I will either give you for the trouble you have had in the commencement of the picture £100, the picture shall remain your own property – & this shall put an end to all further negotiations; Or, you shall paint another picture for me the size of Mr West's Pylades & Orestes with figures upon the same scale & the price shall be settled after wards by arbitration.[56]

Haydon had calculated his debts at this time to be £616 10s. Loss of the 500 guineas that would have come his way, had Sir George accepted the picture, was therefore a serious blow and it was not softened by the £100 offered in compensation. He refused both the money and the commission for a smaller painting. It was more than ever important that *Macbeth* win the 300-guinea premium. Constable told Farington that Haydon was confident and 'much elated with His prospects'.

If Farington's mischievous informant was further to be believed, Haydon was to be heard speaking 'very slightly' of the Royal Academy, and 'saying as they had lost the opportunity when they might have elected Him, it might now [be necessary] for them to send a Deputation to solicit him to be of the Society'.[57] True or not, Haydon was about to launch an attack on the Academy that would contribute to the blighting of his entire future career. While awaiting the Directors'

decision regarding the 300-guinea premium, and before starting work on his next painting, he made his second foray into journalism.

Three years after the death of the history painter James Barry – the first, and until the early years of the twenty-first century, the only member to have been formally expelled from the Royal Academy in its history – a two-volume collection of his writings on art had been published. The connoisseur and Director of the British Institution, Richard Payne Knight, contributed an article to the *Edinburgh Review* in which he criticised Barry for perpetuating the notion 'that greatness of size and extent of space [were] necessary to greatness of character and effect', and that vast wall and ceiling spaces were essential for displaying the genius of a Raphael or a Carracci. Knight believed that these two masters 'would have displayed more talent, and deserved more reputation, had they only been employed upon easel pictures of moderate size'. This issue of scale was especially relevant to an assessment of Barry, a man who had left, as his artistic legacy, more than 1,700 square feet of painted mural, on no less a grandiose subject than *The Progress of Human Culture*, in the Great Room of the Society for the Encouragement of Arts. 'When the whole of a picture does not come within the field of vision . . . [so as] to show the beauties of particular expression and detail,' argued Knight:

> it is too large; since its effect on the mind must necessarily be weakened by being divided, and the apt relation of the parts to each other, and to the whole, in which the merit of all composition consists, be less striking when gradually discovered, than when seen at once.[58]

For Haydon, 'too large' was a phrase without meaning. His first letter 'To the Critic on Barry's Works', appearing in the *Examiner*, mocked the very idea that a work of genius could be 'too large', suggesting that, if a picture could be too large, then by the same token so could a building, a statue or a ship:

> that the neat little cottage and snug little box were more adapted to us as a nation, than such buildings as St Paul's . . . – that little bronze figures for our chimney-pieces and our side-boards, were more adapted to us than monumental statues or colossal heroes, – that the snug

little cutter and the nice little brig, were more consonant to our comforts than the seventy-four [gunner] or the ninety-eight.[59]

The second letter, although still ostensibly addressed to 'the Critic of Barry's Works', directed its fire at the intrigues and cabals of the Academy alone:

[T]here are a set of artists who would willingly see high art sink, and secretly give her a stab while sinking; there are a set whose imbecile prejudices against the rising Students are apparent, and against the Institution, and against every person and every place that will foster and protect them; . . . composed of all those who have struggled a short time in the higher walks of art, then sunk into picture dealers, and then sunk to nothing; composed of all those who know the moment the Students are well grounded in the means of their art, and the people's eyes are opened, will lose the little they have in either.

The invective reached a climax:

The Royal Academy, instead of becoming, as the King intended it, a vehicle of grand Art, and improving and elevating the minds of the people, from being placed in the hands of incompetence, is become a *vast organ* of *bad taste* and *corruption*.[60]

Although he again signed himself pseudonymously 'An English Student', Haydon was widely suspected of being the author.

Wilkie was appalled. Having been elected an Associate in 1809 and a Full Member in 1811, he now felt his loyalty to the Academy seriously compromised by this friendship. Also, the 'English Student' had mentioned him by name as a single exception of genius in the swamp of mediocrity, and Wilkie was afraid that he would thereby 'become a sharer in the recriminations'[61] he believed certain to be directed at Haydon. He tried to distance himself from collateral damage by requesting the return of a ticket to the Exhibition that he had previously given to Haydon, 'as I believe that under the present circumstances your going to a private view at the Royal Academy with one of my tickets would do me a very serious injury'.

His objections to Haydon's outburst in the *Examiner* were not

entirely self-interested. He believed his friend was, inadvertently, giving ammunition to his enemies:

> You have laid yourself open not merely to the charge of spleen and disappointment, and to the resentment of the Academy ... but to a charge that is much worse ... that of reviling the Academy in order to ingratiate yourself with the [British] Institution.[62]

Haydon had, indeed, made reference to the exemplary conduct of the Institution, to the assistance it offered to students and particularly to its admirable practice of awarding premiums.

A third letter from the 'English Student' continued his onslaught on the Academy. He attacked it for electing Sir Anthony Carlisle as Professor of Anatomy – 'one who had absolutely written *against Anatomy*'. He attacked the painters for their incompetence of finish and execution. He attacked the sculptors for their paucity of inspiration, for fashioning 'wretched feet and ill-formed limbs' and for filling St Paul's and Westminster Abbey with monuments that would 'disgrace the nation'. And he attacked the prevailing hegemony of the portrait painter, filling the Exhibition, year after year, with a 'portrait of this man, portrait of that man, standing on legs tapered like nine pins'. The Royal Academy was supposed 'to sanction fine taste and high art'. Instead, it had been 'perverted to gratify vanity and get sitters' and 'made subservient to get business for mediocrity'.[63]

Haydon was later inclined to agree with Wilkie that his 'English Student' letters had done him considerable damage. He would explain and justify them as deriving from the 'personal disappointment' of his failure to be elected an Associate in 1810. The irony was not lost upon him that the letters written to the *Examiner* in defence of James Barry had made of him also a pariah:

> I was heaped with calumnies, anonymous letters, had everything put on my shoulders [was] accused of envy & hatred, called a Barry, when I have always preferred clean sheets, a glass of wine, & a clean house, & am naturally happy tempered.

He was, of course, aware of the unfortunate outcast's squalid latter years, haunted with paranoiac delusions of the Academy's persecu-

tion and besieged in a near-derelict building that was daily pelted by local children with stones, bones and dead cats.

<div align="center">★</div>

Two conflicting scenes competed in Haydon's mind as subjects for his next painting. *Achilles Arming for Battle* had been the first on his Dover list of 'Subjects Suitable for Painting' four years previously. He now made a sketch: 'brassy, gleaming, dreadful Armour against a dark blue sky – his spear a comet – Horse – blazes – in back ground Army shouting for miles.' He was still tempted by it in March, lying awake until three o'clock in the morning imagining it all: 'the sea roaring, Achilles beaming, his horses dashing, the God descending'. But it was beginning to give way to another subject from his list:

> Solomon's fine heroic features, with his manly locks, conscious of his wisdom, half smiling at the anxiety of the young, beautiful, deeply-bosomed pathetic mother, who regarded only the safety of her offspring, had darted forward as the executioner lifted his sabre to divide it; the terror of a beautiful girl who imagined the deed was really to be done . . .

Early in April 1812, his decision made, his canvas up – twelve feet by ten, 'a grand size' – he started work on *The Judgement of Solomon*.

The week before he had heard the inner voice again. 'Trust in God', it told him. He prayed for protection in future 'pecuniary emergencies'. He prayed that his father and uncle would survive until he was independent and able to take care of his sister. 'O God,' he added, 'let me not die in debt.'

Everyone seemed agreed that the British Institution Exhibition of 1812 was a particularly poor one. Westall thought it 'a very bad collection', while Payne Knight, who might have been expected to be more sympathetic to the body of which he was a director, wrote that 'those who had not pictures there might be pleased in not having their works mixed with such a Collection'.[64] Sir George Beaumont, also a director, thought it 'a wretched display, & that it wd. be better to admit not more than a dozen respectable pictures than such a heap of bad pictures'. He was of the opinion that the offer of premiums should

be withdrawn that year and 'it wd. be better . . . to select & purchase at liberal prices such pictures as might be sent for Exhibition but not as from Candidates for Premiums'.[65] While Sir George may not have intended depriving Haydon of his coveted 300 guineas, his suggestion was partially adopted by the Committee and another painter was made the beneficiary.

Henry James Richter's 'first attempt at Historical Painting',[66] *Christ Giving Sight to the Blind*, was not even in the British Institution's Exhibition, but in that of the Society of Painters in Watercolour, Bond Street,[67] when Lord Mulgrave and Sir George saw and 'violently praised' it. Sir George declared that the head of Christ was 'admirable' and that he 'had never before seen the *Divine Character* so well expressed'. It was on their recommendation that the Directors of the British Institution agreed to buy the picture for 500 guineas. Richter's two champions justified the decision loudly and, cornering Benjamin West at a social gathering, 'pressed upon [him] the most extravagant eulogiums on the picture which they continued to do for a long time'. West was then asked what he thought of it. He paused before answering, and then replied coldly, 'That it was a picture which had much promise in it.' Speaking privately to Farington, however, he declared that the British Institution had displayed a 'want of judgement . . . in thus purchasing a mere *work of promise* for a purpose for which works of established merit only should be procured'. Such works, after all, were intended, eventually, to form the core of a National Gallery. 'They would have acted more properly,' West added, 'had they given [Richter] 500 guineas as an encouragement and returned him his picture.'

When Haydon was told of the purchase, he 'was confounded & scarcely believed the report to be true. Haydon had been the Hero of His Lordship & Sir George but now [saw] another honoured & placed before Him.'[68] But worse was to come.

After news of the purchase of *Christ Giving Sight to the Blind* for 500 guineas came the not unconnected news that the first and second premiums promised for historical painting, totalling 500 guineas, would not be awarded. A joint meeting of the Directors and Governors had resolved on the opinion:

that No. 64, Mr Joseph's Picture of the 'Procession to Mount Calvary' is the best Picture of those in competition; and No. 56, Mr Haydon's

Picture of 'Macbeth', the next in merit – but . . . that no one of the Pictures, is worthy either the first or second Prizes; and that the third Prize only should be given to No. 64.

Three days later the Committee of Directors convened to ratify this opinion. To that injury was now added insult, with a second resolution. 'That in case either of the other six competitors shall think proper to accept the sum of 30 guineas, on account of the expense of Frames . . . it shall be paid them.' The Committee's third resolution was ordered to be pinned up in the Gallery:

> That, altho' the Directors of this Institution are no less than ever desirous of promoting the progress of the Art of Painting by Rewards, both Honorary & Pecuniary; yet considering the difficulty which they have experienced, in awarding the Prizes offered under the present Regulations, they feel it expedient to give Notice, that for the future they will certainly withhold the Premiums entirely, unless so far as any Picture offered shall appear to possess sufficient merit fully to deserve the Reward.[69]

Ironically, the 'English Student' had suggested just such a policy, as a means of maintaining artistic standards, in the third of his letters to the *Examiner*:

> If the Directors make the Pictures of one year a criterion for the next, and never suffer any Pictures to carry off prizes on the year following, that are not better or equal to those preceding, Art *must advance*.[70]

Haydon was devastated by the decision, his disappointment being the subject of much conversation and the Committee's conduct 'universally reprobated'.[71] Over dinner at Farington's, West condemned the Committee's conduct and said that *Macbeth* should have been rewarded. Constable, sitting next to the President, gleefully informed the party that Haydon had 'lately been troubled with bowel complaints . . . attributed to anxiety of mind from having lost the Premium'.[72] It was said that friends had advised Haydon to take the thirty guineas offered for the expense of the frame, but that he had declined to. Besides, he later claimed that actually his frame cost sixty guineas.

He believed that the root of this and all his subsequent troubles and failures was to be found in those three letters signed 'An English Student'. Over a decade later, in conversation with the banker Jeremiah Harman, as the wreck of his financial affairs moved him inexorably towards the King's Bench Prison, he admitted: 'My crime was the refutation of Payne Knight.'

'It was.'

'It will never be forgiven.'

'It ought not. Young men should not give themselves *airs*.'

Surprisingly, however, when the Directors had discussed the question of the proposed premiums, support for Haydon's picture had come from an unexpected individual. According to Farington, it was Payne Knight who moved: 'That as it was resolved to give [only one] Premium, that *Haydon's* picture of *Macbeth* should have it.'[73] But he was overruled and the lowest of the premiums was given to the picture painted by Joseph.

<div align="center">*</div>

'Let me not die in debt.' The appeal was to figure ever more frequently in Haydon's prayers. He began his picture of *The Judgement of Solomon* with debts of more than £600. He would finish it two years later in debt to nearly double that sum.

Having prayed to be supported through 'pecuniary emergencies', he relied on friends when divine assistance was not forthcoming. The brothers Hunt were especially generous. John Hunt gave an assurance 'that as far as his means went [Haydon] might be easy'. Leigh Hunt offered 'a plate at his table' for as long as it was needed. Haydon recalled meeting Robert Hunt in the street:

'How are you?' asked Hunt.

'Dreadfully anxious.'

'Why?'

'I have got fifty-eight pounds to pay today & have only got fifty, I am going to try if that will do for the week.'

'My dear Haydon, stop a moment.' And Hunt disappeared around a corner, pawned his watch and returned to press eight pounds into the painter's hand.[74]

Another friend, however, was less generous. When Haydon told

Wilkie he needed 'the common necessaries of life', the Scotsman looked terrified. 'Will you advance me ten pounds in addition to the twenty-four pounds I owe you?' Haydon asked, and Wilkie refused. 'He stammered out he could not spare more.' Believing that his friend's difficulties arose from his attacks on the Royal Academy and offending Payne Knight, Wilkie kept saying: 'I told you so, I told you so.' Haydon left empty-handed.

As for the 'common necessaries of life', his most pressing obligation was to his landlord, to whom he already owed £200 in back-rent. Having just rubbed in *Solomon*, Haydon called in Henry Perkins and stated his case. 'Perkins, I'll leave you if you wish it,' he said, 'but it will be a pity, will it not, not to finish such a beginning.'

The landlord looked at the canvas. 'It's a grand thing; how long will it be before it is done, sir?'

'Two years.'

'What, two years more, and no rent?'

'Not a shilling.'

'I should not like ye to go,' said Perkins, rubbing his chin. 'It's hard for both of us,' he muttered. 'But what I say is this, you always paid me when you could, and why should you not again when you are able?'

Haydon agreed with this line of reasoning.

'Well, sir, here is my hand,' said Perkins. 'I'll give you two years more, and if this does not sell . . . why then, sir we'll consider what is to be done; so don't fret, but work.'

Similar kindness was extended him at John O'Groat's chop-house. One evening Haydon asked if he might pay for his meal the following day, and on his way out a serving girl called him into the back room where the proprietor nervously stammered out an offer of long-term credit. Haydon accepted. 'Two years did Mr Seabrook, Rupert Street, receive me with a smiling face and an open hand, without one complaint, one surly air, & one shade of disrespect, as if I had paid like a Nobleman.' So fortunate was he in those ensuring his shelter and sustenance that he imagined himself to be under just the divine 'merciful protection' for which he so often prayed.

★

Although it would take him two years to finish *The Judgement of Solomon*, he had gained sufficient experience from the struggles and false starts of his previous pictures to make rapid initial progress. In just two days he had drawn in the figures, 'ascertained the perspective proportions of all the heads; squared in the pavement; oiled [the] ground'. He had 'advanced' his picture, in short, 'more methodically', his hand rendered 'more certain . . . from wading through the drudgery of Macbeth & Dentatus'. Four days later he had got in the architecture, the sky and part of the background, together with the central figure of Solomon. The following day he got in the figures of the two mothers. The disputed child was drawn from his landlord's baby son. The dead child – discarded and crumpled in the bottom right corner of the composition – was sketched from one of Charles Bell's bottled specimens.[75] Corporal Salmon, his splendid body naked to the waist, would pose for the executioner raising his sword to cut the living infant in two. The figure of Solomon was also derived from drawings of Salmon, although the face – 'luscious youthful love mingled with profound wisdom' – would be Haydon's own.

Having worked at his picture industriously for almost a month, he borrowed Wilkie's horse and rode to Hampton Court to spend 'a delicious four hours' with the Raphael Cartoons. It may have been his first sight of these seven monumental paper tapestry patterns, although, as a student at the Royal Academy, he would have been familiar with the full-size copies by Sir James Thornhill, used as teaching aids at Somerset House.[76] Refreshed by his ride and standing in the gallery specially designed for them by Christopher Wren, Haydon stared up at masterpieces that he would always revere alongside his beloved Elgin Marbles. He compared the features of St John from one composition to another: 'the same look of purity, piety, benevolence, meekness, and voluptuous rapture, with a glowing cheek enveloped in long heavenly hair'. He studied the girl, at the far left of *The Healing of the Lame Man*, carrying a basket of fruit on her head, and his appreciation wavered slightly from the pure and pious:

Never was there a more exquisite creature painted. It is impossible to look at her without being in love with her, without longing to press such an innocent creature to your bosom, and yet tremble for fear of offending her . . .

He compared her with the voluptuous monsters of Fuseli:

> Think of [his] savage ferocity, his whorish abandoned women, the daughters of the bawds of Hell, engendered by lecherous, dusky demons, and then bring to your fancy this exquisite, graceful, innocent creature.

That year Haydon fell under the spell of a woman who, according to his description, might have stepped fully formed – one of those 'whorish . . . daughters of the bawds of Hell' – from Fuseli's most feverish imagining. The identity of this 'infernal abandoned creature' being unknown, her very anonymity becomes a source of fascination. That she was married – to 'the worthiest of men' – and had five children are the only facts Haydon let slip. The rest is an hysterical diatribe in which the charm, vivacity and flirtatiousness of a practised society hostess are delineated as a study of pathological sexuality:

> Such was her corruption that every . . . object that seeing, smelling, touching, or tasting, could reach were to her sources of licentious gratification. The perfume of flowers, she would say, trembling with passion, has *an amorous smell!* The richness of a Summer evening, the silence of a woody grove affected her vitiated fancy only as affording more refined means of lechery & lust.

She would play off one besotted victim against another, and Haydon claimed to have seen her 'at table surrounded by such lovers, all nervous, agitated, trembling & melancholy, all watching her looks, all in love, all jealous of each other . . . all submitting'. He saw her 'smile like a beautiful Devil & enchant the whole [company], and yet with such consummate art was this managed, that she contrived to make her husband invite them!'

The 'commonest expressions, & the most innocent words' became 'a vehicle of vice', but he was all too well aware that nothing in the conversation and behaviour of this 'devil of vice & corruption, iced over with snowy reserve' would seem untoward to the objective witness: 'To a third person who *heard*, nothing could appear but to the lover who *saw*, everything.'

Precisely when he became acquainted with her, how long he strug-

gled against temptation, and when, finally, he 'escaped without vice', is unclear. A sketch of her, dated November 1812 and inscribed enigmatically 'Exactly her moments of her vicious torture', might indicate the latter stage of the liaison. Earlier, in June, he had painted his model, Miss Green,[77] posing for the 'wicked mother' in *Solomon*, but the expression he used was the memory of that momentarily glimpsed on the face of his mysterious tormenter. Miss Green was terrified when she saw it: 'Surely, sir, I never looked so dreadfully?'

'No,' he replied, 'your head and form have only been the objects to paint from and put the expression in. God forbid that under any circumstances you should look and feel like that.'

The memory of another expression was called on for the true mother, dashing forward with raised hands to prevent the executioner from dividing the child with his sword. A sketch appears in the journal, recollection of a traffic accident Haydon had witnessed.

> . . . a poor creature who saw her Son dashed in pieces by a Horse, near Temple Bar. Nothing could exceed her dreadful agony. Her nose & cheeks became a settled purple, a burning tear fixed, without dropping, on her lid, her livid lips shook with agony, while she screamed & groaned with agitated hoarseness on her dear boy!

The model for a young mother at the far left, fleeing the scene with her two children, was Patience Smith, a lustrous black-eyed 'Gypsy' whom Haydon claimed to have met by the fire of an encampment on the outskirts of London. She was 'about sixteen, with jet hair and brunette face – a perfect Raffaele'. This young beauty occupied the same place in his composition as the 'exquisite creature' who had so impressed him in *The Healing of the Lame Man* at Hampton Court.

Patience had a husband – 'just the mixture of raff dandy and pickpocket you meet at Epsom and Ascot' – who would keep her always on just the wrong side of the law.

<p style="text-align:center">★</p>

At an early stage of his work on *Solomon*, Haydon was introduced to William Hazlitt at Northcote's house, just around the corner from his

own lodgings in Great Marlborough Street. They left together and, as they walked, Hazlitt praised Haydon's *Macbeth*. Haydon invited the critic up to his painting room to see the new work. 'Thence began,' he recalled, 'a friendship for that interesting man, that singular mixture of friend and fiend, radical and critic, metaphysician, poet and painter, on whose word no one could rely, on whose heart no one could calculate, and some of whose deductions he himself would try to explain in vain.'

At the end of November, due to 'the continuance of his Majesty's lamentable indisposition',[78] the Prince Regent opened Parliament and Haydon was there to see the ceremony. The Prince read the speech given to him 'admirably, with the greatest perspicuity, not the slightest provincialism, pure English'. He applauded recent military successes against the French in Spain and urged Parliament's 'cordial support in a vigorous prosecution of the war', which the United States of America had declared the previous June. Turning to domestic matters and the activities of Luddite mobs, he deplored 'the spirit of outrage and insubordination which had appeared in some parts of the country' and expressed satisfaction at the measures adopted for suppressing it. These would result, the following January, in the execution of seventeen of the ringleaders and the transportation of forty-seven more. His Highness 'appeared affected', towards the end of his speech:

> I trust I shall never have occasion to lament the recurrence of atrocities so repugnant to the British character; that all His Majesty's subjects will be impressed with the conviction, that the happiness of individuals and the welfare of the State, equally depend upon a strict obedience to the laws, and an attachment to our excellent Constitution.

Haydon went back in the evening to listen to a debate on the Prince's speech and heard the Marquis of Wellesley's passionate plea that more resources be given to his younger brother's Peninsular Campaign. He pointed out that before the battle of Salamanca, far from making a tactical withdrawal to lure the enemy on, Wellington's forces had been in retreat, and it was only due to a miscalculation by Marshal Marmont that the allied victory was secured. 'Was it upon such a ground as this,' Wellesley demanded, 'that a wise nation would

rest for success, – was it upon such accidents as this that it was to found its system of action? The country may, indeed, well build on the talents of the General . . . but they who reckon upon the errors of the French Generals, will probably find that they build upon a very insecure foundation.'[79]

As Wellesley spoke, Haydon observed that he 'put himself repeatedly in the attitude of Raphael's St Paul at Athens', suggesting less his Lordship's familiarity with the master's works as the master's accuracy in conveying truth of oratorical gesture.

Haydon later claimed to have been distracted from the eloquence of the debate by the shabby decorations and 'miserable tapestry' in the Peers' chamber and claimed that this inspired the murals he would dream of creating for the rest of his life, and so abjectly fail to accomplish: 'an illustration of the best government to regulate without cramping the energy of man': the first was to show the horrors of anarchy; then the injustice of democracy; then the cruelty of despotism; the infamies of revolution; then the beauty of justice; and to conclude with limited monarchy and its blessings'.

His journal entry of 30 November made no mention of this idea, but throughout December he wrote at great length on the need for an extension of state patronage beyond the Arts of Architecture and Sculpture to that of Painting, and although he had clearly not, at this early stage, decided on the subject matter of his projected pictures, he at least knew what purpose they might be intended to serve. Just as Barry's masterpiece, *Progress of Human Culture,* urged on the Society's members in their task of encouraging the Arts, so Haydon's decorations were to urge his country's statesmen on to enlightened good governance:

[C]onceive the House of Lords with its spacious & ample sides clothed with illustrious examples of Virtue & Heroism. [F]ancy – as [a] Nobleman of genius in the enthusiasm of debate illustrates his assertion with pointed finger to an example before his eyes – 'My Lords, I refer you to the illustrious example of Virtue before you; let it stimulate you to do your duty to your Country & your King . . .' Can it be possible to conceive any thing more likely to impress truth, virtue, & such examples and such allusions in the heat of debate & the fury of discussion?

Nine days after opening Parliament, the Prince Regent was plaintiff in a libel trial: *The King v. John and Leigh Hunt*, heard in the Court of King's Bench, Westminster Hall.

The previous March, an article had appeared in the *Examiner* deemed by the Attorney General to be defamatory and intended 'to traduce and vilify His Royal Highness'.[80] It called him:

> a violator of his word, a libertine over head and ears in debt and disgrace, a despiser of domestic ties, the companion of gamblers and demireps, a man who has just closed half a century without one single claim on the gratitude of his country or the respect of posterity.[81]

Despite the best efforts of their able barrister, Henry Brougham, on the evening of 3 February 1813 the defendants – publisher and editor respectively – were beginning their two-year sentences in separate prisons. John Hunt was at Clerkenwell in a House of Correction whose reputation for severity seemed reinforced by its very name: Cold Bath Fields. His brother was south of the Thames in Surrey Gaol.

Haydon lost no time in crossing the river to visit Leigh Hunt, but was turned back at the lodge gate in Horsemonger Lane by Mr Cave, 'the Under-Governor or gaoler', who told him that the prisoner would write to his friends when he wished to see them. Refused admittance, Haydon indulged in a fulsome Gothic fantasy, which he communicated to the convict as the next best thing to a visit:

> I see you, as it were in a misty vision. I imagine myself quietly going to you in the solemnity of evening; I think I perceive your massy prison, erect, solitary, nearly lost in deep-toned obscurity, pressing the earth with supernatural weight, encircled with an atmosphere of enchanted silence, into which no being can enter without a shudder. As I advance with whispering steps I imagine, with an acuteness that amounts to reality, I hear the oozing on the evening wind, as it sweeps along with moaning stillness, the strains of your captive flute . . . I then stop and listen . . . afraid to stir, lest I might lose one melancholy tone, or interrupt by the most imperceptible motion one sweet and soothing undulation.

Hunt's 'captive flute' was soon augmented by a lute and a pianoforte, his pair of prison rooms decorated with rose-and-trellis wallpaper, ceilings painted with sky and clouds, windows covered with Venetian blinds, the whole transformed into a 'poet's bower' furnished with bookcases, flowers and statuary, and presided over by the tender housekeeping of his wife's sister Bess.[82]

<p style="text-align:center">★</p>

Although he had given thanks, in January 1813, that he had 'completely recovered . . . tranquillity & conquered the agitation from that infernal woman', Haydon would continue his struggles against sexual temptation over the following months. 'I felt this morning an almost irresistible inclination to go down to Greenwich and have [a] delicious tumble with the Girls over the hills. I fancied a fine creature in a sweet, fluttering, clean drapery, spotted with little flowers, a slight, delicate, muslin white scarf crossed over her beating bosom, with health rosing her shining cheeks, & love melting in her sparkling eyes, with a soft warm hand & bending form ready to leap into your arms, confiding & loving!' But Art won out in the end. 'After a short struggle, I seized my brush with a spasmatic effort, knowing the consequences of yielding to my disposition, & that tho' it might begin today, it would not end with it.'

His journal yields little precision upon his relations with women. 'I never was refused, but always accepted,' he would write of his sexual conquests, however unreliably, more than twenty years later, 'and God knows I proposed often enough – I had 4 on my hands at once. What a heartless Shame! – one dear girl is an old maid yet.'

On a late Friday afternoon in April, Haydon was invited to attend the christening of William Hazlitt's son. He arrived punctually at four to find that no preparations had been made for visitors, Hazlitt's wife, 'thin pale and spitty', huddled by the fire with influenza, and the child 'chubby . . . squalling, obstinate, & half-cleaned'. The father himself, who had left it until the last minute to search for a parson, arrived late without having found one, and the infant remained at the end of the day in the same spiritual condition in which he had been at the beginning. Writing some thirty years later, Haydon numbered 'Charles Lamb and his poor sister'[83] among the party, but the more immediate

journal account had only 'a young mathematician' and 'an old Lady of Genius with torn ruffles'. The mathematician was subject to a facial spasm, jerking one side of his mouth up and screwing an eye shut whenever he spoke.

The first object to arrive at table was 'a plate with a dozen large, waxen, cold, clayy, slaty potatoes'. This was followed, after an uncomfortable interval – during which the guests stared forlornly at the potatoes, fearing them to be the only offering – by a joint of overdone beef: 'burnt, toppling about on seven or eight corners, with a great bone sticking out like a battering ram; the great difficulty was to make it stand upright! but the greater to discover a *cuttable* place, for all was jagged, jutting, & irregular'.

Haydon went home as early as he could, reflecting that, although 'beastliness & indifference to the common comforts of life may amuse for a time, they soon weary & disgust those who prefer attention & cleanliness'.

<center>★</center>

Late the previous year Haydon had made a last application to his father for financial assistance. The reply – that it was impossible, and that what he had already been given was beyond the old man's means – was received philosophically:

> I am in the middle of a great picture without a penny for the necessities of life or for models . . . This was my situation while engaged on Macbeth. Being new it cut me deeply but never checked or depressed me. But now, broken in to misfortune, I can look at her without shrinking . . . and by God's help . . . I have no doubt of subduing my picture with honour, and coming out of the battle invigorated and ready for fresh combats.

Six months later, he was hard at work painting the figures on the left of the executioner. One of his ill-afforded models – 'a Negro' – seemed to confirm the racial theories he had expounded in the *Examiner*, and he 'found all the marks of brutality more strongly than ever'. It was while painting a head above this, in the top corner of the canvas – that of a man climbing a pillar to get a better view of the central

action – that he received a letter from Plymouth informing him of his father's death. He carried on painting. So intense was his concentration that the news made no impression 'till the head was done, & the excitement over . . . [and] the loss [he] had sustained rushed on [his] mind.' He also felt that he would never 'exceed the head of the man climbing up the column'.

He worked frantically. 'I do not recollect a week since I began the Art of greater exertion than the one past,' he wrote in September. 'I . . . have painted & drawn night & day without intermission.' Even so, coming back to the canvas 'after 3 days absence', he found faults: 'Executioner's legs too thick, body not full enough; Black's head too big.' And he noted anxiously, 'the Picture must be fine or I am ruined'.

Just before Christmas, after seventeen hours' continuous work – from ten o'clock in the morning until three in the morning of the following day – he finished painting the head of Solomon. His model had departed, exhausted, after six hours. Determined it should be done before he slept, Haydon worked on by himself, the painted face becoming his own.

In January 1814 he celebrated his twenty-eighth birthday and *The Judgement of Solomon* was nearing completion. Despite the injustice he felt had been done to him two years before, Haydon 'prefer[ed] exhibition [of his picture] in the British Gallery to any other'. But he had missed the sending-in date. He professed himself willing to hold the picture back for the following year's exhibition, but only if 'the Directors think proper to assist me' with compensation for another twelve months without the opportunity of a sale. He knew this to be unlikely, however. Apart from the Royal Academy – and when Wilkie advised that destination, he replied that *Solomon* 'should perish first' – the only other exhibition open to him was that of the old Water-Colour Society, which had become the Society of Painters in Oils and Watercolour, 'who then admitted pictures'.

There was still a considerable amount of work to be done and for a fortnight he laboured in a frenzied delirium, living on potatoes 'because I would not cloud my mind with the fumes of indigestion'. For about half of that time he worked sixteen hours a day and hardly slept. This 'imprudent excess' caused a breakdown from which, thirty years later, he claimed never to have entirely recovered. Fuseli came

to see him, the lavish praise for his picture mingled with concern for his health:

> By Gode, you will never paint finer things; it was in ye, I always said, and now, by Gode, it's out. You have a marrowy touch, quite Venetian; but you look damned theen. Take care of the eyes; that is your curse: it will get hold of ye at last; hard work and oder things won't do, Master Haydon, by Gode.

The long hours of close work by candlelight had indeed taken their toll and – not for the last time – Haydon's eyes were perilously strained. He was saved from losing his sight entirely by the fortuitous visit of Sir William Adams, surgeon and oculist-extraordinary to the Prince Regent.[84]

> [He] came just as I was laying my head down, by the advice of a little apothecary, to have my temporal artery opened. Adams in his blunt way said: 'If that's done he will be blind. He wants stimulants, not depletion': and he saved my eyes.

The doctor's orders were for a richer diet than potatoes, and the necessary stimulant of wine, a luxury that he could not afford. Haydon summoned his vintner:

> showed him Solomon, said I was in bad health, and appealed to him whether I ought after such an effort to be without a glass of wine which my medical man had recommended. 'Certainly not,' said he. 'I'll send you two dozen; pay me as soon as you can, and recollect to drink success to Solomon the first glass you taste.'

By similar appeal he persuaded a carpenter to supply his ten-foot by twelve canvas with a frame, on credit.

Further assistance came from fellow painters. William Hilton offered 'a large sum' from the 500 guineas he had received from the British Institution for *Mary Annointing the Feet of Jesus*, and Haydon accepted thirty-four pounds. Despite the 'English Student's' campaign against the Academy, Benjamin West remained friendly. He declared that there were parts of Haydon's picture 'equal to anything in the art'.

'But get into better air,' the old man added, 'you will never recover

with this eternal anxiety before you. Have you any resources?'

'They are exhausted,' replied Haydon.

'D'ye want money?'

'Indeed I do.'

'So do I,' said West, and then explained that his presidential salary had been stopped, but that Fauntleroy, his banker, was arranging an advance. 'If I succeed, my young friend, you shall hear, don't be cast down – such a work must not be allowed to be forgotten.' Fifteen pounds arrived later in the day 'to keep the wolfe from the door'. The covering letter carried apologies that 'the gout in my right hand has made it deficult for me to write this note inteligeble'.

★

Ten years later, in Edinburgh, a young painter asked David Wilkie his opinion of the treatment that Haydon and *The Assassination of Dentatus* had received at the Academy. 'Oh, yes! He was ill-used – badly treated in that matter,' Wilkie replied:

> But he should never have heeded, – [should have] passed it by, and got in [as an Associate] . . . for he has vast powers, stores of varied acquire-ments, and a command of language that none in the Academy at present can combat with. Besides a career of success alone is the best answer to make, both to enemies and to men who are envious of superior powers. Success gives a wonderful stimulus to man's natural powers and re-assures, as it were the efforts of genius; whilst trouble and misfor-tune tend to unnerve a man, and damp the ardour necessary to carry him on to great results. But you see . . .

And it was as if the ever-cautious Scot had suddenly recollected himself and realised he might have said too much:

> But you see . . . I am myself of the Academy, and it is a rule that 'birds are not to foul in their own nests', so, if you please, we will change the subject.

But then he carried on:

Haydon has great power in his art; there is nothing in our times to compare with parts of his 'Judgement of Solomon', – that is truly a great work, well gone through in all its parts, nothing slighted, nothing little, and it combines tenderness and delicacy of feeling with real power over his materials and his art. Ah, it is grand! . . . But large historical pictures, such as Haydon's, have this disadvantage, – that they are beyond the scale of private purchase . . .[85]

In April 1814, as he prepared to exhibit that enormous picture, Haydon took stock. He found himself £1,100 in debt; £400 was accounted for to his landlord, the patient Mr Perkins. He owed forty-nine pounds to Mr Seabrook at John O'Groat's for two years' worth of meals. The rest, in unspecified distribution, was due to his baker, his tailor, his coal merchant, his wine merchant, his carpenter and a myriad of other creditors.

His picture was rolled and taken to Mr Wigley's Rooms in Spring Gardens: a former Huguenot chapel, a former concert hall where Mozart made his London debut, and the former home of Cox's Museum of Mechanical Works of Art. Stretched and resplendent in a frame that had yet to be paid for, *The Judgement of Solomon* was given a 'grand centre place', in the Great Room, 'on the left with nothing near it'.

PART THREE

TRIUMPHS
1814–21

Caroline Amelia Elizabeth of Brunswick-Wolfenbüttel, Princess of Wales, estranged wife of the Prince Regent and future uncrowned Queen of Great Britain was, in the spring of 1814, shortly to quit her adopted country for a six-year scandal-gathering tour of the pleasure grounds of newly pacified Europe. On Saturday 23 April she was to be seen at the Private Day of the Tenth Annual Exhibition of the Society of Painters in Oils and Watercolour. She perambulated the Great Room in the company of Mr Payne Knight. 'Her person had become very large and coarse,' noted Joseph Farington a couple of days later. 'Her shoulders and arms greatly so.'[1] She paused in front of Haydon's *The Judgement of Solomon*. Mr Payne Knight looked closely at the canvas, declared it 'Distorted stuff!' and murmured something to the Princess. Whatever additional remark he made, her Royal Highness evidently concurred and walked away without giving *Solomon* a second glance. She was heard to remark that she was 'very sorry to see such a picture here'. The Princess of Wales's disapproval, while it dismayed the Society's President and officials, did not dampen the artist's spirits. 'My dear friends,' he told them, 'wait for John Bull!'

The nobility came and showed some interest in Haydon's picture, 'though one said it was very large.'

The Academy came, as though despite its better judgement. Flaxman had been passing 'by sheer accident'. Smirke was there 'by the merest chance'. Another came, also 'by accident'. Turner came. 'But Turner behaved well,' conceded Haydon, 'and did me justice.' After looking at the picture, the little Academician left a message: 'Tell Haydon I am astonished.'

On Monday 25 April, the Gallery threw open its doors to the public and John Bull came and declared himself gratified by *The Judgement of*

Solomon. 'I was there,' a friend told Haydon, '& found the whole roomful of people with eyes riveted on it.'[2] In the first thirty minutes a gentleman approached the artist, opened his pocket book and showed him £500.

'Will you take it?' he asked.

It was £235 short of the asking price.[3] 'I cannot,' Haydon replied. The gentleman invited him to dinner to discuss the matter further. Sitting over their wine, the asking price having finally been agreed, the gentleman's wife demanded: 'But, my dear, where am I to put my piano?' and the agreement came to nothing.

Two days later, Sir George Beaumont and Mr Holwell Carr arrived at Spring Gardens, authorised by their fellow Directors to purchase *The Judgement of Solomon* for the British Institution. While they were standing, discussing its merits, the Secretary of the Society walked up to the picture and attached a label to it: SOLD.

'Sold?' said Sir George.

'Yes, indeed,' replied the official.

'Oh! But we came to buy it.'

'Ah but, sir, you did not say so.'

'Oh no, but we were going to.'

'Ah but, sir, a gentleman came up and bought it whilst you were talking.'

'God bless me!' said Sir George, 'it is very provoking.'

And he wandered around, to the quiet amusement of the entire room, telling everyone he met that 'the British Institution meant to have bought it'.

Haydon arrived, caught sight of the 'SOLD' label attached to his picture frame and gave silent thanks to God. Then Sir George was approaching, holding out his hand and pronouncing himself – like Turner – 'astonished'. Haydon shook the proffered hand with both of his own and, before the crowded room, they were reconciled, the four-year acrimony forgiven, even for the moment forgotten, in the warmth of congratulation: 'You must paint me a picture after all. Yes, indeed, you must . . . yes indeed'. And although the rash promise of another commission was never fulfilled, Sir George would at last agree to buy the disputed *Macbeth*, even expressing reserved satisfaction with it. They were joined by Lord Mulgrave and General Phipps. All swore the *Solomon* was 'as fine as Raphael'. Mulgrave would brook no excuse: 'Haydon, you dine with us to-day, *of course!*'

Another set of men sat down to dine at the Academy Club, and Joseph Farington heard of the sale to a pair of Plymouth bankers, Sir William Elford and his partner, Mr T.J. Tingcombe. The picture was 'allowed by all to be a work of considerable merit, but there was much difference in the proportion of approbation'.[4]

The proportional difference had been noticeable also in Spring Gardens. While Robert Hunt was extolling the *Solomon* 'with all the enthusiasm of his good heart', the Academician William Owen, who was standing behind him, turned and addressed the others present: 'If any man maintains that that picture is fine in colour, he is ignorant of what colour is.' William Hazlitt 'abused the picture in his spitish humour' to his companion, but encountered the artist himself some minutes later, 'and holding out his two cold fingers' greeted him with the words, 'By God, sir, it is a victory.' He then went away and wrote a review in the *Morning Chronicle*, equally balanced between praise and reservation. Whilst the painting rightly claimed 'a place in the higher department of art', was evidence of 'a bold and aspiring mind' and exhibited 'considerable variety of expression, attitude and character, and great vigour and rapidity of execution throughout', the critic felt bound to add:

> that the success is not always in proportion to the effort made; that the conception of character is sometimes erroneous; . . . that there are great inequalities in the style, and some inconsistencies in the composition; and that, however striking and admirable many of the parts are, there is a want of union and complete harmony between them.

Admirable parts were the two Jewish doctors on the right of the composition. Hazlitt could not 'recollect any figures in modern pictures which have a more striking effect'. And the good mother had, he thought, overcome 'the greatest difficulty of the art – the union of beauty with strong expression'. He also praised Haydon's conception of the figure of Solomon: 'raised above the rest of the picture, and placed in the centre – the face fronting, and looking down, the action balanced and suspended, and the face intended to combine the different characters of youth, beauty, and wisdom'. He did not point out that the face combining these rare qualities was the painter's own. The colouring of the head he felt to be 'unexceptionable'.[5]

The twenty-eight-year-old Mary Russell Mitford, future bestselling author of *Our Village*, was eager to see her friend Sir William Elford's acquisition. She arrived at the Gallery with a lady companion just as the Exhibition was closing for the day, but after bribing the attendant with half a crown they went and stood in front of the picture. 'The evening sun, with its fine mellow light, was just on the figures,' she wrote, 'and such a picture I never beheld. All that has been said of it falls short of its beauty.'

The only other person in the room was a young gentleman who seemed amused at the ladies' negotiation with the doorkeeper. Apart from indicating the best position from which to view the painting he had no conversation with them, but Miss Mitford surmised him to be the painter. Like Hazlitt, however, she failed to recognise the original of the principal figure's portrait. 'One thing, and one thing only, gave me pain in this charming picture', she wrote to Elford:

> and that is the inveterate and most distressing likeness which King Solomon bears to Queen Anne. It is Queen Anne, with beauty, with intellect, with majesty, with penetration; but still it is Queen Anne.[6]

It would be another three years before she became a friend of the true model for King Solomon.

Purchase of his picture was welcome news for Haydon's creditors. He was able to pay £200 of the £400 he owed Mr Perkins, and his landlord's 'honest joy was exquisite'. And £42 10s wiped all but £6 10s off his slate in John O'Groat's. He paid his baker. He paid his tailor. He paid his coal merchant. He presumably paid his wine merchant, although neglecting to record the fact. Of the 700 guineas he received from Elford and Mr Tingcombe, he paid out £500 in the first week. This outlay did not come near to halving his debts, but it maintained his credit.

One creditor who did not require repayment was Leigh Hunt. Writing from his surprisingly salubrious quarters in Surrey County Gaol, he told Haydon that he should be considered last in any settlement of obligations. 'I have not yet got rid of all my own difficulties,' he admitted, 'but *you* could not do them away & I have every prospect of overcoming them myself.' He congratulated Haydon on the success of *Solomon*, adding that he 'would have liked also . . . to have obtained

a sight of it had it been possible'.[7] In gratification of this idly expressed desire, Haydon had the 140 square foot of canvas taken to Horsemonger Lane and put up in the gaol for three days 'to relieve the tedium of confinement'. He then had it taken north of the river, for another three days, to cheer John Hunt's confinement in Cold Bath Fields Prison.

<p style="text-align:center">*</p>

Just before the turn of his fortunes, leaning against a post in the Haymarket, with debts of £1,100 weighing on his mind, Haydon had countenanced the terrible possibility of his *Judgement of Solomon* not selling and had decided upon a course of action in that eventuality. Now, with the picture sold and money in his pocket, his course of action was precisely the same: 'Order another canvas and begin a greater work.' The canvas he ordered was three feet wider than the last, and another three in height. And he had a subject which would leave that of his last work 'far in the abject rear'.[8] He claimed that the idea for *Christ's Triumphant Entry into Jerusalem*, 'the mob in enthusiasm, all expressing their various emotions', had come to him the day before *Solomon* sold:

> After a miserable night of restless anxiety . . . I got up . . . in a perfect fever, and turned over the testament in discontent, when [the passage] caught my eye. The whole scene rushed into my brain as if the sun had burst out at midnight.

His last picture having 'given that shock to Art' its creator intended, having 'roused the people . . . affected the Artists' and 'excited the nobility', Haydon prayed for the virtues of modesty, propriety, delicacy and magnanimity in his prosperity. Then – a not inconsiderable 'one request more' – he added:

> spare my life till I have reformed the taste of my Country, till great works are felt, ordered, & erected, till the Arts of England are on a level with her Philosophy, her heroism & her Poetry, and her greatness is complete.

Three days later he had his new canvas 'up & ready', and he prayed again for the 'power to cover it with excellence and to advance the great cause'.

But first, he took advantage of the temporary end of European hostilities to make his first excursion abroad. During the short interval of peace, between the allied occupation of Paris and the 'Hundred Days' following Napoleon's escape from Elba, English tourists swarmed across the Channel. A major attraction, apart from that of continental travel for so long unthinkable, was the opportunity to view the vast accumulation of artistic pillage – from Egypt, from across Europe and particularly from Italy – that the Emperor had amassed in the Louvre.

Haydon and Wilkie set out in the company of Mr Sewell – a Lincolnshire man, 'a good fellow, and a thorough John Bull' – met by chance on the beach at Brighton while they waited to embark. Eighteen hours' overnight passage on the Channel Packet, with a raucous company of French officers, former prisoners-of-war, returning home – Wilkie, in his red nightcap, too seasick to respond to the Gallic badinage at his expense – brought them to Dieppe at three o'clock in the afternoon. From Dieppe they travelled south by *cabriolet*, a conveyance that would not be introduced to England for several years, perfected under the design and patent of Joseph Aloysius Hansom, and its name contracted to 'cab'. Another English traveller of 1814 advised: 'that a cabriolet for three Frenchmen will accommodate but two Englishmen . . . for the continentalists have universally a power of contracting their bodies and legs, and of recon-ciling their minds to bear this contraction for a number of hours altogether impossible to an Englishman'.[9] Haydon, Wilkie and Sewell made the best of the cramped conditions and, on 30 May, left Rouen euphoric with champagne, bawling out 'God Save Our Gracious King' at the tops of their voices. It was the day the peace treaty was signed in Paris, and the ratification of their country's victory over her tradi-tional enemy inspired patriotic fervour. Haydon imagined the locals muttering, 'Bah! Voilà trois Milords!' as they rattled triumphantly past.

Wilkie, the thrifty Scot, was keeping a careful record of his expen-diture. Passage to Dieppe had cost a guinea and a half; dinner, tea, bed and breakfast, nine shillings and sixpence. Throughout their time

in France, Haydon and Wilkie fell into regular dispute over how much to pay their postilions, Haydon being chided for giving too much, Wilkie too little. The postilions themselves said that the one gentleman was 'bien généreux', while his companion was, 'sans doute', not an Englishman.

After passing through Saint-Denis, the nearest town to Paris, they crossed a recent field of battle, their postilion pointing out the trees splintered by cannon shot and 'some large mounds of earth which he said had been made for the burial of the dead'.[10] They could also make out, on the heights of Montmartre, the defensive lines of French artillery emplacements.

First impressions of Paris were of 'inextricable confusion, houses, figures, carriages, men, women, & children, all huddled together in dirt, mud & filthiness'. It was a little under two months since the allied occupation of Paris, the abdication of the Emperor and the restoration of the Bourbons, and the city, peace treaty notwithstanding, was 'bristling with bayonets'. The travellers spent their first night at the 'uncomfortable and extravagant' Hôtel Villedot, close to the Palais-Royal. It was, reported Wilkie, 'like a house for a nobleman, the apartments ... very large, and the walls ... covered with tapestry. The furniture had an old-fashioned costliness about it, but was so inter-mixed with the effects of tear and wear that every idea of comfort was removed.'[11] They resolved to spend only one night there and to make other arrangements the following day as soon as they could.

Exploration of the city provoked in Haydon all the thrilled, blus-tering abhorrence for vice of the fascinated puritanical tourist:

> Paris is a filthy hole, and the Palais Royal a pandemonium in the midst of it ... the alleys full of shops, and the houses full of gaming and brothels ... The whole is illuminated, the walks & gardens ... full of villainy & depravity ... that as you enter you feel a heated, whorish, pestilential air flush your cheek & clutch at your frame. The blaze of the lamps, the unrestrained obscenity of the language, the indecency, the baudy, bloody indecency of the People, bewilder & distract you.

Also observing, that first evening, the external lines of the Louvre, he wrote dismissively to Leigh Hunt: 'There is something grand in the extension of its square, but the building itself is mean. Small

windows by thousands, and chimneys by hundreds, make it look more like a model in wood for a larger building than like the palace itself.' The view from Napoleon's 'childish and useless' triumphal arch, through the Tuileries, across the place de la Concorde, and down the Champs-Élysées to the Arc de Triomphe at the other end, was 'certainly very long', but that was all, there being 'nothing natural or affecting in such *ropewalks*'.

At six o'clock the following morning Haydon hurried to the Louvre, only to be told by a National Guardsman that he should come back when the doors opened at ten. Returning with Wilkie and Sewell, he found the interior architecture as much a disappointment as the exterior. A sense of littleness prevailed. The Upper Gallery, although of 'inordinate length', seemed small, 'as when one looks through the wrong end of a spy-glass'.[12] Haydon raced forward eagerly, Wilkie following languidly at his own pace. The Scot was soon diverted and left standing in front of a Jan Steen. Not surprisingly, the painter of *The Blind Fiddler* and *The Village Politicians* took an especial interest in this master of genre. But Haydon had higher work in his sights and did not stop until he reached *The Transfiguration*. He felt let down, perhaps through over-anticipation, by Raphael's masterpiece and found it 'small & rather insignificant'. Hanging opposite was Correggio's *Mystic Marriage of St Catherine*, which did 'injury to Raphael in sweetness'. Other neighbouring works also served it badly. Compared to a Titian, it looked 'raw', and to a Tintoretto, 'tame'.[13]

Another painting Haydon saw was Poussin's *Judgement of Solomon*, the main figure of which, disconcertingly, was similarly posed and positioned to that of his own version back in London. The Frenchman's picture, however, at little more than three feet by five, was considerably smaller.

Wilkie too was dissatisfied by the quality of the works on show. Although struck by Veronese's *Marriage at Cana*, 'which exceeded all that [he] saw', he found the representation of the French School 'not so good as those in London'. As for the Dutch, there were some good Ostades, 'but perhaps not so fine as Lord Stafford's'. The Teniers, on the other hand, 'looked better than the Ostades'.[14] Mr Sewell's opinion of the art is not recorded.

Despite their intention to move to less expensive lodgings, the travellers discovered that sharp practice on the part of the hotel management – neglecting to register their guests' passports with the Préfecture

until the time they had bargained for their accommodation expired – had committed them to a charge for an extra night's stay. After that, 'paying, as all must pay, for a little experience', they abandoned the frayed splendours of the Hôtel Villedot for more modest, congenial and cheaper rooms on the Left Bank, at 6 rue Saint-Benoît in the Faubourg Saint-Germain.

Haydon later admitted that 'political events were so overpowering' that he did not devote as much time to the Louvre as he ought to have done, and it was the daily spectacle in the streets of the occupied city that fascinated him. 'Why stay poring over pictures,' he reasoned, 'when we were on the most remarkable scene in the history of the world?' Of the polyglot conquering forces, as observed in the middle of the day on the bustling rue Saint-Honoré, the Russians were the most impressive, whether the 'half-clothed savage Cossack horseman, his belt stuck full of pistols and watches . . . crouched up on a little ragged-maned, dirty-looking, ill-bred, half-white, shaggy pony' or 'the Russian Imperial guardsman pinched in at the waist like a wasp, striding along like a giant, with an air of victory that made every Frenchman curse within his teeth as he passed him'.

It was not only against the Russian occupiers that curses were directed. Haydon and Wilkie attended a performance of *Hamlet*, translated by Jean-François Ducis, at the Théâtre Française and when, during Act IV, the King described England as a country 'too often abounding in crimes',[15] the whole pit erupted with furious cries of 'Bravo, bravo' and 'à bas les Anglais!', pointing and hooting at Englishmen wherever they could be identified in the audience. 'What was all this childish spite,' Haydon reflected, 'but the mouthing of beaten boys on the ground, afraid to get up after the blow that has floored them?'

On another evening, crossing the Tuileries after witnessing an inferior performance of *Cupid and Psyche* at the Théâtre Vaudeville, he looked up at the dark shape of the triumphal arch silhouetted against the dusk and thought of Bonaparte: 'how little good all his industry had done the World or himself. All his monuments will serve now but to remind one of his folly, & his vice, his cruelty & tyranny.' The morning after, while Wilkie went back to the Louvre, Haydon took an excursion, by *cabriolet*, to the east of the city. His first stop, as

though to confirm the previous night's reflections, was the fortress of Vincennes:

> There was something severely terrible in the look of the castle [giving] one an idea of state tyranny, that nothing in England excites the slightest association of.

He met the Governor, 'a fine, soldierly, polite fellow, who had lost his leg at the battle of Wagram', and was conducted around the chateau by an aide-de-camp. Haydon asked about the murder of the Duc D'Enghien, shot in the castle moat ten years previously on the orders of the Emperor, but the shrugged replies he received on this delicate matter were 'indirect'. From Vincennes, he had himself driven north to Pantin by way of Belle Ville and the heights of Chaumont. It was along this ridge that cadets of the École Polytechnique had defended Paris against the Russian advance a couple of months before. He entered cottages stripped of furniture for firewood by the marauding troops. In Belle Ville, 'Many houses were absolutely bored with musket shot, and several had their corners and roofs beat in with cannon shot.' At Pantin he explored a large private residence:

> a beautiful house, furnished in an elegant manner, absolutely reduced to a shell, to bare walls. In the parlour, horses had stabled, and their dung was yet on the marble floor. All the windows and cupboard doors had been wrenched off to burn; the paper of the rooms had been torn down; the wainscot had been beaten in with the butt end of muskets here & there, in order to see if valuables were concealed, and the glasses shivered to atoms.

Haydon stood in the wreckage with the old man who was showing him around: 'You fight for the *good* cause,' said his guide.

'Yes, I do,' replied the Englishman, 'but recollect that you had given Europe the same sort of proof of a *good* cause, and you amused yourself at Moscow, and now they amuse themselves here.'

'Ah, cela est vrai, Monsieur – la sorte de la Guerre. But it is not the French people who have been guilty of such conduct, but their Governors.'

Haydon could not resist impressing upon this representative of a

conquered people a short lecture on civic duty and the evils of despotism: 'Then why do you suffer yourself to be duped by such Governors? I'll tell you what, if your Nation were a little more attentive and a little more interested about the conduct of your Governors, and took more interest in your national affairs and constitution, you would not be at the mercy of every rascal who chose to struggle for the lead.'

'Ah, c'est tous vrai, Monsieur.' But Haydon was not at all sure the old man had fully grasped the drift of his argument.

Back in Paris by late afternoon, he went with Wilkie to visit the life class of the Palais des Beaux-Arts. With some difficulty they found it, at the end of a 'disagreeable looking hall or ante-chamber' where an old attendant took their coats. The *académie vivante* was in a small room, 'filled with students of all ages, and seemingly in all conditions of life', Wilkie recalled. 'The figure they were studying from was an old man, and of a much worse character in point of form than any . . . in our Academy in London. They never have any females in their Life Academy; and if they had, the Academy would require [it] to be conducted in a very different way, for it would seem to be open to everybody.' They were told that this month the celebrated François Gérard was acting as instructor, but, disappointingly, he was not present that evening. Nobody seemed to have taken his place, 'either to preserve order or instruct the student'.[16] Haydon's opinion of the Palais des Beaux-Arts was succinct: 'never did I witness such a dirty set of rooms, filthy, and the people worse'.

Having failed to meet M. Gérard on this occasion, they visited his studio, and the face of the Emperor, painted ten years before, glared out at Haydon from among a number of other portraits: 'Good God, what a picture! Heavens, a horrid yellow for a complexion, the tip of the nose tinged with red, his eyes a watery, dull, fixed, stern, tiger like, lurid fierceness; his lids reddish and his mouth cool, collected, & resolute . . . Never in my life do I recollect being so horridly touched. All the other heads in the room looked like the heads of children in comparison.' Not even a visit to the Jardins des Plantes the following day – the beasts, birds and insects beyond anything he had ever seen before – could erase from his mind the memory of Gérard's 'dreadful facsimile . . . that cruel, bloody, glassy eye, that looked you through without mercy, without feeling!'

And yet, along with the delicious frisson of horror experienced at the sight of a man who had been his country's enemy for as long as he could remember, there was the beginning of another emotion, and a lifelong fascination. It was a feeling akin to that manifested a year later by some 8,000 English sightseers in a motley flotilla of little boats in Plymouth harbour, when Bonaparte stepped out on the deck of a British man-of-war, on his way into exile. They would cheer him – not as an enemy but as though he were a national hero – the most famous man in the world, whose very celebrity transcended national boundaries and distinctions between friend and foe. 'Setting aside every consideration of Bonaparte's cruelty,' Haydon reflected, 'there is something melancholy in the recollection of the height from which he has fallen. There are moments when one forgives one's bitterest enemies and laments rather than revenges their cruelty or conduct.'

Everywhere he went in Paris and its environs there was occasion for further musings of the same kind. With Wilkie he engaged a *cabriolet* to take them to Versailles, putting up at an inn for two nights and exploring the palace and gardens. They visited the Grand Trianon, 'frequently residence of Bonaparte', and, while Wilkie noted a 'most fine Poussin', Haydon was enchanted to find signs of recent habitation in the Emperor's study. The surface of a table where Bonaparte had leaned was rubbed; the chair where he had sat, worn; the tongs and poker in the fireplace, black; the ashes, fresh. Wilkie had not the same relish for such associations, and the following day Haydon set out alone for Rambouillet, fifteen miles south-west of Versailles, to see another former residence of the Emperor. On the way he had the coachman stop to give a lift to a youth of nineteen, a grenadier who had been wounded at Chaumont. Of sixty companions from his home town of Chartres, he was the only one left alive. The young man declared that 'if Bonaparte had reigned longer, he would have murdered all the World, and then made war upon the animals'.

At the chateau of Rambouillet, the reverent visitor was shown into the Emperor's *salle de repos secret*. It was a small room, the most remarkable feature of which was a vaulted alcove containing a satin couch and cushions. The arch above was painted in gold with the names of military triumphs: Austerlitz, Marengo, Friedland and the rest; while the walls were decorated with 'groups of warlike arms & instruments'

and the emblems of tributary states. Haydon indulged in a welter of imaginative empathy:

> Here he used to retire when exhausted, or . . . for extreme & silent reflection. Here as he lay . . . he was reminded of his former actions, and as he cast his eye down the walls, Austria, Prussia, Italy . . . would fan his fancy or stimulate his mind to arrange new conquests . . . Here was his private, secret, sacred closet, painted & arranged by his own orders and for his own particular gratification. This was the stimulant to a Conqueror's appetite . . . Here he lay in dim twilight, revelled in associations of dominion, and visions of conquest.

Trembling at such thoughts, Haydon felt he was 'in the very midst of [Bonaparte's] soul'. The custodian of the chateau was tactful enough to remain silent until his visitor had 'enjoyed the full luxury of meditation' and had fully recovered himself.

Back in Paris, Haydon and Wilkie visited the Gobelins factory to see tapestries made from the Raphael Cartoons, and the Hôtel Benevent's collection of Flemish pictures – 'Van Dyck . . . black, Teniers dirty, Rembrandt brown, Rubens overpower[ing] all near him' – in the very room where the Treaty of Paris had been signed less than a month before. Haydon made up for his previous neglect of the Louvre and worked his way systematically through the French, Flemish and Dutch, Spanish and Italian schools, now appreciating the advantages of such a comprehensive collection, barely conceivable in England until the establishment of a National Gallery ten years later. 'You settled principles in an hour,' he recalled, 'by the instant comparison of schools, which it would have taken months to arrive at when each school had its own works distinct in its own town'. He studied Titian's *Martyrdom of St Peter*, 'full of sweetness, feeling & sensation', alongside work by Veronese, and judged the latter to be 'flat and unsubstantial' in comparison. Tintoretto was 'strawey, rushed, & careless, without the solidity of Titian or Rubens'. As for the contemporary French painters, they had 'immense knowledge', he observed, 'but their taste is bad'.

It was Wilkie who received first word of his friend's good fortune when, towards the end of June, his brother wrote with news that Sir George Beaùmont and the other Directors of the British Institution,

despite their disappointment at being beaten to it by the Plymouth bankers, had agreed to award Haydon's *Judgement of Solomon* a premium of 100 guineas. So, when Wilkie returned to England in early July, Haydon – finding himself providentially richer than when he arrived in Paris – decided to extend his holiday by a couple of weeks. He visited Fontainebleau, travelling by large unwieldy *diligence* in the company of six French ladies and arguing about France and England, war and peace, all the way. The Chateau, where Bonaparte had signed his abdication the previous April, was 'gorgeous beyond description' but Haydon seemed more interested in talking to people who had known the Emperor. The paramount question that exercised him was whether or not Napoleon had wept when he abdicated. His guide, who had served the Emperor for ten years and seen him ten minutes after he signed the document, assured Haydon that 'he had not the least appearance of crying', that 'he behaved with courage & firmness throughout' and that the only time Napoleon had appeared 'pale, agitated, & shaken' was when he returned to Fontainebleau after the fall of Paris.

Haydon strolled into the town and watched the remnants of the Imperial Guard on parade: 'a disciplined banditti, without the irregularity but with all the depravity; desperate indifference, & blood . . . burnt into their veteran faces; black mustachios, gigantic caps, a slouching air, and a ferocious expression'. He spoke to a group of them and they told him how they had all wept when Napoleon bade them farewell, how the standard-bearer who delivered the Eagle to him had to turn away his head because 'he was weeping so profusely', and how even Sir Neil Campbell, who escorted the Emperor to Elba, wept, as did the Prussian and Austrian commissioners, 'but not the Russian'.

Haydon could not resist the question: 'Did the Emperor cry?'

'Non! Bougre!' swore a grizzled veteran, 'il était toujours firme!'

After two more days back in Paris, spent sketching at the Louvre, Haydon boarded the *diligence* for Calais and home. He would later write of his visit in glowing terms: 'The knowledge I gained by this tour was endless, and the advantages of seeing the Louvre in its glory can never be properly estimated but by those who did so see it.' Nevertheless, just after his return he was still speaking of the 'meanness' of the Louvre and its contents, and Joseph Farington reported

amusement at table when the company was told how Haydon had felt disappointed 'at not finding works by the Great Masters on a larger scale'.[17]

<center>★</center>

It was not until 19 August that he began work 'in reality' on *Christ's Triumphant Entry into Jerusalem*, but no sooner had he started than a recurrence of his eye trouble necessitated seaside recuperation. By mid-September he was lodging in a farmhouse on the south coast, west of Hastings at a place called Bopeep, now St Leonards, and within sight of a Martello tower. He spent the time 'sketching & studying the habits of pigs, ducks, chickens, & geese', bathing among the roaring breakers in the morning, horseriding after breakfast, fishing for eels before dinner and walking at night by the starlit shore, musing on the likelihood of Resurrection. 'Impossible! Impossible to conceive,' he protested:

> that the Power which created us . . . should not recompense the agony we feel at our palpable weakness, by a resuscitation after Death, more stable, more firm than the renewing of the Sea, the monthly reanimation of the Moon, & yearly refreshing of the Earth.

It was while he was at Bopeep that earthly immortality, of a sort, was bestowed and he received news that his home town had granted him its highest honour. At a meeting in the Guildhall on 26 September 1814, it was proposed by old George Eastlake, seconded and carried, 'that Mr Benjamin Robert Haydon, a native of Plymouth, be nominated and elected a Burgess or Freeman of this borough as a testimony of respect for his extraordinary merit as a historical painter, and particularly for the production of his recent picture, "The Judgement of Solomon," a work of such superior excellence as to reflect honour on his birthplace, distinction on his name, lustre on the art, and reputation on the country.' It was also anticipated that 'the same ardour and enthusiasm which have hitherto inspired his pencil will stimulate him to bolder exertions for the production of still higher excellence'.[18]

Returning to London, he could not resist sharing his news with a

fellow native of Plymouth, the begrudging Northcote, who, instead of offering congratulations, showed him an old book 'to prove that his grandfather had been *mayor* 200 years ago'. Haydon was not surprised, believing the old man had hated him from their first meeting and had followed his subsequent career with a spiteful relish for every setback, every success a torture.

<center>★</center>

By the beginning of November he was hard at work on his big canvas and had finished a head that he considered to be 'an immense advance . . . more soft, more fleshy' than any he had done before. His method of working involved his bringing the heads of his figures to a high degree of finish at a comparatively early stage in the composition, and even two years later Wilkie would report that 'nothing but heads are finished'.[19] It was curious that Haydon, professing a lifelong disdain for portrait work, should take such pains over his faces. According to one account, he 'would pay exorbitant sums for some of the models for his heads. For instance, the Jews screwed out of him whatever they demanded: and even then he was obliged to cover up the figure of Christ, otherwise they refused to sit to him at any price. He would pick up a beggar in the street, and for fear of losing him would bring him home in a coach.' So much for the faces. 'Then there were . . . female figures – hands, feet, and so forth – all costly, for he did not paint without both drawing and studying every part . . . first. Every nostril, every finger-nail . . . a complete study.'[20] To ensure anatomical accuracy beneath the drapery, all main figures were first sketched nude.

Over a three-month period towards the end of 1814, Haydon spent £14 3s on models.[21] 'Little Borwood, the pocket Hercules', charged a shilling an hour and earned two pounds for three days' work. Well known to all who had sat on the benches of the Life Academy at Somerset House, Borwood posed for the kneeling Centurion, laying his sword and oak-leaf crown before Christ. An unnamed 'Female' with 'exquisite hands' was given £1 12s 6d, and a further two pounds 'for suffering her hands to be cast'. Five Grenadiers posed 'for a group' earning a modest 12s 6d between them, and a 'Fine Jew' received £1 3s 6d for two days, probably sitting for the head of Joseph of Arimathea.

Haydon did not mention whether he was obliged to conceal the main protagonist of his picture during the sitting.

Patience Smith sat, naked to the waist, for the preparatory drawing of Jairus's resurrected daughter, kneeling below the extended left hand of Christ, her arms crossed demurely over her breasts. During the three months, Haydon paid her a total of £3 5s 6d. She fell ill early in 1815, smallpox disfiguring her pretty face, and the destruction of her looks may have pitched her further into a life of crime, or what Haydon referred to as her 'gypsy ways'. A note that he added to a sketch suggests her eventual fate: 'Transported an Incorrigible!'[22]

His most hard-working model was Corporal John Salmon, of the 2nd Horse Guards, receiving a total of £6 9s 6d for twelve days. He posed for the figure of the Saviour, but Haydon also used him when other models were unavailable. An important visitor called one day when Haydon was out, and Salmon showed him the picture:

Lord Elgin said who sat for that, & who sat for this & the old Soldier (bolt upright) as if on duty said to every question *I did My Lord*. Who sat for the Mother? said Lord Elgin – *I did my Lord* . . . and who sat for that beautiful Girl? *I did My Lord*, said Salmon.[23]

The engraver John Landseer paid a visit. 'When do you let your beard grow and take pupils?' he demanded.

'If my instructions are useful or valuable,' Haydon replied modestly, 'now.'

'Will you let my boys come?'

'Certainly.'

It was arranged that the two elder Landseer boys, Charles, sixteen, and Thomas, twenty, were to attend every Monday and that Haydon would give them their course of study for the week. The youngest, thirteen-year-old Edwin Landseer, who showed most promise, was sent away with the loan of Haydon's anatomical drawings, John Bell on *Bones, Muscles and Joints*, and was advised to dissect animals.

Haydon had assumed the role of teacher before, as early as 1809, when he acted as mentor to Charles Lock Eastlake. But John Landseer's request for the tuition of his sons opened the prospect of something altogether more ambitious: 'My great object is to form a School,' Haydon explained later, 'deeply impregnated with my prin-

ciples of Art, deeply grounded in all the means, to put the clue into the hands of a certain number of young men of genius that they may go on by themselves . . . so that we may raise old England's head to honour & glory, & greatness in Art.' The lofty aims and ideals precluded any mention of tuition charges. Years later, when he imagined his former pupils were denying his contribution to their success, Haydon would claim to have given of his time, experience and expertise for nothing, and on occasion he did, when a young man showed promise and his parents could afford no more than his subsistence in London. Other cases were more businesslike, with an agreement, like that drawn up for George Robertson, promising three years' tuition for £210.[24]

Month by month the composition of *Christ's Triumphant Entry into Jerusalem* developed. At the end of January 1815 he planned a trio of women, carrying an emotional subplot of a complexity to challenge any artist's communicative skills in paint:

> a penitent, abandoned daughter, pale, lovely, blushing, trembling, shrinking, yet entreating with her fair hands pardon of her Saviour, protected by her Mother, who in the agony of apprehension, is clasping her, yet has a gleam of hope & smiles through her tears, encouraged [by her] pure & virtuous sister, who gently presses her shoulder & smiling at her to give her hope, at the same time feels pain for her viciousness.

Two of this group, probably the mother and virtuous sister, were drawn from Maria Foote and her mother. Mrs Foote, wife of a theatre manager in Plymouth, had been a close friend of Haydon's mother. The eighteen-year-old Maria had just made her debut, to great acclaim, at Covent Garden in the eponymous role of *The Child of Nature*.[25] Haydon for a time was besotted with her and wrote a breathless account of an evening 'accidentally alone with her, the flutterings of the heart, the longings for disclosure, the trembling approaches! The heaving & bursting of her beautiful bosom, hardly concealed by a snowy slip of lawn, which takes the form of its undulations!' Six months later, during a three-hour sitting, temptation returned, but was firmly crushed:

as she leant over, my hair & cheek accidentally grazed the silk that covered her exquisite bosom – I could have eat[en] her bit by bit – but her Father had trusted her to my honor.

She was, by then, the mistress of Colonel William Berkeley,[26] with whom she would have two children.

<p style="text-align:center">★</p>

'I painted a Portrait of a Friend, a long promise!' he wrote in April. Leigh Hunt had been released from the Surrey Gaol on 2 February and the picture – commissioned by John Hunt, who was set at liberty the same day – may have been intended to celebrate the occasion. For Haydon, it was an irksome distraction from his serious work:

> I miserably feel . . . different sensations after concluding the [portrait] to those after a day's work on my Picture. The one was all the timid, mean sensation of a face similist; the other all the swelling, bursting glories of realising . . . visions of imaginations. I feel the beauties of individuality as much as any one, the sharpness and softness of flesh, the delicacy of touch, and calm sweetness of breadth & melting, racy flush of colour; but if all these tend to elicit a mean character, of what value are they?

He was yet to recognise, or at any rate to articulate, the meanness of Hunt's character. The face, apart from its prison pallor, looked none the worse for two years', albeit comfortable, incarceration. The pouting lips, the round cheeks, the eyes untroubled by responsibility of any kind made him seem younger than his thirty-one years. Even the broad, floppy white collar, inseparable from a Romantic poet's throat, contributed to the boyish look. Here was the original of that which would mature, by an inverse ageing process, into Charles Dickens's childlike Harold Skimpole: 'more the appearance . . . of a damaged young man, than a well preserved elderly one'.[27]

The obligation discharged, Haydon hoped that his career as a portrait painter was over. 'Do not forget,' he told Hunt, 'that your Portrait is the only one I have painted, or probably ever will.'[28] The next one, eight years later, would be painted under duress, with a wife and three

children to support and following a term in debtors' prison.

By the middle of April Haydon was penniless. The 700 guineas he had received for *Solomon*, together with the British Institution's 100 guineas, had settled some of his debts, but nearly two months abroad, his living expenses and those for his models had 'swept off the greatest part' of the remainder. The following month he paid his first visit to a moneylender. He described a 'little, low fellow, with red eyes, his lids hanging down over his pupils so that he was obliged to throw his head back & look at you through the slit, as it were, his eye lids made'. A complicated transaction followed. Before he would lend £100, the usurer insisted that Haydon buy a 'rascally sketch of Rubens' from him for twenty guineas. By this means he increased his return on the debt well beyond the regular rate of interest. This individual, who carried on a legitimate trade as a wine merchant, had an upper room 'full of every thing on earth – Pictures, books, shirts, leather breeches, shoes, hats, jewellery', for his desperate clients to choose from. Between negotiating the loan and collecting his money the next day, Haydon finished painting the drapery and arms of the Canaanite woman at the bottom right of his composition: 'the best things I've done, thank God'.

A further temporary respite from financial worries came in June when George Philips, MP for Ilchester in Somerset, commissioned a 500-guinea picture and gave him £100 on account. Two months later he supplied Haydon with a further £100. But Mr Philips would have to be patient. *Christ's Agony in the Garden* was not to be delivered for another six years.

Above the Canaanite woman, and providing a balance to the three women on the left, Haydon conceived an anachronistic trio of men: the sceptic Voltaire would appear 'as a sneerer at Jesus', Sir Isaac Newton 'as a believer' and 'the living poet', William Wordsworth, as another believer, 'bending down in awful veneration'.[29] It is not known precisely when Haydon was introduced to Wordsworth, but on 23 May he records them having had breakfast together, and by the middle of June he had been allowed to make a plaster cast of the poet's face. 'He bore it like a philosopher', Haydon having derived some fun at the expense of Wordsworth's dignity. He allowed a friend who happened to visit the rare treat of spying on the great poet sitting in his host's dressing gown, his entire face encased in plaster and breathing

through straws, 'hands folded, sedate, steady, & solemn . . . with all the mysterious silence of a spirit'.

The cast would prove a useful reference for the artist when his subject was not available to sit in person. When the time came, however, to put Wordsworth's head into the painting, Haydon wrote to enquire when he would be back in town. 'I wish to have your hands and every part as it ought to be,' he explained, 'which one cannot do from a cast.'[30] Ever alert to posterity, Wordsworth wrote back to say that it so happened he had had casts made of both hands and hoped 'the substitute may not be wholly useless'.[31] He entrusted them to Sir Robert Southey, shortly to be visiting London. The current Poet Laureate did indeed call on Haydon and saw the great picture, pronouncing himself 'much taken with both',[32] and doubtless delivered the hands of the future Poet Laureate on the same occasion.

It was Johann Christoph Spurzheim who supplied the cast of Voltaire's face.[33] Haydon had attended one of the German phrenologist's lectures and was inspired with a lifelong belief in the importance of cranial bumps and depressions in determining human character. By the raised or lowered contours of the right and left parietal bones – accounting for the largest area of the skull between the frontal and occipital bones – the character of a man could be read as benign or brutal. Haydon's own head was cast by Spurzheim, who complimented him on the development of his frontal bone and on the 'Ideality and . . . hatred of injustice' this denoted. Ten years later, at a crowded gathering in Sir John Soane's 'perfect Cretan labyrinth' of a house to view the alabaster sarcophagus of Seti I by lamplight, Spurzheim greeted Haydon's frontal and parietal bones with a cry of recognition: 'Vy, your organs are more parfaite den eaver. How luckee you lose your hair.'[34]

<p style="text-align:center">*</p>

Early in June 1815 an elaborate satirical attack was launched against the British Institution and its Directors. It came in the form of a substantial seventy-four-page pamphlet, distributed gratis and bearing the innocent title: *A Catalogue Raisonee* [sic] *of the Pictures now Exhibiting at the British Institution.* The works referred to were 146 'celebrated Pictures, by Rubens, Rembrandt, Vandyke, and other eminent artists

of the Flemish and Dutch Schools' on loan from more than fifty
private collections, 'for the gratification of the public, and for the
benefit of the Fine Arts in general'.[35]

Purporting to be a picture-by-picture commentary by two opposed
critics – 'Defender' and 'Incendiary' – the *Catalogue Raisonee* started
from the premise that, because the British Institution's founding prin-
ciple was support of contemporary British art and living British artists,
the Directors' only possible motive for mounting an exhibition of
paintings by dead foreigners was to demonstrate them to be inferior.
It was therefore assumed that only poor examples of work by the old
masters had been deliberately gathered together and displayed, to
prove how much better modern British painters were. The 'Defender'
therefore heaped scorn on painting after painting, in professed defence
of the Directors' secret intentions, while the 'Incendiary' made occa-
sional interjections, undermining the Directors' plan by praising the
works exhibited.

The 'Defender' provided the most entertainment. The Dutch and
Flemish painters, as a whole, were dismissed as 'Black Masters',
Rubens's landscapes as 'brown studies'. Rembrandt's ladies and
gentlemen of fashion looked 'as if they had been on duty . . . in the
Prince Regent's new sewer'. Rubens's *Brazen Serpent* was described as
a 'mass of soddened flesh, evidently on the turn . . . a sight better
suited to the shambles than any person's apartment who pretends to
the least delicacy and refinement'.[36] The greater the scorn, it was
reasoned, the more successful the exhibition, and the more worthy
of praise the Directors were deemed to be for their choice of foreign
atrocities to show the work of native painters – such as those to be
seen in the Royal Academy's Exhibition – in the best possible light.
Whenever a particularly fine painting could not be held up to ridicule,
it was explained away as 'one of the blinds the Directors found them-
selves under the necessity of introducing to disguise their intentions',[37]
and briskly passed over. Such examples, however, were rare. Even
when a picture was not condemned as a bad example of a particular
master's work, the 'Defender' took delight in shaking the lender's
confidence in its authenticity: 'If the owner of this picture thinks he
has got a Vandyke, we are happy in as far as his feelings are concerned,
but if we may presume to put our own conjectures up against his
judgement we are sorry for him.'[38]

As a Director of the British Institution and a lender to the exhibition, Sir George Beaumont was particularly agitated. He told Farington that the printer and author would have been liable to prosecution, had either attached his name to the publication. Besides, he thought, 'it was not written by one person but by four or five'.[39] He was also convinced that the scurrilous publication was the product of some cabal within the Royal Academy who felt threatened by the display of masterpieces in Pall Mall. Haydon, of course agreed. 'I suppose they think we want teaching,' he heard Lawrence growl, turning away from Van Dyck's magnificent portrait of *Cornelis van der Geest*.

At Somerset House opinion was divided as to the attribution and quality of the *Catalogue*. Smirke suspected Thomas Phillips was the author, because of an observation in the text concerning ultramarine that he had heard the other painter voice in conversation.[40] Phillips, in turn, would come to suspect Smirke because the satire reflected his sense of humour.[41] For himself, Smirke thought it 'very well written', as did Lawrence, who believed that '*an Artist* must have been concerned in writing it as there were passages that it was not probable [were] by one not of the profession'.[42] In the portrait painter Henry Edridge's opinion, on the other hand, it was 'very ill-written',[43] and even Sir Abraham Hume, himself a Director of the British Institution, thought it so poor that it could not be imputed to any Academician, 'as it would, in that case, have been better done'.[44]

A year later, the appearance of a second *Catalogue Raisonee* would exercise Haydon's mind considerably, but in June 1815 there were more momentous matters to occupy him. He claimed to be one of the first men in London to hear the news of Wellington's victory over Napoleon at Waterloo. The battle took place on 18 June but word took three days to reach England. Haydon had spent the evening on the Edgware Road at the house of John Scott, editor of the *Champion*. Having stayed late, he was walking back to Great Marlborough Street and crossing Portman Square when he was approached by a Foreign Office messenger:

'Which is Lord Harrowby's? The Duke has beat Napoleon, taken one hundred and fifty pieces of cannon, and is marching to Paris.'

'Is it true?' asked Haydon.

'True!' barked the messenger, 'which is Lord Harrowby's?'

In his excitement, Haydon lost his bearings and thought himself

closer to home than he actually was. He pointed across Portman Square to the same position that he knew Lord Harrowby's house to occupy in Grosvenor Square: 'There!' The messenger rushed into the premises indicated, where the fashionable hostess Mrs Boehm was holding a ball. Haydon ran back and along the Edgware Road to tell Scott: 'The Duke has beat Napoleon, taken one hundred and fifty pieces of cannon, and is marching to Paris.'

Scott began to ask questions. 'None of your questions,' said Haydon, 'it's a fact!' And both of them shouted 'Huzza!'

It is a good story, but Haydon's journal contains mention of neither messenger nor misdirection, and the real events of that night seem to have been mangled and appropriated for his *Autobiography* twenty-five years later.

News of Wellington's triumph was brought to London on the night of 21 June, by Henry Percy, the Duke's aide-de-camp, riding in a carriage with captured French eagle-standards poking out of the windows. Percy was still battle-soiled, his uniform heavily bloodstained, and with the brain fragments of a fellow officer lodged in the folds of his sash. Having called first at Downing Street in search of the Prime Minister, he proceeded to Lord Harrowby's house in Grosvenor Square, where Lord Liverpool and the rest of his Cabinet were dining. Finally, the exhausted ADC did indeed interrupt Mrs Boehm's ball, although this was not in Portman Square, but St James's Square, his object being to present the eagles to the Prince Regent, who was attending the party.[45]

Joseph Farington records that the victory was announced to the populace by cannon-fire from the Tower and Parks at ten o'clock that night, but he did not hear the explosions and was told the news by Smirke at breakfast on the 22nd, by which time the full report had been published in a *London Gazette Extraordinary*. And Haydon learned of the victory in exactly the same way most Londoners did:

> I read the Gazette four times without stopping . . . I read [it] again, the last thing going to bed. I dreamt of it & was fighting & waking all night. I got up in the morning in a steam of intense feeling. I read the Gazette again, ordered a Courier for a month, called at a Confectioner's shop, & read all the Papers till my stomach ached.

It dominated his conversation and journal for days afterwards.

'Terrible Battle this, Haydon,' said Leigh Hunt.

'A glorious one, Hunt,' said Haydon.

'Oh, certainly,' said Hunt, but he had reservations, 'affliction and disgust' at 'the sight of so many lives destroyed, so many public burdens increased, and so much misery of all sorts occasioned to families'. The two men argued at length over dinner.

Hunt believed that Bonaparte, in defeat, was to be preferred to the despots of the old order who now triumphed over him, and that he still 'may be the means of producing something better because he is not so powerful as he was formerly'. The Allies, of course, were unwilling to give him the benefit of the doubt. Neither was Haydon. Recalling his observations of the previous year, he declared that it was not only Napoleon, but the French nation as a whole that was irredeemable: 'vain, insolent, thoughtless, blood-thirsty, active, & impetuous by Nature . . . they [were] not to be considered like any other Nation'. But even Haydon was tactful enough not to discuss the battle with another friend. William Hazlitt, a Republican to his marrow, took the news of Waterloo particularly badly, going into dishevelled and debauched mourning for the downfall of Napoleon. 'He seemed prostrated in mind and body,' Haydon recalled, 'he walked about unwashed, unshaved, hardly sober day by day, and always intoxicated by night, literally, without exaggeration, for weeks.'

<p style="text-align:center">★</p>

A year after bestowing freedom on its native son, Plymouth's evaluation of the new Freeman's work might have been called into question. Sir William Elford and his partner Mr Tingcombe intended presenting The Judgement of Solomon to the Corporation, provided the profits from exhibiting it in the town would reimburse them for its purchase. The exhibition proved a failure with the inhabitants of Plymouth, and the bankers were only able to realise a return on their investment by selling the picture. The new owner, Edward Prideaux, tried to profit from exhibiting it in Exeter, Bath and, finally, in May 1815, at 5 Princes Street, London, on the corner of Sidney's Alley, Leicester Square. This exhibition, however, did not cover the expenses and Prideaux consigned the picture to Haydon's care. Following

Prideaux's bankruptcy, the assignees managing his affairs saw no reason to alter the arrangement.

No journal entries account for Haydon's activities between 26 July and 4 August. The lacuna is significant, not because of what he did during those ten days, but because of an opportunity he missed: the chance to see Napoleon Bonaparte in the flesh. As HMS *Bellerophon* lay at anchor in Plymouth harbour, hundreds of small boats crowded with sightseers clustered around to catch a glimpse of the former French tyrant walking the deck each afternoon between five and six. It is said that some came from as far north as Glasgow to see him. 'I resolved to go,' Haydon recalled. 'But my picture – was it manly to desert it?' The journey would have incurred expenses that he could ill afford and, 'after an acute struggle,' he concluded, 'Art was victorious.' His sister joined the crowd on the first Friday and deplored the conduct of her fellow townsfolk, who rose up in their boats to applaud their country's former enemy:

> There is so much that is mysterious and prepossessing about him, and now in his great misfortunes so much pity is felt, that it is dangerous, I think, to the loyalty of the people to keep him here long; they all seem fascinated.

She herself was disappointed to be kept at such a distance that it was impossible clearly to distinguish his features. Nevertheless, she was able to report Napoleon to be of 'a good figure and dignified [with] a large stomach, though not otherwise fat'.[46]

Charles Eastlake got closer. It is said that Napoleon, seeing the painter sketching from his boat, cooperatively posed in the ship's gangway until he had finished. From the study, Eastlake painted three versions of *Napoleon Buonaparte on board HMS Bellerophon, 1815*, the popular work that established his reputation. He was the first and only British painter to portray the former Emperor from life.

That Haydon made no mention in his journal of this extraordinary coup is testimony perhaps to how much he must have envied his former pupil. Nevertheless, a generous, unsigned notice appeared, in the first number of a new quarterly, for which Haydon was most probably responsible:

Of the identity of this picture to the original, we are not qualified to decide . . . [But] it is a picture of the first class of historical portraiture, full of beauty, sentiment, and truth; – giving the character of the extraordinary being it represents, with a truth of resemblance that must be abundantly gratifying to all of the present day, who delight in the elucidation of physiognomical problems.[47]

Haydon would eventually paint more than forty canvases of 'the extraordinary being' without having once set eyes on his subject.

That August his last familial links with Plymouth were broken. His sister married James Haviland and moved to Bridgwater, in Somerset. The house and business of Haydon & Cobley was sold. 'There is something melancholy in this,' he reflected, 'to be cut off as it were from the dwellings of my Ancestors, and the scenes of my youthful associations, but this life rolls on – one thing succeeds another and obliterates the last.'

Once again he was in financial difficulties and once again he applied to Sir George Philips for another advance on his picture. A further £100 was supplied and, with the money, a piece of advice:

As you decline to paint portraits & undertake only great subjects of composition, the execution of which requires much time, & labour, your expenses must I fear for the present increase more rapidly than your professional gains . . . I must say that with a view to your own advantage you should I think reduce the size of your pictures – the public taste is not reconciled to figures larger than life & few private houses are spacious enough to receive a picture of the dimensions of that on which you are now employed. It would also be for your interest & in my judgement, not inconsistent with your professional reputation, if you were to choose subjects that do not compel you to exhibit such a large assemblage of persons. A picture consisting of a small number of characters would be finished in a much shorter time, & would probably sell for more money – I throw out these hints merely for your consideration.[48]

This advice, or something like it, had been offered previously, by other friends. Not for the first time, and not for the last, Haydon chose to ignore it.

★

'I was greatly concerned to hear that your eyes had failed you,' wrote Wordsworth in October. 'To a painter this is more lamentable than to any one else,'[49] he added. Back in July, having decided to forego a glimpse of Bonaparte and continue work on his picture, Haydon had experienced the first symptoms. After painting all week 'with intense application', and with the Canaanite woman finished, he complained of 'excruciating pains in [the] optick nerve from continued staring'. In September his sight had again proved 'inadequate to intense application' and, on Sir William Adams's advice, he went to the south coast 'to bathe & brace up for the winter'.

Looking for lodgings in Brighton, he rejected the accommodation offered by a young woman 'in a clean frilled bed gown, which hung over her bosom & shelved off at the bottom . . . into the contour of her lovely shape', on the grounds that his doctor had ordered rest and quiet. He took rooms, instead, with 'a little, deformed, horrid creature, who spoke almost unintelligibly'. He passed a pleasant evening 'musing on the happiness of that period of life, when the passions are cool & one's reason predominates'. But at three in the morning he was woken by the infernal hammering and clatter of a blacksmith's shop starting work for the day below his bedroom window. Further sleep proved impossible and he informed his hunch-backed hostess that he would have to leave. She regretted losing 'so nice a Gentleman', but insisted that he pay her the week's rent as agreed. He found quieter lodgings in Clarence Place and, during the remainder of his stay, noticed the 'vacancy' sign go up in his former landlady's window every morning and come down every afternoon as she 'got all her money by getting people in & then making them pay to get out again'.

Uncle Cobley's friend, and his own first contact in London, Prince Hoare, was in Brighton and agreed to introduce him to 'the characters & intellects of the Town'. There was an eighty-year-old poet married to a wife half his age and 'very fond of Majors and colonels, [who] gave gay assemblies . . . and suffered her inspired old greyhead to give vent to his effusions to the Muses without jealousy or a sigh'. Hoare's set also included two parsons, one of whom had written 'a fine tragedy', while the other, Reverend James Douglas, was author of a twelve-volume survey of burial mounds, entitled *Nenia Britannica: A sepulchral history of Great Britain from the earliest period to its general*

conversion to Christianity. When left to himself Haydon happily observed the passing show of the Prince Regent's playground: 'all the elegance of St James Street, backed by the roaring ocean, which gives a fairy, enchanted look . . . of an evening as if all the Nereids had landed for a walk, so lovely, so angelic, so rosy are the Darling creatures who parade its shores'. He was reading *The Sorrows of Young Werther,* Goethe's still-fashionable, dangerous novel, reputed to have given the youth of Europe a taste for blue coats, yellow breeches and suicide. He had been introduced to it by the anonymous 'infernal woman' three years before. 'Take it home,' she had told him, 'but promise to read it *through.*' He had tried, but abandoned it, 'affected . . . so horribly . . . that self destruction once or twice glittered to [his] blurred intellect'. Now, under its influence, Haydon's train of thoughts passed from lovelorn longing for a woman – any woman – to death:

> Can there be a finer time to quit the World than when one has the keenest relish for its raptures? Who would ever live till all his pleasures are the remembrance of these delightful creatures? . . . Why should I live till I crumble to uselessness & be kicked aside? Why not go when all are interested, when 20 hearts beat at one's sight & pity would bewail one's departure?

Melancholia reached a luxuriant crisis one Sunday. After dinner he sat looking out to sea: 'calm & grand, lit up by a golden autumnal afternoon Sun'. He thought of his mother and father. 'Thus *they* sat,' he reflected, 'and talked of those who were gone before them, and thus I sit and think with tears of them.' He felt his parents' influence envelop him 'like a melancholy dream', and the calm expanse of water before him erupted, as his musings took a visionary, apocalyptic turn:

> I thought of Death! of Creation! of God! of the World! of the deluge! of the Earth! changing its polarity, & the Sea finding a new level, rushing forward with a dreadful roaring & destroying all the works of man! Perhaps many Worlds have thus been destroyed. How insignificant for a moment did the applause of this World seem . . . & so would reputation be insignificant if it ended here!

He was spending too much time on his own, and Wilkie's arrival in mid-October provided a healthy distraction. With the help of local soldiers, they assisted the Reverend Douglas in excavating a Bronze Age burial mound and uncovered a clay urn containing the remains of a charred human skeleton. But the solemnity of the occasion rapidly turned to farce as the site was invaded by cockney tourists pilfering the bones. Haydon recalled the parson leaping into the pit and haranguing the crowd on 'the wickedness of disturbing the ashes of the dead . . . his large sack of a body, his small head, white hair and reverend look, his spectacles low down on his nose, and his grave expression as he eyed the mob over them'. Wilkie, with the observation for character and eccentricity of a true genre painter, could not contain his amusement. 'Dear, dear; look at him!' he kept whispering to Haydon. 'Look at him!'

There were quieter moments. Wilkie drew his friend sleeping: lying on his side, arms crossed over his chest, right hand resting on a book, and still wearing his spectacles. It is an uncharacteristically tranquil, gentle and vulnerable image of Haydon, approaching the mid point of a restless and turbulent life.

They travelled back to London together, and a week later Haydon sat staring at his great canvas with the uncomfortable knowledge that it was in exactly the same state it had been three months previ-

ously. Turning from it and looking at his drawings from the Elgin Marbles, he reflected on 'the glorious times' when he had done them: 'No weak eyes! No fear of cold!' He was two months short of his thirtieth birthday and making himself miserable brooding on the comparative career of Raphael: 'At my age he had completed a Vatican Room.'

While the condition of his eyes still precluded sustained work on his canvas, he took the opportunity to request permission to have casts made from the Marbles, still in their temporary accommodation behind Burlington House. At first Haydon was told he could take casts of some feet from the metopes, but then, 'with fear and trembling', he asked if he might mould one of the fully rounded sculptures taken from the Parthenon's west pediment, 'the exquisite lying figure', thought to be that of a river god, from the extreme left corner: the *Ilissos*. Against expectations, permission was granted, and Mazzoni, the plasterer, set his men to work. It was a delicate operation, not least because of other artists and connoisseurs threatening to wreck the enterprise. Haydon expected 'some one would go & cant & pretend it was injuring Lord Elgin's property' and that permission would be withdrawn at any moment. He 'told the men the value of expedition', and Mazzoni, 'by great exertion, got the mould completed & off & home by four o'clock'. It was none too soon. 'Just as I had expected,' Haydon wrote in his journal on 17 November, 'an order came down to put a stop to moulding yesterday afternoon.'

Coincidentally, the same week that he acquired his cast of the *Ilissos*, and dreamed happily of being in Rome, pouring scorn on all the sculpture he saw there and declaring 'that our Elgin Marbles were the only true works of art', the most celebrated living sculptor that Rome had to offer was in London to view the collection. Antonio Canova had been in Paris overseeing the transfer of Napoleon's artistic loot back to Italy. He had been greatly assisted in this task by the diplomatic exertions of his old friend William Hamilton, Under-Secretary for Foreign Affairs to Lord Castlereagh. Hamilton, when secretary to Lord Elgin, had superintended the removal of the sculptures from Athens, and he remained a leading supporter in the campaign to secure them for the nation. Canova was now eager to repay the debt of gratitude to his friend by enthusiastic endorsement of the Marbles, in the hope of influencing Parliament's deliberations.

When Hamilton introduced him, Haydon fell immediately under
the Italian's spell: 'when he smiles the feeling sent forth is so exqui-
site that one fancied music would follow the motions of his lips.' It
was said of Canova 'that what *English* He does speak is remarkably
pure and correct'.[50] But he and Haydon communicated in French:

'Ne croyez vous pas, Monsieur,' Haydon began, 'que le style qui
existe dans les statues d'Elgin est supérieur à tous les autres connus?'

'Sans doute,' replied Canova. He predicted that the truth and the
unevenness of flesh and form replicated in the figures were so accu-
rate and so beautiful that they were going to produce a great change,
overturning the mathematical principles governing all the Arts.

Delighted, Haydon turned excitedly to Hamilton: 'N'ai je pas
toujours dit la même chose il y a six années?'

A day or so later, calling on Haydon at Great Marlborough Street,
Canova expressed interest in everything shown to him. He pronounced
the composition of *Jerusalem* 'plus belle', and murmured 'charmante,
charmante' over the head of Patience Smith. 'Parfaitement bien,' he
said when Haydon showed him some drawings of hands, 'vous êtes
un brave homme.'

Haydon spent a day squiring the great man around London: to the
Duke of Devonshire's, to Turner's and finally, at Canova's request, to
Northcote's. Haydon derived malicious satisfaction from this last call.
Not expecting company, the old man 'was in all his glory of filth and
beard'. He had no important historical works to show the distinguished
visitor, but 'kept bringing out wretched Portraits'. Finally, 'conscious
what a figure he cut before such a man, he looked up as he spoke,
with a twist of his body and a mortified insignificance in his face, his
whole air, as it were, assuming a withered littleness', and offered the
excuse of one who had made a degrading choice between profit and
the loftiest ideals of his calling: 'We can only paint portraits here.'
Witnessing Northcote's humiliation, Haydon was avenged for all the
slights and spites of their acquaintance.

Just before Christmas, responding to Haydon's request for a manu-
script copy of his next poem, Wordsworth sent three sonnets. One of
them, an appropriate reflection on the inevitable, even beneficial, role
of adversity in the work of genius, carried a personal dedication, 'To
B.R. Haydon'

High is our calling, Friend! – Creative Art
(Whether the instrument of words she use,
Or pencil pregnant with ethereal hues)
Demands the service of a mind and heart,
Though sensitive, yet, in their weakest part,
Heroically fashioned – to infuse
Faith in the whispers of the lonely Muse,
While the whole world seems adverse to desert.
And oh! When Nature sinks, as oft she may,
Through long-lived pressure of obscure distress,
Still to be strenuous for the bright reward,
And in the soul admit of no decay,
Brook no continuance of weak-mindedness –
Great is the glory, for the strife is hard!

His eyes had still not fully recovered from 'obscure distress' as the year came to an end. He estimated that, as a result of his 'imprudent excess' in the latter stages of painting *The Judgement of Solomon*, he had been unable to work for three months of 1814 and for January, March and the last five months of 1815. Nearly an entire year had been blighted. His physician, Dr Darling, diagnosed the causes of his weakness as 'indigestion and derangement of liver, from hard thinking, bad feeding, and the foul air of a small painting-room'. The patient was advised to eat regularly and take 'a good walk every day in pure air'.

But with the start of 1816 his sight had improved sufficiently for him to begin painting again. He stood on a table in front of his canvas and dashed in a head, preparatory to his model coming the following day. He was happier than he had been for months, 'singing & shouting & quoting the whole time'. A week later he got Christ's head into the picture. Six months later he could report himself 'in full health & spirits, & full of my glorious Art'. He painted for seven hours without strain and, had he not been afraid 'to do too much again', could have painted for fourteen.

<p style="text-align:center">★</p>

At the beginning of the parliamentary session, Lord Elgin presented a petition to the House calling for a Select Committee to decide on

whether, and under what terms, the Parthenon sculptures might be bought for the nation. His petition came at an unfortunate time, when concerns were being voiced about the numbers of distressed seamen dismissed from the Navy with the onset of peace. During the debate Lord Brougham made the memorable objection to buying the Marbles that: 'if we could not give [the veterans] bread, we ought not to indulge ourselves in the purchase of stones'.[51] But at the end of February 1816 the Select Committee met to deliberate on the worth of the sculptures and to make recommendations on the amount his Majesty's Government should be asked to pay for them. Elgin himself was interviewed for two days. He explained the circumstances under which he had acquired the collection fourteen years before and submitted an estimate of £74,240 as his total expenditure. This enormous sum did not of course represent the true value of the sculptures, but rather the amount of compensation that Elgin was relying on. William Hamilton was then examined, and he valued the Marbles themselves at £60,000. Then followed a number of expert witnesses, and Haydon readied himself to be called. The sculptors Nollekens, Flaxman, Westmacott, Chantrey and Rossi were questioned, as were the painters Sir Thomas Lawrence and Benjamin West. The ailing President of the Royal Academy was too ill to attend, but sent in his written opinion. All these men were asked how the Parthenon statues compared with the classical masterpieces of Italy: were they as good as the *Apollo Belvedere*? Did they come up to scratch with the *Laocoön*? The consensus was that they were and did. The formerly sceptical Nollekens now said they were 'the finest things that ever came to this country'. They were the 'finest works of art' Flaxman had ever seen. 'Infinitely superior to the Apollo Belvedere,' declared Westmacott. Lawrence said that they embodied 'a union of fine composition and very grand form, with a more true and natural expression of the effect of action upon the human frame than there is in the Apollo or in any of the other most celebrated statues'.[52] None of the artists was prepared to venture an opinion as to the value that should be placed on the statues. Next came the connoisseurs, the foremost of whom, Richard Payne Knight, exercised no such restraint. He testified that the collection was of mixed quality, but that the best of it was decidedly second-rate and that a derisory £25,000 for the lot was more than twice what he believed they would fetch on the open market.

Haydon was not, after all, invited to give evidence. Later he claimed the snub to be 'out of delicacy' to Payne Knight. But he was, more than ever, determined that his views be registered. Between the Select Committee's rising and the delivery of its report, fearing that Knight's opinion would be given greater credence than it eventually was, Haydon launched a pre-emptive attack on his enemy's evidence, across the pages of the *Examiner* and the *Champion*. His article, 'On the Judgement of Connoisseurs being preferred to that of Professional Men', argued principally that 'in no other profession is the opinion of the man who has studied [a subject] for his amusement preferred to that of him who has devoted his soul to excel at it'. And in making the case that artists alone – and not dilettantes like Payne Knight – should be trusted in matters concerning the Fine Arts, he ventured the proposition that: 'No man will trust his limb to a connoisseur in surgery.'[53]

When its report was published, in April, the Select Committee pointedly disregarded Payne Knight's testimony as to the quality of the Marbles, although its valuation of them came closer to his contemptuous estimate of £25,000 than to the £60,000 suggested by Hamilton. The £35,000 which the Government at length offered fell nearly £40,000 short of the money Elgin had actually spent.[54] He was forced to accept the offer, and the Elgin Marbles were secured for the nation. The report had vindicated his actions and absolved him from the charges of spoliation levelled at him from some quarters. But he remained mired in debt for the twenty-five years of life left to him.

Haydon's intervention did not help Lord Elgin's case – at worst, it may have been an irritation to the Committee during its deliberations, resulting in a lower-than-otherwise valuation. It did, however, serve his own prestige and brought his name to social prominence for the first time in the two years since he exhibited his last picture: 'In a week my painting-room was again crowded with rank, beauty and fashion, to such excess that I ordered the front doors to be left open.' He ensured his international reputation by having the article translated into Italian and French and sending 100 copies to Rome, 100 to Florence and 200 to St Pertersburg.[55]

But it also brought penalties, 'secret denunciations of vengeance from all connoisseurs', and certainly did his career immediate harm. Lord Mulgrave had just laid a plan before the Directors of the British Institution, which would have brought considerable benefits.

'What the devil is Haydon about?' his Lordship raged to a friend.
'Upon my word, I don't know, my lord.'

'Here have I been planning to get him a handsome income for three
years and send him to Italy, and out comes this indiscreet and abom-
inable letter.'

Nothing came of Mulgrave's scheme. The Directors may not have
agreed with Knight's opinion of the Marbles, but he was one of them,
and Haydon's attack on connoisseurs was an attack on them all.

Knight's reputation was destroyed, not by Haydon's article, but by
the obvious wrong-headedness of his testimony. Joseph Farington, as
he read the parliamentary report, expressed satisfaction that Knight
'had so publickly committed Himself . . . Thus will the judgement &
ignorance of this presumptuous Connoisseur be recorded.'[56] The name
of Richard Payne Knight was omitted from the list of Royal Academy
invitations that year.

While he had waited in vain to be called by the Select Committee,
Haydon was for a time distracted from the fate of the Marbles by a
chance passer-by:

> I was walking along the Strand, when a little, lovely, plump, ambling
> creature minced by, dressed in a white flowered [dress] with little brown
> leaves, full sleeves, & ruffles covering her tapering fingers. I passed, but
> her image had sunk into my soul . . . I went home, & went out again
> to look after her, but to no purpose.

He thought of her all evening, dreamed of her all night. In the morning
he 'arose in a steam, a heat, an eagerness', could not touch breakfast
and wandered all day up and down the Strand, 'but never saw her
again'. He had recently turned thirty. 'What are the passions of eighteen
to these?' he asked, speculating whether it was proof of 'inferior or
superior capacity'. Two months earlier he had been erotically obsessed
by a woman identified by the single initial 'V', and had stared at an
empty seat in his painting room, brooding on the memory of what
it had so recently contained: 'that heavenly figure, those full exquisite
thighs pressed out by the chair, with silk drapery that covered without
concealing their delicious shape'.

In the late spring of 1816 he found a more substantial sentimental
fixation. The object of an earlier infatuation, Maria Foote, acted as

intermediary, calling unexpectedly at his lodgings one evening, asking to be escorted home:

> Not far from my house she requested me to stop a moment whilst she left a letter with a lady who was going into Devonshire. I waited; a servant came down, and requested I would walk up . . . and in one instant the loveliest face that was ever created since God made Eve smiled gently at my approach.

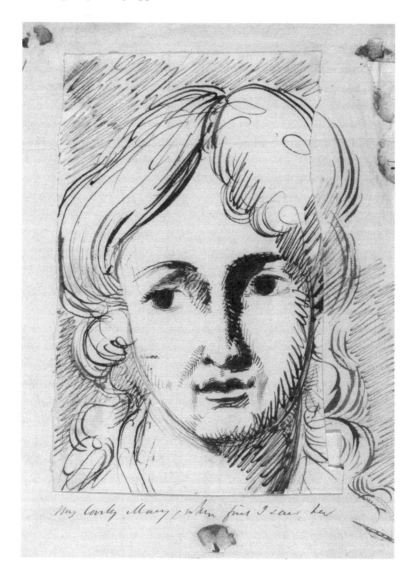

My lovely Mary, when first I saw her

Her name was Mary Cawrse Hyman, his future wife. Later, he would sketch her from memory and attach the drawing to his journal, inscribed: 'My lovely Mary when first I saw her'. Apart from Mary and Miss Foote, there were two other people in the room: 'a dying man, and a boy about two years old by his side'. The man was a Devonport jeweller, considerably older than his beautiful young wife and would be dead within three years. The child was Orlando Bridgeman Hyman, their son; another, named Simon after his father, was born that same year.

In the days that followed their first meeting, Haydon haunted the street outside for another glimpse of Mary. He gave a neighbour half a crown for allowing him to sit and watch for her coming out. He pursued her and 'grew more and more inextricably enraptured'. She rejected his advances and kept him at a distance, although he saw that he had 'touched her heart'. Her husband suspected this as well, 'but . . . his confidence in her', Haydon insisted, 'was justified by her virtue'.

<p align="center">★</p>

The exhibition of Italian and Spanish masters that opened on 25 May 1816 at the British Institution included two of the Raphael Cartoons from Hampton Court: *The Miraculous Draught of Fishes* and *Paul Preaching at Athens*. Haydon hoped that this would become a regular practice and that two more be exhibited every year, 'and that when they are all gone through they will begin again'.[57]

As with the previous year's exhibition of Flemish and Dutch masters, so with this, the notorious *Catalogue Raisonee* had its fun. Again, the 'Defender' wrote in ironic praise of the Directors' support for British contemporary art, by pouring scorn on the dead foreign masters. 'We feel perfectly satisfied,' he declared, 'that the moderns will derive benefit in every way from the introduction of [Titian's *Bacchus and Ariadne*] to the world . . . its nonsense and its defects are too gross not to be immediately obvious.'[58] The 'Incendiary' retaliated, accusing him of being 'a most barbarous Goth'. The 'Defender' referred to the notice, prominently displayed in the gallery, complete with pointing hand: 'It is particularly requested, that no one will touch the Pictures.' He assured his readers that he would not even touch Andrea del Sarto's

Head of a Boy with a pair of tongs, 'except, indeed, it were for the purpose of insinuating it between the bars of a well-heated kitchen range'.[59]

Again, the *Catalogue* provoked lively discussion as to who was responsible. Thomson believed that neither Phillips nor Smirke was the author, and thought Mr Walter Ramsden Fawkes a more likely culprit. Fawkes was not an Academician, but he was a friend of Turner, who had been highly praised in the first *Catalogue*. James Perry, co-editor and proprietor of the *Morning Chronicle*, told Thomas Lawrence that the Earl of Egremont had financed the publication.[60] Lawrence thought it not the work of 'an established writer and author'.[61] Having sifted the gossip, Farington would not commit himself to a precise opinion as to authorship, thinking it most likely to be the work of 'some person who hangs about the art'.[62]

The first *Catalogue Raisonee* had provoked little more than speculation in the ranks of the Academy, and outrage among the Directors of the British Institution. Publication of the second drew a more measured response. Hazlitt would devote three articles, in three consecutive issues of the *Examiner*,[63] to attacking the *Catalogue* and its authors, while Haydon would condemn it through the pages of a new quarterly publication: *Annals of the Fine Arts*.[64] 'Malignity and false abuse are not genuine satire,' he declared, 'nor is commonplace vulgarity, wit.'[65] He deplored the mean-mindedness of artists for sniping at the exhibition, when they should have been 'bowing, with a real consciousness of their own defects, before productions sanctioned by the approbation of ages . . . grateful for this opportunity of informing their minds . . . going daily to study them, and returning home, endeavouring to put in practice . . . what they had gained'.[66]

He urged the Directors to 'defy the snarling and malice of intriguing malevolence' and not be 'diverted, by disgust at such ungrateful treatment from their proper course; or from employing their extensive influence and property for the benefit of the rising artists'.[67] And Haydon's motive in leaping to the defence of 'this useful Institution' may not have been entirely disinterested. He was defending a body of men, including Richard Payne Knight, that he himself had attacked only months before in his article 'On the Judgement of Connoisseurs'. That diatribe had scotched Lord Mulgrave's plan to get him money

for three years in Italy. Perhaps he believed that his support in print might persuade the Directors to revive the scheme. It did not.

<p style="text-align:center">★</p>

Heeding his doctor's recommendation for 'pure air', and with his appetite whetted by the sight of the two Cartoons on display in Pall Mall, Haydon rode to Hampton Court to reacquaint himself with the other five. After studying them for three hours, he rode back, stopping to dine on Richmond Hill at the popular but overpriced Star and Garter.[68] By chance or prior arrangement he spent a pleasant interlude with a young woman whom he was careful not to name. 'The three summits of human happiness,' he wrote in his journal the following day, were 'the consciousness of having done your duty . . . The next, success in great schemes'. And, thirdly:

> a lovely girl who loves you, [in] the dining room of the Star & Garter at Richmond, sitting after dinner on your knee, with her heavenly bosom palpitating against your own, her arm round your neck playing with your hair, enough of consciousness to keep her cheeks blushing, her eyes lustrous & her lip shining and her form twining & bending.

Nothing betrays her identity, not even a bare initial, as with his 'sweet, dearest V——' of five months earlier. Conjecture alone might point to a woman more recently met, a woman still married, a woman whose very name and whose unfaithfulness to her husband he could not acknowledge even to his own journal. Richmond would come to have a special significance – 'the scenes of our love & courtship' – for Haydon and Mary Hyman. Her first husband safely dead, they would dine together respectably at the Star and Garter in July 1821. They would do so again in October 1822, celebrating their first wedding anniversary. But whether they were also thereby commemorating an adulterous tryst of June 1816 cannot be known for certain. However, if relations had been maintained within strictly honourable bounds while her husband lived, the implication of four lines of verse attached to the sketch of his 'lovely Mary' – particularly the conditional phrase in the third – is puzzling:

O God that we had met in time
Thy heart as fond, thy hand more free
Then thou had'st lov'd without a crime
And I'd been less unworthy thee.

He returned to London 'totally steeped in feeling, as if a spirit had dipped me in racy nectar, & left enough about me to keep me in a constant tingling'. This ecstasy he attributed to the Cartoons, to 'the deliciousness of nature' and to his anonymous companion, designated by a horizontal stroke of the pen. She was not the only vision of love-liness given to him that afternoon. As William Blake once saw angels among the mulberry trees of Peckham Rye, so, on Saturday 1 June 1816, Haydon claimed to have seen a host of them in Richmond Park:

I felt for a moment as if the mortal film was taken from [my] eyes, & I saw all but the great Creator. I saw millions on millions of genii who guarded every shrub & fruit & flower, bent with their little arms across their breasts in adoration, & smiling beauty. I saw millions on millions of angels who guarded Mankind . . . I saw millions with shaded wings in one circle & millions with bent heads, & millions with uplifted hands, and there stood the great Archangels round a light so bright that they could not bear to face it, stood round it, & it shone out round them & through them & yet nothing but light was seen & yet all bowed to the being that dwelt invisibly in this dreadful light, and these Genii & Angels & Archangels, whose numbers defied contemplation, all as with one deaf'ning shout, *cried, 'hail to the great Jehovah,'* and the light shined out fiercely, & the wings of the millions fluttered, and then the light & the Archangels rose slowly, and again the millions shouted *'hail'* & the Archangels waved their terrific hands, which cast a streaming shadow on the myriads in sign of approbation, and again the vision rose higher & grew brighter . . . & floating clouds of gold encircled the Archangels, & the light shined through the golden clouds, and I saw the Archangels as bedimmed by golden tissue, and the myriads once more in high Voice cried *'hail'* & gradually the vision rose and gradu-ally it vanished, and by degrees all was silent.

As consciousness returned, he lay with his eyes closed 'unwilling to be alive to this world or any thing in it . . . praying that my mortal

existence might no more return but that I might forever remain insensible to all but such immortal glories!'

*

In July the first issue of *Annals of the Fine Arts* appeared. Edited by James Elmes, a friend of Haydon since they were students together at the Royal Academy, for the next five years its unashamedly partisan pages provided an outlet for Haydon's concerns and views: his extolling of the Elgin Marbles, his attacks on the Royal Academy, his condemnation of the *Catalogue Raisonee*. The readership was kept constantly informed of his activities, the progress of his *Jerusalem*, the doings of his pupils. 'We have been several times accused of having mentioned Haydon's name ... oftener than that of other artists,' admitted one editorial statement:

> To this we answer, that we have mentioned it oftener than other artists, and shall continue so to do, while he stands the most prominent in the art ... and is every where to be found standing up for its advancement and its high interests.[69]

About a year after the Landseer brothers formed the nucleus of Haydon's 'School', a young man of twenty, newly arrived from County Durham, was sketching among the Elgin Marbles in the shed at the back of Burlington House. His name was William Bewick, the son of a Darlington upholsterer. Haydon invited him home, gave him breakfast and showed him the drawings he himself had made of Lord Elgin's hoard just seven years before, together with his great work in progress. He also supplied a letter of introduction to Fuseli, requesting that the youth be admitted to draw at the Academy. Despite his assurance to the Keeper that Bewick 'promises something' and 'seems to have a feeling for doing things in a large way',[70] the request was ignored. Bewick himself believed his rejection was due to his not having given the doorman a shilling to deliver the letter, but it may have been that Haydon was not the most persuasive of sponsors for the Royal Academy. The following year Bewick would apply again, and be admitted, still neglecting to tip the doorman, but this time without a letter of recommendation from Haydon.

It would not be until September, following correspondence with Bewick's father, that Haydon formally took him on as a pupil. 'See what you like,' he told him, 'do what you choose, and have anything I can conveniently spare.' He promised 'every assistance in his power',[71] offered casts and engravings to copy and guaranteed free access, through his contacts, to the great private collections of Lord Stafford, Lord Grosvenor and Thomas Hope. All he demanded in return – and Bewick senior had made it clear that he could not afford tuition fees[72] – was that his pupil 'be industrious and have patience and perseverance'.[73] When profits of the upholstery business would not allow further parental support, Bewick turned to his teacher. 'We talked matters over,' he told his brother, 'he thought like a father, and with as much concern as if I had really been his son, he confessed to me that he only had £5 left. "However," says he, "I'll let you have five shillings, that will help a little."' Haydon even offered 'to pass his word for the payment of a quarter-year's living at an eating-house',[74] possibly his own former resort for tick, John O'Groat's in Rupert Street. Bewick, however, uncertain of his prospects and with a healthy fear of debt, declined the offer.

<center>★</center>

Late in August, Haydon was to be found drawing from the two Raphael Cartoons in the British Institution. First he copied a series of nineteen or twenty heads, in black and white chalk, 'same size as the originals'. This exercise alone would have accounted for every single head in *St Paul Preaching at Athens*. Next he drew 'a whole length of the same dimensions of St Paul . . . with the surrounding groups'. The figure of the Evangelist was something over eight feet high. Artists, students and amateurs alike, copying in the Gallery, were highly entertained. 'It was a subject of general ridicule; one asked Haydon if he intended getting plate glass to preserve it! another if he had ordered a portfolio for it! a third would go away with a knowing wink, and say, "a pretty *little* drawing that!" and all agreed that the artist must be mad who could possibly think of making a drawing in chalk of such dimension.'[75]

He was still working at the Gallery a month later and, following 'a week [of] inveterate labour', his 'faculties worked to a high pitch of tuned sensation', he became so deeply affected by studying the

drapery of two youths sitting to the right of St Paul that he almost lost consciousness. 'I felt it in my arms, with a sort of rheumatic ake; my eyes became dizzy, & I sat down reeling.' The near-collapse was likely brought on by optic strain as much as the overpowering beauty of Raphael's drapery. A fortnight later he complained to Farington of a cold caught towards the end of his exertions at the British Institution, and, following another strenuous 'attack' on *Jerusalem*, and a recurrence of his chronic affliction necessitating recuperation for his eyes, he rented a cottage in Pond Street, Hampstead for the month of October. Writing to the poet John Hamilton Reynolds, from this suburb of poets, he gave directions in kind:

> Lest you might go, quite far beyond
> I beg to say the Street is Pond
> Turn to the right along the road
> You soon find out my still abode
> The number's seven.[76]

Just north of his lodgings, Leigh Hunt was living in the Vale of Health and their friendship was at its most cordial. Returning a copy of Vasari, the *Examiner*'s editor inscribed it with a sonnet:

> Haydon, whom now the conquered toil confesses
> Painter indeed, gifted, laborious, true,
> Fit to be numbered in succession due
> With Michael, whose idea austerely presses,
> And sweet-souled Raphael with his amorous tresses;
> Well hast thou urged thy radiant passage through
> A host of clouds; and he who with thee grew,
> Thy bard and friend, congratulates and blesses . . .[77]

This prompted in turn a poetic foray from Haydon:

> Thy sonnet, Bard & Friend, in truth I read
> To the last moment of my going to bed,
> And when at length the candle was put out
> Long to myself thy sonnet did I shout
> And still in sleeping on thy sonnet dreamt

And when before I well knew what I meant
Thy sonnet mutter'd! – (Trust in what I say)
At the first dawning of the creeping day
When Lads and Lasses gin to rake their hay,
And Lovers drop and doze, after long amorous play.[78]

Throughout the month he was much in Hunt's company, but although thinking him 'one of the most delightful companions on Earth, full of Poetry & wit & amiable humour', their relationship began to show signs of strain. They could argue happily 'with full hearts' on any subject bar two: Bonaparte, for Hunt, and religion, for Haydon. Ten years' acquaintance had taught them that these were far too serious topics for friendly disagreement. Sometimes, however, clashes were unavoidable. One Sunday Haydon arrived late at Hunt's among a gathering 'of the cleverest unbelievers of the age' and made the excuse that he could not have come earlier as he was at church. As the ridicule subsided, Haydon cut in icily:

I'll tell ye what, gentlemen, I knew when I came amongst ye . . . that I was the only Christian of the party; but I think you know that I will not bear insult; and I now tell you all that I shall look upon it as a personal affront if ever this subject be mentioned by you in my hearing; and now to literature or to what you will![79]

Hunt was in the habit, after much talk and wine, of opening the Bible, pointing to a passage of scripture and demanding of his guest: 'Haydon, do you believe this?' And when Haydon said that he did indeed believe it to the letter, Hunt would shut the book, exclaiming: 'By heavens, is it possible!' And, after peering through the window 'with an affected indifference', he would pound out Così fan tutte on the piano as though cheerily changing the subject from Haydon's unfortunate shallowness of mind. Particularly provocative was his refusal to discuss matters of faith other than as a joke. On one occasion he referred to St Paul as 'Mr Paul', to which Haydon took exception:

'Oh, the question irritates you,' said Hunt.

'And always will when so conducted,' Haydon replied. 'I will not suffer so awful a question as the truth or falsehood of Christianity to be treated as a new farce, and if you persist I will go.'

Hunt was also trying to dissuade Haydon from including Voltaire in the *Jerusalem* crowd, correctly interpreting the sneering French philosopher as a critical reflection on sceptics such as himself. 'Now, Haydon, there is no disgrace in acknowledging an error,' he said. 'Therefore candidly say you are wrong, & put out his head!' Such cajoling merely ensured that the head stayed, while Hunt's never received the accolade – afforded other friends – of inclusion in the picture.

Following a three-hour sitting, 'pouring out the result of a week's thinking', Hazlitt's profile would appear, beyond Christ's outstretched left hand, 'scrutinising',[80] between the heads of St John and St Peter. The head of Haydon's latest pupil, Bewick, would also be pressed into service: 'a person speaking loud to another, to give an idea of the noise of the crowd'.[81] That other, in profile and also shouting to make himself heard, was the portrait of a young cockney medical student with poetic ambitions, encountered during the month in Hampstead.

When Haydon returned to Great Marlborough Street, John Keats was invited to his painting room for breakfast on 3 November, to be given a view of the great work, and the young poet looked forward to 'seeing so soon this glorious Haydon and all his Creation'.[82] An evening later in the month was commemorated by a series of drawings. One was a profile of Keats similar to that face in *Christ's Triumphant Entry into Jerusalem*, but with mouth closed, emphasising a pronounced overbite. Then there were two self-portraits by Haydon and a childish attempt by his guest inscribed 'a vile caricature of B.R. Haydon by John Keats'.[83]

The following morning Keats wrote to say that the evening had 'wrought [him] up' and enclosed a freshly composed meditation on the three paramount men of the age: Wordsworth, Hunt and his host:

> Great spirits now on earth are sojourning,
> He of the cloud, the cataract, the lake,
> Who on Helvellyn's summit wide awake
> Catches his freshness from archangel's wing;
> He of the rose, the violet, the spring,
> The social smile, the chain for freedom's sake:
> And lo! whose steadfastness would never take

> A meaner sound than Raphael's whispering;
> And other spirits are there standing apart
> Upon the forehead of the age to come:
> These, these will give the world another heart
> And other pulses. Hear ye not the hum
> Of mighty workings in a distant mart?
> Listen awhile, ye nations, and be dumb.[84]

Haydon replied by return of post, shrewdly suggesting the penultimate line be shortened to the first three words and promising to send a copy of the poem to his fellow 'great spirit' in the Lake District. Poetic tributes to Haydon were arriving with increasing frequency, each one carefully stuck into his journal. The painter James Anthony Minasi penned one in Italian, a four-verse *Sonetto a Haydon Pittore*.[85] Just two days after Keats's, another arrived from Reynolds:

> Haydon! Thou'rt born to Immortality!
> I look full on; – and Fame's eternal star
> Shines out o'er ages which are yet afar:
> It hangs in all its radiance over thee!

It ended with the couplet:

> Soul is within thee; – Honours wait without thee: –
> The wings of Raphael's Spirit play about thee.[86]

In December, the drawings of eleven ladies and thirty-seven gentlemen, including Haydon and his pupils, went on show at the British Institution. 'At present we are alive in art,' Wilkie wrote to Sir George Beaumont. 'The entire south room is filled with large drawings of heads and groups of the Cartoons. Haydon has made a great number, of which it is not saying much that they are the best, though there are others of great merit.'[87]

The making of full-sized copies from Raphael had been a summer activity for Haydon's 'School'. With the requisite coolness of late autumn and winter, his pupils could resume their study of the flayed human form at Sir Charles Bell's 'Theatre of Anatomy' in Windmill Street. Here, Bewick and the Landseer brothers 'dissected every part

of the muscles of the body, and made drawings in red, black and white chalk, the size of nature'. So thorough was the work that they continued some way into the summer of 1817. Warmer conditions making the labour unwholesome, they spent three weeks 'hanging over a putrid carcass, dissecting and drawing for twelve or fifteen hours a day at a time of year when surgeons generally give it up'.[88]

By then Bewick had been admitted into the Royal Academy Schools. When his drawings were praised by Fuseli, Haydon urged his protégé: 'Tell the Professor, plumply, if he speaks to you, that you are a pupil of mine, I want it to be known.'[89] In time there were other pupils. James Webb was introduced to Haydon by Sir George Beaumont in 1819, but after a period of 'drawing hands', became impatient and disillusioned with the painting profession, ending as the proprietor of a dairy business and occasional benefactor to his old teacher. Edward Chatfield would feel the same devotion as Bewick, once signing himself, in a letter, 'your devoted son (for you have ever been a father to me)'.[90] Another pupil was William Harvey. Then there was Edward Prentis and George Lance, John Borrow and Frederick Say. Thomas Christmas told Farington that Haydon also claimed his brother as a pupil, 'but he was Not'.[91] There was also Henry Jones, and William Mayor.[92]

*

Towards the end of 1816 Wilkie came to inspect progress on *Jerusalem*:

'It will make a decided impression,' he said.

'God grant it may,' Haydon replied modestly.

'It is *very imposing*,' added Wilkie, 'and a great advance beyond Solomon.' They examined the canvas head by head in the light of a candle and 'criticise[d] each with the severity of the most acid criticks'. Wilkie reported to Sir George Beaumont: 'He has finished a row of heads on the left hand of Christ – all good, – and the head of St Peter is, I think, the finest character he has done. Though nothing but heads are finished, it begins to look full of subject.'[93]

With the beginning of 1817 Haydon's friendship with Leigh Hunt became strained. It reached breaking point at Horace Smith's dinner table in Knightsbridge Terrace, Kensington Road. Hunt, his wife Marianne and sister-in-law Bessie were there, as was Thomas Hill, a

small round City businessman with pretensions to literary patronage, mocked for settling any and every argument with the words: 'Sir, I happen to *know* it!'[94] His contributions to this particular evening's conversation, however, were not recalled by anyone present. Keats was there, but was as silent to posterity as Hill. Opposite Haydon sat another poet – a 'slender, feeble creature'[95] – Percy Bysshe Shelley. The notorious author of *The Necessity of Atheism* eyed the devout Haydon from behind a vegetarian platter, on which he was 'carving a bit of brocoli [*sic*] or cabbage . . . as if it had been the substantial wing of a chicken', and drawled in 'feminine and gentle' voice: 'As to that detestable religion, the Christian religion . . .' The rest of the sentence is not recorded.

Haydon would not get the full measure of his opponent's views until nearly a year later, when he had 'waded through [an] infamous, boyish, & profligate publication' entitled *Queen Mab*. Published in 1813, its nine cantos comprised Shelley's opposition to monarchy, war, commerce and religion, and his support for republicanism, atheism, free love, and vegetarianism. Following a point-by-point refutation of the poem, spread over several pages of his diary, Haydon would conclude: 'Every thing this man thinks on, passing through the filthy gloominess of his own horrid fancy, comes out slimy, morbid, bloody & diseased.'

But there is no reason to suppose that Haydon had read a word of Shelley when the poet uttered his provocative words about Christianity at Horace Smith's dinner table. Hunt smirked, the women simpered, but Haydon did not rise to the challenge until he had finished his meat and Shelley his vegetables. Over dessert Shelley returned to the attack and said that 'the Mosaic and Christian dispensations were inconsistent'. Haydon said they were not and declared that the Ten Commandments were 'the foundation of all the codes of law in the earth'. Shelley said they were not, and Hunt agreed. Haydon reiterated that they were. Neither side was 'using an atom of logic' and there the argument might have stalled, had not Shelley raised the heat by declaring that Shakespeare 'could not have been a Christian', citing the Gaoler's speech in *Cymbeline*[96] as evidence. Few men could best Haydon in a duel of Shakespearean quotation and he countered – three shots for one – with Marcellus and Horatio in *Hamlet*,[97] Portia in *The Merchant of Venice*,[98] and Isabella in *Measure for Measure*.[99]

Eventually the argument became personal and 'unpleasant things' were said on both sides. During a lull, Shelley was overheard to say: 'Haydon is fierce.'

'Yes,' said Hunt, 'the question always irritates him.'

But it was Hunt, more than Shelley, who irritated Haydon. And it was not only the arguments about religion of that evening, or those of the previous October in the Vale of Health, that irritated him. A persistent bugbear was Hunt's perceived contempt for women. Charles Lamb had heard him say 'he would not mind any young man, if he were agreeable, *sleeping with his wife!*'[100] Haydon had watched Hunt pawing his sister-in-law while she played the piano and suspected 'they went further' when she had kept house for him in prison. Long suffering the torments of sexual frustration for want of any woman, Haydon was particularly agitated at the idea of a man having two. 'His poor wife has led the life of a slave,' he raged, 'by his smuggering fondness for her Sister.' And he simultaneously felt abhorrence at the fondness not being consummated 'to the full extent of a manly passion, however wicked'. His very disgust at Hunt's sublimated activities was expressed in near-masturbatory prose:

> He likes . . . to corrupt the girl's mind without seducing her person, to dawdle over her bosom, to inhale her breath, to lean against her thigh & play with her petticoats, and rather than go to the effort of relieving his mind by furious gratification, shuts his eyes, to tickle the edge of her stockings that his feelings may be kept tingling by imagining the rest. And who is this whose mind he so debauches and whose body he so slimes by the sickly pukings of lechery? His wife's Sister, the Aunt of his four little children.

Haydon's feelings may have been complicated by the belief that the sister-in-law Bess, 'pretended to be dying [with love] for [him]'. Her own mother had told him as much, but Haydon had not reciprocated. As Horace Smith's party was breaking up, Hunt reverted to the earlier argument about religion when he pointed at the ladies dressing to leave and asked: 'Are these creatures to be damned, Haydon?'

His mind roiling with overheated fantasies about Hunt's supposed ménage, Haydon might have been provoked to a variety of rejoinders. As it was, he dismissed the question as betraying 'a morbid view

of Christianity'. Two months before, he had written in his journal: 'If I ever loved any man with a fullness of Soul, it was Leigh Hunt.' After that evening he revised the statement, qualifying it with an emphatic '*once*'.

Hunt was among eminent company. On the same page, following the words 'If I ever adored another', Haydon returned to alter 'it was' to 'it is not', before the name of another friend subsequently found unworthy: William Wordsworth.

Three days after his introduction to the Republican Shelley, Haydon was presented to the future Czar of Russia – Grand Duke Nicholas – among the Elgin Marbles newly arrived at the British Museum. The meeting was reported in *The Times*: 'From the specimens which we have seen of Mr Haydon's talents, we know no man more able to explain [to the distinguished visitor] the grand principles and higher beauties of art whether displayed in painting or sculpture.'[101] Haydon dropped into the conversation the name of his uncle 'in the Russian Service' and the Grand Duke replied that he knew Thomas Cobley intimately and now looked on the nephew with increased favour: 'Monsieur, je suis enchanté de faire votre connaissance.' The meeting would prove beneficial, both to Haydon and to the state of Russia. A year later the Imperial Academy of Arts in St Petersburg commissioned him to acquire casts of the Marbles. He would preserve and prize a letter from the President of the Academy, Alexis Olenin, thanking him for his 'kind intentions' and 'particular marks of attention', leaving to his judgement the choice of sculptures to be moulded and hoping that their correspondence would continue 'for the benefit of arts in Russia'.[102] Haydon would receive, in return, the gift of three casts from the imperial collection: a bust of Achilles, a statue of Venus and a small statuette of Silenus. He would also be elected a member of the St Petersburg Society of Arts in recognition of his services, and would receive notification of the honour five years later within the walls of the King's Bench Prison.

*

Haydon's friendship with Mary Russell Mitford began shortly after his bad-tempered withdrawal from Leigh Hunt's circle. Their correspondence opened somewhat testily, her first visit having been thwarted

by an officious servant. 'Do not lay your vain attempt at my door,' he told her:

> but to your own delicacy. Had you suffered my servant to bring in your name, I would have come out to you immediately, and if you could have amused yourself for a moment with my drawings, I should have been at leisure.[103]

He then assured her that she, and any friends she chose to bring, would be welcome on the following Monday, 'punctually at 3'. He apologised for being so particular as to the time: 'but you are aware of my occupations'.

Two months later, in the Great Room at Spring Gardens, during the 13th Exhibition of the Society of Painters in Oils and Watercolour a drawing by Haydon moved Miss Mitford sufficiently to add to that growing body of verse written in his praise. She had seen his *Judgement of Solomon* three years before in the same gallery, and the epic conception of *Jerusalem* in his painting room, but this work was on a more intimate scale: 'the very triumph of expression,' she declared. 'People stood silent before it.'[104] The drawing was of an exotically dressed young woman, who may have been Patience Smith, his 'Gypsy'. Haydon told Miss Mitford that his subject was 'a mother who had lost her only child'. It was inscribed with a quotation from Tasso,[105] a translation of which formed the first line of Miss Mitford's poetic tribute 'To Mr Haydon on a Study from Nature, exhibited at the Spring Garden Exhibition, 1817'.

> 'Tears in the eye, and on the lips a sigh!'
> Haydon! the great, the beautiful, the bold,
> Thy wisdom's king, thy mercy's god unfold;
> These art and genius blend in union high,
> But this is of the soul. The majesty
> Of grief dwells here; grief cast in such a mould
> As Niobe's of yore. The tale is told
> All at a glance. 'A childless mother I!' . . .[106]

Leigh Hunt paid Haydon a visit in March and a short-lived reconciliation was effected. 'Old associations crowded on us,' Haydon recalled,

the unpleasantness of the Horace Smith dinner forgiven for the moment. Hunt glanced at the face of Voltaire, now incorporated, sneering, into Haydon's composition, and made no comment. The painter 'was ready with a broadside for the dog if he had'. For the time being, they were friends again. Miss Mitford recounted an anecdote which, if true, would probably have occurred a fortnight after this declaration of peace, on 31 March:

> Leigh Hunt . . . is a great keeper of birthdays. He was celebrating that of Haydn, the great composer – giving a dinner, crowning his bust with laurels, berhyming the poor dead German, and conducting an apotheosis in full form. Somebody told Mr Haydon that they were celebrating *his* birthday. So off he trotted to Hampstead, and bolted into the company – made a very fine animated speech – thanked them most sincerely for the honour they had done him and the arts in his person. But they had made a little mistake in the day.[107]

It would not be long before they quarrelled again.

<p style="text-align:center">★</p>

The Elgin Marbles attracted 1,002 visitors one Monday in May, a greater number, Haydon was told, than had ever visited the British Museum on a single day since its foundation. More than 160 students had entered their names in application to copy from them and, needless to say, among these were members of Haydon's school 'drawing from the originals', the *Annals* assured its readers, 'the full size, as from the Cartoons of last year; by which means they are practising their hands and rendering their minds adequate to great works'.[108] Bewick produced two life-size chalk drawings from the female groups 'in a most pure and fine style for his own studies and improvement'. These were 'liberally purchased' by Sir William Hamilton.[109]

Meanwhile, the British Institution had brought another two of the Raphael Cartoons from Hampton Court: *Elymas the Sorcerer*[110] and *The Death of Ananias*. Haydon's pupils again went to work, Bewick justifying 'the hopes excited by his drawings at the B.M., by the promise his new drawings at the B.I. gives for truth of expression'. The efforts of Thomas Christmas and the Landseer brothers were also praised,

their copies 'finely felt, seized, and completed with as much spirit and vigour as any pupil of Raphael's period could have done'.[111]

A satirical engraving by John Bailey would appear twelve months later, entitled 'A Master in the grand style & his pupils'.[112] It showed Bewick, Christmas and the Landseers, mounted on platforms and stepladders to work at huge canvases erected in front of *Elymas the Sorcerer*. Haydon appeared in the shape of a bird flying above, blowing a trumpet labelled 'Director of the Public Taste'. Both Charles Landseer and Christmas are shown using compasses to ensure the correct proportions of their copies. Joshua Reynolds's reproving comment on the use of such instruments appeared below: 'A Painter who relies on his compass leans on a prop which will not support him.'

<div align="center">★</div>

'I do begin to feel my weakness of sight a heavy, heavy misfortune,' Haydon had complained in April. His state of health was becoming critical. It was not only the periodic trouble with his eyes brought on by long hours of close work in dim light. He was eating irregularly, not from want of food, but from negligence, and a prey to 'stomach aking & sinking'. Such problems were exacerbated by the debilitating atmosphere in his rooms, now so full of casts and possessions that the air could not circulate. The accommodation was 'so small, the air so confined, the effluvium of paint so overpowering' that 'after painting 8 & 10 hours, cleaning [his] brushes and palette [he] almost fainted, with the sickly, soapy smell'. Even casual visitors found the place intolerable and 'models [had] often gone sick the air was so confined'. The fumes of paint and turpentine were so pervasive that in his pokey bedchamber he had to sleep next to an open window or suffocate. One winter night of harsh frost so chilled his breath and throat that in the morning he could barely speak. And the air was as unwholesome outside as in: 'On a dark foggy November day the stench was too horrible; . . . it was pestilential closeness, in the midst & heart of sickening fogginess, not fit for human lungs.' In addition to these discomforts, he had practical problems. While the ceiling of his painting room had just about accommodated the ten-foot *Solomon*, his current canvas, higher by an extra yard, could not be raised on an easel, but, propped against

the wall, entirely filled one side of the room. Haydon was forced to paint the low parts of the composition lying on his side on the floor '7 hours at a time, & get[ting] up faint, aking, exhausted & blind'. Well-meaning friends were urgent in their advice. 'If you stay here you cannot live,' Horace Smith told him.

Determined to find more congenial quarters, he took temporary lodgings in Somers Town, North London, which he used as a base for house-hunting. During intervals in his search he sat for the sculptor Edward Hodges Baily, who was diversifying from monumental and mythological subjects to make his first portrait bust. It may have been Baily who heard that another sculptor, the Academician John Charles Felix Rossi, was at that time in straitened circumstances and might have rooms to rent. Haydon called on Rossi – who seven years previously had received him 'with great vulgarity and almost pushed [him] from the door', when canvassed for his support in the Associateship election – and the sculptor now seemed eager to have him as a tenant. Owning a large house in Lisson Grove, he offered Haydon the gallery as a painting room and agreed 'to fit the rooms near it into [accommodation] large enough for a bachelor'.

Haydon calculated the cost of 'removing and furnishing' at £300. He approached Jeremiah Harman, principal partner of the banking firm Harman & Co. and currently serving as Governor of the Bank of England, for a loan of £500. Harman at first declined, then reconsidered and at last consented to the request. George Philips paid the £300 balance on the picture he had commissioned two years previously – a picture he would not receive for another four years. Haydon placed the £800 in an account at Coutts's bank. He was now able to pay the arrears owed to his old landlord Mr Perkins and advance Rossi, his future landlord, sixty pounds – two quarters rent – to pay for the necessary alterations to his new home. Less than six months later, his borrowed funds exhausted, Haydon would have to borrow more, but for the present all was well. He was in holiday mood.

On 18 June a new bridge of nine granite arches was opened, crossing a bend in the Thames by Somerset House and linking the timber yards, breweries and manufactories of Lambeth and Southwark with Covent Garden and the Strand. It was to have been called the 'Strand Bridge', until renamed by Act of Parliament to commemorate the

country's most recent military triumph. *The Times* pointed out that Bonaparte had given the names of Jena and Austerlitz to two new bridges over the Seine, but those structures, 'however elegant and convenient', were 'but trifles in civil engineering' compared to that opened with due ceremonial on the second anniversary of the battle of Waterloo.

Sometime after three o'clock the Prince Regent boarded the royal barge at the Whitehall Stairs and was conveyed downriver, followed by the Lord Mayor's barge and barges belonging to the Admiralty, the Navy and other public offices. Cannon-fire accompanied the procession the full half-mile to the Lambeth end of the new bridge, where his Royal Highness disembarked and climbed the steps leading to the roadway. Then, flanked by the Duke of York and the Duke of Wellington and 'followed by a number of military officers, officers of state, and persons of distinction, and attended by a military guard of honour', he walked across. He then descended the steps on the Strand side to board the royal barge, which had by this time crossed the river to receive him. The cannon-fire began again and continued while the barge made its way back upriver to the Whitehall water gate, ceasing only when the Prince Regent had disembarked and returned to Carlton House.

Between Blackfriars Bridge and Whitehall both banks of the river were thronged with immense crowds comprising 'all descriptions of persons of both sexes, from the curious of the lowest order up to the elegance of the highest of fashion'. The glorious summer weather created a holiday atmosphere, encouraging many to venture onto the water itself, and 'little pleasure-vessels of the amateurs of aquatic pleasures enlivened the scene by the neatness and facility of their movements'.[113] From one such craft Haydon witnessed this glorious occasion in the company of the woman who was to become his wife: Mrs Mary Hyman. Details are sparse, but it seems likely that Maria Foote, who had first introduced them, and her mother were also of the party. 'On that sunny lovely day,' Haydon recalled, 'we glided away up the glittering river & passed the evening in sunny shade and sweet conversation!'

★

'Take care of your twinklers,'[114] Horace Smith had advised him. His new accommodation now secured and only awaiting alterations, Haydon set off on a convalescent itinerary that would take him to Somerset, Oxfordshire and Norfolk. In July he stayed with his sister Harriet and her husband in Bridgwater. Then in August he spent a delightful week in Oxford, only regretting that he had not been educated there '& was thus deprived [of] the power of presenting at a future time [his] portrait when worthy to be thought an honour'. He went to Blenheim Palace after writing an obsequious letter to the Duchess of Marlborough requesting that he be allowed to linger in front of the Rubens pictures for 'the whole of the public two hours', instead of joining the guided tour with the ordinary visitors, and that he would deem this 'the greatest blessing ever bestowed on him throughout his life'.[115] Privately, it irked him that Rubens 'should be made subservient like the upholsterer to adorn the Breakfast Rooms & Dining Rooms of a General'. Nevertheless, *The Rape of Proserpine*, and particularly the back view of the nymph Arethusa – 'the purest form of woman ever painted' – was 'worthy all the battles & intrigues Marlborough ever won'.

Towards the end of September, following three weeks in Yarmouth, he was back in London and preparing to move out of the cramped, unwholesome conditions in Great Marlborough Street. He reflected on the changes wrought in almost a decade since he first took up residence there. He had been twenty-four years old. He was now thirty-four:

I was now known & famous. I was then obscure & young, but I was healthy, vigorous, high spirited, with a rosy colour, and a luscious head of hair. I am now leaving . . . with my health shattered, my strength affected, my colour going, and my hair falling off.

An announcement in the *Annals of the Fine Arts* described his 'spacious apartments at Lisson Grove . . . a painting room of great dimensions, and ante-rooms for his numerous casts, with every accommodation for him to pursue his art with comfort, and without being cramped as heretofore'.[116] Number 22 was halfway up Lisson Grove North on the right, at the corner of St John's Place,[117] 'a nice comfortable house' in an area of purer air away from 'the continued rush of fashion' that

had left him no rest in Great Marlborough Street. On 28 September he breakfasted for the first time in his life using his own cup and saucer, his own knife and sitting in his own chair. He looked at 'the good, frank, innocent expression' of his servant Martha as she brought him his tea that first morning and felt relieved that he had not attempted to seduce her the previous night. He had been acutely aware of her presence in the room close to his own and had lain sleepless, listening to her every sound: her soft step, the rustle of her gown, the creak of her bed. Three weeks later, the unsullied Martha continued to exert her innocent but powerful influence on his over-heated imagination:

> I became haunted in the solitude of night, the silence of noon, & the intervals of Study, by the intense sensation of a female presence in the House! The slightest noise! the slightest rustle! the least movement! set my heart swelling & heaving so that I thought it would come bursting through my bosom! It was impossible to bear this. I awoke in the night, almost in a convulsion, & was obliged to gasp for air. My brain got fiery, & I stretched out with an 'oh,' as if some hot hand pinched my head.

The rest of the passage in his journal, containing the climax of the crisis – about ten lines of it – was heavily scratched out.

Friday 7 November was devoted to another surge of emotion as he participated in the national outpouring of grief following the death of the twenty-one-year-old heir presumptive, Princess Charlotte, sole issue of the Prince Regent's loveless coupling with his despised wife Caroline. In tune with the deluge of popular senti-ment – fuelled by press, pamphlets and poems – Haydon declared the loss to be 'irreparable', that she had been 'our rallying point, our hope, our sunny land of promise & consolation'. He had felt particularly warm towards the Princess, having encountered her by accident, alone in a print shop. He had walked in from the street, 'she turned round & placed her glass to her eye', and he, not wishing to intrude on her privacy, withdrew. But some days later, in the park, she had bowed to him in passing from her carriage and he was convinced it was 'from the amiable feeling, as it were, of remuner-ating [him] for a disappointment'. Whatever the reason, several

gentlemen standing nearby 'scrutinised [him] with all their eyes'. And so, on the Tuesday of her funeral, as shops and businesses remained closed, he 'strolled away into the Country to muse'. All over London, all over the kingdom, church bells tolled at minute time. In Hampstead, as at Richmond the previous year, he experienced a visionary train of thought:

> On a sudden the bells ceased, with a distant sinking like Aeolian harps, and I immediately imagined the people all in at prayer, and I saw as it were a steam of incense agitate the air, like the steam from a lime kiln, and ascend up in a straight line till it lost itself in the sky! . . . I thought of all the churches in the whole Empire sending up their streams of incense and felt elevated to where I could see the whole Empire like a map spread out before me, and I saw thousands of streams ascending like silvery smoke! . . . The conduct of my glorious countrymen on this whole occasion makes one . . . sensible of the value and virtue of the private character of the Princess, they felt her loss as if she had been one of their own daughters.

Three years later he would feel less in sympathy with his 'glorious countrymen' as they demonstrated their loyalty to Caroline, the Princess's mother, with illuminations and the breaking of windows.

By the beginning of December he was again in financial difficulties: 'All the money advanced last Summer had been swallowed up in removal & expenses & [he] found [himself] in a delightful house without a farthing to support it.' This time, to relieve his 'temporary distress', he approached Thomas Coutts, requesting a loan of £400, to be repaid with interest within a year. Coutts agreed, albeit reluctantly. In the past the banker had lent money to Joshua Reynolds, Fuseli and Thomas Lawrence, and such experience, he explained, 'almost blasts my hopes, as I have assisted several in your line in the course of a long life, & have never succeeded; on the contrary I have seen their prospects disappointed, and my money lost'.[118] Nevertheless, Haydon was invited to what Coutts called his 'shop' to sign for the money and was greeted 'with distinction and affectionate interest'. As he was being shown out, a beggar – 'a poor negro, lame' – came shambling towards him. 'Get away,' the servant growled at him, 'and let this Gentleman pass!' Haydon went home philosophical:

'Poor fellow! he asked for 2d. & was spurned by a Servant, *I* for £400 & was received like a Prince!'

That month Wordsworth was in town and Haydon was able to prevail upon him to sit for his portrait, so essential to the conception of *Christ's Triumphant Entry into Jerusalem*. Wordsworth sat, declaiming Milton and his own 'Lines composed a few miles above Tintern Abbey', his 'Character of the Happy Warrior' and more: 'some of his finest things'. His physical presence was remarkable. 'He looked like a spirit of Nature,' Haydon thought. 'His head is like as if it was carved out of a mossy rock, created before the flood!' The poet sat again later in the month, this time entertaining the painter with Book IV of *The Excursion* in its entirety.

Just after Christmas, Haydon hosted a party. As the year had begun with a memorable assembly of genius at Horace Smith's, so it ended with another in the painting room at Lisson Grove. He would later refer to it as 'The Immortal Dinner'. An intimate gathering: Wordsworth, his wife's cousin Thomas Monkhouse, John Keats and Charles Lamb were the dinner guests, and a few less-favoured friends would be arriving later for tea. There were to have been six at table, but John Reynolds had not responded to the invitation. This provoked a 'very sharp & high'[119] letter from Haydon, followed by another, 'in palliation', more offensive than the first. Reynolds's 'cutting' reply completed the damage to relations. Another cooled friendship was unrepresented, despite the coincidence that Leigh Hunt and his family were now in residence a matter of doors away at 13 Lisson Grove North. Haydon had recently quarrelled with Hunt – not, this time, over religious faith, but over knives and forks. His new neighbours had put the very catering of his 'Immortal Dinner' in jeopardy. Keats told the story he had heard:

> Mrs H[unt] was in the habit of borrowing silver of Haydon, the last time she did so, Haydon asked her to return it at a certain time – She did not – Haydon sent for it; Hunt went to expostulate on the indelicacy &c. they got to words & parted for ever.[120]

The five men sat down to dine, Wordsworth, Keats and Lamb with their backs to the canvas of *Jerusalem*, its mighty composition 'occasionally brightened by the gleams of flame that sparkled from the

fire'. It is not known what they ate. Haydon's record of the occasion was devoted exclusively to conversation. They had 'a glorious set to on Homer, Shakespeare, Milton, & Virgil'. Wordsworth pontificated solemnly, quoting Milton 'with an intonation like the funeral bell of St Paul's & the music of Handel mingled'. Lamb, a spare little figure with a disproportionately large head, provided the light relief, 'the fun & wit of the fool in the intervals of Lear's passion'. Keats recited the 'Hymn to Pan' from his *Endymion* in a 'low Chaunting tone', as he had at his first meeting with Wordsworth a few days before, when it had elicited the older man's verdict: 'A very pretty piece of Paganism'.[121]

Lamb became very drunk very quickly and remained so until his departure. He gave a speech, pretending to forget that his host was present, and exhorted everyone to drink to the health of their absent friend Benjamin Robert Haydon. He then turned to Wordsworth: 'Now, you old lake poet, you rascally poet, why do you call Voltaire dull?' There had been, in *The Excursion*, reference to *Candide* as 'the dull product of a scoffer's pen'. When the others rallied to Wordsworth's defence, saying that Voltaire might, in a certain state of mind, seem dull, Lamb offered another defiant toast and, turning to the towering canvas behind them, raised his glass to the wizened philosopher beside the freshly painted head of Wordsworth: 'Here's Voltaire – the Messiah of the French nation, & a very fit one.'

Then, just as Hunt had objected to the inclusion of Voltaire, Lamb abused his host for including Newton: 'a Fellow who believed nothing unless it was as clear as the three sides of a triangle'. Keats agreed: 'Newton destroyed all the Poetry of the rainbow, by reducing it to a prism.'[122] Another toast was proposed: 'Newton's health' – glasses were raised to the painted profile – 'and confusion to mathematics!'

Eventually they left the table and moved to take their ease and tea in a neighbouring room, where Haydon's other guests were expected. Lamb had by now reached a state of intoxication in which consciousness – along with his participation in the conversation – came and went. The three men who completed the party were an artist, a medical man and a civil servant. The painter and engraver, John Landseer, father to three of Haydon's pupils, was stone-deaf, but did his best to follow the conversation by cupping his ear and darting his eyes from speaker to speaker to catch the meaning of gestures. The

young surgeon, Joseph Ritchie, was about to lead an expedition south
from Tripoli to Timbuktu in search of the source of the Niger. Haydon
introduced him to the company as one 'who is going to penetrate
into the interior of Africa'. The announcement must also have pene-
trated the sleeping Lamb, because some time later he suddenly woke
up: 'And pray, who is the Gentleman we are going *to lose?*' he asked.
Everyone roared with laughter, including Ritchie. But Lamb's drunken
query proved apposite. In just under two years Ritchie would be dead
of fever at a town called Murzuq in the Sahara.

It was the third of the latecomers who was to provide, inadver-
tently, the greatest entertainment of the evening. His had been a last-
minute invitation, Haydon recalled:

> In the morning of this delightful day, a gentleman, a perfect stranger,
> had called on me. He said he knew my friends, had an enthusiasm for
> Wordsworth, and begged I would procure him the happiness of an
> introduction. He told me he was a comptroller of stamps, and often
> had correspondence with the poet. I thought it a liberty; but still, as
> he seemed a gentleman, I told him he might come.

John Kingston was in fact Deputy Comptroller of the Stamp Office
and it was partially true that he knew Haydon's friends, in that he had
been introduced to Keats at Horace Smith's the previous week. But
it was in his official capacity that he had corresponded with
Wordsworth. For the previous four years the poet had held the office
of Distributor of Stamps for Westmorland, South Cumberland and
the port of Whitehaven, responsible for collecting Inland Revenue
stamp duties on wills, pamphlets, papers and insurance policies, as
well as granting licences to the likes of stage-coach operators, pawn-
brokers, appraisers, dealers in thread, lace and medicine. He received
no regular salary, but a commission of 4 per cent on all monies that
he collected brought him between £200 and £400 per annum. Quarterly
accounts had to be drawn up, signed and sent to the Stamp Office in
London. The hitherto faceless bureaucrat who received, inspected and
approved these accounts was the man who now shook Wordsworth
by the hand.

'I have had the honour of some correspondence with you, Mr
Wordsworth.'

'With me, sir?' Wordsworth answered, trying to place the name, 'Not that I remember.'

'Don't you, sir? I am a comptroller of stamps.' Haydon described him as 'frilled, dressed, & official, with a due awe of the powers above him and a due contempt for those beneath him'. Kingston's interaction with Wordsworth combined awed respect for the great poet with awareness that he was also an administrative subordinate. Realisation of Kingston's superior status had a visible effect on Wordsworth. His income as Distributor of Stamps was very precious to him. He allowed himself, in consequence, to be the prey of this bore for the rest of the evening. Kingston talked earnestly about poetry.

Lamb woke up: 'What did you say, sir?'

Kingston repeated what he had just said.

'Do you say so, sir?'

'Yes, sir.'

'Why then, sir, I say . . .' and Lamb hiccupped, '. . . you are – you are a silly fellow.'

'My dear Charles!' Wordsworth expostulated, anxious not to offend Kingston. But Lamb had relapsed into unconsciousness. Haydon, Keats and Ritchie stifled laughter. The deaf Landseer tried in vain to follow what was happening. Kingston tried to take Lamb's eccentric behaviour in good part and turned back to Wordsworth:

'Pray, sir, don't you think Milton a very *great genius*?'

Lamb woke up and started singing:

> Diddle iddle don
> My son John
> Went to bed with his breeches on
> One stocking off & one stocking on,
> Diddle iddle don
> My son John . . .

He always sang this particular ditty when drunk. He now used it as a weapon against Kingston, interrupting his every attempt at serious conversation with a roaring chorus of: 'Diddle iddle don.'

Persecution of the poor man became more alarming when Lamb lurched to his feet, grabbed a lighted candle, staggered across the

room and thrust it in front of Kingston's face to study his 'phreno-
logical development' or, as Keats mimicked it, to 'show us wh-a-at-
sort – fello he-waas'. It was probably at this point that the others
bundled Lamb into the painting room and Monkhouse made prepar-
ations to take him home. While Keats and Haydon did their best
to placate the ruffled Kingston, Lamb could be heard next door
struggling with Monkhouse, singing snatches of 'Diddle iddle don'
and saying: 'Who is that fellow? Let me go & hold the candle once
more to his face.' The clowning masked an 'inexplicable moral
antipathy', a sober Lamb afterwards explained to Wordsworth: 'I
think I had an instinct that he was the head of an office. I hate all
such people – accountants, deputy accountants.'[123] Haydon shared
Lamb's distaste and 'felt pain that such a Poet as Wordsworth should
be under the supervisorship of such a being as this Comptroller'.
Later, when his feelings towards Wordsworth altered, he professed
to have seen the cause that evening: 'my respect waned from that
moment – & so would any body's to see his slavish servility to a
superior in Office'.[124]

Over the following twenty years Haydon would return to the
account of the 'Immortal Dinner' in his journal, and make supple-
mentary notes, as one by one his guests died: 'Ritchie is dead! 1819 . . .
Keats too is gone! 1823 . . . Lamb is gone too! Monkhouse, the other
Friend, is gone. Wordsworth & I alone remain of the party . . . 1837.'
He had forgotten about John Landseer, who would outlive him by six
years. As for Kingston: 'If the Comptroller lives I know not.'

★

With the beginning of a new year it became apparent that his more
spacious lodging and the purer air of Lisson Grove did not offer a
remedy to all Haydon's health problems. For over half of January 1818,
he was 'laid up in [his] eyes' and incapable of painting. But his concep-
tion of the great work matured nonetheless. The head of Christ
haunted him, and wherever he looked he saw it 'at present in a confused
state, but every hour . . . clearer'. He imagined the forehead 'calm,
mild, serene, liquid, heavenly . . . the forehead of another region. The
hair [would] float round it with a lovely and fleecy tenderness.' As he
walked along the Strand he saw it, for the first time, 'distinctly in [his]

mind'. He was also shrewd enough to recognise an opportunity to dispose of the picture profitably when finished. Concerned by the godless condition of the masses and fearful of Republican tendencies in the wake of the Napoleonic wars, Parliament had recently voted one million pounds for the building of 100 new churches.[125] Haydon woke at five in the morning and lay in bed composing his argument, 'getting it all arranged in the dark', before rising and dashing off a twenty-two page pamphlet entitled *New Churches with Respect to the Opportunities they Afford for the Encouragement of Painting*. In it he urged that 'three per cent were set aside for the purchase of one Altar Picture, out of every sum of money voted for the building of new Churches'.[126] He sent a copy to the influential connoisseur Charles Long, Member of Parliament for Haslemere, a Director of the British Institution and frequent consultant on artistic matters to the future George IV. It was said that 'the Prince Regent saw through Mr Long's spectacles'.[127] If anyone could further Haydon's scheme for the encouragement of historical painting, it was Long. The connoisseur passed the pamphlet to the Chancellor of the Exchequer, Mr Nicholas Vansittart, but the answer came back: 'Let us build churches first and think of decorating them afterwards.'

<center>*</center>

Haydon admitted to being 'ignorant, nearly so, of the anatomy of the horse', but towards the end of March he endeavoured to redress the deficiency, at least as far as a working knowledge of the donkey necessary for his picture was concerned. First he acquired and 'dissected the front half of an ass & gained immense knowledge'. The following day he dissected and drew for seven hours and spent two hours at night poring over George Stubbs's *Anatomy of the Horse*. The day after he drew 'the fore part in all ways & all positions' for nine hours and spent another two with Stubbs. Two days later, having drawn for another nine hours, his sight was strained and he was obliged to lose a day 'steaming & fomenting' his eyes. By 3 April he had drawn for another seven hours and had finished, 'having mastered all the forms & positions of the fore part'. Although resolving to 'proceed as soon as possible with the hind part', this did not prove to be necessary because the animal in his picture would appear head-

on, its rear concealed among the crowd. Sir John Leicester, later Lord de Tabley, ordered an oil study of the creature and Haydon generously persuaded him to transfer the commission to his pupil 'as he was a young Man of promise'. Bewick received sixty pounds for painting the 'Sicilian ass',[128] but it entered the collection at Tabley House as being by Haydon.

His name also appeared in the catalogue of the Royal Academy Exhibition for the first time in ten years, albeit as subject rather than artist. The bust by Edward Hodges Baily, modelled the previous year in Somers Town, received a notice in the *Examiner* that was flattering to sculptor and sitter alike: 'With beautiful execution, Mr Baily has precisely hit off the ardent, genius and impressed look of Mr Haydon.'[129] The *Sun* was more flippant: 'If Mr Haydon is so furious a fellow as this bust represents him, we tremble for the Academicians!'[130]

At the end of May he planned to start work in earnest on the long-deferred challenge of Christ's head, but the journal entry announcing this resolve was the last, for two and a half months, in his own handwriting. The following five pages were 'Dictated to Bewick while [his] eyes were ill'. He blamed the condition on 'painting in too strong a light'[131] and it was the beginning of what he would subsequently describe as 'six months . . . laid up in my eyes in torture of mind & body'. He was 'unable to paint, to read, or to write, or do any thing that required the slightest exertion of his eyes'.[132]

Sir William Hamilton wrote from the Foreign Office towards the end of October with an interesting proposition. If Haydon had a mind to go to Italy, 'free of expense', he could be entrusted with a bag of dispatches and the Government would 'pay the full expenses of a post-chaise'[133] as far as Naples. The dispatches delivered, he would be at liberty to stay in the country as long as he liked and arrangements would even be made, when necessary, for the expense of his return. It was an expedient means of achieving an open-ended period of recuperative travel and inspirational study, comparable to that which Lord Mulgrave had tried to arrange for him two years previously. It was an opportunity to see Rome – essential, surely, to any painter's artistic development and progress. But Haydon found ample excuses for allowing the opportunity to pass: he felt this to be a crucial time; he was 'bringing things really and truly to a point,' he argued and 'the

public was interested'. A man might return from foreign travel to find that point passed, the public interested in someone else. He offered the same excuse that had kept him from going to see Napoleon at Plymouth: work on his picture was pressing and 'there was much to do'. In the years to come he would be able to convince himself that not seeing Rome might even have benefited his mental health. 'A Tour of Italy,' he reasoned, 'seems on the whole to unhinge the mind', while the Immortal City itself, 'in which the greatest human efforts . . . now lie in ruins creates a melancholy sensation of the futility of all human attempts'.

He had another reason for not wishing to leave London at this time. For the third year running, another two Raphael Cartoons – this time *The Healing of the Lame Man* and *Christ's Charge to Peter* – had been brought from Hampton Court and included in the British Institution's Summer Exhibition, and again his pupils had been much in evidence drawing 'largely' from them. 'I feared if I left them now in the very crisis of the struggle the whole thing might cool before I returned.'

That year's crop of copies from the old masters again went on show in December. 'It was putting the young artists to a severe test,' declared *The Times*, 'to place their imitations side by side with such originals', but they emerged, 'not only without disgrace, but with high honour'. Singled out for specific praise were 'those exquisite copies from Raphael's cartoons'[134] by the Landseers, Bewick and Christmas. Haydon set about arranging an exhibition, early in the new year, that would further enhance the reputation of his pupils and himself. The Private Day, held on Saturday 30 January 1819, in the Great Room at 29 St James's Street, was, Haydon declared, 'the most proud . . . perhaps of my life'.

A satirical print, published by Forres of Piccadilly, showed the wide thoroughfare congested with coaches of dignitaries arriving that morning, and St James's Palace visible in the distance silhouetted by the rising sun.[135] A flock of critical geese – one labelled 'catalogue raisonnee' – pecked at the boy holding a placard advertising the exhibition, and one large bird, labelled W.C., attacked the figure of Haydon shown crossing the street. This referred to the connoisseur William Carey, who had questioned whether the public was receiving value for money by being charged a shilling for admis-

sion to a show of just eight chalk drawings, and a further sixpence for a catalogue. Elsewhere the response was favourable. *The Times* was enthusiastic, suggesting that the exhibition's success – despite the austerity of the work on display – was testimony to an improvement in 'general taste and feeling for the higher walk of art'. No concession had been made to popular preference: 'no glare, nothing meretricious to attract, nothing but the purest expressions and the purest forms, conveyed by the simplest methods of imitation; and yet every visitor [had] been delighted, and many . . . expressed themselves in terms of enthusiastic admiration.'[136]

An elaborate fantasy appeared in the *Annals*, probably written by Haydon himself, in which the figure of Envy watched the crowds arriving at 29 St James's Street: 'rank and talent in both Houses of Parliament, most of the Foreign ambassadors, ladies of rank and beauty'. Losing control of his faculties, Envy tottered home, passing a miserable night unable to eat or sleep. In the macabre climax, this embodiment of Haydon's detractors – the Academicians, the connoisseurs, the shadowy authors of the *Catalogue Raisonee*, and the rest – suffers a gruesome fate that is chillingly prescient:

> He got up the next morning; and looking in the glass to shave himself, he saw – ! Haydon's face in the glass, upon his own shoulders! And his lips grew yellow with bile; and his frame trembled, and he took a razor, still keeping his eyes fixed on what he thought was Haydon's countenance in the glass, and he moved it slyly up, and his faculties became blurred, and he gave a sudden gash in hopes of cutting Haydon's throat, and *he cut his own!*[137]

The *Annals* had been keeping its readership abreast of progress on Haydon's picture since the first issue. 'Mr Haydon's grand picture of Christ entering into Jerusalem, is in a great state of forwardness' had been the bulletin then, in July 1816, 'and its completion may be speedily looked for.'[138] The third issue 'expected [it] to be finished in the course of the ensuing year'.[139] The following year, patience was urged: 'Haydon's picture advances to a conclusion. He is complained of by more than one correspondent as slow. Gentlemen, wait, and your complaints will vanish.'[140] In 1818 the picture was confidently described as 'beginning to get to a conclusion'.[141] But later the same year his

failure to deliver was explained by 'a complaint in his eyes, brought on by over anxiety to get his great picture done'.[142] Then, at the end of 1819, came the diffident announcement:

> We are almost afraid to speak of Mr Haydon's picture, having so often anticipated its conclusion . . . but if his eyes and health continue, in the strength they have for the last ten months, it will be finished, and exhibited in the Spring. All the figures are finished, and the back ground is on the point of conclusion.[143]

★

The extraordinary building erected opposite the mouth of Old Bond Street on the south side of Piccadilly, to house William Bullock's collection of natural and ethnological curiosities, had opened its doors to the public in the spring of 1812, as the London Museum.[144] It was designed by Peter Frederick Robinson in an architectural style recalling the 'Egyptomania' that had swept the country following Nelson's victory at the battle of the Nile. The pylon-shaped façade, its sides appearing to slant away from the humdrum verticals of the buildings on either side, made it look taller than it actually was. The entrance was between columns decorated with a papyrus motif, and at the first-

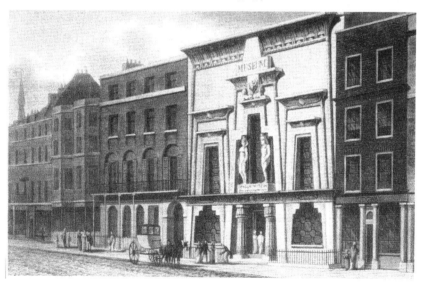

floor level three tapering windows were topped with cornices supported by spread vultures in bas-relief. The taller central window was surmounted by a pair of sphinxes back to back, and flanked by colossal figures: Isis held a lotus blossom, while Osiris, with an *ankh* in one hand, pressed a miniature crocodile to his thigh with the other. Unsurprisingly, Bullock's London Museum soon became known simply as the Egyptian Hall.

Inside was a variety of exhibition rooms. A chamber on the ground floor contained the military carriage of Bonaparte, captured after Waterloo and displayed 'together with the horses of the ex-emperor by which it was drawn; the gold and silver necessaire, his personal wardrobe, diamonds, &c.'[145] The display was visited by approximately 220,000 people. Napoleon's coachman, having had an arm amputated, but otherwise fully recovered from his wounds, was an added attraction. Up the stairs to the right, on the first floor, was the London Museum itself, a vast room in which more than 25,000 examples of natural history – 'including birds, fishes, serpents, shells, fossils and minerals' – competed for the visitors' attention. In the middle, was the so-called 'Pantherion', an enclosure purporting to display stuffed specimens of 'every known quadruped: including the vast camelopard, elephant and rhinoceros and the fierce inhabitants of the woods and deserts of the torrid countries . . . disposed . . . in a forest formed of exact imitations of such trees and plants as are considered the most curious of beauty and rarity'.[146]

But in 1819 Mr Bullock, evidently sensing that the crest of its popularity had passed, sold his entire collection at auction and offered the Egyptian Hall for rent as a suite of exhibition and retail spaces. An advertisement in *The Times* announced that 'the great apartment lately occupied by the Museum is fitted up in a style of corresponding architecture with the exterior of the building, and is probably the finest Egyptian chamber in existence . . . 60 feet in length by 40 in height'.[147] It was to be the setting for the greatest triumph of Haydon's life.

'Take care of your rent!' an anonymous Academician advised Bullock, hearing that he was negotiating with Haydon for the hire of his Great Room at a cost of £300. Bullock later told his tenant he had been so disgusted by the Academician's words that 'even if he had believed such a caution necessary he would have let the room to Haydon at once'. Haydon, of course, did not possess £300. Everything depended

upon the success of his picture and the paying visitors who would come to see it.

The death of George III on 29 January 1820; the succession of George IV; the death of Benjamin West on 11 March – the last historical painter to be President of the Royal Academy in Haydon's lifetime – all passed unremarked in Haydon's journal as he made preparations for his exhibition. The succession of Thomas Lawrence eighteen days later would likewise go unnoted in the euphoria following *Jerusalem*'s triumph. Had it been otherwise, the election of a portrait painter to the Presidency might have been cause for gloomy reflection on changing times and the declining status of historical painting. As he waited for the three Life Guardsmen – his 'favourite factotums' – to carry the canvas from Lisson Grove to the Egyptian Hall, Haydon offered his customary prayers for its success:

> Bless it now it leaves the house this day, bless it when exposed to public view, grant it may keep alive Christian feeling & do good to Christian principles, grant it may meet success & enable me to discharge those debts incurred during its progress, preserve it from fire, accident, & misfortune, & grant my powers may encrease & brighten for still greater works & more extraordinary efforts. Amen, Amen, with all my Soul.

The men arrived, the canvas was taken off its stretcher, rolled and heaved onto their shoulders. They began their two-mile march to Piccadilly.

Upstairs in the Great Room the canvas was unrolled and refastened to its stretcher. Notwithstanding Haydon's faith in divine insurance so earnestly entreated, he was ill with anxiety supervising the raising of the picture to the wall. The Guardsmen were 'nervous as infants'. A sturdy iron ring snapped at the first attempt under the 600-lb weight of the frame. But at last it was 'safely put up, after great effort'. For a week he glazed the canvas, with asphaltum and oil, by the last day working his shoulders and body to utter exhaustion. On the Thursday, two days before the opening, thirty pounds given him by Sir George Beaumont towards exhibition expenses had been spent and the lengths of drugget required for draping the walls

to set off the picture had still not been bought. He went to Coutts's, borrowed another fifty pounds, then on to a warehouse in the City, where he paid for the purple brown stuff he needed and brought it back by coach. Mr Binns, the upholsterer, was then persuaded to employ his entire staff of six women to get the room ready. Haydon promised each a guinea extra and by the Friday night before the Private Day, 'all was sewed, nailed, & the whole Picture ready'. Also displayed were *Joseph and Mary, Dentatus, Macbeth* and *Solomon*, together with a selection of drawings. But it was *Jerusalem* that the customers would each pay a shilling to see when the doors opened to the public on Monday 27 March. It was this, five years in the painting, that the 800 guests he had invited for noon on the Saturday would, he hoped, applaud.

Christ, mounted on an ass, emerged from the crowd. Main foreground individuals were identified and described in the sixpenny *Description*: the good centurion; the Canaanite woman; the anxious mother with her penitent daughter; the penitent daughter's married sister with her little son; Jairus and his daughter, and a prostrate worshipper intended to represent the resurrected Lazarus. Behind Christ's right shoulder was Joseph of Arimathea, behind his outstretched left arm were ranged the faces of Saints John, Peter and Andrew. The crowd was a great mass of individual portraits jostling for attention. On the far right of the canvas stood Voltaire, Newton and Wordsworth. John Keats was further back, talking animatedly with Bewick. William Hazlitt was behind and to the right of St Peter. The face of St John was painted from an American actor, John Howard Payne, who had recounted to Haydon his ill-treatment on the London stage, attributable he thought to the jealousy of English colleagues and malice of the press. 'Sir,' Haydon had replied, 'I regret from my soul the treatment you have met with; I regret it as an Englishman, and I am ashamed of my country. I wish it were in my power to do anything that would make you the slightest amends; but the only way in which I can show my sense of the injustice you have suffered, is to make you the St John in my picture.'[148] The single eyeball peering over Christ's left shoulder was all that remained of a portrait of the engraver and mystic William Sharpe.

Beyond the recognisable, diminishing into barely perceptible figures on the farthest horizon – including one tiny individual

halfway up the trunk of a palm tree – stretched 'a sea of distant people rolling in motion, and united in sentiment'. This crowd, declared the painter, '[was] one of the most imposing and impressive sights in nature'.[149]

In contrast to the painted multitude, the Great Room of the Egyptian Hall just before noon on the Private Day was occupied only by a line of empty chairs and the attendants waiting to receive Haydon's guests. He anticipated the worst. 'Perhaps nobody will come,' he thought and retreated in despair to Hatchett's Coffee Rooms, where he lurked, watching the clock, until half-past twelve. He returned to the Egyptian Hall. Corporal Salmon told him that Sir William Scott had arrived and Haydon's confidence returned. 'That will do,' he said, '[Scott] always goes to every exhibition on earth, and brings everybody.' He went off happily for a good lunch and a couple of glasses of sherry and returned at half-past three to find Piccadilly blocked by carriages. The entrance hall was heaving with servants, 'and all the bustle and chat, and noise and hallooing of coachmen'. Upstairs the room was full. Keats was talking to Hazlitt. Sir George Beaumont, Lord Mulgrave, Prince Hoare – 'all the world of fashion was there'. As he came in he met Lady Murray: 'Why, you have a complete rout,' she told him. The Persian Ambassador entered with his entourage and studied the picture. 'I like the elbow of soldier,' he announced.

The face of the Saviour had given the painter considerable anxiety – it was the seventh version he had painted – and no one quite knew what to make of it. Even Haydon thought it a failure: that he had worked on it too much, that 'when it ought to have looked best it looked worst, and looked well only when the whole picture could not be seen'. But he kept quiet about it. Then Mrs Sarah Siddons, who, it was generally supposed, knew a thing or two about physiognomy, pronounced it 'decidedly successful! and its paleness gives it an awful and supernatural look'. It was a remark that Haydon was at pains to communicate to anybody he thought might be contemplating a notice in the press, immediately dashing off a note to William Jerdon, editor of the *Literary Gazette*, trusting that he would have no objection to mentioning, in his review, that the great tragedienne 'decidedly approved of the Christ's head'. The notice, which appeared the following week, suggested that the face of the Saviour was 'the least

felicitous part of [Mr Haydon's] design', but, in accordance with the painter's request, included a footnote:

> To show what different opinions may exist on this subject, it may suffice to mention that Mrs Siddons (no incompetent judge of the majestic and awful) expressed her decided admiration of the Christ. Quite unlike any other representation of his divinity, it would be astonishing if all connoisseurs agreed upon its character.[150]

The Times expressed the reservations of the gathering before Mrs Siddons's intervention: 'If there is anything to be altered, we would suggest that the head of our Saviour is inferior to the other parts of the picture.' But, with scrupulous fairness, the correspondent balanced his opinion with that of the one person present who 'must be allowed to be an excellent judge of expression' that the face had 'an awful and supernatural air'.[151]

His guest appearance in the crowd did not prevent Hazlitt from expressing reservations in the *Edinburgh Review*. While conceding that 'Mr Haydon is a young artist of great promise, and much ardour and energy' and that his painting had 'carried away universal admiration', that it contained 'bold contrasts, distinct grouping, a vigorous hand and striking conceptions', he nevertheless suggested that the artist had merely 'laid in the groundwork, and raised the scaffolding, of a noble picture'. The critic wanted more: the addition of 'fine gradations' to 'bold contrasts', 'nice inflections' to 'masculine drawing', 'softened and trembling hues' to 'vigorous pencilling', and 'exquisite finishing' to 'massy and prominent grouping'. In short, Hazlitt concluded: 'Mr Haydon has strength: we would wish him to add to it refinement.'[152]

Jerusalem hung in the Great Room of the Egyptian Hall for seven months, during which time it attracted crowds bringing the artist nearly £2,000[153] in admission charges. For five months it even sustained comparison with Théodore Géricault's *Raft of the Medusa*, in the 'Roman Gallery' on the ground floor. But no one came forward with the 3,000 guineas necessary to buy it. Not since the acquisition of Benjamin West's *Christ Healing the Sick* for 3,000 guineas by the Directors of the British Institution in 1811, had so outlandish a sum been demanded, let alone received, by a living

painter for a single work. And it was that precedent which must have been in Haydon's mind when he set the asking price for *Jerusalem*. It was, he considered, barely adequate remuneration for six years' labour. So when a visitor asked Corporal Salmon, on sentry duty in front of the picture, 'if £1,000 would buy it', Salmon answered firmly, 'No.' Clearly no private purchase for the full amount was to be hoped for. Instead, Sir George Beaumont urged his fellow Directors to buy it for the British Institution, but this time the proposal was rejected. *The Times* reported: 'that a public subscription is about to be opened for the purchase of "Christ's Entry into Jerusalem", in order to present it to a church. We hail with pleasure a plan which is calculated to encourage historical painting.'[154] George Philips, MP, and the indefatigable Sir George were responsible for this initiative. They opened an account at Coutts's with ten guineas received from the Earl of Yarmouth, but after three months only £145 19s had been raised.

Nine years later Haydon recalled what he had heard of the would-be patronage of one hesitant aristocrat, identified only by initial. The 'Duke of C' told the 'Hon. Mrs A.P.' that he so admired the picture he was minded 'to get it purchased for a church'. Afraid to commit himself too impulsively, he arranged to meet the Honourable Lady the following day and take another look at the picture. Having studied it again, he declared that he 'thought higher of it than ever'. But a week later they met at a rout and the Hon. Mrs A.P. asked him 'how the picture got on'. His Lordship replied: 'Upon my word, I have heard it so abused by the portrait-painters, I am diffident of my own judgement.'[155]

Undismayed by the doubtful prospects of *Jerusalem*, Haydon ordered another canvas for his next picture, the biggest he would ever complete: *The Raising of Lazarus*. He explained to Mary Mitford, when he showed her his preparatory sketch, how his conception differed from conventional treatments of the subject. 'All the other pictures represent Lazarus as rising from a horizontal position,' she reported to a friend. 'Mr Haydon, following the custom of Jerusalem, where all the tombs were excavations in the rock, and the bodies placed upright, represents him as walking from the hollow in which he had been enclosed, and throwing off the grave-clothes at the command of Christ.'[156] However, he got no further than rubbing in the main lines of the

composition on the fourteen- by twenty-foot canvas before starting work on the more modestly sized and long overdue *Christ's Agony in the Garden* for Mr Philips.

<p style="text-align:center">*</p>

'I have passed the most enchanting fortnight mortal creature ever passed on Earth,' Haydon wrote in September. Mary Hyman, two years a widow, had re-entered his life. He had heard of her husband's death, but – conscious of his 'precarious & dangerous' prospects – made no move towards reviving the relationship. For her part, uncertain of his intentions, Mary had become entangled with 'a fascinating young man, full of light reading', for whom she felt nothing. Her visit to London was a bid to extricate herself from the flirtation. The enchantment began with a carriage stopping in Lisson Grove one evening, a woman's voice asking if he were at home, and her appearance, barely recognised in the dim light thrown by his shaded candle. Exclamations, explanations and declarations followed. Haydon was entranced. The following day they strolled and sat in a sunny Kilburn meadow, and 'disclosed [their] feelings to each other in the tenderest strain'. He lay on his side in the grass, supporting his head on his right hand, looking up at her as she knelt, face shaded by her fringed parasol. It was there, and in that attitude, that he proposed marriage.

For the two weeks they were together the weather was glorious, with light like a Claude painting. One evening they drove around Highgate and Hampstead, entering the Heath just as the sun was setting: 'her divine features shot out into a trembling tenderness of love that made [him] quiver'. He thought it a momentary anticipation 'of a higher state of existence'. There was playfulness as well as transfiguring ecstasy. He laughed while she pretended to shave him with an ivory paperknife. Leaving her for a moment in the painting room, he came back and she was hiding, giggling at the top of his stepladder. He made studies of her for inclusion in his next picture. He painted her while she slept and thought it the best head he had ever sketched. She may even have consented to pose in the nude. 'She is one of those rare creatures,' he observed, 'who think nothing a degradation for the man they love.'

When she returned to Plymouth, he accompanied her in the coach for the first two stages. They spoke little, 'all passed in looks, the tenderest & most piercing'. He stood in the road and watched her out of sight, then walked back to Hounslow and returned to town. She had agreed to marry him whenever he saw fit.

*

In November, following the end of their triumph at the Egyptian Hall, painting and painter reached Scotland by different routes and conveyances: the canvas, rolled up and under the care of Corporal Salmon, by sea from London to the port of Leith aboard the smack *Queen Charlotte*, Haydon by mail coach, departing 'in the midst of crackers and bonfires',[157] during a ferment of popular and political turmoil.

Feelings had been running high in the capital since June, when Caroline Amelia Elizabeth of Brunswick-Wolfenbüttel, formerly Princess of Wales and, since the death of her father-in-law, Queen of Great Britain, returned to assume her rightful position on the throne, beside her estranged husband George IV, regardless of their mutual loathing. She took up residence at the home of her chief adviser, Sir Matthew Wood, in South Audley Street, Mayfair, where crowds would gather each evening to see her appear on the first-floor balcony. Haydon had seen her there and sketched her bulbous form surmounted by ostrich feathers.

For three nights after her arrival in London a state of near-riot prevailed. Mobs went from door to door demanding that residents 'illuminate' in support of the Queen. Households showed their loyalty to this overweight matron by placing candles, lamps and backlit transparencies in their windows. Unilluminated windows were at risk of being smashed with stones by the sentimental throng.

From 17 August, for part of September, throughout October and into November, the House of Lords deliberated on a Bill of Pains and Penalties, intended to grant the King a divorce on the grounds of adultery, allegedly committed by his wife during her five-year absence from the country. Despite salacious rumours of gropings and couplings with her Italian courier – the bewhiskered Bartolomeo Pergami – in various Mediterranean locations, the Queen's attendance at Westminster to

hear the charges against her caused widespread public acclamation. Among the crowd, but unsympathetic to the prevailing mood, Haydon had been disgusted at the temerity of the mob hooting their betters as the Duke of Wellington, and others of the King's faction, rode by. A Tory at heart, Haydon believed that 'the fury of the people for the Queen [was] not from any love of her, but from that innate propensity to seize any opportunity of thwarting, annoying, or mortifying those who by their talents or station enforce obedience'. Approval of Caroline, in short, signalled disapproval of her husband.

On 10 November – the testimony of sundry disreputable foreigners concerning sleeping arrangements and stained bed linen having being discredited – the 'Bill of Pains and Penalties' was withdrawn. News of the Queen's triumph brought the London crowds back onto the streets to demonstrate their loyalty with rattles, horns and firecrackers, and with stones for unilluminated windows. Loyal houses blazed with ever more elaborate transparencies: 'Carolina Regina', 'Virtue & Innocence Triumphant', 'Caroline in spite of them, still Regina!', 'May the blossoms of Liberty never be blighted / Or a virtuous woman ever be slighted.' Haydon and the three other gentlemen who shared the northbound coach remained silent passing through the London crowds, keeping their opinions to themselves, until they passed an apothecary's shop decorated with a transparency reading: '**INJURED INNOCENCE!**' It was the catalyst for furious debate between the four men, upon this most urgent topic of the time, as their vehicle rattled on into the night.

They probably left London on 12 November, this being the second night of 'illuminations' and festivity. The coach would have reached York thirty hours later on the night of the 13th. Spending two days in York, and taking the opportunity there to visit Castle Howard, Haydon departed for Edinburgh on the evening of the 15th, reaching his destination late the following day. He passed his first night in a Princes Street hotel, finding rooms, the following morning, in a lodging house on the corner of Princes Street and Hanover Street. It was run by a Mrs Farquharson: 'capital specimen of an old Scotch housewife . . . – talkative, shrewd, cunning, saving, full of capital sayings, and always, under every disguise of religion, affection, or respect, keeping her eye on the main chance'. She advised him what to be on his guard against in the town, 'as a "puir body frae the south" who knew nothing

and must be taken care of by a gude housewife experienced in the ways of the wicked world'. But even the canny Mrs Farquharson was unprepared for the turbulent events of Haydon's second night in Edinburgh.

From Princes Street that morning he went to Leith and watched as the *Queen Charlotte* sailed into the harbour, his canvas safely stowed below, his man Salmon waving his hat from the deck.

The picture was to be displayed in the Great Room of William Bruce & Co., auctioneers, at the Regent Bridge, Waterloo Place, 'with much greater advantages of light and situation', declared *Blackwood's Magazine*, 'than it ever enjoyed in London.'[158]

John Gibson Lockhart and John Wilson, the *Blackwood* editors, were not known for their admiration of anything connected with or coming from 'Cockaigne',[159] as they called the cockney capital. Over the previous three years Wilson and Lockhart had published a coruscating series of articles denouncing 'The Cockney School of Poetry'.[160] Aimed primarily at Leigh Hunt and Keats, the journalistic assault was said to have hastened the younger poet's death: 'snuffed out by an Article',[161] as Byron jeered. Slighting reference had also been made to Haydon as 'the Cockney Raphael'[162] who 'as little resemble[d] Raphael in genius as he d[id] in person, notwithstanding the foppery of having his hair curled over his shoulders in the old Italian fashion'.[163] Two years later, however, the *Blackwood* editors were uncharacteristically free with their praise of both painter and picture: 'It is quite evident, that Mr Haydon is already by far the greatest historical painter that England has yet produced. *In time*, those that have observed this masterpiece, can have no doubt he may take his place by the side of the very greatest painters of Italy.'[164] Support for the 'Cockney Raphael' might have been explained by the fact that Lockhart's father-in-law, Sir Walter Scott, had become acquainted with Haydon earlier in the year, had seen and approved of the painting while it was at the Egyptian Hall, and had probably planted the suggestion in the Englishman's mind that he should bring the canvas to Scotland. Haydon's first social call in Edinburgh accordingly took him just a short walk along Princes Street from Mrs Farquharson's to 39 Castle Street. He heard the great man stamping his polio-wasted leg downstairs. Leaning over the first landing, the 'author of *Waverley*' brandished his stick: 'Hurrah! Welcome to

Scotland, Haydon.' And at the bottom of the stairs he vigorously shook the visitor's hand.

'How d'ye like Edinburgh?'

'It is the dream of a great genius!' Haydon replied.

This was a remark that he had probably been rehearsing in his mind since the first view, from his hotel window, of 'the castle and the old town right opposite, enveloped in the sunny mist of morning'. He used a variant in the letter to Mary Mitford, containing a fuller account of his first impressions:

> The two towns, old and new, are built on two ridges, which are joined by land bridges . . . Some streets run over others, and afford beautiful combinations quite surprising. Towers, arches, houses, streets, bridges, rocks, castles, and craggy hills are tumbled together in a wildness and profusion of contrast and daring beauty, that render the whole town like *a wild dream of some genius*.[165]

The remark was well received: 'Well done!' boomed Scott, 'when will ye dine with me?'

Handbills began appearing on the morning of 17 November, instigated by mischievous elements of the Edinburgh citizenry, calling upon all inhabitants to 'illuminate' in support of Queen Caroline. The Lord Provost, the Sheriff and magistrates, apprehensive of riot, issued a proclamation urging abstention from all such 'illumination' and promising to 'maintain the public peace . . . against all attempts to disturb it, by employing for that purpose the civil and military force which the law placed at their disposal'.[166] The proclamation was to be in vain, the apprehension entirely justified.

On Friday night, inflamed by the handbill campaign, the mob descended from the narrow wynds of the Old Town onto the spacious squares, crescents and streets of the New. The Lord Provost's house in Abercromby Place was attacked and all its windows smashed. Unilluminated houses at the end of Leith Walk, on Princes Street, Hanover Street and York Place shared the same fate. Haydon was asleep in his room at 1 Hanover Street when the gravity of the situation was communicated to him in startling fashion: Mrs Farquharson thumping on his door and screaming at him to 'Light up!' He grabbed the lighted candle from her, but before he could put it in the window

the first stone struck, scattering broken glass on the floor. 'The shout of the crowd was savage.' He put the candle against the window, but the flame was extinguished by the draft from the broken pane and more stones were thrown. Mrs Farquharson screamed 'for her drawing room glass'. Haydon was just able to close the wooden shutters before every other pane of glass in his bedroom and the rest of the house was destroyed. According to *The Times*, there was 'scarcely a house in Hanover Street but bore marks of popular vengeance'.[167] Haydon was shaken, but impressed. It had been 'certainly a more ferocious crowd than a London one'.

The public who came to view his crowded canvas of *Jerusalem* at Mr Bruce's Great Room were, by contrast, deeply respectful and he was amazed at 'the enthusiasm of the Scotch . . . and even their awe'. On one occasion he came into the hushed exhibition room with his hat on, and 'a venerable Scotchman' came over and whispered: 'I think you should take your hat off in sic' an awfu' presence.'

A 'Sonnet to Haydon' was published in the February 1821 issue of *Blackwood's*. It was signed Δ – the Greek character 'Delta' – a pseudonym adopted by one of the magazine's regular contributors, Dr David Macbeth Moir of Musselburgh:

> Genius immortal, industry untired,
>> The power and the capacity of thought
>> Sublime, to mighty aspirations wrought,
> Are thine, by thirst of great achievement fired.
> I need not tell thee, Haydon, thou hast felt
>> The fears, the ecstasies of daring art,
>> The heavings, and the sinkings of the heart,
> At obstacles that oft like vapours melt,
> And oft like rocks oppose us. It is thine,
>> After a warfare silent, but most deep,
>> To triumph and o'ercome: thy name shall shine
> In fame's unfading record, – like a river,
> That having toil'd o'er rocks, is left to sleep
>> 'Mid everlasting hills, and gleam for ever!

Haydon's Edinburgh triumph stayed in the memory of less articulate Scots than the sophisticated bard of Musselburgh. The painter liked

to recount a story, told to him by a friend who had been on a sketching expedition in the Highlands the following year. While he was at work on a drawing, 'a poor Highland woman crept out of a mud hut near him' and the following exchange occurred:

'Ar' ye fond of pectures?' she asked.

'Yes.'

'Did ye see a pecture at Edinburgh, of Christ coming into Jerusalem?'

'I did.'

'Yon *was* a pecture!' said the woman: 'I went to see it, and when I came in all the lads & lassies had their bonnets off, and I just took off mine and sat me *dune* and *grat!*'

He left Edinburgh for Glasgow in the first week of December, staying only long enough to secure an exhibition room for his picture. He then travelled south, overnight to Carlisle, cheering with the other English passengers as the coach crossed the border at Gretna Green. He stopped in Keswick to spend a day with Southey, before travelling on to Ambleside and calling on Wordsworth. He stopped in Kendal, where he fell in with 'a little, active, pot bellied, turn up nosed, & healthy dog' who 'hated the French – loved the King, thought the Queen a whore – but . . . would be damned if any Woman should [be] ill used, whore or no whore'.

The popular reception of Haydon's picture in London and Edinburgh made of 1820, by his own assessment, 'the most glorious Year of my life'. The three-month exhibition at Mr Bruce's Great Room brought him £500 in admission charges and *Description* sales. A further £400 was earned in Glasgow. The total sum, with the London takings, of nearly £3,000, however, would be quickly swallowed in satisfaction of the debts incurred during the five years it had taken him to complete the painting.

He hurried back to London to finish *Christ's Agony in the Garden*, Mr George Philips's picture, for which he had already long since been paid in full. Writing anonymously in the *London Magazine*, Hazlitt judged the new work 'a comparative failure'. It was not merely because of certain infelicities of composition, such as the main figure of Christ 'thrown in one corner . . . like a lay figure in a painter's room'. The problem was more a matter of scale:

[The picture] is inferior in size to those that Mr Haydon has of late years painted, and is so far a falling-off. It does not fill a given *stipulated* space in the world's eye. It does not occupy one side of a great room. It is the Iliad in a nutshell. It is only twelve feet by nine, instead

of nineteen by sixteen; and that circumstance tells against it with the unenlightened many, and with the judicious few. One great merit of Mr Haydon's pictures is their size. Reduce him within narrow limits, and you cut off half his resources. His genius is gigantic. He is of the race of Brobdignag, and not of Lilliput . . . He bestrides his art like a Colossus. The more you give him to do, the better he does it . . . Vastness does not confound him, difficulty rouses him, impossibility is the element in which he glories.[168]

Haydon himself, in an all-too-rare outburst of self-deprecation, considered it far from his best work: 'The very desire to make a noble return cramped my feelings; and except the Christ's head and the St John sleeping it was the worst picture ever escaped from my pencil.'

PART FOUR

KING'S BENCH, KING'S PATRONAGE

1821–30

On the morning of Haydon's first arrest for debt, 22 June 1821, a Sheriff's Officer waited in the painting room while his charge shaved. The twenty-foot-long, fourteen-foot-high stretched canvas stood on its easel, as yet some two years short of completion, but with the main outlines of the composition established.[1]

The ten-foot central figure of Christ stood in profile, his right arm raised in a beckoning gesture: 'Lazarus, come forth!' Kneeling to his left and right were the dead man's sisters, Martha and Mary. Behind Martha stood St John hands clasped and bending forward. Behind St John, St Peter recoiled, with hand to forehead. In the space between the two main protagonists, Lazarus's mother moved forward to embrace her son while her husband kept her back, as though urging caution. Behind Christ was a pair of Jewish priests: the Pharisee watching the miracle 'with spite and doubt', the Sadducee turning away his head 'as if in joke and contempt'.[2] In the top right corner was a cluster of figures: a woman carrying water, an old woman exhorting her young companion not to grieve, a man giving thanks, his eldest son pointing, the younger clinging in alarm to his father's robe. Slightly apart from the others, and at a safe distance from the main action, a young man peered intently from behind a rock. In the foreground, the first grave-opener fell back in consternation, while the second, one hand clapped across his eyes, the other stretched, open-palmed in front, like a rugby player clearing a passage, made to flee the scene in a blind, crouching rush. The dynamic focus of all this attention and repulsion stood at the far left of the canvas, framed in the entrance of the tomb: four-days-dead Lazarus pulled aside the shroud from his face to stare directly at his Redeemer.

It is not known how long the Sheriff's Officer waited in that baleful

presence, but by the time Haydon returned from his ablutions he found the superstitious functionary a changed man. 'My God, Sir, I won't take *you*,' he said, greatly shaken by his solitary communion with the picture. 'Give me your word to meet me at twelve at the Attorney's, & I will take it.'

The debt had been called in by a tradesman to whom Haydon had already paid £300 for fitting out one of his rooms, but who – 'out of pique' because his client had subsequently patronised another tradesman – was demanding the balance of his money.

At midday Haydon was able to convince the Attorney of 'the gross injustice of the proceeding'. The Sheriff's Officer, most recent enthusiast for the power of historical painting, needed no convincing, claiming 'he'd be damned if he did not see through [the tradesman's claim] from the beginning'. Having received an assurance that matters would be arranged by the evening, the Attorney ordered that the painter should remain in the Officer's custody until then. 'Not *he*,' said the man who had gazed on the most awesome of Christ's miracles earlier in the day, 'let him give me his word & I'll take it, [even if] I am liable to pay the debt.'

The balance of the tradesman's bill was raised by the painter, together with eleven pounds to the Attorney and three pounds to the Sheriff's Officer, and all was paid by nightfall. While waiting in the Officer's parlour, a document lying on the man's mantelpiece caught Haydon's eye. It was a peremptory demand for taxes and gave rise to a meditation upon the circuitous economics of debt:

> With the £3 . . . paid him . . . he pays his tax gatherer, who is then paid for getting the tax, out of the very money I paid him for violating the law, which he, the Sheriff is paid to enforce.

From the Officer's house, Haydon walked to Lord Grosvenor's and entered 'a room full of lovely women, splendid furniture, exquisite Pictures'. There he met Sir George Beaumont, who insisted that he come back to see his latest pictures. That night Haydon found himself walking back across Grosvenor Square with Sir George's servant – sent to escort him on his way – 'the servant of a man of high rank at my heels, as grandly as a Bashaw, after having had a bailiff two hours before!' He arrived home to find the son of an old friend of

his father's waiting for him. The young man had lost a situation, come to town by coach and been forced to leave his trunk as surety for the fare. Haydon lent him what he could spare to liberate the luggage – 'little enough, God knows,' he admitted, '& away he walked as happy as I did from the Sheriff'.

Less than a month after his arrest Haydon was a participant in the most ostentatious display of profligate wealth in British history: the Coronation of George IV on 19 July 1821. The black and red ticket – eight inches by five, embossed and emblazoned with roses, shamrocks, thistles, oak branches, leaves and acorns, and surmounted by the Royal Crown irradiated – arrived only the day before, leaving him a bare afternoon to make his preparations. He rushed from friend to friend collecting formal paraphernalia: Sir George Beaumont lent him ruffles and frill, someone else lent a blue velvet coat and another a sword. He bought his own buckles. He went to bed at ten o'clock the evening before, only to rise at midnight. Holders of tickets to Westminster Hall who had not occupied their seats by seven o'clock in the morning would be refused admittance and Haydon took no chances. Joining the queue in New Palace Yard at half-past one, he found only three ladies in front of him. At four he was allowed to take his place in the lower of two galleries on the east side, between the door and the throne, and from there he had an uninterrupted view of the entire glorious, tawdry, at times shoddy, spectacle. Some of the attendants were already drunk. Famous stars of 'The Fancy' – the pugilists Tom Cribb, Bill 'The Black Terror' Richmond, Jack Randall and 'Gentleman' John Jackson – had been recruited as doorkeepers 'for the more effectual maintenance of order', as The Times put it, 'employing avowed peace breakers to keep the peace'.[3] The King himself was not due to arrive until ten o'clock, and so Haydon had ample time to observe the gradual filling of the Hall below with Ushers, Heralds, Pursuivants, Yeomen of the Guard, Gentlemen Pensioners, attendants in mulberry-coloured frock coats, ruffs and white sashes carrying wands, the sixteen Barons of the Cinque Ports who were to escort the King's canopy, the King's Herb Woman and her six maids in white muslin and flowers, King's sergeants, Knights of the Bath, Knights Commanders of the Bath, judges, privy councillors, viscounts, earls, marquises, dukes, bishops, archbishops and minor members of the royal family.

Among the crowds gathered outside there was consternation, around six o'clock, at the arrival of the King's estranged wife, Queen Caroline, looking 'like a blowsy Landlady',[4] as William Offley told Joseph Farington. Refused entry to the Abbey for the Coronation ceremony, she had had herself driven over to Westminster Hall accompanied by Lord Hood, and 'the faithful companions of her affliction', Lady Hood and Lady Anne Hamilton. There were cries from the crowd of 'Shame, Shame!', 'Off, Off!', and but a few of 'Queen'. *The Times*, however, reported general acclamation with only an occasional dissenting hiss. The Hall was 'barricaded as against a hostile power'[5] by the time she arrived. Her 'raging and storming and vociferating'[6] demands to enter were politely but implacably refused by the officers on guard, backed by the hired pugilists, and the door was slammed in her face. Ordering the top of her carriage lowered to show herself, and 'amid the astonishment and acclamations of the people' and some shouts of 'Shame' and 'Go away',[7] she was driven home to Brandenburgh House where, less than three weeks later, she was to die from a blockage of the bowel.

The feared civil disorder in her support did not, after all, take place and the Coronation proceeded without disruption, but 'the attempt of the Queen agitated the Hall,' Haydon reported. It was a hot day and the atmosphere inside – exacerbated by the warmth of more than 3,500[8] overdressed human bodies – was not relieved by twenty-six enormous chandeliers blazing level with the highest tiers of seating and dripping wax onto the people below. 'The superb dresses of the peers and peeresses were spoiled by the profuse globules [and] if a lovely female dared to raise her look to discover from what quarter the unwelcome visitation came, she was certain of receiving an additional patch upon her cheeks.'[9]

Haydon had been in his seat for six hours when, at ten o'clock, the excitement reached its climax, his journal entry rendered immediate by the present tense:

A whisper of mystery turns all eyes to the throne! . . . Something rustles, and a being buried in satin, feathers, & diamonds rolls gracefully into his seat. The room rises with a sort of feathered, silken thunder! Plumes wave, eyes sparkle, glasses are out, mouths smile, and one man becomes the prime object of attraction to thousands!

Beneath a black hat encircled with white ostrich feathers and surmounted by a black heron's plume, beneath the chains of the Golden Fleece, the Guelphic Order, the Order of the Bath and the Order of the Garter, the King was 'habited in full robes of great size and richness', his twenty-seven-foot train supported by eight, instead of the customary six, Eldest Sons of Peers. Of the unprecedented £238,000 that the entire Coronation is estimated to have cost, £24,704 8s 10d was spent on the King's costume alone, so heavy with ermine, velvet, brocade and gold encrustation that the feeble, corpulent, tightly corseted monarch nearly fainted several times under its weight and heat. The procession, led by the Herb Woman and her maids, moved slowly down the length of the Hall and onto a fifteen-foot-wide walkway outside, which snaked a passage, lined with soldiers, through New Palace Yard, along the edge of St Margaret's Churchyard and into the Abbey. The King waddled beneath a canopy of straw-coloured silk embroidered in gold and was twice heard to hiss instruction at the eight Eldest Sons of Peers carrying his train to 'Hold it wider!'[10]

Haydon's ticket only secured him a seat in the Hall and so there was a long wait until the next instalment of ceremonial. In the meantime he could watch the setting of the tables for the banquet, three along each side. By two o'clock the silver plates and cold meats for the 336 guests had been laid out, but it was not until after three-thirty in the afternoon that the doors were thrown open to admit the returning procession, led by the flower girls and culminating in the crowned King bearing the orb and sceptre under his golden canopy. The thought occurred to Haydon that even the Queen's embarrassing intervention, on such an occasion, had served a useful purpose: that 'if mortality did not occasionally hold up his mirror . . . such unparalleled beauty & splendour would drive [any human being] mad'.

After the first dishes were brought in, to the blast of trumpets and clarions, the Duke of Wellington, the Marquis of Anglesey and Lord Effingham entered on horseback and rode to the bottom of the steps leading up to the throne. At this point Anglesey, as Lord High Steward, was supposed to dismount and uncover the dishes on the royal table. Unfortunately, the celebrated casualty of Waterloo, who used two types of artificial limb – depending on whether he was riding or walking – was unable to quit his horse with ease as he had not his walking leg with him. There was an awkward pause as he was helped

down by pages and propped up to fulfil his office, before being heaved back into the saddle. Anglesey's problems that day were not over. The obligation of a courtier never to turn his back upon the sovereign presented difficulties when the courtier was on horseback. While no man was more capable of backing a horse the length of Westminster Hall than his Grace the Duke of Wellington, the Marquis of Anglesey was less able and his horse became restive. Haydon thought Wellington showed irritation, suspecting his old comrade-in-arms of trying to attract attention to himself.

To another blast of trumpets, the doors were thrown open to reveal the King's Champion, a mounted figure in full dark armour. A herald read out the proclamation:

> If any person of what degree soever, high or low, shall deny or gainsay our Sovereign Lord King George the Fourth . . . to be right heir to the Imperial Crown of this United Kingdom . . . here is his Champion, who saith that he lieth, and is a false traitor, being ready in person to combat with him.[11]

The armoured figure threw down his gauntlet. Traditionally, had anyone taken up the challenge and engaged him in combat, the Champion – if he survived – would have been allowed to keep both the horse and armour. On this occasion, there being no response to the proclamation, the gauntlet was returned. Further down the length of the Hall, the herald's proclamation was reiterated, the gauntlet thrown down again, and again returned. For a third time this ritual was repeated, and at last the King presented a goblet of wine to his Champion, who proposed and drank his Majesty's health. The boyish treble of the Champion's single utterance somewhat spoilt the effect and Sir Walter Scott felt that young Dymock had 'a little too much the appearance of the maiden-knight to be the challenger of the world on the King's behalf'.[12] Haydon, however, considered the ceremony of the Champion to be 'the finest sight of the day'.

After the departure of the King and nobility, the spectators fell to looting: 'baskets, flower pots, vases, and figures were everywhere disappearing, and those were followed by glasses, knives and forks, salt spoons, and, finally, the plates and dishes'.[13] Haydon made no mention of this, but, late that evening, as he walked home through the dispersing

London crowds, resplendent in his blue velvet coat, his ruffles, frills and buckles and with his sword at his side, he amused himself by muttering a phrase of Horace: *Odi profanum vulgus* – 'I hate the common herd'.

<p style="text-align:center">★</p>

Mary Hyman had been in London for the Coronation and she and Haydon visited the Star and Garter in Richmond. They sat by an open window watching the sun set: 'I turned my head back & looked up,' he wrote, 'a face hanging over me, full, rosy, smiling & devoted! that pressed my lip with inside kisses ripened! amorous & moist!' They scratched their initials into the pane with a diamond. Later that year, on 10 October 1821, they were married at the new Church of St Mary le Bone, in what is now Marylebone Road. Haydon's bride combined: 'the simplicity of a child, the passion of an Italian Woman, joined to the wholesome tenderness & fidelity of an English one'. Miss Mitford believed her to be Jewish, and Hazlitt thought she 'might sit for the portrait of Rebecca in *Ivanhoe*'.[14] Mary was not an educated woman and 'could hardly spell her own name' when Haydon married her. She had an annual income of £52 10s, the interest on £1,000 settled on her by the will of her first husband: a meagre compensation for the financial burden on her second husband of her two young sons, Orlando and Simon. Lord Mulgrave thought that a man of Haydon's 'force & manner' could have had anyone and that he had 'let himself down'. His disapproval may have been as much to do with Mary being a Jewess as with her lack of education and fortune, although, of course, a substantial dowry would have offset that social disadvantage.

In the first flush of love for his 'dearest Mary' Haydon produced a painting called *Cupid Cruising*. It was described by the *Scotsman* as 'a *bit* for the *connoisseur*'[15] and showed the diminutive god sailing a nautilus shell equipped with a narwhal horn for a mast, a yard-arm made from his bow and using an arrow for the tiller. Haydon sold the painting in Edinburgh, but presented Mary with a sketch of the composition, which she kept on her dressing table.

The morning after celebrating his recent nuptials in the company of David Wilkie, Haydon was arrested for a second time.[16] 'Have you no Friend, sir?' the Sheriff's Officer asked.

'Certainly,' Haydon replied, thinking of the previous evening spent with Wilkie, dining and drinking to the success of his marriage. And to Wilkie's he was driven in the Officer's gig. The reception was frosty.

'I thought it would come to this,' Wilkie said, expressing great unwillingness to stand surety alone. It was only when Haydon promised to persuade Perkins, his former landlord, and other friends to share the obligation, only when he promised to 'use every exertion to raise the money to discharge the debt',[17] that Wilkie grudgingly signed his name to the bond.

Later that day he received a letter from Haydon, 'a dreadful torrent of sarcasm and truth', upbraiding him for his unfriendly behaviour. As the letter made no mention of finding another guarantor, Wilkie visited Perkins and was told that he had been out when Haydon called, but even had he been in, 'he could not bail for him'.[18] Finding himself saddled with sole liability for his friend's debt, Wilkie considered 'giving up his acquaintance'. How long it took to discharge the debt and destroy the bond as promised is not known, but within four days Haydon had left London for Edinburgh to exhibit *Christ's Agony in the Garden* at Bruce's Rooms[19]. The exhibition had incurred a loss of £166 in London, but it fared little better in Scotland, with receipts of £271 9s swamped by expenses of £371 3s 10d. It would be another two years before Haydon met Wilkie again, and the two men's demeanour on that occasion would be 'cold & mutually mistrustful'.

The arrests became more frequent, and it was while Bewick was sitting for the face and figure of Lazarus that the third came in a single day. The young man was maintaining a tottering pose, 'seated upon a box, placed upon a chair upon a table, mounted up as high as the head in the picture', when Haydon was called from his painting room to receive the unwelcome visitor. Presenting him with an execution by the firm of Smith & Warner, colourmen of Piccadilly, the Sheriff's Officer seemed to respect the painter, if only for not pretending he was someone else or sending word that he was away from home. He flattered Haydon by honourable comparison with no less a debtor than the President of the Royal Academy: '*Sir Thomas Lawrence makes a point never to be denied.*'

Sending him away with a letter requesting bail from Perkins and arranging to meet him again in the evening, Haydon hurried back to his painting room and his precariously placed Bewick. Picking up his

palette and brush and mounting his high stepladder, he turned to his model: 'Egad, Bewick! I have just been arrested: that is the *third* time; if they come again, I shall not be able to go on.' But he soon became absorbed in his work and, when he had got in the head, exclaimed 'I've hit it now! – I've hit it!' By the time the face, two hands and the drapery were finished, both painter and model were exhausted. They were 'all painted at once,' Bewick recalled, 'in one day, and never touched afterwards, but left as struck off . . . never . . . even "softened"'.[20]

At the beginning of May 1822, Mary Haydon discovered she was pregnant. Their son, born the following December, would be the first of eight children, five dying in infancy. Meanwhile, work progressed on *Lazarus*. The study Haydon made for Christ's left hand, from his pupil William Harvey, he thought 'the most perfect drawing [he] ever did'.[21] His washerwoman gave him the face for Lazarus's mother, and during one sitting the old lady made the rather incongruous remark that it was 'better to bear the difficulties than the reproaches of this world'. The beautiful face at the far right of the composition was Mary's. There were other interruptions. He was able to negotiate a week's respite from a threatened execution for unpaid rent from Rossi, his landlord, only for another to be threatened after a fortnight. Rossi was neither as patient nor as understanding as Perkins, and although conceding the sculptor to be a man with a large family, and feeling for his wants, Haydon nevertheless thought himself unjustly treated, having been 'always regular for the first 4 years'.

By the end of September he had completed all the figures in the composition of *Lazarus*. One of them, the youth looking over the rocks to the left of the corner group, was executed in one day. 'This is the way the old Masters used to do,' he thought, 'and the rapidity of their application is the great reason why their figures all look to hang together so well.' In November the Sheriff's Officer and a sedate little bailiff arrived to serve an execution from Evans & Co., chemists. Leaving the bailiff in sole possession of his painting room, Haydon went and confronted the 'miserable apothecary', asking if this was 'manly', in view of his wife's condition. Evidently ashamed, Mr Evans accompanied him to the Attorney. The Attorney told them that the Sheriff's Officer had 'exceeded his instructions' and wrote him a letter that Haydon delivered. The Officer duly signed a release from the

execution and, in parting, said: 'I hope, Mr Haydon, you will give me an order to see your Picture when it comes out.' Hurrying home, he found the bailiff still sitting by the fire 'lost in contemplation of Lazarus'. While Haydon had been out arguing his case, some ladies and gentlemen had called to see the picture, and the bailiff made clear that he had exercised discretion and not betrayed the reason for his presence, assuring the painter 'he knew how to behave'. He congratulated Haydon on getting rid of the execution and he also hoped that, when the picture 'came out', he might be allowed to bring his wife to see it.

It was finished by the time Mary went into labour. On 12 December, Charles Heathcote Tatham, architect and collector of classical antiques, was in Haydon's painting room; Mrs Tatham, who had borne fourteen children, was with Mary, while Haydon himself sat on the stairs listening to his wife's moaning. At a quarter past eleven in the morning the moans turned into a 'dull, throttled scream of agony', followed by silence. Then there was 'a puling, peaked cry'. Mrs Tatham emerged from the bedroom with the news: 'It's a boy!' At first he was to be named Benjamin Robert, but this was scratched out in the journal entry and 'Frank' substituted. Haydon prayed that he might 'make a greater man than his Father'. Six years later, on 13 July 1829, neither Sir Walter Scott nor Miss Mitford, his godparents, were present when 'Frank Scott Haydon' was baptised and christened. A parish clerk and pew opener acted as proxies.

In early February 1823 *Lazarus* was rolled and transported to the Egyptian Hall. Salmon superintended the move and Haydon was aware of the contrast with his anxieties of fourteen years previously, when he had accompanied the porters carrying *Dentatus* along the Strand to Somerset House. This time he left it to his servant '& walked coolly away', even though, with a wife, two stepchildren and a new-born baby to support, more depended upon *Lazarus* than on any of his previous pictures.

At first it was hung in the west corner of the room, where it had a dark, brooding look that frightened Salmon. The following day it was moved to the opposite wall and, in a southern light, the colours brightened, 'the workman exclaimed', the artist himself 'trembled'. With the light fixed and the other windows darkened, and having fortified his resolve with prayers on the Sunday, Haydon began to

glaze the giant canvas. By the end of the Monday his arm ached from the labour, but he had adjusted the tones in the six figures to the right of Christ. The following day he glazed Christ's drapery with crimson madder and cooled the background with 'black over green, & then asphaltum worked in with tones of lake & brown pink'. On the Wednesday he glazed the figures of the father and mother, the sky and the rocks. The following day he finished Lazarus, part of Mary and the figure group in the top right corner. There was 'no delight on Earth in Art equal to that of bringing a Picture into tone,' he declared. '[It] makes one's soul utter musical notes.' Nevertheless, by the end of that Thursday his 'optic nerve aked with pressing pains'. The glazing finished, he had a clear fortnight before the opening of his exhibition, to ponder his next great work – *The Crucifixion* – and to spend time with his wife and little son. He was convinced the baby was developing a taste for art because he would 'look at nothing but Pictures & busts'.

During the last week of February, as he prepared for the opening of his exhibition, he communicated a sudden pang of intense anxiety to his God and his journal. The cause, it seemed, was a particularly voracious creditor:

> I am in the clutches of a villain; grant me the power entirely to get out of them, for Jesus Christ's sake. Amen. And subdue the evil dispositions of that villain, so that I may extricate myself from his power, without getting further into it.

Despite his fears, the Private Day passed without threat of execution or anything else untoward. It was not, however, as triumphant as that of *Jerusalem* in the same room, just three years before. When the exhibition opened to the public, in rain and wind, on the Monday morning it 'succeeded very well for such weather'. The following day receipts doubled and it 'made the greatest impression'. But the next day, although the 'impression' continued, Haydon was forced to admit it 'had not made the sudden burst the other did'. Nevertheless, he remained confident it would 'grow into a swell by time' and prayed for 'gratitude and patience'.

Notices were favourable, *The Times* considering it 'the best of his works' and the face of Lazarus 'one of the very finest objects . . . both

as to design and execution'[22] that the correspondent had ever seen. The *Observer* devoted three columns to the picture, illustrated with a line engraving. The Government was urged to purchase it for the nation and thereby support with its patronage the history painter who, otherwise, must rely on the shillings paid at the door by members of the fickle public. Haydon's success thus far was 'a matter of speculation', the perceptive writer warned:

> . . . a cow with two heads, or a giant without one are very likely to divide the attention of his patrons; and we will venture to say, if any man were this week to arrive from abroad with a bit of the North Pole, or the very stone with which David killed Goliath . . . Lazarus might soon glare unnoticed at the drugget and chairs . . . So far Mr Haydon is safe. No wonder greater than his own has sprung up to divide the attention of the town.[23]

There would come a day when the town's attention would indeed be divided, not by a giant, but by a dwarf, and the chairs and drugget would remain in sole communion with Haydon's last exhibition.

<center>★</center>

A week after the Private Day he began work on the *Crucifixion*. Nothing survives beyond sketches in his journal, but from these it is clear that Haydon's composition was to have been truly epic and painted on a canvas about the same size as *Lazarus*. At either extremity only the horizontals of the thieves' crosses were to be seen, focusing attention on the central cross bearing the body of Christ. One study showed the Magdalen entwined around the base of the cross, kissing the Saviour's feet. To the right a group of women supported the collapsed figure of Christ's mother. On the left a soldier raised a sponge on the end of a spear, while the Centurion struggled to control his frightened horse. In the background crowds fell to their knees, horses reared, clouds loomed.

The last day of March was, Haydon believed, the crisis point of his exhibition: 'had it failed today it would have sunk,' he wrote in his journal. He told Salmon he would give him a guinea if there were 500 visitors, and the servant returned home 'tipsy with glee' bringing

receipts of £31 11s. The first day of April was almost as successful, with receipts of £31 5s 6d. A week later his creditors were becoming restless. Any one of them visiting the Egyptian Hall, and seeing 'the crowds of people and the piles of shillings pouring in', would have good grounds for wondering when so successful an artist might settle his account. On 9 April, Haydon argued 'to no purpose' with a creditor, leaving the man angry while he himself distracted his mind on the way home by composing the light and shade for the *Crucifixion* and deciding it would be a good idea to put a piebald horse somewhere in the composition. Then, after reading a few threatening letters from his creditors' legal representatives, he 'made a very good sketch' and declared it 'a pity . . . that [he] should be so harassed'.

By early May he had got in one side of the picture. Two days later he rubbed in the Good Centurion. He had had half a dozen meetings arranged to try to settle his financial affairs, but broke them to go on painting. On another afternoon he was going out on such business when he was drawn back to his canvas, 'put on [his painting] jacket & set to at the background immediately and never ceased till dinner'. He expected two executions the following day and felt 'piercing twinges of the consequences' as he worked.

Three days later he called into the Egyptian Hall and found a Sheriff's Officer standing guard over *Lazarus*. An execution had been enforced and the great heavy-framed canvas, still hanging in its sublime southern light, was no longer his to sell. Executions on *Jerusalem*, and the other pictures hanging in the same room,[24] and on the contents of 22 Lisson Grove followed. Two broker's men moved in and bivouacked in the painting room to ensure nothing of the property was removed before the inevitable insolvency sale. 'Such scenes in the House,' Haydon wrote afterwards to Walter Scott:

> Reptiles, intoxicated with tobacco & beer . . . My painting room, where none but rank & talent had ever trod, was now stenched with the sleeping heat of low-lived beasts, slumbering in blankets! At the foot of the *Crucifixion*.[25]

These were the cheerfully corrupt minor functionaries of any and every age. They even offered him a deal. 'Why don't you clear the House,' they said to him, 'lock us up in the Plaster Room, give us

Wine – we won't hear a [sound]!'[26] But Haydon declined and they
took their refreshment anyway: 'drank my wine,' he raged, '. . . plun-
dered the property they were protecting; . . . quarrelled with the
servants!'[27] At one point his patience snapped and he came close to
making matters worse:

> That night in a fit of fury as they were admiring a Portrait of my Wife
> I rushed in with a knife & cut it out before their faces – had they uttered
> a syllable I would have cut out their heart strings.

Eventually, early one morning, after a night nursing their baby son
through a fever, Mary sleeping and Haydon 'dozing in a heated sort
of insanity', there was a knock at the door and he was arrested. He
was given leave to breakfast, then taken away and allowed a few hours
to settle his affairs upon his oath that he would surrender himself later
in the day. The interval gave rise to dark and desperate notions: 'I
thought of burning my House,' he admitted, '& murdering my family.'
Instead, discarding 'such bloody insanity',[28] he surrendered himself.
On 18 May he had prayed: 'spare me the agonising disgrace . . . Spare
me for Jesus Christ's sake that horror.' His prayer was in vain. Four
days later he was in a 'sink of dimness and gamblers'.[29]

The King's Bench Prison lay in an angle formed by the junction
of Borough Road and Blackman Street.[30] One of three places of
incarceration within a relatively small area of Southwark, it was
little more than a hundred yards north of the Surrey County Gaol,
former temporary home of Leigh Hunt, and less than a quarter of
a mile south-west of the Marshalsea, where a twelve-year-old Charles
Dickens would visit his insolvent father early the following year.
Prisoners, or 'collegians' as they styled themselves, lodged in a large
four-storey brick building 120 yards long, with a wing at each end
and a chapel in the centre. There were about 200 rooms. On arrival
the prisoner had to pay a commitment fee of ten shillings and
twopence. He was then given a 'chum ticket' entitling him to a
room. Thereafter, a weekly rent of a shilling was to be paid. An
individual's rent was reduced to sixpence if he was 'chummed' with
another prisoner, or to fourpence if three people shared the same
room. When a prisoner could afford neither commitment fee nor
'chummage', the conditions of his existence would be cramped

indeed. It was not uncommon to find six or eight persons of the poorer classes sleeping two in a bed, or on the floor, in rooms measuring sixteen feet by thirteen.

In front of the main building was an extensive flagged courtyard, enclosed by a thirty-foot-high wall spiked at the top with *chevaux de frise*. This space formed the recreation area where collegians might enliven the tedium by playing fives, rackets, skittles and 'bumble puppy'.[31] The four racket grounds were run by an elite of senior prisoners, each of whom had purchased rackets and goodwill from a predecessor on his discharge from the prison. The 'racket-masters' thereby maintained a profitable monopoly on such leisure activities, charging their fellow collegians for hire of the equipment.[32] There were other amenities: 'a coffee house, two public-houses, shops and stalls, for meat, vegetables, and necessaries, of almost every description [giving] the place somewhat the appearance of a public market'.[33] One of the pubs was a large taproom called The Brace, from its having originally been run by two brothers named Partridge. At times of severe overcrowding, the poorest collegians unable to pay 'chummage' were allowed to sleep here on tables and benches, as many as forty-eight at a time. Above The Brace was another big room, occupied by a pris-

oner who sold newspapers, tea and coffee, whilst many of the ground-floor rooms giving on to the courtyard had been converted by their occupants into chandler's shops. There was also a Public Kitchen, where prisoners could have their meat roasted or boiled. This service was free before one o'clock, after which time a charge of two or three pence a joint was levied, depending on size. According to regulations, only ale, porter and wine were to be sold from the taproom, but in practice gin was freely available for sale from many of the rooms.

Haydon spent his first night of incarceration in temporary quarters: 'a filthy blackened bed room above the Coffee House', where he was woken periodically by 'the songs and roaring of the other Prisoners'. Once he felt something tickle the palm of his hand '& closing it crushed a black worm'. In the morning he was obliged to report to the turnkeys, 'that they might know [him]'.[34] This was a security measure, for only the turnkeys' practised memory for facial features enabled them to distinguish prisoners from visitors and prevent absconding.[35] The new arrival was assigned a room on stairway 10 and, having enough money to pay his way, was able to avoid being 'chummed' with another prisoner.

Haydon scrutinised the other collegians. 'Prisoners of all descriptions seemed to get a marked look. Neglect of person is the first requisite, and a sly, cunning air, as if they were ready to take advantage.' The debtor moved in a small, circumscribed world – bound in by unwelcome coincidental encounters as much as *chevaux de frise*. The first man Haydon met was Gurney, at one time attached to his sister Harriet, and from whom she had had a lucky escape. He had been 'plunged in every sort of dissipation, a gambler, & a rascal!' Gurney had been imprisoned for debt, but was out and well married and had just driven up in a carriage with his wife to visit a friend. Both men were affected by their meeting. Gurney offered money. Haydon refused. On the same day, as Mary arrived to visit, she in turn caught sight of a man she knew. Later there was a knock at Haydon's door and the same man asked if this was room 13, stairway 10. It was not and he went away, but Mary recognised the sinister croaking voice as being that of the individual who had caused the ruin of her first husband. It must have seemed to her as if the man was now threatening her second. Such meetings within the walls could be distressing, but liberty brought its own anxieties. Granted a Rule of Court to leave the prison for a day 'to transact his Affairs & to return again before

Banc R.

THE BEARER

[manuscript text] hath this Day a Rule of Court to go out of the Prison of the Kings Bench, granted to him to transact his Affairs & to return again before 9 o'Clock on the same day. Dated this 30th Day of May 1823

'Clerk of the Day Rules.

9 o'clock on the same day', Haydon was minded to abscond, but found at last that he 'did not dislike the idea of returning'. Facing the difficulties of his financial affairs may have made him all too glad to get back. 'At any rate in a Prison,' he reasoned, 'if you are shut out from the World, the World is shut out from you, and this is a comfort.'

But the World shut out from the painter's prison refuge had to be appeased, and his solicitor, Thomas Kearsey, convened a meeting, at one o'clock on 28 May, to which were invited a Strand draper and tailor named Ashton, along with all the other individuals, in ascending alphabetical order – 150 of them – to whom Haydon owed money. It was Mr Kearsey's 'painful task' to inform them that his client's affairs were 'in such a state of embarrassment and insolvency as to make it necessary for him to submit them to his creditors at large in order to come to some arrangement of terms for the liquidation of them'.[36] Debts amounted to an astonishing £8,000. Haydon wrote a letter the day before the meeting, to be read out to the assembly. 'I am in the prime of my life', he told his creditors:

> My practice, my talents and my fame are in full vigour. I only want security for my time and my person, to obtain resources by their exercise and make gradual liquidation; but if I am kept locked up, with no power of putting my art in practice, what will be the result? – depression, disquiet and ruin. I shall infallibly be destroyed, and how can you be benefited by my death?

But, set at liberty from 'this horrid place', he promised them, 'in two years the produce of my labour shall be laid before you, and payment made'.[37]

At nine-thirty every night a bell was rung and the turnkeys' shouts echoed up each stairwell: 'Strangers, Women and Children, All Out!'[38] On the evening of 28 May, distracted perhaps by talking over the probable results to be expected from the creditors' meeting that afternoon, Haydon and his wife must have heard neither bell nor cry. The gates clanged shut as usual at ten o'clock, the keys rattled in the locks and Mary was trapped inside the King's Bench for the night – 'separated from her infant, from [whom] she never had been a moment since it was born'. The panic to which she succumbed was a release from the tension and anxiety of the previous weeks and months: 'She lost all self possession & became in such a state that [Haydon] never thought she would have lived till the morning. All attempts at calming her were useless, till exhausted she fell into a sleep. The candle went out.' He recalled a letter she had sent him just before their marriage, looking forward to her life at Lisson Grove 'as the place of rest & repose for the remaining days'. Now, looking down at her face in the moonlight, on his pallet bed in a debtors' prison, he reflected: 'Dear Girl. It has been a place of little repose to thee; repose is not to be had in this Earth! for either of us.'

Less than a fortnight later what little repose prevailed in the house on Lisson Grove would be drowned by the roar of conversation, the shouting of lots and bids and the banging of the auctioneer's hammer. The meeting of his creditors having failed to reach an agreement allowing the painter two years in which to repay them by exercise of his brush, his entire property – including his brushes – was put up for sale. The catalogue, comprising 443 lots, from his precious collection of casts to the oil cloth in the entrance hall and the slop bucket, was offered to 'Artists, Connoisseurs, Print and Booksellers, and Others'.[39] The sale was conducted over two days in June by Mr Crook of Skinner Lane.

After the auction, with 22 Lisson Grove devastated, his room on stairway 10 of the King's Bench Prison had become home, according to a telling journal entry: 'Home all day with dearest, dearest Mary.' The incongruously blissful interlude – probably accompanied by what he would euphemistically describe as a 'sacrifice to her beauty' and resulting in conception of a child born 274 days later – must have conjured comparisons in his mind with their former bedroom, and

a

To Artists, Connoisseurs, Print and Booksellers, and Others.

A CATALOGUE

OF A VALUABLE COLLECTION OF

PAINTINGS,

ENGRAVINGS AND BOOKS OF PRINTS, .

THE FIRST CASTS FROM THE ELGIN MARBLES,

A VARIETY OF OTHER CASTS,

Valuable Silk Embossed Draperies

SELECT LIBRARY OF BOOKS,

PLATE, LINEN, CHINA, GLASS,

WINES,

Household Furniture,

AND OTHER VALUABLE PROPERTY OF

R. B. HAYDON, ESQ. HISTORICAL PAINTER,

WHICH

WILL BE SOLD BY AUCTION, BY

MR. CROOK,

ON THE PREMISES,

John's Place, Lisson Grove,

PADDINGTON,

On Wednesday, June 11th, 1823, and
following Day, at 11 o'Clock.

May be viewed on Monday and Tuesday preceding & Mornings
the Sale, when Catalogues may be had on the Premises, and of
Mr. CROOK, Auctioneer, 61, Skinner Street, Snow Hill, at
1s. each.

King & Brock, Printers, 20, Upper Thames-street.

he compiled an inventory from memory of all that had been swept
away:

By dearest Mary's dressing table hung a medal of Napoleon, struck
just after his fall; over a fine head of Raphael; by her ewer where
she dipped her lovely face, a sketch of mine, Cupid . . . Inside was
the cot of our dear Child . . . Our bed was simple, hung with green . . .

Near the door Mary had placed a cupid drawing his bow, which I bought of an Italian. She had crowned his head with a wreath of white roses . . . and strung his bow with silken ribbon. Behind, a fine copy from Titian of a naked woman, a head of Alexander graced the left, while a beautiful cast of Clytie sinking gracefully into a flower was behind him . . . In this little nest of taste & happiness, have we enjoyed the most rapturous & enchanted moments of our lives! Delight to its remembrance! Rapture attend for ever its recollection!

He was unaware, when he wrote this elegy, that certain items had been saved, by the judicious bidding of friends, to give him something on which to rebuild his life and career when set at liberty. Some of the most highly prized pieces from his cast collection had been retained in this way, including the *Silenus* from St Petersburg and the *Ilissos*, 'the first cast ever made' from the Elgin Marbles. His seven-foot-high *Apollo Belvedere*, however, was retrieved later and by his own efforts. Sold in 1823 for five pounds, the piece had originally cost him twenty-five. Fourteen years later, in 1837, the man who had acquired the bargain was himself ruined and Haydon was able to buy it from his insolvency sale for just two pounds and a shilling.[40] The main article of furniture preserved by his friends from the debacle of that 'nest of taste & happiness', the first-floor front bedroom, was the 'simple' bed, described in the catalogue as a '5ft four post bedstead, with carved and panelled mahogany feet [&] pillars, lath bottom, and green calico furniture'.

The sale of Haydon's property, which he estimated had originally cost him a total of £2,300, fetched only £600. The maw of debt demanded further sacrifice, and an advertisement in *The Times* drew the attention of 'Trustees of Churches and Chapels, Connoisseurs, Exhibitionists, and Others' to another opportunity:

MR CROOK respectfully informs the Nobility, Gentry, and Public in general, that he has received instructions to SUBMIT by public AUCTION, at the Egyptian Hall, Piccadilly, on Friday, June 20, 1823, at 12 o'clock . . . those TWO inestimable PAINTINGS in massive rich gilt frames, the Raising of Lazarus and Christ's Triumphant Entry into Jerusalem . . .

According to the notice, this sale was to be conducted 'under circumstances that will not admit any reservation'.[41] It might just as well have said that the 'inestimable' works might be had for a song. *Christ's Triumphant Entry into Jerusalem*, which had made Haydon nearly £3,000 in admission charges, was sold for £220. *The Raising of Lazarus* – for which he claimed to have been offered, and refused, £1,000 the previous month – was acquired for £350 by Mr Edward Binns, the upholsterer who had decked out the room in the Egyptian Hall for the exhibition of both pictures.

The following week a letter found him at the King's Bench:

HAYDON,

I am glad to find you are so comfortable, and have made so good a sale of your property. Your present quarters are nicely adapted for study. All who know you say you are a low coxcomb, and a rotten-hearted scoundrel.

YOUR HATER

London, June 25 1823[42]

On the same day that Haydon's anonymous correspondent was expressing his satisfaction, Mr Henry Peter Brougham stood up in the chamber of the House of Commons and presented a petition on the painter's behalf. During the previous month, a fortnight before his arrival at the King's Bench, painting his *Crucifixion* and threatened by near-daily executions, Haydon had found the time to call on the Member of Parliament for Winchelsea and communicate his views on the necessity of state support for historical painting. The dashing advocate, who had made his name conducting the successful defence of Queen Caroline in 1820, was supportive: 'took great interest and seem[ed] to give . . . more hope than any member ever did before'.

The views expressed by Haydon in that conversation, and in the petition he subsequently persuaded Brougham to deliver, were essentially those published in his pamphlet *New Churches* five years previously. Although Parliament had voted one million pounds to church-building, thereby encouraging the arts of architecture and sculpture, no part of that budget had been allocated to the art of painting. He recalled the deliberations on the Elgin Marbles and urged members to appoint just 'such a Committee . . . to inquire into the

state of encouragement of historical painting, and to ascertain the best method of preventing . . . those who devote their lives to such honourable pursuits . . . from ending their days in prison and disgrace'.[43]

The petitioner was, Brougham informed the House, 'overwhelmed by ruin, and without hope of redress, owing to his having refused to take portraits, and to his having confined himself exclusively to one branch of the art, historical painting, in which, from the state of the market, it was not possible that more than one or two persons should succeed'. Mr Brougham concluded his remarks by saying that he had met the painter only once, but that 'all he had seen of him upon that occasion was calculated to leave a very favourable impression upon his mind of Mr Haydon's talents and general conduct'. He then moved that the petition 'be brought up', and sat down.

Sir Charles Long, Member for Haslemere, stood up and informed the House that Haydon had first called on him to present the petition, but that he had refused, not being able to see how such encouragement of historical painting as the petitioner called for might be effected. He also observed that the honourable and learned Member for Winchelsea, who had agreed to present the petition that so approved the work of the 1816 committee on the Elgin Marbles, had himself been strenuously opposed to the carrying out of that committee's recommendations. Mr Brougham replied that he had never argued against the proposed benefit to the country of acquiring the Marbles, only their proposed cost at a time when the country could ill afford them.

Mr John Wilson Croker, Tory Member for Downpatrick, spoke next. He took issue with the petitioner's scorn of portraiture. 'If there were any artist so attached to historical painting as to say that he would not condescend to paint portraits,' he declared, 'that artist ought to be reminded that Titian, Raphael, and Rubens were not more distinguished for their historical paintings than they were for their skill in portrait-painting.' Mr Croker felt it necessary to mention this 'to prevent young artists from giving themselves up to the same foolish idea which appeared to have acted so injuriously to the fortunes of Mr Haydon'.

This being all that was raised in debate of the petition, it 'was then laid on the table, and ordered to be printed'.[44] Despite the reserva-

tions expressed by Long and Croker, Haydon was ecstatic: 'At last . . . the cause, the cause has been brought forward in the House . . . The ice is broken *for ever* & . . . it will be done.'

*

Under the provisions of the 1813 Insolvency Act, a court sat in Portugal Street, Lincoln's Inn Fields, for the relief of individuals imprisoned for debt. 'A temple dedicated to the Genius of Seediness', was how Dickens described it:

> not a messenger or process-server attached to it, who wears a coat that was made for him; not a tolerably fresh, or wholesome-looking man in the whole establishment . . . The very barristers' wigs are ill-powdered, and their curls lack crispness.[45]

On 22 July, no less than two months to the day from the date he was imprisoned, Haydon was entitled by law to attend this court and petition for his discharge. His fate depended on whether any of the 150 creditors believed that more money might be extracted in settlement of their accounts by his continued imprisonment. Included in his petition was a complete schedule of his assets – to be turned over, if deemed appropriate, to an assignee appointed by the court. The assignee would marshal the assets and distribute them pro rata to the insolvent's creditors.

Only one creditor remained obdurate, entering his name as an opponent to Haydon's discharge. This Mr Turner may have been the 'villain' into whose clutches he had felt himself being drawn as he prepared to exhibit *Lazarus*. He may also have been the anonymous correspondent, Haydon's 'Hater'. The grave, black-robed court official rose and intoned: 'Benjamin Robert Haydon! Does any one oppose? Benjamin Robert Haydon!' No reply came and it was clear that, at the final moment, to Haydon's relief, Turner had withdrawn his name. The insolvent approached the bench, his heart beating violently. He put his clenched right fist on the judges' platform, his hat beside it, over which he loosely rested his left hand, and waited. There was a scratching of pens and a buzz of conference. He turned his head and looked at the court, a row of counsellors 'looking like ferrets, knit-

ting their brows'. Beyond, he could see 'nothing . . . but faces, front & profile, staring with all their soul'. He turned back to the judges, 'their glasses off, darting their eyes with a sort of interest'. There being no creditor come forward to offer opposition, Haydon was informed that he was entitled to his discharge. He would, however, be compelled to await his freedom for a further three days until certain formalities had been completed. About half-past eleven the following Saturday he stood again before the tribunal in Portugal Street and was discharged, a free man. He considered the ordeal of his two months' imprisonment to have been a test of his honour and his character, and even claimed to 'feel grateful for it'.

Reunited with his family, they retreated to lodgings at 8 Philpot Street on the south edge of Paddington Green, opposite St Mary's Church and graveyard.[46] The *Crucifixion* was abandoned for ever. Five years later, he attached a note to an early essay at autobiography, supposedly written by some future editor of the manuscript:

> Shortly after the Lazarus was finished this remarkable man, B.R. Haydon, died. He always said it would be his last Great Work. Another, John Haydon, painted in imitation of the former a few small works: but *he* was a married man – had five children – sent his Pictures to the Academy, asked a Patron or two to employ him, and, in short, did all those things that men must do who prefer their own degradation to the starvation of innocent beings . . . J. Haydon is now living – a portly, family, bald, prudent fellow.[47]

<center>★</center>

It was Wilkie who had coordinated the purchasing of items from the sale, using money raised by subscription for the purchase of *Jerusalem* in 1820. In August he wrote to Haydon on behalf of Dr George Darling and Sir George Beaumont, authorising collection of 'the things at Mr Rossi's'[48] they had succeeded in saving for him. But Haydon was unmoved and unimpressed, still harbouring bitterness at the treatment received when he had asked his friend to stand bail for him after his second arrest for debt. Later, referring to the death of one he regarded as a worthier man,[49] he would write: '. . . and such reptiles as Wilkie, with their nasty, cold blooded,

detestable selfishness are permitted in safety to crawl in this miserable obscurity!'

Another friend who would from time to time sink to a despicable level in Haydon's estimation was Wordsworth. Like Wilkie, he had been found wanting when approached at a time of financial need, and like Wilkie he became the object of the unsuccessful sponger's resentment. Approached for the loan of fifty pounds, the poet's response – that his high regard for Haydon would not allow him to give money – fuelled a long, sneering letter to Miss Mitford:

> his regard was such that he would rather see me obstructed daily in concluding Lazarus – than aid me & prevent these obstructions by advancing me 50 from his stamp collecting income . . . he will write you [a] Sonnet, & see you starve that he may write you another – but as to giving you a loaf . . . he has too *much regard* for you.

In addition, Wordsworth had been so rude and offhand in the company of Mary that Haydon 'longed to pull his great antediluvian nose'. His abandonment of youthful radicalism for mature conservatism was remarked upon as were his fawning obsequiousness in the presence of aristocracy, his personal vanity and, when pomposity gave way to joviality, even the older man's physical imperfections were held against him: 'Wordsworth's face always puts me in mind when he laughs, as if he was an old satyr . . . there is something, so lecherous, animal, devouring looking in those wrinkles & straggling decayed teeth – . . . he is an old beast, cloaked in piety of verse.'[50]

In September, Haydon unwillingly embarked on his portrait career, first with a chalk drawing of Charles Heathcote Tatham for ten pounds, then with the more lucrative painting of an unnamed 'Gentleman'. Despite initial misgivings, and pacing the garden of his lodging 'in sullen despair' before the sitter arrived, his labour proved not entirely onerous, 'a note of considerable amount' being slipped into his hand as the 'Gentleman' departed after the first session. A few days later Haydon even became so engrossed in his work as to be irritated when the 'Gentleman' had to leave just as he was 'beginning to *feel* it'. He worked on, painting the clothes, in the client's absence. For this he used the lay figure that had worn the costumes of Dentatus, Christ, Newton, the Centurion and Lazarus. 'Disgraced by a black coat and

waistcoat! [the figure] bowed his head as if ashamed.' Haydon finished this first commission within three weeks and the *Portrait of a Gentleman* belatedly joined umpteen portraits of gentlemen, by sundry other hands, in the Royal Academy Exhibition of 1826. For all his grumbling, for a short period at least Haydon remained resolute: 'My devotion to Historical Painting has plunged me into vast debts. Portraits & success are my only chance of paying them.'

But in between portrait sittings he was able to start work on two purely speculative pictures, modest in size and, with an eye to the popular preferences of the commercial market, humorous: *Puck Carrying the Ass's Head to Place it on Bottom's Shoulders* and *Silenus, Intoxicated and Moral, Reproving Bacchus and Ariadne on Their Lazy and Irregular Lives.*

The lodging in Philpot Street – shared with 'two old reptiles' who relied on the rent from subtenants to pay their own landlord and taxes – was not conducive to High Art. 'I am so mingled up with the House,' Haydon complained, 'and have not that secluded, cut off room I had before.' What passed for a painting room was so small that unless he opened a window he became ill from the turpentine fumes. The loss of his casts also pained him. One night, working on *Silenus*, he needed to consult examples of feet, but had to be content with remembering those of his former collection. Even the few casts of Elgin fragments saved by his friends provided scant consolation and 'seemed forlorn & scattered'.

By November the fifty pounds earned from the Gentleman's portrait had gone, and in December Haydon was forced to pawn all the books retrieved from the wreck, with the exception of Vasari, Shakespeare, Tasso, Lanzi and Milton. On another occasion he had to go out in the rain to borrow money for coal. Yet, with the new year of 1824, his condition appeared to lighten. He could have been seen one Friday at the Panorama in the Strand viewing *The Ruins of Pompeii* and afterwards remonstrating with the custodian of the late Emperor Napoleon's white barbary horse, on display at the Waterloo Rooms in Pall Mall. 'The Man would not let me mount,' he protested indignantly, '[but] I am determined I will . . . & shall when the room is less crowded.' The following day he had an encouraging meeting with Brougham concerning proposals for painting 'national subjects' and the prospect of reforming public taste.

At this time, in early January, and with no discernible change in his financial circumstances, he was able to sign an agreement for the lease on a house, at a rent of £120 per annum.[51] But before the little family could complete their move from Philpot Street to Burwood Place,[52] the shadow of the King's Bench caused a final unpleasantness. One of the 'old reptiles' had recently learned of her outgoing tenant's former address and, despite forty-six pounds in rent having already been paid her, became agitated that the discharged insolvent would leave without settling the outstanding £4 10s. She confronted him at his work. Despite the shortage of casts for reference, Haydon was just putting the finishing touches to the best feet he claimed ever to have painted, when in walked the 'old, short, bawdy looking wicked eyed, wrinkled, waddling, gin drinking, dirty ruffled . . . poor old bit of asthmatic humanity' and demanded her money 'with the air of an old demirep duchess'. Haydon brought his considerable charm to bear and, placated but irritated by his smile, she departed. The interruption at an end, he sat down and finished his feet.

But one week later the Sheriff's Officer arrived bearing a distraint for the £4 10s. Although easily and quickly settled, this execution hurt Haydon more than that which had ruined him the previous year. Also shaken by the reminder of that traumatic episode, his pregnant wife suffered for an hour or two and Haydon suspected the 'superannuated spider' of trying to bring on a miscarriage to keep them under her roof. He appealed to his new landlord, and more men were assigned to get the house ready ahead of schedule. By 25 January 1824, Haydon's thirty-eighth birthday, they had moved into their new home 'without a plate or a teacup, [but] with a great deal of experience'.

That night he was one of a large crowd watching a group of men in long red robes who appeared to be searching for someone. He enquired what was going on and was told: 'They are looking for Haydon who has escaped from Prison.' Then a cry went up: 'There he is, there he is!' and he was grabbed and held fast between two of the men in red robes. One was Mr Jones, the Marshal of the King's Bench, the other his deputy. He looked behind and found twelve men in red jackets, arms linked against his escape:

At last we came at full gallop to the Walls of an immense prison, with a wide ditch; the tide was in and we could not cross, & I saw the sandy

shore gradually appear. We crossed & I heard the buz [*sic*] of endless Prisoners.

His last, anxious thought before he awoke, bathed in sweat, was that he would not be able to dine, as arranged, with the portrait painter and Royal Academician, Sir William Beechey.

<div align="center">★</div>

Haydon's new landlord was a man in the mould of Perkins, his landlord at Great Marlborough Street. He was to become a faithful friend, benefactor and patron, a man of inordinate patience, seemingly reconciled never to receive all the rent due to him, who amassed a sizeable collection of his tenant's paintings and was even prepared to lend him money. Mr William S. Newton lived in Margaret Street, off Cavendish Square, and was a carpenter by trade.

Miss Mitford congratulated Haydon on his escape 'from two such disagreeable oddities as [his] late landlord and landlady'. She wished him 'all prosperity in [his] new abode'. She did not wish him happiness, she said, because he already had it. 'With such a wife and such a boy, and such a consciousness of those blessings, I do really think you the happiest man in the world.'[53] Another blessing was imminent. Mary Haydon was now six months pregnant with a child conceived within the walls of the King's Bench Prison. Their first daughter – the only one who would survive beyond infancy – was born on 17 March and christened Mary Mordwinoff, in honour of the Russian connection established by her father's adventurous Aunt Harriet.

Haydon's two comic paintings, worked on in tandem since his release from prison, were exhibited within two months of each other. The first to be completed, *Puck*, was shown in February at the British Institution, where *The Times* called it: 'a spirited picture . . . executed in a very powerful style', praising especially the 'arch humour of Puck's expression' and the 'admirable buoyancy of effect in his figure, which actually seems to glide through the air'.[54] *Silenus* appeared in the inaugural exhibition of the Society of British Artists, Suffolk Street, in April. The *Times* critic, as ever sympathetic to the painter's contributions, praised the colouring as 'uncommonly rich and powerful', while

expressing slight reservation. He attributed the problem to the picture's size and to 'the painter of such colossal works as the "Entry into Jerusalem," and the "Raising of [Lazarus]" not being yet sufficiently accustomed to minuteness of execution to give to a picture of such moderate dimensions as the present the requisite degree of finish.' Haydon's other contributions included portrait drawings of *Charles Heathcote Tatham, A Greek Lady of Zante* and a nine-year-old mathematical prodigy from Cabot, Vermont, *Zerah Colburn, the Calculating American*,[55] drawn in profile to emphasise the protuberant forehead and barrel-like depth of head from front to back. An oil *Portrait of a Gentleman* was, *The Times* declared, 'distinguished by a depth of colour and breadth of effect which remind us forcibly of some of Titian's most powerful works.'[56]

By early May Haydon was at work on his next historical painting: *Pharaoh Dismissing Moses & Aaron in the dead of night, terrified by the loss of his Eldest born at passover.*[57] When John Borrow, a former pupil, called in the company of his brother George, future author of *Lavengro, The Romany Rye* and *Wild Wales*, the figure of Pharaoh was in outline, that of Moses all but finished. The two brothers had just visited Suffolk Street and seen *Silenus*. 'I now and then dabble in the comic,' Haydon told them, 'but what I do gives me no pleasure, the comic is so low; there is nothing like the heroic . . . I'll stick to the heroic.' The three men turned to look at *Pharaoh Dismissing Moses*. 'I intend this to be my best picture,' he told his visitors.

John Borrow had recently been approached by the councillors of Norwich, his native town, and offered £100 to paint a portrait of their new Lord Mayor, to be pictured emerging from the Norman arch of the cathedral. An 'heroic' conception was required and, either not wanting to accept the commission or feeling unqualified to execute it, Borrow had suggested his former teacher for the job, and was asked to mediate with the painter. 'Really,' said Haydon, when this was explained to him, 'it was very kind to think of me.' He confessed to being not very fond of painting portraits. 'But a mayor is a mayor,' he conceded, 'and there is something grand in the idea of a Norman arch.' There was another important consideration: he was 'confoundedly in need of money' and had even feared his visitors' knock at the door to have been that of 'some dun'.

While his brother and Haydon talked, George Borrow was looking

at the figure of Moses, and noticed 'something defective – something unsatisfactory'.[58] The legs were too short.

When the Society of British Artists exhibition closed, *Silenus* was returned to Haydon unsold. 'My last hope,' he lamented, 'my last hope!' Five months later it was disposed of, dispiritingly, at half-price for £150, he and Mary 'melancholy the whole evening'. As for *Puck* – a picture that had carried the modest price of eighty pounds when exhibited at the British Institution – Thomas Kearsey, Haydon's attorney, took it off his hands for just twenty pounds. The man who had defended him during his imprisonment had become a supportive friend and patron following his release. Kearsey now gave Haydon that most difficult of portrait commissions, in which a single sitter's personal vanity was multiplied into a shemozzle of hopelessly irreconcilable demands, the *Family Piece*:

> a mother and eight daughters! Mamma *remembering* herself a beauty; Sally and Betsey, &c., see her a matron. They say, 'Oh! this is more suitable to mamma's age,' and 'that fits mamma's time of life!' But mamma does not agree. Betsey and Sally, and Eliza and Patty want 'mamma!' Mamma wants herself as she looked when she was Betsey's age, and papa fell in love with her.

Haydon was 'distracted to death' and had 'a great mind to paint her with a long beard' like a Salavator Rosa hermit.[59]

Then, in October, Kearsey devised a means of more long-term financial support. For one year, from 1 January 1825, he would 'come forward' at intervals, when needful, and provided he believed Haydon was deserving, with payments of money up to a total of £300. The attorney's proposition was bounded by conditions. Haydon was to make every effort to get himself portrait commissions at strictly regulated prices: a whole length was not to be undertaken for less than seventy-five guineas, a three-quarter for fifty guineas, a half for thirty to thirty-five guineas. When not occupied painting portraits, the artist might be 'actively engaged in painting historic or compositions of fancy, but only of a small, and at most not larger than a saleable cabinet size'.[60] Any advances Kearsey paid the artist, beyond the agreed £300, were to be repaid from the income accrued from portraits or historical paintings when sold, with interest at four per cent.

In February, a month after Kearsey's system of dole began, Haydon acquired another pupil, a young woman by the name of Georgiana Margaretta Zornlin. Her mother pronounced her 'delighted with the prospect before her of receiving instruction from the highest source of information, and of being permitted to associate with real talent'. She proposed that 'each visit be considered in the light of a legal consultation'[61] and that a fee of two guineas be presented to Haydon at each meeting. The tuition was productive of at least one striking portrait, of her teacher: 'painted under his especial superintendence', Georgiana recalled, 'the hand was a portrait as well as the head . . . the colours were provided and mixed by Haydon'.[62]

Following his release from prison, Haydon had made £665 from portraits alone.[63] In the Society of British Artists exhibition in Suffolk Street, March 1825, he showed seven of them,[64] prompting *The Times* to bemoan the artist's fall from the loftier heights of his profession:

> Mr Haydon seems at last to have totally abandoned historical painting . . . Whatever may be the result of this resolution so far as regards the artist, the public at least have cause to regret it.[65]

The correspondent felt that, sometimes, having insufficient experience in portrait painting, and 'aiming at power of effect he degenerate[d] into coarseness'. Nevertheless he expressed surprise that Haydon had managed this transition at all, 'to the level of common life', after so long painting figures on the largest scale, and anticipated that 'he only want[ed] a little practice to give him complete accuracy in the adaptation of his execution to the standard most suited to portrait'.[66]

George Borrow visited the exhibition to see the outcome of the commission that his brother had passed to Haydon: the large portrait, *Robert Hawkes, Mayor of Norwich*. Borrow knew Hawkes to be 'a mighty, portly man, with a bull's head, black hair, body like that of a dray horse, and legs and thighs corresponding; a man six foot high at the least'. He studied the picture and found the original greatly diminished: 'To his bull's head, black hair and body the painter had done justice [but] the legs were disproportionately short.' Having met Haydon and observed his physique, Borrow suspected that he had 'clapped his own legs upon the mayor'.[67] But the stunted legs of

Hawkes were only an extreme example of a common failing in Haydon's figures, following his removal from the luxury of the large painting room in Lisson Grove. It is quite possible that he could never, subsequently, get far enough away from his canvas to ensure correctness of proportion. His poor eyesight was an added difficulty and, if a later account of his eccentric painting method is to be believed, it was a wonder the disproportions were no worse:

> He would wear, one pair over the other, sometimes two or three pairs of large round concave spectacles, so powerful as greatly to diminish objects. He would mount his steps, look at you through one pair of glasses, then push them all well back on his head, and paint by his naked eye close to the canvas. After some minutes he would pull down one pair of his glasses, look at you, then step down, walk slowly backwards to the wall, and study the effect through the one, two, or three pairs of spectacles; then, with one pair only, look long and steadily in the looking glass at the side to examine the reflection of his work; then mount his steps, and paint again.[68]

George Borrow, having noticed a similar shortness of leg to that of Hawkes in the representation of Moses the previous year, was relieved that he had not agreed to sit for the corresponding figure of Pharaoh when Haydon had requested him to do so. 'If I had, the chances are that he would have served me in exactly a similar way as he had served Moses and the mayor.'[69]

There is no record of Robert Hawkes's opinion of his likeness, but Miss Mitford told Haydon that she considered her portrait, also on show in Suffolk Street, 'as like as what I see every day in the looking-glass' and added: 'even if it were as ugly as Medusa I should always think it the greatest honour of my life that it was painted'.[70] Others were less indulgent. The portrait was 'so exaggerated, both in size and colour,' she told one correspondent 'that none of my friends could endure it. My father declared he would not have it home.'[71] Even the otherwise favourably disposed reviewer from the *Examiner* rose indignantly to the lady's defence:

> Mr Haydon has . . . sinned both in regard to truth and gallantry, which need never be disunited. He has made the amiable and highly-gifted

writer look full ten years older than she is – a deed which, we must insist, partakes more of a foul than a fine art![72]

<div align="center">★</div>

Haydon had had no contact with Henry Fuseli for over a decade, and among the most recent epithets levelled against the old man in his journal, following some unspecified offence, had been 'Traitor – mean, malicious, cowardly & debauched'. News of his death, however, on 16 April 1825, loosed a tide of reminiscence and affectionate tribute covering several pages. It was 'an irreparable loss' to historical painting, he declared, and in particular a loss to the Academy, where the 'nest of Portrait Painters [were] enjoying the full fruits of their own pernicious supremacy'. He visited Somerset House to pay his respects and found the frail old body of the 'Wild Swiss' lying in state, his large, horrific *Vision of the Lazar House*[73] looming over the head of the coffin. Haydon noticed that the catafalque occupied the precise spot on which he himself had stood in 1807 when presenting the Keeper with a silver cup on behalf of his fellow students. 'The tears trickled down [his] cheeks' at the memory. Afterwards, he followed the funeral procession to St Paul's, where Fuseli was interred in the crypt between John Opie and Sir Joshua Reynolds.

Later that month *The Judgement of Solomon* was unrolled and revealed for the first time in two years. 'Soft & fresh by miracle', the canvas was stretched, framed and hung at the British Institution's exhibition of 'works of living British artists'.[74] The Tuesday before the opening was varnishing day, and Haydon felt gratified to see his work of seventeen years before placed alongside those of Royal Academicians, and believed that his talents had a fair opportunity to show themselves, 'in comparison with those who [had] ever ran [him] down'.

Having finished varnishing *Solomon*, Haydon caught sight of James Northcote and went over to congratulate him on his paintings. 'Ah, but they want varnishing, they say,' Northcote replied.

'Well, why don't you varnish them?'

To which the feeble old man shook his head helplessly.

'Shall I do it?' Haydon offered brightly.

'Will 'ee?' said Northcote, 'I shall be so much obliged to you.'

As he perched on top of the ladder varnishing the canvases of a man whose spite and vindictiveness he had always been certain of, Haydon imagined the other Academicians present wondering: 'Now what damn motive has he got?' While not acknowledging it, even to his journal, Haydon indeed had a motive for the kindly action. He was engaged in repairing bridges. The following year he would embark on a campaign of canvassing once again for Associate Membership of the Academy.

★

Haydon had appeared almost proud of the mixed reception his seven portraits had provoked in Suffolk Street. 'I do not believe any portraits ever made more uproar,' he wrote to Miss Mitford in April. 'There has been a regular yell, but it is dying off.'[75] Worse, however, was still to come. A month later, Theodore Hook's weekly newspaper, *John Bull*, attacked him with all the venom of a personal vendetta. Hook's notice condemned the entire exhibition as 'a display of the most hideous trash . . . ever . . . to disgrace the walls of an exhibition-room', before turning the full blistering flame of its scorn upon 'the gigantic absurdities of MR HAYDON, against whom, were his pictures receivable as evidence, a statute of lunacy would most decidedly issue'. The correspondent then proceeded to detailed ridicule, of the sitters as much as the paintings:

[In] a huge daub called 'The Convalescent' . . . a huge double-chinned yellow man, in a chintz dressing gown, is represented twiddling the fingers of a colossal half tipsey old woman in a flaxen wig; . . . a girl evidently smelling something unpleasant about her papa, and consequently averting her head . . . behind these, an elderly gentleman in a fancy dress, with his hair powdered, is sucking his thumb, while in the opposite corner, we have another member of the ugly club, acting as supporter to an idiotic grinner in the centre – the ludicrous faces and figures of the people thus doomed to ridicule by MR HAYDON, are nothing of themselves, because nature . . . who made them must be answerable for them – but the artist is answerable for the abominable painting of which he has been guilty.[76]

It was characteristic of Haydon that he refused to acknowledge criticism of the quality of his work, seeing instead the attack on his subjects as a 'cruel & new mode' of attacking him: 'ridiculing the personal peculiarities of my Sitters,' he protested, 'as if I could help it'. At most he admitted to imprudently putting too many pictures into the exhibition. 'It excited envy,' he explained.

The family portrayed in *The Convalescent* mercifully could not be identified by name. Not so the portrait of *Dr Darling*, described as having the appearance of 'a subject which has long been immersed in water . . . ghastly and hideous'. And it is difficult to imagine the political career of Mr Mayor Hawkes being enhanced by reference to his 'greasy, brawny, idiotic countenance . . . [and] the evident disunion of his body and limbs', not to mention reference to a neighbouring portrait of *Mrs Hawkes* as 'this unhappy dumpling-eater's wife'.[77] Haydon was appalled to have 'innocently . . . been the means of bringing a set of kind men into public to be covered with scurrility'. Inevitably it affected business. He claimed to have bought £37 15s worth of frames for portraits ordered, but that after Theodore Hook's offensive, 'those sitters engaged never came back afterwards' and the frames were left on his hands, an addition to his already mounting new debts. Five years later, in a statement to the Insolvent Debtor's Court, he 'attribute[d] much of his [subsequent] misfortunes to his having been attacked in the *John Bull* newspaper – he had been . . . going on well before, and could have kept himself out of debt had it not been for that attack'.[78]

<p style="text-align:center">*</p>

Early in April – happily over a month before Hook's devastating notice – John Hunter,[79] an East India merchant whose portrait Haydon had painted and shown at the Society of British Artists, offered him another commission, 'the size to suit his Chimney Piece'. It was 'unlimited in price' and, because the client had left him to name his subject as well as his fee, Haydon was able to continue work on *Pharaoh Dismissing Moses*, for the sum, when finished, of 500 guineas. By July, the picture had made such progress that Haydon was tempted to think it his best. Lord Egremont, introduced by the sculptor John Carew, thought it Haydon's best also, and the painter anticipated future patronage: 'If he gives me a commission, I will paint a better.'

The two protagonists stood opposite one another, Pharaoh raising his arm in a gesture of dismissal, Moses gesturing with his right hand to the central group of Queen, daughter and dead son, and with his left to heaven, the direction whence the last, terrible plague on the Firstborn had come. Beyond, in the thick darkness of the background, guards kept back the crowds of Egyptian bereaved, dimly lit by burning torches. Most light, as well as the emotional focus of the picture, fell on the central tableau. The corpse of Pharaoh's firstborn had been painted from Haydon's stepson Simon. 'The boy, the girl, and the mother are successful,' he decided:

> My eyes filled with tears, as I painted the mother, and so have the eyes of others now it is done. I have put the old servant burying his face in his cloak, and my little girl, who can only speak a word or two, looked at it and said, 'Poor – poor.' It will do, depend upon it.[80]

Early in December, Mary presented him with another child, Alfred, after a strenuous labour; 'her smile when released . . . that of a suffering Soul, springing from the tortures of Hell to the bright ecstacy of Peace & Heaven!'

Haydon had been uncertain where to exhibit his first serious history painting in three years. He eliminated the Society of British Artists from the outset on account of the 'ruinous light' prevailing at their Suffolk Street gallery: 'A man might as well exhibit his picture under the ray of a burning lens,' he explained to Miss Mitford. 'The members are modern landscape painters, who want all the staring light possible, destroying all sentiment and all Art.'[81] Sir William Beechey urged him to send it to the Academy, assuring him that 'Justice [would] be done to it.' But Haydon sent it, instead, to the British Institution where, in January 1826, it was greeted with relief by the *Times* correspondent who had deplored his excursion into the despised art of portraiture the previous year:

> We are glad to find that Mr Haydon has returned to historical painting . . . Though not comparable with his *Judgement of Solomon*, [the *Pharaoh Dismissing Moses*] nevertheless possesses many fine points. The colouring is in general good, and many parts are carefully drawn.

Among the parts commended to the public were the right hand of Pharaoh and – George Borrow's reservations concerning the deficiency of leg notwithstanding – particularly 'the feet of Moses'.[82]

In April, as he prepared to submit two other pictures to the mercy of the 1826 Royal Academy's Committee of Selection, Haydon reviewed his dealings with an institution he had felt himself at war with for almost two decades. He had in fact been steering himself towards a reconciliation since his release from prison. Two years before, following a meeting with Sir William Beechey, he had observed what 'a great deal of skill & a great deal of knowledge' the old man had to offer. His varnishing of Northcote's pictures – 'the poor Old Mummy . . . in raptures' at the bottom of the ladder – was a move in the same direction. Now, as he sent off *Venus Appearing to Anchises*, commissioned by Sir John Leicester for 200 guineas, and a *Portrait of a Gentleman* to Somerset House, he could fully justify to himself the offer of peace they represented. 'The greatest part of the men now leading are my old fellow students,' he reasoned:

> The Academy is not what it was when I attacked it . . . The party that . . . brought the Academy into contempt is dead & powerless . . . Young men of talent have been admitted & the whole state & condition are improved.

Meanwhile he began work on a small canvas, three feet by three-and-a-half, of *Mercury and Argus*, and one twice that size, of 'the finest subject on earth', *Alexander Taming Bucephalus*. It was to George Stubbs, and to having once dissected an ass's forequarters, that Haydon owed his entire knowledge of the equine form. As a painter, he found the eighteen plates of skeleton and gradually pared-back musculature comprising Stubbs's monumental work of 1766, *The Anatomy of the Horse*, somewhat unsatisfactory: 'They are delicate, minute, & sweetly drawn, with great character,' he conceded, 'but they want substance, for they have hardly any light & shadow.' They would form a useful enough starting point for study, however, until he went 'to nature'.

Both of the pictures he sent to Somerset House were selected for exhibition, and although the *Portrait of a Gentleman* was consigned to the despised Ante-Room, Sir John Leicester's *Venus and Anchises* was

given a place in the Great Room. But, at only thirty by forty inches, it probably suffered the fate of many a modestly sized canvas in that august chamber: plugging a gap high up in one of the corners. 'The picture . . . is not seen to advantage in the place where it is hung,' observed *The Times*. It could, however, be seen sufficiently well for its good and bad points to be compared. The female figure was painted 'with the artist's accustomed talent', his management of the light was 'particularly fine', but the figure of Anchises was 'somewhat coarse, and appear[ed] to have been been painted in a hurry'.[83]

At the same time that Leicester's 200-guinea painting was being displayed, albeit disadvantageously, at the Royal Academy, Haydon learned that the 500 guineas due to him from John Hunter for *Pharaoh Dismissing Moses* was not coming his way after all. Later he would describe Hunter as an 'East Indian Merchant who failed in the Panic', a series of financial crises that hit Britain in December 1825, with repercussions into 1826. In desperation at the loss of this substantial sum, which he 'had depended on from the distresses of Time', he wrote to Lord Egremont, who had expressed admiration of the picture, explaining his predicament. A fortnight later, his Lordship called. Haydon had been, for a week, 'laid up in fever' from anxiety and overwork. But on the afternoon of 14 May he was taking the air on the leads of the roof in the company of his wife. Looking down into Burwood Place, they saw a carriage arrive, Lord Egremont emerge from it and enter the house opposite, that of their neighbour, John Carew. The sculptor was in the fortunate position of working exclusively for his Lordship in exchange for a generous settlement of £1,700 a year.[84]

'What bedevilment has Haydon got into now?' his patron demanded.

'None, my Lord. He has lost commissions he relied on, and of course, having a wife & 5 children, he is anxious they should not starve.'

'Is he extravagant?'

'Not in the least, my Lord; he is domestic, economical, & indefatigable . . .'

'Why did he take that house after his misfortunes?'

'Because the lights were good, & he is at less rent than in a furnished lodging.'

'Well, I must go over & do something.' One matter still troubled

Lord Egremont, however. Why had Haydon done himself so much harm by criticising the Academy?

'My Lord, he was a very young man, & I believe he sincerely repents.'

His Lordship left Carew and walked across the street by which time Haydon and his wife had come down from the roof and were watching anxiously from behind the curtains of the parlour and nursery respectively.

'I hope, my Lord, I have not lost your esteem by making my situation known to you,' Haydon enquired delicately as his visitor came up to the painting room.

'Not at all, I shall be happy to assist you.' Then, looking at the six-by-five-foot work in progress propped on the easel – *Alexander Taming Bucephalus* – he said: 'I should like this. You must go on with it, & I shall call up occasionally.' Within little more than a fortnight Haydon had lost one 500-guinea patron and gained another.

By the end of May he was impatient to 'get nature' for Bucephalus. He tried sketching a thoroughbred colt belonging to the jockey and trainer Samuel Chiffney the Younger, and found it 'a pretty creature but too delicate for a war horse'. Then through the influence of Lord Egremont, he was given access to the Horse Guards riding school in St John's Wood. His patron had written to the Colonel in charge, requesting that Haydon be offered a choice of the finest man and animal available. A bare-legged young Guardsman mounted his black stallion and galloped it round for the painter until the creature was winded. He then drew the horse up and halted him to a stand. By watching this action repeated several times, both from a gallop and a trot, Haydon was able to 'observe narrowly the agreeing action of hind and fore quarters and neck, when pulled in.'[85] The Colonel himself rode a grey mare round until it was breathing hard, so that Haydon could study the working nostrils. He was only able to make chalk drawings in the riding school, but a couple of days later the Colonel allowed him to take the young Guardsman and his horse home. The expertly drilled animal walked in through the front door of the house in Burwood Place 'like a dog'. Horse and rider then stood placidly in the small ground-floor parlour for six hours while Haydon painted his oil sketch.

In July, true to his promise to 'call up occasionally', Lord Egremont came to view his investment. He also came in response to a plea from

Haydon that his 'resources were exhausted'. The patron pronounced himself pleased with the picture and nodded approvingly when the artist said he wished to make Alexander an 'aspiring youth'.

'Don't make the Queen damned ugly.'

'No, my Lord, that I won't.'

'The King promises finely. Clytus I like very much. It is very fine,' he concluded. Then, after studying the canvas for some time, he asked: 'What have you been about all your life?'

'Painting large pictures in hopes of the sympathy of the Public, my Lord.'

'That was imprudent,' Egremont replied.

'It was,' Haydon agreed.

'Well, I have brought you £100.'

'That is salvation.' His Lordship smiled and laid the five large twenty-pound notes on a chair. He then wandered into the next room, where the artist kept what remained of his cast collection. Haydon followed him.

'Take up your money,' said Egremont, and Haydon obediently ran back and collected the £100. 'Where are your large Pictures?,' his Lordship asked.

<div align="center">*</div>

Haydon had started bridge-building the previous month: 'taking into consideration the kind reception [he] had met with in the Royal Academy, by the hanging of [his] pictures, & the great good . . . derived from the sending them there, [he] called on Callcott.' This visit was the overture to an intensive period of lobbying in preparation for the following year's election of Associate Members. Haydon would later refer to it as 'the disgrace of my life'.

He told Augustus Callcott that he now felt differently towards the Academy and 'weary of keeping aloof from the profession'. The land-scape painter listened gravely, but Haydon could tell he was pleased at the lost sheep's return to the fold. 'Why, really, Mr Haydon, I won't hurt your feelings by saying what I think of your former violence.'

'Yes, but, Mr Callcott, remember the Cause,' replied the supplicant and proceeded to repeat the arguments, the justifications, the griev-ances rehearsed for eighteen years. 'Remember,' he concluded, 'I never

criticised the works of any living Artists. What I did was on public grounds.'

'Well, Mr Haydon, we won't talk of the matter. If you wish to reconcile you will have *heavy work.*'

'Well,' said Haydon, 'Christian, in Pilgrim's Progress, shook off his load at last, and so shall I.' Callcott shook his hand, wished him success and goodbye. He still looked grave, but Haydon could swear he was pleased.

It was another month before he called on Martin Archer Shee, one of the committee he blamed for banishing *Dentatus* to the dark. Recovering from the agitation of finding Haydon on his doorstep, the Irishman invited him in and they talked. When *Dentatus* was mentioned, Shee declared that he himself had received treatment 'just as bad' at the hands of selection committees in his time, but Haydon was not willing to let that go unchallenged. 'Portraits are paid for,' he reminded the portrait painter, 'Historical Pictures are the work of years', and the history painter faced ruin when a patron like Lord Mulgrave had faith in his investment shaken by disadvantageous exhibition. As to Haydon's writing against the Academy, Shee declared complacently: 'My dear Sir, a Public body is invulnerable; a public body is only *amused* at the attacks of *individuals.*' The visitor did not rise to the bait, lest it threaten their reconciliation. Similarly, the assertion 'Portrait Painters, when *they paint History, beat the Historical Painter!*' was greeted with silence; 'good breeding render[ing] it necessary to bow'. But if the meeting did indeed represent a reconciliation, it was short-lived. Three years later Shee would refer to Haydon's 'crawling meanness' on this occasion and would regret 'that the profession of the arts should be disgraced by such a character.'[86]

Next Haydon visited Beechey, who was 'hearty & sincere'. Then he called on the Academy's hunchbacked Professor of Sculpture. 'Mr Flaxman,' he said, 'I wish to renew my acquaintance after twenty years' interval.'

'Mr Haydon, I am happy to see you, walk in.'

'Mr Flaxman, sir, you look well.'

'Sir, I am well, thanks to the Lord. I am seventy-two and ready to go, when the Lord pleases.' Within five months Flaxman would be dead and unable to influence Haydon's cause either way. From

Flaxman, he went to Westall, but Westall was out of town, so he went on to see Edward Hodges Baily, the old friend who had sculpted Haydon's bust eight years before. They ate and drank wine together, and Baily promised his support when the time came. Thomas Stothard, the Academy Librarian, also promised his support and said that he had complained at the time about the treatment of *Dentatus*, but to no avail. The Librarian seemed 'highly gratified' by Haydon's visit. Next he called on the Academy Secretary, Henry Howard, then Henry Bone, then the Professor of Architecture, John Soane, who was 'crabbedly good natured' and, like the rest, apparently pleased to see him. Later James Ward professed himself astonished when told by Haydon that he had 'never criticised any modern works whatever'. And Henry Thomson – Fuseli's successor as Keeper – picked over, in good-natured fashion, several instances of rudeness that Haydon protested energetically he had 'never meant or thought of'. Thomson was to resign as Keeper the following year on the grounds of ill health. Consequently he did not sit on the committee that would pass judgement on his visitor's candidature.

Haydon completed his lobbying on 25 July, when he visited the rest of the Academicians whose feelings he believed he had hurt. 'I hurt the feelings of some,' he admitted, 'of whom I had no right to complain, but as they were of the body corporate.' He had a long confabulation with the 'kind but peevish' Thomas Phillips, on the range of colours available to artists in the ancient world. Haydon was careful to flatter the older man by feigning ignorance of a subject of which he believed himself master. 'God, sir, I know so little,' he confessed at one point, 'really I have no idea. What is your [opinion], Mr Phillips?' Then he called on the President of the Academy, Sir Thomas Lawrence, and was 'amazingly struck by the beauty & force & grace of his women in his gallery . . . the only man since Vandyke who has detailed, without destroying, the beauty of a face!' But the means whereby he had stroked Phillips's vanity were not attempted with Lawrence: 'I did not say all I thought, because it might look like praising him to ingratiate myself.' Finally he went to see Abraham Cooper. The historical painter of battles and animals was a consolation after 'so many commonplace people', and they 'spent an intelligent, argumentative, & instructive half hour'. So involved did Haydon become in the conversation that he almost forgot the object of his

visit, to gain support for his election as Associate in 1827: 'at last it came in incidentally, and was again buried in matters of more important discussion'.

<div align="center">★</div>

'It will do. You may order a Frame.' With these words Lord Egremont expressed approval of *Alexander Taming Bucephalus*. A fortnight later, after spending a week with his family in Brighton – teaching the four-year-old Frank to ride, driving about with Mary 'whose whole spirit [seemed] enlivened by the Scene' – Haydon left them there and set off alone to Petworth for five days as the guest of his patron.

'What a destiny is mine!' he wrote in his journal, having woken surrounded by velvet bed-curtains slashed with white satin, in a magnificently appointed room, the green-damasked walls hung with aristocratic portraits and with a view of the deer park through the high window. 'One year in the Bench, the companion of Demireps & Debtors – sleeping in wretchedness & dirt, on a flock bed, low & filthy, with black worms crawling over my hands, – another, reposing on down & velvet, in a splendid apartment, in a splendid House, the guest of Rank & fashion & beauty!'

His fellow guests were Lord Egremont's daughter and son-in-law, Mr and Mrs King; a daughter-in-law, Lady Wyndham; a clergyman by the name of Crow; and two military cronies, Bruhl and Meade, who for five years had drunk his Lordship's wine, eaten his Lordship's game and ridden his Lordship's horses and who now appeared to resent the parvenu Mr King, who had merely married his Lordship's daughter.

Haydon wonderingly familiarised himself with the economic statistics of the place: 'The expenditure of establishment at Petworth is 40,000 a year! His Lordship's income is 80,000. There were 5 men cooks, stables for 60 horse, 90 beds are made up, in short, the whole thing was munificent & Princely!' For the man himself, he felt nothing short of adulation:

Such is Lord Egremont, literally like the Sun. The very flies at Petworth seem to know there is room for their existence . . . The dogs, the horses, the cows, the deer & pigs, the Peasantry & the Servants, the guests & the family, the children & the Parents, all share alike his bounty &

opulence & luxuries . . . The meanest insect at Petworth feels the ray
of his Lordship's fire in the justice of its distribution.

The night before he left, he wrote to thank his host 'for the Princely
manner' in which he had been treated and to assure his Lordship that
his own was added to 'the voices of thousands who never utter [his]
name without a blessing'. The following morning Lord Egremont
issued an order from his bedroom and the head housemaid approached
the departing guest: 'My Lord begs you will take a hare & pheasant
to Mrs Haydon, Mr Haydon, sir.'

As he waited, with his bags and his sack of game, for the Brighton
coach, a villager asked if he was 'the great painter'.

'I do not know,' Haydon replied modestly.

'But you painted the Entry into Jerusalem?'

'Yes, my Friend.'

'Ah, sir, that was a Picture! What a Donkey!'

After another two days with his family in Brighton, he returned
alone to London where, able to work undisturbed, by the end of
November he judged *Alexander* to be finished. However, the following
February he admitted to reservations about the picture: 'I fear I must
take out & repaint the whole of Alexander . . . Lord Egremont was
right; it is at present too much like a full grown, muscular man.' By
the end of February 1827 he believed he had captured in the figure
the requisite 'youth and vigour', and showed it to a visiting tradesman:

'What do you think of Alexander's head?'

'Why, sir, he looks with a great deal of *determination for his time of
life.*'

Haydon continued touching and improving the picture until April,
when he sent it to Somerset House for the Exhibition. Like *Venus
Appearing to Anchises*, his last contribution, it was granted an unsatisfac-
tory place in the Great Room, and Lord Egremont was 'angry & mort-
ified that [it] was not in a good situation'. He appeared at one with
Haydon in ascribing responsibility to the machinations of the dominant
faction in the Academy: 'It is those Portrait painters,' he declared.

Press reaction was discouraging. *The Times* faintly praised the
picture's 'good colouring and bold drawing', while the *Morning Post*
deemed it 'ill-grouped, ill-drawn, ill-coloured and extremely vulgar'.[87]
The picture was later to become an object of superstitious fascination,

at Petworth, for one of Lord Egremont's nieces. When pregnant, she would stare for hours at the baby, painted from Alfred Haydon, that appears in the bottom left foreground. When asked why, she replied that it 'was *the picture* of what a Baby ought to be, and she thought it might influence *hers*'.

During the Exhibition Haydon wrote his name and his designation, 'Historical Painter', on the sheet of paper pinned up in the Academy, inviting candidates for the Associateship election. By the time the paper was taken down at the end of May, forty-five names had been subscribed: two architects, four sculptors and thirty-nine painters. As was customary, the Committee to elect Associate Members to the Academy would meet on the first Monday in November.

<div align="center">★</div>

By May 1827 Haydon was working on a cabinet-size picture of *The Death of Eucles*, the soldier who had brought news of the battle of Marathon to Athens and expired proclaiming 'Victory!' Although at first appearing to welcome the challenge of this small but popular size of canvas, he was soon dissatisfied with the reduction of scale. 'When I was painting Lazarus I used to wonder at the insignificance of human beings when I left my painting-room, *now* when I return to my painting-room, I wonder at the insignificance of my own paltry imitation.' It must have seemed all the more paltry when compared with the work of a new acquaintance, who was forced to knock a hole in the ceiling to accommodate his latest work. It was probably Lord Egremont who had introduced Haydon to 'young Lough, the Sculptor, who is just burst out'. Haydon found him 'unaffected, docile, simple, high feeling', and sat up until past one in the morning listening to his story. The third son of a Northumberland farmer, John Graham Lough had come to London on board a Newcastle collier, and enrolled at the Royal Academy Schools. In a room over a greengrocer's shop off the Strand, having made the necessary excavation in the lath and plaster of the ceiling, he had just completed a ten-foot-high statue of *Milo*,[88] the Croton athlete who trapped his hand in the cleft of a tree and was eaten alive by wolves. Lough was self-taught, proof for Haydon that genius was 'not acquired, but innate'. He and his brother had spent their childhood making clay figures inspired by

Pope's translation of *The Iliad*. They read Gibbons's description[89] of the Colosseum and stayed up all night making their own clay model, filled with clay gladiators. The only artist they had heard of, while growing up in Shotley, Lough told his new friend, was 'Benjamin Robert Haydon'. The two brothers had read of *Christ's Entry into Jerusalem* and had sketched the Saviour and the ass on the cottage wall as they imagined them to have been. Haydon was, not surprisingly, 'highly delighted' to hear this. He visited Lough's room in Burleigh Street to examine the giant figure by artificial light and, despite proportional disparities between hands and feet, and an anatomical defect in the region of the loins thrown into especially sharp relief by the candle flame, Haydon pronounced the statue 'beyond praise'. Not since the Greeks had there been anything to compare with it, he thought, not Michelangelo, not Bernini, not Canova. Its back was 'as fine as the Theseus', he declared and made it clear that, coming from him, this was 'no small thing to say'. He felt able to lavish such praise on the up-and-coming man because Lough represented no competition. A sculptor could be lauded as highly as Haydon's beloved Greeks, so long as his own status in the field of historical painting remained unchallenged. He was even able to indulge in the wistful notion that Lough was a younger version of himself and described him as 'the only man I have ever seen who gives me an idea of what people used to say of me. In short the only man I have ever seen who appears a Genius'.

Exhibition space had been found for the *Milo* at Coxe's Rooms in Maddox Street, and on the day the statue was moved, Haydon supervised the operation, as anxious as if it had been his own. The Private Day was 11 June, and he believed that it was in no small part due to his efforts that 'it was a brilliant one'. He had persuaded the seventy-two-year-old Mrs Siddons – so decisive in her critical estimation of *Jerusalem* seven years before – to attend. Haydon conducted her into the room, the crowd parting before her 'as if Ceres was coming in'. Then, conscious that he should not be perceived as 'too principal in the affair' – not least by a number of Academicians present – and harm his protégé by association, he surrendered Mrs Siddons's arm to Sir Richard Westmacott, while he conducted the great lady's daughter. The eminent sculptor might, for all he knew, be a power on the Committee to elect Associates in November. 'As a *young* gentleman ambitious of Academic honours,' Haydon reflected ironically, 'it became

me to be modest. I followed. Had I led, & left [Westmacott] the daughter, I should have lost his vote!'

No notice of the exhibition having appeared in *The Times*, Haydon undertook to supply one. It appeared in the form of a letter to the editor and was signed 'A Constant Reader'. He praised the sculpture, related the sculptor's background and described the adversity out of which the *Milo* had been created, 'without instruction, without foreign travel, without money, mostly without food'. He ended with reservation and warning:

> He has done a wonderful thing, but not a perfect thing. He has the feeling of Phidias; but he is not yet a Phidias . . . He wants deep anatomical knowledge, and this want nothing can supply; he has done wonders with the little he has; he will do greater things when he knows more . . . If he be not emasculated by a journey to Italy, he will be an honour and a glory to the country.[90]

His promotion of Lough had, for a time, distracted Haydon from his own difficulties, but later in June catastrophe loomed again, no longer to be ignored. 'There is an execution in the house,' he reported to Miss Mitford, 'and in all probability our very beds will be stripped from under us.' His wife, six months pregnant, was particularly tried. 'Dear, dear Mary, her face haggard from grief . . . My God, what she has to endure! She won't survive it. She cannot.'[91] To add to their worries, the four-year-old, Frank, fell ill with 'inflamed lungs'[92] and Haydon borrowed money to take the family to Brighton for the boy to recuperate. When he returned to London alone, 'agitated and distressed' after two sleepless nights, he was arrested and taken to the sordid limbo of a sponging house at 4 Cursitor Street. Seven years later Charles Dickens, by then a reporter for the *Morning Chronicle*, would bail his father from the same establishment, kept by Mr Abraham Soloman, and known as 'Sloman's'.[93] Entrance to Cursitor Street – roughly bottle-shaped in plan – was as though down the neck, a narrow turning off Chancery Lane. Number 4 was on the left, where the street widened slightly. Access was gained to Sloman's through 'an inner door,' Dickens recalled, 'the upper part of which was of glass, grated like the windows of this inviting mansion with iron bars – painted white to look comfortable' and by the operation of 'an

immense wooden excrescence, which was in reality a lock, but which, taken in conjunction with the iron nails with which the panels were studded, gave the door the appearance of being subject to warts'.[94] Inside and up an ill-lit and uncarpeted flight of stairs to the first floor, the 'coffee room' was to the left, and elsewhere, continuing the illusion of comfort and domesticity, a 'back parlour' and even a 'front drawing-room, where rich debtors did the luxurious at the rate of a couple of guineas a day'.[95] In desperation, Haydon wrote to his landlord: 'Newton for God's sake come to me – immediately – If I do not get back time enough to prevent my dearest Mary from knowing it she will go distracted . . .'[96]

But it was his main creditor who visited that evening, an attorney by the name of Hawke, whose capricious behaviour, according to Haydon, seemed motivated by the purest malice. This man had already had him arrested once and released on the same day – with apologies and the excuse that he had been 'in a passion' – only to put in a further execution shortly afterwards. At Sloman's he appeared to toy with Haydon, inviting him to take some wine, telling him not to bother going to bed as he would be set at liberty that night and helped out of his difficulties. Left alone, Haydon sat up 'in a state of hope, and fear, and faintness',[97] only to receive word from Hawke after an hour that nothing could be done that night after all. From Sloman's he was sent to another interim lodging: – 'Sweet's Lock Up House, Southampton Street'[98] – and thence, 'over the water',[99] to the more familiar confines of the King's Bench. He was visited there by Hawke's clerk and made an arrangement to pay off the debt by instalments. The clerk went away promising to return at noon the following day with his discharge. Haydon heard nothing more for ten days, during which time the meagre resources he might have used to pay the first instalment were exhausted by the inflated living expenses in the Bench. Maddened with anxiety for his family, he could only rage against his torturers: 'if anything happens to me or my wife,' he wrote to the clerk, 'may my curses and blood rest on you and your Master & his children, may they & he die in wretchedness & poverty, longing and refused the very dunghills of the street'.[100] A more productive outburst was published in the *Morning Chronicle*, and it would have been a stony-hearted citizen indeed who could have read it over his breakfast without being moved:

If I am kept here . . . to ponder on the unprotected state of my family
left alone and undefended – . . . children, who must starve if I sink;
and a wife hovering on the bloody tragedy of child-birth – to . . .
fancy I hear the last agonising throttled screech of labour, a fit sound
to usher into life and breath another puling, helpless creature, to suck
and eat – to grow and think – to ripen and sin – to wither and rot –
and I, the cause of the agony – the husband – cut off by iron doors
as impenetrable as the heart of my creditor, and unable to offer those
soothings at such dreadful moments, a husband alone can give! – I
shall go mad![101]

Haydon's consummate emotive rhetoric persuaded a few total
strangers to send him limited financial assistance. But even as he wrote
his letter to the *Chronicle*'s editor, during this his second term of impris-
onment, a tragi-comic event was agitating the racket ground below
his cell window, which would provide him with the subject matter
for a commercially successful painting on his release.

The main protagonist, Joshua Paul Meredith, had been imprisoned
as a debtor for the previous two years, latterly without recourse to
the 'Rules' – which would have allowed him to occupy lodgings outside
the prison, within a fixed radius of the walls – having on more than
one previous occasion abused that privilege. His debts were small
compared with the potential revenue from a large estate he possessed
in Ireland, but he was unable to arrange his affairs so as to gain his
freedom. He had recently been rescued by the Court of Chancery
from the ruinous trusteeship of a lawyer who, pretending to manage
repayment of his client's debts, had persuaded him to sign over his
entire property in exchange for a weekly stipend of five pounds and
a daily allowance of wine. It was later alleged that a sinister faction
of Meredith's fellow prisoners had held the unfortunate man 'in a
degree of intellectual and personal thraldom . . . scarcely to be
conceived, while they despoiled him alike of his property, his reputa-
tion and his health'.[102] His decrepit condition was exacerbated by heavy
and habitual drinking. The entire lining of his stomach having been
destroyed by ulceration, he was unable to hold down nutrition of any
kind. A hydrocele – or fluid-filled tumour of the scrotum – was the
mildest of his afflictions.

Meredith was known, variously, as Lieutenant, Captain, even

Colonel, and was described by *The Times* as being 'no small source of amusement to his fellow-prisoners, from his eccentricities and peculiarity of manners'.[103] It appears that two prisoners persuaded a young Irishman to conduct a vote among the inmates as to who was the greatest fool and the following day a placard was hung up announcing the 'State of the Poll' and declaring Meredith to be victor. On Wednesday 11 July it was probably the same pair of wags who informed him that the environs of the King's Bench now constituted the newly formed 'Borough of Tenterden'[104] and that two Members of Parliament were to be elected for the purpose of 'redressing all grievances which the inmates of the gaol laboured under', and to 'assist the Marshal in the performance of the various duties connected with the prison'. It was further pointed out that the glorious opportunity of political office might be his if he felt inclined to put himself forward as a candidate. The joke worked to perfection. Meredith became very excited, declared that he was 'extremely desirous of becoming a member of Parliament', and immediately set about canvassing promises of votes, stairway by stairway, landing by landing and room by room throughout the prison.

Meanwhile, to elaborate the jest, Mr Robert Stanton, who had actually been returned for two years as a Member of Parliament for Penrhyn, in Cornwall, before his fiscal embarrassment, together with a Mr Robert Birch declared their intention to stand.

The following day the hoax took on a life of its own. An electoral committee was formed, presided over by a 'High Sheriff': the young Irishman who had conducted the original poll, Jonas Alexander Murphy, wearing a chain of office made out of the curtain rings from his cell and carrying a mop handle tipped with an empty basketwork strawberry-pottle. Poll clerks, scrutineers and other officers were appointed, and the three candidates began addressing the electorate 'in speeches fraught with humour' from hustings erected on the racket ground. The former Honourable Member for Penrhyn particularly distinguished himself, appearing 'dressed up in the most grotesque manner imaginable',[105] enveloped in the quilt from his bed and wearing a yellow turban. The other candidate, Birch, posing as Lord Mayor, wore his dressing gown and carried a white staff. Throughout, Meredith appeared actually to believe he was standing for Parliament, eagerly soliciting votes and displaying visible morti-

fication whenever one or other of his opponents appeared to be ahead in the poll, as the electoral tide shifted and changed. As a Member of Parliament, he would be entitled to free postage of any letters 'franked' by his signature, and therefore promised constituents of the Borough of Tenterden 'franks for ever'. At the end of every speech he delivered he vowed 'to fight up to his knees in blood for the rights of his fellow prisoners'.[106] He was encouraged by no less a celebrity than the pugilist Henry Josiah Holt, known to the Fancy as 'the Cicero of the Ring'.[107]

Haydon had watched that Thursday's opening procession, the sounds of laughter having drawn him to his cell window from the gloomy bulletin on the unprotected condition of his wife and children that he was composing for the *Morning Chronicle*. The following day he joined the crowd: 'baronets and bankers; authors and merchants; painters and poets, dandies of rank in silk and velvet, and dandies of no rank in rags and tatters; idiotism and insanity; poverty and affliction, all mingled in indiscriminate merriment, with a spiked wall, twenty feet high, above their heads'. As he watched the gaudily dressed and debauched figures declaiming from the hustings, Haydon turned to his companion, an insolvent banker, and 'asked him if he believed there ever were such characters, such expressions and such heads on human shoulders assembled in one group before'. He announced his intention to paint it, and as the proceedings on the racket ground gained momentum, the bustling composition of *The Mock Election* matured in his mind. 'Lord High Sheriff' Murphy waved the black crescent of his hat, urging restraint on the furious Meredith, who defiantly brandished fist and blackthorn stick, while 'the Cicero of the Ring' imparted council to his ear of the best punches to throw. The other two candidates, Stanton and Birch, looked on, dressed in bed quilt and dressing gown respectively. The white-jacketed 'head pollclerk' swore in a couple of voters representing contrasting stages of fortune in the Bench – one 'just imprisoned, with a fifty guinea pipe in his hand, a diamond ring on his finger . . . red Moroccan slippers',[108] the other a prisoner of three years, smoking a threepenny cigar, and red Moroccan slippers worn away to expose his toes. Meanwhile another 'poll-clerk', buried deep in the press of the hustings and visible only as crossed legs, a pair of hands and a silk top hat bent over his writing, entered their names in the electoral roll.

Throughout that day and the days to come, electors came forward to cast their votes, having first sworn solemn and entirely bogus testimony of their suffrage qualification: 'The debt for which I am confined is under ten pounds. I have paid my chummage, and have regularly paid up all my dues to the Marshal.' The Chief Poll Clerk then placed a piece of wood in the voter's hand, demanded whether 'all this is true so help your Bob' and finished with the injunction: 'Kiss your tibby.'[109] On the Friday a man dressed and painted as the 'Election Clown' fractured his leg from a fall while dancing on the racket ground. It was the only injury sustained throughout the entire proceedings. Nevertheless, electoral business was suspended for the rest of the day and 'a liberal subscription immediately set on foot' for the invalid.

The 'election' campaign was resumed in the morning, and carried on throughout the day 'with perfect good humour, the candidates, the committee, and other official persons, occasionally parading round the building with music, banners, &c., sometimes for the purpose of bringing up voters to the poll, and at other times to give *eclat* to the visits of the candidates to the respective apartments of those who were somewhat backward in giving their suffrages'.[110] It was said that a creditor called at the gaol and, 'observing so much amusement' and 'meeting none but smiling countenances', decided that it was no punishment to place a man there. He sent for the person who was indebted to him and had him released, 'adding that he thought he should have a better chance of getting his money than before'.[111] The proceedings closed for the day at seven o'clock with a speech from each candidate in turn, Meredith again promising 'to fight up to his knees in blood for the rights of his fellow prisoners'. The 'High Sheriff' declared that the polls would finally close on Monday, when the two successful candidates would be 'chaired in good form'. The committee spent Sunday preparing for the climax of the 'election': planning the final procession, procuring more flags, banners, decorations for the chairs and other requisite paraphernalia.

On the morning of Monday 16 July, the committee assembled for the purpose of swearing in a number of 'constables' to preserve the peace. A programme for the chairing of the successful candidates was circulated to all parts of the prison, together with 'an abundance of good-humoured squibs' exhorting all 'collegians' to 'conduct them-

selves in an orderly and peaceable manner'.[112] As the 'High Sheriff' was being escorted to the hustings to formally open the final day's polling, a message came from Mr William Jones, the Marshal, requiring the immediate presence before him, in his room in the outer lobby, of all three candidates: Messrs Meredith, Stanton and Birch. Expecting nothing more than 'a caution to be orderly and peaceable in their proceedings', the trio readily reported as requested and were immediately ordered into close confinement in the strongroom, a cell reserved for the most recalcitrant and violent prisoners.

Word spread and a meeting of some sixty or seventy prisoners convened on the racket ground to protest at Mr Jones's heavy-handed measure. Another message came, summoning four members of the 'committee' to the Marshal's room: Murphy, the 'High Sheriff', the prize-fighter Holt, together with a Lieutenant Newman and Mr Benjamin Rooke, who had been, before his financial difficulties, the Coroner for Hertford. Having heard the fate of the other three, these four men declined the invitation. The Marshal then appealed for a body of police to arrest the four remaining ringleaders and, on this being refused by the local constabulary, he applied for military assistance. The chum-master, Mr Colwell, was sent for, a man known for 'perpetual acts of benevolence', seemingly at variance with an alarming countenance characterised by 'dark globular Eyes, one eye awry'. Colwell was instructed to sign an affidavit to the effect that 'the prisoners were in a state of dangerous riot and had set the authority of the Marshal at defiance'. Mr Jones himself took this affidavit to the Secretary of State for the Home Department, and a detachment of Grenadier Guards from the Palace was dispatched to the prison. The rumour was scarcely believed among the crowd until the shout went up: 'They are come, they are come!'[113] and in through the gates marched a party of six soldiers with fixed bayonets, led by a sergeant carrying a halberd and flanked by a number of turnkeys, who were to indicate the offenders to be seized. More troops waited outside. A roar of indignation went up from the men on the racket ground, and women and children were seen to scatter, screaming, in all directions as the red-coated guards, following the turnkeys' pointing fingers, waded into the crowd and grabbed Murphy and Holt. The pugilist was heard appealing for calm among friends inclined to resist. The next man seized was Newman, who put up a fight until the sergeant

threatened him with the point of his halberd. Mr Rooke took refuge
in his room and made it known that he would not stir unless taken
by force. And taken by force he was.

Haydon would paint the scene the following year as a companion
piece to *The Mock Election*. *Chairing the Members* was not an accurate
depiction of the scene as it occurred, the three candidates having
already been confined in the strongroom by the time the military
arrived. Instead, it 'combined in one moment what happened at
different moments': three guardsmen at ease facing a little boy with
a tin sword and banner calling for 'Freedom of Election'; Murphy
threatening them with his mop-stick and pottle; Birch with white staff,
and hand on heart, protesting at the violation of Magna Carta;
Meredith, held shoulder-high by his supporters and being pulled down
by a turnkey, defending himself with a champagne flute; Stanton being
pulled at by another turnkey, while the Captain of the Guard bran-
dished a pike. Haydon himself leaned from an upper window in the
background observing the scene:

> I, as an Englishman, felt bitterly wounded that the most heroic troops
> on earth, the Guards of the Sovereign, should have been sent for, to
> out-flank Harry Holt and cut off the retreat of four gentlemen in
> dressing gowns![114]

Murphy, Newman, Holt and Rooke were brought before the Marshal
and, some documentation having been signed in witness by a turnkey
and watchman, were summarily consigned to the strongroom. 'Am I
not allowed to make an observation, Mr Jones?' asked Rooke. He was
not. The strongroom, which now held seven people, measured twelve
feet square, was 'in a miserably filthy condition' and had an open privy
in the corner. Compared with this accommodation, Haydon was told,
'the Black Hole of Calcutta was a palace'. Mr Rooke continued to
complain loudly and demanded that a legal representative be sent for.
His demand was ignored. He then asserted his right to 'lay a complaint
upon affidavit before the Lord Chief Justice, *instanter*', but his demand
that a messenger be sent to procure the attendance of his Lordship's
clerk, in order to take this affidavit, was likewise ignored.

Elsewhere, peace in the prison was maintained overnight by four-
teen Grenadier Guards, the turnkeys and Mr Gibbons, the chief tip-

staff and his men. The coffee house and porter rooms were cleared by ten o'clock.

Conditions in the strongroom were not improved by the early hours of Tuesday when Meredith, known to have had a history of nervous attacks, was seized with convulsions and continued 'in a dreadful state' for several hours, occasionally vomiting blood from his ulcerated stomach and 'exhibiting other very alarming symptoms'. A surgeon attended and pronounced him to be in some danger, but he was kept in the strongroom overnight and for much of the following day.

In the morning the Marshal informed Rooke that he might be set at liberty within the wider confines of the prison, if he apologised for his behaviour. Rooke declared that, having committed no offence, he could have nothing to apologise for. At one o'clock he was again conducted to the Marshal, who again asked him to apologise. Again Rooke refused. After some more conversation, the Marshal ordered that he be released from the strongroom without an apology 'for this once'. Rooke, before he went on his way, assured the Marshal that 'the matter would not end thus; he had been treated as a vile criminal without the shadow of a cause, and he would have redress from the laws of his country, if it could be obtained'.

Meredith was also released in the afternoon and taken to his own room 'in a precarious state'. When the report was published in *The Times* two days later, it was assumed that the other five prisoners were still being kept closely confined in 'the heat and stench of the strongroom'. It was understood that instructions had been given to a legal gentleman to proceed against the Marshal and that a petition to the Secretary of State was 'in the general course of signature throughout the prison, praying for an inquiry on the spot'.[115]

In fact, two petitions were signed. The second, addressed to the Lord Chief Justice of the Court of King's Bench, ran as follows:

We, the undersigned . . . confined for debt in the King's Bench Prison, most earnestly entreat your Lordship to remove from the government of this prison, William Jones, esq., the Marshal, who, without any cause, or reasonable pretext . . . did barbarously and wantonly bring into this prison, a company of soldiers with fixed bayonets, enforce an unwarrantable and puerile exercise of arbitrary power, to the great danger and annoyance of His Majesty's faithful and dutiful subjects, who can

no longer consider ourselves in peace and safety, while subjected to
the control of such unwarrantable and wicked power.[116]

Neither petition was heeded, and William Jones would continue as
Marshal for some years to come.

Outside, plans were afoot to effect Haydon's release. On 23 July 'the
friends of this much-admired artist' met at the Crown and Anchor
Tavern, in the Strand, 'for the purpose of raising a subscription to
enable him to return to his family, and to resume his professional
pursuits'. Lord Francis Leveson-Gower, younger son of the 1st Duke
of Sutherland, took the chair. Haydon had submitted a statement of
his financial position, which was read to the meeting. During the four
years since his first term of imprisonment he had borrowed a total
of £1,131 17s and had earned by exercise of his brush £2,547 11s 2d.
This earned and borrowed income had to be set against old debts of
£636 held over from 1823, 'house rent, professional and family expenses'
of £3,671 18s 7d incurred since, and the aforementioned debts of £1,131
17s. A deficit was left of almost £1,760.

Haydon's only asset was his unfinished *Death of Eucles*, which could
be sold on completion for 500 guineas. The artist gave the meeting to
understand that, if set at liberty, he would 'devote the whole produce
of his labours in future to the payment of his debts'. He also proposed,
'in order to guard against casualties', to ensure his life for £1,000. This,
with the anticipated sum from his picture, would more than meet his
obligations. It was agreed that the picture, when finished, should be
exhibited and that the profits attending that exhibition be divided –
after payment of a portion for the benefit of the artist's family – pro
rata among his creditors. In the meantime, a subscription of up to
500 guineas was to be raised on *Eucles* and, following exhibition, the
picture would be raffled among the subscribers. Two trustees were
appointed, John Gibson Lockhart and a Mr J.J. Burn, who would ensure
that the subscription money was paid to Haydon's creditors. By the
end of the meeting £120 worth of shares in the painting had been
sold, and a week later *The Times* could report that the subscription
raised had 'restored [the] artist to his family and pursuits'.[117]

On 15 August 1827, Haydon began work again 'after two months
of suffering & anxiety not to be described'. But he was still not free
of the predatory Hawke, who wrote immediately to the trustees now

governing Haydon's affairs, threatening to put him in prison again if the thirty-pound debt and costs were not paid. When Haydon accused him of cruelty, Hawke replied: 'This money is not your money, Mr Haydon!'[118]

Two days after his release, he was back in the King's Bench, this time as a visitor, making sketches for *The Mock Election*. He was there the following week, thrilling to the experience of being a free man among captives. A smuggler sat for his portrait, one who had carried the Union flag in the election procession. Haydon enquired whether prison life hurt his health after being at sea. 'My health, sir? I keep up my health with grog,' he said, turning to a crony, 'Eh, Bob?'

'How many tumblers d'ye average?' asked the painter.

'Why, I think, sir, I may say *five and twenty!*'

Henry Holt sat over two days and Haydon was particularly fascinated by the way his hair sprang up from his forehead like wire, in a way he had last seen on a classical bust of Alexander the Great. 'I have always heard of you, sir, for these twenty years,' the pugilist told him, 'but not knowing any thing of Art, I thought you were an *old Master.*'

On other visits he collected heads of young Murphy, the 'High Sheriff'; of Stanton, the former Member for Penrhyn, who would die in an asylum for the insane; of Birch, the 'Lord Mayor', who would die 'miserably from drinking'. Unable to gain access to Meredith for a sitting, Haydon drew on an amalgamation of physiognomy: 'from a remembrance of the principles of an Idiot's head . . . Child's cheeks, woman's nose, age's lips & chin, fool's forehead.'

<p style="text-align:center">*</p>

At a quarter past six in the morning of 14 September, attended by Dr Darling, Mary was delivered of another boy after 'a sharp & rapid agony'. The child's father, in the light of his most recently completed painting, considered calling him Alexander, but settled upon Frederic. 'In such a mess of trouble at that time', his parents neglected having him christened until a career in the Royal Navy was contemplated, requiring a magistrate's certificate, thirteen years later. A middle name was then added in honour of the most eminent of his godparents and he was baptised 'Frederic Wordsworth Haydon'.[119]

By the end of September, Haydon had completed the swirling oval composition of the central group in his picture. There remained the background of sky and prison walls, and the balancing figures on either side of the foreground. It was in the group to the left that Haydon invested the weight of social criticism in *The Mock Election*. Painted in late October, it is 'a good family in affliction', not dissimilar to the artist's own:

> The wife, devoted, melting, clinging to her husband! The eldest boy, with the gaiety of a child, is cheering the voters; behind is the old nurse sobbing over the baby, five weeks old; while the husband, virtuous and in trouble, is contemplating the merry electors with pity and pain.

He holds a document that reads: 'Debt £26 10s. *paid* – costs £157 14s *unpaid.*' The legal firm responsible is 'Treachery, Squeeze & Co.', its address 'Thieves Inn'. Because 'troubles never come in single files, but whole battalions',[120] the family is in mourning for the recent death of another child, an affliction not to be visited upon the Haydons for a further four years.

The figure to the right of the central group takes neither part nor interest in the 'Election' and thereby dominates the picture. Dressed in white, in contrast to the distressed family's black, and with a scarlet scarf loosely knotted below his muscular throat, Major Campbell exerted a strong fascination over Haydon. A man of good family and a veteran of the Peninsular War, he had eloped with a ward in Chancery and was brought before Eldon, the Lord Chancellor, who declared it to be 'a shame that men of low family should thus entrap young ladies of birth'. Campbell's reply that his family was 'ancient and opulent' and, unlike his Lordship's Tyneside antecedents, 'neither coal heavers or coal heavers' nephews', was never forgiven and he had been in prison for nine years. Long confinement had made him 'reckless and melancholy', Haydon wrote:

> He has one of the most tremendous heads I ever saw in nature, something between Byron and Bonaparte . . . Indifferent to the humour about him . . . he seemed, like a fallen angel, meditating on the absurdities of humanity!

By his side, empty bottles, dice box and dice, cards, a racket and ball 'announce[d] his present habits'.[121]

★

Of the twenty-one committee members, voting in the election of Associates to the Royal Academy, eight had been lobbied by Haydon the previous year. In November 1827 two vacant Associateships were contested, but Haydon's lobbying had been in vain and he received not a single vote. His former pupil, Charles Eastlake, was more fortunate. Despite losing the first election, he succeeded in the second. His rise had begun. Three years later he would be made an Academician and, twenty years after that, President.

The Mock Election was finished by the end of the year and exhibited at the Egyptian Hall the following January. Critical reaction in the press was diverse. The *Examiner* felt it approached Hogarth in 'moral attributes', while in the 'more mechanical and technical' attributes of 'arrangement, pencilling, and drawing' it surpassed him.[122] The *Times* correspondent felt no compunction about criticising the picture, he said, 'because we have always been amongst the foremost and warmest admirers of [the artist's] talent'. However, it was feared that 'so long as Mr Haydon gets praised for painting mediocre pictures, he will never attempt to paint good ones'. The writer deplored 'the bad colour of the flesh . . . quite unlike nature . . . Character . . . every where strained beyond the bounds of truth – coarseness . . . substituted for power, and maudlin feeling for pathos'.[123] Some days later the critic paid another visit to the Egyptian Hall and arrived at the conclusion that the picture 'improve[d] upon looking at'. There were, he felt, 'some very fine passages, and enough of these (with all the faults) to make it worth going to see'.[124] Notwithstanding his positive revision of opinion on this second viewing, he went on to devote a great part of the article to picking out more faults.

Towards the end of January 1828 five-year-old Frank suffered a recurrence of ill health and was 'seized with an attack on the lungs'. For a week Haydon was faced with losing 'a fellow string of the same instrument as [him]self . . . dear little intellectual, keen, poetic soul!' Curiously, it was while brooding on this melancholy prospect, in the child's sickroom – 'sobbing quietly, in bitter grief' – that his mind was

distracted by the idea for another crowded picture of London life. '*Punch* . . . darted into my brain and I composed it, quite lost to *everything*, till dear little Frank's feeble voice recalled me.' He regarded this 'involuntary Power' of inspiration at times of extreme adversity as a gift from God and offered Him 'gratitude for its possession'. By the end of the first week in February the child was out of danger.

The Mock Election was still being exhibited in mid-April when an inquest on the body of one of its central characters was held in the waiting room of the King's Bench. It was said that Joshua Paul Meredith had been singing a few minutes before he died. He was in his thirty-first year. A surgeon who had attended him for some time past testified that in his opinion 'the coats of the deceased's stomach [were] entirely destroyed . . . reject[ing] every thing like food he swallowed, and nothing would remain on it but some strong stimulant, such as brandy'. The coroner's jury of prisoners – half from within the walls, half from outside in 'the Rules' – returned their verdict that Meredith had died by 'visitation of God'. The reporter from *The Times*, however, did not disguise his contempt for those who had variously exploited the unfortunate man in life:

> The deceased was the gentleman whose name and person were sported with, under the title of Captain Meredith, at that disgraceful scene called 'The Mock Election', in this prison, some time ago, and which Mr Haydon, the artist, who was then a prisoner himself, has made the subject of a profitable exhibition picture.[125]

The correspondent could not have suspected just how profitable. Four days after the inquest King George IV sent for the picture, liked it and bought it for 500 guineas.

Nine days later, having delivered *The Mock Election* to Kensington Palace, Haydon returned to the King's Bench to make sketches for its sequel, *Chairing the Members*. The irony was not lost on him: 'Friday week in the Palace of my Sovereign! – today in *his Prison*!' He spent the morning 'sketching heads worthy of Shakespeare', and then was able to affect the munificence of a court painter. He sent out for lunch and wine and ate and drank with them: 'What a scene, What expressions, What fiery, flashing vigour of diabolism! It was 8 months since [he] had seen them, and the weather beaten sailor, who boasted he

drank [twenty-five] glasses from sun rise to sun set, was completely altered – flabby, – nervous, – gouty . . . The Bench is the temple of idleness, debauchery, & Vice! Impiety, vice, & want of principle flourish only in health; let weak health come, and how those who have boasted of their Courage, shrink, tremble, & quiver.' Meredith's death had affected them all.

The 'High Sheriff' was a notable absentee from the impromptu banquet. Jonas Alexander Murphy had benefited from publicity arising from the events of the previous summer. 'The notoriety this Mock election had brought him into, induced his Friends to pay his debt,' Haydon was told, 'and he is now living with a Friend who is a Surgeon and endeavouring to get into habits of business & regularity, that he may earn a respectable subsistence.'[126] But on his way home later that afternoon, Haydon met the young Irishman in a street near the prison, 'loitering about the detestable neighbourhood, as if enchanted!' He invited Murphy to come to Burwood Place and sit the following day.

There was another prisoner who could have benefited from Haydon's picture of the Mock Election. When the canvas was delivered to Kensington Palace, the King had been particularly intrigued by the rakish figure in the foreground. 'That's a fine head,' he commented to William Seguier, Keeper of the King's Pictures, 'it's like Bonaparte.'

'Your Majesty,' replied the other, 'Mr Haydon thinks it's like Bonaparte & Byron.'

Having been apprised of the prisoner's story, His Highness sent a message to the King's Bench, by Sir Edward Barnes, 'to command Campbell to state his services and his wishes, and they should be gratified'. A royal pardon appeared in the offing. But Major Campbell was too proud to accept or reply. He spent, in all, thirteen years in prison before being discharged in 1834 when Henry Brougham had succeeded the vindictive Lord Eldon as Chancellor.

Chairing the Members was finished at the end of August 1828, and Haydon was gratified that he had 'accomplished this work in precisely the same time as the last'. The Duke of Bedford called to see the picture and said: 'I suppose the King will have this to complete the suite.' Haydon hoped he would, reflecting that it was 'a satire touching so nearly on depravity that nobody but a King could sanction it'. The

picture went on display in early October, upstairs at the Western Exchange Bazaar, a forerunner of the modern department store, between the Burlington Arcade and Old Bond Street. *Chairing the Members* was hung with *Venus Appearing to Anchises*, *Pharaoh Dismissing Moses*, a whole-length portrait and two former triumphs: *Christ's Triumphant Entry into Jersusalem* and *The Judgement of Solomon*. Lord Egremont agreed to lend *Alexander*, but too late for it to be listed in the catalogue. As for *The Mock Election*, Haydon had hoped to borrow it from the King – indeed he had been assured that he might have it, but this proved impracticable. He would later accuse William Seguier, along with sundry other betrayals, of sabotaging the loan.

The Times applauded *Chairing the Members*, finding it 'somewhat superior' in execution to *The Mock Election*:

> The artist may be congratulated on having hit upon a kind of painting
> which, while it is admirably suited to his peculiar talent, is inexhaustible,
> – because the humour of the English character is inexhaustible, – and
> which cannot fail to be popular.[127]

Haydon had made it known that a third picture, to be called *The Election Ball*, was in preparation and would complete the series. But if this work was ever begun there is no evidence it was ever completed.

Buoyed up by his sale of *The Mock Election*, and with hopes for *Chairing the Members*, Haydon had once more put himself forward as candidate for Royal Academy Associateship. This year the twenty-five Academicians, presided over by Sir Thomas Lawrence, who met on the first Monday of November comprised eleven whom Haydon had canvassed two years previously. The committee also included John Jackson and David Wilkie.

From the thirty-eight candidates who had placed their names on the list, the first round of voting produced a clear front-runner in Gilbert Stuart Newton, with thirteen votes. Bone, Wyon and Witherington were in joint second place, with three votes apiece. Haydon and two other candidates received one each. Another round of voting gave Witherington second place, before a deciding round made Newton that year's Associate.

Haydon, of course, had been well out of the running, requiring another two votes to take him through even to the second round. But

a tantalising question remains. Jackson, Wilkie and Haydon: insepa-rable, high-spirited fellow students of twenty years before, nightly supper companions in the chop-houses and 'ordinaries' of Poland Street, St Martin's Court and Rupert Street, sharers of youthful triumphs and youthful dreams; of these old comrades two, now full Academicians, sat on the committee that barred the third from their number for the last time. If one of them cast the single ballot in his favour, which one of them did not?

With nothing now to lose by a renewal of hostilities, Haydon dashed off a thirty-six-page pamphlet: *Some Enquiry into the Causes which have Obstructed the Advance of Historical Painting, for the Last Seventy Years in England.* Predictably he blamed the Academy in general, and the portrait painters in particular, for the obstruction. He accused them of ruining and persecuting the careers of one history painter after another: Hussey, West, Barry, Fuseli, even Sir Joshua Reynolds. Having published his pamphlet, and extended its readership by sending it as a letter to *The Times*, where it appeared in two instalments during early January 1829, Haydon next raked up his principal ancient grievance against the Academy when he wrote to Martin Archer Shee, 'frankly asking him if he was or was not on the Committee of 1809, which hung Dentatus'. Shee replied, in meas-ured terms, that Haydon's recent publication had only served to confirm the impropriety of his conduct and declined 'all further communications . . . on any subject relating to the Arts or the Royal Academy'. Haydon wrote again, accusing the portrait painter of 'evasion' and of 'conduct lately' that was 'petty, paltry, & malignant'. To the charge of evasion, Shee replied that he claimed a full share of responsibility in the 1809 Committee's decisions and that 'the place which they assigned to [Haydon's] picture, did ample justice to its merits'. Regarding more recent conduct, Shee had no idea what his correspondent was referring to, and thought it 'hardly worth a conjecture', whatever it was. He then proceeded – selecting his words with wounding precision – to remind Haydon of his own conduct three years before:

> when with that crawling meanness, which so happily alternates with insolent presumption in your degraded career, you obtruded yourself on me and other members of the Academy, to solicit forgiveness for

your offences, which you unequivocally acknowledged, and for which you expressed the most abject contrition.

Although never able to think of Haydon with respect, Shee claimed always to have spoken of him with 'commiseration' for his distress, however ill deserved, even suggesting that the Academy Council ought to subscribe to his relief. He was now determined to spare himself such even-handed sentiments:

> and when any person may be desirous to know my sentiments of Mr Benjamin Robert Haydon, I shall not hesitate to express my regret and mortification that the profession of the Arts should be disgraced by such a character.[128]

Haydon had made an implacable enemy of a man who, just twelve months later, would be elected President of the Royal Academy.

The reference to his recent conduct that puzzled Shee may have alluded to an exchange that Haydon was told of, between an unnamed prospective patron and a likewise anonymous representative of the spiteful enemy faction, an Academy portrait painter:

'I am glad the King has bought Haydon's picture,' said the patron.

'My Lord, it is a mere act of charity,' the portrait painter assured him. 'The King never saw & never intends to see it!'

Haydon gave no credence to the 'infamous reply' from a portrait painter who might have been Martin Archer Shee, although he could well have wondered why else his Majesty did not take the opportunity of acquiring the companion picture to *The Mock Election*. The parting words of his letter to Shee referred again to the alleged exchange: 'I have the pleasure to tell you, I have sold my Picture this morning, which will give you as much satisfaction as you expressed at the purchase of the last.'[129]

At the end of 1828 Haydon had indeed negotiated the sale of *Chairing the Members*, to an Exeter man, but for only £300, '225 less than it [was] worth, from sheer necessity'. Even this reduced sum would not be paid for a further three months, due to the curious misgivings of the purchaser. Mr Francis was a young tanner who became nervous when he discovered that the picture was a companion to one owned by the King and feared retribution from so powerful a rival. Haydon under-

stood him to be concerned that it might injure his standing in the tanning trade. It was only the following April, after a lengthy correspondence, 'harrassed, fretted . . . & . . . brought to the brink of ruin' over an outstanding butcher's bill, that the bargain was concluded and the painter received his money.

A couple of weeks after this happy outcome, *The Death of Eucles* was shown to the public in its as-yet-unfinished state at the Western Exchange Bazaar. The purpose of this exhibition was to invite subscriptions for the picture's raffle – 'chances costing ten guineas'[130] – in accordance with arrangements made at the Crown and Anchor Tavern in 1827. The *Times* correspondent was scrupulous in his assessment of the work:

> We . . . find it impossible, in its present condition, to form an opinion on it that could be satisfactory to any one. We think that it will be quite time enough to criticise it when it is a complete picture.[131]

The *Literary Gazette* held the view 'at present that Eucles is a noble and spirited composition of a very high class'.[132] Nevertheless, premature exhibition of the picture invited, and received, criticism. This was particularly aimed at the bizarre foreshortening of the main figure. 'They find fault with the leg', Haydon noted.

<div align="center">*</div>

At half-past two in the morning of 6 March 1829, Dr Darling again in attendance as 'medical man', Mary Haydon gave birth. Ten minutes later her husband recorded the event in his journal: 'a sweet little girl, the prettiest new born Infant I have been blessed with (Fanny Haydon)'. The brief entry concluded with a piece of parliamentary intelligence, curious in the circumstances: 'Catholick [sic] bill brought 3 hours before.' In the teeth of opposition from his own party, but with the enthusiastic support of the Whigs, the Duke of Wellington had bent to external pressure – notably the threat of civil strife in Ireland – to bring before the Commons a bill 'for the Relief of His Majesty's Roman Catholic Subjects'. Enacted the following month, it allowed Catholics for the first time to serve as members of lay corporations and to sit as MPs. It split the Tories and prepared the way for their Party's

collapse the following year when Wellington refused to bend so readily before the pressure for parliamentary reform, even though faced with the threat of civil strife across the entire kingdom.

Fanny Haydon suffered from a congenital condition, probably that in which one or more vertebrae fail to develop fully, leaving part of the spinal cord exposed beneath the skin in the form of a pulpy tumour: spina bifida. Later the 'sweet little girl' exhibited the concomitant characteristic of hydrocephalus as fluid accumulated within the skull. She would be the first of the Haydon children to die.

<p align="center">★</p>

Towards the end of April *Eucles* was removed from the Western Exchange Bazaar to be finished, and another picture, first shown at the British Institution three years previously, hung in its place. An advertisement evoked the drama of what was now called *The Passover*, to attract another paying audience: 'Pharaoh Dismissing Moses in the Dead of Night, at the Loss of his eldest Child – The Queen and Royal Family on the Ground in an Agony of Grief – Populace Breaking into the Palace. The whole subject is awful and terrific.'[133] If he had been irritated by faults found with *Eucles*, Haydon was exasperated by one critic's comment on the *Pharaoh*'s second showing, that 'the Queen & all the family were too much dressed for the time of night'. Haydon was minded to reply that he had it on good authority that the family 'were too anxious that night to take off their clothes' and that, according to the purported Phoenician author Sanchuniathon,[134] and backed up by a bogus volume and chapter reference:

> the Ladies of the family came out of their apartments in their tunicks only, the Elder Sister with only one sandal & one earing, the younger with no sandals & no ear rings, and that Pharaoh had his night cap on when he first got up, but being reminded by the Eunuch in waiting, he took it off, & put on his crown.

He did not reply to the criticism, however, and the entertaining correspondence this might have initiated came to nothing.

Within three months of removing *Eucles* from the Western Exchange

he declared it finished, 'though if it stays a year,' he added, 'I should find something to do'. He had done nothing, however, to address the problems of his hero's leg.

He was now able to begin work on the crowded canvas of *Punch*, the composition of which had come into his mind while sitting at his son's sickbed, early the previous year. By the beginning of August he had completed the figures of the Farmer and the Sailor. Ten days later he was painting the Farmer's Dog. Haydon had encountered his model driving a flock of sheep down the New Road, 'hailed the drover, & engaged the dog *instanter*'. His dissection of a lioness twenty years earlier 'came into play immediately, being the same construction'. The Sweep and the Sweep Girl exercised him for the rest of August and early September, then he turned to the Apple Seller. By the end of October he had put in the sky and the architectural features beyond the crowd. 'The character of a Back-ground,' he pronounced, 'ought to be simplicity, breadth, & an aerial common rendezvous for all the tints of the foreground.' On 12 November he recorded, '*Punch* done.' It had taken him just under four months.

<center>★</center>

The younger of his stepsons, Simon, embarked on his naval career as midshipman aboard the *Prince Regent* in December and, like a latterday Polonius, Haydon provided sixteen improving maxims and pasted them to the inside of his seaman's trunk. Three concerned debt:

> Never purchase any enjoyment if it cannot be procured without borrowing from others.
> Never borrow money. It is degrading . . .
> [N]ever lend if by lending you render yourself unable to pay what you owe; but under any circumstances never borrow.

Six months later, Simon's brother Orlando would also leave the family home, having won a scholarship to Oxford University. Haydon advised him that 'he must go as the son of a poor man to make knowledge & virtue his great objects, and to consider all privations as the price'.

Early in 1830 the Royal Academy of Arts lost its President. 'Lawrence is dead,' wrote Haydon. The election of this portrait painter ten years before, on the death of Benjamin West, had been, he declared, 'a blow to High Art' from which it had never recovered. It never would, unless the Party members of the Academy seized this opportunity to elect as President an historical painter, a sculptor, an architect, a landscape painter, even a painter of low-life genre – anyone but another portrait painter. 'If they do not,' declared Haydon, 'they will sign the death warrant of the Art in England.' The day after this critical election was held, Haydon rejoiced to read a statement in the *Morning Chronicle* announcing that David Wilkie was the new President. He hurried to The Terrace, Gray's Inn Lane,[135] knocked on the door of number 7 and shouted to Wilkie's sister, Helen: 'I congratulate you!'

'Why?'

'On David's Election.'

'It is very kind of you,' and she ran upstairs to tell her brother.

Wilkie came down, 'really affected', sat on the sofa, bathed in the glow of triumph and lectured his old comrade on the advantages of circumspection with regard to the Academy: 'I have not been always right,' he said, 'but you see how it *has ended!*'

As Haydon left – delighted, and perhaps imagining that Wilkie's election could not do his own prospects any harm – the cautious Scot said something which made him suddenly aware that his friend's elevation would have brought no preferment, and that nothing, between himself and the Academy, would have changed: 'Don't let out you have called on me.'

Later that morning, in the City, Haydon caught sight of a copy of the *Morning Journal* and realised that the *Chronicle*'s report had been incorrect. Phillips and Callcott had received one vote each, Wilkie two and Beechey six. But the successor to Lawrence, with eighteen votes, was another portrait painter, and a sworn enemy: Martin Archer Shee. Haydon lost no time in sending Wilkie a note, to prepare him for the cruel disappointment, that 'the Chronicle might be wrong'.

At the beginning of March *The Death of Eucles* again went on display at the Western Exchange. *The Times* declared that Eucles's wife, on the steps, in an attitude 'expressing grief mingled with horror', was

the best figure in the composition, while the child next to her was 'a far less happy effort'. The man, seen from behind, leaping from the foreground towards the dying hero was 'marked by bold drawing and a great vigour and felicity of colouring'. However, the figure of the messenger from Marathon himself combined 'the most remarkable faults and beauties of the whole piece'. The face was good, the upper body 'well expressed'.[136] It was from the waist down that the faults began. Lord Egremont had recognised a difficulty three years before when the picture was barely rubbed in; that in order for the action of Eucles, collapsing from exhaustion, to be convincing, he needed to be seen dropping into someone's arms. 'If you do not make a man catching him,' his Lordship had said, 'you can't tell the story.' Haydon, dispensing with that useful supernumerary to the rear, attempted to give the impression of his hero falling backwards by foreshortening the legs, the left with moderate success, the right disastrously, bent back at the knee and skewed at a ninety-degree angle to one side, as though broken. The *Times* correspondent, having deferred criticism the previous April until the painting was finished, now declared the figure of Eucles to be 'as incorrect in drawing, as distorted, and as

mistaken in conception as any thing we ever remember to have seen in any picture of real pretensions'. The fault was the more to be deplored for its having been pointed out to the artist when the picture was first exhibited. Haydon had privately dismissed the picture's detractors. 'A Man who has never seen the human figure but in an easy chair,' he wrote in his journal, 'must be shocked at the daring foreshortenings produced by the convulsions of passion.' But it was the comments he made in his catalogue description that irritated the usually indulgent *Times* correspondent, who concluded his assessment of the picture with a well-turned thrust:

> [Mr Haydon] might . . . without any disparagement to his good taste, have spared a very clumsy attempt at witticism, in which he vindicates his own practice by a sneer at the manner of foreshortening, which, as he says, has been adopted by other painters for the last three centuries. During that period there have been painters with whom we should think Mr Haydon can scarcely have thought any body would compare him, and whose reputation is not likely to be displaced by such pictures as that we are now describing.[137]

Alongside *Eucles* hung Haydon's latest effort at a type of painting that *The Times* had earlier extolled as 'admirably suited to his peculiar talent . . . and which cannot fail to be popular'.[138] Like his previous two exercises in social satire, *Punch* offered a densely populated canvas. In the New Road,[139] with the portico and tower of St Mary's[140] church rising above the heads of the crowd, a squat farmer, up from the country, stood entranced in front of a Punch and Judy booth, a dandy trying to engage him in conversation, a street Arab reaching from behind for his coat pocket. The puppet show was watched by two boys, the farmer's dog and a baby being held aloft by its mother. A little crossing sweeper clapped ecstatically, eyes screwed shut with laughter. Distracted from the show by the sight of a bashful young woman, a sailor blew pipe smoke past the face of an Italian image-seller whose head supported a miniature *Theseus* and *Belvedere Apollo* in plaster. Peering around the ramrod back of a cavalry officer, as from behind a tree, a Bow Street Runner stalked the young pickpocket. In the bottom right corner of the picture were three May Day characters: the 'Sweep Girl' with a brass ladle to solicit 'tin', the extrava-

'I do not despise portrait. I only don't like it. I am adapted for something else.' B.R. Haydon. (Clockwise from left: Georgiana Zornlin's portrait of Haydon and Haydon's portraits of Leigh Hunt, Mary Russell Mitford, William Wordsworth)

'The evening sun, with its fine mellow light, was just on the figures and such a picture I never beheld. All that has been said of it falls short of its beauty.' Mary Russell Mitford

'A sea of distant people rolling in motion, and united in sentiment... is one of the most imposing and impressive sights in nature.' B.R. Haydon

'Baronets and bankers… painters and poets… idiotism and insanity; poverty and affliction, all mingled in indiscriminate merriment, with a spiked wall, twenty feet high, above their heads.' B.R. Haydon

'I, as an Englishman, felt bitterly wounded that the most heroic troops on earth …should have been sent for, to out-flank… four gentlemen in dressing gowns!' B.R. Haydon

'The king thought there was too much in the Punch. He admired excessively the apple Girl, but thought the dancing chimney sweeper too much like an opera girl.' B.R. Haydon

'When all the Figures in the Picture get up to walk away, I beg leave to secure the little girl in the Foreground.' Samuel Rogers

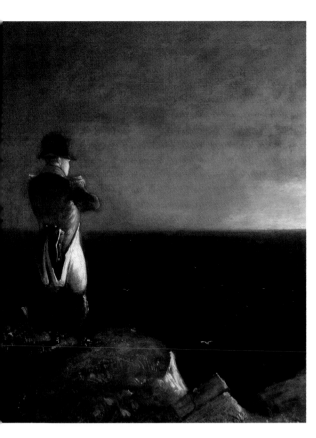

'An admirable likeness of the late Emperor as he was when I had the honour of attending on him.' Barry Edward O'Meara, Napoleon's surgeon on St Helena

'The greatest Man on Earth, & the noblest – the Conqueror of Napoleon.' B.R. Haydon

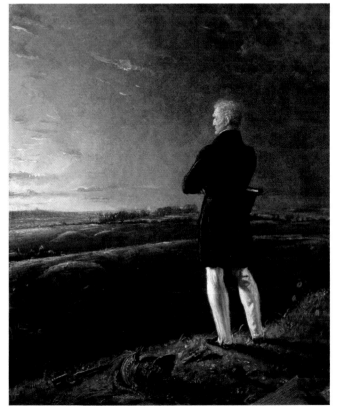

Lazarus unrolled, 29 November 2007.

gantly dressed, blacked-up 'Sweep' and, between them, the 'Green':
a mass of foliage betraying its human occupant only by a pair of bare
feet and a single, staring eye. A coach passing by the trio, was embla-
zoned with a coat of arms showing hearts pierced by arrows, the
driver and black postilion wearing white ribbons in their hats, a newly-
wed couple at the window. Behind was a funeral cortège, its white
plumes, and the driver's white-shrouded top hat, showing it to be that
of an unmarried girl.

The picture was praised for its harmony and variety of colour and
its delineation of character. Fault was found with a similarity of feature,
bordering on mannerism, in several of the protagonists. Along with
Eucles and *Punch*, the exhibition comprised the now-familiar *Alexander*
and *Solomon*, a little Lady Macbeth, entitled '*He is about it*' and a small
rendering of a scene from Milton: *Uriel Revealing Himself to Satan*. In
addition there was a picture Haydon had begun late the previous
November and finished in a fortnight, 'a pretty bit of sentiment', called
Napoleon Looking at a Sunset: the late French tyrant in exile, standing
on a cliff, Britannia and her lion in the clouds. It was the first of many
pot-boilers on this theme.

William Seguier arrived a couple of hours early on the Private Day,
Saturday 27 February, with instructions from the King to look at *Eucles*
and *Punch* '& if worth seeing to bring them down' to Windsor. 'Now,
I must see the King tomorrow,' he told Haydon, 'and if he should
wish to have them down, what must I say, because I like to know
before hand.'

'Why, say they shall be sent instantly.'

'If the King should keep them, it will ruin [your exhibition] with
all this expense.'

'The Eucles, of course, he can't purchase,' said Haydon because it
was to be raffled, 'but if he should buy the Punch, on a proper explan-
ation he will be induced perhaps to lend it.'

'I will tell him, he must not keep them *now*, & if he buys it, it can
be said *purchased by his Majesty*.'

'It would not be fair to take them entirely away,' Haydon agreed,
although ready to accommodate any whim of the royal patron, 'but
at the same time, if his Majesty should wish it, let it be done. I will
take the consequences.'

'These people,' the jaded courtier assured him, 'know nothing about

your expenses & preparations.' He himself was at the beck and call
of the King and joked that he might as well go and live on the Windsor
Road, so much of his time was spent going to and from the Castle.
'I had invited two friends to dine tomorrow,' he complained. 'I must
put them off. *It is an enormous bore.*'

'What must I say today if the Nobility ask about the Punch, if I
have an offer, for instance?'

'*Take it.*' Seguier was adamant.

'That I won't,' Haydon assured him, 'until the King has seen it.'

'Then *you're a goose!*' said Seguier.

Haydon was anxious to extract as much prestige as possible even
from the dangled possibility of a sale:

'Of course you have no objection to my saying the King has sent
for them?'

But Seguier counselled discretion: 'You had better not.'

'It will *make* my exhibition if I do,' Haydon pleaded.

'No matter,' came the cool reply, 'stay a little.'

And away he went down Bond Street. A few days later he informed
Haydon that the King had ordered *Punch* to be taken to Windsor the
following Saturday, as soon as the exhibition closed for the weekend,
and promised that it would be back in the Western Exchange by
opening time on Monday. Haydon was horrified, not only to learn
that Seguier had impressed on the King the importance of a week's
entrance receipts to the artist and his family, but also that his original
orders had been to have *Punch* sent to Windsor the previous Saturday:

'Good God! You did not tell me that.'

'No,' said Seguier, 'was I to stop your private day, and besides, you
are such a violent fellow, you would have sent off the picture directly.'

'And why should I not?' shouted Haydon. 'Do you not know my
gratitude to the King? What must he think of me? You have ruined
me, Seguier. He will not buy Punch! You might as well have put a
pistol to my head! What right had you to conceal his orders, to go
down with excuses, as if from me, as if I authorised you, when I knew
nothing of his wishes. Was there ever such treachery? My prospects
in that quarter are blasted for ever.' And so it proved.

'The King did not like your picture,' Seguier explained when it was
returned to the Western Exchange on Monday morning. His Majesty
had thought it cluttered, that there was 'too much' in it. He had

'admired excessively' the apple-seller, but said the dancing chimney sweep was 'too much like an opera girl'.

Whether or not the King would have found the picture more congenial had he been allowed to view it on 27 February instead of 6 March, Haydon remained convinced that he had rejected it because he was offended 'he did not see it *first*'. He was now sure that Seguier was a traitor.

On the same, dispiriting day that *Punch* returned, unsold, from Windsor, Haydon's wife was informed that the £1,000 left her in trust by her first husband had been forfeited in the bankruptcy of John Wells Bozon, the attorney into whose care the trustees had placed it.[141] Her second husband being 'on the brink of ruin', the loss of this capital sum, together with the annual income of £52 10s interest, was a serious blow indeed.

<center>*</center>

The Death of Eucles was disposed of by raffle on 5 April at the Western Exchange. Fifty-three share tickets had been bought at ten guineas apiece. Each contestant was entitled to three throws of the dice for every share he held. For those holding more than one share, the highest score amassed from any three throws would be counted. The first round resulted in a tie, at twenty-eight, between Mr Strutt of Derby, who, with twelve shares[142] had taken thirty-six throws, the Duke of Bedford, holding five shares, who had thrown fifteen times, and Mr Nathaniel Smith of Dulwich,[143] the holder of just one ten-guinea share. A deciding round of throws between these gentlemen secured *The Death of Eucles* for the lucky Mr Smith, who agreed to allow the picture to remain on show for the duration of the exhibition. *The Times* was given to understand 'that Mr Haydon means immediately to raffle the *Punch*, in 50 shares of 10 guineas each'.[144] Certainly, the raffle of *Eucles* had 'established a principle', one that offered patrons the possibility of acquiring a work of art for a relatively painless outlay of money. It also offered the painter a guarantee of receiving his full asking price for a painting, sparing him the uncertainty of reliance on a capricious single buyer. It would have offered Haydon such benefits, had not the entire 530 guineas subscribed been destined for his creditors.

Meanwhile, although he had begun work on a new historical picture, *Xenophon and the Ten Thousand*, for a month he had been unable to apply himself to the canvas, so distracted was he by 'sheer harrass, day after day racing the town, assuaging irritability, begging mercy, and praying for time'. During this frenzied round of negotiations, the importunate tradesmen to whom he owed money must have repeatedly raised the subject of his recent earnings and, in particular, the amount raised by the well-publicised raffle of *Eucles*. To put an end to this speculation, he placed a notice in *The Times* informing his creditors of 'the correct amount of his receipts and expenses from 1 July 1827, to 1 April 1830'. He had taken this liberty, he declared, 'as a great many notions, erroneous and unjust, exist to his injury, of what he has received and what he must now possess'. Itemised receipts of £2,398 12s 8d were set against itemised expenditure totalling £2,371 4s 10d, of which 'law expenses alone, on paltry debts', amounted to £67 1s. 'His creditors may depend on it,' the notice concluded pointedly, 'that law proceedings will only ruin him, and obstruct all hope of his paying them.' The announcement was not only aimed at allaying the suspicions and entreating the patience of his creditors. It was also directed at those who had helped him in the past, and whose help he now appealed for again:

> From mere want of employment, he is verging fast again to unavoidable embarrassment. In short, if his friends, and those who think he is entitled to protection, do not instantly support the scheme for the disposal of Punch . . . he will be overwhelmed by law, without the possibility of helping it.[145]

By an incidental coincidence of typesetting, the announcement placed immediately above Haydon's concerned an individual who had contributed to his difficulties. John Wells Bozon, Mary's erstwhile attorney, whose financial collapse had taken her £1,000, now placed all his effects in trust 'for the benefit of such of [his] creditors . . . who shall execute the . . . indenture of release and assignment'. According to Haydon, this man had all but killed Mary's first husband 'with harrass & cruelty', and had even attempted to seduce her. Following his ruin he had twice attempted to cut his throat and was at that moment dying, 'in the same horrid condition' as the late Mr Hyman. 'Great God!' reflected Haydon, 'thou art indeed just!'

In his *Times* announcement Haydon addressed those who had aided and supported his release from the King's Bench three years before and asked 'whether, if he deserved to be taken from a prison, he ha[d] not proved since he deserved to be kept from one'.[146] But the pressing weight of executions and demands for settlement were pushing him towards an inevitable return.

Debt engendered debt. He owed £20 and paid off half; £8 16s in legal expenses was added to the £10 outstanding, bringing the debt to £18 16s. He paid off a further £5 and agreed to reduce the debt at £5 per week. He defaulted and an execution was issued, carrying with it a legal fee of £4 10s 6d. He now owed £18 6s 6d.

To another creditor he owed £10, added to which was £11 in costs. To another he owed £6, with £18 added in costs.

To several other debts, totalling £140, costs of £93 had been added.[147]

On 19 May he closed his exhibition and was preparing to send *Eucles* to its new owner when Messrs Herne & Co., proprietors of the Western Exchange, refused to allow any of the pictures to leave the premises until forty-eight pounds arrears of rent were paid. Lord Egremont's *Alexander*, *Solomon*, and *Napoleon*, now the property of Mr Kearsey, were all impounded. Haydon returned home and had time to write explaining the crisis to Nathaniel Smith:

I am ruined quite . . . too full of misery and harass to know hardly what I am writing. With seven children, and two boys beginning life – one in the King's service – and my wife approaching confinement again! Depend upon it we shall be overwhelmed. However, take care of your picture immediately, and do try to see Mr Herne early (before eleven tomorrow). At present say nothing.[148]

He had just finished this letter when he was arrested on another, of many, executions. This was for £15 16s. A painful scene ensued: Mary, six months pregnant, pleading, in tears, with the Sheriff's Officer; 'the man was touched, but could not yield'. Her husband was taken to a 'sponging house' in King Street, Soho,[149] near the junction with Dean Street, his barred window offering a view down on the tombstones of St Anne's churchyard. The following morning a last letter appeared in *The Times*: 'I am sinking fast again into ruin, and to a prison where I must be moved to-day.'[150] A week later the

paper would publish an editorial statement: 'It is impossible for us to insert any more of Mr Haydon's appeals to the public except as advertisements. We have already done more for that gentleman, by the publication of his case, than for any other of our numerous correspondents.'[151]

He had written to Newton on his arrival at the sponging house, imploring him to come to his aid as soon as he had breakfasted.[152] But his landlord's subsequent action appeared, on the face of it, anything but friendly. A document was prepared, signed and issued to Mr Thomas Eames, Broker of Great Portland Street, authorising him 'to seise [sic] and distrain the Goods and Chattels of Mr B.R. Haydon on the Premises . . . situate in Burwood place No.4'. The following day another document was prepared and signed by the Broker for presentation to Haydon:

> TAKE NOTICE, By Virtue of Authority to me given by Mr W.J. Newton your Landlord I have this Day Distrained the . . . Goods, Chattels and Effects . . . in your House . . . for the Sum of One Hundred and Twenty One Pounds Eleven Shillings being for Four Quarters Rent due at Lady-Day last. And that unless you pay the said Rent so due and in Arrear, with all Costs and Charges of this Distress, or Replevy the said Goods within Five Days from the Date hereof, they will be Appraised and Sold according to Law . . .[153]

Since neither the rent was paid nor the goods and chattels sold, it was clear that Newton had deliberately seized his tenant's property in order to prevent its seizure by other, less scrupulous and understanding creditors. Newton also paid off the outstanding rent at the Western Exchange, took possession of *The Judgement of Solomon* and paid for its storage at a warehouse in Dean Street.

Haydon, meanwhile, again took up residence at his old address off Blackman's Lane, settling back into the accustomed routine of the King's Bench – now a veteran collegian. He strolled the racket ground after the gates were shut, deep in conversation with two men who had fought at Waterloo – Colonel La Tour and Major Bacon – and 'never passed pleasanter evenings'. Friends outside tried to persuade him to pay the requisite fee for the privilege of going 'into the Rules', but he refused, preferring life inside the walls: '*here* is a perpetual fund

of Character!' he explained. Given the chance of more salubrious accommodation, promising better air, higher up his stairwell, 'top 8 in 10, a nice room,' he stayed only one night before descending to his old quarters. He blamed the 'want of circulation of air though high up', but it was 'not being able to see & study character' that had made him restless. There were times, however, when more 'character' prevailed than was to his taste. He passed one Sunday, in particular, 'in all the buz, blasphemy, hum, noise & confusion of a Prison'. He had just read prayers to himself in the morning when he heard, from a neighbouring room, 'Such language! Such jokes! Good Heavens.' This was 'character' indeed:

> One of them had mixed up an enormous tumbler of mulled wine, crusted with nutmeg, and as it passed round some one hallowed out, 'Sacrament Sunday, gentlemen!' Some roared with laughter, some affected to laugh ... & then there was a dead silence, as if the blasphemy had recalled them to their senses! After an occasional joke or so, one, with real feel[ing], began to hum [the] 100th psalm, not in joke, but to expiate his previous conduct.

Haydon was fortunate in his personal acquaintance. A powerful creditor was HM Treasury, but the Home Secretary, Sir Robert Peel, lost no time in requesting that 'every indulgence consistent with the public interest might be lent to [him] under the unfortunate circumstances in which [he] was placed', and the Treasury Secretary was persuaded 'in the meantime [to] suspend any proceedings for enforcing payment' of the tax arrears in question. Peel was hopeful that Haydon might be 'enabled to resume [his] professional labours and . . . [his] wife and children . . . allowed to remain unmolested'. Further to this end, he sent Mrs Haydon ten pounds lest she 'be in immediate difficulty'.[154] Other benefactors responded to Haydon's distressed letters with small sums of money. Lord Stafford sent ten pounds, as did Lord Durham. Lord de Dunstanville also gave limited assistance. Knowing Lord Mulgrave to be ill, Haydon had written to the Countess, who replied, enclosing ten pounds and apologising for the smallness of the sum. 'No apology is requisite,' he assured her:

Indeed my Lady I feared giving offence; it is very handsome and very kind more than I had any right to expect. Dear Lord Mulgrave was ever to me an honourable Patron, and a kind Friend – had *his* example been followed, I should have never known distress.[155]

He would write to the Countess once more, following her husband's death, expressing somewhat overstated condolence: 'Oh My Lady, no one, not even yourself, felt more affected than I did at the death of dear Lord Mulgrave.'[156]

On 26 June 1830 King George IV died. 'The only Monarch that felt for me',[157] Haydon claimed. 'I have lost in him my sincere Admirer, and had not his wishes been perpetually thwarted, he would have given me ample and adequate employment.' His fourth and final imprisonment for debt in the King's Bench, six years later, would be during another king's reign and directly attributable, he believed, to losses incurred by the exhibition of a painting commemorating parliamentary reform.

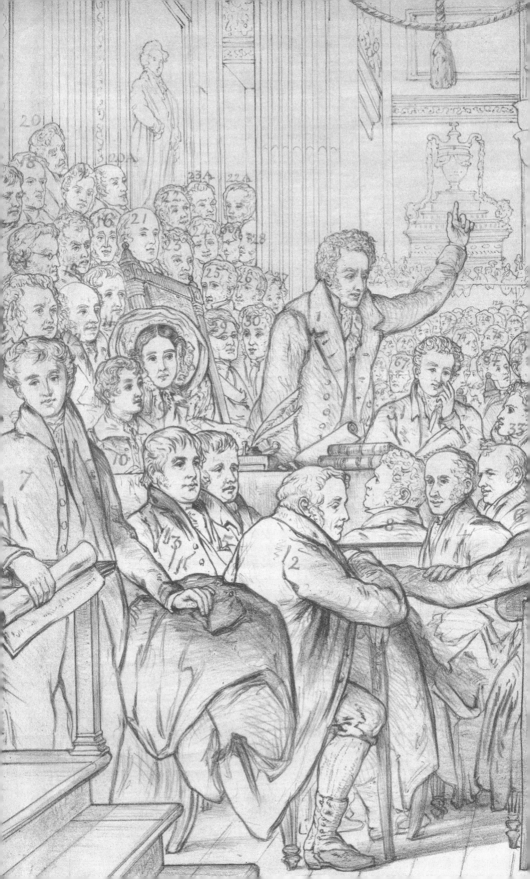

PART FIVE

CAMPAIGNS
1830–41

Haydon's first attempt to exert influence on his country's government was in November 1811 when he wrote to Spencer Perceval just six months before that gentleman's place in history was assured by becoming the first, and only, British Prime Minister to suffer assassination. Perceval did nothing, during his remaining time in office – and this world – to encourage historical painting. Nor did he set aside, as his correspondent implored him to, '£4000 a year for the decoration of our public offices'[1] with such pictures.

Haydon wrote to the Foreign Secretary, Lord Castlereagh, in 1815, pressing the same suit; and, three years later, to George Canning, president of the Board of Control, urging that provision be made for paintings above the altars of a hundred new churches, for the building of which Parliament had recently voted a million pounds.

His first petition to Parliament was presented in the House by Henry Brougham in 1823 while the petitioner himself was imprisoned for debt. His second petition was presented by Mr Lambton in 1824, and his third by Mr Ridley Colborne in 1826. All three documents proposed Government support for historical painting, as the only means of keeping historical painters such as himself from ruin.

In 1828 Haydon submitted a plan to the Prime Minister, the Duke of Wellington, 'for adorning the Admiralty, [and] Chelsea Hospital . . . with paintings to represent the leading points of our naval and military history, and in the House of Lords four subjects illustrating the best form of government'.[2] He begged his Lordship's leave to dedicate to him the forthcoming pamphlet *Some Enquiry into the Causes which have obstructed the advance of Historical Painting for the last seventy years in England*, but the Duke explained that he had 'long found himself under the necessity of declining to give his

formal permission that any work whatever should be dedicated to him'.[3] He did, however, agree to peruse the pamphlet. Two months later, in February 1829, his Lordship was presented with a further plan: 'for putting aside an annual grant of public money, viz. £4000 every two years, for six years, then to be renewed every ten years, according to the success or failure of the plan, for the encouragement of Historical Painting in England'. Haydon predicted that 'without such support Historical Painting "will decay and become extinct"'.[4] The Duke reserved his opinion upon the encouragement proposed 'until he will see the practical Plan for such encouragement'.[5] He did, however, 'object to the grant of any Public Money for the object'.[6]

The presentation of Haydon's fourth petition to Parliament, on 4 June 1830, found him at the same address as at the presentation of his first. When the text was published in the *Spectator*, it carried the wry note: 'dated from an *appropriate* place for the pursuit of historical painting – namely, the King's Bench Prison'. The sponsor on this occasion was Mr Agar-Ellis, MP for Okehampton, a connoisseur and the man who had been instrumental in persuading Parliament to purchase Sebastiano's *Raising of Lazarus* and other works from John Julius Angerstein's collection four years previously. This was a connection that the petitioner felt could only strengthen his argument:

> That though your Honourable House has most generously afforded the student the most distinguished examples for the improvement of his taste, in the purchase of the Elgin Marbles and Angerstein pictures, yet the attempt of any British artist to approach, however humbly, the great works amongst those splendid productions, is as much an effort of uncertain speculation and probable ruin as before they were purchased.[7]

Agar-Ellis had been pessimistic at the prospects for success of lobbying Wellington the previous year, fearing it to be 'impossible at present to expect aid of this nature for the arts in this country'.[8] He had not altered his view. Having read Haydon's petition to the House, he told Members that, 'anxious as he felt to encourage the Fine Arts, he could not recommend a grant of money for the purpose'.[9]

Haydon had been a prisoner for the statutory two months when

he was brought to the seedy court in Portugal Street to claim protection of the Insolvency Act and petition for his release. Fortified with a good lunch and a glass of sherry poured into a tumbler of water, he faced the presiding commissioner and the opposing barrister acting on behalf of Messrs Ecksted and Yarrop, his main creditors. The insolvent made a statement to the court that his difficulties had been caused by want of adequate employment, law expenses and a large family and, in particular, by the hostile notice of his portraits that appeared in Theodore Hook's newspaper five years previously: 'I am ruined by the John Bull!' he declared loudly, and noticed all the journalists 'scribble away with delight directly'.[10] The opposing barrister then enquired as to the value of what appeared to be the insolvent's sole asset, his picture of *Punch*. Haydon told him that although a comparable picture, *The Mock Election*, had been bought by His late Majesty for 500 guineas, he did not think that *Punch* would sell for more than 300 because 'things were changed'.[11] Apparently satisfied that at least 300 guineas might be paid into court and distributed pro rata among the creditors, the opposing barrister raised no objection to the insolvent's immediate discharge, and the following day he was returned to his family.

The big canvas of *Xenophon* rested on the easel where he had left it. 'Now to work,' he wrote, 'like a Lion after a fast.' But he passed the following day 'in a dull stupor, as if recovering from a blow', and it was a full fortnight before he felt inclined to paint again; and then it was only to make use of his smaller easel and paint necessary portraits: one of his grocer, and another, at ten guineas, of Dr Darling. It was miserable work. 'A leaden demon seems to weigh on my pencil,' he complained, and even while he vacantly 'scrawled about' on these puny canvases, he found himself looking to either side of them through the struts of his easel and studying the composition of *Xenophon* beyond.

During the latter half of August, as well as 'Portrifying [his] old Friend Darling', he was working on a 'paltry small' seven-year-old picture of *Mercury and Argus* that his landlord had commissioned him to finish, and on another small historical subject: *Achilles Solacing his Anger with the Lyre*. He was negotiating with publishers about a print of *Napoleon Looking at a Sunset* and had also 'greatly improved the back-ground to Xenophon'.

At half-past five in the morning of 19 August 1830, Mary gave birth to 'a fine boy'. They thought of calling him Benjamin Robert, but settled instead on Henry. He would be 'Harry' for the course of his short life. Haydon's family now comprised a wife and six young children. His two teenaged stepsons – Simon conducting himself well as a midshipman, Orlando having won a scholarship to Wadham College, Oxford, during his stepfather's last term of imprisonment – would remain financially dependent for some time to come. One Saturday in October, three months after her husband's release, Mary had been kept up all night tending two sick infants while suckling Harry. There was no money in the house and creditors were losing patience: 'Butcher impudent – Tradesmen all insulting'. Haydon took a book of sketches and two prints of Napoleon and walked into the City. He managed to realise five guineas on the sketchbook and sold both prints, coming home with £8 4s in his pocket. A week later he was to be seen in town again with a roll of prints under his arm. 'Several people looked hard at me,' he remarked, 'but I feel more ashamed at borrowing money than in thus honestly selling my labours.' That day he sold sufficient to keep his family for a week. By the beginning of November the whole first impression of *Napoleon Looking at a Sunset* was sold out. He had also sent the Prime Minister a first proof copy of his Grace's old adversary, a gift acknowledged immediately despite pressing affairs of state: 'The Duke of Wellington presents His Compliments to Mr Haydon. The Duke begs leave to return His thanks to Mr Haydon for his Letter, and for sending to the Duke a Print.'[12] A month later Haydon wrote again, broadly reiterating the plan he had outlined early the previous year, pointing out the support given by the state to historical painting in France and contrasting it with conditions in England. He sent his letter by the nine o'clock post and had Wellington's response at two in the afternoon:

It is certainly true that the British Public give but little encouragement to the Art of Historical Painting. The reason is obvious; there are no funds at the disposal of the Crown or its Ministers that are not voted by Parliament . . . and applied strictly to the purposes for which such funds are voted. No Minister could go to Parliament with a Proposition for a vote for a Picture to be painted and there can

therefore be no such encouragement here as there is in other Countries for this Art.[13]

Haydon replied at some length. He suggested that provision be made similar to that for the purchase of the Elgin Marbles and the Angerstein collection, that a separate fund be established for 'Encouragement of Historical Painting, leaving it open to the House to support or object . . . according to the success or failure of the measure'. He warned that:

> High Art is essentially requisite to a manufacturing country . . . but if High Art be permitted to decay . . . we shall ultimately and inevitably sink beneath the nations of the Continent, not because we are . . . their inferiors, but because . . . we alone continue to be deprived of the encouragement and public support which Continental nations so liberally afford their professors.[14]

Haydon assumed this to be an irrefutable proposition that in the Arts, as in other things, Britain ought to be pre-eminent in Europe; after all, he was addressing a man who had personally led victorious armies across the Continent. Wellington, however, merely acknowledged his letter and added: 'Mr Haydon's own good sense will point out to him the impossibility of doing what he suggests.'[15] The Prime Minister had other matters on his mind; indeed, it was remarkable that he could spare the time or attention to make any reply whatsoever to Haydon's communications.

Across the country, instead of High Art, the clamour was for parliamentary reform. On 11 October, in Birmingham, a middle-class crowd of 4,000, sitting down to a dinner in commemoration of the French Revolution, had been addressed by Thomas Attwood, leader of that city's Political Union. Asked if they would follow him 'to the death in a righteous cause',[16] they responded by singing the 'Marseillaise'. There had been another revolution in France only the previous July, reviving, in Tory imaginations, fear of the same on this side of the Channel, and the response to Attwood's words must have seemed, to diehard Ultras, a prelude to an onslaught of *sans-culottes*. In Carlisle effigies of Wellington and Sir Robert Peel were burned at the market cross.[17] Nor was unrest confined to the North. Throughout October

the farming communities of eastern Kent had been terrorised by a spate of machine-breaking and cornstack-burning. Rioters were 'marching about in great numbers, breaking the machines in open day, and many of them armed with hatchets, hammers, saws, and even guns, which they discharge[d] in the midst of cheering when their work of destruction [was] accomplished'.[18] By contrast, incendiary activity was conducted by night, gangs setting fire to hayricks, barns and, on occasion, farmhouses. The outrages, though undoubtedly criminal, were not unprincipled. The *Brighton Gazette* reported 'that the conspirators do not seek money or plunder of any kind. On the Contrary, when offered money not to destroy property, they have uniformly refused it, and they have on no occasion robbed.'[19] This apparent high-mindedness indicated ideological motivation, and although the *Kent Herald* declared that there was 'little direct political feeling among the perpetrators', its further analysis suggested otherwise:

> [It is] a war of poverty against property, of destitution against possession. The poor feel that they are not permitted to enjoy, and they are determined that the rich shall not. This is the natural feeling of ignorant, coarse-minded, and ill-treated men, and it seems to have spread wide, and taken deep root.[20]

According to one activist, the destruction was part of a campaign with long-term revolutionary ends: 'We will destroy the corn-stacks and threshing-machines this year. Next year we will have a turn with the parsons; and the third we will make war upon the statesmen.'[21]

State patronage, for the time being denied him, Haydon explored the prospects of institutional patronage. An exploratory letter to Lord Farnborough having brought an assurance that 'the Directors [of the British Institution] are quite as ready to reward [his] exertions according to their judgment as they are to recompense those of any other artist whose works are laid before them',[22] Haydon presented them with a proposition. He began in practised style: 'in his present struggling condition, with 8 children and nothing on Earth left him in property but what he is clothed with after 26 years of intense and ardent devotion to Painting'. At length he arrived at the proposal: 'if the Committee would aid him by a moderate though not an unimportant sum to

finish his Xenophon, it would enable him to keep out of debt for the rest of his life.' He offered to show them the picture before they decided whether they thought him entitled to assistance. He pointed out, in support of his application, that of the £14,000 given over the years by the British Institution in premiums, he had received only £200.[23] But he had low expectations of success: 'I shall receive a cold official reply & be referred.'

As it spread from rural to urban areas, social unrest brought other issues and other grievances to the fore. In London there were strong feelings, not only for parliamentary reform, but against the New Police; against the Prime Minister who stood in the way of the one, and against the Home Secretary responsible for establishing the other. A 1,500-strong mob that marched behind a tricolour across Blackfriars Bridge, along Fleet Street and the Strand and down Whitehall on 8 November chanted: 'Reform', 'Down with the Police', 'No Wellington' and 'No Peel' as they went. There is no record of an assault on the Home Secretary, but Wellington had recently been surrounded by an angry crowd and pelted with gravel while riding in St James's Park,[24] and two days later he received intelligence from Alderman Key, the Lord Mayor-elect, that 'a set of desperate and abandoned characters'[25] intended attacking him on the occasion of the King's visit to the Guildhall on 9 November.

Haydon had also received information of an imminent plot against Wellington from his servant, who had heard it from her father, who, she said, knew one of the ringleaders. Questioned later, the girl denied her original story, having been 'scolded by her mother for saying anything about it', and so Haydon sent for the father, but he did not come. He wrote to the Duke himself. Wellington was probably expecting another appeal on behalf of High Art as he opened the letter but, to his credit, responded with no more and no less alacrity to Haydon's warning than he had to his supplications:

> The Duke requests that Mr Haydon will be so kind as to call upon Mr Phillips, the Under secretary of State at the Home Office, and state to him in detail the circumstances to which he adverts in his Note.[26]

Haydon, however, was unwilling to 'turn informer' because he had been unable to discover any further details of the plot, either from

his servant or her relations. Although the royal visit to the Guildhall was cancelled as a result of Alderman Key's intelligence rather than his own, he remained convinced 'that had the King gone to the City, most dreadful scenes would have happened'.

Reply from the British Institution came cold and official, as he had predicted. However, the Committee did not refer his case, but dealt with it on the nail, albeit not so generously as he had wished. 'The only way in which [the Directors] can entertain the subject of [your letter],' the secretary informed him, 'is by requesting your acceptance of fifty pounds.'[27] Haydon swallowed his disappointment, but managed to write to the Committee with a good grace, conveying his 'very deep sense of their kindness and to assure them it will be a very effective aid to the [well-being] of his family'.[28] The following day he called on Lord Farnborough, who had assured him of the Committee's readiness to reward his exertions. His Lordship 'seemed ashamed of the 50'.

<div align="center">★</div>

'Grey is coming in,' a supporter of the Whigs told Haydon.

'Is he?' said Haydon. 'When I see Wellington out, I'll believe it.'

A week later he heard the news: 'Wellington is out!'[29] Twenty-three years of uninterrupted Tory power had come to an end. Indeed, apart from a bare twelve months under the Whig administration of Lord Greville, the country had been Tory since William Pitt kissed the hand of George III in 1783. It had been a Tory administration that had gone to war against Napoleon and it was the outgoing Tory Prime Minister who had finally defeated him. The momentous significance of the Tory fall was not lost on Haydon when he wrote to Wellington: 'Thus ends for the present with your Grace's resignation that series of Ministers whose true English feeling and invincible bottom carried this great country through the most terrific contest that any Nation was ever engaged in.'[30] And Wellington expressed his acknowledgements 'for Mr Haydon's favorable opinion'.[31]

Having bidden farewell to the old guard, Haydon established contact with the new. He called to congratulate Brougham: no longer the plain Henry Brougham who had presented his petition to the House of Commons in 1823, but, since the formation of the Whig adminis-

tration two days earlier, Lord Chancellor, Baron Brougham and Vaux. Sending in his card, Haydon asked for a minute of his time. The servant returned to the door and there was an arch inflection to the reply: '*My Lord's* compliments; *he can't.*'

By contrast, Sir Robert Peel – his public responsibilities in temporary eclipse – had ample time to spare him. Haydon had recently sent him a proof of *Napoleon Looking at a Sunset* and Sir Robert wished to commission a whole length of the subject. He called at Burwood Place, appeared impressed with *Xenophon*, and expressed great interest in the plaster collection, although Haydon was shocked at Peel's confusion of the *Ilissos* with the *Theseus* and his mistaking the fragment of Neptune's chest for the *Borghese Torso*.

'Do the Elgin Marbles deserve all that has been said of them?' Peel asked.

'More, if possible,' Haydon replied.

'Why?'

'I will tell you.' And Haydon took it upon himself to remedy the woeful inadequacy of the former Home Secretary's education. He marshalled legs, thighs and feet, he pointed out the roll of skin at Neptune's armpit and proved that 'the union of the accidents of Nature with Ideal beauty was the great principle of Phidias, which all subsequent ages omitted in search of a higher Ideal beauty, & made *Life* no longer visible'. He felt that Peel saw all this at once.

Negotiation of the commission was not so satisfactory as the tutorial. Peel asked what he charged for painting a whole-length canvas, and Haydon told him 100 guineas. But in his own mind he drew a distinction between a 'common' whole length and the poetic sublimity of the painting he contemplated. The following day he regretted not having told his new patron 200 guineas. He finished the picture in a month, only to spend another month altering it. By the middle of March it was done and Peel was 'much pleased'. In customarily bullish spirit, Haydon claimed that 'never was a picture so admired, or . . . made so complete a hit with the Connoisseurs' as when *Napoleon Musing at St Helena* was exhibited in the Western Exchange in April 1831. There was, however, 'Objection . . . made to the large size of the epaulettes, and the colouring of the sea'.[32] The press being greatly preoccupied with constitutional matters that month, there were few notices, but happily *The Times* was fulsome, declaring that, while the

painting's qualities of scale, costume and likeness were within the reach of any and every artist, 'that which elevates this picture above the ordinary rank of portraits, is the imagination and poetical feeling with which the painter has invested it'. It was, 'in point of execution . . . one of Haydon's best works . . . painted in a broad free style, and wholly free from those violent, and sometimes coarse contrasts, which have diminished the merit of many of his former productions'.[33] It also received the endorsement of Barry Edward O'Meara, Napoleon's surgeon on St Helena, who wrote, after visiting the exhibition, that the picture was 'an admirable likeness of the late Emperor as he was when I had the honour of attending on him'.[34]

Haydon received commissions for two more *Napoleons* on the strength of his exhibition, but was disappointed by the level of attendance, which he attributed to distraction by increasingly exciting political issues. At the end of April, following a week of 'politicks, heat, fury, discussion, & battling' inside the House of Commons, and public uproar, illuminations and broken glass outside, Haydon closed his exhibition unnoticed.

Late in the previous year, under Lord Grey's Whig administration, a bill for parliamentary reform had been introduced, strenuously debated and narrowly but inevitably defeated. Following the dissolution of Parliament, the prospects of a second bill were to be greatly improved by a general election.

Captain Geoffrey Elliot circulated his printed address, introducing himself to 'The Worthy and Independent Freemen of the Borough of Plymouth', a small body of men that constituted the entire electorate:

> I appear before you as a steady supporter of the general measure of Parliamentary Reform, lately proposed by His Majesty's Ministers, convinced as I am that at the present crisis nothing can be so calculated, in its consequences to afford security to the Throne, stability to our Institutions, a full and free development of the Resources of this Great Empire, the extinguishment of Discontent, and the happiness of all Classes of His Majesty's Subjects.[35]

As a Freeman of Plymouth, Haydon was one of that select minority qualified to vote and send two representatives to the unreformed

House of Commons. On this occasion, however, he informed the Town Clerk that he would be unable to exercise his electoral rights. He expressed his admiration for Captain Elliot's 'straight forward & manly' address, but regretted that his vote could not be relied upon:

> [T]he neglect of the powerful and opulent in both parties, have so reduced my resources that I am too poor to pay for the expenses of a Journey . . . It will therefore be entirely impossible for me to Vote at all on this great & important question.[36]

In his absence, the incumbents, Sir Thomas Byam Martin and Sir George Cockburn, were re-elected with 101 and 91 votes respectively, while Elliot was the loser with sixty-three. Had he attended, Haydon would have witnessed scenes rich in material for another genre painting: the defeated Captain Elliot was drawn through the streets in a car decorated with laurels by hundreds of respectable – but as yet unfranchised – tradesmen while Sir George Cockburn, the successful anti-reform candidate, had to be escorted from the hustings by a military force brought out to defend him against the angry crowds. The Freemen who voted for Cockburn had their windows smashed, while the newly re-elected Member himself escaped with a cut below the ear from a well-aimed stone, and was thereafter confined to his hotel in fear of further physical assault, before making his departure for Devonport secretly under cover of darkness. His beaten pro-reform opponent, by contrast, left town 'attended by a band and a vast multitude'.[37]

There may have been another reason why Haydon did not exercise his Freeman's rights. Sir George Cockburn was a friend, and Haydon's 'personal feelings' were such that he could not contemplate voting for anyone else, despite his sympathy for the pro-reform candidate. Had he cast his vote for Cockburn, he would certainly have joined him as a target for the pro-reformers' stones.

<p style="text-align:center">★</p>

It was when Haydon delivered Sir Robert Peel's picture to his London home, following the close of his exhibition, that the delicate matter of the price was raised for the first time since the original commission. He now claimed that he had made a mistake in his original estimate

and that he should be paid 200 instead of 100 guineas. Peel had already paid an advance and, later, the balance on the 100 he believed to have been agreed for the work. His version of the circumstances of the agreement, and what was said at the time, differed from Haydon's. 'I must beg leave to remind you,' Peel wrote:

> That . . . my question was not 'What you had for a whole length?' but expressly what would be the charge for painting the size of life the picture of Napoleon of which I had seen an engraving? I cannot help confessing my regret that if you had made a mistake as to the terms, you did not at once apprise me of that mistake.[38]

He enclosed, however, a draft for an extra thirty guineas and considered the matter settled.

When Wordsworth came to see Peel's painting at the Western Exchange, Haydon requested a sonnet, pleading that 'if he would or could, he'd make the fortune of the picture'. A couple of months later the poet complied:

> Haydon! Let worthier judges praise the skill
> Here be thy pencil shown in truth of lines
> And charm of colours; *I* applaud those signs
> Of thought, that give the true poetic thrill;
> That unencumbered whole of blank and still,
> Sky without cloud – ocean without a wave;
> And the one Man that laboured to enslave
> The World, sole-standing high on the bare hill . . .[39]

On the same day this paean arrived in the post, Haydon returned from a walk musing on his 'certain posthumous fame', and was confronted by a creditor. Following an altercation, and receiving no satisfaction, the man departed, calling him 'a shabby fellow, a damn shabby fellow!' The epithet 'shabby' made Haydon uneasy for the whole evening. 'One does not like to be called shabby,' he observed.

Not having entirely given up the prospect of getting more for *Napoleon* than the 130 guineas he had already received, he sent Peel a copy of Wordsworth's poetic testimonial and followed it, a week later, with a further estimate of the picture's true worth. Peel replied

curtly: 'I decline paying any thing more than I have already paid for the picture to which you refer.'[40] But even this was not the last word on the subject. Four years later Haydon was still attempting to justify himself and the value he placed on his work. 'You even inform me,' wrote the indignant Sir Robert, 'that the charge ought to have been three hundred.'[41] Sticking this letter into his journal, Haydon added a note: 'Ought to have been 500.' He was eventually prepared to admit, however, that he had 'acted with great folly from beginning to end [and] offended . . . Sir Robert Peel by abominable confidence in his generosity'.

★

In September 1831 the picture dealers C. & C.J. Everett wrote to inform Haydon that they had sold *Christ's Triumphant Entry into Jerusalem* to two American clients: Cephas Crier Childs, an engraver and commercial lithographer, and Henry Inman, a portrait painter. The picture was to be shipped by the first available packet, and would form the centrepiece of the Academy of Fine Arts in Philadelphia. Haydon went to Everett's premises to see the painting for the last time and give advice 'as to the best method of packing it . . . cleaning & preserving the colours'.[42] There was a 'very fine head of a Pope, by Velasquez' in the same room and he picked it up and held it against his own picture for comparison. He was gratified to see that, although the Spaniard's head was fresher and lacked the yellow cast that predominated in many of his own, 'the penitent Girl, & the Centurion & the Canaanite Woman kept their ground triumphantly'. Reassured by the test, he determined to 'fear no competition with any other work'.

Meanwhile, another heroic canvas neared completion and, on the same day he visited Everett's showroom to bid farewell to *Jerusalem*, he ventured further application to the British Institution requesting financial assistance for *Xenophon*. He was, he informed the Directors, 'at present suffering the greatest miseries for want of means to finish it'. He had recently been forced to pawn both his lay figures, but 'the resource availed by this shocking alternative [was now] exhausted'.[43] There is no record, favourable or unfavourable, in the British Institution minutes of a response to this appeal, and Haydon was forced to

complete his picture as best he could. The Duke of Bedford helped him with ten guineas, and the lawyer Thomas Noon Talfourd, whose portrait Haydon had painted in 1827 and who had since become a 'real Friend', contributed five pounds. He was also paid by Kearsey for a small picture with a long title: *The First Child of a Young Couple – very like Papa about the Nose and Mama about the Eyes*. He began it on a Monday and finished it at four o'clock on the Tuesday afternoon. 'I never painted a Picture so quick in all my life,' he wrote with satisfaction. But when he delivered it, two days later, and Kearsey remarked: 'Ah, I suppose this was done in ¾ of an hour,' he took offence. 'What was that to the purpose?' he asked and, anticipating by forty-six years James Abbott McNeill Whistler's more celebrated justification of the market price for facility, he added: 'Were there not all the requisites of Art, & all the experience of my life?'[44]

Whether dashing off such pot-boilers or improving *Xenophon*, chasing money to pay his children's governess or deferring payment of taxes and rates, Haydon was avidly following events in the Palace of Westminster, 'Never so excited since the battle of Waterloo about Politics.' After the general election, a second bill for parliamentary reform had been introduced, strenuously debated, inevitably passed by the Whig majority in the House of Commons, and just as inevitably rejected by the Tory majority in the House of Lords. Haydon captured the mood of tense anticlimax in a picture entitled *Waiting for The Times, the Morning after the Debate on Reform, 8 October 1831*. In the White Horse Cellar coffee house on Piccadilly, one man, concealed behind newsprint, devours the report while another gloomily awaits his turn. The *Times* editorial that morning began ominously:

> The debate is over, – the decision is made. May it not be 'the beginning of the end!' . . . 'What is this fearful crisis to result in?' Is any man on earth prepared to conjecture what will take place in England before this day week?[45]

A fortnight later, signing himself 'Radical, Junior', Haydon wrote to the editor, deploring the fact that the British people who had paid their taxes, spilled their blood and 'put down Napoleon for the honour of old England' should be denied their electoral rights and branded 'seditious' when they demanded them. He declared that, if the chance

of reform 'be suffered to rise and to ebb from want of nerve', then the nation would deserve 'the contempt of the world' and its rulers 'a disgust which history will immortalise'.[46]

Later in October, *Xenophon and the Ten Thousand, first Seeing the Sea from Mount Thèches* was finished. On the crest of a ridge at the very top of the composition the tiny figure of the Spartan commander, mounted on a rearing skewbald charger, raised his helmet and pointed to the horizon. The words 'Thalatta, Thalatta' could be imagined echoing down the mountainside, 'The Sea, The Sea', as the cry was taken up and repeated back through the weary, desperate army. At the bottom of the canvas the foreground was dominated by a white Arab stallion on which a General carried his wife. To the left an old soldier supported an exhausted youth who had collapsed, unable to go further, while behind the horse on the right a young man carried an old man on his back. Cymbals clashed, banners waved, trumpets blared and the dense throng could be seen passing through a cleft in the rocks to appear on the far side of the crag below Xenophon, 'the horses excited and snuffing up the sea air with ecstasy'.[47]

The picture was to be raffled as soon as eighty ten-guinea shares in it had been sold. Unlike the 500 guineas raised in subscriptions for *Eucles*, which was paid to the trustees and distributed to his creditors, the 800 guineas expected for *Xenophon* would accrue directly, albeit intermittently, to the artist. In addition, the quality and nobility gracing his subscription list would reflect well on him and enhance his reputation. And so, when a letter arrived from Windsor Castle, it was not just the prospect of another ten guineas that sent Haydon into transports: 'A Glorious day! The king, William IV, has consented to place his name at the head of my list for Xenophon. Huzza! God bless him.' Later, his Majesty's sister-in-law, the Duchess of Kent, and her daughter, the Princess Victoria, would occupy second and third places on the list.

<div align="center">★</div>

Widespread unrest had occurred during the month following defeat of the second bill. Along with the customary smashing of anti-reformers' windows, there were more serious outbreaks of violence against property. Riots broke out in Nottingham, Derby and, worst

of all, Bristol, where over three days in early November, a large number
of buildings in the centre of town were burned, along with the Bishop's
palace. Order was eventually restored, as it had been at St Peter's Field
in Manchester twelve years previously, by cavalry charge:

> Numbers were cut down and ridden over; some were driven into the
> burning houses, out of which they were never seen to return, and [the]
> dragoons after sabreing all that they could at the Square, riding at the
> miserable mob in all directions; about 120 of the incendiaries were
> killed and wounded here.[48]

The total number of casualties in the so-called 'Bristol Reform riots'
was put at around 400.

A second letter, bearing the signature 'Radical, Junior', appeared
on 19 November. It included the account of a gentleman – presumed
to be the correspondent himself – visiting a political dissident in prison
a decade previously, and finding him 'manly, unshaken, but bowed by
oppression'. John Hunt was, in May 1821, beginning another incarcer-
ation at the Cold Bath Fields House of Correction, this time for
libelling the Commons as a body of 'venal boroughmongers, grasping
placemen, greedy adventurers, and aspiring title-hunters . . . a body, in
short, containing a far greater portion of public criminals than public
guardians'.[49] Later, during the evening, the gentleman found himself
at a fashionable ball, 'a scene of enchantment, [such] a contrast to the
hell he had just left, and the oppressed man he had just talked to, that
it was not to be borne without agitation'. Retreating to a less-congested
chamber, he recognised the government minister most identified with
the suspension of habeas corpus, the very embodiment of state oppres-
sion, Lord Castlereagh, 'bending down in close whisper with the French
Ambassador . . . a smiling air of despotism and self-will in his hand-
some face not to be forgotten'. The gentleman, thinking of the pris-
oner he had lately left, stared at 'the oppressor in all the luxurious
enjoyments of life' and asked himself: 'how long . . . can this last? . . .
What must be this man's end?' A year later, his Lordship was observed
by the gentleman again, at George IV's coronation, but the following
year Castlereagh slit his throat 'and was lowered to the grave with
the execrations of the people'. Haydon's extraordinary homily urged
restraint and forbearance in the wake of a further setback to reform:

'Be patient – be enduring – but never yield.'[50] When the Great Reform Bill of 1832 was finally passed, Haydon would claim a measure of the credit for its success, from 'these glorious letters, the best thing I ever wrote'.

A third and final letter was promised from 'Radical, Junior', but this would have to wait another four months.[51] The day his parable on Lord Castlereagh appeared, Haydon's family was in mourning. At half-past one in the afternoon of 18 November, his daughter Fanny, whose delivery had coincided with the passing of the bill for Catholic emancipation, died, aged two years and eight months. She had never walked or learned to speak. Her father had noted in passing an unspecified illness five months previously, but the fatal crisis must have been of much shorter duration. After she died he made reference to her being 'diseased . . . in the mesenteric glands', a condition that usually meant abdominal tuberculosis. On the last day they had managed to calm the violence of her convulsions with a warm bath. She became conscious of her father's presence and stretched out her arms to him, in terror at what was happening to her. 'Do you love me, Fanny?' he asked her, and he claimed that 'she moaned a distinct sign of assent'. Again she was convulsed and again lay still, 'her eyes became fixed; she gasped at intervals'. He left her for a moment to go to his painting room and when he returned she was dead. 'What a blessing she is gone, sir,' the surgeon remarked. Her enlarged head and 'deranged spine' alone would have condemned her to a crippled life, 'dependent and wretched'.

During this, his first direct experience of death since that of his mother, Haydon examined the detachment of his behaviour with some bemusement. While out ordering a coffin for the child, he could yet call at the Egyptian Hall to make arrangements for the exhibition of *Xenophon*, early the following year. Coming out into Piccadilly, he recalled that there was no ketchup at home, stepped into 'a celebrated shop' – probably Fortnum & Mason Ltd – to buy a bottle and carried it back to Burwood Place in his pocket. 'I wept bitterly at her death,' he observed, '& did not feel less hungry of my dinner!' The day after Fanny was buried in Paddington churchyard, Haydon began work on a new painting, using his six-year-old son Alfred as model. The subject, he anticipated, would be a 'piercing' one. Like his late sister, Alfred had been sickly from birth, his glands never right, his joints painful.

Haydon wept as he painted the child. 'There he sat, drooping like a surcharged flower; as I looked at him, I thought what an exquisite subject *a dying child would make* . . . There he dozed, beautiful & sickly, his feet, his dear hands, his head, all dying, drooping, & decaying.' *The Dying Boy* took him just two months to paint and he accepted an offer of twenty-five guineas before it was finished. It would be a further sixteen months before Alfred Haydon actually died.

'There is no artist who makes happier hits or greater failures than Mr Haydon, and this picture unites the two extremes.' So wrote the correspondent of the *Gentleman's Magazine* when *Xenophon* went on show at the Egyptian Hall in March 1832. Although conceding that 'the beauties predominate' over the failures, notably in the foreground figures, he expressed serious reservations about 'the limitation of canvas'. At 11½ feet by 9½, this was Haydon's biggest since *Lazarus*, but it would have taken something much closer to that mighty expanse to allow the composition to spread and fully meet the expectations raised by its subject. As it was, everything seemed cramped, and even the extra breadth of the frame might have made a difference. Xenophon would have had room to raise his helmet as he shouted, 'without destroying half of it'. Then 'a few more inches of space' would have eased the congestion for the army rushing through the pass at the left. At the bottom 'ten inches or a foot of canvas would have given us the horse's legs . . . now cut off at the knees', while with the same added at the right, 'the head of a horse might have been introduced instead of his nose only'.[52] Sadly, the canvas was to suffer further 'limitation' in its later history: when it was sold at auction in 1991, two and a half feet appeared to have been cropped from its longest dimension and even the horse's nose was gone.[53]

Opposite *Xenophon* hung *The Mock Election*, on loan from the King, while elsewhere in the room there were fourteen or fifteen smaller pictures, 'executed in a sketchy manner' and of 'a dauby appearance', among which were *Achilles Solacing his Anger*, *Doll Tearsheet Soothing Falstaff*, *The First Child*, *The First Start in Life*, *The Dying Boy*, *Sunday Evening – Reading the Scriptures*, *Waiting for the Times* and a scene from Ovid: *Mercury playing Argus Asleep, to release Io from the shape of a Cow*, which the *Gentleman's Magazine* deemed 'a miserable performance'. There were also three 'very poor' *Napoleons*: one musing in Egypt, one in Fontainebleau and one 'on his future Grave

at St Helena'. All but the *Napoleons* were prominently labelled 'Sold', prompting the critic to ask, somewhat disingenuously: 'How can Mr Haydon complain of want of patronage?'[54] In his sixpenny catalogue Haydon took the opportunity of outlining the crisis besetting 'High Art' and the danger of its 'sinking to the lowest depth of impotence and insipidity', unless the government 'take up and foster the historical art of the country'. He also informed the public that he worked 'under every disadvantage' and, without making any mention of the Royal Academy, left no doubt as to the organisation responsible:

> The personal enmity of forty men . . . who from my earliest years have ever underrated, whatever merit I may have possessed, personally or professionally, without in the first instance my doing any thing to provoke them is a load I have always had to labour under, and always to combat.[55]

Wilkie visited, looked at *Xenophon* a long time and said: 'It is a great work, let 'em say what they will.' The Duchess of Kent and the thirteen-year-old Princess Victoria came and saw the picture their ten-guinea shares afforded them the chance of winning, but made no recorded comment. 'They know nothing of High Art,' a courtier whispered to Haydon as the ladies left.

Meanwhile the campaign for parliamentary reform ground slowly on. Following defeat by the Lords in October, the bill had been reintroduced in December, debated perfunctorily – since everything, both in its favour and against, had already been said – and again passed by the Commons. It scraped a passage partway through the Lords by a majority of nine, only to stall when Tory diehards voted to dismantle the all-important clause for disfranchising fifty-six rotten boroughs. The crisis kept Haydon awake from one till four in the morning, 'heart beating violently about this Reform bill'. Grey and his ministers resigned en masse, only to resume office six days later, having been given an assurance that the Upper House would pass the bill without further interference – or be flooded by fifty to sixty newly created Whig peers to ensure it did so.

With the return of Grey and successful passage of the bill assured, the threat of violent insurrection, even civil war, was averted. The

greatest manifestation of popular rejoicing took place in the Midlands
when, on 16 May 1832, a vast crowd assembled on Newhall Hill to
hear Thomas Attwood, head of the Birmingham Political Union and
the man who had once exhorted his members to follow him 'to the
death in a righteous cause'. It was Attwood's moderating leadership
and insistence on peaceful protest, however, that had ensured the
authorities were given no provocation and no excuse for the deploy-
ment of dragoons wielding rough-sharpened sabres intended to inflict
the most ragged possible wounds.[56] Attwood gave a speech of congrat-
ulation and thanks, urging the necessity for patience while the bill
continued its passage into law. But the most stirring moment had
come at the very beginning of the meeting when, as 'all hats were
taken off, and the most death-like silence pervaded the immense
assembly', the Reverend Hugh Hutton stepped forward to deliver an
extemporised grace:

> We thank thee, the God of all blessings, for delivering us from the
> bonds of our oppressors, and the designs of designing and bloody-
> minded men. . . . Grant that we may so use and improve the great privi-
> leges thou hast conferred upon us, that we may secure them to us and
> our children, for thy glory, and for the universal benefit of the family
> of man.

The collective murmur of 50,000 voices rumbled: 'Amen, Amen.'[57]

Haydon later claimed to have wept when he read the account,
although his journal at the time makes no mention of it, being more
concerned with events in Parliament, painting a small Crucifixion,
selling the copyright of *Waiting for The Times* and his usual money
worries. He had written to a number of *Xenophon* subscribers, including
the King, explaining that because the exhibition had not met with the
success he had anticipated, he 'was without a resource'. He also wrote
to Sir Robert Peel, offering to paint him a portrait of the fourteenth-
century Church reformer John Wycliffe, but this was clearly an appli-
cation too far for Peel's sorely tried patience. 'I think it rather hard,'
came the reply:

> that because I manifested a desire to assist you in your former difficul-
> ties I should be exposed to the incessant applications which I have since

received from you . . . I cannot give you commissions for pictures which I do not require.[58]

The following day a letter was sent from St James's Palace bearing a less blunt, but equally discouraging message:

I am commanded to state that the demands on His Majesty are so pressing and numerous that His Majesty is unable to comply with your request, with reference to any Pecuniary assistance.[59]

Unabashed by such disappointments, Haydon embarked on a work intended to catch the great wave of political euphoria sweeping the country. He had been considering a 'Reform' picture for some weeks, seeing it as a potentially 'glorious conclusion' to the series he had contemplated for the walls of the House of Lords since 1812 and still hoped to accomplish. Even before the triumphant meeting of the unions on Newhall Hill, he had written to Attwood asking to be given prior notice of such events, but having missed both that and an even larger gathering at the same location the week before, he determined to recreate the sublime moment at which the Reverend Hutton raised his hands and gave thanks to God for blood-less victory, based on the portraiture of those involved, together with eye-witness testimony. Hutton responded immediately to his request for cooperation, promising 'easy access' to 'most of the principal actors' and observing that some of them had 'remarkably striking heads for such a picture'.[60] Attwood also promised every cooperation, but this did not extend to making a contribution to Haydon's coach fare: 'The men of Birmingham are rich . . . in virtue & public spirit,' he told the painter, 'but certainly we are sufficiently poor in pocket.'[61] Clearly the Birmingham Union was in no position to commission the picture either, and so Haydon evolved a plan. If he did it as 'a private speculation', he would have to paint the scene half the size of life, about the same size as *The Mock Election*. That would be a pity, he told Hutton, as the subject would then lose 'half its power, its national interest, and its sublimity'. A picture the size of *Solomon* – twelve feet by ten – would be preferable, paid for by public subscription, and the 'sublime scene' displayed in some public room in Birmingham 'as a memorial as long as colours & canvas . . .

will last'.[62] This proposition having been agreed to, trustees appointed and an announcement inviting subscribers printed in the *Examiner*,[63] Haydon set about gathering funds for his journey and, after a day's travel – 'alternately baked, drenched, squeezed, cramped, & broiled' – arrived in Birmingham.

Attwood was the first to sit, telling anecdotes of the struggle for reform, quoting at length from one of his first speeches: 'Suppose, my Friends, we had two million of threads; suppose we wound these two million threads into a good strong rope; suppose we turned that rope into a mighty cable, with hook at the end of it, & put it into the nose of the borough-mongers, d'ye think we should not drag the Leviathan to shore?' The blood rushed to his face as he talked.

Hutton sat, eyes raised, hands lifted and clasped in re-enactment of his celebrated prayer. He invited Haydon to dine: 'two bottles of wine bought for the occasion, shaken & hot, a leg of mutton, home made tarts, & everything denoting a limited income & principle'.

A veteran named Beddell sat. 'What's your name,' he asked the painter, 'Baker?'

'No, not Baker,' Haydon replied.

'What then?'

'Haydon.'

'Haydon! I never heard of 'ee.'

Beddell's radical ambitions went further than the modest parliamentary reform that Lord Grey was steering into law. 'I shall never be happy,' he told Haydon, 'till I see the damned Oli*gracky*'s nose brought to the mud, & all the Aristo*crits* along with it.'

George Edmonds, who once stood trial for seditious conspiracy, sat with arms crossed. Haydon thought his powerful features would make a 'Capital head for Committee of Public Safety, 1793, Paris'.[64]

Joshua Scholefield, Vice-President of the Political Union, sat. He explained over dinner that 'the strong Republican feelings at Birmingham' were due to the town's trading links with America.

It proved impracticable to recreate the great assembly on Newhall Hill for Haydon's benefit and he had to be content, instead, with attending a large indoor meeting of the Union Council. He was standing in a passageway, sketching and observing the heads by lamplight, when someone came and pressed a ragged scrap of paper into his hand. The ink-blotted message read: 'Sir, Be careful or you will

take Cold by standing in the draft.'[65] Haydon stuck the relic in his diary 'as a proof of the kind feeling of the people of Birmingham'.

After a week and a half of intensive work, sometimes producing three chalk portrait heads a day, Haydon exhibited his drawings and returned to London. Another announcement appeared in the *Examiner*:

HAYDON'S GRAND PICTURE of the SUBLIME SCENE at NEW-HALL HILL . . . To be painted by subscription of One Guinea each from 500 Reformers – the names of the subscribers to be painted on the back – each subscriber to be entitled to a print in mezzotinto; and the Picture to be presented to the Town of Birmingham by the Trustees . . . Mr Haydon has made sketches of Mr Attwood and all the leading men, which are pronounced decided likenesses, he has all his materials ready . . . and he calls earnestly on all the Reformers in the three Kingdoms to support him at once . . . It is the most extraordinary subject in history.[66]

There followed the names of sixty-five people who had, thus far, agreed to subscribe. In the same week that the advertisement appeared, Haydon called on Lord Grey to solicit his name and a guinea to lead the subscription list. As he waited to be admitted, Haydon drew a sketch of the composition he had in mind. Grey appeared remarkably fresh for all the strain, 'fag & labour' he had undergone during the previous turbulent month, and Haydon complimented him on his looks. Then they talked of Newhall Hill and the picture for which his Lordship's support was wanted. Haydon sensed a patrician contempt for the Birmingham radicals and, when handed the sketch, Grey returned it without a word and barely a glance. 'I wish to explain to you,' he then said, 'it would not be delicate for me, as a Minister, to head any subscription connected with the Unions.'

'Perhaps it was indelicate in me to expect it,' Haydon replied.

All was not lost, however, and his Lordship went on: 'But I should be happy to subscribe to any other subject connected with Reform.'

'My Lord, I should be proud to paint the great Leaders – the Ministry.'

'Suppose,' said Grey, 'you paint the grand dinner in the city, where we shall all be on the eleventh.'

'I should be delighted.'

Grey 'seemed much pleased' and instructed his secretary to write to the Lord Mayor requesting a good place at dinner for the painter.

Haydon began painting his Birmingham canvas at the end of June, but thereafter the sublime scene on Newhall Hill became less and less likely to be immortalised, as it appeared that only thirty of the sixty-five reformers named in the *Examiner* had actually paid their guinea. Towards the end of July, as the recruitment of subscribers languished, the Reverend Hutton counselled patience. The list was 'advancing quite as fast as [he] expected' and he was 'sanguine in . . . anticipation of complete success'. By the time the picture was finished, he 'look[ed] with confidence for a great augmentation of names'. Haydon, meanwhile, was to keep his mind 'fixed upon [his] immortal work'.[67] But Haydon's mind was understandably distracted by the unpleasant thought that, even taking into account the generosity of one trustee who had contributed fifty guineas to keep the scheme afloat, the total amount raised thus far was only eighty guineas. He therefore lowered his sights from the 500 guineas he had originally demanded to a bare 100, if only another twenty subscribers could be persuaded to make up the sum. The list of subscribers increased, but so did the number of defaulters. 'The fact was,' Haydon recalled, 'that one hundred of these gentlemen put down their names as subscribers, and never paid their subscription.'[68] By September the picture had been abandoned, and was eventually taken off its stretcher and divided into smaller canvases. An oil sketch measuring three feet by nearly two and a half is all that remains in Birmingham of the 'immortal work', together with sixteen portrait heads, half of them damaged by fire.[69]

Happily, Haydon's other *Reform* picture fared better: 11 July 1832 found him at the Guildhall sitting underneath a reeling mass of marble figures comprising Pitt the Elder, two ladies representing Commerce and Manufacture, Britannia, a lion, assorted boys, a cornucopia and a beehive – all, as an eminent artist once observed, 'tumbled out of a wagon from the top of the pyramid'.[70] From the vantage point of John Bacon's monument to the First Earl of Chatham, he had a fine view of the eastern end of the hall, where the great window had been blocked up for the occasion, covered in black material with a crown, the letters W and R and, above the royal initials,

the single word 'REFORM', all picked out in gas jets. 'Underneath, flags and weapons of various descriptions were grouped together with very exquisite taste',[71] and dropping from there to the floor a series of mirrors reflected the length of the hall and its west end, dominated by crests and insignia: the Cap of Maintenance, crossed Sword and Sceptre and an elaborate transparency of the Star of the Order of the Garter.

Haydon had arrived early in the morning and worked throughout the day, painting the main architectural features and decorations of the room 'amidst gas men & waiters & uproar' and all the confused preparation for the great banquet: 'the crashing of twenty-four hundred plates (for every body had three) on the tables in ten minutes, from huge baskets placed at intervals; the jingling of thousands of knives and forks; the dead thumping of hundreds of salt-cellars; the music of thousands of glasses, tumblers, and bottles; the calling and quarrelling of waiters; the scolding of directors; the tacking of upholsterers; and the hammering of carpenters'.[72]

In the evening, when the hall was full, he 'dashed away' at his canvas. 'What a night!' he wrote to William Newton, 'I painted . . . before 800 people!'[73] Just as he had painted himself leaning from an upper window of the King's Bench Prison as witness to the farcical climax of the Mock Election, so, in the finished picture of *The Reform Banquet*, Haydon would appear in profile, recording the scene, halfway up the extreme right edge of the canvas.

He had told Grey that he would be making a sketch in oil 'while you are all at dessert', this being the course of the banquet that he would represent in the finished picture. He warned that 'likeness is out of the question' in the preliminary sketch, but gave assurance that 'the effect will be gorgeous'. He had also endeavoured to prepare his patron for the unappealing early stages of a work of art, mysteries normally confined to the privacy of the painting room. 'Do not you be shocked,' he told him, 'only let me do as I like – take no notice.'[74] Nevertheless, the artist ensconced by the Chatham Memorial proved 'an object of great interest to all the Nobility', was treated with 'great distinction' and plied with wine, which he was 'obliged to sip' for fear of being 'more inspired than was requisite'. He was, nonetheless, intoxicated by the very splendour of the occasion: 'The gorgeous scene was so exciting that when I came home I was almost

like a Woman *in a fit* . . . Altogether it was the proudest day of my Life.'[75]

A week later he called to show his patron the finished sketch and settled the details of the commission. Asked how much it would be, Haydon replied 500 guineas. His Lordship's secretary, Charles Wood, was present when the price was agreed: '500 gs., so no mistake'. Lady Grey entered the room and was shown the sketch.

'Anne, I mean this for Howick.'

'I am delighted to paint it for your Lordship,' Haydon gushed, 'where it will be kept for ever in your family. I glory in it,' he added.

'And so do I,' said Lady Grey.

Her husband looked pleased. 'You like your subject, I am sure,' he said to Haydon.

'Indeed, do I,' Haydon replied.

Four days later he was back for Grey's first portrait sitting.

'How long will you be?'

'Half an hour, my Lord.'

'May I read?'

'If your Lordship will hold your head high.'

'Where must I sit?'

'Opposite the window.'

His Lordship sighed as though it was all a great bore. He read documents from a ministerial box as he sat. There were minor interruptions of household business and at one point Grey had to leave the room. Haydon, left alone, eyed the box, realised that he had only to walk across the room to probe the secrets of the nation, but kept to his post and his honour, filling in the background of the drawing while he waited. His Lordship returned and resumed sitting.

'Why do you not exhibit?' he asked at one point as the conversation turned to the Royal Academy.

'My Lord, we had a quarrel.'

'Ah, but that may be set right?'

'I fear not, my Lord.'

A week later Grey advanced him 250 guineas, half the fee. It enabled Haydon to pay off some debts, rearrange others and take his family to Broadstairs for the best part of a month. All were 'vastly benefitted', little Alfred in particular. 'After the warm bath, [he] said he had not had pains in his knees for two days!'

Haydon had hoped that the subscription for *Xenophon* would reach its target sum of 800 guineas during the run of his exhibition, but at the time the catalogue was printed, only forty-three shares had been sold and it would be another four years before the list was full and the raffle could take place. And if subscribers were slow to join his list, the public had not flocked to his exhibition, either. A month after the opening he noted: 'Xenophon is not failing, but it is not succeeding.' This unremunerative limbo lasted for five months and, when he closed and moved his pictures out of the Egyptian Hall at the end of August and receipts of £167 6s 3d were offset against expenses of £170 10s, he found he had suffered a small loss of £3 3s 9d. 'A blessing not to lose more,' he remarked philosophically.

<div align="center">*</div>

For eighteen months, from September 1832 until early 1834, Haydon painted more than 100 individual portraits – Lords, Members of Parliament, Deputies, Committee men – for the commemorative carpet of faces that was to become *The Reform Banquet*. A list of sitters was drawn up in consultation with the Duke of Sussex.[76] Only those gentlemen who had attended the Guildhall banquet were to be shown sitting at table. Certain old reformers and Whigs, 'who were invited but did not come', or whose contribution to the cause required recognition, were placed in a group on steps at the left, as if merely observing the occasion. Each one, whether participant or absentee, required several sittings – first a careful chalk drawing was made, sometimes an oil sketch, before the head could be 'put in' to the picture.

Haydon called first on Lord Brougham to request a sitting, but the Chancellor was too busy to see him without an appointment. Lord Nugent, however, sat happily amidst a bustle of baggage and servants, preparing to embark for the Mediterranean; he showed off his dogs and weapons and invited Haydon to Corfu. 'You can be out in 3 weeks in a steamer', he urged.

Lord Melbourne sat, 'a delightful, easy, frank, unaffected, man of Fashion'. They talked of Hazlitt, Leigh Hunt, Keats and Shelley, and his Lordship was amused by the painter's anecdotes. Haydon was, as ever, entranced by aristocracy: 'There is nothing like 'em when they add intelligence to breeding.'

Lord Althorp sat in Downing Street, 'not so conversational as Lord Melbourne, but the essence of good nature'. Haydon tried to get him talking about the cliff-hanging political drama of the previous May: 'My Lord, for the first time in my life I scarcely slept, when Lord Grey was out during the Bill – were you not deeply anxious?'

'I do not know,' came the reply, 'I am *never really anxious.*'

A second visit, the following day, to paint an oil sketch proved a disaster. Althorp had agreed to sit to an engraver at the same time, and Haydon felt degraded by contact with the lesser artist, 'herded with the trade' when he should have been 'treated with a distinction, that separated [him] from the cattle'. Irritated and distracted, he was uncomfortably aware of painting badly. Wickam, his Lordship's secretary, came behind him to watch the progress and Haydon saw 'a slight shade of painful feeling' pass over the sitter's face. 'I have no doubt Wickam had made a sign, "It was not like."' Nevertheless, Althorp later agreed to purchase a set of eighty chalk sketches of the reformers from Haydon for £210.

Lord Lansdowne sat. As a boy, he had known Reynolds and remembered his ear trumpet. Later he had sat to Lawrence. 'Did Lawrence require many sittings?' asked Haydon.

'*Many,*' replied Lansdowne.

'Did he talk much?'

'A great deal.'

'Was he literate?'

'Why, he had much English Poetry . . .'

It occurred to Haydon that, 'by painting the same people Lawrence . . . painted, and looking afterwards at his Portraits of them, [he would] pass through a fine course of Portrait study'. He painted Lansdowne in profile, as Lawrence had done, but was not happy with the result.

Lord John Russell, who had framed the Reform Bill, sat and was highly pleased with his portrait. 'Did you ever paint the Duke of Wellington?' he asked Haydon. Haydon said that he had not and, moreover, in view of his Grace's opposition to reform, he had no interest in ever doing so. It would be another six years before he started work on his first portrait of the hero of Waterloo.

The Duke of Richmond sat: 'a fine head – spare, deep toned colour,

& keen look'. The Duchess came in to watch and Haydon suspected she thought the study not handsome enough.

Lord Goderich sat, and they talked of the Royal Academy and its imminent move from Somerset House to share premises with a National Gallery in Trafalgar Square. Haydon deplored the prospect of 'bringing the annual efforts of British Artists in[to] comparison with the choicest works of the choicest ages', because 'the opinion of British Art [would] sink'. He assured this captive sitter, as he would every person of greater or lesser influence who sat to him at every opportunity in the coming months, that the only hope for British art was 'a moderate and regular vote [of money by Parliament] to support History'.

Haydon divided his aristocratic sitters into three categories: 'Those Noblemen who come to me, those who oblige me to come to them, and those who do not sit at all'. For some time the Lord Chancellor was of the third category. The painter had made several attempts at an appointment, but his elusive sitter was either too occupied in ministerial business or sick. 'Lord Brougham is very ill in a quinzey,' he was told on one occasion. Then Lady Brougham wrote to say that her husband had recovered his health, but had far too many official engagements to sit. After four months Haydon was losing patience. 'Brougham may talk of the Burden of the Peerage,' he observed, 'but no man *born* to the Peerage affects so much the Peer.' Eventually he was forced to the unsatisfactory expedient of painting the head from a cast. 'Ah, but it is like him,' someone said, 'as much as to say "damn him."'

Along with the Lords who had supported and voted for reform, the members of the committee responsible for organising the Reform Banquet were to be included. Mr Fletcher, the Chairman, sat, and a number of other committee members and deputies that Haydon did not dignify by naming. He was amused by the contrast between these self-important City types and his aristocratic sitters. While Lord Cavendish, comfortable in his rank, told the painter he could make whatever use he wanted of his face – full, half or three-quarters – and put him anywhere he liked, the committee men would 'march up to the Picture & say, "Put me *there*,"' as close to Lord Grey as possible.

Lord Grey himself, as serving Prime Minister, was often difficult

to pin down for a sitting. In October, the focus of international affairs being the enforcement of Belgian independence from the Netherlands, he was much in conference with the Prussian and French ambassadors. After Haydon had waited an hour and a half in an ante-chamber, he was told by Grey's son that Talleyrand had been there earlier, 'but it is *that Bulow who keeps him*'. In December the closing stages of a French siege of the Dutch garrison in Belgium became a preoccupation. 'My Father is so engaged I can't promise when he will sit,' Colonel Grey advised. '*You had better stop till Antwerp is taken, Mr Haydon.*'

Lord Auckland sat, both he and the painter excited by Whig successes in the recent general election, the first since the Reform Bill's passing. 'Truly it justified *all* that had been done for the middle classes,' said his Lordship. Sir John Hobhouse and Sir Francis Burdett had been elected to Westminster, and Haydon said he would have carried Hobhouse round himself 'if a chair was wanting'. His old friend Sir George Cockburn, no doubt recalling the thrown stones of his previous candidature, did not stand at Plymouth, leaving the field open to two unopposed Whigs, who were sent to the House of Commons by an electorate increased from 255 to 1,415. Under the provisions of the new Act, however, Haydon was not one of them. Freeman though he was, as a non-resident of the constituency he had lost the franchise. Even before the bill became law, he had written to Lord Grey suggesting that 'it would be honourable to Genius if those who had their freedoms voted to them, either for their talents or bravery, should be still allowed to retain their rights, notwithstanding they were non-residents'. Grey, however, was not minded to alter the provisions of the bill for the benefit of Genius, however deserving.

By Christmas Haydon was 'sick of Sitters'. A butler brought cutlery, plate and candlesticks from the Mansion House, so that Haydon could work on the inanimate elements of his composition. He revelled 'in plate, rich half tints against flesh, gold behind black coats, and glitter by the side of silvery cravats'. On the last day of 1832 he painted for ten and a half hours, his 'eyes like iron', and on the first day of 1833 he resumed his schedule of sitters with Joseph Hume, MP for Middlesex, finding him to be of like mind upon important matters. The Royal Academy had invited him to their dinner and Hume had

refused. 'He agreed with me in everything,' Haydon enthused. He promised to 'move a Committee of examination' to call the Academy to account and, it was to be hoped, he would prove '[a] useful lever for the Cause of Art'.

Late in January, Brougham's refusal to sit was becoming a joke. Haydon had painted him from the cast to look as ugly as possible. Lord Melbourne had been the first to see the result, and kept chuckling and talking to himself as he looked at it. Ladies saw it and chided Haydon with 'doing something mean to Lord Brougham'.

Lord Grey visited with his son, and Colonel Grey said, 'At any rate, you have made the Chancellor monster enough.'

Lord Grey began to laugh and Haydon protested, 'What can I do? It must remain if he does not sit.'

The trick worked. Word of the monstrosity reached the Chancellor's home and a letter arrived from Lady Brougham making an appointment for eleven o'clock, Sunday week.

'Ah, ah, my Lord,' crowed Haydon, 'by Heavens you should have descended to Posterity as ugly a chancellor as ever wore wig.'

Brougham proved worth the wait. 'It is many years since I saw you, Mr Haydon,' he said as they shook hands. And Haydon noticed that, in the interim, his appearance had greatly improved. His manner, dress, even his facial expression were relaxed in 'the consciousness of his superior elevation'. He had made an effort for his sitting, 'hair in apple pie order', and 'wetted his lips to make them look red, & lessened the protruberance'. He was abusive about Lawrence's portrait: six sittings and it looked nothing like him. 'If he would sit to me six times,' Haydon thought of saying, 'I would make it like him.' But Brougham complained that he 'had not a hal'penny worth of time' and Haydon had to make what he could of the extraordinary face before him:

> His eye is as fine as any eye I ever saw. It is like a Lion's watching for prey; it is clear grey, the light vibrating at the bottom of the Iris, and the cornea shining, silvery & tense. His hair is dark grey, but straggling over very grey. His brows were quite dark grey, & a little shaggy; his complexion clear & healthy, & his whole face cut up in strong divisions.

During the following week the Duke of Cleveland sat, also Lord
Westminster, Lord Ebrington and, on the Sunday, the Lord Chancellor
again. Brougham's stepdaughter, Anne Spalding, stood to Haydon's
side as he worked. 'I can't sit long,' Brougham had warned as he came
in and when the Lord Advocate, Francis Jeffrey, sent in his card, he

started out of his chair: 'I must go.' Haydon was, at that moment, producing 'the very best sketch [he] had ever made in chalk', and pleaded for more time.

'Five minutes more, my Lord, for God's sake.'

'I can't, I can't.'

'Consider the importance, Papa', urged Miss Spalding, she and the painter working on the busy statesman until he agreed to another five minutes before noon. When the drawing was finished, Brougham said it was the best ever done of him. He signed and dated it, mistaking 10 February for the 9th.

'Shall I say "H. Brougham" or "Brougham?"' he asked.

'"Brougham,"' said Haydon.

Three days later, hard at work putting the Chancellor's head into his picture, between Lord Althorp's and the Lord Mayor's, Haydon's ally of the previous sitting, Miss Spalding, called. She was accompanied by her friend, the Honourable Mrs Caroline Norton, poet and beauty. The ladies teased him with the accusation of flattering Brougham. 'You should paint *us*, Mr Haydon,' said Mrs Norton archly. It was the first reference to her in his journal. He was smitten: 'every body else looks ugly by her side – pale, intelligent, & extremely delicate. She looked like a bit of Greek sculpture, just breaking into life.'

Author of long narrative poems *The Sorrows of Rosalie* and *The Undying One* – a variant on the legend of the Wandering Jew – Caroline came from a refined but impecunious family, descended from the Irish dramatist Richard Brinsley Sheridan. She and her two sisters, Lady Seymour and Mrs Blackwood, rivalled one another in looks and were known in society, predictably, as 'The Three Graces'. Haydon was dazzled by all of them, but it was his infatuation with the brilliant and vivacious Mrs Norton that was later to place a strain upon his marriage. Caroline's own six-year union with the Honourable George Chapple Norton was a loveless, drifting wreck.

A fortnight later he dined at the lady's home, in the company of Lord Melbourne, Benjamin Disraeli and others. Disraeli, he thought, 'too much affect[ed] the tone of fashion, without the real consciousness that birth gives'. Suspicious of this suave young novelist and would-be politician, especially of his enthusiasm for the East, Haydon framed a question in his mind, 'if he preferred Aegypt, where Sodomy

was *preferment*, to England, where it very properly was *Death*'. He had a horror of homosexuality and regarded Disraeli's flamboyant dress and behaviour as sure signs of the abomination: 'no man would go on in that odd manner, wear green velvet trowsers & ruffles, without having odd feelings. He ought to be kicked. I hate the look of the fellow.' A notorious sexual scandal was about to set the drawing rooms of London buzzing, when Charles Baring Wall, MP for Guildford, was charged with 'an attempt to commit an unnatural offence on the person of John Palmer, a policeman'.[77] The case would provoke indignant protestation from Haydon: 'The very look of a man is enough to make one sick – any man. The touch of a man is poison to one's feelings. When I have a model, I hate even to touch his wrist. I always put myself in the attitude, & let him imitate. It is dreadful!' At Mrs Norton's table he considered voicing his thoughts on the comparative attitudes of Englishmen and oily foreigners to the vice, but did not do so. In fact he 'could have talked better than any, but did not like to intrude'. Instead he mused on the contrasting attractions of his hostess and Mrs Blackwood:

> Mrs Norton's head was grand, her Sister's bewitching – not so regular, but mild, tender, enticing. There she sat, with a skin that shone with the glossiness of silk and firmness of marble, her ringlets playing about, her voice like a Syren's, her air grace itself . . . [Mrs Norton] had something awful in her beauty & deep. You expected a voice like a Priestess of Delphos. In the other you fancied music in her very motions.

Loyalty, however, recalled him on his return home: 'Mary's dear face assumed its wonted beauty; neither in reality could compare with her.'

<div align="center">*</div>

Unable to gain access to the Prime Minister for a sitting one day, Haydon conversed with Lady Grey. She seemed anxious about her husband's popularity as a Whig bill for the suppression of disturbances in Ireland was pressing forward in the House. 'I like popularity,' she told him, 'and should be sorry if he should lose it.'

'He won't, my Lady,' Haydon replied. 'Remember a great

Statesman must *lead* as often perhaps as *yield*, for the sake of the people.' He assured her that 'the Middle Classes were sound'. They talked of the political unions and the views that Haydon expressed showed how strongly his sympathies now lay with those moderate reformers who had dined at the Guildhall, and how far withdrawn from the radicals and defaulting subscribers of Birmingham. 'If [the unions] were not put down the people would never be tranquil,' he told her. Attwood was not to be underrated, believing himself 'called for a great purpose . . . to wield the people in masses to overawe Parliament'. If this was not stopped, 'there [was] no knowing the consequences'.

Sir Francis Burdett, 'hands strong & coarse, like a horseman's', sat at the Whigs' club, Brooks's, in the little parlour inside the door, to the right. A veteran radical, his arrest for a breach of parliamentary privilege had sparked the 'Burdett Riots' of 1810, and gave him the distinction, among the diners at the Guildhall, of having been incarcerated in the Tower of London for a little over two months. Haydon asked him nothing of such matters, merely enquiring how he maintained his rude good health. The sixty-three-year-old answered that he 'used the Bath, not regularly, but often; drank no wine, except when he dined out, & was always better without it'. This, and hunting, 'agreed with him'.

Lord Saye and Sele sat. He had been overlooked in Haydon's original list of sitters, but Lady Saye and Sele 'called, & sounded' and the painter 'enquired & found all right', and so put him in, much to the old gentleman's gratification.

Haydon dined again at Caroline Norton's, with her brother and Lord Melbourne, and afterwards went with them to see an American farce at Covent Garden. Earlier in the day Francis Jeffrey had sat and told him the lady had expressed her admiration of the *Reform* picture and had said 'she was in love with the Painter too!' Haydon felt 'highly honoured', but his wife's face was a 'safeguard'. That night, as he went to bed, he looked down at Mary's 'dear, beautiful face, in a broad bordered night cap'. She was pregnant again and consequently pale:

And when she opened her lovely eyes & glistened into mine, when I looked at her lovely Baby, Harry, sleeping by her side, rosy & graceful,

when I recalled our sufferings in prison, her submission in love, her
Heroic majesty in trials, I even reproached myself for dining out that
night & having an enjoyment *she* did not share.

Mrs Norton's 'grand majesty of beauty' was indeed sublime, 'but her
mouth [was] not sufficiently voluptuous to kiss with *inside lip*'. Besides,
he reflected, 'when [a] woman of fashion says she *is in love*, she only
means she admires, and would have no objection to admit a man in
her train of adorers'. Such a company was not for him. He never
sighed until he was quite sure he would be 'sighed at'. He determined
instead to paint her and 'do her beauty justice'.

Lord Plunkett sat. Haydon was asked when the Irish reformer Daniel
O'Connell was going to sit and his Lordship suggested, 'If you could
take *his head entirely off*, you would do great good to Society.'

The King's brother, the Duke of Sussex, came to sit, and his Royal
Highness spent some time abusing Joseph Hume. Haydon diplomat-
ically conceded that the Middlesex MP was 'active minded, but had
not the feelings of a Gentleman'. His Highness declared Hume
was a Republican, and Haydon said he was convinced of it. His
Highness said 'a Republic would not do', that the country was nothing
less than 'a monarchy founded on Republican principles!' and Haydon
entirely agreed. Haydon then told 'a mean thing' about Hume. After
his sitting he had given Hume a portrait drawing 'as a *present*', and
suggested that a frame and glass would preserve it. Hume then asked
him, as a favour, to have it suitably framed for him, but when Haydon
had it delivered, the notoriously parsimonious Hume sent the
messenger away without paying for the frame. The following day
'back came . . . the drawing, frame & all, [with a message] saying the
drawing was not liked' and Haydon was sure he himself would have
to pay for it. His Highness asked what they had talked about and
Haydon 'told him Politicks', but gave no further details. 'I did not like
to betray a sitter even to a Prince,' he explained. Later, Haydon discov-
ered the Prince had left his pipe behind, 'China, with Royal Arms',
and sent word after him. His Highness replied that Haydon might
keep it as a memento.

Lord Grey finally gave him a sitting, but it was not successful. 'The
appointment was his own, yet nothing was ready – no fire in the
room, nothing comfortable. He came & found it cold, got out of

humour, & began to say nasty things.' Later, Sydney Smith, canon of St Paul's, arrived and sat, joking and talking politics with Grey. Haydon went on drawing, but badly. When Grey retired for lunch, he invited Smith to join him, before extending the invitation to Haydon. Deeply offended by his treatment, Haydon took his leave and went away. He could not help comparing Grey's behaviour with that of other patrons of opposing political persuasion:

> It was not like dear Lord Mulgrave, with whom I used to sit at lunch & breakfast – & shine. The Whigs are Tories in practice, & the Tories Whigs in principle. Lord Mulgrave & Sir George Beaumont made an Artist happy, & so does Peel when he invites them.

On reflection, Haydon thought that Grey's seeming unwillingness to sit was attributable to his having recently lost his teeth. Lady Grey helpfully suggested that a bust by Thomas Campbell might prove a useful substitute to flesh and blood.

During the last week of April, Haydon was fighting illness. First, Mary and the children were 'laid up in influenza', then her condition worsened and he was affected. By early May he was recovered, but 'Mary on the point of delirium'.

Lord Morpeth sat and talked of the Academy Exhibition. 'Not an historical work, not one! – above the line!' This would have been unthinkable under Reynolds's presidency, under West's, under Lawrence's, but 'the Art as well as the Nobility [felt] degraded' by the current incumbent, the hated Martin Archer Shee. Everything considered, the Exhibition was a miserable affair and Haydon was gratified to learn that 'the Dinner went off wretchedly'. Lord Essex sat and complained about the number of portraits on show. 'They all do that,' Haydon observed, 'and encourage nothing else.' In the Academy, as in Parliament: 'Nothing will do but a radical Reform.'

On the evening of 16 May, Haydon was at Westminster. To facilitate his work on Grey's commission, he was allowed to come and go in both Houses as he pleased. Excited roars came from the Commons and Daniel O'Connell emerged. 'How d'ye go on?' Haydon asked. 'Oh,' replied the Irishman, 'Peel is tearing poor old Cobbett to pieces!'[78] Haydon took the opportunity to arrange a portrait sitting with the Member for County Clare, but did not enter the chamber, and instead

went home 'from anxiety about Alfred'. No recent anxiety had been expressed as to the boy's welfare, and his name had not been mentioned in connection with the influenza outbreak of the month before. But complications must have ensued and the child died at seven o'clock the following morning. 'I should like to see Papa' were his last words. The maid ran down to fetch him and Haydon arrived, half-dressed at the bedside:

> He gave no sign of recognising me. His eye was fixed, and mucus was rattling in the air tubes. In a few minutes this little Victim to suffering passed quietly off without a struggle!

Haydon sketched the head, in profile on the pillow; labelled it 'Dying'. The immediate cause of death was probably the same as Fanny's, tubercular growths in the region of the small intestine, and Haydon thought it 'a great blessing' they had both been taken: 'They would have been cripples here.'

Alfred's death coincided with matters that engaged his father's attention in equal measure to mourning a lost child. Barely a year after the passing of the Reform Bill, a reaction against the Whigs had set in. Another mass meeting was held on Newhall Hill and Mr George Frederick Muntz gave a speech in which he declared that 'Parliament, under the guidance of the present ministers had done nothing for the people . . . had refused . . . to alter the Corn Laws . . . had refused to abolish taxation, or to substitute one tax for another – to have a property tax, because that would be for the Country gentlemen to tax themselves.' Thomas Attwood, newly elected MP for Birmingham, spoke of his disillusionment with the present government, of its 'atrocious measures brought forward with regard to Ireland' and its attacks on the liberties of the people of both countries. His Majesty's ministers 'refused to inquire into the distress of the people . . . in the face of . . . the most unanswerable proofs of distress . . . amongst the manufacturing, the agricultural, the labouring classes'.[79]

In London, a meeting of the Union of the Working Classes, gathered on land behind the Cold Bath Fields House of Correction, was broken up by baton-wielding police, one of whom, Robert Culley, was fatally stabbed. The inquest jury returned a verdict of justifiable

homicide, on the grounds that no Riot Act had been read before the police charged, 'that the Government did not take the proper precautions to prevent the meeting from assembling, and that the conduct of the police was ferocious, brutal, and unprovoked by the people'.[80] The seditious verdict was later quashed as being 'at variance with the law . . . applicable to the case'.[81]

Between his son's death and funeral, Haydon's journal was remarkable for the evidence of a mind swinging between his private grief and the political issues of the day. Having prayed that Alfred's death 'make a deep impression on his little Brothers & Sisters of the uncertainty of Life', his thoughts turned to the perilous uncertainties of public disorder blazing from Newhall Hill to Clerkenwell. 'All depends tomorrow at Birmingham,' he wrote on 19 May, the day before Alfred was to be buried. 'God grant it may be a failure! – else I dread the result coupled with this inquest . . . for fear if it ends in Anarchy & blood.' What seemed to exercise him was the danger that widespread discontent would bring down Grey's Whigs, and usher in another Tory administration. He pronounced an apocalyptic curse at the prospect:

> If the English People again submit to the Tories, may they be ground to dust & crushed to atom . . . may they become slaves to Frenchmen, and their name as a Nation be blotted from the Earth; may plagues, fornication, famine, leprosy, & foreign rule come over . . . May adultery be a blessing, murder a relief, parricide an amusement, & incest a daily exercise – these things & worse is my ardent prayer. Amen.

The grave in Paddington churchyard was opened and Fanny Haydon's little coffin – eighteen months in the ground and 'quite uninjured' was taken out so that her brother's could be placed beneath it. The Reverend Gifford, 'a young man of innocent expression & sedate in air', conducted the service. Shortly after the funeral, Edward Pendarves, Member of Parliament for the Western Division of Cornwall, was expected for his sitting and Haydon felt he ought to be preparing for him. 'But I am sitting still, staring at my Picture, & musing on my boy's expression when he died.' The best-dressed man in the House of Commons, Thomas Slingsby Duncombe, former Member for

Hertford, also sat, but it was 'a painful struggle' and 'very languid in the drawing'. Three more Haydon children would die: in April, June and May of the following three years.

<center>★</center>

Taking a rare day out and away from his work on the *Reform* picture, Haydon called at the King's Bench to visit an acquaintance, still a prisoner after eighteen years. The former collegian was welcomed in the yard like an old friend. A man who used to run errands for him saluted: 'God bless ye, Mr Haydon; I was in hopes when I saw ye, you were *come in again!*'

'Thank ye, my Hero, you are very good,' returned the comparatively prosperous visitor.

'Ah, Mr Haydon,' a protagonist from *Chairing the Members* greeted him. 'You are looking quite fat & jolly!'

'How d'ye do, sir,' said a turnkey, 'God bless you. Why, you've quite deserted us!'

These acquaintances would be more solidly renewed three years later.

<center>★</center>

Edward Ellice, brother-in-law to Lord Grey and Member of Parliament for Coventry, sat. He had not actually attended the banquet but, as a valued supporter of the reform movement, was to be portrayed in the group of honourably acknowledged absentees, mounted on steps at the side. He had been an early friend of Byron, and he and Haydon spoke of the poet's greatly abused wife.

'She used him ill,' said Ellice.

'She was a prig,' declared Haydon, 'she married him to reform him.'

'Yes,' said the sitter, 'not only to *reform* him but to *refuse* him.'

Haydon was not surprised. 'Fancy a prig like that, taking it into her head she was saving his soul by checking his natural appetites,' he raged, the misogynistic rant discreetly confined to his journal:

If I had been Byron, I would have smacked her bum first, and prostrated her by force! – at any rate a man can't be hung for a rape on

his wife. Think of my dear Mary, with her Miranda beauty & melting form, refusing me!

Ellice was shortly to provide desperately needed help, when Haydon was served with an execution, arrested by two Sherriff's Officers and 'hurried, half bewildered' to a sponging house. 'After a day & night of torture . . . after very nearly putting an end to [him]self during the night', he appealed to the sitter 'whose head expressed such sympathy', and Ellice responded by providing fifty pounds and effected the painter's release. He also wrote to the Duke of Cleveland, who provided fifty pounds more.

On 27 June, six weeks after Alfred's death, the Haydon family was replenished by the birth of a daughter. The day before this happy event, the proud father had spent a delightful evening with Caroline Norton, who at one point in the conversation said that she would exchange her talent for poetry 'to be as perfect a beauty as [her sister] Lady Seymour'. The ladies' mother, Mrs Sheridan, had recently asked him: 'Which do you think the most beautiful?' and he had replied, gallantly: 'They are Venus & Minerva.' Now, sitting *tête-à-tête* with the more intellectual of the pair, Haydon reflected upon the judgement he had made:

> Mrs Norton's splendid head would in some expressions wither Venus. But still her Mother thought this was declaring Lady Seymour the handsomest . . . & so the little darling is, the sweet creature, but yet my allegiance to Mrs Norton is not shaken.

He gave his newborn daughter six forenames: Jane Georgiana Seymour, after 'Venus', and Caroline Elizabeth Sarah, in honour of 'Minerva'. The family would call her 'Giorgy'.[82]

At the first anniversary of the Guildhall banquet, Haydon was painting the table display. Having chosen the moment, during the sweet course, when Lord Grey was on his feet 'returning thanks', he was able to incorporate a swathe of much-needed colour into the dark formality of the scene. In between sitters, he was 'hard at work on fruit'. The centrepiece was a large pineapple surrounded by peaches and, as though loathe to abandon the exotic object he had taken a liking to, he painted it again, inexplicably, between Messrs Warburton

and Pendarves, near the left edge of the canvas. He also lost an entire day – when he should have painted Sir John Sebright – to sickness, having eaten 'too many strawberries after [he] painted them'.

Throughout July he saw much of Caroline Norton, sometimes in company, sometimes alone. On one occasion he recorded spending three hours 'in converse exquisite'. On another he left a dinner at Blackwall early and jumped aboard a Greenwich steamer to Westminster so that he could see her for the rest of the evening. 'When I am with her I am confused,' he admitted:

> When I am absent I do nothing but muse, and think how much more agreeable I might have been. Then I think what I didn't do, then what I did, then what I ought to have done, then I whistle & feel my heart ake, take up my brush, put it down, curse the ugly faces I am obliged to paint, think of her.

His confusion sometimes led to embarrassment in her presence: 'I felt so ashamed . . . I couldn't look her in the face – only by stealth.' At such times he seemed to keep a dangerous obsession within safe bounds by calling other objects to mind: the lady's sister, and more importantly, his own wife. '[I] think of her, [&] Mary, & dear Lady Seymour, & curse my fate I have not got 'em all *three!*' Temptation became harmless fantasy: 'Three such Women as Mary, Lady Seymour, & Mrs Norton would be Paradise. I'd satisfy 'em all, the darlings, if they were mine!' This elicited from his son Frank, reading the journal many years later and understandably impatient with his father's behaviour, the marginal comment: 'Thou silly gentleman!'[83]

Haydon would always maintain that he had 'never in thought or deed been unfaithful'[84] to his wife. However, there was one occasion when he may have overstepped the bounds of propriety. A gap of twelve days occurred in the journal between his arrest for debt at the end of July and an enigmatic reference: 'I have been thrown aback lately by a quarrel with Mrs Norton' – the name crossed out, but still discernible – 'which, when I feel inspired, I will state in my journal. This is the reason & the interval of days.' Nine days later he wrote the heading: 'Some account of my recent mistake', before thinking better of it and scratching out the words. Elsewhere there was a reference that invites as much speculation as it satisfies:

I roused her pride, by telling her I loved her, but that there could be
no hope in innocence. This angered her. She was not used to this from
men – and away I was whistled.

Whatever 'mistake' he made in his behaviour towards Caroline Norton,
she 'very properly kept [him] at a distance for a year'.

In August *The Reform Banquet* was beginning to sicken him. He
had painted ninety-seven heads in nine months. By February 1834 the
head count had increased to 107. He calculated that he had written
500 individual letters, 'every letter varied to suit the character induced
every man to come', and there had been 'a great deal of manage-
ment required to induce Nobility to undergo the torture of sitting,
to please you & not themselves – it is a different thing writing to
them to sit from their writing you to paint them'. Lord Grey's son-
in-law, 'Radical Jack' Lambton, the first Earl of Durham, refused to
be in the picture on the grounds that he had not attended the banquet,
but was in St Petersburg at the time. He also refused to occupy the
place on the stairs where the rest of the absentees were herded.
Haydon thought of incorporating him somewhere among the
Guildhall decorations as a sculpted bust, or of inscribing his name
on one of the banners, but Lord Grey forbade this. 'Lord Durham
has the greatest merit with respect to the Reform bill,' he told the
painter, 'but if his name is inscribed there are plenty of others who
will say theirs ought also.' Haydon put in the name anyway, 'concealed
on a Standard', assuming that his patron would not find it until it
was too late: '100 years hence, when the picture is taken down to be
cleaned, they'll say, "Bless me, here is Lord Durham's name – &
Bentham's."' The philosopher, radical and champion of reform had
died on 6 June, two days after the bill was successfully voted through
the House of Lords. His body was dissected, in accordance with his
will, in the presence of select friends, on the 8th, the day after Royal
Assent made the measure law.

Haydon put in another head without Lord Grey's knowledge,
'thinking Leigh Hunt was entitled to the distinction of a place in
such a commemoration'. The *Examiner*'s editor sat, but the reunion,
after twelve years, was a cold one. Hunt was dismissive of the Act
and declared that it did not go far enough. Shortly afterwards Haydon
rubbed the head out 'and the Company seemed relieved of an uncon-

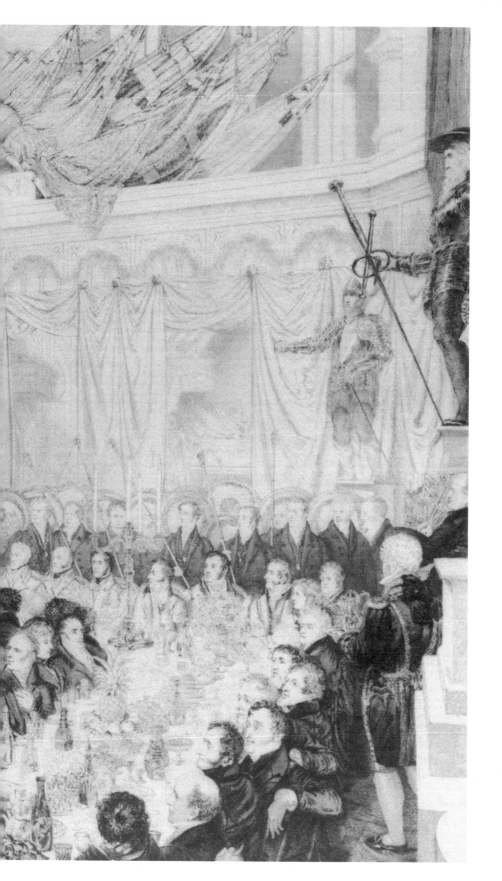

genial face . . . the composition . . . much improved by its expulsion'. It was on the same day that he put in the names of Lord Durham and Jeremy Bentham.

One of the last reformers to sit was Daniel O'Connell. Haydon was shown into his study, 'a complete Irish pig stye – a shirt hanging by the fire, a hand glass tied to the window bolt, papers, hats, brushes, wet towels, & dirty shoes, gave intimation of dear Ireland!' The Member for Clare 'rolled in, in a morning dressing gown, a loose black handkerchief tied round his neck, God knows how, and held together nobody knows why, with a wig, & a foraging cap bordered with gold lace'. The Irishman was under the impression that he would have to pay for the portrait, but was assured this was not the case. The suggestion that he was expecting money from his sitter nettled Haydon, this being the first time such a confusion had occurred during the entire eighteen months he had been engaged on the picture: 'O'Connell is the only man who has treated me like a Blackguard.'

Later the same day, the gentleman who was paying for all the portraits sat for his own the final time. 'I hope you will please my Friends with my head,' Lord Grey told the painter. 'You have not yet.'

'Don't fear, my Lord.'

'Instead of making so many sketches, if you had made one good one . . .'

'Yes,' said Haydon, 'but the position was not settled. You must make many sketches for a principal figure, even for the hands, before you fix – *now* I have fixed there is an end of changing.' But it would be another three and a half years before this portrait would be finished to its subject's satisfaction.

Grey took his leave. 'I heartily wish you success,' he said.

'I trust this Commission will be the pivot of my fortune,' Haydon replied, 'in Society it has re-established me.'

'I hope it has,' and Grey shook his hand, 'I hope it has.'

He stepped into his carriage, drew up the window and favoured Haydon with a last bow as he was driven away.

The twelve-foot-by-eight canvas was moved into Hickman's Great Room at 26 St James's Street, framed and hung, glazed and toned, the drapery and blinds arranged, the lighting adjusted. The exhibition opened to the quality on Saturday 22 March and to the general

public the following Monday. *The Times* critic pointed out how 'unmanageable' the subject was, 'the persons ranged in formal rows . . . without the possibility of varying postures or grouping, or of getting a good foreground'. It was 'a creditable, rather than an entirely successful effort', but considering the difficulties with which he had to contend, 'Mr Haydon ha[d] produced a picture which does him no discredit, and [was] worthy of the great event it commemorates'.[85] The *Times* was a supporter of the reform movement. Two months later a publication that was not so sympathetic would heap scorn on both the banquet and the artist's representation of it.

Haydon recorded that his Private Day was 'beautifully attended', but all further details of the occasion, happy or otherwise, were obliterated: five lines heavily scratched out and the succeeding four pages inexplicably torn from the journal. The record was resumed seventeen days later, in time for another child's death. Three-year-old Harry had been knocked backwards in play by an elder brother and sustained a blow to the head, 'which shook his brain so that it produced effusion'. He seemed comfortable on the Saturday night when Haydon sat up with him, but the following night he just screamed and on the Monday morning 'Death was evident, making rapid strides. His eyes were sunk & bewildered. He looked confused & glaring. He fell into a sweet sleep for an hour & ½ and awoke dying.' They tried to get him to drink, 'but the rattle was in his throat; he could not swallow. The rattle encreased, & then he lay panting out his Life, and looking with his dear & beautiful long lashed eyes as if he saw another World.' At one point his father asked, 'Do you know Mama, my dear?' and the eyes slowly opened, looked at her and closed. The surgeon prescribed sherry and while Haydon ran to fetch it, there was a slight convulsion and, at five minutes to two in the afternoon, death. After four days, during which the father made sketches of 'his beautiful head', the little coffin was closed and joined those of Fanny and Alfred in the grave.

Haydon claimed that 'a long series of collateral causes had enfeebled the child's constitution', that the anxieties of the mother, while her husband was in prison, had affected him in the womb, and that he 'came into the World with the seeds of disease'. To a stronger boy the accident might not have had such disastrous consequences, he

believed, but Harry's brain had been 'delicate, refined, & tender'. He also blamed 'the carelessness of a stupid nurse' for leaving the child unattended to be 'butchered in a nursery'. It was never divulged which 'violent, healthy, & ungovernable Elder Brother' – Frederic, aged seven, or Frank, aged twelve – was responsible for the death.

<p style="text-align:center">*</p>

Five days after burying Harry, and a month and a half after finishing *The Reform Banquet*, Haydon began work on an historical subject he had been considering throughout the long chronicle of frock coats, cravats and side-whiskers. He also had a model in mind and 'meant to paint [Mrs Norton] as Cassandra'. Relations had not thawed since their 'argument' the previous year, but he made a start on the picture, with the hope that he could melt the ice later and persuade her to sit.

Meanwhile, he tried to interest Lord Grey in his long-nurtured plan for the House of Lords, showing him sketches for 'a series of subjects to illustrate the best Government for mankind', culminating in the passing of the Reform Bill. He explained that such decorations would make an admirable replacement for the shabby old sixteenth-century Flemish tapestries, depicting the defeat of the Spanish Armada, that currently shrouded their Lordships' House.

'They are a fine series,' said Lord Grey, casting his eye over Haydon's proposal, 'but there is no intention I know of to take down the Tapestry, and the House of Commons is in such a temper for expenditure, that I could not propose such a thing.'

Haydon then asked if there were any possibility of his gaining employment on such a project in the future and could his Lordship, perhaps, sanction it? 'I *could not*,' replied Grey, although he had no doubt Haydon would 'get through' such a series 'and do the Country honour'. Then he asked: 'How does your Exhibition go on?'

'Badly, my Lord, I am losing money every day.'

'I am very sorry for it.'

'My Lord, the Middle Classes do not come.' Haydon refused to admit that the picture was not liked, insisting that he had never painted a picture 'more liked by the Artists or the Visitors'. It was, he believed, because the Middle Classes connected his exhibition with the

Government that it shared the Government's current unpopularity. He had even expressed fears to Lady Durham that the picture might be vandalised. At another point in their conversation, intimating he had anxieties of his own, Lord Grey confided: 'I don't know how long *I may be in!*'

Following the hard-won battle for reform, Grey's administration was foundering on Irish issues. Against the background of agrarian unrest, a line was being walked between two measures brought into law the previous year: the Suppression of Disturbances (Ireland) Act and the Irish Church Temporalities Act, the object of the latter being to appropriate surplus ecclesiastical revenue to the secular purpose of relieving the peasantry. The tension between coercion and conciliation was splintering Grey's Cabinet with resignations and he was shortly to tender his own.

Receiving no comfort from Grey, Haydon appealed to his Lordship's son-in-law, who had rescued him from a sponging house the previous year. 'The exhibition has failed entirely,' he told Ellice, 'and I have every prospect if not instantly employed of being ruined . . . of sinking again into that state of degradation, humiliation and disgrace out of which I had hopes of Lord Grey's commission . . . extricat[ing] me, both by its influence & success'.[86] The assistance that once arrived with such alacrity was not forthcoming. Ellice's son wrote from the War Office to say that his father had no advice to offer.[87]

In a desperate attempt to draw more people into the exhibition he added a picture that had not been seen by the London public for more than ten years. Borrowed from his erstwhile upholsterer, Edward Binns, he 'moved in Lazarus' to Hickman's Great Room. 'It looked grand & awful', but made little difference to the takings.

He wrote to Caroline Norton, told her the exhibition had failed, added the somewhat heavy-handed corollary that 'if she would not sit for Cassandra, [his] family would be ruined' and, with the subtlety of a bludgeon, informed her 'that Men of Fashion said she was merciless & unforgiving, passionless & cold & cruel & vengeful', in the hope that she would prove them mistaken. This attempt at reconciliation coincided with a period of tension in his marriage. He had already confessed to Mary his 'unfortunate infatuation', probably at the time of his break with Caroline Norton, the previous August, and she trusted his good faith and honour. 'My dear,' she told him, 'you

would never do to be wicked.' However, she became uneasy at seeing him musing again about the other woman. Then, an unconsidered remark that he made – implying she had been customarily neglectful of Harry's bedtime and that this might have contributed to his weakened constitution and ultimately hastened his death – provoked a domestic row. It was a month to the day since they had placed this third child in the ground and Mary, unsurprisingly, 'went into violent Hystericks'.

An answer to his letter arrived the following day. Haydon was overjoyed. 'We have made it up again – Huzza!' Caroline Norton regretted that his exhibition had failed and agreed to sit for Cassandra. As for the opinions of the 'Men of Fashion', she had only this to say: 'that those who know me, know them to be false – and those who do not know me, are welcome to their *conjectures* of what my disposition may be'. It was not altogether clear into which category she placed her correspondent, and the letter ended far from warmly: 'I shd. like a line to say what day I am to begin sitting.' For his part, Haydon seemed oblivious to her cooler tone: 'Now for Cassandra! Huzza! It is very noble of her, & worthy of her grand soul.' He also thought that the sittings would perform a therapeutic purpose. 'By seeing her I shall vanquish my intense passion,' he hoped, 'by absence it only grew worse.'

Haydon's exhibition of *The Reform Banquet* had been running at a loss for more than two months when it came under fire from a particularly hostile quarter. Tory by inclination and entirely out of sympathy with parliamentary reform, *Fraser's Magazine* published a notice, in June 1834, of such consummate viciousness as only a combination of personal dislike and political antipathy could produce. The critical tone was set in its first paragraph, with the painter referred to as 'an insufferable coxcomb'. In the second, his early career was traced by the spoiling and smearing of 'a very considerable piece of canvas' in which the only 'decently executed' part ensured that he be 'universally known in the profession as the Jackass Painter'. The third paragraph described his subsequent portraits as 'colossal caricatures of the ugliest people catchable'. Then the butchery began in earnest. If the exhibition received any business at all afterwards, it was no thanks to the anonymous critic, who declined to inform his readers where the picture might be seen 'lest [they] go and waste [their] money in

so inglorious a pursuit'. He had, himself, 'twice visited . . . and on both occasions found in the room a crowd of three . . . screaming with laughter at the absurdity of the painting, and . . . the illustrative book'. The review was particularly cruel for the extensive use it made of Haydon's own description of the picture, to ridicule both it and him. Its avowed purpose was 'to squash this Haydon, and spread him out over his own canvas, like a piece of high beef over a nasty piece of bread, and make a kind of dirt-sandwich of him'. Passage after passage of the painter's overblown and often banal prose – the breathless fawning over nobility and rank, 'the dead thumping of hundreds of salt-cellars', and repeated references to 'the magnificence of the gas' – were quoted back at him, and the sublimity of aspiration held up against the shortcomings of accomplishment. After nine pages of this, the Tory critic made a final observation condemning by backhanded compliment both the painting and the Reform Bill: atrocious as the work was, he considered it 'worthy of the event it proposes to immortalise'.[88] It was a near-echo of the more straightforward comment in the Times that The Reform Banquet was 'worthy of the great event it commemorates'.

The beginning of June had brought threats of 'Executions, poverty, misery, insult and wretchedness' and 'Mary [began] packing up her little favourite things – expecting ruin with creeping pace.' Haydon had already disposed of books and some of his best drawings before going out to 'the dingy hell of a [pawnbroker's] back room' and getting four pounds for some children's clothes and his wife's favourite gown, all of which had once cost forty pounds. He returned home to find a letter from George Granville Leveson-Gower, 2nd Duke of Sutherland, enclosing a cheque for fifty pounds. 'Such is Life!' he remarked. 'Perhaps you may draw some historical sketch,' his Lordship suggested, 'if I happen soon to think of a subject I will name it.' A month later, having seen the work in progess, Sutherland agreed to buy Cassandra Predicting the Murder of Agamemnon, when finished, for 400 guineas.[89]

Haydon had thought that renewal of his acquaintance with Mrs Norton would 'vanquish [his] intense passion' for her. Instead, it inspired another slew of journal references, through which he indulged the infatuation seemingly sanctioned by his having already confessed it to his wife. However, Mary 'accidentally read what [he] had absurdly

written' and there was another scene. He tried to convince her it was 'merely imagination on [his] part', that he was 'perfectly innocent of infidelity – in thought even' and promised to 'root it out', just as soon as he had painted her head for *Cassandra*. In the meantime he gave his troubled wife a notebook 'to put down [her] thoughts, as relief to feelings that [could] no longer contain themselves'.[90] She filled several pages of this 'commonplace book' with incoherent, barely legible ramblings about the mental agonies she was suffering and the woman she believed was threatening her marriage:

> I have passed another night of great suffering. Oh God what will all this extreme pain of mind come to? . . . and what do these feelings amount to [but a] deep deep desire for revenge. This is a thought that never leaves for a moment. I *feel* it even in my sleep. I find myself praying for it in my dreams . . . I feel my poor heart expand to bursting and I know the day will come when I shall level [in] the dust this accursed this everlasting cursed cause of all I have suffered.[91]

Caroline Norton proved an unreliable sitter. Sometimes illness prevented her reincarnating the Trojan prophetess, her cold so bad, 'face swollen and . . . eyes . . . so red that the spirit of prophesy would be ashamed to look out of them'.[92] Sometimes the pressure of a giddy social life distracted her and, having promised to write and act some charades for a friend, she was 'so entirely hurried & occupied' that she had 'delayed or forgotten everything'.[93] The charades were performed at Mrs Leicester Stanhope's and Haydon attended, 'delighted . . . to find [himself] in such high Life again, honored & preferred by Beauty'. The evening was 'elevating and inspiring; lovely girls, accomplished Women, talent, grace, & refinement'. In one of the charades she had devised, Caroline Norton played a Lady of Fashion 'in a style which no actress could accomplish – it was really beautifully done'. Haydon stayed until the Greek tableaux, then went home to his wife, 'tumbled into her dear arms with rapture and confidence' and made conciliatory, perhaps guilty, love to her. During the following month Mary brooded on her rival:

> If the eternal curses of one that has already suffered enough from various privations to satisfy the fiend[s] that glut their imaginations in

the pain of other[s] be of any *aid* to thee in thy gaudy flutter through life it is thine. When I wake in the morning . . . I shall curse thee.[94]

In lighter, but no less vindictive, vein she wrote a mock epitaph:

> Here lies a beauty who was deaf to each duty
> Who thought all things a bore
> But playing the W[hore].[95]

At some point, and it is not clear when, the two women met and Mrs Norton attempted to allay Mary's suspicions of her husband by assuring her 'nothing like *connection* could take place from the nature of a *complaint* she was subject to'. The nature of the complaint, and whether Mary believed in it, is not known. Two years later Mrs Norton would be at the centre of a very public scandal, her name coupled in the transcript of court proceedings, not with Haydon, but with the man replacing Lord Grey as Prime Minister.

Having tendered his resignation to the King on 8 July, it was not until mid-August that Grey vacated the Prime Minister's official residence in Downing Street. Haydon went early in the morning of the last day to bid him goodbye. He was shown up and found his Lordship at breakfast. Shaking Grey's hand, wishing him health and happiness, thanking him for all his past kindness, Haydon's voice broke. 'I shall never forget,' he wrote that evening:

> the lift & look of his keen eye as he examined my face with a searching air of intense feeling. I am sure it must have convinced him of my *sincere* feelings.

But as his pen scratched the next sentence into his journal, Haydon's mind was already on future campaigns. Lord Grey had 'done little for art', he reflected. 'Let us see now what I can do with Lord Melbourne.'

At last Caroline Norton found time to sit for Cassandra. Haydon, however, after such long anticipation, did not rise to the challenge. Overawed by the 'beautiful creature', and with 'a nervous feeling in [his] hand', he 'began but did not succeed'. This was, in fact, the lady's only sitting and the head was painted in her absence, from imagination, from an earlier sketch, from his wife and from 'little Mary', their

ten-year-old daughter. It was, he claimed, 'a better head of Cassandra than if she had sat'. Mrs Haydon's suspicions and hatred of Caroline Norton were subsequently communicated to her children. While their father was out, they carried a fine bust he had of her down to the court at the back of the house and 'beat it all to pieces'.[96]

*

At the end of August he closed his 'Unfortunate Exhibition' with a loss, in rent and other expenses, of £240 16s 8d. The landlord, John Hickman, insisted on holding the still-unraffled *Xenophon* as security for the outstanding rent, and Haydon was left with the mournful calculation that, when losses were deducted from the 500 guineas he had been paid for *The Reform Banquet*, he had made just £285 for nearly two years' work and all of it was spent. In addition there were five signed cognovits totalling £74 6s hanging over his head, all due, and an execution on them would mean ruin. 'But for the Commission of the Duke of Sutherland I should have been crushed,' he reflected, 'and but for the protection of my Great Protector of all things I shall be crushed yet.' In desperation he wrote to Sutherland requesting a further advance on the commission.

For a week he was unable to work on *Cassandra* 'from sheer harrass', running about in the City from one creditor to another: placating, entreating, promising. But there were moments of inspiration even there. Waiting in St Martin's le Grand while an intermediary persuaded a particularly severe creditor to wait another fortnight, Haydon stared at Sir Robert Smirke's new General Post Office building[97] and realised he could adapt it to serve as Agamemnon's palace. He bought a sixpenny sketchbook, borrowed a pencil from the shopkeeper and made a drawing. By the time his friend returned from the delicate negotiations, Haydon had a new background for his picture.

A month later the instalment of £100 arrived from the Duke of Sutherland, just in time to meet an execution for taxes. The broker's man, an old soldier built and trained to intimidate the recalcitrant debtor, was ushered into Haydon's painting room, engaged in conversation about the Peninsular War and persuaded to pose for Cassandra's hand, wearing a Persian bracelet. When the broker arrived to collect the money, his man was standing 'upright & steady,

as if on guard', with right arm outstretched in prophecy of Agamemnon's doom.

★

In the wake of extraordinary constitutional changes wrought by parliamentary reform, it was appropriate that changes to the very fabric of the Palace of Westminster should follow, albeit accidentally. Between six and seven o'clock in the evening of Thursday 17 October 1834, fire broke out from an overheated stove in a room below the debating chamber of the House of Lords. A huge store of ancient tally sticks, previously used for accounting purposes, was being cleared prior to establishment of a new Court of Bankruptcy, and it was thought that this was 'a very safe and proper place' for the thousands of notched pieces of wood to be incinerated. The panelling of the room caught fire and it spread upwards. By half-past seven, their Lordships' House was a raging inferno, and the roof fell in. Twenty-two years after his mind had wandered from a speech on the conduct of the Peninsular Campaign by the Duke of Wellington's elder brother, Haydon was there again, in the company of his wife, and at a safe distance, to watch:

> From the bridge it was sublime. We . . . went into the room of a public house, which was full . . . the jokes and radicalism were universal. If Ministers had heard the shrewd sense and intelligence of these drunken remarks! I hurried Mary away . . . 'There is no House of Lords,' said one of the half drunken fellows; 'they are extinguished, Sir.'

Needless to say, with the gutting of the Lords, the 'miserable tapestry' he had so disparaged was also destroyed. 'The fire [spread] to the House of Commons, and the whole range of buildings were soon wrapped in one blaze . . . The flames shot up to a great height, and obscured the light of the moon, increasing, rather than diminishing, the apparent darkness of the night, and contrasting, in a striking manner, the brilliant light they threw upon the surrounding objects, with the general blackness of the sky.'[98] There was a rumour that Lord Althorp had been heard to say, 'Damn the House of Commons – save the Hall.' More because of a change in wind direction than any

action taken on his Lordship's orders, the ancient Westminster Hall
survived and it was there that a great exhibition of prospective deco-
rations for the new Parliament buildings would be held nine years
later. Haydon was probably the first to anticipate the creative possi-
bilities of the disaster. 'The comfort is,' he remarked in his journal
that night, 'there is now a better prospect of painting a House of
Lords.'

Another artist who had been at the scene was J.M.W. Turner. The
Academician made a number of pencil sketches on the spot, and then,
as was his practice, a series of watercolours from immediate memory
when he got home. In the oil painting, exhibited at the British
Institution the following year, a view was taken from the opposite
bank of the river and the Thames seemed ablaze in reflection, as did
the Westminster Bridge with light cast on it from the holocaust.
Haydon also saw the pictorial possibilities:

> Nothing in the world . . . finer than the awful solemnity of the massy
> roof of the Hall against the blazing splendour of the dreadful confla-
> gration contrasted by the silvery moonlight on the Thames . . . the
> rushing of the fire engines over the Bridge, the galloping of Horses,
> & the energy of fire men pressing to the fire – make up material for
> as fine a Historical picture as ever was painted.[99]

He never painted it,[100] but three days after the fire, while the ruins
still smoked, he called on Lord Melbourne to suggest an altogether
more ambitious programme. After a little preliminary conversation
the Prime Minister demanded: 'What now?'

'Now, my Lord . . .', Haydon was on his feet in his eagerness to
plead his case.

'Sit down,' said Lord Melbourne.

Haydon sat down. He began again: 'Do you admit the necessity of
State support?'

'I do not.'

'Why?'

'Because there is private patronage enough to do all that is requisite.'

'*That I deny!*' said Haydon, and Lord Melbourne laughed and
rubbed his hands together, as though warming to the fray. Then he
walked over to a mirror and started combing his hair. 'My Lord, that

is a false view,' Haydon addressed the back of the Prime Minister's head. 'Private patronage has raised the School in all departments where it could do service, but High Art cannot be advanced by private patronage.'

'But it is not the policy of this Country to interfere.'

'Why?'

'Because it is not necessary.'

'You say so,' replied Haydon, 'but I'll prove the contrary.'

'Well, let's hear,' said Melbourne, settling down to a longer discussion, 'where has it ever flourished?'

'In Greece, Egypt, Italy.'

'How? By individual Patronage?'

'No, my Lord, *alone* by the support of the State.' Haydon at length arrived at the purpose of his visit: 'Now, my Lord, Lord Grey said there was no intention of taking down the Tapestry. *It's down!* A new House must be built. Painting, Sculpture, & Architecture must be combined. Here's an opportunity that never can occur again [and it] will ultimately rest on a Minister. Have you no ambition to be that man?'

Melbourne appeared thoughtful, but did not reply.

'For God's sake, Lord Melbourne, do not let this slip – for the sake of Art, for your own sake – only say you won't forget Art.'

Still there was no reply. Haydon pressed for an answer: 'Depend on my discretion. Not a word shall pass from me; only assure me it is not hopeless.'

Lord Melbourne looked up and said, with an apparent gravity and sincerity that Haydon communicated, underscored, to his journal: '*It is not.*' It was not hopeless. The supplicant departed satisfied. There would be a temporary building until Parliament reconvened, then plans for the new House would be made. 'There's time enough,' he reflected. A fortnight later he had written and delivered a petition to Lord Melbourne pleading, as had his former petitions, for government assistance of the arts, but with especial reference to the rebuilding of the Houses of Parliament. He gave his Lordship another week to read it and called again.

'Well, my Lord, have you seen my petition to you?'

'I have.'

'Have you read it?'

'Yes.'

'Well, what do you say to it?'

Melbourne affected preoccupation with a letter on his desk.

'What answer does your Lordship give? What argument or refutation have you?'

'Why, we do not mean to have Pictures,' Melbourne replied. 'We mean to have a building with all the simplicity of the Ancients.'

Haydon suspected the corpse-like hand of the Royal Academy blighting his cherished proposal and believed that the source of the contagion was to be found in the glittering Kensington social set of Whigs and wits that revolved around Henry Richard Fox, 3rd Baron Holland, and his vivacious wife. 'I fear, Lord Melbourne, since I first saw you, you are corrupted. You meet Academicians at Holland House,' he said. 'I am sure you do,' he added archly.

'I *do*,' said Melbourne, returning the arch look and rubbing his hands, 'I meet Callcott – he is a good fellow.'

'Good enough – but an Academician.'

'Ha! Ha!' crowed Melbourne.

'Now, my Lord, do be serious.'

'Well, I am. Callcott says he disapproves the system of Patrons of taking up young men to the injury of the old ones; giving them two or three commissions, & letting them die in a Workhouse.'

'But if young men are never taken up, how are they to become known?' Realising his Lordship's account of Callcott's opinion on private patronage was diverting the conversation from the substance of his petition, Haydon steered it back: 'But to return. Look at *Guizot* [the French Minister of Public Instruction]. He ordered four great Pictures to commemorate the barricades for the [French] Government. Why will not the Government do that here? What is the reason, Lord Melbourne, that no English Minister is aware of the importance of Art to the Manufactures & Wealth of the Country? I will tell you, my Lord; your tutors at the Universities . . .' Haydon was in full flow – his hand raised as preliminary to its being brought down in emphasis of his next point – when the door opened and in walked Lord Brougham.

Proffering two fingers to shake, he asked: 'How do you do, Mr Haydon?'

There was a moment's awkwardness. The Prime Minister, clearly

embarrassed at his Lord Chancellor's lack of respect, entering the room without deigning to knock, looked 'as if his nose had been pulled'. Haydon wondered whether to make capital of the interruption and say to the sponsor of his 1823 petition for the encouragement of historical painting: 'My Lord, I am glad you are come, as I know you will back me', but wisely decided not to do so . . .

Lady Blessington, when told of the incident, would place her own construction upon the interruption, assuring Haydon that it was only because he knew Caroline Norton to be abroad that Brougham had 'no delicacy in bursting in!' Talk was already buzzing in London society a year and a half before the Honourable George Chapple Norton initiated proceedings to divorce his wife for alleged infidelity with the Prime Minister.

. . . Lord Melbourne appeared to recover his composure, turned to Haydon and said: 'I wish you a good morning.' That it was in fact after one o'clock in the afternoon suggests either a lapse in Haydon's recollection or in his Lordship's equanimity. Bowing to each man in turn, the painter left the room. As he did so, he overheard the ostensible purpose of Brougham's visit – 'I want to put off our little dinner; Mrs Fox . . .' – cut by the closing door.[101]

There had been, in Brougham's behaviour towards his superior, 'a cool familiarity, as if handling a warming pan!' The departing guest sensed an approaching crisis. 'If that is the way a Prime Minister is treated in his House – by a Lord Chancellor or any body else – I wouldn't give one farthing for his Ministry.' A week later William IV used the death of the 2nd Earl Spencer, Chancellor of the Exchequer, as an excuse to dissolve the Whig administration and call on the Tories to form a government. The Duke of Wellington was Prime Minister for a little over three weeks until Sir Robert Peel assumed the office himself for a further four months.

*

Haydon completed *Cassandra Prophesying the Murder of Agamemnon* on the last night of the year, and on the following day he opened the Bible at random to read his destiny for 1835: 'Say to them that are of a fearful heart, Be strong, fear not, behold, your God will come with vengeance, even God with a recompence; he will come & save you.'[102]

The year began hopefully with a commission from Moon, Boys &
Graves, print-sellers and publishers of Pall Mall, to paint the Duke of
Wellington musing on the Field of Waterloo. Haydon wrote to the
Duke requesting leave to make a chalk sketch of the sword and clothes
he had worn under his cloak during the battle. He also asked for a
half-hour sitting to 'make a rapid Sketch of [his] Grace's figure'.[103] His
greatest concern was with the political gulf separating this commis-
sion from the one he had painted for Lord Grey and it was with excru-
ciating diffidence, and barely comprehensible clausal complexity, that
he made his overture to the foremost opponent of parliamentary
reform:

> I acknowledge to your Grace, & approach you with every delicacy and
> prepared to withdraw with every apology this intrusion, considering
> my feelings as a conservative reformer & Whig, be considered unwar-
> rantable or impertinent.[104]

His Grace's reply was plainer, but far from encouraging:

> The Duke of Wellington presents his Compliments to Mr Haydon and
> has received his note. The Duke hopes Mr Haydon will excuse him but
> he really has not leisure at present to sit for a Picture.[105]

Assuming that Wellington's lack of leisure did not necessarily relate
to his clothes, Haydon wrote to Colin, the Duke's valet, who spoke
to Mr Mugford, his steward, and Haydon was invited to Apsley House
to select what he needed. For a couple of days he had, in his posses-
sion, the Field Marshal's hat, sword and frock coat, but without the
Field Marshal's permission, and when the Duke was informed of what
had been lent, 'there was the devil to pay'. Before returning the items,
Haydon had some fun with them. *The Reform Banquet* had still to be
delivered to William Bromley for engraving and dominated his painting
room. He laid his Lordship's sword in front of it, directly below the
commanding figure of Lord Grey. He draped his Lordship's coat over
what he called his 'Reform Chair', and placed his Lordship's hat in
the depression of the seat, which had contained the buttocks of over
a hundred of his Lordship's political enemies as they sat for their
portraits. He prayed that 'the *Virus* [of reform] might sink into & . . .

innoculate his Grace's Vestments [before] they again touched his person'.

He informed the Duke that he intended destroying the picture he had begun, but Wellington told him he could do what he liked with it. 'I have not the smallest objection to your painting and engraving a picture of me,' he declared. 'It is impossible for me to have any feeling upon the subject.'[106] Instead of destroying the canvas, Haydon painted a related subject over it: *An Imperial Guard Musing at Waterloo*. The line of the Duke's sword could still be traced across the trousers of the Guard, and the Guard's right arm was contained in the sleeve of the Duke's blue coat. It was, he said, the first time that one of Bonaparte's elite had 'extinguished' Wellington. It took him two days to paint and he sold it immediately to another print-seller and publisher for £31 10s. His next commission to paint Wellington would be more straightforward, more profitable and would meet with greater success, but he would still have to contend with his subject's unwillingness to sit.

<div align="center">★</div>

Early in March a Select Committee of MPs and peers was appointed 'to take into consideration . . . the best means of carrying into effect His Majesty's most gracious wishes, with reference to the rebuilding of the two houses of Parliament',[107] and Haydon immediately petitioned the Chairman on this 'most favourable opportunity of developing the acknowledged talent now in England, by state employment'. He gave his assurance that he had 'no personal object in thus intruding himself' on the Committee's notice, 'having for 30 years of an anxious life given public evidence of being always more animated by a love for his country's honour, than by any desire for gain or emolument'. He felt, however, that there could be 'no dereliction of principle' in saying that he was 'ready at a moment's notice' to show the Committee a series of designs 'to illustrate the superiority of the British Constitution, [as] a fit ornament for a British Senate-house'. He reminded the Committee that those 'memorials of former times' – the tapestries in the House of Lords, the murals in St Stephen's Chapel and the Painted Chamber, 'now lost forever' – had been evidence that 'even in the middle ages the Sovereigns of this country gave large and liberal encouragement to historical painting'. He concluded by asking:

Whether it will not be subject of regret to the future historian if an age so far advanced in knowledge, and so distinguished in talent, as the present, should prove itself less sensible of the great value of history painting than one so remote and comparatively uncivilised.[108]

The day on which he composed this petition Haydon described as 'Idle', doing no work in his painting room, but making a number of calls. He visited William Hamilton to consult about the new Committee; looked in on Joseph Hume for the same purpose, but learned he was 'knocked up abed'; dropped in to see Mrs Stanhope and make a sketch of 'her pretty little child'; and finally called at a gun-maker's premises with his eldest son, Frank. Isaac Rivière's establishment at 315 Oxford Street had a shooting range, and father and son fired six shots each with a pistol and another six with a rifle. The thirteen-year-old hit the target twice with the pistol, his father just once – and only when steadying his arm on the ring. 'That child Frank,' he wrote, 'brought up a species of London Boy, has an innate love of [fire arms] as I had. It must be in the blood.' Later he would boast that both his sons were 'capital shots', but the elder especially: 'Frank can hit a half crown,' he declared proudly, 'beware how they insult his father's memory!' Just over half a century later, Frank Haydon was to die by his own hand, a pistol barrel clamped in his mouth.

<p style="text-align:center">*</p>

The Society of British Artists Exhibition opened in Suffolk Street, Pall Mall in mid-March 1835 and Haydon claimed that his *Cassandra* was 'much liked'. One paper referred to him as the '*Veteran Haydon*', which he ruefully thought 'the first knell towards the grave', anticipating '*Old Haydon*' and then '*Poor old Haydon*'. Not all the press was so deferential, however. *The Times* found the group 'crowded', the expression 'exaggerated', the drawing 'more than usually extravagant', while the left arm of Clytemnestra 'display[ed] so outrageous a fault as no eye can overlook'. Although it was generally known that the head of Cassandra had been painted from the Honourable Mrs Norton, and 'some resemblance in the outlines of the upper features of the face' could be discerned, the mouth was 'no more like than it [was] flattering to the model'.[109]

Haydon himself was 'abashed' to find other faults when he saw the picture again in the Duke of Sutherland's London home early the following year. Cassandra's head was too small, as were all the other heads, while the man kneeling in the foreground was too large. 'One gets flattered so in one's own painting-Room, and thinks so highly of one's immediate efforts.' The middle and background, however, he pronounced 'admirable', and the figures of Aegysthus, Clytemnestra, Agamemnon and the horses, 'capital'.

Throughout April and May, he was working on a six-foot-by-five canvas, *Achilles Discovered by Ullysses at the Court of King Lycomedes*, for William Newton, in lieu of 400 guineas rent. Later in the year he painted *Christ Raising the Widow's Son* for his landlord, the same size, to pay off the same amount in rent arrears. To help maintain his tenant's family, Newton agreed to pay another 100 guineas for each picture at a rate of five guineas a week. Haydon was also at work on a comic genre picture showing an apoplectic old Tory reading the morning paper: *John Bull at Breakfast – 'We Are a Ruined Nation'*. Peel's Tory administration was foundering, as Grey's Whig administration had the previous year, over the issue of Irish ecclesiastical revenues. Having failed three times to push the Irish Tithe Bill through the Lords, Peel resigned and twelve days later: 'Lord Melbourne in again!' wrote Haydon, 'huzza!'

The health of his two-year-old daughter Giorgy was causing concern. At the end of March he had taken her to visit the physician and accoucheur to Queen Adelaide, Sir Charles Mansfield Clarke, but the outcome of the consultation was not specified. Then, at the beginning of June, Sir Charles attended the child again and said 'she ought to do well'. Haydon thought she 'looked like a suffering & prostrate lily' and had her baptised 'in case of the worst'. The following day she was 'better'; the day after, 'quiet & better'; the third day she was 'sinking'. He tried to sketch her head, between convulsions. Five days after Sir Charles's visit, Haydon was by the bedside in 'a sick & dying Chamber' at five in the morning, 'the heat & glare inside . . . with the saffron streak & freshness of breaking day' beyond the curtains, to record with morbid fascination her last hour alive: 'face fixed & rigid, her hands clenched & cold, her fine eyes dimming, and nothing living but heart & lungs, which struggled hard to resist the suffusion of the brain! . . . Her lips opened & gasped! – fainter & fainter &

fainter – then they stopped – then a heaving, slighter & slighter & slighter! – till scarcely an undulation was perceptible! Then a stiff, straightened convulsion – a last expansion & wild stare of the eyes! – a lovely smile – a twinkling of the lids – the eyes closed, the life stopped – and the dear, lovely innocent was dead!' He had not allowed Mary to keep this vigil, 'as she [was] advanced in pregnancy'. Ten weeks later, on 22 August, she gave birth to another child, the last, and likewise doomed. They named the boy Newton after their beneficent landlord.

<center>★</center>

'He was decidedly nervous, you could see it in the corners of his mouth.' On the evening of Wednesday 9 September, Haydon stood in front of an audience for the first time, at the London Mechanics' Institution, 29 Southampton Buildings, Chancery Lane.

As he had mounted the platform 'all his distresses, humiliation, and ruin "crowded" on his mind'.[110] The audience applauded and then there was a silence as he surveyed the packed hall. He took off his spectacles and slowly and thoroughly polished them. He held them up to the light, as if to satisfy himself that the lenses were entirely clear of blemish. He carefully replaced them on his nose. Then, having used this necessary and practical activity to allay his 'heart-beating anxiety',[111] he opened his book and began his discourse. His introductory remarks – an anecdote about the actor David Garrick, called as witness in a celebrated trial and suffering the unaccustomed terrors of tongue-tied stage fright – were designed to disarm and flatter his listeners. 'If this were the case with one who had obtained his immortal reputation by public appearance, how much more likely is it to be so with another who, for thirty-one years, has lived in the solitude of his study, and who now for the first time . . . ventures to intrude on an assembly so keen and intelligent.'[112]

He spoke of Sir Joshua Reynolds's *Discourses*, and reiterated his own first lesson from those 'exquisite productions' when he devoured them as a boy. 'If you have great genius,' he told his audience, 'industry only can prove it; but if you have not, industry, though it may increase by practice the powers of your mind and hand, will certainly never supply the original deficiency of nature.'[113] He told them, at the outset,

what he could and could not teach them. They could learn to 'draw, decently', to 'compose, fairly', but they could not learn 'expression of the passions', they could not learn 'how to invent'.

He introduced the all-important study of anatomy and described how he once dissected a lion and recognised 'its similarity as well as its difference in muscular and bone construction to the human figure'.[114] This, he thought, was 'the finest bit' of the lecture. He spoke of his beloved Elgin Marbles and the absurdity of Sir Anthony Carlisle's assertion that the Greeks knew nothing about the workings of musculature and bone, because they never dissected.

He described the Royal Academy Exhibition as 'a giant of genius struggling to convey his meaning in a language of which he did not understand the grammar'. *The Times* thought this 'very fine, but . . . not very intelligible'.[115]

He railed at the 'degeneracy of taste' currently prevailing in England: the paucity of memorials to national glory, the lack of 'pictures to illustrate the beautiful deeds of the great Christian founder' in St Paul's Cathedral, and the plethora of shop windows stocked with the 'simpering affectation' of the sentimental print, the 'prize ox or the last favourite of the Derby'.[116] He was gratified with his reception. 'The audience paid . . . keen & intense attention, and ultimately were enthusiastic,' he wrote. As the hall emptied, the Institution's founder, Dr Birkbeck, said to him: 'You *have got 'em*. It is a hit.'

The weeks following his lecture were taken up by money worries, 'Harrass, threats, harrass.' He pawned the dinner suit that had cost him ten pounds and received just £2 15s, knowing that he would somehow have to retrieve it in time for his next lecture. He pawned a pair of spectacles for five shillings to get him through one day, then the tea urn for ten shillings to get him through another. In October he called a meeting of his creditors and, after considerable negotiation, managed to agree terms for payment with all but the most importunate, who continued to harass him.

Away from the sordid round, an hour's interview with Lord Melbourne yielded what Haydon considered a major concession, but only after his Lordship had indulged in a little fun.

'Is there any prospect, my Lord, of the House of Lords being ornamented by Pictures?'

'No,' came the reply, 'What is the use of painting a Room of *delib-*

eration?' It was a good question. Haydon would later claim that his series of designs showing the best and worst modes of governance were intended to inspire the Lords during their deliberations, even to act as reference points in the heat of debate. But for the present he appealed to the Prime Minister's legacy of office: 'Let *me* honour your reign,' he implored.

Melbourne strode about the room in his grey dressing gown. At length he said playfully: 'Suppose we employ Callcott.'

'Callcott!' Haydon erupted, 'my God, a *Landscape Painter*! Come, my Lord, this is too bad.' Melbourne sat down, opened his ministerial boxes and began to work. But when his visitor suggested that he return another time with the designs he had in mind for the House, Melbourne consented. 'He *consented*', Haydon wrote excitedly when he got home, 'this is further than Prime Minister ever went before. God knows what will come of it . . .' But Melbourne had only consented to a further meeting. A fortnight later Haydon was back with his six designs showing the rule of Anarchy, Democracy, Despotism, Revolution, Justice and Monarchy. Melbourne voiced his reservation concerning the picture of Revolution. He felt that showing the last tumbrel to the guillotine might offend the French, a nation that was now Britain's ally. Indeed, he declared that 'the Subjects ought all to refer to the House of Lords & English History'. Haydon argued that government 'should be an abstract idea illustrated from the History of the World'. But Melbourne was not convinced. Haydon placed as favourable a construction on the meeting as he could, however. If his Lordship was really not in favour of the scheme, why had he suggested the name of another man to bring it before the House? And if he was not sympathetic with his visitor's views, why – when talking of the Royal Academy – had he said: 'They made a great mistake founding *that* place'?

<p style="text-align:center">★</p>

Reading Lord Brougham's recently published *Discourse of Natural Theology*, Haydon mused on mind, matter and the mechanics of suicide. The Lord Chancellor – soon to be relieved of his office by Lord Melbourne – proposed that 'the existence of the mind is complete in itself, and wholly independent of the qualities or the

existence of matter'.[117] If it were otherwise, he argued, the immaterial soul could not survive corruption of the material body. Haydon differed. 'The Resurrection will be of the Body,' he declared 'as it was of Christ's.' He cited the case of the 2nd Marquess of Londonderry, Viscount Castlereagh, and demanded that 'if mind is independent of Body, why are [its] powers deranged by derangement of Body?' On 12 August 1822, when Castlereagh stabbed himself in the throat with a penknife – his pistols and razors having been taken away from him by his anxious physician – it was, Haydon believed, entirely due to indigestion:

> He was overworked – his digestion out of order, his brain too full of blood. He [ate] buttered toast – to a healthy stomach indigestible, to a diseased one ruin; his brain filled with more blood; he became insane; he cut his carotid; the moment his blood flowed & relieved his brain, he had his reason [again] & said [to his physician], 'Bankhead, it's all over.'

And when the law reformer, Sir Samuel Romilly, killed himself, Haydon argued that the same physical connection between mind and body was proved, because mental lucidity briefly returned after he slit his throat and 'he asked for pen & ink' to record his final thoughts.[118]

Haydon deplored Brougham's attempts to prove philosophically the immortality of the soul, on the grounds that 'No body can prove. We are told we shall *be* hereafter. Is this not enough?' Natural theology's probing into the tenets of religious belief was a heresy: 'The Christian Religion wants no *help* & proof for belief, and he who wants any help & proof . . . never was & never will be a *Christian*.' But it was Brougham's remarks on the dissociation of mind and body that drew Haydon back, as though fascinated, to Castlereagh, his buttered toast and his penknife. Caused by a physical disorder beyond the individual will, personal responsibility for the act was abnegated. Only thus could Haydon, a devout Christian, justify and excuse the sin of self-slaughter. For a week he hardly touched his brushes, returning again and again to convoluted analysis of the subject, until optimism prevailed with the composition of a limerick in which art, learning and matrimonial happiness, together, drew him back from the brink of a stark finality in the last line:

> Oh hail, my three blessings of Life,
> My Pencil, my Book, & my Wife,
> Never mind the alloy,
> While these I enjoy,
> I defy both the bullet & knife.[119]

On the last night of the year he again counted his blessings. He thanked God for 'raising [him] up such a Friend as [his] dear Landlord'. He had completed four pictures in the previous twelve months. He was in health, 'blessed in Children, & dear Mary . . . more beautiful than ever'. But 1836 began with 'Harrass! harrass! harrass!' Nine-year-old Fred was ill and the house was in great anxiety lest the youngest, little Newton, be infected. Haydon had to run into the City to delay an execution. He began an *Adoration of the Magi* and prayed that he might 'make . . . a fine thing of it'. A providential five pounds arrived from the Duke of Bedford, which enabled him to redeem his dinner suit from pawn in time for his second Mechanics' Institution lecture, and on 13 January he addressed his audience on the subject of bones and the Elgin Marbles, but with a lengthy digression on the suicide of Castlereagh. Towards the end he spoke directly to the seeds of future hope sown in the hall:

> If there be any noble-minded boy who hears me, who is resolved to devote himself to keep alive the historical feeling which . . . Barry, West, Reynolds, Fuzeli, Etty, Hilton, Lane, and myself, have contrived to save . . . from utter decay; let me tell him his bed will not be a bed of roses, and his habitation as often perhaps a prison as a palace; but if he be of the true blood, if he possess that great characteristic of our dear country – Bottom! – neither calumny nor want, difficulty nor danger, will ever turn him aside from the great object of his being.[120]

He was received with applause and congratulations and the next morning, still basking in the approbation, he was served with an execution for fifty pounds. He wrote to Melbourne, who sent him seventy pounds 'to relieve . . . present difficulties'. He added, however, 'You must not think me hard if I say . . . that I cannot do this again.'[121] Haydon, in his 'grateful reply', took the liberty of a pointed joke: 'telling him I should think nothing *hard* but his building the House of

Lords without Pictures'. He was sure his Lordship would laugh heartily when he read this.

The following week he lectured 'On the Muscles' to 'a most brilliant audience & [was] *cheered!*' The day after, his dinner suit was returned to the pawnbroker.

Melbourne was dismayed to receive another letter from Haydon, just over a month later, requesting an interview. 'I cannot see you if it is on the subject of money,' he replied. 'I told you before my resolution upon this subject & I never depart from what I have said.'[122] Haydon responded with wide-eyed ingenuousness: 'How can you suppose it was on the subject of money?'[123] he asked, and gave his word, moreover, that such a topic would never be mentioned between them again. Melbourne begged 'a thousand pardons for [his] misapprehension'.[124] Haydon claimed he had merely wished to engage his Lordship in further discussion on the subject of art and, in particular, the decorations for the new House of Lords. He also had good news to impart: Melbourne would be pleased to learn that he had received 'two handsome commissions . . . from a nobleman'.

George John Thicknesse-Touchet, 20th Baron Audley, was fifty-three, 'somewhat above the ordinary stature' and of such bulk that, when he died the following year, his laden coffin was said to be 'about 8 hundredweight'.[125] He was habitually drunk, and 'undoubtedly at this time insane'.[126] The family boasted direct lineage to Lord James Audley, whose valour during the most decisive battle of the Hundred Years War had earned him an annuity, of which, 480 years later, his decayed descendant was still in receipt. The 20th Baron was understandably proud of his heritage, and one of his favourite stories was of George IV insisting on kissing his forehead 'in honour of Poitiers'. He confessed to having had his own pecuniary difficulties. He once lost £300 given to him from the privy purse gaming in a coffee house, went straight to Lord Dudley's house at midnight and was given a cheque for £1,500. In all such applications, he told Haydon, 'You know I always brought in Poitiers.' Unsurprisingly the first part of the commission he offered Haydon was for a canvas, over six foot by nine, commemorating the bravery of his illustrious forebear: *The Black Prince thanking Lord James Audley at the Battle of Poitiers*. The price of 500 guineas was agreed and he instructed his agent to pay an immediate advance of fifty pounds.

He came to dine at Burwood Place, complimented the Haydons on the beauty of their daughter Mary, now twelve years old, talked of giving her presents and promised that if William, his younger son, liked her and she was prepared to marry him, he would settle £50,000 on them. Haydon began to have misgivings and determined that if Audley did 'any thing out of the way in point of liberality', he would write to his Lordship's eldest son. 'I do think he is eccentric,' he observed. But it was difficult not to be seduced by the expansive generosity of a man who told him, 'Money is at your command', and that their meeting 'was providential and [Haydon] should never want'.

As with many an alcoholic, it did not take much wine – 'two bottles between us – & Sherry at dinner' – to top up the level in Audley's system and make him 'excessively tipsy'. At the end of the evening Haydon called a cab to take him to the New Hummums, a seedy establishment in Covent Garden where 'a bed was always to be got . . . any hour of the night'.[127] Audley called a few days later and gave Haydon another eighty-five pounds, but made no further mention of his younger son or the £50,000 marriage settlement. 'Lord Audley is different today,' Mary observed to her father. The 20th Baron was sober.

The money from Audley had secured Haydon's dinner suit from pawn and on the last Wednesday of March he lectured again at the Mechanics' Institution, 'On Composition', and spoke against the Academy. A member of the Institution's committee told him afterwards: 'Your enthusiasm carried them on, or they would not have borne it.' Haydon believed otherwise. 'It was their understandings carried them on. They have an instinct against oppression. They know I am the Victim.' At his fifth lecture, 'On Colour', given 'with great applause' the following week, Sir William Hamilton 'seemed astonished at the hearty & manly reception of the audience'.

★

In 1821 Sir George Philips wrote 'a long puff' in the *Globe* of *Christ's Agony in the Garden*, the picture he had commissioned from Haydon and recently taken possession of, a picture the artist himself would come to regard as the worst he had ever painted. Fifteen years later Sir George's opinion of the *Agony* more closely approximated Haydon's,

and he wrote to inform the painter 'that he may have his picture . . . whenever he may be inclined to send for it, as Sir George has no intention of hanging it up either in his house in town or in the country'.[128] Privately, Haydon suspected another opinion was behind Sir George's: 'It is Lady Philips who is to be pleased, & I hate her,' he wrote, 'a pair of breeches would suit her better than a Picture.' At first he assumed that another picture was required in exchange for the 500-guinea *Agony* and, although feeling it to be 'a bore', was willing to accommodate the 'poor dear amiable good hearted' patron. But another letter from Sir George made it clear that he did not wish to exchange the picture and that his motive in returning it was purely magnanimous, from 'a belief that [Haydon] could derive some advantage from the possession of it'. He also clarified his reasons for refusing it further wall space. He had not altered his opinion of many 'highly creditable' parts of the picture, he explained, 'but his objections to the principal figures of Christ & Judas . . . have increased in proportion as he has seen more works of art & . . . improve[d] his judgement in them'.[129]

<div align="center">★</div>

Crossing the Haymarket, one Sunday in April 1836, Haydon and his son Frank were startled when a dog ran out from under a cab and 'howled most dreadfully'. The cab driver called out: 'That's for you or me, sir.' The night before Haydon had dreamed of his father. 'I never do,' he commented, 'but some calamity is coming.' The health of the baby, Newton, was causing anxiety. They hired a wet-nurse, but the child did not thrive, so they paid and dismissed her. As she left the woman said, 'Ah, sir, I dreamt of my poor Mother last night – I thought some misery would happen!' Haydon made a note: 'It must be in a fortnight or it means nothing.' It came in a month.

Meanwhile he concluded his series of six lectures at the Mechanics' Institution. The audience gallantly applauded Mrs Haydon as she took her seat with Frank in the front row. According to a newspaper clipping that he stuck into his journal:

[Haydon] asserted the supremacy of historic and epic painting over portraiture; and he argued that this supremacy could never be main-

tained in this or any other country without national encouragement. He deprecated the apathy of the Government and the public on this subject, ascribing it greatly to the deadening influence of the Royal Academy . . . In particular, he urged the favourable opportunity afforded by the rebuilding of the Houses of Parliament.[130]

Towards the end of the lecture he told his audience of a question once put to him by 'a noble Lord', known to them all. It was while discussing his first petition to Parliament in 1823, and the individual – Henry Brougham, himself a champion of the Mechanics' Institution – asked: 'Do you think the people will ever have any taste?' Haydon surveyed the crowded hall and allowed the question to hang in the air:

> Suppose I had said to him, when he was founding a university, Do you, my Lord, think the people will ever have any knowledge? No, he would have replied, unless you give them schools and books, and open their understandings: and so I say of art. How can they have taste if you found not schools of design, or show them fine works?[131]

He was 'rapturously applauded on taking his leave, and especially when he hinted at meeting his audience again'.[132]

The money he received for the Mechanics' Institution lecture series,[133] together with advances from Lord Audley, enabled Haydon to pay off the sixty-six pounds balance of rent still owing to Mr Hickman, the last of what he called his 'Reform loss'. *Xenophon*, ransomed and restored, could at last be raffled. On Sunday 10 May, the subscribers gathered in the Great Room of the Thatched House Tavern, St James's Street, under the painted gaze of 'two of Sir Joshua's finest pictures of the Dilettanti Society'.[134] The Duke of Sutherland in the chair, it took just under an hour for all fifty-eight contenders for the picture, or their representatives, to make the three casts of the dice for each share they had purchased. At the end of the process the Chairman announced that the highest scores thrown were those of the young Earl of Mulgrave with 10, 8 and 11, and the Duke of Bedford with 8, 11 and 11, and the Duke of Bedford was declared the winner by one. 'No body bears losing except men of breeding,' observed Haydon. Thomas Kearsey was of a different stamp and 'got into a perfect fury' when his throws of 12, 4 and 9 were overtaken. 'The

[Chairman] seemed to wonder who he was – a great, rolling, fat, grand looking dog, flinging about his handkerchief.' The Duke of Bedford presented his prize to the Russell Institution in Great Coram Street, where it was hung in the Library.

Haydon himself was weak with influenza and aching in every limb. He had spent the night before in a fever and, until the start of the raffle, had been sheltering from the wind, toasting himself by a fire in a nearby trumpet shop. Thanks were proposed at the end of the proceedings, and the Duke of Sutherland 'expressed his pleasure in presiding, and hoped all parties were satisfied at the anxiety betrayed by Mr Haydon to meet his engagement'.[135] Haydon was convinced, however, that he had offended one exalted subscriber by a breach of protocol and thereby spoilt his chances of future patronage. He had sent Princess Victoria an ordinary ticket, promising to 'admit' her to the raffle, instead of one craving 'her Royal pleasure'. He received no reply. The following year she would be Queen and the old courtier, Sir Thomas Hammond, assured Haydon: '*She will never forget it.*'

<center>*</center>

A month after the dog howled in Haymarket, Newton Haydon died, aged eight months and three weeks. There had been an exhausting accumulation of ailments and effects: 'He had teething, which affects the brain; measles, which inflames & weakens; influenza, which enervates by fever.' The customarily reckless administration of powdered mercury was intended to relieve the discomfort of dentition by encouraging the production of saliva but, if continued too long, it caused the pathological condition of ptyalism, in which the tongue and salivary glands became inflamed, filling and overflowing the mouth with a foul-smelling, frothing drool. This 'depleted him more, swelled the tongue, prevented his sucking, & he died the Victim of mismanagement . . . from sheer exhausted debility'. Two years previously, Haydon had blamed Harry's death on the negligence of his nurse, but the 'mismanagement' contributing to the loss of Newton he suspected was his own. Dr Darling had ordered the powders to be left off but Haydon, in 'the hurry of progressive occupation', neglected to inform his wife. The mercury poisoning was continued.

A few days before the child's death, Haydon, along with the rest

of polite London society, was preoccupied with news of the impending action which the Honourable George Norton was bringing against Lord Melbourne in the Court of Common Pleas. Servants had been examined, linen inspected, papers seized and evidence gathered, which would enable the plaintiff to take custody of his children and divorce his wife on grounds of adultery with the Prime Minister.

Haydon's sympathies were for Melbourne, whom he regarded as the lady's 'complete victim'. His own besotted adoration for Mrs Norton had turned to loathing, and he gloated at the prospect of her being proved 'as dreadful a whore as ever cursed the World since Messalina'. He felt himself fortunate in his escape and that only the strength of his marriage had saved him. But as Norton's lawyers prepared their case, rifling through the lady's private correspondence, Haydon feared he might yet be drawn into the scandal if his 'imprudent letters' were to be read in court. 'There is nothing criminal,' he protested, 'I have always kept my moral character, & I have not lost it, though my cursed notes would shake the belief of the World in my purity.' The defendant in the forthcoming trial had more to lose than his moral character. For 'criminal conversation' with Mrs Norton, the prosecution was seeking damages from Lord Melbourne amounting to £10,000.

The case was heard before Chief Justice Tindal and a special jury in the course of a single day and the public benches were excessively crowded. Proceedings were reported and transcribed across four pages of *The Times*. In his opening remarks Sir William Follett, council for the plaintiff, explained to the court that, having at Mrs Norton's request appointed her husband to the position of police magistrate to the Whitechapel District, the then Home Secretary had become a frequent caller on the lady at their home in Storey's Gate, Westminster. Visits occurred in the afternoon, whenever his Lordship's parliamentary responsibilities spared him, and when Mr Norton was engaged at his official duties in the East End. Servants were questioned and it was ascertained that Lord Melbourne called most days of the week, always in the afternoon, and was entertained in the first-floor drawing room by Mrs Norton; that he never stayed for less than an hour, very often for two, and on rare occasions for three; that he always came through the secluded back door off Birdcage Walk on the park side, in preference to the main entrance in Prince's Court; that when he was not there the drawing-room window blinds were usually only half-down,

'but when he came they were pulled wholly down'; that while he was there, the mistress left orders that she was not at home to any other visitors and was not to be disturbed.

Eliza Gibson, house and lady's maid, testified that during Lord Melbourne's visits Mrs Norton customarily left the drawing room and went upstairs, 'her collar and her hair generally tumbled', and that, after washing her hands, applying fresh rouge and putting her hair and dress 'to rights', she would descend again before her guest took his leave.

The children's nurse, Anne Cummins, told of entering the drawing room on various occasions and seeing 'Mrs Norton sitting on the sofa with Lord Melbourne and her hand on his shoulder . . . Mrs Norton kneeling on the carpet by Lord Melbourne's knee, and her hand on his knee'. The coachman, John Flook, claimed he witnessed a more compromising tableau when he entered the drawing room to deliver a message. Lord Melbourne was sitting by the fire with his elbows on his knees, head reclining on his hands and looking towards Mrs Norton, who was lying on the floor, her feet towards the door and her head on the hearth-rug. 'Mrs Norton's clothes were up,' Flook recalled, and he could see 'the thick part of her thigh'. Mrs Cummins, who had charge of the household laundry, was asked her opinion as to stains on Mrs Norton's 'day linen' and whether they were damning 'marks of connexion' or merely symptomatic of an 'effeminate weakness'. Mrs Cummins declared her mistress to have been 'such a strong body'.

After eight and a half hours an exhausted Sir John Campbell presented the case for the defence. He discredited most of the prosecution witnesses as being 'discarded servants' and of 'bad character'. As for the testimony of Mr Flook, the jury was asked, 'would they hang a dog upon it?' By the time Chief Justice Tindal had finished summing up – also referring to the revelations of Flook and leaving them to the jury's discretion – it was approaching midnight. A verdict came immediately. The jury had been instructed that they must only find for the plaintiff if there were positive proof that an act of adultery had taken place. The circumstantial evidence of window blinds, frequency and pattern of visits, disordered dress and hair, stained linen, even the glimpse that Flook alleged to have had of his mistress's thigh, did not constitute such proof. When the jury foreman announced a

verdict in favour of the defendant, Lord Melbourne, the court erupted in bravos, cheers and hissing, a 'breach of decorum' quelled only by the threat of arrest. As silence fell inside the court, 'a similar expression of feeling [could be heard] on the result being made known to those who were assembled outside'.[136]

Haydon was disappointed. For him there had been only one guilty person, regardless of the fact that she had not been on trial: 'Caroline was acquitted . . . but surely not in the mind of any impartial person'. He was still concerned about his 'imprudent letters', as was his wife. Mary wrote to Caroline, asking that they be destroyed, and received a reply containing reference to the difference in their 'relative stations'.[137] Haydon bridled at the supposed slur on his own pedigree and wrote in defence of the 'long line of honorable mention' from which he sprang. He then attacked Caroline's character, accusing her of having a 'diseased appetite to flirt without heart & intrigue without meaning'. Disgusted as she was by her own unhappy marriage, she 'delighted to torture Men, & lacerate the feelings of their wives'.[138] He also wrote to her alleged 'victim', Lord Melbourne, charging her with bringing 'misery into every family . . . evil follow[ing] her beauty like a shadow', and he recounted a catalogue of blighted pregnancies to support his claims:

> I know one married Woman whose anguish was so excessive that a premature confinement came on, and the infant died! – I know another [in] whom the milk withered up in the bosom from the torture of Mrs Norton's advances to her husband, and the infant died!

The third case he recalled may well have been that of his own wife, giving birth the previous year, 'who suffered such agony during the *cursed time* that in her delirium she cursed her like a maniac, from having reason to suspect her husband'.[139] Unsurprisingly, Melbourne did not reply, and relations cooled markedly thereafter. Seeing the painter in the street one day, he turned smartly into the Home Office as if to say 'Damme, here's *Haydon*.' Three years later Haydon would be inordinately pleased – as by a raindrop after a drought – when the Prime Minister threw him a smile and a 'How are ye?' as he passed.

Within two days of Charles Norton's private pleas case collapsing, the proceedings of another tribunal claimed Haydon's attention. In

July of the previous year William Ewart, MP for Liverpool, moved that a parliamentary Select Committee 'be appointed to inquire into the best means of extending a knowledge of the arts and of the principles of design among the people (especially among the manufacturing population) of the country; and also to inquire into the constitution of the Royal Academy, and the effects produced by it'.[140] The Committee on Arts and Manufactures had sat in 1835 and was reconvened in June 1836 to investigate the constitution of the Academy, hear the defence testimony from a number of its most prominent members, and the complaints of detractors. Haydon was summoned to give his evidence towards the end of the month and 'the result was glorious'. Asked by Ewart for his principal objections to the Academy, Haydon replied:

> Its exclusiveness, its total injustice . . . the academy is a House of Lords without King or Commons for appeal. The artists are at the mercy of a despotism whose unlimited power tends to destroy all feeling for right or justice . . . It is an anomaly in the history of any constitutional people the constitution of this academy . . . It is extraordinary how men, brought up as Englishmen, could set up such a system of government. The holy inquisition was controlled by the Pope, but these men are an inquisition without a pope.[141]

Having given his evidence, he haunted the hearings as an observer, noting with satisfaction the discomfiture of Henry Howard, one of the Hanging Committee in 1809 responsible for the banishment of *Dentatus* to the Ante-Room. 'Good God! How he looked! How altered! How humbled!' After giving his testimony, the old man stood down and left the chamber without showing due courtesy to the Chairman and so 'Mr Ewart sent after him and brought him back.' Haydon 'never saw a man look more foolish'. On the day the President was examined, Haydon 'placed [him]self right opposite Shee, which seemed to disturb him'. Rattled by the Chairman's interruptions of his testimony, and at one point presumably angered at some imputation of a lack of respectability, Sir Martin gestured wildly at Haydon and said with heavy irony: 'That's the *respectable* man!' The former prisoner of the Bench felt that reference to his past misfortunes reflected more honour upon himself than his opponent. 'Honourable Sir Martin! First to drive

me into distresses, and then grossly allude to them before a Committee called for the purpose of enquiring on the effects of Institutions.'

Haydon believed that the Select Committee had been established as a direct consequence of his lobbying. When Melbourne sat for his *Reform* portrait in 1833, a Parliamentary Commission had been investigating municipal corporations in general. Haydon asked: 'Why do you leave out the Academy in this Commission on Corporations?' to which his Lordship replied: 'You may have it in if you please.' So when his enemies were summoned, questioned and made to justify their statutory privileges, Haydon felt as though they had been brought to book at his behest; as though he himself stood in vengeful, righteous judgement over them:

> Was not the whole scene a scene of retribution? The very men, the very hangers – Shee, Phillips, & Howard – who . . . used me so infamously in hanging Dentatus in the dark – by which all my prospects were blighted for ever . . . were now at the bar before me like Culprits under examination – ransacked – questioned – racked! Ah, they are deservedly punished! . . . Gratitude & Huzza!

The Committee's report, when published later in the year, fell far short of the explicit condemnation of the Academy that Haydon had anticipated while watching the proceedings. It pointed out the ambiguous status of a body that claimed to be a private society, its system of exclusive privileges unaccountable to parliamentary scrutiny, while at the same time claiming '"public" or "national" status to secure royal patronage, diplomas, public accommodation, *ex officio* appointments for the President as a trustee of the British Museum and National Gallery, and a monopoly in advising government'.[142] It made no direct recommendation for a reform of the Academy's constitution.

<div align="center">★</div>

Success of the *Xenophon* raffle had convinced Haydon to begin another large picture to be disposed of in like manner. The subject – an incident of the Peninsular Campaign – was one that Wilkie had had great success with nearly a decade before. During the defence of the Spanish town of Saragossa, Agostina – lover of an artillery sergeant killed with the

rest of his gun crew at the Portillo Gate – ran forward and fired the cannon at close range into the French attackers and thereby broke the assault. Prospects for *The Maid of Saragossa* seemed more favourable than for the other history painting Haydon was working on. The euphoric bubble of the Audley commission – gilded by promises that his family should never want – burst when it became apparent that no further funds could be expected from the 20th Baron. 'Lord Audley has completely deceived me about his resources,' Haydon lamented, 'after telling me he was the *richest* Peer, it turns out he is the *poorest*!' Appeals to his agent 'met with dreadful disappointment', Mr Pike 'behaving cruelly & abominably'. Creditors, meanwhile, again became clamorous.

At the end of August he dreamed of 'an enormous wave, curling & rising & black'. He was on the seashore with Mary beside him, watching the 'sublime wave' as it rolled towards them. Just before it struck there was 'a terrific flash of lightening' and the wave roared past without wetting them and broke harmlessly on the beach. 'I know that a Storm is coming,' he wrote, 'but I feel we shall weather it, under God.' Less than a fortnight later, the overwhelming tide of debt struck, sweeping him away to depressingly familiar incarceration. He was eating breakfast with his children when there was a discreet ring at the front door and a whispering in the hall. He 'affected uncon-cern', nonchalantly balancing his spoon on the edge of his teacup. 'If you please, sir,' the servant said, 'Mr "Smith" wishes to see you.'

Frederic Haydon, then nine years old, remembered when the Sheriff's Officers came for his father: 'the expression of pain that passed over his face as he rose and left the room, not venturing to look any of his children in the face. "Tell your mother I have gone out," he said, sadly; that was all.' They gathered at the window and saw him driven away in a hackney coach, 'accompanied by two men, one sitting on the box'.[143] He spent three nights' confinement at Davis's sponging house in Red Lion Square, Holborn, and then, on 12 September, he was committed once again to the King's Bench. Mr Davis redirected a gloating creditor's letter to that address:

Allow me to tell you that the public thinks that you are one of the lowest, mean beggars that is in England, that you are a lazy good-for-nothing fellow, and can do nothing, and ought to be sent to the tread-mill as an impostor.

The anonymous author had obviously read about the raffling of *Xenophon* and declared that a subscription, instead, should be got up for the purchase of a broom to sweep the streets and give him employment as a night-soil collector. The note was signed with initials C.M.D. and 'A Hater', the envelope addressed to 'B.R. Haydon, *the Beggar*'.[144]

The prisoner, in turn, wrote to former and potential patrons. He reminded Sir Robert Peel of his own 'absurd conduct relating to the Napoleon', mentioned his conviction at the time that it 'would be the seed of future embarrassment' and implied that the Right Honourable Gentleman's underpayment had contributed to his present condition. 'I assure you I calculated on receiving more from you,'[145] he complained. Sir Robert's reply has not survived. Haydon also wrote to Melbourne, explaining his predicament and offering to paint him a picture, but his Lordship was still cool after the letter relating to Mrs Norton: 'You know that I am not a purchaser of works of art,' he reminded Haydon. 'I am very sorry for your misfortunes.'[146]

One evening there was a knock at his door and Mr Colwell, the chum master, eyes dark, bulbous and divergent, sidled in desiring conversation. Apologising for the disturbance, he sat down and spread a blue cotton handkerchief across his knee. 'Perhaps, sir,' he began, 'you would hardly suppose, that from 7 years old, Divinity & Medicine are my passions.'

'Certainly not, Mr Colwell,' said Haydon, assuring the visitor that he did not find it at all hard to suppose such a thing.

'Ah, sir, it's true, & I know, I assure you, much more than most of the Doctors or Parsons. Why, sir, you little think I always cured the Cholera. You may wonder, but it is a fact. I never lost a case, & in 24 hours they were as well as ever. I do it all by harbs, Mr Haydon, by harbs . . . I gather [them] under *the Planets* – ay – and it is wonderful the cures I perform . . .' He had cured his wife, he said, '*often & often*'.

Mr Colwell next broached his other lifelong passion. He had incontrovertible proof that Joseph of Arimathea landed at Glastonbury, '*for at that time the Sea came all up to the Abbey, and what was to hinder him?*' He also assured Haydon that when, in Luke Chapter 3, verse 23, Mary's husband Joseph was referred to as the 'Son of Eli', it actually meant he was the son-in-law, Eli being the father of Mary.[147] Each revelation was separated from the last by Mr Colwell pulling his chair closer, wiping his mouth with the blue cotton handkerchief and asking, 'Mr

Haydon, would you believe it?' He could prove that Abraham was circumcised on the day before Sodom and Gomorrah were destroyed. 'Would you believe it, Mr Haydon?'

'Will you take a glass of Wine, Mr Colwell?' Haydon asked. And after partaking of his charge's hospitality, Mr Colwell put the blue cotton handkerchief away and departed for room 14 in stairway 10 'to give the Gentleman [there] his Chum Ticket'. He promised to return and supply Haydon with books that would confirm all that he had spoken of.

The Bench's riotous atmosphere remained unchanged since the days of the Mock Election. Early one Sunday he was awoken by 'a roar as of Fiends . . . from the racket ground . . . swearing, fighting, cursing, drinking, gambling, & strumpeting! What an offering to the Almighty for the blessings of Life!' A mild, benevolent-looking prisoner named John Phillips fell dead of an apoplexy in his room and Haydon was appalled that 'the levity of the Vicious & thoughtless' prevailed, as heedless of this tragedy as of the Sabbath. 'Gambling, whoring, swearing, & drinking went on as usual' and, while Haydon mused on life and death, 'the bloods and blackguards of the place were singing duets outside [his] door at midnight'.

Mary came and they passed their fifteenth wedding anniversary in his sordid room. He 'did the Wedding night' and swore he did it 'with more fury'. Another conjugal visit was marked by 'Rapture belonging to Heaven'. He 'devoured her, crushed her', climaxing in such a 'convulsion' that, had it lasted a moment longer, 'insanity would have resulted'. He told her an anecdote from his recent reading of Moore's *Letters and Journals of Lord Byron*, in which the poet's mistress, finding him with another woman, dragged her out of the room by her hair. 'Ah, that's just the way I would have served Caroline,' Mary told him. Haydon thought this 'Exquisite'.

He had been in prison for two months and at four o'clock, when the book closed on the last day for creditors to register opposition to his release, no one had done so. Five days later, on 17 November, he attended the Insolvent Debtors' Court in Portugal Street for what was to be the last time, and petitioned for protection of the Act. His debts amounted to £1,220 6s 6d.[148] 'The insolvency was ascribed to losses in the exhibition of the Lord Grey picture in celebration of the passing of the Reform Bill',[149] to an attack on the painter's art and reputation

by *Fraser's Magazine*, and to expenses in law costs. Haydon was 'treated with the greatest humanity' and his discharge was 'hastened . . . with the rapidity of lightening'. The following day he was reunited with his family.

In September, when Haydon was arrested, William Newton had taken possession of his property in lieu of rent, but with the laudable motive of keeping it from his tenant's less charitable creditors, and promising that it would all be returned to him. Just under twelve weeks later, his brushes and grinding stone restored by his landlord, Haydon was able to resume work. With the heightened senses of a man long deprived, he 'relished the oil, could have tasted the Colour, rubbed [his] cheeks with the brushes, & kissed the Palette!' He stared at *The Maid of Saragossa*, rubbed in before his arrest, and might even have whispered the fervent words committed to his journal later that day: 'Ah, could I be let loose in the House of Lords!'

His final lecturing engagement of the year was to the Mechanics' Institution 'On the Effect of the Different Societies in Literature, Science, and Art, on the Taste of the British Nobility and People'. He attacked the Dilettanti Society for an 'exclusive delight in the productions of the dead render[ing their] minds on the whole callous to the real genius of the living'.[150] He criticised the British Institution for its failure to patronise living genius, governed, as it was, 'more by a desire to afford amusement for the day, and the dinner, than any solid hope to correct soundly, to advance legitimately, or develop powerfully, the energies of the British people'.[151] He condemned, as was to be expected, the Royal Academy for 'keeping up their own monopoly at the expense of the people'. And he roused his audience with the ringing assertion:

> From the people, and the people alone, must grand art spring; let them be instructed and educated, and they must react to the privileged classes; and in a very few years . . . schools of design soundly established, and professors at the universities, art will begin to bud on a solid foundation.[152]

As he uttered these words the new Government School of Design – an establishment that would evolve, first into the National Art Training School and, by the end of the century, into the Royal College

of Art – was taking possession of apartments in Somerset House recently vacated by the Royal Academy. The Academy, meanwhile, was moving into 'temporary' accommodation in the east wing of the National Gallery, which it would occupy for the next thirty-two years.

The Government School of Design was far from the 'soundly established' institution Haydon had in mind when he spoke at the Mechanics' Institution of encouraging grand art to bud. He learned that life drawing was deemed unnecessary as a basis of the art education conducted there, and that all students were made to sign a declaration 'not to practise as history painter, portrait painter or landscape painter'. He learned that four Royal Academicians had been appointed to its council: Chantry and Callcott 'doing everything . . . to quash and ridicule the plan', Eastlake and Cockerell 'good men, but *timid*'. He wrote to Lord Melbourne urging him 'to prevent the School from getting into such hands' and becoming 'a discredit and a disgrace'.[153] A year later he would pay a visit and find all his prejudice confirmed: '*Nine* poor boys drawing paltry patterns – no figures – no beautiful forms! And this is the School of Design the Government of great Britain has founded in its capital!'[154] He felt his cheeks crimson.

The initial six lectures he had delivered to the Mechanics' Institution between September 1835 and May 1836 had been supplemented by four more, 'begun in my Painting Room', he wrote in March 1837, 'continued in Prison, and completed under the blessing of God, in my Painting Room'.[155] A week after finishing his tenth lecture – 'On a Competent Tribunal and its Importance to a Nation where Art is concerned', which addressed the question of how the taste, not of the Nation but of its Government, might be improved – he was on his way north, to address a Scottish audience for the first time, at the invitation of the Edinburgh Philosophical Association. He left London, on the night of Saturday 11 March, aboard the latest addition to the General Steam Navigation Company's fleet, the 'magnificent new steam ship *Clarence* with accommodation for passengers unrivalled for extent, convenience and splendour',[156] and which promised the passage from Blackwall to Leith docks 'with extraordinary rapidity and regularity'.[157] In the hold was *Christ Raising the Widow's Son*, borrowed from William Newton. A new association, the Edinburgh Society of Artists, was mounting its inaugural exhibition and the Secretary's

letter, couched in terms that could admit no refusal, had requested from Haydon:

> one of your Works, reflective of your great talent, which will not only be a point of attraction and support our humble efforts, but also a study for many young Artists who seldom have an opportunity of comparing their Works with an acknowledged, great, and finished production.

Mr Craig also pointed out that the picture would 'elicit a preliminary interest in favour of the object you have in View with regard to your Lectures – the creating of a taste for the higher walks of the fine arts'.[158]

On Sunday the *Clarence* was hit by a furious gale off Flamborough Head: 'the black & foaming wave, the Watery & lowering Sky, the screaming gulls & cracking rigging . . . the persevering energy of the steam paddles, which nothing stopped, [giving] a tremendous idea of the power of Science, contesting . . . the Elements of God!'

At sunset on Monday night an old piper on board skirled out an air as they caught their first sight of the Cheviot Hills, and at the following daybreak Haydon was on deck again, never having seen Scotland from the sea. 'The first thing was Arthur's Seat & the Pentland Hills, encircled in mist – & the Sun rising beautifully behind them.' He found the city of Edinburgh, after sixteen years, greatly improved, especially in its provision of sanitation. Water closets abounded and 'the Town [was] much more wholesome & sweet'. His landlady proudly showed him her own, 'as much as to say *now you can't resist*'. Several old friends were dead, including the man who had first welcomed him in 1820 and eased his reception with the *Blackwood* set. 'The place ha[d] lost half its charm from the loss of Sir Walter.'

Although Sir William Hamilton had given him letters of introduc-tion to 'persons of rank & Consequence', Haydon delayed making use of them and declined all invitations to dine, wanting 'to keep quiet' until he was halfway through his lectures, 'for fear of getting ill'. He had good reason for caution as his schedule was strenuous. The entire series of ten lectures was to be delivered twice: first on Mondays and Fridays at 8.30 p.m. in the Adelphi Theatre, then again on Wednesday and Thursday afternoons in the saloon of the Royal

Hotel at two o'clock, 'for the benefit of those who cannot conveniently attend in the evening'.[159]

During the first week, the 'New Exhibition of the Works of Living Artists' opened at Mr Bruce's Rooms in St Andrew's Square, *Christ Raising the Widow's Son* prominently displayed and greatly admired. 'It is a fine effort of genius,' declared the *Edinburgh Evening Courant*: 'The composition . . . chaste and powerful – the colouring broad and harmonious, with a pleasing simple harmony, and warm yet subdued glow. The drawing is admirable, and evinces a masterly knowledge of the human figure.' The *Courant* also reviewed his performance at the Adelphi Theatre:

> Independent of his manner of lecturing, which is singularly happy and amusing, Mr Haydon possesses such a power in the use of his crayon, and sketches his illustrations with so much facility, accuracy, and beauty, that, as mere lessons in drawing, they must be invaluable to the artist and amateur. There are few things better calculated to form and improve the taste in matters of art than these lectures which we heartily recommend.

The highlight of his third lecture, 'On Muscles', came when he brought onto the stage 'two admirable specimens' of naked manhood hired for the occasion from the barracks of the 42nd Highland Regiment at the Castle, and which he placed 'into a variety of attitudes favourable for developing muscular structure'.[160] That evening he overran by three-quarters of an hour, but was convinced his audience would have listened 'till 5 in the morning'.

When he was not lecturing, he 'hunted out all the remarkable places' connected with Scottish history, 'every spot, street, hill, & mountain . . . celebrated for some fierce struggle or desperate murder'. He visited Holyrood Palace and bribed a housekeeper to let him come back after dark and walk by candlelight up the staircase that Ruthven and Darnley had climbed to murder Rizzio. 'It is extraordinary,' he observed, 'this desire to feel a grand & new sensation – of horror!' Edinburgh was 'rich in the damnedest places on Earth' and he was able to indulge in vicarious horrors of more recent date: 'the den where Burke murdered those poor Souls – now occupied by *dogs* – like Hell!'

On the Saturday following his last lecture, the Edinburgh Philosophical Association honoured him with a public dinner in the Royal Hotel. 'The company was numerous and highly respectable', the *Chronicle* declared. Each guest had paid 10s 6d to attend. The cloth removed and the usual toasts to the King, the Queen, the Princess Victoria, the Army and Navy having been proposed and drunk, Mr Maurice Lothian, Chairman of the Association, gave the toast of the evening. He traced the early landmarks of their guest's career: the *Solomon*, the *Jerusalem*, the *Lazarus*, and reminded the assembly of the 'lately exhibited' *Christ Raising the Widow's Son*: 'art which awakens the sympathies, and leaves its moral and magic impress on the tablets of the human heart'. He extolled the painter's 'excellence in the satirical and humorous departments [*The Mock Election* and *Punch*] . . . distinguished exhibitions of his Hogarthian powers'. And he paid tribute to the writer, scholar and charismatic lecturer:

> We have witnessed him absolutely rioting among his stores of Greek and Roman learning . . . commanding the unflagging attention of overflowing audiences . . . and no one ever saw him handling his chalk without being struck by the observation that his very touch is a thought.

Primed by his subject, Mr Lothian spoke, in conclusion, of Haydon's oppression by 'an oligarchy of artists' and of 'the evils of unchecked and irresponsible power'. And he concluded on a note of heartfelt hope for their guest's ultimate triumph:

> May he be compensated by . . . the support of an honest public; and may he be honoured to hasten the day . . . when our public buildings, illuminated by the instructive splendours which delight the eye and expand the soul shall rival the glories of an Athenian temple. Of one thing I am certain, that that voice which cannot be fawned on or bribed . . . – the voice of posterity – will do him justice.

Glasses were raised and drained 'amidst loud and continuous cheering'. As he rose to respond, Haydon seemed 'much agitated . . . at the extraordinary enthusiasm with which his health had been received'. He told the company that he had had 'two high honours' in his life. The first was being elected a Freeman of Plymouth in 1814, the second,

Wordsworth's sonnet to him of 1815. The one, he said, had been dismissed by 'carpers' as an empty honour because it had been given by his native town and by people who knew, or were perhaps related to him. The other had been belittled on like grounds because Wordsworth was his friend. 'But at last,' he told his hosts, his voice gaining in energy:

> At last I have got hold of an honour – so pure in principle – so sincere in public sentiment – so unadulterated in intention – from men, not one of whom ever saw me before this visit, amongst whom I have no uncles or cousins, no domestic or private connexions, that I will now defy all the *carpers* in England, Scotland, and Ireland; and no man can accuse me of insincerity, when I solemnly declare, from the bottom of my soul, it is the highest honour of my life.[161]

From Edinburgh he travelled to Glasgow, where he boarded the steamship *Unicorn*, which took him to Liverpool in eighteen hours. The seven o'clock train from Lime Street Station took him the thirty miles to Manchester in an hour.[162] From Manchester he travelled down to Leicester, where he delivered his original series of six lectures to 'crowded & enthusiastic audience[s]' and 'with great applause', in just under a fortnight. Between these engagements he visited a length of Roman wall and various Roman pavements, a factory for braces and children's boots, the site of Bosworth Field and the well from which Richard III was supposed to have drunk during the battle.

The day after delivering his last lecture he hurried back to London, arriving home in time to celebrate Mary's forty-fourth birthday. It was the evening of 11 May, exactly two months since he had set out for Edinburgh. His tour had proved 'a complete triumph!'

Five days later he was off again by train, covering the 186 miles from London to Manchester in nineteen hours. He lectured at the Royal Institution until he was sick of lecturing. The condition of art education in Manchester was 'dreadful', he wrote, 'No school of design. The young men [in the Royal Institution] drawing without instruction. A Fine Anatomical Figure shut up in a box; the House keeper obliged to hunt for the key!' Invited to the foundation stone-laying of the new Athenaeum, he was introduced to the crowd and received three cheers. But he was also troubled by what he perceived

of the social conditions, contrasts and inequalities in this booming industrial town. 'The association of those hideous mill prisons for Children destroys my enjoyments in Society,' he wrote:

> The people are quite insensible to it, but how they can go on as they do in all their luxurious enjoyments with huge factories overhanging the sky is most extraordinary.

He must have mentioned his misgivings because he was subsequently taken to visit some model workplaces and declared his former views 'imagination'. He examined large factories: '2000 in one room, & found the Children healthy, strong, & the room well aired & wholesome'.

He travelled to Liverpool 'to settle about lecturing', returning to Manchester the same day having spent £1 8s 6d on 'coaching & railwaying & lunching' in an apparently wasted journey 'without any definite arrangement'. Liverpool, however, was to bring him dividends before the year was out.

After five weeks and 'the greatest success in Manchester' he returned to London. While he was away, and entirely unremarked in his journal, King William IV had died, succeeded by his eighteen-year-old niece, Victoria. Sensing an opportunity, Haydon asked the Duchess of Sutherland, Her Majesty's Mistress of the Robes, to 'interfere with the Queen' to appoint him her Historical Painter. No answer came, and when George Hayter was appointed instead, Haydon was convinced that Victoria was still offended by the ticket he had sent to 'admit' her to his raffle. He was able to convince himself that he had not wanted to be her Historical Painter anyway and that it would only have hampered his independence of thought and expression, lost him his liberty, and he would have 'died a slave to caprice'.

Towards the end of August, he was at Lord Grey's London home making final alterations to *The Reform Banquet*. He put in some swagged curtains at the top and repainted his former patron's features for the last time. A housekeeper, who brought his lunch, told him that Grey 'looked better when he lost his teeth than before – his teeth projected so'. Haydon finally 'made up' the face from a ten-year-old portrait by Sir Thomas Lawrence[163] and from his own memory. He was promised ten pounds for this additional week's labour on the picture, but

a month later his Lordship had neglected to instruct his agent to make the payment. This seemed only natural:

> The Unfortunate Banquet! It ruined me . . . & thus my enthusiasm for the cause, which they never would have carried but for *the people* and which they have lamented carrying *ever since, has been my bane!*

He even believed that it would blight his plan for adorning the House of Lords. The plan would be adopted, he thought, but given to others to accomplish, he himself being 'entirely left out' of the scheme by the very statesmen he had spent so long painting: 'Because there is no hatred like that hatred one Man bears another, when he believes he has been handed down to posterity, not so handsome as he fancies.'

With the 'end of Royal Patronage for High Art', and the fading prospects of parliamentary patronage under a Whig administration, more hopeful news came from Liverpool of what was to be Haydon's first commission from a public body. He had been asked 'on what terms and within what time' he would be prepared to paint a picture of 'Christ Blessing Little Children'. He replied that the subject 'had been in his thoughts for many years and that he would engage to finish such a Picture as the one proposed to him in the course of next year for 400 Guineas'.[164] The commissioning body was the Liverpool Blind Asylum and the picture was destined for their chapel, John Foster's handsome neoclassical temple on the corner of Great Nelson Street and Duncan Street, perched high above the cutting that brought the railway from Manchester into Lime Street Station. The Committee met on 5 September and unanimously agreed that Haydon's terms be accepted.

It might be thought that a 400-guinea painting was a superfluous and extravagant adornment of a chapel for the blind, but the intended benefit was more for the sighted public than for the Asylum pupils themselves. Attending Evensong and listening to the blind choristers was a popular sentimental attraction in Liverpool at this time. 'It was impossible without emotion,' remarked one visitor, 'to witness fifty or sixty of these unfortunate beings, among whom there was not a ray of vision, lifting up their voices in sweetest harmony, in a chorus of praise to their Creator.'[165] The collection plates were accordingly well filled by a tearful congregation.

Haydon travelled to Liverpool by train, leaving town at eight in the morning and arriving at midnight. He took with him an oil sketch of the desired subject for the commissioners' approval, dined with the Committee and was treated with 'great kindness & distinction'. Visiting the chapel, he was shown the space, to one side of the altar, that his picture was to occupy, counterbalancing the large canvas by William Hilton opposite. *Christ Healing the Blind* was 'broad but chilly in colour', Haydon thought, 'but . . . a good Picture & creditable to his talent'. His own sketch approved, he returned home and, by mid-October, began work on the commission. 'Liverpool,' he declared in a passage subsequently added to one of his lectures, 'is the only distinguished town since the reformation which has had the moral courage to employ native historical painters, on the true, thorough-bred principles of patronage, which produced such glorious results in Italy and Greece!'[166]

<center>★</center>

During his visit to Edinburgh, and as a result of the success of his lecture series there, Haydon had been invited by the publisher Adam Black to contribute an article on 'Painting' to the seventh edition of the *Encyclopaedia Britannica*. It was intended to accompany Hazlitt's 'Fine Art' of 1816, an essay remarkable for a singular omission. 'In . . . speaking of English Art,' Haydon noted indignantly at the time, 'he mentioned every living painter now eminent, but me!'[167]

Although the limitation imposed by his subject did not allow him to direct as much attention to his beloved Elgin Marbles as he would have liked, Haydon devoted more than thirty of his 160 pages to Greek painting, regardless of the fact that not a single work in that medium survived and that its very existence was only known of from the writings of Pliny, Quintilian and other ancient commentators. Nevertheless he argued that this vast body of lost paintings must have been either greater than, or as great as, anything that Western art had subsequently produced. Having seen the Elgin Marbles, his justification had a disarming simplicity: 'have we not . . . ground to argue from what we *do* see in one art, that what we do *not* see in another was equally excellent?'[168]

Concentration on the historical did not preclude comment on the

contemporary and personal, and as he described the decadent state of art under the Roman Empire – 'When native art is despised, and spurious foreign productions are preferred; when connoisseurs of what *is past* abound, and connoisseurs of what *is passing* exist not'[169] – he intended readers to be reminded of an England in thrall to scholars like Payne Knight; of the Duke of Sutherland paying a high price for Paul Delaroche's *Earl of Strafford on His Way to Execution*; of Thomas Hope's purchasing Antoine Dubost's *Damocles* for 800 guineas, while objecting that Haydon's comparably sized *Solomon* was too big.

Turning at length to the painters of the Italian Renaissance, Haydon was particularly critical of Michelangelo, finding him 'brutal in expression, fierce in action, and distorted in position'.[170] Needless to say, 'in comparing this illustrious sovereign of modern design with Phidias, or the Greeks generally, in the naked figure, he must unquestionably yield to them the palm'.[171] As for Raphael, although conceding that 'in composition he was perfect; in expression, deep; and in telling a story, without a rival',[172] like Michelangelo he was 'far inferior to the Greeks' in beauty and form. Haydon's hierarchy was briefly expressed: Michelangelo was 'a giant in art', Raphael 'an angel', Phidias 'a god'.[173]

At every opportunity, whether tracing the development of German, Spanish or French painting, he stressed the hostility to true genius represented by such institutions as the Royal Academy. 'It is quite ridiculous,' he declared, 'to find the kings of Europe still continuing to found and embellish these useless establishments.'[174] In Italy alone, when Academies were established in Parma, Venice, Ferrara, Modena, Florence or Naples, 'genius fled'.[175] As for the progress of British genius, '[it] will never have fair play or be soundly advanced, till the Royal Academy is removed, or effectively remodelled'. The casual reader, consulting the *Encyclopaedia Britannica* for a history of European painting, was presented with a short manifesto of cultural and educational reform to complement the constitutional reforms of 1832:

If the capital and provinces were freed from the predominance of those men [of the Academy]; . . . if the whole national galleries were turned into a great school, with branch schools in the great towns; if the [Raphael] Cartoons were removed to London for the occasional sight of the people . . . and if a Native Gallery were arranged for the best productions to be purchased as they appeared, and the House of Lords

adorned with a series of grand works referring to the British constitu-
tion; then would the government do a real good to taste, refined pleas-
ures, and design for manufactures, such as would entitle them to the
everlasting gratitude of the nation.[176]

Having begun what he called his 'rapid History of Art' on 22 November
1837, five weeks later he was 'obliged to be out in the air, as writing
so many hours ha[d] hurt [his] eyes'. His article was two and a half
times the length of Hazlitt's. Shortly after its publication Haydon asked
Wilkie whether he had read his treatise. Wilkie replied that he had
begun it, 'but it was very learned'.

The Liverpool picture progressed. He had originally perched one
of the children on Christ's knee, but decided this was 'too familiar
& crowds him'. Ten days later, following radical repainting, his prin-
cipal figure was 'free and totally unembarrassed'. By April of 1838
he was working on the woman kneeling in the foreground to Christ's
right, her bare shoulder 'firm without hardness, & fleshy without
flabbiness'.

He was becoming dissatisfied with his new patrons. They had prom-
ised an advance of fifty pounds more than a week before and he was
being harassed for rent, rates and taxes. After nearly a year living
without such worries, he felt 'lowered again . . . the usual blessing . . .
of devoting one's self to a large Picture on *contingencies*'. He pressed
on with the work, but had to pawn his anatomical books for two
pounds to pay his models. His dinner suit went the same way, yielding
thirty shillings for immediate household necessaries. The following
week he redeemed the suit to dine in the City, only to pledge it again
two days later. But by the end of the month the fifty pounds had
arrived from Liverpool and he had acquired a young lady as a pupil,
and payment from her father of 100 guineas.[177] Such were the vagaries
of Haydon's precarious existence. The Committee treasurer had been
ill, forgotten him, recovered, remembered and sent his money. The
terms of engagement as the young lady's tutor had been negotiated
while he sat at table, in a suit from which the pawnbroker's ticket had
just been removed for the evening. On the last day of April, Haydon
had £150 in his pocket. The following morning he received news from
the Far East.

It took more than half a year for a letter to reach London from the

port of Trincomalee, on the coast of what is today Sri Lanka. Haydon had written to his stepson Simon on board her Majesty's sloop *Wolf* on 11 January 1837. Simon replied on 20 July with a letter that reached his stepfather in February 1838. After some months patrolling neighbouring waters, defending merchant shipping against the depredations of Malay pirates, he was being transferred to the ten-gun brig *Algerine*, expecting to rejoin the *Wolf* in November, before his return to 'dear old England' the following March. But by the time Haydon had informed his wife of the imminent arrival of her second-born son, acting Third Officer Hyman had been dead for four months, a fact that would not be communicated to his family for a further eleven weeks. The letter from his commanding officer, Captain Edward Stanley, arrived on 1 May. The young man had died on 9 October 1837, on the *Algerine*, at anchor in the Madras Roads:

when a sea-serpent came on board, having been hooked by a marine. The late Mr S. Hyman took it in his hand and the animal when irritated seized hold of his hand over the metacarpal bone of the fore finger and held the doubled up skin firmly between his jaws until he was forced to let go his hold. This occurred at 7.30 a.m. Mr Hyman held the occurrence lightly, went down to his breakfast and soon after felt some uneasiness in his throat which quickly began to swell. The patient felt giddy, not long after insensible, and died exactly at 10.30 a.m. three hours after the accident. A few exceedingly small punctures were seen where the animal bit the hand. Soon after death the throat was discoloured, the body spotted, which in a few hours became offensive and it was found necessary to bury it at 4 p.m. the same evening.

This report would have provided more than sufficient information for the grieving family. But Captain Stanley was an amateur zoologist and proceeded to give a joyously meticulous physiological account of the guilty creature:

The snake was . . . found to be six feet six inches in length, general colour yellow, with forty-three black rings nearly equidistant. Its thickness about six inches near the vent, from which the tail projected vertically flat or compressed; upper jaw two rows of small teeth, the inner row indented in the intermaxilliary bones like the common adder but

no fang teeth could be detected, nor could it be seen whether the snake
had hollow or tubed teeth from want of a powerful lens. Under jaw
had one row of teeth, many broken and worn from age.[178]

From this description it has been identified as *Hydrophis spiralis*,
commonly known as the banded sea snake, and 'weight for weight,
its venom . . . twice as toxic as that of a cobra'.[179] Haydon delayed
breaking the news to his wife for at least twenty-four hours, and three
weeks later she 'still continue[d] very low'.

Captain Stanley gave his assurance that Simon's possessions,
'according to his verbal wish', would be returned. 'His clothes (naval)
may come in for his brother,' Stanley added, 'as my poor unfortunate
shipwrecked brother's did for me.'[180] And among the late midshipman's
effects, his thoughtful commander enclosed the pickled corpse of
Hydrophis spiralis for the family's edification. Mary's reaction is not
recorded. Mr Henry Downes, however, Director of the United Services
Museum in Whitehall Yard – primarily a repository of ancient, modern
and ethnographic weaponry, but also boasting a natural-history collec-
tion – expressed the thanks of his Council for Haydon's generous
donation of the specimen.[181]

Two days after receiving news of Simon's death, Haydon had
finished the kneeling woman in his Liverpool picture. Halfway
through the month and he judged the right hand of Christ 'the best
hand [he] ever painted'. He had also painted the Saviour's feet 'pretty
well', and a week later he had finished Christ's other hand. Visitors
to his painting room made adverse comment on the 'muscular beggar'
in the bottom right corner of the canvas, a figure for which he had
engaged a Horse Guard as model. After considerable anxiety and
numerous alterations he yielded to criticism, took the beggar out
and sent for his female model. The resulting foreshortened form of
a girl lying on the tessellated pavement, 'teaching the babe to lift up
its tiny hands in the attitude of supplication',[182] proved to be one of
the most successful and admired parts of the composition. By the
end of May he had finished the two bottom corners and all the prin-
cipal figures. He reflected that 400 guineas would be scant payment
for his work on the picture and brooded ruefully that Sir Thomas
Lawrence had received twice that sum 'for a single figure in boots,
cloak & gloves!'

Visitors continued to offer criticism and suggestions. Lord and Lady Burghersh called and thought that the background would be greatly enhanced by the removal of a column. Her Ladyship was the confidante and niece of the Duke of Wellington and an amateur painter of some talent. Haydon took out the redundant column, thereby widening the vista of landscape background, and found the improvement to be '*enormous*'. The Duke of Sutherland visited and, although pleased with the head and character of Christ, thought that the children were 'not Jewish enough'. A month later Haydon would more than compensate for the racial deficiency by engaging two Jewish children, 'another Jew' of unspecified age and sex and a 'beautiful Jew girl' for the widow's head in the upper left quarter of the picture. Mrs Haydon proffered advice upon a subject of which she had had no little experience. The baby held by the widow was close to the kneeling woman's red cap, and Haydon had accordingly given its flesh a red tinge from the reflection. 'Mary came in, & said, "Children who suck are not red, but milky." This was the sound criticism of a mother' he remarked.

The seventy-five-year-old poet and connoisseur Samuel Rogers called. The previous year they had had a conversation about Delaroche, Haydon being of the opinion that there was 'no flesh in French Pictures', that 'the basis of all French Art [was] the Theatre & the lay Figure' and that consequently the 'flesh [was] smooth & bloodless'. The old man had playfully dug him in the ribs and said: 'Give us something better of the same sort – *you could.*' Now Rogers stood in front of *Christ Blessing Little Children* and was 'highly pleased'. He pointed at the chubby infant being ushered towards the Saviour by the kneeling woman and said: 'When all the Figures in the Picture get up to walk away, I beg leave to secure the little girl in the Foreground.' Haydon thought this 'a pretty compliment'.

By the end of August he was making final adjustments to his picture. Christ's left leg and knee, now unencumbered by the child, was still not right. 'Drapery,' he declared, 'will always look awkward if it be not the vehicle of the limb it invests.' He worked at the problem, 'bewildering the Center of the Picture', an inner voice telling him: '*You* KNOW it's wrong. When the *people* know it as well as you, *they'll* find it out, & you'll be dead, so you had better not shirk it.' Finally, having made the requisite alterations and successfully put into prac-

tice 'all the study of Dentatus & Macbeth' into Christ's two legs, he declared the picture finished.

The Duke of Sutherland allowed him to move his picture into the new National Gallery building for final adjustments and at last Haydon was able to see it in a large room. Comparing it with a nearby Murillo, he found his own background greatly inferior and repainted it blue-black, an improvement 'not to be described'. From a distance of forty feet he was able to recognise an additional fault in the proportion of his central figure and raised Christ's knee and thigh, realising how hampered he had been working on so large a canvas in the cramped space of his painting room. A hundred and seventy years later Christ's left leg looks well. It is the left arm that fails to convince, appearing far longer than is physically possible under the 'vehicle' of its drapery.

Although a seasoned railway passenger, Haydon rarely failed to remark on the miraculous speeds achieved by this new mode of transportation. On 19 October his journey to Liverpool of 210 miles took just nine and a half hours, arriving in Lime Street Station at seven-thirty in the evening. His great rolled-up canvas followed by sea from Pickford's Wharf. He had shared the coupé with a young American who flashed a lot of high-denomination paper money and boasted of his country's victories in the Anglo-American War of 1812. Haydon gently countered with the surrender of the USS *Chesapeake* to the British frigate *Shannon* and the burning of the Capitol building in Washington, and the other fell silent. The American then claimed to be able to 'animal-magnetise' and offered to demonstrate his skill. Haydon stared back into his eyes for some minutes, but the attempt at mesmerism failed and, finding his subject still awake, the American excused himself by saying he had been ill.

'Mayhap you are a *strong mind*,' he suggested.

'So they say,' replied Haydon.

All the following week he was occupied with his picture: supervising the stretching, framing, raising and hanging and making final adjustments to it on the wall. On the Friday it was unveiled to local dignitaries and newspaper correspondents, and 'universally recognised as a noble specimen of modern art, fully calculated to sustain the reputation of the painter'.[183] The *Liverpool Mail* reported that there were no fewer than eighteen figures in the picture and drew special

attention to the shoulders of the kneeling woman and to the 'remark-
able portrayal of juvenile innocence' in the child, which had caught
Samuel Rogers's fancy. The hair and shoulders of the girl in the bottom
right corner were also 'much admired by those who . . . inspected the
painting'.[184]

From Liverpool he went to Manchester, staying a couple of days
to make arrangements with the engineer William Fairbairn, who was
engaging Frank as an apprentice, the boy having taken 'a fancy for
steam engines at 17'.[185] He then travelled to Leeds, where he deliv-
ered his entire Edinburgh series of lectures over twelve successive
nights, thanking God that he had the strength. He also hoped to secure
a commission for an altarpiece, but this was deferred until the church
was built and nothing ever came of it. Returning to Liverpool, he
lectured at the new Mechanics' Institute, in Mount Street, where he
was affronted to find 'no attention or civility' in his young audience.
'They look on a Lecturer as a Porter,' he complained, but determined
to 'teach them differently'. An eye-witness recalled him facing the
unruly Liverpool crowd:

> He had got up two wrestlers on the platform to demonstrate the laws
> of muscular action in the living subject, [and] the audience having
> laughed at some contortion of the pair, Haydon fiercely addressing the
> laughers as 'You fools!' checked the merriment, and ordered his hearers
> to observe and admire, with more respect for God Almighty's handi-
> work.[186]

Subsequent lectures were received by audiences he had 'never [seen]
more attentive'. One lady was heard to say: 'It is so simple a child can
comprehend it', a remark that Haydon accepted as 'High Praise'. But
there was adverse criticism from certain quarters, and Thomas
Winstanley, one of his Liverpool contacts, was frank in passing it on
to the lecturer:

> Some . . . express their doubt as to the Abilities of one who . . . finds
> fault in every thing – who rails against all academies and institutions
> as well as at individual artists, making his own works the standard of
> perfection, – others say . . . that your lectures are a discouragement to
> living Artists – and more than one Artist has told me that you appear

to attack M. Angelo, and other great Masters . . . and seemed to praise nothing but the Elgin Marbles and to find no purity of taste of perfection in any but your own works.[187]

Winstanley suggested that the effect would be improved 'if you were to mix up *less* of *yourself* in your lectures'. And he warned that 'the public in general think that your opposition to the R.A. and all such cliques, arises from *personal* disappointment and vexation and . . . you should conceal it more than you do'.[188] There is no reason to suppose that Haydon took such criticism to heart.

Whilst finishing *Christ Blessing Little Children* in late August, Haydon had prayed that it might 'lead to other & grander Employment', and M.D. Lowndes, one of the Committee, had pointedly referred to this as his 'first Liverpool Commission'. Both prayer and optimism were realised by the time of his departure for London in mid-December. When Lowndes suggested he paint 'a grand Historical Picture' of the Duke of Wellington, it was 'the very thing [Haydon had] been thinking of for these 2 years' and he prayed that Liverpool would possess his 'best Historical Picture, & . . . grandest effort of the pencil in Portrait'.

He checked his watch as he began work in front of the eight-foot-by-ten canvas on the morning of 22 December. It was six and a half minutes to ten. Two days before he had used his porte-crayon to sketch in the faint outline of horse and man. Workers from a firm of colourmen were in his painting room to stretch the *Poitiers* canvas. 'That's the Duke, isn't it, sir?' said one. At four minutes to ten he applied the first touch of colour. 'Huzza & Success . . . Huzza! Now it's afloat – Huzza! & one cheer more – Huzza!'

*

At the end of the previous September, Haydon had communed with his inner voice about whether to enter the competition to design a monument to Nelson planned for the centre of Trafalgar Square. 'Here is at last the very moment you have sought for,' the voice told him. 'Will you miss it?' There was but one answer and, his decision made, he knelt to pray: 'God almighty . . . bless my Imagination with fertility, & bless my conception & execution & my plan & design.' Four months

later they were ready. His submission consisted of the ground plan and elevation of a neoclassical temple, perspective watercolour drawings of exterior and interior, and a four-foot-by-three oil sketch of the interior alone. The chamber was to be lined with four painted tableaux: Nelson receiving the swords of Spanish officers on the quarterdeck of the *San Josef* at the battle of Cape St Vincent, the explosion of the *L'Orient* at the Nile, Nelson's ultimatum to the Danish Crown Prince at Copenhagen and, finally, Trafalgar and death. A colossal statue of the hero was to stand in one corner.

He thought his application 'as likely to succeed as any thing else [he] ever did for a Committee'. During the following months he waited impatiently for the Committee's decision. He lobbied the secretary, Mr Scott, suggesting that scale models be made of the best two designs and the public asked to choose the winner.[189] He wrote to a prominent member of the Committee offering the same suggestion, but received a brusque reply:

> The Duke of Wellington presents his Compliments to Mr Haydon. The Duke *is a Member* of the Committee for the Execution of the Plan for the erecting of a Monument to the memory of the late Lord Nelson. He is not the *Committee*, not the *Secretary* of the Committee, and above all, not the *Corresponding Secretary*.[190]

On reflection, Haydon supposed 'there was an indelicacy, as a candidate, of writing him'. Yet he felt no indelicacy at bringing pressure to bear on another prominent Committee member, his old friend Admiral Sir George Cockburn. Sir George favoured the idea of a 170-foot column, but was willing to be persuaded otherwise. Haydon argued strenuously that 'height alone would not do [but that] breadth was as essential'. Sir George said 'he would go in to give judgement uninfluenced in any way'.

That the temple's 'breadth' was passed over by the Committee, in favour of the 'height' of William Railton's winning proposal, was partly due to Haydon's estimated cost being £40,000 in excess of the £30,000 upper limit specified. It is also probable that the inscription suggested in his plans did not quite catch the requisite commemorative tone for a national hero's monument:

NELSON
A Little Body with a Mighty Heart[191]

He himself felt that he had not put enough time and effort into his proposal. 'A Man should never contest for anything with half his strength,' he wrote, 'do it effectually or not at all.' He believed, however, that if he had had time to produce oil sketches of the whole series of pictures that were conceived as adorning the interior of his mausoleum, and had the people been allowed their say, he would have succeeded.

★

When Haydon next went north, he was accompanied as far as Manchester by his 'dear innocent Boy Frank', embarking on an engineering apprenticeship with Mr Fairbairn. He remarked on the lad's 'utter ignorance & inexperience' and, although trusting to the classical and religious education he himself had imparted, confessed to some qualms about 'the Vice of a manufacturing Town'. Having settled Frank in lodgings, Haydon travelled on to Newcastle. The North of England Society for the Promotion of the Fine Arts had as its specific purpose the application of the higher departments of the arts and design to industrial manufacture. It was founded in Newcastle-upon-Tyne in 1836, a year before the establishment of the first state-supported School of Design in Somerset House. Haydon's lectures to this pioneering institution were 'received every night with increasing enthusiasm, till the last night was crowned with a Victorious cheer.' He went next to Hull and 'never witnessed more enthusiasm any where', and then to Warrington: 'Enthusiasm just the same.'

One Monday he took the train from Warrington to Liverpool and 'settled every thing with [the] Committee about the Duke', then travelled to Manchester, 'saw Frank, paid up his arrears', before dashing back to Warrington in time for tea. 'Good Heavens, what superb travelling,' he enthused, '73 miles in two hours & 40 minutes, for that was all the time it took.' One reason for his Liverpool visit was to ask Hugh Hornby, the Mayor, to write to Wellington impressing on him the necessity of a portrait sitting. At seventy, the Duke was no more cooperative than when Haydon had last attempted to paint him. His response to Hornby's letter, however, began warmly:

I am much flattered by the desire of the gentlemen of Liverpool to possess a picture of me . . . [and] I will with great pleasure see Mr Haydon and . . . endeavour to fix a time at which it will be in my Power to give him sittings to enable him to finish the Picture.

But he added: 'It is not in my Power at the present moment.'[192] And a week later when the artist requested a sitting of just an hour and a half, he replied, 'Mr Haydon might as well ask . . . for ten days at present as for a sitting of an hour and a half.'[193] Nevertheless, when told of the picture, by Mathew Cotes Wyatt, 'he seemed pleased'. Wyatt was preparing to sculpt the gigantic equestrian statue of Wellington which, seven years later, would cause critical outrage and public derision when planted on top of Decimus Burton's triumphal arch at Hyde Park Corner. Haydon was piqued to learn that the sculptor had been granted a sitting when he had not. Meanwhile, he worked as best he could without his subject, gathering material for the background from a large-scale model of the field of Waterloo in the Egyptian Hall. He also studied sunsets, necessary for the elegiac atmosphere of his conception. On one occasion he had Fred stand against a particularly 'delicious' one, posed like the Duke.

When a request to borrow his Grace's 'Horse accoutrements' – so that at least progress might be made on Copenhagen's portrait if not his master's – was refused, Haydon lost patience. 'If his Grace had been so deprived of his material he would not have gained *his* battles,' Haydon observed. 'I must gain my battle without & I *will*, that's more.' He called on Lord Fitzroy Somerset, one of Wellington's former aides-de-camp, explained his difficulty and was directed to the man who had made all his Grace's saddles, 'from Salamanca to Waterloo'. John Whippey – one whose very name might have destined him to work in leather – offered to 'fit up every thing as the Duke wore it . . . put it on a Horse, & let [Haydon] paint from the real things'. Haydon was delighted with this 'fine fellow' and brought him home to inspect the painting. Although finding fault with the drawing of the bit, he thought that the head of Copenhagen was 'capital & like the Horse'. A week later Haydon was painting a study of saddle and bridle on 'an old Hack' in the sun, and was greatly improving his picture.

The twenty-fourth anniversary of Waterloo came and went, with Haydon writing his congratulations and wishing his Grace might see many more. He called at Apsley House, but was told the Duke had a cold and could see no one. He wrote again, enquiring 'if his grace [wore] his sash, sword and belt outside his undress Frock Coat'. He then requested the loan, for a fortnight, of certain items of clothing: 'his blue frock coat, his blue trowsers, boots and spurs, his grace's sword belt and sash . . . a pair of military gloves & a cocked hat such as worn at Waterloo'.[194] In a testy reply, Wellington presented his compliments and hoped to have 'some cessation of note writing about Pictures'. He now professed to have forgotten his promise to Hornby the previous month and declared that he knew 'nothing about the picture which Mr Haydon proposes to paint'. Finally, with reference to the painter's latest request: 'the Duke must decline to lend to any body his Clothes, Arms, and equipments'.[195] This was only to be expected, and Haydon comforted himself that, four years previously, when given the unauthorised loan of such items by the Duke's valet, he had 'painted six views of his cocked hat, measured his coat & sash, drew his boots & spurs'. It only remained to visit Wellington's tailor and order a pair of trousers – exactly like his Grace's, but to fit Haydon – and he could 'kill two birds with one Stone – wear 'em & paint 'em.' Lady Burghersh had indiscreetly told him of the pet name that she and her children used for her uncle, and it was thus that the painter, with gleeful impudence, addressed his recalcitrant subject from the safe privacy of his journal: 'So, my Dukey, I *do* you in spite of ye.'

In August, having ascertained that there was no immediate prospect of securing a sitting from Wellington, and thirty pounds 'having unexpectedly come in', Haydon set out on the second and last journey abroad of his life. He was accompanied by Mary, who like a 'Heroine' had 'agreed to endure [his] rapidity of journey'. They boarded the packet from Dover on a Wednesday evening and reached Ostend, 'after the usual miseries of a wet, stormy passage', two hours later. From there, the following morning, they travelled to Brussels and, on the Saturday – this being the primary purpose of the excursion – to the field of Waterloo.

In order to sketch the background for *The Hero and his Horse*, Haydon took up a position on the low ridge, just to the left of the

road leading south across the shallow valley towards the old French lines. This was the position Sir Thomas Picton had commanded on 18 June 1815, until a rifle bullet to the temple ended both his life and his command at an early stage of the battle. Below, Haydon could see the roofs of La Haye Sainte, the farm fortified and defended by 400 of the King's German Legion and only relinquished to overwhelming French forces late in the day, for lack of ammunition. Off to his right, beyond the monument to Sir Alexander Gordon, he could see the Butte du Lion. It was impossible not to see it: the 200-foot-high grass mound topped with a twenty-eight-ton bronze lion, purportedly cast from captured French cannon, dominated the landscape in memory of the entirely undistinguished part played in the battle by the Prince of Orange. To excavate the necessary quantity of earth to raise this monstrosity, the Belgians had lowered the entire ridge to the west of the road by six feet. The more modest Gordon Pillar, erected by 'a desperate sister and five brothers . . . to him who was their dearest affection', appeared paradoxically raised six feet by the lowering of the surrounding ground. Long gone was the elm

beside which the Duke was said to have watched the action. The so-called 'Wellington Tree' had survived the fighting, only to be killed by tourists cutting bark from it for souvenirs, the remains being bought by an enterprising Englishman and made into a chair. 'They have spoiled my battlefield,' the Duke remarked sadly when he revisited the place after 1820.[196]

Haydon was to take more liberties with the landscape when he painted the background to his picture. The view of La Haye Sainte was impossible from the angle at which he drew it, the Butte du Lion was given even greater prominence than it had in reality by being placed in the centre of the composition, and the sun appeared to be setting in the east. He and Mary visited every site of interest: 'examined' the other fortified farmhouse of Hougoumont, 'recognised the locale of the last charge of the [Imperial] Guards', dined near Napoleon's field headquarters at La Belle Alliance, and, in the village of Waterloo itself, paid their respects in front of the monument to the Marquis of Anglesea's leg. Haydon resolved to visit the battlefield again '& spend a week, & indulge [his] poetry of Imagination'. He never did.

Back in London, he worked on the background to his picture, haunted Parliament to make sketches of Wellington as he went about his political business, and waited patiently for the long-promised sitting. At last the letter came and he was invited to Walmer Castle, 'whenever it may suit him'.[197] A sixteenth-century fortress built by Henry VIII, and official residence of the Lord Warden of the Cinque Ports, Walmer Castle stands on the Kent coast just north of Deal. On Friday 10 October 1839 Haydon set out by steamer from London to Ramsgate and then by chaise to Walmer, his arrival at the castle announced by 'a great bell'. After taking tea and dressing, he was ushered into the drawing room. The company was small: Wellington; his Grace's surgeon, Sir Astley Paston Cooper; his Grace's friend, Charles Arbuthnot; and another friend, Mr Booth, 'who had served with his Grace in Spain'. Haydon listened entranced to the talk. Wellington spoke of managing troops during the Spanish Campaign and of how 'Bivouacing was not suitable to the English character'. The English soldier, he explained, 'got drunk, & lay down under any hedge. Discipline was destroyed.' But when tents were provided, 'every Soldier belonged to his tent, & drunk or sober, he got to it before he went

to sleep'. Haydon ventured to point out that the French always bivouac. 'Yes,' said the Duke, 'because French, Spanish, & all other nations lie anywhere. It is their habit. They have no homes.' He said that 'the natural [state] of man was plunder' and that for this reason civilised society was founded upon the principle of association for protection and security of property. His mind perhaps turning to the civil unrest of the previous decade – the threats to his own person, the mob pelting his horse in St James's Park – he concluded that mankind was 'coming to the natural State of Society very fast'. But the walls of Walmer were thick, the ramparts defended by cannon and the mood of the company relaxed. Arbuthnot dozed and eventually his Grace yawned tremendously and announced it was time to retire. Candles were rung for and distributed. The Duke lit two and, giving one to Haydon, paused in the little hall as they emerged from the drawing room to remark on an eighteenth-century painting of Dover Castle, before leading the way along the corridor bisecting Walmer's central keep. Sir Astley had been assigned Mr Pitt's old room and bade good-night with 'God bless your Grace'. At the far end of the corridor they descended two steps and came to Haydon's room, number 10, on the right. 'God bless your Grace,' he said and watched as Wellington walked on to his own room next door to Mr Arbuthnot's on the opposite side. Haydon lay awake in a state of high excitement. 'Here I am,' he thought, 'tete à tete with the greatest Man on Earth, & the noblest – the Conqueror of Napoleon – sitting with him, talking to him, sleeping near him.' And he murmured 'God bless his Grace' before he slept.

Breakfast was at ten o'clock on the Saturday morning and Haydon ate heartily. He was amazed at the unfamiliar spectacle of the Iron Duke unbending with a noisy group of small children. Six of them had been brought in while the company was still at table and they clustered around him shouting, 'How d'ye do, Duke? How d'ye do, Duke?' One little boy, 'young Gray',[198] demanded tea. 'You shall have it,' said the Duke, 'if you will promise not to *slop it* over me as you did yesterday.' Tea was poured and the child duly tried to slop it over his Grace's frock coat. After breakfast Bonaparte's nemesis was out on the leads, romping around the cannon with the squealing children. 'You did not expect to see this!' Sir Astley whispered to Haydon.

The Duke had promised a portrait sitting when he returned from hunting and at two o'clock they started, the ride having made him 'rosy & dozy' and freshened his colour. 'All the portraits are too pale,' Haydon observed. Wellington, he thought, 'looked like an eagle of the Gods, who put on human shape . . . got silvery with age & service'. The room had been arranged so that light from the window shone directly on the sitter's face. 'Does the light hurt your Grace's eyes?' he asked at one point. 'Not at all' came the reply and Wellington glared defiantly into the light as if to say: 'I'll see if you can make me give in, Signor Light.'

After an hour and a half he got up and, the following day being the Sabbath promised to sit again on Monday. Haydon held the door open for him as he left the room and thought it 'the highest distinction of his life'. Wellington bowed. 'We dine at seven,' he said. That evening, his guest continued recording the minutiae of his visit. His Grace took half a glass of sherry with water before dinner, and Mr Arbuthnot one glass. Haydon himself took three. After dinner his Grace read 'every iota' of the *Standard*, a lit candle at each elbow, while Haydon watched, fascinated.

On Sunday morning Haydon was told by Arbuthnot to ask at the parish church for the Duke's pew. He was there early and, from its 'bare wainscot, the absence of curtains, the dirty green footstools, and common chairs', he thought at first he had been directed to the wrong one. The Duke and Arbuthnot arrived after the service had started, Arbuthnot discreetly squeezing Haydon's arm to warn him he was sitting in his Grace's place. Haydon quickly moved and Wellington, without apparently noticing the faux pas, 'came into the presence of his Maker without cant, without affectation, a simple human being . . . pulled out his Prayer Book, & followed the Clergyman in the simplest way'. Haydon was deeply affected and felt he would rather have seen Wellington on that Sunday morning, in that pew, in that church, than at Waterloo, or 'in all the glory & paraphernalia of his entry into Paris'.

After dinner in the evening, the Duke read the *Spectator* as he had read the *Standard* the night before, with a candle on either side. 'There are a great many curious things in it, I assure you,' he told the company. Haydon was reading Captain Sherer's two-volume work *Military Memoirs of Field Marshal the Duke of Wellington* and had reached the

account of one engagement in which he was said to have 'rode in front of 80 pieces of artillery, but God protected his head'. Looking up from the book, he 'studied the venerable white head that God still protected. It was really beautiful.' His Grace yawned, as usual, and announced that he would sit early the following morning, at nine o'clock. Haydon was up at five-thirty setting his palette and rubbing in a small canvas from the drawing he had made on Saturday. At nine his Grace entered and it was clear that the morning did not treat him kindly. He looked 'extremely worn – his skin drawn tight over his face; his eye . . . watery & aged; his head nodded a little'. The eagle of Saturday was 'beginning to totter from his perch'. He seemed impatient, looked at his watch three times during the sitting and at ten o'clock stood up and said: 'It's *ten*.' Again Haydon held open the door for him. His Grace seemed to brighten over breakfast, especially when the children came in. He looked over at Haydon and said: 'D'ye want another sitting?'

'If you please, your Grace.'

'Very well; after hunting, I'll come.'

He looked fresher after his ride, but Haydon was still dismayed by the feebleness of the morning. At three Wellington sat again, Lady Burghersh in attendance keeping him talking. Haydon found that the expression he had caught in Saturday's sketch and transferred in paint to the canvas that morning was much finer than the one he now saw and decided not to spoil the study by further work. He therefore corrected the figure and legs and declared himself finished. 'He has done,' said Lady Burghersh, '& it's very fine.'

'I am very glad,' said the Duke, regarding it as a point of honour not to look at any drawing or oil sketch connected with his picture. Later that evening, when they retired, Haydon took leave of his host, explaining that he had to depart for Ramsgate at six the following morning. 'I hope you are satisfied,' said his Grace. 'Good-bye.'

Back in London, a month after his visit to Walmer, Haydon finished *The Hero and his Horse*, 'the Duke's head beautiful in expression . . . simplicity without weakness, & energy without caricature . . . a complete hit'. Colonel Gurwood, Wellington's private secretary, visited and, although suggesting two or three necessary corrections, pronounced it 'a very fine Picture'. Two fellow guests from Walmer called. Lady Burghersh 'authorised [him] to say the likeness of the

Duke was admirable, & so said Arbuthnot'. Samuel Rogers was also pleased with the picture and said 'it was the Man', but Haydon suspected that, as a Whig, he did not find Wellington half so interesting as Napoleon. This was confirmed when Rogers commissioned a painting of the late Emperor from him, with one particular modification. It was to be another *Napoleon Musing at St Helena*, but 'not so fat as he really was'. He said that when Talleyrand and the Duchess de Dino visited Sir Robert Peel and saw his picture, it was the fatness and broadness of the figure that they objected to. Ever hungry for the opinion of celebrity, Haydon asked, apart from that, what they had thought of the picture. 'Most highly,' Rogers told him, 'but *that* always pained them, as they never saw him so.'

During December 1839 and January 1840, Haydon earned a handsome £81 17s for five weeks of lecturing in Leeds and Hull. But although this lucrative occupation represented 'the renovation of [his] fortune', he was finding it increasingly difficult to reconcile his lecturing engagements with his work as an artist. 'So much time is lost,' he complained, 'from the fatigue after.' The only work he was able to accomplish during the three weeks following his return to town was the rubbing in of the thinner *Napoleon* for Rogers, before he set off again to lecture in Bath. Then, after just three days back home, he travelled to Oxford. This time, however, he set aside immediate profit for a speculative venture, offering a course of lectures, to which, the handbill promised: 'All Heads of Colleges and their Families, as well as all Members of the University, will be admitted – FREE.'[199] His Oxford lectures were based on the principle of 'the importance of Art as a source of knowledge to the future Statesmen of the Empire'. Ten years previously, when Sir Robert Peel had visited his painting room to commission the picture with which Talleyrand and his mistress found fault, Haydon had been surprised at the then Home Secretary's lack of artistic education. 'Now had I been lecturer on Art at Oxford when he was a student,' he had written in his journal, 'Sir Robert, as a Minister of England, should not have mistaken a fragment of the Elgin Marbles for the Torso of the Apollonius.' Lord Ripon had once told him 'there was nothing less known than Art in the Government vote on annual sums or employ'. Haydon therefore regarded his six lectures, delivered gratis, in the Ashmolean Museum[200] on consecutive Tuesdays, Thursdays and Saturdays as an investment in future state subsidy for the Arts.

Oxford affected Haydon's imagination 'vastly', he wrote, 'such silence & solitude & poetry – such unquestionable antiquity, such Learning, & means of acquiring it'. He gloried in the company of 'the most learned & enlightened in Europe'.[201] He discussed the *Agamemnon* at table with the Fellows of Exeter College, and 'though evidently not a Classical Scholar', he admitted modestly, '[they] see I seize the thoughts & value the beauties of the great Classical beings'. Now and then he thought he noticed an expression or tone of mistrust, as when he paid a call on John Symmons, the translator of Aeschylus: 'I think I perceive a slight suspicion as if I had an eye *ultimately* to be Professor! I should glory in it, but it has never entered my head.'

His most attentive host was the Warden of New College, Dr Shuttleworth, soon to become the Bishop of Chichester. A man 'of fine dry humour',[202] less than three weeks after Haydon's departure Shuttleworth would tell a twenty-one-year-old John Ruskin of a piece of mischievous academic fun he had had at his guest's expense. Haydon had been pointing out in a lecture the face of one of Raphael's apostles as 'especially beautiful'. The following day Shuttleworth sent him an article by 'an old Frenchman', which identified the same face as that of Judas, exhibiting 'traces of every bad passion on earth'.[203]

Returning to London in triumph, having gone to 'try a new ground', Haydon felt his gamble had paid off. 'It was neck or nothing,' he wrote, 'and all Classes rushed to hear me till the Mania became extraordinary.' He believed that he was 'the first to break down the Barrier which has kept Art begging at the Universities', and when, in April, the council of King's College Cambridge appointed a Professor of Fine Art, he regarded it as too much of a coincidence – coming just a month after his final Oxford lecture – not to take some credit for the innovation.

The generally kind treatment he received in academic circles was in marked contrast to the harshness of a critical reception that greeted him on his return. He had written to his landlord from Oxford, hoping 'the Samson is gone & all right'.[204] Commissioned by Newton and completed three years previously, *Samson and the Philistines* was shown for the first time at the Society of British Artists in Suffolk Street. It was the only historical picture exhibited and, as such, the *Athenaeum* singled it out for particularly scathing comment:

With every disposition to be gentle with one who has so long been fretting away life and talent amidst the vexed waters of controversy, it must be stated that this picture contains excuse in full for those who have denied the supremacy of its artist's genius . . . [S]etting aside technical deficiencies, the whole expression of face and attitude given to Samson is a flagrant mistake . . . Nor more happily imagined than Samson, is Dalilah, as she crouches at his side, – lazy, and loosely-zoned, so scant of attraction, as to be no type of meretricious pleasure. There is forcible handwork in portions of this picture, but nothing better.[205]

The Times was more succinct: 'It is clever as a composition, but full of bad taste, extravagance, and folly.'[206] Haydon did not exhibit again for another two years, and the memory of Samson's treatment remained hurtful: 'All the sound principles of its composition, its colour, its story, its drawing, its light & Shadow were utterly unseen,' he wrote later, '& the Picture held up as an abortion not to be tolerated.'

<p style="text-align:center">★</p>

Haydon made no allusion to Orlando Hyman's attendance, or otherwise, at his Oxford lectures. A Fellow of Wadham College – barely a hundred yards from the old Ashmolean – Hyman not being present at his stepfather's triumph would have been a calculated snub. But if their relationship was half as tense as it became a month later, an encounter would not have been welcomed by either of them. 'I fear he has a bad heart,' Haydon had hinted darkly the year before, 'though with great talents.' But it was when the twenty-six-year-old Fellow was down for the vacation that nerves became frayed: 'He [has] nothing to do, & passes his time in eating, Idling, smoking, and disturbing the economy of a family regularity. He is in that detestable state of mind when sophistication takes the place of Religion & common sense, abroad on all principle, alive to every caprice.' A conversation over breakfast sent Haydon, in a fury, to his journal: 'He dined out yesterday, and they asked him to say Grace; though *ordained*, he did not *know what to say!* He thought this a good joke.' Leigh Hunt's circle, twenty years before, had been left in no doubt that religion, for Haydon, was

no joking matter. Far less was it such in the tighter circle of his own family:

I, with all my imperfections, who had just risen from prayer . . . felt so shocked at this – it has disturbed me all day. I have so intense a perception of the daily presence of the Almighty, my life in Art is so perpetual a hymn, under the idea of duty – it was dreadful . . . it is to me such infamous sacrilege.

Reading this 'outburst of virtue'[207] some years after its author's death, Frank Haydon, by then the journal's custodian, touched at the root of the complaint: 'Hyman was better educated than my father.' And the natural son contributed an irritated, bitter commentary alongside, which he could not have voiced while his father was alive:

You never liked [Hyman]. His cynicism was bitterer than your own, his conversational readiness in sarcasm greater, his knowledge of books infinitely superior, & the family readily saw, & acknowledged it. He owed much to you . . . but you expected . . . an amount of gratitude which no human being ever yet paid to any other, a perpetual song of praise to perfections which you didn't possess, for, like most men you were most vain of your weakest points.[208]

It was at about this time, just a year after his father had left him in Manchester, that eighteen-year-old Frank renounced his engineering ambitions and abandoned his apprenticeship to Mr Fairbairn. Haydon's anxiety regarding 'the Vice of a manufacturing Town' proved well founded, it seemed. 'Having been coddled & caged all his life,' Frank wrote of himself, 'very naturally as soon as he got a little freedom, [he] became slightly fond of amusement and dissipation . . . & fell into bad health.'[209] His father claimed that it was Hyman who now persuaded his half-brother to go to college. 'This is not true,' the older Frank retorted in his marginal commentary: 'Hyman did nothing of the kind. He persuaded me *against* going to College – . . . the real fact is *my father* persuaded me to go to College, *Hyman* was against it.' And Hyman was against it, wrote Frank, because 'he too well remembered the degradation which he himself had suffered in consequence of my father's unpunctuality [in paying

of his fees]'. As Hyman suffered at Oxford, so Frank was to suffer at Cambridge, his embittered account providing a harsh counterpoint to the father's increasingly desperate efforts to support his son over the following five years:

> My College Bills were unpaid, promise after promise to Tutors, Bankers, Solicitors, broken, and my name became disgraced – or worse, I was *pitied* as the son of a man without a particle of honour in his character. My College Tutor had to pay, *out of his own pocket . . .* a large arrear on my 1st year's bills. My father dishonoured the bill which he had given the Tutor for the amount, & the letters which he wrote to my father having been long unanswered, he applied to me, with so much gentleness & sympathy for my painful position that I confess I was fairly disgusted with my father's conduct from first to last.[210]

<p style="text-align:center">★</p>

On 12 June 1840 the British and Foreign Anti-Slavery Society met to 'consult on the most effectual method of abolishing the curse of Slavery from those countries which, in spite of the noble example set them by England, still maintained it in all its atrocity and horror'.[211] The day before, Haydon had been visited by a deputation of Quakers wishing to commission 'a sketch of the Scene'. To enable him to make a decision as to whether he wished to undertake the work, they invited him to attend the opening of this 'World's Convention', whose deliberations were to take place over the following eleven days in the Freemasons' Tavern.

Various taverns had served The Craft as London meeting places before this, their first hall, was built in the last quarter of the eighteenth century. The word 'Tavern', however – its connotations of sawdust, spirits, ale and tobacco perhaps alarming to the high proportion of Quakers in the anti-slavery movement – was something of a misnomer for the opulent establishment on Great Queen Street, Covent Garden that the Grand Lodge of Free and Accepted Masons called home. Its lofty hall was hung with chandeliers, its walls lined with alternating pilasters and whole-length portraits of worthies. At one end was a mighty pipe organ, at the other a visitors' gallery and,

between, an ample acreage of floor space capable of accommodating the very largest charitable dinners and mass meetings.

Haydon returned from witnessing the first day's proceedings of the Convention 'Exceedingly excited, exhausted'. His decision to undertake the commission required little thought and he immediately embarked on the now-familiar labour of multiple portrait sittings for another great ocean of heads. A breakfast meeting was arranged for the following morning with the abolitionist veteran who had presided over the first day's meeting. The eighty-one-year-old Thomas Clarkson had been unsure whether 'old age and infirmities, being lame and nearly blind',[212] would permit him to attend, but as Chairman he delivered the rousing address and benediction that Haydon would take as the 'moment' of his painting:

After solemnly urging the members to persevere to the last, till Slavery was extinct, lifting his arm and pointing to heaven (his face quivering with emotion), he ended by saying, 'May the Supreme Ruler of all human events, at whose disposal are not only the hearts but the intellects of men . . . guide your councils and give His blessing upon your labours.' There was a pause of a moment, and then, without an interchange of thought or even of look, the whole of this vast meeting, men and women, said, in a tone of subdued and deep feeling, 'AMEN! AMEN!'[213]

The 'moment' was not dissimilar to that Haydon had chosen for the abandoned *Meeting of the Unions on Newhall Hill* eight years before.

After breakfast he made a preliminary drawing of the old man and drawings of his daughter-in-law and grandson. Mrs Mary Clarkson would be 'the most beautiful of the group', he decided. He returned for breakfast a few days later and made another 'more aged Sketch' of Clarkson, before going to the Freemasons' Tavern to arrange for more sitters. Over five days he produced fifty-two portrait heads. There were 103 names on the first list he was given, and about another thirty would be added before the end of the commission. One name was the formidable Mrs Lucretia Coffin Mott, a Quaker minister from Pennsylvania and a delegate of the American Anti-Slavery Society. But despite her twenty-year record of work in the abolitionist cause, Haydon's conversation with his sitter revealed

a divergence between his own religious belief and a Quaker's. Finding her to have 'infidel notions', he decided against giving her 'the prominent place' he had first intended, reserving that 'for a beautiful believer in the Divinity of Christ'. Mrs Mott, however, had already been made abundantly aware of her place on the first day of the Convention. There was a 'very long and irregular discussion', *The Times* reported, concerning:

> a considerable number of ladies who had been delegated from the states of Massachusetts and Pennsylvania. It was contended [to be] contrary to the custom and usage of this country to admit ladies to a participation in public discussions.[214]

The delegate from Barbados, Samuel J. Prescod, declared that 'it would lower the dignity of the Convention and bring ridicule on the whole thing if ladies were admitted'. The Reverend Nathaniel Colver of Massachusetts argued that 'Women [were] constitutionally unfit for public or business meetings.' When it was pointed out by an opponent 'that the coloured man too was said to be constitutionally unfit to mingle with the white man',[215] the Reverend Colver left the hall in a rage, but the motion to admit women into the body of the meeting was defeated by a large majority and Mrs Mott was consigned with the rest of the women delegates to the visitors' gallery. In his finished painting Haydon would employ the pardonable artistic licence of including nine women – including Mr Clarkson's daughter-in-law – in prominent positions as though they were actually participants. But no such licence was exercised in the placing of Mrs Mott. Identified at number 127 in the key, her tiny portrait is barely distinguishable among the generic mass of bonnets ranged in the distance behind the red bar of the visitors' gallery, numbered and designated collectively as '132. Ladies'.[216]

John Scoble sat and Haydon told the English abolitionist he intended placing him close to Henry Beckford, an emancipated slave from Jamaica, in the central foreground of the picture. Assuming that 'an abolitionist on thorough principle would have gloried in being so placed', Haydon was surprised to detect some resistance to the arrangement:

[Scoble] sophisticated immediately on the greater propriety of placing the Negro in the distance, as it would have much greater effect. Now *I*, who have never troubled myself in this Cause, gloried in the Imagination of placing *the Negro* close by his *Emancipator*. No – the Emancipator shrunk.

The real or imagined objection made no difference and Scoble was eventually placed shoulder to shoulder with Beckford. Haydon amused himself by making the issue of who was willing to sit next to the 'Negro' a private test of the abolitionist credentials of his sitters. J. Harfield Tredgold, like Scoble, equivocated and failed to pass. George Thompson said he 'saw *no objection*', but this was not good enough for Haydon and he also failed. William Lloyd Garrison, prominent American abolitionist and publisher of the cause's most important newspaper, the *Liberator*, sat and passed the test, Haydon making 'a successful hit' with his drawing.

The educationalist and campaigner for slum improvement, Lady Noel Byron, sat, 'looking like an old Nurse', but Haydon seemed less interested in testing her racial tolerance than in her being the widow of a celebrity. 'Good heaven!' he exclaimed, 'that, Byron's wife! . . . no more fit for him than a Dove for a Volcano.' It seemed as though the notorious emotional, even physical abuse of her disastrous marriage was etched upon her face: 'About her mouth was a pouting & clenched expression of a shooting pang.' The second portrait sitting was not helped by the presence of her friend, novelist and future art historian Anna Brownell Jameson. The sitter was 'fidgetty', which made Haydon 'fidgetty' and the drawing 'turned out bad'. When Mrs Jameson found fault with his effort, Haydon said: 'Come, don't look Criticism', which appeared to annoy both women. He summarised his two encounters with Lady Byron: 'the first day, I thought Byron a brute – the second day I was convinced *she* was.'[217]

Sir Thomas Fowell Buxton sat and Haydon 'never saw such childish vanity & weakness'. The philanthropist brought his clerk to the sitting and insisted on 'dictating letters, signing, correcting' and discussing abolitionist business with two American delegates also in attendance. Haydon was so distracted and irritated by all the bustle that his portrait sketch suffered: 'Conceive my having sketched the Duke,' he reflected, 'Lord Grey, & Lord Melbourne and never having seen any thing of

this, not the least affectation of this sort, though Nations reposed on their Shoulders.'

If mature consideration had not succeeded in altering the views on 'Negro' intelligence expressed in his *Examiner* letters nearly thirty years previously, conversation with a former slave owner certainly did. James Gillespie Birney, a delegate from New York, told him that 'Negro children equal Whites till seven, when, perceiving the degradation of their Parents, they felt degraded & cowed.' Haydon was appalled:

> There was a time when I believed that the negro, however deep his sympathies and affectionate his heart, was separated from the intellectual European irrevocably; when I believed his brain and bodily conformation were so inherently deficient, that no education and no ameliorated condition could ever improve them. I have lived, I thank God, to be convinced to the contrary.[218]

Phrenological examination of his sitters, he claimed, helped him towards the change of mind: 'The head of [the] negro, Beckford . . . and the other, Barrett,'[219] he declared, 'are as fine in physical construction of brain as any European in the picture.'[220] It was Birney, or one of the other American abolitionists, who told him stories, haunting his imagination and disturbing his rest, of the clinical precision with which the whip could be used by a skilful plantation overseer, 'to cut a negro into gashes . . . so as to punish him most severely, *without crippling him for the next day!*[221] So impressed was Haydon by these horrors that he began collecting slavery artefacts, which he hung around his painting room and scared visitors with. The seven-year-old son of his frame-maker would remember the collection into his old age:

> whips and lashes, branding-irons, manacles, iron rings and chains, and so on, the uses of which, and the cruelties practised with them towards the poor slaves were explained to me by Mr Haydon, and I was greatly shocked.[222]

The grisly display may have served to inspire Haydon's imagination to the issues under discussion at the Freemasons' Tavern, or even as source material for some contemplated picture of slave revolt.

'We will guarantee thee against loss for the Sketch,' John Beaumont, a committee member, had promised, reflecting the Quaker belief that a work by Haydon or any other man – no matter how large the canvas – was no more than a rudimentary 'Sketch' compared to the work of God. Haydon and Beaumont met and, with the completed portrait drawings before them, 'ticketed all the heads according to desert' and their positions in the composition. The exercise was similar to that performed by the Duke of Sussex, seven years previously, deciding on the pecking order of the Reform Banquet. The head of Lloyd Garrison, despite being such 'a successful hit', was not transferred to Haydon's canvas, presumably having been vetoed by Beaumont. The *Liberator*'s proprietor had arrived from Boston a couple of days late for the opening of the Convention and had been so angered by the exclusion of the female delegates that, by way of protest, he joined the outcasts in the visitors' gallery refusing to take any formal part in the proceedings. It was also probably due as much to Beaumont's instigation as to Haydon's suspicions of her 'infidel notions' that Mrs Mott's features were rendered imperceptible in the finished picture.

Quaker followed Quaker to Haydon's painting room, contrary, he believed, to their religious convictions. 'They are averse to pictures of any kind,' he told everyone, 'and never sit for their likenesses.'[223] Day by day and cheek by jowl they covered the canvas. The Duchess of Sutherland visited and remarked that she 'never saw such an assemblage of honest heads collected together'.[224] In August, after just six and a half weeks' work, Haydon had painted thirty-two of them and estimated 'the neck of the Picture . . . broken'. He was astonished at how rapidly he was capable of working. 'Finished a head, hand, & figure in two days,' he wrote, 'truly the result of all my previous fagging – for years.' He offered thanks and reflected on how much he had to be grateful for. 'Evil [was] mixed . . . in the midst of success', however, and Mary's health was a cause of occasional anxiety. She was 'attacked in her womb', he noted, '& lies helpless & suffering'. The unspecified gynaecological troubles continued for several months and her husband referred to them occasionally and briefly in his journal. 'Dear Mary ill,' he wrote in August, and 'Dearest Mary in bad health', a month later. Deprived of marital relations by her indisposition, he suffered unaccustomed frustration. 'I have horrors of my fidelity,' he confessed, 'God protect me. Amen.'

Wordsworth had received a first proof of Thomas Lupton's engraving of *The Hero and his Horse*, which Moon, Boys & Graves were to publish, and on the last day of August, during a walk up Helvellyn, the muse took him and he composed a sonnet, which he sent to Haydon with a request not to circulate it widely because it was 'warm from the brain, and may require . . . some little retouching'. Haydon began a new volume of his journal in honour of the tribute and attached it to the opening page:

> By Art's bold privilege, Warrior and Warhorse stand
> On ground yet strewn with their last battle's wreck;
> Let the Steed glory, while his Master's hand
> Lies, fixed for ages, on his conscious neck.
> But, by the Chieftain's look, tho' at his side
> Hangs that day's treasured sword, how firm a check
> Is given to triumph, and all human pride!
> Yon trophied Mound shrinks to a shadowy speck
> In his calm presence! Since the mighty deed
> Him years have brought far nearer the grave's rest,
> As shows that face time-worn. But he such seed
> Has sowed that bears, we trust, the fruit of fame
> In Heaven; hence no one blushes for *thy name*,
> Conqueror! 'mid some sad thoughts, divinely *blest*.

Three letters followed, at four-day intervals, containing the poet's anticipated alterations to his text. 'He seems anxious to make this Sonnet worthy of himself, the Duke, & the *Painter*,' Haydon wrote, with a self-deprecatory 'hem!'[225]

In October, 1840 the future Lieutenant Governor of Van Diemen's Land, Sir John Eardley Eardley-Wilmot, sat, expansive in talk as well as name. He told stories of the personalities of the day, of Caroline Norton's 'Babylonish beauty' and of how it was 'a Babylonish captivity [he] should be proud of'. He confirmed Haydon's opinion of the young Queen Victoria's inadequate artistic education, knowing 'a little of everything and nothing thoroughly'. Swapping anecdotes, the two men 'laughed & enjoyed [them]selves heartily'. Haydon had not had such a morning for a long time, the worldly conversation cheering his spirits after the Quakers' worthiness. 'I had had so many pious

people,' he explained, 'they had frightened me by assuming I wanted grace.'

He worked at a furious pace throughout October, one day painting from seven in the morning until ten at night. 'Had my eyes lasted I could have gone on all night,' he noted. But the following day his eyes were strained. Little time was wasted on food, a quarter of an hour sufficing for lunch, ten or fifteen minutes for dinner. Not a relaxing table companion, he customarily ate 'at a gallop', then read while Mary finished the course at her own pace. 'It makes her ill to eat as I do,' he admitted.

By the end of the month the picture was three-quarters done, including half the architectural background of the Freemasons' Tavern: the pilasters, pillars and arches, and the chandeliers. Then in November he was told that another thirty-one heads had to be fitted into the composition, 'after arranging 103'. Haydon thought this 'rather a joke' and remained philosophical: 'if they like, they shall have heads all over, like a peacock's tail'. But he was tired from seven months' work, 'welnigh night & day', and wanted 'a short change'. He was also exhausted by 'great anxiety for . . . dearest Mary'. The change he needed came in the form of a short lecture tour in the North and Midlands. At Birmingham he dined with Quakers at the home of Joseph Sturge, a Vice-President of the British and Foreign Anti-Slavery Society. All but one other of the party were teetotal, and Haydon had only a sherry before dinner and a single port after. 'How completely it is habit,' he reflected, 'this need for alcohol.' However, when he got back to his hotel he felt weak and ordered his usual glass of port negus[226] before retiring. 'I have no time to feel weak,' he wrote, thinking of his forthcoming lectures. Besides, he suspected that the old infirmity of his eyes proceeded from scrofula and 'alcohol is a necessary stimulus'.

The last six days of November he spent visiting factories and lecturing to Quakers. 'If you inspire the Broadbrims with a love of the Arts you will indeed do wonders,'[227] a London friend wrote to him, and William Hamilton wished him 'a merry Christmas amongst [his] newly enlightened friends'.[228] The convenience of rail travel made a strenuous schedule possible and he had good reason to guard against weakness: for part of December he was speaking at Birmingham and Liverpool on alternate nights. 'Don't say anything

to *Mary,*' he implored Newton. 'Don't let it out – for it will make
her uneasy.'[229] He spent Christmas Day alone, 'not being able to join
[his] dear family', and on 31 December he made his customary review
of the closing year, among strangers in the Mosley Arms at
Manchester. 1840 had been profitable and fulfilling. His 'pecuniary
resources . . . from Constant employment [had] been great'. Art
progressed, and the people were 'certainly advancing'. He had
'lectured on the naked Model in London, Edinburgh, & Manchester,
& lately had wrestlers to struggle before 1500 people at Liverpool,
with immense approbation'. Fresh engagements continued to 'pour
in'. His children were well. He thought of his wife, of her delicate
condition, of his enforced celibacy and isolation from the marital
bed for so many months. If he considered 'the Vice of a manufac-
turing town' such a cause for anxiety when leaving Frank in
Manchester the previous year, the thought was dismissed with a
struggle and a fervent prayer:

> I thank thee no passion has induced me to forget my allegiance . . . to
> her on whom My heart is fixed, and that I am daily becoming recon-
> ciled to my isolation, temporary I trust. Keep me virtuous, O God . . .
> and when thou restorest her again to my heart, I may be able to press
> her dear lips, as unstained *as now* from the lips of another!

After lecturing in Sheffield, his audience 'impressed, but dull', he
arrived home in mid-January to find 'dear Mary *very ill*'.

He returned immediately to work on his great canvas. An unnamed
architect visited and told him 'it did not look like a Picture, but like
the thing itself'. He put in three heads one day, three more the next.
He called to sketch Daniel O'Connell and, finding him asleep in bed
at ten in the morning, was obliged to return at eleven. The campaigner
for Catholic emancipation had 'a keen, lynx look, and great good
nature, but cunning & trick[y]'. The two men got on well, except
when the Irishman told a demeaning story of Haydon's newest idol.
The Duke of Wellington was, O'Connell swore, 'wounded in his bum
in Spain'. He assured his companion it was absolutely true and that
he had been told it by one of the Duke's aides, but, sensing the frosty
reaction, did not press the point. 'I could have put my fist in his face,'
Haydon wrote afterwards.

By mid-February he had put in O'Connell's tousled and fleshy features at the left edge of the composition and finished the self-important Thomas Fowell Buxton's hand. He had also completed the head of a 'deaf man', the American abolitionist George Bradburn, just below Buxton with a hand cupped behind his ear.

Mary's health worsened towards the end of the month, and Haydon carried on working as best he could 'in the midst of great domestic harass'. There was a tender moment at her bedside as he counted the cost of nearly twenty years of marriage:

> As I myself washed her pale face & hands, for she would let no one else touch her, as I looked at her beautiful, shrunk face, the tears trickled over my cheeks, and seeing me crying she wept bitterly herself. After having born up so heroically, followed me to prison, never left me, saved my brain & my health, in poverty, in struggle, with a house full of Babies, nursing by day, watching by night, & harassed always – now, when my circumstances are better, when we pay our way & are in comparative Comfort, down breaks her health, her dear health!

This seems to have been the crisis of her condition, her health subsequently improving, because Haydon made no further reference to it. But his own wellbeing, and in particular his sight, began causing him concern. He had recently experienced dizziness from painting for eight hours at a stretch, but at the beginning of March he was working twelve hours a day, his eyes 'fatigued & strained', he could barely see. He recalled the devastating effects of eye strain when he was in his early thirties. He was now fifty-five: 'At this time of life, if I come to get an attack like 1818, I should be blind.' For a few days he eased the intensity of his work, strolling into the City, making social calls and painting only during the morning. One Sunday evening before retiring he entered his painting room to look at the picture. Not wearing his spectacles, he could make out only the blurred 'general effect' of the composition, but immediately saw, in the top right corner, an area for 'glorious improvement'. Over the next few days, while incorporating three more heads – Baptist, Quaker and Anabaptist respectively[230] – he made his improvement: a large billow of scarlet drapery, across which he proposed inscribing the names of three heroes of the abolitionist cause.

As the picture neared completion, there was a rush to be included. 'Such is the anxiety to be in it', Haydon told Mrs Clarkson, 'that abolitionists have come I verily believe from all quarters of the Globe.'[231] Quakers would arrive at his door carrying notes from Joseph Sturge: 'Friend Haydon, I would thank thee to put in the bearer (an old abolitionist).' By the end of March there were 129 identified heads and he had to travel to Bristol to sketch the 130th. 'What will you do with my mouth?' Joseph Reynolds asked. 'I have lost a tooth.' Haydon told him he was going to 'sketch it as it is'. He could also have reassured the old man that his face was destined for a position so far back in the crowd – and with the mouth closed – the deficiency would not be noticed.

After just three days back in London, and having ascertained that Mary was 'happy & well', he set out again by steamboat for Ipswich to visit Thomas Clarkson and his wife at Playford Hall. He had, of course, already sketched the principal figure of his composition nine months before and had also borrowed Clarkson's coat, waistcoat, cravat and shirt for reference, apologising afterwards to Mrs Clarkson for ripping the shirt down the middle while wrestling it onto his lay figure. Now he wanted a further two-hour sitting before finally completing the picture. He sat with the octogenarian after his wife and niece had gone to bed. Clarkson had a bottle of ale on a stool by his chair and turned the bottle round and round in front of the fire until it was hot and ready for pouring into a tumbler. He had two boxes of pills, marked 'A' for aperient, a laxative, and 'S' for sedative. Without the combination of pills and hot ale, and the servant strapping up his arthritic legs, he could not sleep.

At ten o'clock the following morning he sat for the portrait sketch. Just as Haydon was about to start, Clarkson summoned the servants. 'I am determined they shall see the first stroke,' he explained. In crowded six maids and washwomen to watch as the painter started work. 'There now,' Clarkson told them, 'that is the first stroke; come in again in an hour, & you shall see the last.'

The old man told Haydon he had recently been roused from sleep by a clear and vivid voice saying: 'You have not done all your work. There is America.' He had sat up in bed while text after text rushed into his mind, and his pamphlet, *A Letter to the Clergy of Various*

Denominations and to the Slave-Holding Planters in the Southern Parts of the United States of America, was the result. Haydon recognised precedents: 'Columbus believed he heard a Voice in the Storm, encouraging him to persevere. Socrates believed in his attendant spirit; & . . . Christ always talked as if in immediate communication.' He himself, moreover, just two months previously, had woken from troubled sleep to hear a voice whispering to him: 'Fear not, I am with thee. Be not dismayed, for I am thy God!' And he had heard the voice often before, 'in Prison, in want, in distress, in blindness', the injunction always the same: '*Go on!*', so loud in the brain as to startle.

Clarkson had told his guest, soon after his arrival on the Tuesday, that there was another steamer leaving on Thursday. Haydon was familiar with the tactic, employed by gentry and aristocracy alike, to limit the stay of a sponging portrait painter. In 1809 Sir George Beaumont had let him and Wilkie know, within five minutes of their crossing the parlour threshold, that he and Lady Beaumont would be 'obliged to go in a fortnight', while Lord Egremont had bluntly told the visiting sculptor William Behnes: 'Your bed will be wanted tonight.' So when Clarkson told him of the steamship *Aca*'s Thursday departure, Haydon was prepared: 'Oh, sir,' he replied, 'I took my place in the Mail for Wednesday night.' His sketch completed, and not wishing to outstay his welcome, he was back in London by eight o'clock the following morning.

By the end of April he had put Reynolds's head in, improved Clarkson's and the picture was finished. The last thing he did before the great canvas was moved to the Egyptian Hall for exhibition was paint in the names of William Wilberforce, Toussaint l'Ouverture and another leader, of a more recent slave revolt, Samuel Sharpe. Haydon's Quaker paymaster, however, was not pleased by the innovation. 'They had *nothing whatever* to do with the *Convention*,' John Beaumont told him, 'and must *come out*.' Grumbling about the 'Gratitude of Posterity', the artist obediently painted over the names, but later, when the picture was engraved, he made sure they were reinstated.

Haydon's 'Great Picture of the General Anti-Slavery Convention', containing '137 [*sic*] original portraits',[232] was advertised in *The Times* as opening to the public on 10 May 1841. Although not otherwise

noticed in that newspaper, the exhibition received mixed treatment elsewhere. 'The composition of the picture is consistent with the finest taste,' declared the *Advertiser* politely, 'and the colouring and general treatment appropriate to such a truly sublime subject.'[233] But not since the denunciation of *The Reform Banquet* by *Fraser's Magazine* had so much scorn been poured on his work as that from the *Morning Post*. 'This picture is *great* in more ways than one,' it began with ponderous irony:

> In the first place, it is a 'great' size . . . In the second, there are a 'great' many heads painted on the canvas . . . In the third, there are 'great' mistakes in the essentials of drawing, perspective, and composition; the first being defective throughout; the second, 'null and void'; and the last vulgar. In the fourth place, the painting, as a piece of colouring, is a 'great' daub; and, finally, in the fifth, it is, as a work of art, a very 'great' failure.

The correspondent was clearly beginning to enjoy himself: 'The faces, ascending one over the other in regular tiers, are almost as monotonous as a pattern card of Birmingham buttons, or a batch of baker's rolls stuck up on edge.' Although a 'distant approach to truth of nature' could be discerned in the figure of Clarkson, he had the appearance of 'senility without enthusiasm – a body without a soul'. The rest was 'a congregation of clodhoppers'. Whether or not he was aware they comprised a large proportion of that 'congregation', the writer next addressed himself to the Quaker 'proprietors' of the picture. While those gentlemen might not be grateful for the unfavourable notice, they could be assured that it would bring 'numbers of shillings' their way:

> Had we praised it up to the skies the public would probably not have cared a farthing about seeing it; but, pronouncing it, as we do, a great abortion in historical art, all the world will run to inspect it, for people like to indulge their curiosity upon what is monstrous and absurd.

A final word of advice was given to the artist: 'Let Mr Haydon rather write than paint . . . His pen is sometimes his friend – his brush is *always* his enemy.'[234]

Haydon had taken his wife and daughter to Dover. Returning alone

two days after the *Post*'s notice appeared, and notwithstanding its prediction of a wave of profitable, if morbid, public interest, he found that 'The Picture as an Exhibition has failed entirely.'

<div align="center">★</div>

As soon as *The Anti-Slavery Convention* had left his painting room, Haydon ordered another canvas, ten feet by twelve, but experienced the familiar period of lassitude after completing a large commission, comforting himself with the thought that Dr Johnson had felt thus after finishing his dictionary. It was 'nothing but the over relaxation of the string after constant tension'. Only after seventeen days was he able to begin work on an historical subject, a 'dear Poetical painting', with a fine naked Royal Horse Guard as model. But his financial resources were low. He had used all available money to send Mary to Dover; a fifty-guinea commission had failed to materialise in Birmingham; one of the Quakers had decided against a double portrait; and the balance of his fee from John Beaumont was not due for a fortnight. He pawned the household plate. 'This is the true pendant to High Art in England', he observed. 'I have not wanted Money for a year. The Instant I touch history, away it goes.'

The 1841 census recorded Haydon, together with his wife and daughter, staying at 6 Hubert Terrace in Dover on 7 June. A couple of days later, at Warren's Library, he picked up the *Morning Chronicle* and read of the steamship *Oriental*'s arrival at Falmouth from Alexandria. The week before there had been a report[235] that Wilkie was returning aboard this vessel after three months in the Holy Land, and Haydon scanned the passenger list for his friend's name. Then he read the words, 'Death of Sir David Wilkie', and the announcement:

> with great regret the death of the celebrated painter which took place at Gibraltar on the 1st of this month. It would appear that his death was sudden, as no account had been received of his previous illness . . . Sir David was 56 years of age at his death.[236]

He had been buried at sea. One of their last meetings, in March of the previous year, had been characterised by a customary mixture of irritation and affection. Haydon called in the morning, and Wilkie

kept him waiting in an unheated room while he finished his breakfast. Haydon stormed out and returned home, only to have his dinner interrupted by Wilkie coming to apologise. They had rowed, then chatted, then reminisced, Haydon recalling anecdote after anecdote of their student days for Mary's benefit, Wilkie recounting stories of Sir Walter Scott. There must have been another meeting, closer to his departure for Palestine in August. 'I had begged & entreated him before he went to be cautious of such a journey,' Haydon claimed with hindsight. He had particularly recommended that his friend read Richard Robert Madden's *Travels in Turkey, Egypt, Nubia and Palestine*,[237] 'to understand the nature of the diseases and consider his weaknesses of Constitution'.

During the following months he turned again and again, in his journal, his thoughts and his dreams, to Wilkie, grief jostling with reproach. One night he stood in a cavernous tomb in Jerusalem while his dead friend defended himself against accusation, reminding Haydon of the money lent, of the friendship maintained, despite conflicting loyalty to the Academy. But it was Haydon's dream and he had the last word: that although Wilkie had lent him money, he had 'talked of it with a gross want of delicacy', that he had been 'a slave to the great & the World' and that he had 'feared to show regard for a Man the World had deserted'. He wrote letters 'to relieve [his] thoughts'. One of these began abruptly, with no other preamble or salutation but 'Ah Sir Robert Peel'. Practised anecdotes of 'poor dear Wilkie' followed, then eulogy, changing seamlessly to self-justification and complaint:

> had the Academy but done me the justice they did him – we should have gone on to the grave, as we began – I deserved it – Dentatus & Joseph & Mary had as much claims as the Politicians & the Fiddler & they knew it – & Wilkie knew it – and Wilkie, Collins & Jackson in our early lives were as violent & *more* than *myself* – I kept to my conviction – they deserted theirs – I was ruined – they got a Competence . . .[238]

It had always been the Academy that had come between them, so it was fitting that it should do so one last time. When 225 'Members of the Royal Academy and other professional Artists' signed an address requesting President and Council to convey their sympathy to Wilkie's

family, Haydon declined his signature, suspecting conspiracy: 'They thought my feelings would hurry me away to sign without reflection or reading, & then they would have turned round & said, "See, he acknowledges our authority!"' Someone, probably Wilkie, had once told him of a popular Scottish expression 'for a Man who at intervals labours under temporary delusions'. He would be described as having 'a bee in his brain'.

Less than five months after his friend's body had plunged, in its weighted coffin, to the sea bed off Cape Trafalgar, Haydon delivered a new lecture on Wilkie to a 'brilliant and deeply attentive' audience at the London Mechanics' Institution. He began 'boldly enough', but when he referred to the painter's death, his voice failed him. 'I had hard work to articulate,' he wrote in his journal. 'All the Women began to cry . . . I [was] *deeply* shaken.' The Irish painter Daniel Maclise was there and later entertained his dinner companions with an account of the moment: 'He stood a minute or two [covering his face with his hand] all the time keeping his audience in suspense. They then began a slight clapping of hands and scraping of feet. Still he did not move his hand away, but with the other hand made a deprecatory motion to them to be quiet, and yet he did not uncover his face. Another pause, and then the slight clapping was renewed. Once more the deprecating hand – it was the best bit of *pose plastique* that I ever saw . . . It was nearly five minutes before the face was uncovered and the lecture resumed.'[239]

<p style="text-align:center">★</p>

Having lobbied Lord Melbourne just three days after the destruction of the old Parliament, Haydon had exercised remarkable restraint when, in July 1841, a full year after the foundation stone of a new Palace of Westminster had been laid, he started pestering the architect, Charles Barry. He wanted to know the precise dimensions of wall space in each of the main chambers that would be left empty of decoration and specifically appropriated for painting, when the building was complete. Barry informed him that these expanses were to be considerable: 546 feet long by 16 feet high in the Westminster Hall, 192 feet by 15 feet in Saint Stephen's Hall, 320 feet by 15 feet in the Royal Gallery, 108 feet by 12 feet in the Queen's Robing Room, and

four compartments, each measuring 28 feet long and 16 feet high, in the Central Lobby.[240] In addition there was to be a total area of 4,512 square feet reserved for painting in the public corridors. It must have seemed no more than common justice that some part of that vertical acreage should be filled by the brave and noble compositions that Haydon had been longing, for almost thirty years, to bestow upon his country's seat of government.

'I hope they won't forget me, Mr Barry.'

The response came, guardedly non-committal: 'It will be a great shame if they do, Mr Haydon.'

Then the insinuating half question: 'I hope *you* won't forget me, Mr Barry.' The architect made no reply, but his embarrassment was evident and the petitioner noticed him blush. 'Buz-Buz', went the bee in Haydon's brain.

By the time he pressed Barry on the subject, the fifteen-strong Select Committee appointed 'to take into consideration the Promotion of the Fine Arts in this Country, in connection with the Rebuilding of the New Houses of Parliament' had sat, had called and examined its witnesses, had come to its conclusions and its report was being printed. Barry himself had been the first witness examined. Asked what form of decoration he believed would be most suitable, the architect answered: 'walls . . . where the light is from above, would . . . be painted with the best effect in fresco'. Frescoes were deemed preferable to oil paintings because they would be brighter, their matte surface less compromised by reflections, and because, in this most atmospherically polluted city of the world, they would be easier to keep clean.[241]

Most witnesses subsequently examined could not name a single English artist who had practical experience of painting frescoes, although William Dyce revealed that he knew three: himself and two others. Considerable reference was made to Munich, where the technique had enjoyed a celebrated revival in recent years. Charles Eastlake recalled that it had originated in Rome, and that he himself had been witness there to the first German experiments carried out by Peter von Cornelius, Philipp Veit, Friedrich Schadow and Friedrich Overbeck. Dyce pointed out that Ludwig of Bavaria, having seen the work of these artists in Rome, had allowed them to try their skill in the outdoor arcade of Munich's Hofgarten, and only then in the Royal Palace and

the Glyptothek. Dyce suggested that before they were let loose on Parliament, English artists should be allowed to experiment also, preferably in the most unfavourable conditions – the work being exposed to the London air – because this would 'test its powers most'. He was confident, however, that 'that which succeeds in Munich would succeed in England'.[242] He even suggested the vaulted ceiling of the Strand vestibule of Somerset House as a suitable testing ground for the tyros in fresco.

A single voice was raised against the proposed painting medium. Sir Martin Archer Shee declared 'that fresco would not be a style to be adopted in this country, either as peculiarly suited to our climate, or consistent with the taste of the country'. As for the primary question posed by the Committee, whether 'so important and national a work as the erection of the Two Houses of Parliament' should encourage the promotion of every branch of Fine Art, Shee spoke for all the witnesses:

> I consider it a most favourable opportunity for calling forth the genius of our country, and promoting the Fine Arts to the utmost extent of which they are capable; it is the only opportunity that has occurred for many years, and if it be suffered to pass unheeded, I should say that there is no hope in this country for Artists in the higher department of the Arts.[243]

Haydon himself could have said it no better and, despite his hatred for the President of the Royal Academy, was bound to applaud.[244]

Even as he had furnished the painter with a letter of introduction to Charles Barry, Sir William Hamilton assured Haydon that he 'had no chance of being employed to adorn either House'. Hamilton still believed that had his friend taken advantage of the offer, twenty-two years earlier, of free passage to Naples and the opportunity of a period of study in Italy, he would have been in a better position to compete with the younger men in the running for commissions. Haydon had had two decades to reconcile and justify to himself that lost opportunity, and despite any regrets he may secretly have harboured, his reply to Hamilton would have been well practised. In the Elgin Marbles and in the Raphael Cartoons, he believed, lay everything requisite to education, inspiration and the foundation of High Art in England.

Why should he have left his native country to learn his art when all the greatest geniuses he could think of had stayed where they were and not left theirs? 'Where did Shakespeare go?' he asked, 'Raphael, Phidias, Michelangelo?' The logical inconsistencies of this argument – that Shakespeare was a poet and not a painter, that Phidias lived too early to benefit from learning anything in Italy, and that Raphael and Michelangelo were already living there – did not appear to concern him.

When Hamilton mentioned that Eastlake, who had spent seventeen years in Italy, had been called to give evidence and advice to the Select Committee, Haydon refused to see the connection, suspecting instead the instigation and spite of a vindictive Royal Academy, 'because being my pupil, it may be more mortifying to my feelings. Good God, such is irritated Power!' Such, also, the paranoia. Such the buzzing in his brain.

If frescoes there were to be, Haydon was determined, contrary to Hamilton's opinion, that the lack of an Italian polish to his artistic training need not place him at a disadvantage. Even the acquisition of a painting technique peculiarly suited to the drier, warmer climes of the Mediterranean might be had considerably closer to home. He got his first lesson from Eugenio Latilla, an Italian portrait painter living just off the Tottenham Court Road. He watched the 'good natured fellow' prepare his surface using one part sand to two parts lime, offering his tutor advice from the outset: 'I have painted always in the old way – in oil – & it never cracked,' he told Latilla. 'I advise the old way in Fresco.'[245] But the Italian said 'No' and proceeded to paint in a head, only for the surface to crack, 'from being in too great a hurry to begin & not giving the Lime time to mature.'

Having learned the pitfalls in the process, within a week Haydon had hired a mason to come and tear down part of his painting-room wall and prepare a plastered surface, differing from Latilla's practice, and consisting of two parts sand to one part lime. As much depended upon the skill of the plasterer as that of the painter. The preparatory stages might have been observed in any of the new domestic buildings then under construction in London. 'The plasterer covers [the wall] first with a rough coat of ox-hair and mortar and then crosses with the trowel. When this coat is *freshly* dry, the *second* coat is put

on, less rough, but roughed a little in circles, when spread, to hold the last coat.' The timing and constitution of the third and final coat of plaster were critical:

> When [the] second coat is *freshly* dry, *not too dry*, then fine-sifted river-sand and fine lime are mixed in certain proportions, and polished with water and a hand-board; and on this last coat, when polished, you paint, dipping your brush in water and lime, and rapidly developing your composition. In four or five hours the coat begins to DRY, and THAT is your signal for *ceasing*.[246]

Because the lime in the final layer lightens the paint colour as it dries, the colour needed to be applied much darker than was eventually required. 'You may lay it down as a law,' he would tell an audience, six months after his own first attempt, 'if fresco when wet looks well, it will look ill when dry.'[247]

Fourteen-year-old Frederic Haydon witnessed the experiment: 'trusting to his rapid practice in oil, [my father] painted in genuine fresco, without retouching, a magnificent half-length of an archangel. I remember well its ideal and unearthly beauty, for I had to sit stripped to the waist as the model, and saw him paint it.'[248] The pose was that of Uriel in a picture that his father would begin painting three years later. A slight twist to the waist brought the model's right shoulder to the fore, head in three-quarter profile, right arm bent with hand clasping biceps of the flexed left arm, left hand palm upwards by the side of the neck, in a position appropriate to shot-putting. It took four hours to produce this 'colossal sketch' in 'the new, delightful, and extraordinary mode'. Haydon brought his wife and daughter in to see it. There seemed an immediacy to the image – unconstrained by frame, unsupported by easel – 'as if a new creation had burst open one side of [the] painting-room and stood meditating in the gap'.[249]

Anxiously, he watched the drying process. By ten in the evening, the fresco had been up twelve hours. 'Not a crack has appeared,' he recorded in his journal. The following day Eastlake called and pronounced it successful. But two days later Haydon was still staring at the archangel and monitoring its subtle metamorphoses: 'The lights get brighter & the colour gets drier & darker. They say it keeps

changing the first month.' Within a week he was inviting more people to see the work. Sir Robert Inglis, who had sat on the Select Committee, called and was 'pleased'. Mr Bankes and his niece, Lady Spencer, were 'much pleased too'. The next day another Committee member, Mr Benjamin Hawes, called. 'If they ask about Fresco,' he told the painter, 'there it is', and went away also pleased. Haydon wrote to him the same night offering 'to give up [his] whole Time to Fresco for 10 years for a certain Income'. The following day he again examined the angelic embellishment to his painting-room wall. 'The Fresco is nearly dry,' he noted, 'has got whiter, brighter, & more unearthly.' Sir John Hanmer called and was 'amazingly pleased'. Haydon demonstrated the technique by painting an eye into an area of wet plaster while he watched. The only negative evaluation came from William Dyce, who visited the same day and 'pointed out the colour of the lips, and said it would not stand, and that [there was] too much impasto, and the colours ought to be stained drawing, hatched, glazed and thin . . . it was like Michel Angelo's style of Fresco, and not Raffael's & he was a bungler with his tools'. Haydon replied, disarmingly, that to be like Michelangelo 'was at least something in a first attempt'.

A month after the experiment, 'It has dried & no cracks,' he declared. 'The attempt was a complete success,' recalled Frederic, 'except that it dried lighter than Haydon expected, but this only added to its surprising beauty. The effect was marvellous and highly poetical.' Such characteristics of the sketch would be observed in the large oil painting of *Uriel Revealing Himself to Satan* when it was exhibited in 1845. A perceptive critic remarked on its 'subdued tone, reminding one of a fresco'.[250]

In November 1841 a Royal Commission, chaired by Queen Victoria's German Consort, Prince Albert, was appointed 'to take into consideration the promotion of the Fine Arts of this country in connection with the rebuilding of the New Houses of Parliament'. No artists were included among the commissioners, but one, Charles Lock Eastlake, was elected Secretary.

Eastlake had been Haydon's first pupil.

Eastlake had been privy to Haydon's original decorative scheme, and remembered the gigantic leg sketched in mime with an umbrella on the walls of Westminster Hall.

Eastlake said it was Haydon's conversation that 'had made [him] a Painter'.

And now Eastlake, who owed Haydon so much, was Secretary to the Commission that would be promoting artists for the very work Haydon believed himself born to carry out. 'No one living so fit,' declared Haydon of Charles Lock Eastlake.

But suspicions of Eastlake's loyalty took hold. When the German fresco painter Peter von Cornelius came to London that same month, the Secretary neglected to introduce the distinguished visitor to his former teacher. 'Eastlake knew I had tried a Fresco,' he brooded, 'and it was approved, & yet he seemed to keep him in ignorance.'

On the last day of 1841, he prepared himself for failure. 'A great moment is come,' he wrote, 'and I do not believe any one so capable to wield it as myself, when, from circumstance, & prejudices of all men, I have the least chance of any.' He listed his qualifications:

Because . . . I have loved my Art always better than myself . . .

Because I dissected & drew two years before I painted . . .

Because my pictures of Lazarus, Solomon, Jerusalem, are indisputable evidences of Genius.

Because he had educated Eastlake, the Landseers, Harvey, Bewick, Chatfield, Lance; because he had championed the Elgin Marbles and denounced Payne Knight; because he had been imprisoned four times 'for persevering to improve the people & advance the Taste'; because he had 'first proposed to adorn the House of Lords'; because he had 'had a plan before every Minister for 25 years'; because he had petitioned Parliament, by Lord Brougham, Lord Durham, Lord Colborne, Lord Dover and Lord Morpeth, 'in favour of High Art . . . in specific favour of this very object – the House of Lords'. Because:

I have lost all my property; been refused the honours of my Country; had my talents denied, my character defamed, my property dissipated, my health injured, my mind distracted, for my invincible devotion to the great object now to be carried.

For all these reasons, he concluded: 'I cannot be, ought not to be, & have not any right to hope to be rewarded by having a share of [that

great object's] emoluments, its honour, or its glory'. As the clock hand moved closer to twelve on that last night of December he reflected that the following month he would complete his fifty-sixth year and enter his fifty-seventh. He made a note of the fact in his journal. A phrase in Greek script followed: Νυξ ερχεται 'Night is coming'.

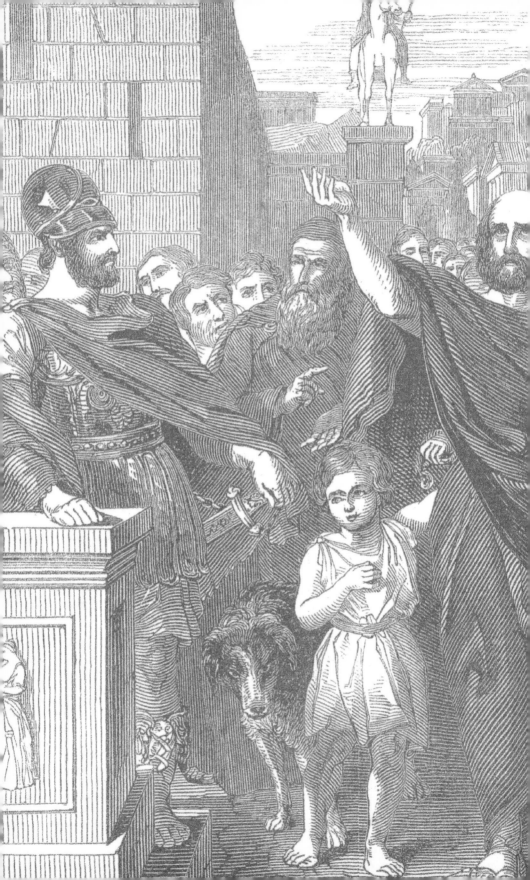

PART SIX

INTO THE GULF

1842–6

'I declare my feelings are as fresh about Art at 56 as at 16,' Haydon wrote, feeling that he was, if anything, even more active at this age than in his youth. Certainly, if his activities during the early months of 1842 were any indication, the course of history painting he had determined on forty years previously had never been more energetically pursued. At the British Institution, he had finished glazing the huge Liverpool picture of Wellington and his horse Copenhagen at Waterloo, in preparation for its first Exhibition. In his painting room the nine-foot-long canvas of *The Black Prince Thanking Lord James Audley for his Gallantry in the Battle of Poitiers* was belatedly nearing completion and destined for the Royal Academy Exhibition, as was the more modestly proportioned, but no less ostentatiously titled *Mary Queen of Scots, when an Infant, Stripped by Order of Mary of Guise her mother, to convince Sadler, the English Ambassador, she was not a decrepid child, which had been insinuated at Court.* Also awaiting his attention was another unfinished picture: *The Maid of Saragossa.* In the upper rooms of the house, his wife and daughter became accustomed to hearing him move the big canvases around and the occasional loud thump sounding from below, as the corner of one or another picture landed heavily on the floor.

When he was not painting, Haydon was lecturing or preparing lectures, although the activity was beginning to weary him. 'Nothing but the wants of my boys induce me,' he complained. The previous August, five years after his half-brother died from the bite of a sea snake in the Madras Roads, Frederic Haydon, aged fourteen, entered the Navy as a midshipman. Whether or not the boy inherited Simon's naval uniform – as Captain Stanley did his brother's – Haydon was put to considerable expense in equipping him for service on HMS

Vindictive. Meanwhile, Frank Haydon, now at Jesus College, Cambridge, had left behind at Caius an overdue tutor's bill for £44 13s. Both sons, their father declared, 'drain me & leave me entirely poor'. He had barely enough cash to support his depleted family at Burwood Place for a week, and still owed three of the ten pounds quarter-rent to his landlord.

It was in these straitened circumstances that he blithely intended making a start on two entirely new, entirely speculative historical paintings. Newman,[1] his colourman, was holding the canvases at his Soho Square premises until they were paid for, but Haydon was able to secure delivery with a cheque promising payment in six months' time. 'There is nothing like a large Canvas,' he wrote, 'the blank, even space . . . restores me to happiness, to anticipations of glory, difficulty, danger, ruin, or Victory! My heart expands, & I . . . stride my room like a Hercules!' He had rubbed in both pictures by the end of January 1842, before setting them on one side while he attended to more pressing concerns. The two new works were *Alexander's Combat with the Lion* and – on a canvas ten feet by seven – *Curtius Leaping into the Gulf.* Livy records a legend from the mythical era of the early Republic:

> It is said that the ground gave way, at about the middle of the Forum, and, sinking, to an immeasurable depth, left a prodigious chasm. This gulf could not be filled . . . and . . . they began to inquire what it was that constituted the chief strengths of the Roman People; for this the soothsayers declared that they must offer up, as a sacrifice . . . if they wished the Roman Republic to endure. Thereupon Marcus Curtius, a young soldier of great prowess, rebuked them . . . for questioning whether any blessing were more Roman than arms and valour. A hush ensued, as . . . stretching forth his hands, now to heaven, and now to the yawning chasm and to the gods below, [he] devoted himself to death. After which, mounted on a horse caparisoned with all possible splendour, he plunged fully armed into the gulf.[2]

*

Haydon had a meeting with Barry early in January and the architect showed him plans of the new Parliament buildings and the spaces where decorations were to go. The Royal Commission had still to

meet and the definitive decision as to 'Fresco or no Fresco' was still to be made.

'Shall I be employed?' Haydon asked him directly.

'Yes.'

'Is Eastlake my friend?'

'I do not know why he should not be,' Barry replied. 'But he is a cold man; there is no knowing what he means.'

In February, at the British Institution's Exhibition, Haydon's portrait of the Duke of Wellington and Copenhagen was 'well hung in a place of honour, & doing [him] Credit' – although there were criticisms, and some amusement, regarding its size. *The Times* declared that 'if 10 feet 7 inches in height by 11 feet 7 inches in width be any recommendation [it] certainly deserve[d] respect'. The correspondent enjoyed himself, devoting more column inches to wry comment on this picture than to any other work in the exhibition:

> If the Duke of Wellington had really been so gigantic a being as is here depicted, and ridden so huge a horse as the painter has imagined, he would, single-handed, have found it no difficult task to have defeated a legion of French guards.[3]

In his defence, Haydon claimed to have measured the Duke in person, '& found him 6 *feet* high, the same height as *my own* Portrait . . . So much for the exaggeration of the press.' Wellington himself came to see the picture, 'staid a quarter of an hour', but, such being the lure of celebrity, 'the people crowded, & he went away'.

★

The Royal Commission's Report, which was expected to settle the debate as to whether 'Fresco or no Fresco' should be utilised in the decorative scheme of the new Palace of Westminster, was still eagerly awaited in early March when Haydon stood behind the lectern at the Royal Institution in Albermale Street and posed a question. 'And what are these tremendous difficulties of fresco?' he demanded of his audience. Some fifteen minutes into the delivery of his 'Thoughts on the Relative Value of Fresco and Oil Painting', Haydon had been deploring the modern fashion for decrying British genius:

The moment some Englishmen set their foot on the continent, the
moment they leave the white cliffs of their father-land, they seem
to doubt whether England *really* be the great country they believed
her; they fear India does not belong to her, and the Cape has ceased
to be governed by her; they question if the Duke's battles in the
peninsula were mere lucky accidents, or Waterloo anything but a
splendid mistake.

In that climate of national self-denigration, doubts had been voiced
as to the competence of British artists to decorate the Houses of
Parliament with fresco, their having had no practice in the medium.
Haydon responded to such doubts with a patriotic flourish designed,
if not to bring his audience to its feet, then at least to prompt a
resounding 'Here! Here!' He declared that English artists had had as
much practice as the Germans. 'And will any man have the hardihood
to assert,' he demanded, 'that there is anything any other nation can
do, or has done, which, with equal advantages, is beyond *our* reach?'

It was then that he asked his question concerning the difficulties
of fresco. He explained that in fresco an artist 'must paint dark, because
it dries light', whereas in oils 'you paint light, when you glaze dark'.[4]
And there was no more difficulty, he told them, than that. The lecture
he pronounced 'a great hit.'

The following day, after lying awake for hours worrying about
Frank's still-unpaid tutor's bill, he was 'out on harrass'. He visited a
man to whom he owed £7 10s and persuaded him to wait a week;
then another who held a bill for ten pounds, who gave him a further
week's grace. Frederic was unhappy aboard the *Vindictive* and so his
father had to call next at the Admiralty and voice his uneasiness about
a fourteen-year-old 'on board a ship in such a state, without School
Master, Chaplain, & the Captain a Veteran lubber'. By five o'clock he
had succeeded in getting the boy moved to HMS *Impregnable*. Two
days later he was running around trying to raise the money to send
Frank in Cambridge. He offered his preparatory drawings for *The Anti-
Slavery Convention* to John Beaumont, for fifty pounds, with no success.
He called on Moon, Boys & Graves, shortly to publish Lupton's
engraving of *The Hero and his Horse*, and asked for an advance of fifty
pounds from the £200 due to him. But they looked at him 'as Publishers
do when you want Money', and he went home empty-handed. Frank

was eventually saved further embarrassment by fifty pounds sent to his father by an unnamed member of the aristocracy.[5]

Financial cares now brushed behind him, for the time being, Haydon was able to finish the ill-fated picture – 'in hand 6 years' – commissioned by the late Lord Audley. The death of the 20th Baron in 1837 had left Haydon with an unfinished six-foot-by-twelve canvas on his hands, only half of which had been paid for. Because his Lordship had died with little more to his name than the pension given to his ancestor by the Black Prince nearly five centuries before, it appeared unlikely that Haydon would receive the balance of his 500 guineas from the Audley estate. On finishing the picture, he wrote to the 21st Baron giving 'legal notice if the Picture was not paid for & taken away', by 1 May, he would sell it. At the same time he made an agreement with his landlord that, in the unlikely event of his Lordship taking the picture, the £262 10s balance would be set against his tenant's outstanding rent, otherwise the picture would become Newton's sole property and Haydon's debt reduced by £525. It was presumably to the satisfaction of both parties that no reply ever came from the 21st Baron and so William Newton at last added *The Black Prince Thanking Lord James Audley for his Gallantry in the Battle of Poitiers* to his increasing collection of Haydon pictures.

The day after finishing *Poitiers*, Haydon mounted his steps and began work on his six-foot-by-ten canvas *The Maid of Saragossa*, rubbed in five years previously.

Lecturing engagements continued to weary him. He could still experience the old euphoria in front of a responsive audience, like that of the Royal Institution, and could still derive pleasure from the overheard remark of a stranger. 'That Man is full of *stern realities*', someone had said of his lecture on Fresco. But, ten days after that 'great hit', he lectured 'to a set of Blackguards at Greenwich'. The subject of his discourse is not known but, although the majority of the audience were 'genteel & attentive', it failed to meet the approval of 'a set of low Artists & low people' at the back. Hurrying home, Haydon found solace in hard work on *Saragossa*.

<center>★</center>

Eastlake was in high spirits when Haydon visited him one Sunday after church. The Royal Commission had met and enquired 'who was

ready to paint Fresco?' Eastlake replied that Haydon was, and had read out his letter on the subject received earlier in the month. He showed his old teacher two types of plaster: *Trevertino* – which Michelangelo would have used – and *Tufo*. Haydon was pleased to see 'so timid a Man so animated'. But there was a calculating side to Eastlake. 'Of course,' he told Haydon, 'you & I must be secret in our Visits.' Understandably mindful of the need for discretion concerning these meetings between 'Devonshire boys', and possible charges of favouritism that would compromise his position as Secretary of the Royal Commission, Eastlake may also have been conscious that, at some future time, it might prove politic to repudiate the connection altogether. In either case, the remark would have reminded Haydon of David Wilkie's qualms about maintaing contact with an embarrassing old friend.

<center>★</center>

Working on *Saragossa*, Haydon fell victim to a rare, but particular, peril of historical painting. While copying a musket, fitted with a bayonet, that would be repeated in slanting ranks beyond the drummer boy on the left side of the picture, he failed to notice that the weapon had toppled to the floor. During his restless pacing to and from his canvas, he impaled his left foot on the point of the blade to a depth of half an inch. Bleeding 'copiously', he carried on painting the foreground area of the picture while awaiting the surgeon's arrival. 'Never lose an opportunity!' he commented cheerfully. That same afternoon, shortly after the accident, Lord Lansdowne, a member of the Royal Commission, called to see his pictures. He seemed 'much pleased' when shown the experiment in fresco, dried to permanence in the fabric of the painting-room wall. 'I hope the Houses will be so adorned', ventured Haydon as they looked at it. His visitor answered 'not a word'.

Incapacitated by his injury, he was unable to paint for a fortnight and spent the time reading and pondering changes to his composition. By the second week of April he had started painting, but hurt his foot again, 'stumping about too soon'.

It was at about this time that he initiated a regular correspondence with the poet Elizabeth Barrett, by sending her the text of his recent

lecture on fresco. An earlier, more direct attempt at acquaintance with the reclusive invalid of 50 Wimpole Street had failed at the front door. 'I count it among my deprivations,' she wrote to him, 'that I was not able to see [you] when [you] did us the kindness of calling here some time ago – but my health unhappily for me, was & is weaker than my will.'[6] In 1838 a blood vessel had burst in her chest, she explained:

> & altho' I have rallied at different times & very much for the last year, it is only within these two months that there is evidence of its healing. And even now, I am so weak as to stagger like a drunken man when I attempt to walk without assistance . . . But I believe I am gradually reviving . . . And with care & *heat* during the winter, I have hope for next summer.[7]

She was thirty-six and, her limited expectations notwithstanding, she would outlive Haydon by fifteen years. They would never meet.

<p style="text-align:center">★</p>

While recovering from his bayonet wound, Haydon had his two most recently completed pictures – *Mary Queen of Scots* and *Poitiers* – delivered to the great domed building on the north side of Trafalgar Square, the south wing of which was the Royal Academy's new home.[8] It had been fifteen years since he last sent work to the Exhibition – the year of his final vain attempt in the Associateship election of 1827, 'the disgrace of [his] life'. He was able to justify sending his two pictures this year as a principled stand against the influence of foreign painting being brought to bear on Her Majesty's Commissioners by the pro-German court:

> At such a crisis it is the duty of all to . . . support & stand by each other, or we shall be invaded by Foreign troops. How far this is on my part a dereliction of duty, God only knows . . . I meant it to help & keep up an Historical air in the Exhibition, & prevent the sneers of Foreigners.

His letter to the Academy Secretary, Henry Howard, when his paintings were accepted, was finely balanced between appreciation and reproach, expressing 'great gratification at the manner in which [the Academy] received my desire to exhibit, [and] by the very handsome

way in which they have hung my pictures'. However, 'It is a pity that
in early life when I had given every symptom of diligence as a student,
kindness of this nature was not thought the fairest way to nourish
and reward them.'[9]

Seeing his work among that of his contemporaries Haydon decided
they 'did not look *firm* enough'. He felt that parts of *Poitiers* were
equal to anything else shown, but 'as a totality it fails'. As for the
smaller picture, the figure of the infant Mary, Queen of Scots was
'fine in tone', and the Queen of Guise 'excellent', but the Page was
'hot' and the Ambassador 'flimsy'. He felt, however, that bringing
himself 'in contact' had done him good. He would improve, and his
next picture would profit by it.

His foot having healed, Haydon resumed work on *Saragossa*. Painting
the face of a fallen Spanish soldier, and trying to capture 'the fixed
glazed look of the Eye' as he dies 'huzzaing', he was reminded of
poor William Eastlake, brought choking home in a blanket to sit for
another dying soldier in *Dentatus*, more than thirty years before. And
from the asthmatic William, his thoughts turned again to the younger
brother, playing what seemed to be an increasingly duplicitious role
as Secretary of the Commission. 'Eastlake is surely greatly to blame,'
he believed, 'in making the German School so prominent.' His suspi-
cions darkened when he heard a rumour that Eastlake was producing
a series of designs for Barry and that Haydon was '*to be employed!*' If
this were true, and he was indeed to be asked to execute his pupil's
designs, he would 'beg to be excused'. Trying to give Eastlake the
benefit of the doubt, Haydon hoped he would not 'prove a Traitor'.
Nevertheless, 'It will be a Trial if after so many years of industry &
suffering & sacrifice, my own Pupil should supplant me.'

But his suspicions were the result of 'restless & eager apprehen-
sion', he decided, 'as *unjust* as *cruel*', when he opened the *Morning Post*
on 25 April:

A Competition for Cartoons, to be executed in fresco for the new
Houses of Parliament. Three premiums of £300, three of £200, and
five of £100 are to be awarded; the drawings are to be not less than 10
feet and not more than 15 feet in their longest dimension. The subjects
are to be taken from English history or from the works of Spenser,
Shakespeare, or Milton. The cartoons are to be executed in chalk or

charcoal but without colours. They will be judged on Precision of drawing, founded on a knowledge of the structure of the human form; a treatment of drapery uniting the imitation of nature with a reference in form, action, and composition less dependent on chiaro-scuro than on effective arrangement. All cartoons are to be delivered to the Westminster Hall during the first week of June 1843.[10]

The announcement was signed C.L. Eastlake, Esq., Secretary to the Commission.

From his burst of euphoria, it seemed as if Haydon had leaped the competition stage and landed in triumph. 'Here is my Pupil,' he enthused, 'whom I instructed, whose dissection I superintended, whose Ambition I excited, whose principles of Art I formed, putting forth a code by my influence & the influence of his own sound understanding, which will entirely change the whole system of British Art.' He called his 'journals, petitions, & prayers & confidences' as witness to show 'how this report must make my heart leap with gratitude & joy to the good & great Creator, who has blessed me through every variety [of] fortune to this great accomplishment of my ardent hopes'. And he called on that same Creator to bless him with 'Life, & health, & Intellect, & Eyes to realise the wishes of the Commissioners'. He called on Him to bless his pupil Eastlake and 'grant we may both live to see the English School on a basis never to be shaken'.

But within a fortnight he felt less confident at the prospect of a competition. 'Surely it is hard for me at 56 to enter the lists, after such pictures as Solomon & Lazarus, which would justify any Selection.' He was 'not quite satisfied', either, with Eastlake's conduct. It still rankled that when Cornelius visited London the previous November, Eastlake had not brought them together. Moreover, he found that when he spoke to Eastlake, 'he listens with a sort of impatience, when I just hint at my claims from having fought the battle for so many years, by my sufferings, by my attacks, by my petitions . . . to adorn the House of Lords'. Eastlake seemed to be preparing Haydon for the inevitably painful revelation that such qualifications would not finally count. 'Ah,' he remarked in one conversation, 'if all this had happened when you were *young!*'

*

Money worries encroached again and Haydon was forced to pawn his dinner suit for thirty shillings. Next he was able to borrow fifty pounds from a moneylender on seventy chalk studies for three months. 'The reptile's mouth watered as he drewled over the Sketches, longing . . . that he might keep them', the ruinous rate of 60 per cent interest he charged on the loan making this eventuality all too likely. A portrait drawing of 'poor Wilkie' and a 'Portrait of Raffael' were sold for an undisclosed sum 'to raise something for the day'. He tried to get fifteen guineas for four of Wilkie's sketches, including those for *Rent Day* and *Distraining for Rent*, but got only five pounds and again was 'relieved for a day'. Over the next twelve months short-term relief from financial pressure was had by pawning Mary's watch for ten pounds, a pair of spectacles for four shillings on one occasion and three shillings on another, and a butter knife for thirteen shillings.

Mary sat for the head of a dead woman slumped, with a baby at her breast, to the right of the cannon in *Saragossa*. Approaching fifty, his wife looked 'as grand in Beauty as she was beautiful in Youth'. Wordsworth called in that afternoon, looking 'capitally well'. He called again the following day, a Sunday, and the two men went to church together, afterwards walking to Samuel Rogers's house across the park. The collector had a party to lunch and Haydon stayed downstairs to look at his pictures – Rembrandt, Reynolds, Veronese, Raphael, Bassano, Tintoretto – while Wordsworth went up to meet the company.

'Haydon is downstairs,' he told Rogers.

'Ah,' said Rogers, 'he is better employed than chattering nonsense upstairs.'

They left later, in the company of the essayist Abraham Hayward and Brigadier-General Duff Green, an American journalist. As they parted, Green said to Haydon, 'I have heard of you, sir, in America.'

'Where have you not heard of him?' Hayward said. Haydon thought this 'agreeable'.

Walking back together across the Park, Wordsworth and Haydon talked of Scott, Wilkie, Keats, Hazlitt, Beaumont, Jackson and Lamb, all of them dead.

'How old are you?' asked Wordsworth.

'Fifty-six. How old are you?'

'Seventy-three,' Wordsworth replied, 'in my seventy-third year. I was born 1770.'

'And I in 1786,' said Haydon.

'You have many years before you.'

'I trust I have,' replied Haydon, 'and you too I hope,' he added, and resolved that they should both try to outlive Titian, 'who was 99' when he died.[11]

Wordsworth sat for his portrait before leaving town for the North. He looked venerable, but had an inflamed eyelid and so could only sit with the light behind and that hurt Haydon's eyes. Despite this, the sitting produced a successful sketch. They talked again of Lamb and Keats and 'The Immortal Dinner'. The weather was sultry and the old poet fell asleep as he sat. 'And so did I nearly, it was so hot,' said Haydon, 'but I suppose we are getting dozy.'

As in the crowd of *Jerusalem*, he portrayed Wordsworth with head bowed, the thinning dark hair of 1819 entirely retreated from the pale dome of scalp, and that at the temples white. It has been suggested[12] that in his choice of title for the finished picture – *Wordsworth on Helvellyn* – Haydon recalled Keats's lines:

> He of the Cloud, the Cataract, the Lake
> Who on Helvellyn's summit, wide awake
> Catches his freshness from archangel's wing . . .

And that 'Cloud', 'Cataract', 'Lake' – if not 'wing' – might be readily discerned in the background. But it is more likely that this portrait commemorated the day in August 1840 when Wordsworth composed his sonnet on Haydon's *A Hero and his Horse*, while climbing the eponymous Lakeland peak in the company of his daughter and Edward Quillinan. It is entirely characteristic of Haydon that he should choose to immortalise his sitter at the imagined moment of contemplating a poetic tribute to the painter's own work.

Saragossa progressed and, in the interests of accuracy, Haydon visited the Woolwich Arsenal to consult on the trappings of ordnance. He was shown twenty-four-pounders, shells, screws, ramrods and matches and was able to make invaluable sketches. 'How Untrue was My Cannon,' he reflected, 'before I went . . . & studied one & drew one and questioned Artillery Men & Officers & got at the Anatomy of

the thing.' By the time he left he felt that he could not only fire such a gun himself, but direct the gun crew in its duties. On the basis of his research he painted a thirteen-inch spherical 'shell & tackling' into the bottom right corner of the composition, at the feet of the dead woman.

On the evening of 26 May, Haydon, Mary and their daughter might have been seen at Her Majesty's Theatre, Haymarket, attending a Charity Ball for the benefit of Spital Fields weavers. According to *The Times*, all proceeds were to 'contribute towards a fund for the erection of a school in which the children of the weavers [were] to be instructed in the arts of design'. The Queen and her Consort attended, Albert looking, to Haydon, 'like a cowed & kept pet, frightened to sit, frightened to stand', while Victoria – 'red, intellectual and fiery' – behaved towards him 'as if they had previously disputed'. The Duke of Wellington entered. 'Nothing,' declared *The Times*, 'could exceed the enthusiasm with which the appearance of the venerable hero was greeted on his entrance by the assembled company, or the cordiality with which he was received by Her Majesty.'[13] For Haydon, it was a trying evening:

> refreshing ourselves with wretched lemonade in stinking glasses, drinking cold tea without milk or sugar, & sitting in draughts of air to get cool & to get out was foul. In the ball room we were crushed, up stairs we were pushed . . . I never saw so few handsome Women.

His wife and daughter, nevertheless, 'declared themselves enchanted & ready for another rout that night'. Ten days later there was an assassination attempt. 'The little dear Queen has been shot at,' Haydon reported. 'What can be the instinct thus to long for the death of Sovereigns! Is it the fiendish hatred of Superiority?' And yet an excursion to Windsor Castle on the longest day of the year gave rise to a meditation on 'the utter insignificance of all human Splendour.' The Queen and her family were, after all, nothing more than 'little specks', with all the weaknesses, diseases and needs of every other speck in Creation:

> The specks that die are buried, decay, become corruption, dress the ground, grow grass, feed cattle, & the specks which are the produce

of the dead specks, eat often a bit of their own Parents, without being aware of it! & talk of the relish of the mutton! or the beef – the taste of the ragout, or fricandeau! & then boast of the purity of their blood, their high descent, their birth, their honour.[14]

There was even a suggestion that such contempt was exacerbated by the ease of modern travel. 'The rapidity of railway communication,' he observed, 'destroys the Poetry & mystery of distant places. You went to Windsor as an exploit for two days. Now, down you go in an hour, see it in another, & home in a third. It is painfully attainable, & therefore to be despised.'

In the wake of the turning year, almost a week after the longest day, he mused on the 'inexorability of Time'. He believed that 'a Man should act as if he heard the Niagara roar of the river of time behind him night and day'. Now he toyed with thoughts of spectacular self-destruction as that raging torrent became, in his imagination, less a spur to action than a way to escape his troubles. 'If the falls of Niagara were near, I would go over them shouting to put an end to this horror of living *here*! Would it put an end? *Here* it might, but where might you *wake*?' He blamed indigestion for such thoughts.

Towards the end of June, with 'the last touch' put to *Saragossa*, and after a fortnight of 'harrass, anxiety, & distractions . . . begging Friends for help, dwelling in agony . . . on the certainty of ruin', he made preparations for his first 'great Cartoon'. He ordered paper, canvas and a frame, thirteen feet by ten and a half. He spent the last day of the month at Hampton Court, looking at Raphael's majestic proto-types, as though absorbing strength for the competition. 'I confess I feel it cruel,' he remarked, 'after 38 years of devotion, to be tried again before I am employed.'

He debated which cartoon to begin first. *The Black Prince Entering London in Triumph*, a subject once intended for Lord Audley, was perhaps most 'suitable to the building' for which it was intended; but *The Curse* – showing Christ, Satan, Adam and Eve and the serpent – was a subject he thought most 'interesting to the World'. He settled on the 'sublimest' and the one that would afford him an opportunity of depicting 'the finest Specimen of the Naked'. He moved the finished *Saragossa* to another part of his painting room, set up the cartoon canvas and by the end of the month was hard at work on it, gums

sore from the concentrated clenching of his teeth, as when he began his studies in London thirty-eight years before, his 'excitement . . . just as great.'

It was a laborious process. The paper had first to be glued to the stretched canvas. Size was then boiled to a workable consistency and brushed over the entire surface of the paper. When this thin layer of size was completely dry, the drawing of the design, in chalk, could begin. Haydon started with Adam's head – got it 'fine, with power & expression' – then spent seven hours on the legs and arms. After five days of drawing and altering, putting in and taking out, the figure was finished to his satisfaction. But the chalk design, at this stage, was friable and could be spoilt with a careless swipe of the hand. To 'fix' it, heat had to be applied to the back of the paper-covered canvas by means of steam. This had the effect of liquefying the layer of size under the drawing and embedding the chalk particles within it, so that, once dry, the design was as permanent as a fly in amber. Further alterations to the fixed design might still be made by the same process of drawing, steaming and again allowing to dry.

Harassed by financial distractions, it took another three weeks to get in the figure of Eve. At one stage, while drawing the eyes – open 'to show her beauty', rather than closed as originally conceived – he was forced to go out into the scorching August heat and negotiate the deferred settlement of a fifty-pound bill, leaving his model, 'a sweet girl,' alone in the painting room wondering what had become of him. There were further delays when the same model could not pose for a few days, being 'knocked up & ill' and he had to work alone, improving and steaming. But by the middle of the month he had finished both central figures: Adam standing, Eve kneeling by his side, each minimally dressed in the customary foliage of *Ficus sycomorus* obtained from a firm of nursery men in Hackney.[15]

It was at about this time that the long-awaited *First Report of the Commissioners on the Fine Arts* was published. Eastlake had promised Haydon a signed copy, but wrote to say that he had received so few himself he had none to spare, but that one could be bought at 32 Abington Street. Haydon feigned indifference to the slight, but privately admitted it was 'really *shocking* to my feelings'. In his contribution to the report – an essay on 'The State and Prospects of the English

School, Considered with Reference to the Promotion of Art' – the Secretary made no mention of his former teacher.

Haydon began work on Satan, a youthful figure sitting on a cloud in the upper right corner of the composition. He had conceived an idea for the face while watching Lockhart in the company of Wordsworth the previous May. It would be a composite of his own forehead, Lockhart's melancholy, Byron's voluptuousness, Caroline Norton's eyes, Napoleon's mouth and Hazlitt's eyebrows, and would 'make a very fine Devil' he thought. It took a week to finish, then he 'Steamed the Devil. Fixed him, the dog, beyond all Power of escape!'

Complex financial juggling attended the end of August and the beginning of September. He had to pay a servant and borrowed four pounds from his landlord for the purpose. Then he approached James Webb, his butter-man. Webb was a former pupil who had renounced the uncertain profession of history painting to pursue a more lucrative business in dairy produce and now prospered, with three establishments to his name.

'Webb,' said Haydon, 'when you were a poor youth I gave my time to you for nothing.'

'You did,' replied the butter-man.

'I want ten pounds.'

'You shall have it, Mr Haydon. I shall ever feel grateful.'

From that ten pounds Haydon paid seven pounds to another creditor and, on the strength of the repayment, borrowed another ten pounds from the same man. With that and the remaining three pounds left from the butter-man, he was able to meet Frederic's mess bill on board the *Impregnable*.

He resumed work on the fourth figure in the cartoon. He experimented with having Christ walking in the garden, but it 'would not do' and the figure was reinstated in the top left corner, 'sitting & reposing', its torso indebted to the *Theseus* of the Elgin Marbles. The Saviour looked 'Better than ever', while, in the opposite corner, 'Satan looked powerfully.' He had to set the drapery covering Christ's lower limbs by arranging it over two plaster legs, because his lay figure had gone the way of his dinner suit and Mary's watch. By the middle of September all four figures were finished, steamed and fixed. It had taken him eight weeks, 'which considering my dreadful harrass,'

he commented, 'is not bad'. A lady visitor, standing in front of the cartoon raised her hands and eyes and exclaimed: 'Oh, what a sublime *Genus!*'

Three days later he had drawn, steamed and fixed the fantastically coiled snake[16] and beyond, in the distance, a lion, supposedly 'stealing along to surprise a herd of deer' and intended to represent 'the first Symptom of the Evil amongst Animals'. His first cartoon was finished. Only one detail bothered him, a familiar fault caused by the cramped conditions in which he worked on such large compositions. As with Moses and the Mayor of Norwich eighteen years previously, Adam's right leg was too short. He could see that the figure was out of proportion and admitted that he should have posed his model thirty feet away when he made his first drawing, as he had done with *Lazarus*. But, short or not, it was a 'nicely worked' leg and he was unwilling to alter it. Then he had an accident and spilt some oil on that part of the cartoon, and the decision was forced upon him. He pasted fresh

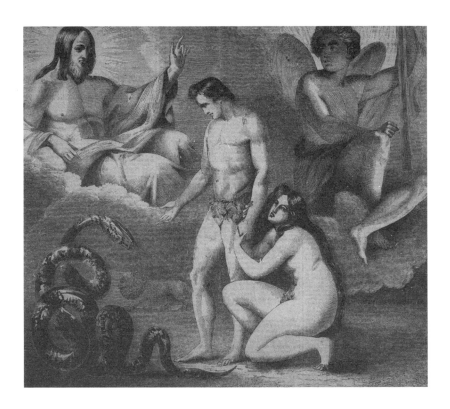

paper over the offending limb, sized it, redrew the leg and 'the whole figure fell into proportion & fitness'.

Henrietta and Arabella Barrett came to see the finished work and 'were delighted, full of admiration'.[17] Their sister Elizabeth, in her Wimpole Street sickroom, was content with second-hand reports and wrote that she had 'seen [the cartoon] with [her] ears'.[18] Haydon showed the ladies other pictures, including the unfinished *Wordsworth on Helvellyn*.

'Oh, how my sister would like to see this!' said Arabella.

'Then she *shall* see it,'[19] replied Haydon and he had the canvas delivered to the invalid. Elizabeth, who had met the poet on two occasions six years previously, felt she had been introduced a third time. 'You have brought me Wordsworth & Helvellyn into this dark & solitary room,'[20] she wrote to the painter, and enclosed a sonnet:

> Wordsworth upon Helvellyn! Let the cloud
> Ebb audibly along the mountain-wind
> Then break against the rock, and show behind
> The lowland vallies floating up to crowd
> The sense with beauty. *He* with forehead bowed
> And humble-lidded eyes, as one inclined
> Before the sovran thoughts of his own mind
> And very meek with inspirations proud, –
> Takes here his rightful place as poet-priest
> By the high altar, singing prayer & prayer
> To the yet higher Heav'ns. A vision free
> And noble, Haydon, hath thine art releast.
> No portrait this, with Academic air!
> This is the poet and his poetry.

Haydon sent a copy to Wordsworth, who wrote to Miss Barrett suggesting a minor change to the eleventh and twelfth lines. His suggestion arrived too late, however, for the poem's publication in the *Athenaeum*.[21]

With one cartoon finished and the second still to do, Haydon turned with relief from the mess of chalk dust, steam and fumes of boiling size to the heroic conception of Curtius launching himself to destruction for the sake of his country. 'I mean to paint my own [face] for

him,' he wrote. 'As I have never done this, I think it but fair.'[22] He did not count the face of Solomon thirty years before and all the other round-faced heroes with their high-domed foreheads – Dentatus, Macbeth, Alexander, even Christ – that he had painted using his own features for reference, when no others were available, and 'only as *a help*'.[23] After painting the face of Curtius for five hours, a lady visited and, not recognising the portrait, said it was 'a head of *self-devotion*'. As for the horse's head, the celebrated model from the Elgin Marbles provided the primary source. He also visited a shambles to make sketches from a dead animal, and the stables of Lord Willoughby de Eresby for the living beast, a fine white Arab.

Early in November, Haydon's attention was drawn to an article in a German morning paper 'for the educated reader',[24] concerning the recent Royal Academy Exhibition. The author was Dr Heinrich Mertz, Professor of Engraving at Munich. Following justifiable criticism of the Academy's customarily overcrowded walls and the impossibility of properly examining the small pictures without 'constant use of ladders and one's knees', the passage that particularly exercised Haydon was the following:

> Theatrical motifs are in common use, empty pathos, stiff representa-
> tion, composition without focus and involvement, no depth of char-
> acter, no identifiable style, crass and trashy costumes and everywhere
> bad colouring . . .[25]

Haydon himself had been just as scathing in his journal after viewing that year's Exhibition, declaring that only six artists represented might, with training, do honour to their country. It was not so much the substance of Mertz's criticism that irked him, but that the criticism should come from a German. There was already, he believed, far too much German influence on English art, not least from the very Chairman of the Royal Commission on the Fine Arts, Prince Albert of Saxe-Coburg. He was also troubled by the perceived Teutonic bias of the Commission's Secretary, Eastlake. Mertz's article provided Haydon with a flashpoint for such suspicions, provoking a correspon-dence in the *Spectator* that would last for nearly two months. He began by questioning:

the right of any other nation to speak of our art with contempt, espe-
cially one which rejects background, light and shadow, appropriate
colour and execution . . . [and] which for truth of imitation may justly
rival though . . . not excel the beauty of a Persian rug.[26]

But another of Mertz's comments had touched Haydon more closely:

There is not a single picture of any significance amongst the historical
compositions. Neither is there any spark detectable in the medium
sized paintings, suggestive of life's sublime truths.[27]

Because he had shown a large historical composition in the
Exhibition, together with a medium-sized one, Haydon took the
criticism personally. He had moved his *Poitiers* and *Mary Queen of
Scots* to the Pantheon Bazaar in Oxford Street when the Royal
Academy Exhibition closed, and there they remained. He issued a
challenge, defying Dr Mertz, or any other interested party, 'to prove
one single error in drawing'[28] in either picture. If further evidence
were required, *The Raising of Lazarus* still hung on the staircase of
the same building, while *Xenophon and the Ten Thousand* might be
viewed at the Russell Institution.

November was a 'dingy month', as he struggled with *Curtius Leaping
into the Gulf*, thick fogs blocking out the light from his painting room.
Sometimes he painted blind – in the dark – and 'could only see results'
with the aid of candle or lamp. One day the upper part of his ten-
foot canvas was so shrouded in gloom that he had to turn it upside
down to work on that portion. He did so 'capitally', impatient and
defiant of 'obstruction & delay,' and by the end was jubilant and felt
'wings growing'. At first, the blue, cloud-puffed sky had extended right
across the top of his composition, then, as though reflecting the murky
conditions in which he was painting, he blotted out all but a chink of
light in the top right corner and encircled his protagonist and the bril-
liant white horse with dark rock, 'as if [they were] passing like a Comet
to Death & ruin'. Despite such bursts of euphoria, in the 'blanket
darkness' he was 'much harassed for money'. Towards the end of the
month he was out all day trying to raise cash, returning home wet
and exhausted, only to fall asleep in front of his painting-room fire,
his palette set, but unused. Again he turned the canvas upside down

to see 'the top paint', turned it back again '& felt as if that was a vast, great effort'.

At the beginning of December he was at the Horse Guards Barracks in Regent's Park to study the action of horse and rider. His model, Corporal Brunskill, despite the season 'stripped to the lower limb,' took a mare over the jumps, while Haydon watched and made sketches. By the middle of the month he had finished the picture and was contemplating his next: *Alexander's Combat with the Lion*.

The unfinished portrait of Wordsworth was still in Elizabeth Barrett's sickroom, and at the beginning of December he sent her the small study of Lord Willoughby de Eresby's stallion. On the back of the canvas was an oil sketch, little more than a foot square, of *Curtius*. 'How kind of you,' she wrote to him, 'to trust these fine things with me. Who shall say that I am alone now? Why here is Wordsworth – & Quintus Curtius – and when I grow weary of that high company, an Arab charger to ride away on.'[29]

<div align="center">★</div>

The silk merchant and poet, Francis Bennoch, had once written a sonnet, 'On seeing *Christ's Triumphant Entry into Jerusalem*', which began with the lines: 'What great magician of the earth art thou, / Who hast such wonders on the canvas wrought?' At Bennoch's home in December 1842, Haydon dined in boisterous company:

> They all asked me 100 questions about Keats . . . Wordsworth, & the heroes gone. I felt like a Veteran but talked like a boy. I was as noisy as any of them. We quizzed, abused, & bullied each other in a very entertaining style for 3 hours.

William Bell Scott, sitting opposite, recalled another topic on which Haydon held forth: the proposed decorative scheme for the Houses of Parliament: 'One master-mind, meaning himself, should have the entire control, and produce sketches which younger men should carry out under his eye!' Scott was convinced 'such a plan was out of the question',[30] especially as he had already seen Haydon's attempt at fresco on his painting-room wall, 'of heroic size and conventional character, already fading out, though only a few weeks done'.[31] The

two men argued across Bennoch's table about the feasibility of working in fresco without having gone abroad to study the method seriously. Scott did not specify how Haydon refuted his points, noting only that 'he made the laugh turn against me', but adding, 'I proved his notion ridiculous.'[32] He would take further revenge, eight years after his dinner companion's death, with a sonnet, 'On Reading Haydon's Autobiography'. It began:

> The coarse-voiced peacock spreads his starry tail,
> And wheels about that all the world may see,
> Of all God's creatures, I am first, quoth he,
> Meanwhile the part that nature meant to vail
> Winks curiously beneath that radiant sail.[33]

*

On Christmas Day, Haydon and his wife sat down to dinner with as many of their remaining family as could be gathered. Their daughter, Mary, was now eighteen. Frank, two years older, was down from Cambridge for the vacation, and his half-brother, Orlando Hyman, from Oxford. Only the sixteen-year-old Fred, midshipman on the *Impregnable* and shortly transferring to the *Howe*, was unable to join them. Despite the tensions between Haydon and his stepson in 1840, the general 'bad conduct & base ingratitude' since, and Frank's equally unspecified 'brutality & insults', which had troubled his father only a month before, the day passed without unpleasantness. Arguments there were, but confined to literature and avoiding religion, they remained amicable. Hyman criticised Milton for his 'eternal display of learning', and for stealing his best effects from Homer, Aeschylus and Lucan. Milton's learning, he declared, 'was a pimple on a splendid face', a bluebottle fly on the nose of Olympian Jupiter. 'Then,' replied Haydon: 'you must be on the lookout for blue bottles. I am not.' Frank asked his father whether he would have seen the bluebottle on Jupiter's nose if it had been carved there by Phideas. 'I replied *no*,' Haydon recalled the conversation in his journal, 'nor should I.'

Hyman then began ridiculing the *Lyrical Ballads*, declared that Wordsworth's reputation would pass and that *The Excursion* was unreadable. It emerged he had not read 'Laodamia', 'The Old Cumberland

Beggar', 'Tintern Abbey' or 'The Happy Warrior'. Haydon was triumphant: 'And thus you presume to pass judgement on a Man, whose finest productions you know nothing of.' Nevertheless, he professed himself gratified by his brilliant stepson, although adding: 'had I not forborne, we should have clashed in a moment'. They passed a pleasant evening:

> We regretted Fred & poor Simon, who was bit by a Serpent, but it was a proud sight to see my two Eldest boys in positions which could only have been obtained by honour, character, and talents.

The new year began with fog, indigestion, influenza and 'Full of anxiety on Money'. He had exactly thirteen shillings and sixpence, but reflected that he was thirteen shillings and sixpence better off than when he began *Solomon* thirty years before. With still another five months to go before the delivery date at Westminster Hall, he began work on his second cartoon, of the Black Prince entering London in triumph with the captive French king, Jean II. The following day he pawned a pair of spectacles for three shillings.

After a fortnight working on his principal figure, he was exhausted and depressed and, thinking it 'bad & ill done', sent for a paper-hanger from Edgware Road to paste over it for a fresh start. 'Paste over that splendid figure!' Mr Crosby said when he saw it. 'You had better wait a day or two.' Then his neighbour, the sculptor Carew, called and told him it was '*very fine*'. Haydon persevered and, although conceding it to be 'very good', still suspected the figure of the Black Prince was 'too large'. Miss Barrett wrote to suggest that he put Geoffrey Chaucer into his London crowd as an observer, and Haydon had 'a great mind to beat [his] own head' for not thinking of it first. There was also to be a cockscombed Fool '*quizzing* the whole human triumph', he told her, 'and that's as good as your Chaucer'.[34] A week later, she suggested that he include the poet John Gower alongside Chaucer. She was also able to congratulate him on *Curtius Leaping into the Gulf* at the British Institution, having read in the *Morning Chronicle* that it was 'the finest work of art in the exhibition'.[35] Although familiar with the composition from the small oil study he had lent her, she could barely imagine, at second hand, the full effect of the ten-foot-high canvas. Her cousin[36] had described to her the 'grand conception' and how 'you almost

tremble while you look at it lest you should be overwhelmed bodily by man & horse'.[37]

Standing in front of his picture, on varnishing day, Haydon felt a hand on his shoulder. 'Well done,' William Etty said quietly. Earlier the Academician had remarked that it was Haydon's example, and Hilton's, 'in early life, [that] had greatly influenced him'.

It was characteristic of the painting that it should inspire neither wholehearted approval nor straightforward condemnation. 'There is hardly a visitor to the gallery, who will not smile at the huge *Curtius*,' the *Athenaeum* began, adding immediately that 'there is genius in the picture'.[38] The *Spectator* praised its 'bold design, vigorously executed', while deploring it as 'utterly deficient in dignity and elevated sentiment'.[39] It was the drastic foreshortening of the horse that seemed to bother the critics. The *Athenaeum* thought its attitude 'resembles more the coiling of an heraldic wyvern . . . than

the plunging of a steed'.[40] The *Illustrated London News* addressed
the problem by frankly declaring that, although it looked wrong,
'Upon a more mature consideration . . . the drawing is discovered
to be as perfect as the general conception is grand and appropriate.'[41]
The *Art Union* was also willing to give Haydon the benefit of the
doubt:

> It can have happened to few to have seen a horse in such a position;
> but we feel at once that it is correctly rendered. The retracted legs, the
> eyes turned back and wildly staring, the whole expressing that frantic
> terror of which the horse is peculiarly susceptible.[42]

To dispel all uncertainty as to the accuracy or otherwise of the horse,
Haydon wrote to the *Illustrated London News* – the only paper, by defi-
nition, able and willing to accommodate illustrated correspondence –
proving, with diagrams, that Curtius only appeared buried in the
horse's body because of the relative positions of the animal's nape
and back when its head was lowered.[43]

One particular criticism, concerning the rider's face, could not be
scientifically refuted and was borne, instead, with gritted teeth. 'Not
a trace of the noble character and lofty purpose of the patriotic
Roman is visible,' the *Spectator* wrote, 'in this florid, chubby-cheeked
physiognomy; the vainglorious expression of which dissipates any
idea of its owner being animated by sublime self-devotion.'[44] It is
debatable whether anyone recognised the youthful, idealised features
of Curtius as a portrait of the fifty-seven-year-old painter, but Haydon
convinced himself that the comment was disingenuous, the mockery
personal. 'The sly malice of the Critics is exquisite,' he told Miss
Barrett, 'they pretended not to know it is myself, call it chubby
cheeked, & a want of the heroic, & all sorts of things to reach me
as if ignorant.'[45]

*

He continued to draw and steam, correct and steam, draw and steam
again. He intended making the Fool and the captive French king 'the
only grave personages' in his cartoon, 'the one grave at the uncer-
tainty of Fortune, the [other] grave at the blindness of human

Triumph'.[46] He regretted this subject did not offer the same oppor-
tunities as had *The Curse*. 'There is not enough of the Naked for me,'
he explained to Miss Barrett:

> It is all Costume & armour, & fleurs de lis & heraldic Lions – the faces
> & expressions & incidents are fine, but the Climate destroys the figure
> by Cloaks & Coifs, & Wimples, & hoods – the naked Majesty of Nature
> is ruined.[47]

By the end of February, it was nearing completion, but he had spent
much of the month distracted by money worries, 'borrowing of one
& paying another', and now faced two court orders to pay by the end
of the week and a warrant for rates expected the following day. In
desperation, he wrote to Prince Albert requesting assistance. He
explained he had been '39 years an historical Painter . . . had brought
up a large family, had lost one boy in her Majesty's service, & had
one boy now serving her . . . had two Sons at the Universities, both
distinguished, . . . had done one Cartoon to the utmost of [his] power
& was half through the other, but . . . was dreadfully distressed'. He
offered to paint his Royal Highness a small picture of the Duke of
Wellington and Copenhagen for fifty pounds. The reply, from George
Edward Anson, the Prince's secretary, arrived while Haydon was having
his tea. He slipped it, unopened, into his pocket and indulged himself
imagining what debts he could pay off with the expected cheque.

Back in his painting room, he opened the letter. Anson informed
him that 'the very real pressure upon [the Prince] from all quarters
does not permit him to make the advance you wish'.[48] It may have
crossed Haydon's mind, as he read the secretary's letter, that Prince
Albert was familiar with his two-month campaign in the pages of the
Spectator, against the 'extremely vicious' style of German art. Later
in the month he wrote to Lord Howe requesting his intercession with
the Dowager-Queen, widow of William IV, for a contribution to the
raffle of *The Maid of Saragossa*. Howe replied that 'as Her Majesty is
not accustomed to belong to raffles, he is honoured with the commands
of Queen Adelaide to decline complying with his request'.[49] The
connection with Haydon's previous rejection was clear. 'My opposi-
tion to the German School, which is strong at Court, has effectually
excluded all hope from the palace.'

By fortuitous advances of cash from other quarters, and 'a heavy expense of Time & property' to the pawnbroker, he 'arranged [his] money matters', suffering neither execution nor further harassment from duns and, by the end of March, after lengthening Adam's foot, raising his shoulder and lowering his arm, he had finished both his cartoons. With 'the relaxation of the String',[50] and the familiar 'vacuum between the leaving of one work & beginning of another', he turned the finished cartoons to the wall and hesitated between *Alexander's Combat with the Lion* and experimenting with a *Virgin and Child* in fresco over his chimneypiece. In the meantime he had *Saragossa* delivered to Trafalgar Square, for it to take its chances in the Royal Academy Exhibition.

The fresco deferred until he could rely on 'a Month's quiet', after three weeks he was making progress with his historical picture. The subject offered 'a fine contrast', he told Miss Barrett:

> The Lion with something of Alexander, & Alexander with more of the Lion, fierce – handsome – flushed – conscious of Victory – his Eyes burning, as he catches the glare of the royal Animal.[51]

He was still struggling with debt, one day needing £6 4s 10d to pay a judge's order and with only five shillings in the house. He got help from his old friend Dr Darling, only to be served with another writ as he was setting his palette to resume work. Two days later he was jubilant, thinking that *Curtius* had sold, but the haggling involved in the transaction – 'as a Draper sells broad cloth'[52] – might have raised doubts. The potential buyer, 'poor devil [having] more taste than money', withdrew and the picture found shelter in the Dean Street warehouse where Newton stored *Solomon*. This 'dust hole' had become the repository, Haydon observed ruefully, of 'my *first* large & now *last* large Work'.[53]

At the Royal Academy Exhibition, the Committee of Arrangement had skied *Saragossa* 'nearer Heaven than it ever was before, or ever will be again'.[54] Haydon believed that the same three men – Shee, Phillips and Howard – who had placed *Dentatus* in the Ante-Room at Somerset House thirty-four years before were again responsible for placing his work so high on the wall of the National Gallery that its 'execution, expression & tone [were] utterly lost'.[55] It was, he declared

with relish, the final 'Mumbling bite with their withered toothless gums before they drop into the grave which yawns to receive them putrid with their own Poison!' He was further convinced that, at this critical time, just before the cartoon competition, his enemies were trying to provoke him to 'fire up, make a great noise, irritate the Patrons' and endanger the last remaining prospect of his life. He determined to remain silent, confiding his accusations to Miss Barrett alone. Nevertheless, he feared that *Saragossa's* appeal as the object of a raffle had been injured.

Notwithstanding the ill treatment of his current work, he was lionised at the Private View for a picture completed twenty years before. An elderly lady approached him: 'Are you the Mr Haydon who painted the Lazarus?'

'Yes, ma'am.'

'Dear me, I thought you must be a decrepit old Man.'

Haydon bowed.

'Ah it is a wonderful Picture – the head of Lazarus. Ah it is wonderful. I always said I never saw such a likeness in all my life to old Colonel Carnack of the 17th Dragoons! You are a great Painter, Mr Haydon, indeed you are!'[56]

The young W.P. Frith, still more than a decade before the phenomenal successes of *Margate Sands* and *Derby Day* would make him the most successful English painter of his generation, came to see the two cartoons, thought them very fine and said so. 'Glad you like them,' said Haydon and, pointing to the figure in the upper right corner, added: 'That is intended for Satan; do you think it like him?'[57]

Towards the end of May, while steaming final alterations to his cartoons before sending them to Westminster Hall, Haydon suffered an accident, badly scalding his right foot. As with the previous year's bayonet wound to his left foot, he remained a near-invalid for the following month, hobbling out when necessary, but unable to paint, being incapable of standing for long periods.

Strict rules of anonymity were observed for all entries to the competition. Each cartoon was to be inscribed on the back with a mark or motto, and accompanied by a sealed envelope containing the name and address of the artist, and inscribed on the outside with the same mark or motto as on the cartoon. For *The Black Prince Entering London*, Haydon chose to paraphrase a passage from

Lamentations: 'I called on the Lord out of my low dungeon; thou camest near & said, "Fear Not."'[58] On the back of *The Curse* he paraphrased Psalms, a motto that might have been an appeal as much to the six judges as to God: 'Desert me not O Lord in my grey hairs, until I have shewn thy strength unto this generation and thy power unto that which is to come.'[59]

The panel comprised three members of the Fine Arts Commission and three of the Royal Academy, Prince Albert having the casting vote. Of the Academicians, two at least had expressed sympathy for Haydon and his work. Only the previous January, William Etty had congratulated him on *Curtius*, while in 1839 Sir Richard Westmacott had voiced the opinion that Haydon's design for the Nelson memorial 'was the only reasonable one'. Of the three Commissioners, Lord Lansdowne had been 'much pleased' by Haydon's experiment with fresco, although refusing to be drawn on its suitability for the Houses of Parliament, while Samuel Rogers was the satisfied owner of a 'not so fat' thirty-guinea *Napoleon*, 'attracting notice of all comers'[60] in his library. The third Commissioner who would be sitting in judgement, however, was Sir Robert Peel, whose dealings with Haydon, over another *Napoleon*, had not been so congenial.

During the month that his burnt foot prevented him from painting, Haydon had much time to brood. He wondered whether he had been right to enter the competition. Even supposing the three artists on the panel were 'sincere', they were still Academicians, imbued with the same malice towards him of the whole institution and could, feigning impartiality, vote prizes to every competitor's work but his own, on the grounds that 'all are so nearly of equal merit'. They could also bring influence to bear upon the three Commissioners, he decided, and 'make them vote . . . against such an old, a bitter, & everlasting enemy as [him]self'. And perhaps Sir Robert Peel would not, after all, require any such persuasion to vote against him. It was not only the disputed price of *Napoleon Musing at St Helena* that he imagined had prejudiced Peel against him. The Prime Minister, he believed, was annoyed also at his constant lobbying:

All my eagerness for the Taste of the Nation he considers impertinent intrusions beyond the limit of my station; every plan he feels as unbecoming a Man who holds no Office.

Haydon prepared himself to be passed over, but the disappointment, when it came, was no less bitter for the preparation. The week before the Cartoon Exhibition was to open and the prize-winners were to be announced, renewed financial difficulties prompted a final, faint expression of hope. 'Worked a little,' he wrote on 27 June, 'but very anxious, as the Cartoon prizes are not yet settled, and I am much embarrassed, after paying away so much.' Three prizes of £300 were to be given, three more of £200 and five of £100. The same day a letter arrived from Eastlake: 'The long & short is that your drawings are not included among those that have been rewarded.'[61]

Haydon wrote immediately to Miss Barrett, entrusting to her care a large chest of books, letters, 'lectures, papers & journals'. He also sent her two precious jars of twenty-seven-year-old oil to be kept in the cellar. 'As *I predicted*,' he told her, '*My Cartoons have no reward.*'[62] It was three days before he brought himself to tell his wife. 'A Day of great misery,' he recorded, 'I said to my dear love, "I am not included!" Her expression was a study! She said, "We shall be ruined."' Anticipating executions and seizure of property, he burned a pile of private letters, sold additional shares in the *Saragossa* raffle and raised seven pounds by pawning the dresses of his wife and daughter.

This financial crisis was, in truth, no more serious than many another he had weathered, but the damage to his pride was desolating. Even so, he was able to convince himself that it was not personal, but national, pride that was affronted. The twenty-six-year-old Edward Armitage, a prize-winner for *Caesar's First Invasion of England*, had been a pupil of Paul Delaroche, the embodiment, for Haydon, of injurious foreign influence on native painting. 'What an insult,' he raged, 'to be told by the French that a pupil of De La Roche beat the congregated power of British Art!' His first instinct, as ever, was to battle it out in the correspondence columns of the press, but Miss Barrett counselled restraint, lest it be said that 'because he is a disappointed man, he speaks as an angry man'. She urged him, instead, 'to cheer in the Hall – cheer to be a Spartan in your exultation!'[63]

And when he visited the Exhibition on the first day, Haydon tried his best to cheer. Seeing his cartoons for the first time from a distance in the vast space of the Westminster Hall, he thought they looked

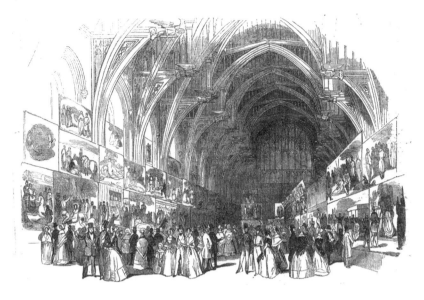

'grand', but recognised 'there were disproportions' and 'gained great knowledge'. Returning home, he wrote to Miss Barrett that he was 'perfectly satisfied', and the display of work was 'an honour to the Country'. He told her also, 'I keep my position . . . the young men rallied round me in a way which was delightful.'[64] William Bell Scott was there on the same day and recorded a very different impression in his autobiography, of Haydon's attempt to hold a crumbling mask to his disappointment:

> He walked about like a man in a dream, now and then waking up, affecting an amused manner, then again collapsing. He, the father and master in this country of high art . . . found himself surrounded by works . . . executed by dozens of young men who had grown up unknown to him, and to whom he was apparently unknown. The inflation was gone; he was suddenly changed into an aged man. Every competition has its dark side: dark with the red light of the nether pit shining through it. Youth can stand much, it takes a great deal to kill at twenty-five, but this veteran on that day was one of the most melancholy spectacles.[65]

The thirty-year-old sculptor John Thomas – soon to be given charge of the stone carving for the entire building – was lunching at a restaur-

ant near the Houses of Parliament when he saw someone he thought he recognised sitting alone at a neighbouring table, a bottle of wine in front of him, leaning forward with his hand to his forehead. As Thomas watched, he noticed tears trickling down the man's face. It was only when Haydon moved his hand that the sculptor recognised him.[66]

'Mortifying, indeed, are some of the flagrancies which have been committed', the *Athenaeum* correspondent observed of the Exhibition, and although anonymity prevented him from identifying the perpetrators, he was able to wound Haydon by mentioning the subjects. *Edward the Black Prince and John of France*, described as 'two Kings of Brentford', was singled out, then a couple of others: 'but these again, are solid compositions, if measured against an Adam and Eve to which we could refer'.[67]

The same issue of the *Athenaeum* carried the announcement that ten additional cartoons had been selected by the Commissioners, each to receive a prize of £100. Again Haydon was passed over. Again he assured Miss Barrett: 'I never felt better – you know I was prepared for this – you know what I said.' But he admitted being 'only wounded at the Cruelty of my Species & its hatred of Truth'.[68] She in turn wrote at length persuading him against feeling persecuted. She was unwilling to believe in treachery or conspiracy. 'Your cartoons may deserve the first prizes,' she suggested, '& you may be a cruelly wronged man. Still *a mistake* may have wronged you, & not treachery.'[69] And he replied – as close as he ever came to exasperation with this invalid, who had hardly ventured beyond the walls of her own room for five years – that he knew the world better than she, and that 'the old cry of Conspiracy' was raised against him before she was born. 'Do not think I am so weak as to believe in a conspiracy,' he told her. 'I am only perfectly sure my Cartoons are fine things, & that the Judges must have remembered to forget them.'[70]

During the month following his disappointment, Haydon had 'given vent'[71] to his feeling in a new lecture on fresco. An hour before leaving the house to deliver it, he shut himself in his painting room '& felt as if conversing with a Supernatural being!' He was at a point of crisis, failure bringing with it 'perpetual ridicule'. But he took comfort from the voice:

Have I not often heard awful Whispers as if from some Awful Spirit! . . .
I cannot have been urged on in this way, to be destroyed & marked! –
no – I shall succeed, & let no doubts torment me.

His Bible lay in front of him. He wondered whether to open it at
random, as was his custom, and 'consult the lots'. He felt he must,
and did, and left the house for his lecture 'cool & collected' by what
he had read.

That evening he spoke 'to a crowded & enthusiastic audience' of
the superiority of Italian over German fresco cartoons. He showed
them 'an exquisite Cartoon by Raphael' to prove his argument and
to account for his recent failure. 'My Cartoons,' he explained, 'tend
to the Italian & not the German & the German being the go at Court,
I had no chance [in the competition].' Among the audience were his
wife and son, Frank. 'They witnessed the Completest Victory of any
lecture I ever gave,' he wrote. Although suspecting he had been cheated
by the man taking money for him on the door, in the euphoria of the
occasion he took it philosophically: 'This is life!'[72] While still 'hideously
pressed', he had escaped 'the immediate danger of executions' and
was able to retrieve his box of papers and, later, his precious oil from
Wimpole Street.

An irregularity in the competition at last gave Haydon an excuse
for disregarding Miss Barrett's advice and making his views known to
the public. When it emerged that Edward Armitage had produced his
prize-winning cartoon while he was in Paris, the Commissioners
invoked a previously neglected clause in the competition rules:

> If a drawing, for which a premium shall have been awarded, shall have
> been executed abroad . . . the judges . . . may . . . require the artist to
> execute in this country . . . an additional drawing as a specimen of his
> ability, and in such case the premium awarded to such artist will not
> be paid unless his second drawing shall be approved by the judges.

This formality having been fulfilled, the judges confirmed that both
Caesar's First Invasion of Britain and the second drawing were by the
same hand and that Armitage was 'justly entitled to receive the
premium awarded to him'.[73] Haydon did not respond at once, but
waited more than a fortnight, until a few days before the exhibition

closed, before inserting an appeal in the classified advertisements of *The Times:*

> The people are respectfully requested to look at Cartoon 118 – to reflect on the character, expression, figure, proportion, and air of Edward the Black Prince – to study and reflect on the mien, character, and expression of King John of France – then to cross over, and study the characters, figures and proportions of Cartoon 64, 'The Landing of Julius Caesar' [*sic*] – to compare Julius Caesar with Edward and John – to compare the horse in Caesar with the horses in Edward – and then to meditate on the decision of the judges . . . that 'the Landing of Julius Caesar' is the finest Cartoon in the room and entitled to the highest prize![74]

When the Exhibition closed, Haydon moved his cartoons to space that he had reserved for them at the Pantheon, where their quality could be appreciated in isolation.

That he should have addressed himself to 'the people' in his press intervention was significant. Haydon had always been convinced of his popular support. The crowds that paid to see *Jerusalem*, and the success of his lectures, was surely proof of that. Had it been left to the people, he felt sure his design for the Nelson memorial would have been approved, even realised. He believed Eastlake to be jealous that he was 'leading the public mind in Art'. Characterising himself as hated by the Academy, by the nobility, by the court, he felt he was 'a Man whom the people would only miss'. Three years later, he would rashly put to the test how highly the people valued his work, and the knowledge would destroy him.

*

Haydon used to dream he was fighting with a lion in the middle of the Strand, the beast having just escaped from Pidcock's menagerie in the Exeter Change. After killing it with his bare hands, he was taken up on the shoulders of a cheering crowd, only to start awake shouting 'Huzza!' himself, as consciousness returned. The Exeter Change had been demolished in 1829 and the collection moved south of the river to the Surrey Zoological Gardens, in Kennington. To find a suitable specimen for *Alexander's Combat with the Lion*, Haydon spent a day

there in broiling heat, distracted and excited by 'the eternal noises of birds & beasts from all quarters of Earth', making sketches from a docile animal that allowed his forehead to be patted and his paw smoothed before falling into a profound sleep. Haydon got all he needed for his picture, caught an omnibus home and, on arrival, the driver gave a 'proof of his grace and taste'[75] by dropping all his sketches in the street while handing them down to him. A week later, he spent a couple of days at a riding school in Bryanstone Square, making sketches for Alexander's horse, Bucephalus, and managed to paint the forequarters on Thursday, the hindquarters on Friday.

By the end of November, 'in spite of all its difficulties' – cognovits and writs, procrastinating one debt to pay off another, borrowing to settle Fred's fifteen-pound bill at sea, Frank's twenty-two-pound bill at college – Haydon had ample reasons for gratification. Frank had passed his 'Little-go' examination, marking a second year at Jesus. Fred had passed his midshipman examination with credit and was now a 'regular middy'.[76] His wife and daughter were in good health. He had at last finished his portrait of *Wordsworth on Helvellyn*. He had 'got through' *Alexander* and needed but to revise it. He had rubbed in a small canvas, six foot by seven, of *George IV and Wellington Visiting Waterloo*, a commission from Francis Bennoch and Richard Twentyman, his two friends in the City, and had rubbed in a full-size *Napoleon* with such force that he strained the ligaments of his right hand. He had painted a smaller *Napoleon* in just four and a half hours. 'Good God', he wrote to Miss Barrett:

> when I look back on the last 9 months – & remember from what ruin I have been saved . . . how gloriously I have kept my own position & the position of my dear Boys – & Women, can I feel otherwise than grateful to him . . . in whom I always trust with a daily intensity that is become a passion[77]

On a visit to Sir Robert Peel's country estate, Drayton Manor, Queen Victoria had admired *Napoleon Musing at St Helena* and this untypical royal approbation resulted in 'orders for small repetitions at a small price'.[78] He painted three of them, he boasted, in sixteen and a half hours: 'Haydon's patent for rapid manufacture of Napoleons musing.' The following January he approached his fifty-eighth birthday and the beginning of his fifty-ninth year with indomitable confidence:

Is it nothing to have a strong clear brain, a vigorous body – activity, health, thought . . . to have something to fight about, & fight for, to love & adore old England – & know I have advanced her Taste?[79]

But a fortnight later, his current hope for the advancement of his country's taste, *Alexander's Combat with the Lion*, was refused by the British Institution. Predictably, he blamed 'manoeuvre & intrigue'. Back in December, the Duke of Sutherland had granted him permission to move the large canvas into the British Gallery, before the sending-in date for the Exhibition, and finish it there. But the Keeper, who was out of town at the time, had not been consulted and was annoyed, on his return, to find that Haydon had taken up residence and was 'toning' his canvas before any other submissions had been received. Haydon had intended sending in two pictures, the *Alexander* and a *Napoleon*, but for a reason he was at a loss to penetrate, the Keeper advised him to send in a third, the *Saragossa*, shown the previous year in the Academy. Then, in February 1844, he was dismayed to learn that his 'enemies in the Committee' had seized the opportunity to penalise him for 'being so unconscionable as to send 3', by accepting the *Napoleon* and *Saragossa*, 'which the public [had already] seen' – and turning out *Alexander*.

He felt he had worked eleven months for nothing, 'for the sale of it', he feared, was 'ruined'. A pattern of unremunerative labour seemed to be establishing itself. 'First came the Cartoons, & now this Alexander affair, no effort I make seems to be rewarded.' And again, he confided this failure to Miss Barrett before he told his wife. 'I fear to tell *all* my difficulties to Mary,'[80] he explained. But his grimmest reflection was confined to his journal: 'This is the first time such an insult [from the British Institution] occurred to me,' he wrote. 'As I get older, I fear it will be repeated.'

His cartoons still hung in the Pantheon and so he took away *Edward the Black Prince*, hung the rejected *Alexander* in its place and put an advertisement in the press:

Haydon's last new Picture of Alexander the Great Killing an enormous Lion at Bazaria (modern Bokhara) has been removed from the British Gallery, where there was no room, to the Pantheon, Oxford Street, and opens this day [7 February 1844] admission free.[81]

He urged Miss Barrett's family 'to go & see it & do me justice'.[82]

Justice, of a sort, was belatedly done him in the *Pictorial Times*. Five months after the Cartoon Exhibition closed, a series of articles appeared on 'The Proposed Decorations of the New Houses of Parliament'. *The Curse* – still on display at the Pantheon – was given particular and effusive praise as having been 'one of the finest works in the exhibition; and, perhaps, as a specimen of grand and essential form, of masterly care, dash, and power of execution, one of the best productions of its kind in the whole existing range of Art, ancient or modern.'[83]

Meanwhile, he was painting *George IV and Wellington Visiting Waterloo*, and contemplating a large Shakespearean subject: 'on the Staircase, after the Murder, Lady Macbeth looking murder & listening'. He had also sketched *Christ looking down on the Temple in its Splendour, foretelling its ruin*. He was painting four more small *Napoleons*, 'a set of his Musings': one 'musing in his garden at Fontainbleau in *his glory!*', another 'musing in his bedroom the night before his abdication', the third, 'musing over the King of Rome in his Cradle', and finally, 'musing at St Helena'. The elegiac tone of the series prompted thoughts of his own passing and posterity. When his time came, he told Miss Barrett, he would 'go out of the World like a Lion in an iron net, who did nothing but roar till he died'. He had also resolved on his final words: 'Like Lear . . . I shall say, "Stretch me no longer on the rack of this tough World."'[84] Only a month later, he would decide on a course of action that ensured the employment of those words sooner than he could have anticipated.

On the morning of 24 March 1844 he awoke with a feeling, so he claimed, 'as if a heavenly choir was leaving my slumbers as day dawned, and had been hanging over & inspiring me whilst I slept. I had not dreamt, but heard the Inspiration.' It was a 'sort of audible whisper', an inner voice that Socrates and the poet Tasso had heard and that had spoken to Columbus 'in the roaring of the Atlantic winds'. Haydon had heard it often at times of uncertainty, the message always plain: 'Go on.' But this time the voice was more specific: 'Why do you not paint your own designs for the House on your own foundation, and exhibit them?' The setting of this epiphany was room 49, on an upper floor of the Adelphi Hotel[85] in Liverpool. Haydon had arrived the evening before, at the start of a customarily strenuous series of

lecturing engagements in both Liverpool and Manchester over the coming three weeks. As the sunlight crept across the floor of his room he knelt up in bed, determined that six huge canvases showing the best and worst forms of government to regulate mankind would be his 'next great works' and he prayed 'heartily to accomplish them, whatever might be the obstruction'. Some part of him may have been aware, by so doing, that he was launching himself into the gulf, because he added: 'I feel as if they will be my last, and I think I shall then have done my duty.'

Shortly after his account of this experience – 'one of the most remarkable days & nights of my life' – he attached to his journal a newspaper clipping. In view of what was to happen two years later, there was a terrible irony in the juxtaposition:

GENERAL TOM THUMB. – On Monday night [1 April], pursuant to the command of Her Majesty, 'General Tom Thumb,' the celebrated American dwarf, had the honour of appearing for the second time before her Court at Buckingham Palace ... His delineation of the Emperor Napoleon elicited great mirth; and this was followed by a representation of the Grecian statues; after which the General danced a hornpipe, and sang several of his favourite songs.[86]

A native of Connecticut, Charles Sherwood Stratton was twelve years old, twenty-five inches high and weighed only fifteen pounds. 'This wonderful man in miniature,' his publicity asserted, 'is smaller than any infant that ever walked alone.'[87] His manager, the American showman Mr P.T. Barnum, had rented 'Catlin's spacious Indian Gallery' at the Egyptian Hall for four months, where 'General Tom Thumb' was displayed to the public as he danced, sang, struck attitudes and answered questions for three hours at a stretch, three times a day. Haydon may have wondered, as he read the article, what indignity the divine Phideas suffered in Stratton's imitation of the 'Grecian statues', but by the end he was convinced the mockery was directed at himself:

The dwarf had scarcely made his appearance in the afternoon at the Egyptian Hall, when the Duke of Wellington honoured the General with a visit. At the moment the Duke entered the room, the General

was in the act of giving an imitation of Napoleon musing at St Helena; and on the Duke inquiring what he was meditating on, he happily replied, 'Upon the loss of the Battle of Waterloo.'[88]

For a man who had completed his fourteenth version of *Napoleon Musing at St Helena* just the day before boarding the train to Liverpool, it had especial and bitter significance. Haydon underlined the phrase and wrote alongside: 'I do not like this. B.R.H.'

<p style="text-align:center">*</p>

He went back and forth by train between Liverpool and Manchester, 'Lecturing, Lecturing, Lecturing.' In the first week of April alone, he lectured ten times and by the middle of the month, when he returned home exhausted, he had given twenty-two lectures in sixteen days. Since his first speaking engagements at Manchester in 1837 – and, he believed, as a direct consequence of, and along the lines suggested by, those lectures – a School of Design had been established in Nicholas Street, attached to the Royal Manchester Institution. Changes had occurred in the meantime and under orders, he suspected, from the Government School at Somerset House, 'those obstinate ignoramuses in London'[89] – the life classes had been discontinued. But 'the young men behaved admirably well', Haydon was gratified to learn: 'so convinced of the soundness of my views – they re-assembled privately – subscribed, & continued on the principle I had taught them.' They set up their own private life class above a china shop in King Street and, Haydon being again in town, brought him their drawings for inspection. He judged them 'admirable for their accuracy, breadth and finish' and decided that, after all, the pernicious influence of the Government School might have been beneficial. The Manchester students, in their room above the china shop, were 'like the early Christians,' he thought, 'persecution is the root of successful reform – and all over the Country they are doing the same'.[90]

Back in London, and with barely a day's rest, he gave the first of six lectures on painting at the Royal Institution in Albermarle Street. It was 'a great triumph . . . to have made people of fashion go through the process of an Artist,' he observed. 'Several Men of Fashion were present & took an interest in the proceedings, and many women of

Fashion & beauty.' They were the same lectures he had given in Oxford, at the Mechanics' Institution and in the North, and he felt he had 'thus . . . made a hit amidst all Classes of Society'. The first volume of his *Lectures on Painting and Design* would be published by Longman's before the end of the year.

<div align="center">★</div>

Preparations were being made by the Royal Commission of Fine Arts and its Secretary Eastlake for another competitive Exhibition of cartoons and frescoes at the Westminster Hall.[91] Sir John Hanmer, who had once watched fascinated as Haydon executed a single eye in the wet plaster of his painting-room wall, asked, when they met in May, 'Do you compete for this Fresco?'

'No', answered Haydon, 'I had enough of Competition.'

'The fortune of War,' said Hanmer.

'No, Sir John,' Haydon replied grimly, 'the treachery of the Enemy.'

Six painters would be chosen from the Exhibition, and each assigned one of the six fresco subjects[92] intended to adorn the arched alcoves in the north and south galleries of the Lords' Chamber. Each painter would produce a cartoon design for his assigned subject and receive £400. This would not, however, guarantee him a commission for the actual fresco. That would be decided by a third competition in the summer of the following year, when designs for the same six subjects would again be invited, and 'as an encouragement to artists who [had] not been selected, the Commissioners offer[ed] three premiums of £200 each'.[93] Again, Haydon would decline. He had six subjects of his own in mind for their Lordships' Chamber.

It was nearly two months after the whispered inspiration in room 49 of the Adelphi Hotel that Haydon began work on a large canvas. The subject that he rubbed in, however, was not one of his six, but a scene from Milton that he claimed had transfixed him as a child in front of his father's shop window. That version, by Fuseli, had been a small engraving. The precise dimensions of Haydon's canvas of *Uriel Revealing Himself to Satan* are not known, although its principal figure alone would be described in *The Times* as 'huge'.[94] The incident, from the end of Book III of *Paradise Lost*, showed Satan, disguised as 'a stripling cherub', having just deceived Uriel, 'regent of the sun', into

directing him to the earthly paradise he was determined to corrupt, glancing back furtively at the gigantic figure of the archangel, before flying 'in many an airy wheel' towards the tiny globe, low on the horizon.

He started the picture, as ever, speculatively. 'When I began who did I trust in? God!' he wrote later. 'A Commission followed.' He had known Edward N. Dennys, cotton printer and 'a Man of refined Taste', for less than a year. Just before Christmas he had 'collared' his new friend playfully in the street: 'Your life or a Napoleon?' he demanded and Dennys had laughed heartily and replied, 'A Napoleon of course.' The *Napoleon* was painted over two days. The *Uriel*, for which Dennys agreed to pay 200 guineas, was to take ten months.

It had taken eight years to sell forty ten-guinea shares in *The Maid of Saragossa* and on 23 May 1844 the picture was raffled. Competition was close, Lord Colborne and Lord Northampton each throwing thirty, while the Duke of Sutherland, who had bought six shares, could only reach twenty-six as the best of his six throws. Then, with only one more subscriber still to compete, James Webb, butter-man and former pupil, threw thirty-two and proved the winner. The raffle's benefit to Haydon must have seemed notional, however, because the 400 guineas collected in subscriptions over the eight years had been long since dispersed and spent on day-to-day survival.

Eastlake neglected to send Haydon an invitation to the Private View of the Frescoes Exhibition. It was a hurtful omission and was not made less so by a curt letter of explanation. 'I am sorry to say that I have overlooked many others,' he wrote. 'I have not tickets enough to satisfy all – my stock has been long exhausted – I can only recommend you apply to any one of the Commissioners.'[95] Haydon brooded on the neglect, recalling the great private collections of Stafford, Bridgewater, Grosvenor and Hope to which he had taken Eastlake, when he was 'an unknown boy' and 'admission was a privilege & honour'. He admitted it was demeaning to complain of such things, 'but shocking to be guilty of them'. A month and a half later he was still haunted by 'Eastlake's base hypocrisy', waking in the morning with his heart pounding.

Seeing the Exhibition the day after it opened to the public, Haydon found only one competitor to have 'a sound view of Art', another's submission 'wretched' and Daniel Maclise 'extraordinary in vicious

talent'. Maclise would eventually be responsible for decorating alcoves in the Lords' Chamber, and for the panoramic *Death of Nelson* and *Wellington and Blucher after Waterloo* that flank the Royal Gallery. 'Altogether,' Haydon concluded, after his visit to the Westminster Hall, 'the material [was] not generally managed.'

★

Uriel was already 'making a sensation' among visitors to his painting room. Dennys, now referred to by Haydon as 'Employer', studied his investment and was 'pleased beyond expression'. The painter himself was 'very proud of it' and thought the archangel's head the finest thing he had ever done, 'except the head of Lazarus'. He experienced such exultation looking at it that he imagined he would be happy 'to die in [his] Painting room, after a successful completion of some grand head'.

Harassing money worries continued. He had no sooner paid the balance on a court order with an advance from Dennys on *Uriel* than £140 4s 6d on his son's college account at Cambridge became due. It took Haydon three days of racing about to raise the money, but, with the help of an advance of £100 from Bennoch and Twentyman on *George IV and Wellington*, he was left with only forty or so to find for Frank.

During the latter part of September and the first weeks of October he worked hard at *Uriel*, getting the devil right, improving the drapery. For the rest of the month he painted pot-boiling *Napoleons*, three of them, and a *Wellington and Horse*, 'at the *wholesale* price' of ten guineas apiece. 'I prefer painting cheap,' he told Miss Barrett, 'if I can keep out of debt.'[96]

His first volume of *Lectures* was published in October and he had amused himself, two months previously, writing a mock dedication:

To that respectable Institution the Royal Academy, which obliged Reynolds to resign, expelled Barry, insulted Wilkie, disdained Hayter, scorned Martin, rejected Sir Charles Bell, [&] persecuted Haydon . . . these lectures are dedicated with all that veneration & gratitude which such irreproachable conduct ought ever to excite in the breast of a Briton.

In the event the book was dedicated, less contentiously, 'to William Wordsworth, the Poet, with Affection, Respect, and Admiration'. The title page carried a line from Wilkie: 'And I now see how superior painting from nature is above every thing that our imagination, assisted by our memory, can conceive.'[97] The *Quarterly Review* praised 'the practical mode in which he treats and illustrates with a strong hand a favourite portion of his subject, the anatomical' and declared that it would 'make his treatise, in the case of the young student, a valuable appendage to Albinus'.[98] It was favourably reviewed also in the *Art Union*, with but a single reservation: 'it is far too much and too grievously tainted with the egotism which has been the besetting error of [the author's] prominent career'.[99]

In November, he stopped work for the time being on *Uriel*, put up another large canvas, twelve feet by nine and prepared to start work on what he pointedly called his 'original designs for the House of Lords'. The Royal Commission for Fine Arts having decided that:

> I, the originator of the whole scheme, shall have nothing whatever to do with it; so I will (trusting in the Great God who has brought me thus far, & through so many troubles) begin my own inventions without employment.

The subject of his first invention – illustrative of the 'Injustice of Democracy' – was the banishment of the Athenian politician Aristides in 482 BC. It was the custom that each citizen cast his vote by writing the name of the unpopular figure on a potsherd or *ostracus*, and the man with most *ostraca* counted against him was duly ostracised for ten years. According to Plutarch, on this occasion the upright and judicious outcast 'appealed to the gods as he left the city, and hoped the Athenians might never again require the advice of Aristides'.[100] Two years later he was recalled to help defend the state against Persian invasion. Haydon stared at his canvas one Sunday in December 'without thought or reflection'. Then, in a 'brilliant flash', came the idea of placing Aristides in the centre of the composition, like the figure of Christ in *Jerusalem*, but with 'the populace hooting him ... the gateways, the Acropolis, the Temple of Theseus, the expression of the Democrats, of ... Aristides' wife, of his child'. For five minutes he was 'lost to external objects & saw the whole, never clearer, never stronger, never finer'.

By the end of the month he had rubbed in the whole conception and 'Got in [the figure of] Aristides gloriously'. The Duke of Devonshire called and 'admired it much', as well as the *Uriel*. He also gave Haydon his last commission of the year: two painted panels to be set into shutters at Chatsworth.

'Napoleon Musing at St Helena, and the Duke at Waterloo,' suggested Haydon.

'Capital Idea,' said his Lordship and wrote out a cheque for half, £20 14s 11d. This went towards the outstanding portion of Frank's college bill.

During the forty years he had lived in London, Haydon had never known it so dark in the middle of the day. The interior of St Peter's in Vere Street was 'a living Rembrandt – the Clergyman with his four candles . . . lighted up in a glory, whilst the mighty shadow of the sounding board enveloped the Ceiling – the Windows were hardly visible, against the dingy Sky – & the Congregation so many sombre masses of dim obscurity'. Groping his way home, he could see, across Hyde Park, the sun blazing on the fog over Kensington 'as if Moscow was burning to the South!'

On the last day of the year he finished his 26th *Napoleon*, for one Chatsworth shutter and, by the second day of 1845, *Wellington* for the other. He hoped the Duke of Devonshire would be pleased; he had painted them 'with great gusto.'

*

January 1845 found teacher and former pupil in uneasy partnership as co-judges of a competition for an *Ascension* commissioned by the trustees of St James's Church, Bermondsey. 'Thank God that's over,' said Eastlake when they emerged, having chosen John Wood on the basis of a sketch 'beyond comparison the best'. But for Haydon, this was not the end of the matter. In the following months he was to take his duties very seriously and, feeling that 'the honour of the Country' was at stake, he wrote to his fellow judge proposing that they should 'advise the young man as he proceeds'. Eastlake replied that, as far as he was concerned, their duty was done. So Haydon visited Wood on his own to check progress and found the work 'shocking, conventional, common-place'. He wrote to the artist,

confessing himself 'not pleased', criticising 'Character, Colour, Drawing & arrangement', declaring 'the feet in the corner are a disgrace' and – if the 'gross defects' were not addressed – threatening to vote against his being paid.[101]

Over a year before, in the wake of his humiliation in the cartoon competition, Haydon had lectured on fresco and cartoons at the Richmond Literary and Scientific Institution. 'In referring to his own position and efforts to sustain high art, he became so excited as to be obliged to give vent to his feelings in a flood of tears, and the Lecture was brought to a sudden close, the audience kindly sympathising in his reverses.'[102] In March 1845 he lectured 'with great Eclat' upon the same subject at the Mechanics' Institution, his emotions under tighter control. It was at about this time that he adopted the practice of displaying the drawings for his forthcoming six great works, illustrating types of government, on the staircase outside the room in which he was speaking. When he announced to the audience, in the course of his lecture, that he intended painting his own designs for the Lords, 'there was a roar of approbation & applause'.

As the first quarter of the year came to an end, he reflected that he was 'not ill employed'. He had painted 'many portraits' and had minor commissions in hand, *Aristides* was rubbed in and *Uriel*, after nearly a year's work, finished. Dennys now began 'boring' him to send the picture to the Royal Academy Exhibition, but Haydon professed reluctance. 'I love my own silent, studious, midnight ways,' he protested, 'I hate the glare, the Vulgarity, & the herd.' But at last, and 'much against the grain', he moved *Uriel Revealing Himself to Satan* to the Academy's temporary home in Trafalgar Square. He felt sorry to see it leave his painting room. It had been 'a consolation to look at & . . . generated higher feelings and noble thoughts'.

A month later, the Great Room at the National Gallery was 'a mass of imbecility', and the prevailing attempts to reproduce the German School deplorable. 'Eastlake this year is hideous,' Haydon thought, 'a distillation' of the foreign influence 'through milk & water'. Prince Albert, he was sure, 'must be in ecstasies!' His own painting was hung outside the crowded Great Room and, for once, benefited from the isolation. The *Times* correspondent called it 'a most remarkable work' and one that 'must arrest even those who are hastening to depart from the Exhibition'. It was, he went on:

A striking contrast to the gaudy colouring on which the eye has been feasted, it appears with subdued tone, reminding one of a fresco. The figure of the angel is drawn with a boldness which some might call exaggerated, but with the simplicity and anatomical effect of sculpture, every muscle looking hard and unyielding as iron. The face is noble and ideal, and a fine effect is produced by the golden colour of the hair. This huge commanding figure is backed by limitless space, represented by a very dark positive blue, and the whole conveys the impression of a simple vastness. There is a certain crudity about the picture, but the impress of genius is unmistakable.[103]

Writing in *Fraser's Magazine*, under the guise of his pseudonym 'Michael Angelo Titmarsh', William Makepeace Thackeray was also arrested by Haydon's picture:

It roars out to you as it were with a Titanic voice . . . 'Come and look at me.' . . . There is something burly and bold in this resolute genius which will attack only enormous subjects, which will deal with nothing but the epic.

He recalled having recently met a stout gentleman, who once attempted to walk on water and 'sank amidst the jeers of all his beholders'. He suggested that, instead of laughing, the crowd 'should have respected the faith and simplicity which led him unhesitatingly to venture upon that watery experiment'. And he urged his readers not to laugh at Haydon either, but to 'give him credit for his great earnestness of purpose'. The satirist's restraint seemed, momentarily, to anticipate the day, only a year later, when the joke would sound hollow:

I begin to find the world growing more pathetic daily, and laugh less every year of my life. Why laugh at idle hopes, or vain purposes, or utter blundering self confidence? Let us be gentle with them henceforth.

Then, as if with a shake of the head, Titmarsh returned to form:

But I am wandering from Haydon and his big picture. Let us hope somebody will buy. Who, I cannot tell; it will not do for a chapel; it is

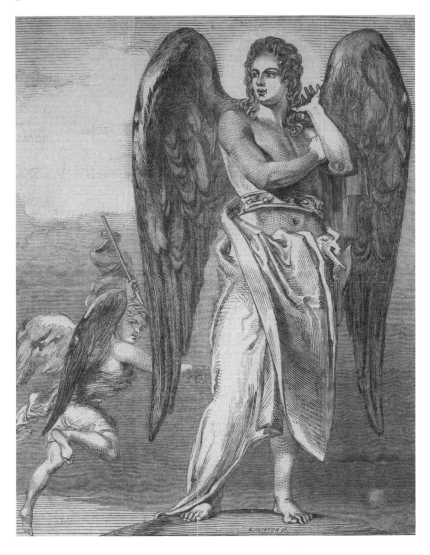

too big for a house: I have it – it might answer to hang up over a
caravan at a fair . . . This may be sheer impertinence and error, the
picture may suit some tastes, it does the *Times* for instance . . .; whereas
the *Post* . . . passes it by with scorn. What a comfort it is that there are
different tastes then, and that almost all artists have thus a chance of
getting a livelihood somehow![104]

Dennys paid Haydon the 200 guineas they had agreed on for the
picture. He declined, however, the offer of a companion to it, the

same subject viewed from a different angle, *Satan Resuming His Shape Watched by Uriel*. It was Dennys's intention to donate the *Uriel* to some Institution or other, but if he could not, he told the painter, 'I must keep it and that must suffice. I shall never commission another but I trust you will meet with an infinitely wealthier and worthier admirer of your Michelangelo genius.'[105] The present whereabouts of the picture is unknown.

Diversity of opinion notwithstanding, Haydon's contribution to the Academy's Exhibition had made an impression, and it may even have served to earn him support from some quarters of the membership. John Rogers Herbert called. 'The Younger Members of the Academy have great respect for you', he told Haydon. The paper, inviting candidates for Associateship to make themselves known, was, according to custom, up for the duration of the Exhibition. 'If you would only put your name down,' his visitor told him, 'you would be elected.' Herbert himself was only an Associate, and would not have a vote on the Council until elected to Full Membership the following year; nevertheless, he seemed convinced that he had tested the water and found it mild. Haydon, of course, refused. Four times he had put his name down, and four times he had been rejected. There was to be 'No more names down'.

<div style="text-align:center">★</div>

For seven years Haydon had been writing his memoirs, ever since the momentous and entirely unanticipated journal entry of 7 July 1839: 'Sunday. Read prayers & began my Life.' Writing intermittently, he had completed only the first chapter by June 1841 and even that was nearly lost to the world when his messenger dropped the package of manuscript in Portman Square on its way, 'as a specimen', to John Murray. Fortunately, some 'poor fellow' found it on the pavement and delivered it safely to the publisher. It was Murray's publication, in 1843, of Allan Cunningham's three-volume *Life of Sir David Wilkie*, and the inaccuracies he found in it, that spurred Haydon on to complete his own first volume of memoirs. 'What a lesson they will be to young men,' he reflected. Having received no encouragement from Murray, who thought he did himself 'injustice by writing so fast',[106] Haydon had passed sections of the manuscript to Elizabeth Barrett for her

frank opinion, telling her that she was to consider it 'sacredly confidential'.[107] Miss Barrett declared the autobiography 'delightful' and recommended that, 'with the suppression of an unmeasured word or two', he should take the public, also, into his confidence and 'throw wide the pleasure'. She observed that 'the spectacle of the life-agony . . . of a gifted mind [was] no less noble & exalting . . . than any shewn by canvas or fresco'. And she hastily added that she meant 'No irreverence to the brush in this!'[108] She was not the first, and would not be the last, to express the opinion, however guardedly, that Haydon was a better writer than he was a painter.

In May 1845 he was writing his eighteenth chapter, nearing completion of what he now called his 'Second Volume of Life & Correspondence'. Taking material from his journal for 1818, he saw himself, aged thirty-two, approaching the greatest triumph of his life. 'I gloried to see how I suffered, how I prayed, how I trusted, how I vanquished. It made me swell & bear up – in gratitude to God!' He had written 285 pages of his second volume. He intended ending it at page 300 with 'the Triumph of my Jerusalem'. The last paragraph of his autobiography was to read:

> I had returned from Scotland victorious, but still deeply in debt. Not all my success had cleared me, and now to crown the affair, I was deeply in love, longing to be married to a young widow with two infants; and Lazarus was a sketch only on the canvas. Two years must elapse before it could be done. Still at the canvas I flew, and made all my studies in gasping anxiety . . . I prayed ardently to get through it, never doubting.

<p style="text-align:center">*</p>

He painted Lysimachus, the son of Aristides, from a 'beautiful little boy model'. It took seven hours in the stifling June heat, his room in confusion, littered with brushes, stepladder draped in drying cloths, the stench of oil and paint, the child exhausted. His canvas was propped up on piles of folio volumes, but even so he had to paint the lower parts of it sitting on the floor. The model for Aristides's wife was Miss Lightfoot, 'a grand female character', who had once taught his daughter music. Having put the face in, however, he thought it 'too individual'

and decided to alter it. He worked at it all day and was on the point of scraping it off and starting again when friends called and said: 'That Mother is *exquisite!*' and he left it. Wilkie had always told him: 'never rub out on the evening of a day's labour'. By the end of the month he was satisfied with his central group of figures.

The third exhibition of cartoons at the Westminster Hall was unpromising. 'In drawing the Youth are not improved,' Haydon decided, '& in Fresco they are not advanced.' Maclise's efforts he thought 'dreadful'. His visit served only to reinforce his conviction: 'I think my six designs by far better than any at the Hall, & so will the public think when they see them.' Eastlake affected to know nothing of his work in progress. 'What six designs?' he asked, and yet Haydon was convinced he must have known. People in 'High Life' were beginning to talk of them, and the Secretary had definitely seen the six studies displayed on the staircase when he had attended one of Haydon's lectures. Nevertheless, Eastlake could no longer feign ignorance after paying a visit to Burwood Place in July and having the whole plan explained to him:

> The Consequences of Anarchy
> The Injustice of Democracy
> The Misery of Despotism
> The Horrors of Revolution
> The Equality of Law
> The Blessings of Limited Monarchy.

Eastlake seemed impressed, but questioned the imbalance between positive images of government and negative ones. 'I like your subjects,' he told Haydon, 'but as for the *horrors* . . . I do not know.'

One of the figures in the mob illustrating 'The Injustice of Democracy' was to be a crippled blind youth. 'Though unable to see, [he] is gratifying his detestation of . . . Aristides by a hiss at him as he passes by.'[109] Fred, home from his duty aboard the *Heroine* and awaiting his appointment to the *Grecian*, and despite 'looking Manly & Fine, such as Danger & the Sea make a Man look', was pressed into service as a model for the blind cripple. Haydon painted him with his eyes closed, but it did not look right, 'the ball of the Eye being perfect, he looked not *blind*, but *asleep*'. In order to get the necessary sunken

effect of a lid closed over a shrivelled eyeball, a visit to the Asylum in St George's Fields 'secured two thoroughly blind People' who had 'lost their eyes from violent Inflamation'. After a successful sitting, Haydon gave them both a good dinner and 'sent the poor fellows home contented'.

With *The Banishment of Aristides* nearing completion, Haydon was fortunate in witnessing a spectacle that provided valuable reference material for his next picture. Returning in the evening with his two sons from a day out in Greenwich – taking the air in the park and eating whitebait at the Old Ship Tavern – he watched as warehouse premises and stock valued at £50,000 was destroyed in a vast fire at 6 Aldermanbury, near the Guidhall. Within a quarter of an hour the entire building, one of the largest in the city of London, was a mass of flame from cellar to roof. *The Times* reported that thousands of people were attracted to the area, and the police had great difficulty keeping them 'at a sufficient distance to enable the engines, at least 20 in number, to work'.[110] Haydon watched and 'studied thoroughly' for his background to *The Misery of Despotism: The Burning of Rome by Nero*.

He had taken advice from Colonel William Martin Leake, author of the recently published *Topography of Athens*, concerning the details of the architectural background to *Aristides*, and consequently when he came to paint it in September he did so in eight and a half hours, covering and finishing the upper ten-foot width of canvas as if it had been a sketch. 'The more experience I get,' he observed, 'the more . . . disposed to treat everything as a whole.'

September proved to be a profitable month. First, he took a pupil – his last – and agreed to instruct David Nathan Fisher 'for the sum of two hundred and ten pounds', provided Fisher was 'willing and desirous to receive such instruction', provided he 'attend respectfully and diligently', and provided he 'follow the advice of . . . Benjamin Robert Haydon *only* . . . as regards the practice and principles of Historical Painting'.[111] The term of tuition agreed to was three years.

The next stroke of good fortune came from a more exalted quarter and might have convinced Fisher's mother of the potential prospects of historical painting and that the investment in her son's education had been a wise one. The 11th Earl of Westmorland, formerly Lord Burghersh, the British Government's resident minister in Berlin, had

been negotiating on Haydon's behalf with several of the crowned heads of Europe over the sale of a ten-foot-by-eight *Napoleon*, painted earlier the previous year in just five and half days. Czar Nicholas I of Russia had declined it, as had the Crown Prince of Prussia. But King Ernest Augustus of Hanover, although initially baulking at the price, agreed to buy it. Five days after David Fisher was contractually inducted into the mysteries of historical painting, his master received a cheque for £200, with a letter from Westmorland regretting that he could get no more for the picture, but saying that it would do Haydon 'great credit' nevertheless, placed in the Schloss Herrenhausen, 'at the end of a long Gallery & mak[ing] a most striking effect'.[112]

These windfalls relieved Haydon of financial pressure for a time, although he experienced almost as much anxiety in disposing of the money – deciding which debts to pay and which to let stand, what property to redeem and what to leave in pawn – as when he needed it. Inevitably, a month later, he needed it again: 'I have received & paid £400,' he wrote, '& so I could 400 more.'

<p style="text-align:center">*</p>

On Monday morning, 29 September, following customary prayers, he drew a horizontal line across his new canvas and marked the 'point of sight'. Then, at twenty minutes past ten, he applied his first touch of the brush. The following day, with *The Burning of Rome by Nero* rubbed in, and seeing, even in this rough preliminary state, the terrific final effect, Haydon 'fluttered & trembled & perspired, like a Woman, & was obliged to sit down'.

The following month was unproductive by comparison. He was vexed and distracted by Wood's *Ascension*, now finished and, to Haydon's mind, finished 'a great deal too soon' for a twenty-three-foot-high composition. He discussed the matter with his fellow judge and proposed advising the Bermondsey trustees to withhold the £500 until improvements were made. Eastlake, although admitting the work would be better if corrected, recommended that the payment be made regardless. Haydon wrote again to Wood and called on the painter, to discuss the matter further, but was turned away at the door by his servant. Returning home, he found a letter from Wood, which he sent back unopened with a covering note: 'After the gross message left with

your servant I cannot possibly hold any further intercourse with you.'[113] There the matter ended, although at church the following Sunday he prayed for Wood, 'that he might properly estimate my motives & be sensible of his own inefficiencies'.

He travelled, 'by Express train', to Plymouth to meet Theophila Gwatkin, eighty-nine-year-old niece of Sir Joshua Reynolds. He wished to consult papers in her possession for information relating to her uncle's month-long resignation from the Academy in early 1790. He was kindly received and got what he wanted, although to what use he proposed putting the information is not known. He visited Ide, intending to pay his respects to his mother's grave, but found that the old church of St Ida had been demolished and replaced, in 1834, by a new one and that Sarah Haydon's last resting place was no longer to be found. He wrote to the vicar and was back in London when he received a reply. The Reverend Earle was able to reassure him that her remains had been 'in no way whatever disturbed', and that they were 'now covered partly by the pews and partly by the boarded floor'. Only the commemorative stone had been moved a few feet, 'that it might still continue visible', into the entrance porch. 'You must actually have placed your foot . . . upon your mother's name,' he cheerfully informed Haydon, 'as you entered the church: If you had cast your eyes upon the ground you would not have failed to have seen it.'[114]

Haydon had not cast his eyes down and 165 years later there is nothing to see. The feet of the Ide faithful have completely worn away every trace of his mother's name from the porch floor.

For the last two weeks of October and much of the next month he was unable to lay a brush on his new canvas. He spent the time making fair copies for the second volume of *Lectures*, which Longman's intended bringing out early the following year. He prepared three new lectures – 'God knows what about', he admitted – to be delivered on successive Wednesday evenings, and also finished small commissions for people who had advanced him money, enabling him to finish *Aristides*. There was a domestic distraction also. Despite the precisely calculated expenditure of £860 10s his father had been put to for his education, Frank had taken only a 'Common degree' from Cambridge and decided that he did not wish to take holy orders. Haydon wrote to Sir Robert Peel, 'not without great pain' and 'anguish of mind',[115]

asking the Prime Minister to use his influence to secure Frank a situation. The previous Christmas, he had written to Peel asking for assistance to pay Frank's college fees and offering to paint a small *Wellington and Copenhagen* in return. On that occasion the offer had been respectfully declined. This time, however, Peel was able to place the young man as a clerk in the Public Record Office, with a salary of eighty pounds a year and 'the usual prospects of promotion'.[116] Frank Haydon would eventually rise to the position of Assistant Keeper.

It was not until towards the end of November that work could be resumed on *Nero*. Haydon had debated whether to place the figure of the Emperor playing his lyre in the foreground or the background of the composition, as the most effective means of conveying the idea of Despotism. Because he wished to show the miseries arising from despotic rule, there was good reason to place the despot himself in the rear and the consequences – a distressed family, fleeing from the conflagration – to the fore. On reflection, he decided to place Nero in front, with the flames of the Bradbury, Greatorex & Teale warehouse fire engulfing Rome as backdrop. He thought this arrangement 'the most impressive & the most applicable', especially as it formed a contrast with his other picture, in which the tyrannical mob was background to the unjust consequence of Democracy. The head of Nero was based on a study made at the British Museum in September and resembled a brass sestertius coin of AD 64–6. Haydon experimented with a turn of the head, but found 'the direct profile was better'. It served also to emphasise the shallowness of the forehead and the lowering of the parietal bones, which, as he had pointed out in his lecture 'On the Skeleton', could render a character 'atrocious or pious' by their depression or elevation, illustrating the point by 'remarkable and collateral evidence' in the profiles of Nero and Socrates.[117]

Colonel Leake called and thought that the fiery background looked too close to the figure of Nero, and so Haydon 'made it more distant by intervening more temples'. This improved the picture 'amazingly'. The year was ending and he felt he had done his duty. Apart from a week in Devonshire, he had hardly left his painting room. Working through Christmas, the figure of Nero done, the drudgery of architectural detail finished, his painting was 'in a glorious state'. On 30 December he heard that Colonel John Gurwood, private secretary to the Duke of Wellington, had cut his throat. Again Haydon pondered

the question of a man's responsibility for such an act, his mind being deranged by an infirmity of the body. First there was Romilly, then Castlereagh, now Gurwood. The same day, foreseeing 'the conclusion of Nero', he ordered the stretching of his third canvas.

The following evening he gave thanks for all he had accomplished in 1845, and prayed for 'a continuance of such mercies' in 1846. 'This year is closing rapidly,' he wrote, 'I almost hear the rush & roar of the mighty wave from eternity that will overwhelm it for ever.'

*

Early in January he was invited by Mathew Wyatt, the sculptor, to eat lunch in the rear end of Copenhagen before the colossal equestrian statue of the Duke of Wellington was assembled. The horse had been cast in two parts and was to be joined along the line of its girth. At the foundry, the back half stood on its edge – haunches and tail aloft, hind legs sticking out horizontally – and the luncheon party entered through an opening, into the gigantic bronze casting, which the saddle was to cover. They squeezed together – Wyatt himself, Haydon, Sir John Campbell, who had served under the Duke in the Peninsular War, other unidentified guests, including several women – and a great deal of fun was had by all. Wyatt's health was drunk, as were the horse's and rider's. 'It will be something to say,' Haydon remarked, 'some time hence, when the Statue is up, I dined in the Horse's Belly!'

A week later, to the dismay of his family, he was contemplating the exhibition of the first two paintings of his six. He believed this to be an opportunity, which might soon pass, of connecting himself with the greatest painting commission of the day 'by opposition', and of winning the approval of the public 'by contrast'. Barry visited and advised that he exhibit. The architect greatly admired *Aristides* and, standing in front of the canvas, asked: 'Why does not . . . Eastlake bring Prince Albert?' Haydon thought of asking 'Why don't *you*?' but did not.

Haydon was well aware of the financial risks entailed by speculative exhibition and, his family having expressed 'great anxiety' at the prospects of failure, he calculated the profit and loss from all ten of his private exhibitions since 1820. The net profit, comprising entrance

money and sale of catalogues, amounted to £1,632 1s 6d. But when the purchase prices of seven pictures was added to this sum – including subscriptions from the *Eucles* raffle, which had gone to his creditors – he was able to convince himself that he had made an overall net profit of £5,233 11s 6d.[118] His birthday was approaching. 'At 60, men are not so bold as at 25,' he reflected defiantly, 'but why not?' He reasoned that if Napoleon had behaved 'with the same spirit' in 1815 as he had when seizing power in 1799, then 'he would not have died at St Helena'.

On 12 January he took rooms for his exhibition, marking the decision with a journal entry in typically momentous style: 'so the die is cast!' The venue he secured had been the setting for his greatest success, the benchmark of his career: the sensational exhibition of *Christ's Triumphant Entry into Jerusalem*. The Egyptian Hall in Piccadilly was now to be the scene of his most devastating failure, a failure tuned to so exquisite a pitch of cruelty and humiliation as to make it, perversely, a thing of genius.

<div align="center">*</div>

The paintings now ready for exhibition were, in fact, the second and third in the series of six. He was uncertain which to begin next. *The Consequences of Anarchy*, being number one in the sequence, seemed the most logical. It was to show the incident, in 404 or 403 BC, during the reign of the Thirty Tyrants of Athens, when Theramenes was illegally seized and sentenced to death for advocating a widening of the franchise, by the reactionary zealot Critias.[119] 'Now for *Anarchy*,' Haydon wrote, when *Nero* was, 'except for Trifles', finished: '*three* cheers for Anarchy.' But friends favoured *The Horrors of Revolution*, fourth in the series, showing the last *charrette*, or tumbrel, arriving at the foot of the guillotine. Finally, however, he decided on the fifth, *The Equality of Law*, later to be called *The Blessings of Justice*, which was to show King Alfred instructing the first British jury. It would be a relief after the violence of Greece and Rome. 'I prefer *now* the quiet beauty of Alfred,' he wrote. 'My heart is fixed on fine English heads.'

With the help of his pupil, Fisher, he was laying a glaze of oil and raw umber on the dazzling white ground of his new canvas prior to sketching in the composition when Sir Robert Inglis called. Haydon

showed the Royal Commissioner *Aristides, Nero* and the designs for the other four. 'Now, Sir Robert,' he asked bluntly, 'what chance have I in the House of Lords?'

'Do you wish me to answer as Commissioner,' came the reply, 'or Gentleman to Gentleman?'

'Both,' said Haydon.

'Then you are *too late!*'

Some days later Haydon visited Barry. He told the architect of his conversation with Sir Robert. He told him also that, at Walmer in 1839, he had shown Wellington his designs for the Lords and the Duke had replied: 'You are *too early!*'

'Ah,' said Barry, 'you are always too early or too late.'

'Barry,' said Haydon, 'I asked an old Friend if you were a Courtier, & he replied, "Barry is a simple minded, honest, straight forward Man." Now answer me – have I any chance?'

The 'straight forward Man' was evasive: 'I know no more than a child,' he said. 'Eastlake is so complete a Diplomat – nothing escapes him. But I am never consulted; if they want to know about a pedestal, I am sent for, but any thing else . . . I have no influence whatever – they think me the Architect & nothing but.' The most he could give Haydon was a promise, however unlikely its fulfilment: 'If I ever have any power, with a space – I'll not forget you.' But he added darkly: 'there is a tide against you in that quarter'.

During the latter part of February, Haydon was in Edinburgh. He lectured on Fuseli and was 'heroically received by a Brilliant audience'. Two nights later, 'They listened as if entranced' to his lecture on Wilkie: 'not a breath, or a whisper, or a hum'. He lectured on fresco, on decorations and cartoons, on the Elgin Marbles. By mid-March he was home again and making his preparations.

A friend had given him £100 for his portrait drawings of the Anti-Slavery Convention and this gave him 'a Spring towards [his] exhibition'. The catalogues and invitation cards were printed, the carpenters hired and the rooms put in order. The two canvases were moved in, unrolled, stretched, framed and hung, the swags of drugget nailed round them. As March drew to an end, he was glazing his pictures and reflecting that '26 years ago', the very same week, he had been in the same place, engaged in the same activity, glazing *Jerusalem*.

His wife had gone to Brighton for her health, but his daughter

helped with the 400 invitations: her father writing the guest's name and signing, Mary sealing the envelopes. 'Noodle, Doodle, & their numerous Friends'[120] were to be admitted to the Private View on Saturday 4 April, from twelve noon until six. Taking the invitations to the post, Haydon dropped three-quarters of them on the pavement and wondered whether to take this for an omen. Some days before, the horse pulling his cab had stumbled. As the Saturday approached, the most trivial mishaps became significant. While he was hanging his drawings, one of *Wordsworth* fell and broke the frame on that of *Lord Althorp*. 'After this what success can come?'

On 4 April it rained the entire day and only a smattering of his guests attended the Private View. Haydon claimed there were only four. Lord and Lady Sutherland had conveyed their apologies. Lockhart was 'so colded' he was unable to be there, but promised Monday.[121] Sir John Herschal was not in town. Faraday hoped to come, but did not. Remembering the glittering assembly that had gathered to admire *Jerusalem*, this wet Saturday afternoon, with the chairs outnumbering his guests, was bleak indeed; '26 years ago,' he remarked, 'the rain would not have prevented them!' His daughter offered consolation: 'People are more disposed to seek after Curiosities than attend to Science and Art.'

The paying public was admitted on Monday, and the *Times* notice that morning was favourable, describing the drawing as 'grand', the characters 'most felicitous' and hoping 'the artist will reap the reward he merits'.[122] But the takings for that first day, from admission charges of a shilling and sale of the sixpenny catalogue, came to £1 1s 6d. The day *Jerusalem* opened in 1820, Haydon had taken £19 16s. On the second day it rained again and receipts amounted to £1 8s 6d. On Wednesday the weather was fine, the receipts worse: £1 6s 6d.

The Easter weekend was approaching and Haydon tried to draw in more business with an advertisement in the press, quoting from the *Times* notice and the *Morning Herald*'s comment that 'These are Haydon's best works.'[123] A conscious attempt to 'catch the profanum Vulgus', and hinting perhaps at more than the exhibition had to offer, he referred to hundreds of Christians being covered with combustible materials and burned 'for the amusement of the savage Romans'. He courted sensation-seekers, who might otherwise be drawn to the spectacular panoramas of Leicester Square and the Regent's Park Coliseum,

when he advised visitors to ascend to the gallery of the room 'to see the full effect of the flame of the burning city' in *Nero*. He appealed, finally, to decent, fair-minded John Bull: 'Haydon has devoted 42 years to improve the taste of the people, and let every Briton who has pluck in his bosom and a shilling in his pocket crowd to his works during the Easter week.'[124] But on Easter Monday only twenty-two people came, three of them bought catalogues and £1 3s 6d was taken. Everybody else, it seemed, with a shilling in his pocket, was patronising another attraction, in the very same building. Mary had been correct in her summation of the public's taste: 'more disposed to seek after Curiosities'.

Following the success of his first visit in 1844, General Tom Thumb opened at the Egyptian Hall a fortnight before Haydon's vain bid to capture the public's attention, and he would continue to draw daily crowds until 20 July, a full month after Haydon's death. During Easter week 12,000 people paid a shilling each to see the American, while Haydon attracted just 133½ visitors, the fraction accounted for by a little girl. When Charles Dickens was told of this, he expressed amazement: 'not that they were so few, but that they were so many'. He had seen the exhibition and described *Nero* as 'quite marvellous in its badness . . . difficult to look at . . . with a composed and decent face'.[125] Another writer, who passed on his way to the rival entertainment, remembered seeing Haydon outside the door of his exhibition: 'stout, broad-shouldered . . . rather shabbily dressed, with a general air of dilapidated power. There was something fierce and bitter in the expression of his face as he glanced across to the groups hurrying to see Tom Thumb.'[126] The noisy, good-natured holiday crowds who queued and shuffled past his empty rooms to see an American midget must have been readily transformed, by his imagination, into the jeering Athenian mob he had conceived as illustrating 'The Injustice of Democracy' – degraded popular taste hooting the noble Aristides from the city:

They rush by thousands to see Thumb. They push, they fight, they scream, they faint, they cry help & murder, & oh & ah. They see my bills, my boards . . . & don't read them . . . It is an insanity, a Rabies, a madness, a Furor, a dream.

For a man who had repeatedly prayed for his life to be spared until he had reformed the taste of his countrymen, it was the clearest evidence that his mission to enlighten the public, to make 'Grand Art sought for, wanted, & protected', had failed utterly. 'I would not have believed it of the English people!' He had but one bitter grain of comfort. It was not his fault. 'No man can accuse me of showing less energy, less spirit, less genius than I did 26 years ago. I have not decayed, but the people have been corrupted. I am the same, they are not, & I have suffered in consequence.' He realised he had been wrong to despise Bonaparte for accepting defeat in 1815 without attempting to repeat his 1799 seizure of power; wrong in thinking that he himself could triumph in 1846 as he had in 1820: 'You can't do anything twice in daring with the same effect on the World . . . The first time they are startled, delighted, astonished, & applaud. The second time they hardly look up.'

He closed his exhibition, rolled up *Aristides* and *Nero* and moved them out with all his drawings. 'Next to a Victory is a Skilful retreat,' he remarked, like Wellington withdrawing to Salamanca, and 'marched out before General Thumb, a beaten but not conquered exhibitor'. He could even make light of the failure, and placed a chipper announcement in the press suggesting that it was not a defeat, that his great work would continue undaunted:

> MR HAYDON, finding his pictures no match in attraction for that interesting little fellow Tom Thumb, has withdrawn Aristides and Nero from the Egyptian-hall till the whole six are completed. The Alfred is well advanced, and the Last Cartload at the Guillotine getting ready. Anarchy, and lastly Magna Charta [sic] will follow; and Mr Haydon hopes to have the series done (under the blessing of God) in two years . . .[127]

But this confidence was belied by the fearful exhortations that had begun appearing some weeks earlier, recurring, with minor variations, in nearly every journal entry over the following two months until the last: 'O God, bless me through the Evils of this day.' The nature of the 'Evils' pressing upon him Haydon did not specify, but a letter he sent to Sir Robert Peel in mid-June suggests that the sheer grinding torment of inescapable debt and implacable 'harass', borne for so

long, had become, in his sixty-first year, insupportable: 'I have suffered so much misery . . . that I really begin to fear my brain. I am on the very brink of ruin again, & unless I can get immediate help . . . must be in a Prison! . . . I begin to think I am a specimen of how far a human being can bear without insanity.'[128] And yet his immediate commitments, that month, amounted to no more than £135 14s 9d, divided between five different creditors, the largest claim being that of James Newman, colourman of Soho Square, who wanted just £31 17s 6d. A quarter's rent of thirty pounds was due to William Newton, to whom so much was owed already that each year he paid a forty-one-pound, premium on a policy insuring Haydon's life and, in the event of his tenant's death, expected to receive £1,000. Another £26 10s was owed to Coutts's bank, which had been understanding of its client's difficulties in the past and no doubt would have been so again. It was true that the sprawling establishment on the corner of Borough Road and Blackman Street – known, since the accession of Victoria, as the Queen's Bench Prison – still fulfilled its primary purpose, and would continue to do so until the 1869 Debtors Act abolished the incarceration of insolvents. But whether Haydon lay in actual danger of a fifth term of imprisonment was perhaps of less relevance than whether he imagined himself to be so.

During the five weeks that followed his retreat from the Egyptian Hall, Haydon appeared to carry on as usual. He socialised. He visited the Academy Exhibition. The failure of *Aristides* and *Nero* had left him £111 8s 10d further in debt, but twelve years previously *The Reform Banquet* had lost him more than twice that sum and, besides, the increase was negligible compared to the totality of a debt he could barely bring himself to quantify precisely, at 'nearly 3000'.[129] He continued to work on the great canvas of *Alfred and the First Trial by Jury*, hoping to advance it significantly by the end of June, declaring that he could do so if he had 'no pecuniary wants', and complaining that it was these which occupied his time. He borrowed to pay instalments on earlier debts, deferred when he could not borrow, went into the City, 'called & parried'. In short, nothing seemed to happen in those five weeks that had not happened before and that had not become a commonplace of life since his first arrest for debt on 22 June 1821, the twenty-fifth anniversary of which was – by chance or unconscious design – to be marked by his own death.

His wife wanted him to declare himself bankrupt, 'to stop payment & close the whole thing'. Haydon refused, determined to struggle on. He now clung grimly to the plan of his six paintings, inspired by 'audible whisper' in a Liverpool hotel room two years before, aware there was prospect neither of their sale nor of his gaining employment in the cherished decorative scheme of the Lords' Chamber, conscious that his work lacked the support, the approval, and even the passing interest of 'the people' by whom it was to have been judged. The futility of the labour must have been apparent to him: 'By the time the six are done they will be all mortgaged, but never mind,' he wrote on 5 June, 'so long as I get them done. The great thing is to get them done.' He added: 'Terrifically hot today.'

The month of June 1846 was the hottest on record, with average temperatures, during the first three weeks, of eighty-four degrees in the shade, 105 degrees in the sun.[130] London was an oven. Fearing rabies, an order was issued by the Metropolitan constabulary that 'All persons . . . take proper steps to keep their dogs chained up or muzzled.'[131] There were outbreaks of typhus. Thames boatmen died of sunstroke. Sewers festered and stank and a covered section of the grossly polluted Fleet River is said to have exploded. Paralysed by anxiety, prostrated by the heat, unable to sleep at night, Haydon sat for three hours one afternoon staring at his picture 'like an Idiot'. Earlier in the day he had experienced some of the old energy and pleasure when, taking the remnants of the family's silver to a pawnbroker in Golden Square, he noticed the proprietor's fine head of white hair and engaged him to sit for one of the figures in Alfred. When he was not painting or attempting to paint, he was 'harrassing about to no purpose in the heat'. One tantalising prospect of relief must have appeared like a shimmering mirage in this inferno. Frederic Haydon claimed that his father had expectations of a £1,000 loan from an old friend – identified only by the initial L – that they met for dinner at a hotel, and following their meal the friend explained he was not, after all, able to advance the money.[132] But John Bryant Lane, the only friend from his student days with whom Haydon dined at this time, was not a rich man and perhaps the expectations were misguided, the £1,000 illusory.

'I have not a friend in the world,' Haydon told his wife, 'I have worn them all out'[133] He had written to Brougham and Lord Beaufort

as well as Peel. A reply came from Peel. The Prime Minister was at this time fighting for his political life against the protectionist wing of his own Tory Party, following his highly contentious repeal of the Corn Laws: 'I am sorry to hear of your continued Embarrassments,' wrote the hard-pressed statesman. 'From a limited fund which is at my disposal, I send as a Contribution towards your Relief from these Embarrassments the Sum of Fifty Pounds.'[134]

Response came from neither Brougham nor Beaufort, but there was the prospect of another fifty pounds from Joshua Evans, a gentleman in Hampstead, who was willing to commission a painting of *Lord Byron Musing at Harrow*, and invited Haydon to dinner to discuss it on Sunday 21 June. That morning, the penultimate entry in his journal was an agonised scrawl: 'Slept horribly. Prayed in sorrow and got up in agitation.' He set out for his dinner engagement, his eldest son accompanying him across Regent's Park. As they walked, he 'complained much of the intense heat, and said, the night before, when lying awake, he had understood how it was people committed suicide'.[135]

The subject had exercised a morbid fascination over him for a long time. Twenty-four years earlier he had speculated that such a desperate act might be provoked as much by physical disorder as by mental anguish. His own anxiety on that occasion had been caused, he thought, by his having imprudently eaten almonds. 'My stomach got heated & affected my brain,' he proposed. 'Suppose in that humour I had shot myself?' The theory had been corroborated by the suicide of Lord Castlereagh. 'His brain filled with blood because his stomach was deranged . . . he ate heartily, encreased the turgid state of his brain, & unable to bear the horrid condition, cut his carotid artery.' And his last words, as reported to the inquest, denoted a return of sanity with the release of congested blood: 'Bankhead, let me fall upon your arm – 'tis over.'[136]

Even when suicide was an expression of rational choice, Haydon had views upon the 'horrid crime' that might have been more admissible in pagan Athens or Rome than for a devout Christian. He thought 'Cato . . . more a hero than Napoleon [for] putting an end to himself', and the suicide of a convicted forger in 1828 could claim his unstinting admiration because: 'There [was] something self-willed and grand about that defiance of an unknown HEREAFTER!'[137]

Nevertheless, he had told Peel the previous week, 'Nothing but the deep religious feeling of my nature keeps me from violence.'[138] But in the sweltering heat of that Sunday afternoon in Regent's Park, he explained to his son how he dwelt 'with pleasure on the idea of throwing himself off the Monument and dashing his head to pieces'. At 202 feet, the highest isolated stone column in the world, the Monument commemorating the Great Fire of London had, for many years, offered a convenient means of dispatch for the most desperate. But in 1842 the gallery at the top had been enclosed in an iron cage to prevent further distressing incidents. Despite the current impracticality of his father's fantasy, Frank was alarmed and begged him not to dwell on such thoughts, and 'after a time he grew more calm'. At the Avenue Road bridge over the Regent's Canal, as the two men parted, Haydon said: 'Tell your mother not to be anxious about me.' Mrs Haydon was not anxious. She told Frank that fears for his father were groundless and laughed at the idea of her husband committing suicide.

He did not dine with Joshua Evans and was home by five o'clock, explaining he was 'not in sufficiently good spirits to stay at Hampstead'. At dinner with his family he rose from his seat and turned a glazed picture to the wall, complaining that the reflected light was hurting his eyes. 'He looked flushed and haggard, and passed a silent and abstracted evening.'[139] He asked his wife to go to Brixton the following morning and fetch David Coulton, a journalist and friend of some eight years standing, with whom he had business to discuss. Only later would Mrs Haydon understand the reason for this request.

Instead of throwing himself, a latter-day Curtius, from the top of the Monument or from any other great height, Haydon left the house early the following morning and walked a little over a mile, along Edgware Road and down Oxford Street to number 315, the premises of Isaac Rivière, gun-maker. There he purchased a pistol 'of the smallest pocket size' with a barrel about two inches long.[140] There would be five pounds missing from the fifty pounds that Sir Robert Peel had sent him.

The walk, there and back, would have taken him somewhat less than forty minutes and he was home again by nine, locked in his painting room. He made his preparations. Opposite the unfinished canvas of *The Blessings of Justice: Alfred and the First Trial by Jury*, he

set up a smaller easel on which he placed an oil study for one of the peasants from that picture, a portrait of his wife.

He wrote a will, unwitnessed, invalid. The executors he named were Thomas Noon Talfourd, Dr Darling and the man his wife would be summoning from Brixton later that morning: David Trevena Coulton.

He wrote letters to Sir George Cockburn and to Talfourd. He wrote to Sir Robert Peel: 'Life is insupportable! Accept my gratitude for *always* feeling for me in adversity – I hope I have earned for my dearest Wife security from Want.' The 'f' and the 'e' in 'Wife' were heavily inked alterations. He had stopped himself writing 'Widow'. He asked Peel not to forget Frank in the Record Office. He added a postscript: 'I gave my word of honour to pay my taxes to the Treasury if they forebore – I must now withdraw it.' Then, bizarrely, he apologised to Lady Peel for any offence caused by his 'gaucherie' when first introduced to her.[141]

He wrote to his wife: 'God bless thee, dearest love. Pardon this last pang, many thou hast suffered from me; God bless thee in dear widowhood. I hope Sir Robert Peel will consider I have earned a pension for thee. A thousand kisses. Thy husband & love to the last.'

He wrote to Frederic: 'God bless thee . . . and render thee an honour to thy Country.'

He wrote to Frank: 'continue in virtue and honest dealing. God bless thee.'

And he wrote to his daughter: 'continue the dear good innocent girl thou hast ever been, and love thy dear mother for ever. Be pious, and trust in God.'[142]

In another letter, addressed to 'My sweetest Angel', he told his wife he had left her the balance of Sir Robert Peel's fifty pounds. He instructed her to give Mary and Frank ten pounds each, Fred five pounds and to keep the remaining twenty pounds for herself.[143]

About ten o'clock his wife paused on her way upstairs and tried the locked door. Haydon shouted fiercely: 'Who's there?' But a few minutes later he emerged and ran up to her bedroom, kissed her and apologised for his abruptness. He lingered for a short time as if wanting to say something, but said little apart from reiterating the request he had made the previous evening that she should fetch Coulton from Brixton. He returned to his painting room and, at half-past ten, wrote his Last Thoughts:

No man should use certain evil for probable good, however great the object. Evil is the prerogative of the deity.

I create good, I create, *I* the Lord do these things.

Wellington never used evil, if the good was not certain; Napoleon had no such scruples & I fear the Glitter of his Genius rather dazzled me – but had I been encouraged, nothing but good would have come from me; because when encouraged, I paid every body. God Forgive the evil for the sake of the good. Amen.[144]

This he laid on the table, with the bundle of letters, his pocket watch and the Book of Common Prayer pressed open at the portion of the service appropriate to the sixth Sunday after Epiphany, and dealing with the Second Coming and the appearance of false Christs and false prophets that will precede it. He turned to a fresh page of the journal he had begun thirty-eight years before. He had meditated then, walking the Dover cliffs, on Shakespeare and King Lear. He returned to the theme for the final entry, leaving it open on the table with the rest:

<div align="center">

God forgive me – Amen

Finis

of B.R. Haydon

'Stretch me no longer on this tough World' – Lear

End

</div>

Then he cocked the pistol and shot himself in the head.

Upstairs, his wife and daughter heard the bang at a quarter to eleven and, while momentarily startled, they were accustomed to occasional gunfire from the parade ground of a nearby barracks and ignored it.

The pistol bought that morning was of a small calibre and had not served to penetrate the brain. Bending forward slightly, Haydon had held the barrel against the top of his head – but at an oblique angle – when he pulled the trigger. Although fracturing his skull, the lead bullet, perfectly flattened by the impact, was deflected, ploughing between scalp and cranium, coming to rest against the parietal bone, three or four inches from the entry wound.

He must have considered making a second attempt, because he half-cocked the mechanism to reload and fire again. Instead, he dropped

the pistol and – traces of blood about the room charting his search for another fatal implement – picked up one of his razors. From a further trail of blood, he appears to have walked across to the door and, grasping the door knob for support with his right hand, inflicted a cut to his neck just below the ear. Realising that he had begun cutting too high, he lowered and altered the direction of the blade, dragging open a seven-inch-long gash to his throat from right to left. It was shallow at the point of origin, deepening, as though with resolution, as it advanced forward and down, finally becoming shallow again so that it exposed, but did not puncture, the windpipe. Leaving a pool of blood at the door, he walked back to his easel and, transferring the razor to his other hand, cut his throat again, this time from left to right.

He collapsed.

Haydon had often been heard moving heavy canvases around, sometimes allowing one to drop suddenly to the floor, and so, five minutes after his wife and daughter heard the gunshot, they paid little heed to the sound of a heavy fall in the room below. Both women left the house together shortly afterwards, Mrs Haydon on her errand to Brixton, her daughter accompanying her for part of the way.

Although neither razor-cut had succeeded in severing the carotid artery, sufficient damage, mercifully, had been done to the right jugular vein. With or without the valedictory lucidity granted to Lord Castlereagh as the pressure drained from him, Haydon died, face-down, in the dark, widening pool of blood. His head rested on his right arm, the fist so tightly clenched that the razor would have to be prised with difficulty from his stiffened fingers.

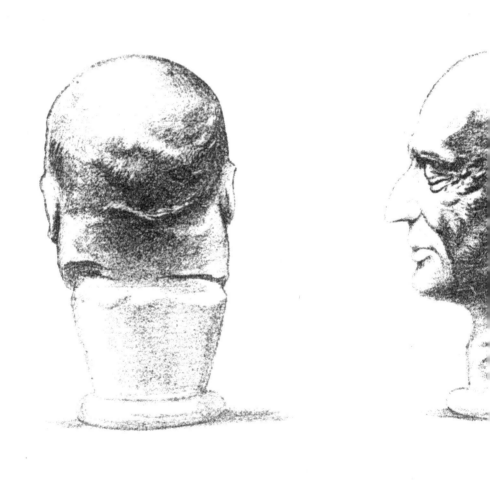

POST-MORTEM

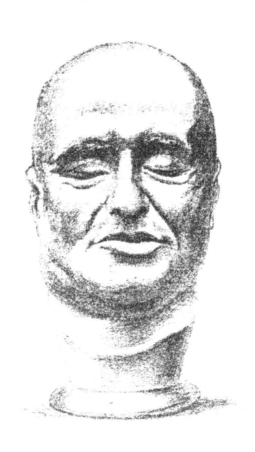

'The Coroner frequents more public houses than any man alive,' observed Charles Dickens. 'The smell of sawdust, beer, tobacco-smoke, and spirits, is inseparable in his vocation from death in its most awful shapes.'[1] So it was that Mr Wakley,[2] coroner for the western division of the country of Middlesex, arrived at the Norfolk Arms Tavern, Burwood Place, shortly after nine on the morning of Wednesday 24 June 1846. It was customary to hold an inquest as close to the scene of death as was convenient and as soon after the event as possible. Wakley immediately proceeded to the house, three doors away, 'where he made a careful examination of the body, and further acquainted himself with all such facts in connection with the melancholy affair as seemed to bear upon the enquiry he was about to commence'. The weather was hot, but the corpse had been left where it fell for two whole days so that it could be examined by all those officially concerned.

During the course of the proceedings Wakley would reveal, in passing, that he had been acquainted with the deceased some thirty years before and had found him 'very eccentric occasionally'.[3] More recently, in 1842, this same Thomas Wakley, MP, had spoken in the House of Commons against the Copyright Bill, and his ridicule of Wordsworth's poetry on that occasion had been noted with disapproval in the dead man's journal. In view of the forensic circumstances of what would be their final encounter, that morning, Benjamin Robert Haydon's scornful evaluation of the Honourable Member for Finsbury four years previously seemed prescient: 'a Coroner, who sees Human Nature only through the medium of Cut throats, stomach pumps, & Arsenic.'[4]

By the time Wakley got back to the Norfolk Arms, the jury of

fifteen had assembled and, the usual oath having been administered, its members were instructed to go, in company with the returning officer, to 'view the remains of the deceased'. The 'dreadful sight' confronting the little delegation was described in all the press reports:

> Stretched on the floor immediately in front of a colossal picture lay the lifeless corpse of an aged man, his white hairs saturated with blood, in a pool of which the whole upper portion of the body was lying . . . The unhappy man appeared to have fallen in the exact position in which he was seen by the jury. He was dressed with great neatness, in the ordinary attire which he wore while engaged in painting. His throat had a frightful wound extending to nearly seven inches in length, and there was also a perforated bullet wound in the upper part of the skull over the parietal bone.

The jurymen, having made their examination, descended to the street again, 'apparently much affected'. On their return to the Norfolk Arms Tavern the inquest began.

The first witness called by Mr Wakley was the daughter of the deceased, Miss Mary Mordwinoff Haydon. She had found the body of her father at about a quarter past twelve on her return to the house from a short walk. She had entered the room, seen the body, and the blood, felt the head and found it cold. Her brother, Frederic, never dared ask her more about it, but a few weeks before her own death she gave him a more graphic account of the moment, of the shadowy room, of the silence broken only by the preternaturally loud ticking of her father's watch on the table, of the huddled form on the floor:

> She stepped close to him, her foot slipped as she stooped quickly and touched his head, which was cold as ice. She looked, and his ruddy cheek was white and waxen . . . a fixed and glassy light was in the eye, and he lay there without motion, pulse, or breath. In a pool of what she first thought red paint spilled upon the floor around her, she saw a razor, and close to it a pistol. Then the awful truth flashed upon her mind. He had destroyed himself, and she was standing in his blood.[5]

Mary Hackett, the cook, rushed upstairs when she heard the scream. Questioned by the coroner, she would testify that she had only been

with the family for a fortnight, but had formed a general impression of her employer that he was 'rather odd in his way'. She had heard him walking about his bedroom at an early hour that Monday morning.

Mary Haydon had run to fetch a surgeon, Mr Walter Bryant, who practised nearby, but he was not at home. Another medical man was sent for and, without waiting for his arrival, Mary took a cab to Brixton in an effort to intercept her mother and break the news to her. But the two women must have passed one another in their respective cabs because Mrs Haydon arrived back at Burwood Place, in the company of David Coulton, entirely unprepared for what awaited her. Coulton took charge and it had probably been Haydon's intention the night before, in sending his wife to fetch him, that he should do so. Coulton delivered the letters to Cockburn, Talfourd and Sir Robert Peel. Peel would reply within two hours and, fearing the family 'might be in need of some immediate assistance, . . . thought it right to enclose a cheque for £200 from the Royal Bounty Fund, as a temporary relief'.[6]

Following the cook's testimony, Orlando Bridgeman Hyman was called. He described himself as 'a clergyman'. He had last seen the deceased the Saturday before his death and 'observed a very great change in his countenance'. Hyman was asked by the coroner to select relevant passages in the last volume of Haydon's journal, which, without disclosing family secrets in any way, might provide clues as to his stepfather's state of mind at the time of his death, and the clergyman retired do so. Meanwhile Elizabeth Western, the housemaid, was called and, her testimony disclosing nothing new, dismissed.

Hyman returned to the stand and began reading the journal extracts he had selected, beginning with entries for March recounting the ominous stumbling of Haydon's cab horse and the dropping of his Private View invitations. Entries for April documented the failure of his exhibition and the triumph of Tom Thumb.

The reading was interrupted by testimony from an unnamed medical man, one of those who had examined the deceased's body. The jury was given the opportunity to inspect the small pistol and the lead bullet, perfectly flattened from its impact with bone, that had been dug out from under the scalp. This witness may have been Dr Elliotson, who would later describe the precise nature of the non-fatal damage done to the skull by Isaac Rivière's tiny firearm: 'a fine circular fracture of the external layer of the bone, with a little groove near it,

from the bone being chipped, containing lead to about one-third of its length: and below this a much larger fracture of the inner layer of the bone, and the latter fractured portion . . . driven down upon the brain and ragged, having wounded an artery and thus given rise to a clot of blood'.[7] He informed the jury he was 'decidedly of opinion that death had resulted from haemorrhage, arising from the wounds in the throat, which [he] felt confident must have been inflicted by the deceased himself.'[8]

Hyman was then allowed to resume his readings from the last pages of the journal. These included the entry for 16 June and the letter received that day from Sir Robert Peel enclosing fifty pounds.

During the course of his concluding remarks to the jury, Mr Wakley made reference to the Tory leader's 'munificent act'. He declared that 'it must speak to the heart of a great many thousand persons, that . . . amidst a pressure of public business almost unparalleled, [the Prime Minister] had not forgotten the suffering of others'. A *Times* editorial of the following morning had no need to remind its readers of the recent battles within the Tory Party: Peel's hard-won abolition of trade restrictions to bring famine relief to Ireland in the teeth of coruscating opposition from the political opportunist Disraeli, and the gratuitously spiteful defeat of an Irish Coercion Bill by disaffected Tories, with the deliberate intention of bringing their hated leader down. In the wake of these contentious issues the reading of Peel's letter, to the coroner's jury and to the reporters assembled in the Norfolk Arms, ensured that his reputation received a rousing and unequivocal fillip in the press:

> From the midst of criminations and controversies . . . in the hour of peril, and in the day of defeat, SIR ROBERT PEEL found time for an act of charity. And if this should be among the last acts of his official life, it will be more to his comfort in his chamber, that he cheered the last moments of a dying artist with the means of leaving a little legacy to his desolate family, than if he had carried all his measures over the heads of an exasperated House, and crushed his combined foes with the sweep of a conqueror into a helpless and humiliated mass.

The editorial described Haydon's suicide as: 'one of those terrible catastrophes which occasionally burst upon the nation, and startle the most giddy and unheeding by a transient but fearful glimpse of the

miseries that are doing their deadly work below the smooth surface of our social state'. Haydon was characterised as 'A gentleman of high talent, untiring industry, exemplary temperance, and fervent piety'. The readership was left in no doubt as to where the blame for the tragedy lay. It was clear that Haydon had been driven to his desperate end by the fickle public:

> The patronage which would have ransomed his pencil and restored his peace was lavished on a rival exhibition of the most puerile and offensive character. The display of a disgusting dwarf attracted hordes of gaping idiots, who poured into the yawning pockets of a Yankee showman a stream of wealth one tithe of which would have redeemed an honourable English artist from wretchedness and death.

Haydon's end and the Thunderer's indignation had no discernible effect on General Tom Thumb's visitor numbers.

In the Norfolk Arms Tavern, the jury, having deliberated, reached their verdict: 'We find that the deceased . . . died from the effect of wounds inflicted by himself, and that the said Benjamin Robert Haydon was in an unsound state of mind when he committed the act.'

<p style="text-align:center">*</p>

Peel had told Coulton that he would 'be quite ready to contribute personally to any subscription raised for Mr Haydon's wife and daughter'.[9] True to his word, he subsequently gave £100 'from his private purse'. Julia Peel, touched by the knowledge that the painter's last letter to her husband had contained 'kind expressions towards [her]self', assigned Mrs Haydon an annual pension of £25 from a fund at her disposal entitling her 'to grant allowances for life to Ladies'.[10] The widow was also awarded a Civil List pension of fifty pounds per annum by Queen Victoria. After the first meeting, on 30 June, of a committee set up 'to devise measures for providing for the widow and daughter',[11] Talfourd could report to Orlando Hyman that a little over £280 had been raised. The Duke of Sutherland had provided the bulk of this sum with a cheque for £200 and among the lesser contributors was Charles Dickens, donating five guineas. Within a couple of months the fund had increased to nearly £1,700.

On 6 July the Royal Academy Council sat, Turner presiding in the absence of the President, Martin Archer Shee. It was moved by William Etty, and seconded by Edward Hodges Baily, 'that £50 be subsidised in aid of the Fund raising for the benefit of the family of the late Mr B.R. Haydon'.[12] The motion was passed. As chairman, Turner would not have voted except in the event of a tie. He had his own views regarding the deserts of a man who had so savagely attacked his alma mater, the Royal Academy, for more than three decades. When the first reports of Haydon's death appeared in the press, Daniel Maclise was at the Athenaeum in Pall Mall. He looked across the room and saw the old Academician, ran over to him and blurted out:

'I have just heard of Haydon's suicide. Is it not awful?'

Without looking up from his paper, Turner asked quietly: 'Why did he stab his mother?'

'Great heaven!' said Maclise, thinking there might be more to the tragic circumstances than he had at first thought, 'You don't mean—'

'Yes,' replied Turner implacably, and without further explanation. 'He stabbed his mother.'[13]

<p style="text-align:center">*</p>

Haydon had written his own epitaph twenty years before it would be needed. He had revised it on the last day of 1841:

> Here lies the body of B.R. Haydon, Historical painter . . . He passed his life in a desperate struggle to make People, Legislature, & Sovereign give efficient support to the highest branch of Art, by public encouragement, which they had neglected to do since the establishment of the Protestant Religion. He was a good Father, & a faithful & tender Husband, and lived an indisputable evidence, if any was wanting, that no affliction is considered an adequate punishment for having told Truth to Power. He died as he had always lived, an ardent & sincere believer in Jesus Christ, his only mediator & Redeemer.

He had wished it to end with a modified couplet from Samuel Johnson:

What various ills the Painter's life assail,
Pride, Envy, Want, the Patron, & the Gaol.[14]

When he was buried in Paddington churchyard among his five children, a shorter inscription was carved into the horizontal slab covering the grave:

HE DEVOTED FORTY TWO YEARS

TO THE IMPROVEMENT OF THE TASTE

OF THE ENGLISH PEOPLE

IN HIGH ART

AND DIED BROKEN HEARTED

FROM PECUNIARY DISTRESS

Since then the weather has entirely effaced from the sandstone even this abbreviated memorial.

*

Haydon's will[15] had stipulated that Mr Longman was to be consulted with a view to publishing his memoirs. Elizabeth Barrett had safe-keeping of the manuscript of his autobiography, complete to 1820, and an account of the rest of his life's struggles and triumphs was to be compiled from correspondence and journals, also at 50 Wimpole Street, 'in a Chest'. Haydon may have had Miss Barrett in mind for the task of editing the material, but did not say so. He wished, however, that his style – which had, he thought, 'the individuality of Richardson' – should 'not be curtailed by an Editor'. Seven years after the coroner's jury arrived at their verdict on the late artist's mental state, Tom Taylor's three-volume *Life of Benjamin Robert Haydon, Historical Painter from His Autobiography and Journals* was published in 1853, and provided the reading public with an opportunity to make their own assessment.[16]

The following year an article appeared that purported to analyse the late painter's character and psychological condition along more scientific lines. *The Zoist: A Journal of Cerebral Physiology and Mesmerism, and their Applications to Human Welfare* published 'an account of the

living and dead brain of the late Mr Benjamin Robert Haydon, historical painter'. It featured a lithograph of the front, lateral and rear views of a plaster cast of the dead man's head. The article was credited to James Straton, the eminent Aberdeen phrenologist, 'and some other gentlemen', but it was one of the latter – Dr John Elliotson – who had initiated it. He had been called in by Walter Bryant to examine the body as it lay in the painting room, late on the day of the suicide. He had also assisted Bryant in the post-mortem operation, during which 'innumerable bloody dots throughout the substance of the brain' were noticed, evidence of 'both chronic and recent vascular excitement'.[17] And it had been Elliotson who had commissioned Signor Casci, a plasterman of Drury Lane, to produce the mould. 'When I took the cast,' Elliotson wrote, 'I longed to lay it before the public, but refrained from delicacy to the deceased and to his family for whom I deeply felt.' Such laudable scruples, however, were swept aside in light of the 'full exposure of the poor man' resulting from Tom Taylor's recent, exemplary publication. 'Now that his character is laid open to the world,' Elliotson went on, 'and I can mention nothing which is not already universally known, and give no opinion which is not already in print, I do not hesitate to discuss his development for the sake of phrenology.'[18] The analysis was cruel nevertheless. The front view of the plaster cast showed 'the great size of the lateral organs – of violence (Destructiveness), cunning (Secretiveness), love of property (Acquisitiveness)'. It also showed 'the deficiency of the central organs . . . of talent for observation and comparison'. The lateral view showed 'the enormous love of Notoriety (vanity)', while the back view exhibited 'the great breadth above the ears and the great size of Combativeness'.[19] Earlier in the article Mr Straton had, on the basis of Haydon's cranial bumps alone, concluded that 'In many departments of science and literature, art or eloquence, he was capable of rising far, very far beyond mediocrity: but in none was he capable of attaining the highest excellence.'[20] But the most gratuitously vicious swipe occurred in Elliotson's description of Haydon's self-inflicted wounds and his failure to sever the carotid artery: 'his study of anatomy availing him no more than it had done in his drawing'.[21]

Dr Elliotson believed Haydon to have been 'unquestionably of unsound mind', but added that he was not insane in the legal sense of the term: 'Thousands who roam at large belong to his class, inflicting

hourly misery upon their innocent wives and children.' He appeared
to lament the fact that, 'should their conduct lead to no acts crimi-
nally injurious to themselves or others, we cannot restrain them'.[22]

<p style="text-align:center">★</p>

Six years after William Newton lost his tenant, he sold his own collec-
tion of Haydon's work at auction. Thirty-seven lots went under the
hammer at Messrs Foster & Son, Pall Mall, on 18 March 1852. Eleven
of these comprised 'Sketch Books, Studies, and finished Pictures';
another thirteen, 'Sketches in Oils'; and a further eleven, 'Finished
Pictures', ranging in scale from a *Napoleon at St Helena* to *The Judgement
of Solomon*. It is not clear when the latter 'grand gallery picture, one
of the finest works of the master',[23] became Newton's to sell. Haydon
had described it in his will as being 'the property of the Assignees of
the late Mr Prideaux of Plymouth, Bankrupt', but the landlord's
payment for twenty-two years' storage in Dean Street may finally have
given him right of ownership. The picture sold for fifty-seven guineas.
It would become the property, in turn, of Haydon's former pupil, Sir
Edwin Landseer, Lady Ashburton and a Mr Jenkins, who bought it at
auction in 1911 for thirty shillings. It subsequently disappeared for many
years, until its rediscovery in 1960. Today the picture hangs – on long-
term loan from a private collector – in Plymouth as its original owners,
Elford and Tingcombe, once intended it should. The Charter Room
is in a part of the Guild Hall rebuilt after the Second World War. It
contains stained glass windows celebrating the 500th anniversary of
the Incorporation of the Borough of Plymouth, and a bronze plaque
honouring the mayors who had presided over that distinction in 1439;
over Plymouth's creation as a County Borough in 1889; and over its
elevation 'to the Title and Dignity of a City', in 1928. In this stark,
white walled, mid-20th century chamber, *The Judgement of Solomon*
looms, gigantic, over the deliberations of seminar groups and
committee meetings, unidentified, unremarked, uncelebrated.

*Edward the Black Prince Thanking Lord James Audley for his Gallantry at
Poitiers* sold for £26 5s and also found its way, eventually, to Haydon's
home town. It can be found in the basement of the Plymouth City Art
Gallery and Museum, hung on its end from a steel storage rack. Stored
next to it is another large Haydon canvas also on its end: *The Maid of*

Saragossa formerly the property of James Webb, the butter-man.

The despised *Christ's Agony in the Garden*, returned, unwanted, to the painter by Sir George Philips and accepted by Newton in lieu of rent, was knocked down for five guineas. Today it hangs in the Victoria and Albert Museum – on a back staircase not accessible to the general public.

One of the eleven 'Finished Paintings' in the 1852 sale was the canvas described in Mr Nutter's sale catalogue, six years previously, as being in 'an extremely forward state'. How *Alfred and the First Trial by Jury* came into Newton's possession is a mystery. According to the press reports of the 1846 auction, it was understood that Sir Robert Peel had lodged the successful bid before the proceedings began, and that – despite a warning to Mr Nutter from the floor that he was not to sell 'the large picture' – it was indeed sold at that price. Perhaps the anonymous interjection had come from Newton, but if this were so, he made no note of the claim on his copy of the sale catalogue, merely marking alongside the lot the sum of £200. It can only be assumed that Peel bought the picture as a charitable gesture and disposed of it later with no eye to profit.

<center>★</center>

Haydon's widow survived her husband by eight years and died, aged sixty-one, on 25 July 1858, 'worn prematurely to death', according to her youngest son Frederic, 'by the sorrows and anxieties of her life'.[24] Frank Haydon left an account of her condition following the stroke that had paralysed her left side and 'ultimately terminated her life'. He recalled that 'her speech . . . was always slower after . . . the attack, & her mind, . . . acting not so rapidly as before, there was a quite noticeable pause between a question from another person & the reply to it from her'. He remembered her saying to him: 'I am like an animal – I have no pretty poetical thoughts now when I come to a bit of land-scape or an old building. I am like a log.'[25]

Mary, the painter's only surviving daughter, had expressed a desire to become a governess and 'educate a genteel child from 4 to 10 – in English, French, Italian & Music'.[26] Six years after Haydon's death, Mary Russell Mitford wrote of her to a friend: 'If you know of any one who wants a thoroughly good and charming young woman as companion, I can thoroughly recommend poor Miss Haydon. She is now teaching as a daily governess at eight shillings a week! She is very

accomplished and intelligent, and has learned truth and goodness from her many trials.'[27] She became a nurse in the service of a Lady Higgins, and died, unmarried, aged thirty-five, at Boulogne-sur-Mer, less than a year after her mother, on 25 February 1859.

<center>★</center>

Haydon's concern had been well founded when, in March 1820, he prayed that *Christ's Entry into Jerusalem* might be protected 'from fire, accident & misfortune'. He had reiterated his concern in September 1831, trusting in God that it would 'be preserved from fire & ruin', when it was shipped to the United States to form the nucleus of the American Gallery of Painting in Philadelphia. It was eventually moved to the Academy of Fine Art in that city. During a devastating conflagration in June 1845 volunteer firemen cut the picture from its frame and dragged it, like an old blanket, from the burning building, along with Benjamin West's *Death on a Pale Horse*. Restored, it is now mounted into the wall of the chapel foyer at Mount St Mary's Seminary of the Athenaeum of Ohio, in a remote suburb of Cincinnati.

After Haydon's death, Richard Twentyman took possession of *The Burning of Rome by Nero* and *The Banishment of Aristides*, at the painter's own valuation of £420 and £840 respectively, in part payment of debts, and emigrated to Australia with them. For many years they hung at the top of the stairs in the Melbourne Aquarium. During World War II the building was commandeered by the Royal Australian Air Force, and *Aristides* received considerable abuse from trainee pilots. Like *Jerusalem*, the paintings escaped fire when the Aquarium was destroyed on New Year's Day 1953. In the late 1960s both pictures were reported to be safely stored, *Aristides* 'in bad condition'.[28]

Curtius Leaping into the Gulf became the main attraction of a gallery attached to the Canterbury Music Hall, Lambeth. Afterwards it was a fixture at Gatti's Restaurant, on Villiers Street, where its astonishing proportions and distortions left an enduring impression on generations of patrons – among them the young Eric George, Haydon's earliest twentieth-century biographer – first in the dining room and then occupying 'a prominent position in the billiard saloon'.[29] In 1933, rescued from these indignities, it was sold to the Royal Albert Memorial Museum in Exeter.

Both of Haydon's Liverpool pictures endured years of vicissitude and neglect. *The Hero and His Horse* gathered dust in a Corporation coach-house store because it was too big 'to hang anywhere in the city's public buildings without upsetting the balance of the other decorations'. In 1958, Hugh Scrutton, director of the Walker Art Gallery, thought that the best solution was to cut the canvas down by one-third to just the Duke and his horse. 'It is not really a masterpiece,' he declared, 'but it has considerable historic interest.'[30] In 1969 it became part of the Walker's collection and survives, unmutilated but undisplayed.

In the late 1840s the railway cutting into Lime Street Station was widened. The chapel of the Liverpool Blind Asylum was taken down, stone by stone, and re-erected on a new site a mile away. *Christ Blessing Little Children* was reinstated at the side of its altar. The building was more comprehensively demolished eighty years later and the picture given to Upholland College, a Roman Catholic seminary, where its condition deteriorated due to water damage and the warping of its stretcher timbers. Purchased by the Walker Art Gallery in 1986, it has been magnificently restored and occupies an imposing space on the main staircase.

<center>*</center>

Frederic Wordsworth Haydon was far more sympathetic to their father than was his elder brother Frank, and became Haydon's apologist, compiling and editing the two volumes of *Correspondence and Table Talk*, published by Chatto & Windus in 1876 and including a long, angry account of the painter's life and trials. He had given up the sea, become a Home Office factory inspector and married Sir Peter Fairbairn's youngest daughter Robina in 1868. Robina bore him a son and a daughter, and died after only four years of marriage. Over the following years Frederic became delusional and increasingly estranged from his wife's family, alleging persecution and complicated conspiracies, and claiming that detectives were following him around London and that a local butcher had threatened his life. He was dismissed from his job for making accusations of departmental corruption and publishing an open letter to Gladstone entitled 'Our Officials at the Home Office'.[31]

His father had derived considerable comfort from the knowledge that none of his children had inherited his love of art. 'I pray God,' his journal recorded in 1842, 'that he will, in his mercy, inflict them with every other passion, appetite, misery, wretchedness, disease, insanity, or gabbling Idiotism, rather than a longing for Painting.'

In July 1884 Frederic was arrested by police, brought before magistrates as 'a wandering lunatic' and confined in the Kent County Asylum at Chartham Down. In December of the same year he arrived in 'Bedlam' – the Bethlem Royal Hospital in St George's Street – where he was diagnosed as suffering the early symptoms of general paralysis, an incurable, psychotic disorder caused by the syphilis he had contracted twenty years before. He degenerated, over the following two years, to a state described in his medical notes as 'almost a typical case of G.P. Tremor of lips and tongue very marked – speech indistinct & tremulous – Expression vacant or "surprised". Occasionally laughs without cause . . . very weak & always wet & dirty.' The notice of death on 12 November 1886, sent to the coroner, was filled in by hand except for the cause – GENERAL PARALYSIS OF THE INSANE – punched out on a typewriter. 'The cause of his death was natural in every way,' the report concluded.[32]

<p style="text-align:center">★</p>

'If God in his mercy spare that Picture,' Haydon wrote in 1824, of *The Raising of Lazarus*, 'my posthumous reputation is assured. O God, grant it may reach the National Gallery in a few years, and be placed in fair competition with Sebastiano del Piombo. I ask no more to obtain justice from the World.'

The giant work that had once graced Mr Binns's upholstery-shop window entered the collection of a Mr Lofft, who in 1868 presented it to the National Gallery. It remained in storage until the 1890s, when the canvas was relined and the picture put on display, although whether close enough to Sebastiano's version to sustain the comparison and competition Haydon hoped for is not known. During the 1930s a monochrome photograph was taken of it and, some time later, it was removed from its stretcher, rolled up and taken to the Tate Gallery on Millbank, where it was again put into storage.

On the morning of 29 November 2007 the fourteen-foot roll of canvas on its wooden roller lay at the edge of an area of taped-down plastic sheeting in storeroom P, the largest space available at the Tate's warehouse facility in south London. Layers of coarse brown-paper wrapping, and the thick tarred paper that had given it protection from water damage, were cut away and the yellow, varnished face of Lazarus was revealed for the first time in more than seventy years. The heavy roll was supported at each extremity by a padded cradle on castors. A line of five handling team members, wearing standard-issue blue latex gloves, held the edge of the canvas, its painted surface down, as the roll was lifted slightly from its cradles by a strong man at each end, rotated, lowered and wheeled a foot or two over the protective sheeting. It was lifted again, rotated, lowered and wheeled. The faces of Lazarus's father and then his mother came into view, curved, on the outer surface of the roll. The two men then lifted the roll from its cradles, lowered it to the floor and five more blue-handed people, shuffling backwards, slowly unrolled the canvas, still with its painted surface down, revealing, as the cylindrical form turned, first the face of Lazarus's sister Mary and the grave-opener's hand, then the red-robed figure of Christ himself. Each face and figure appeared momentarily before disappearing down against the plastic-covered floor as the picture unrolled further. The faces of the Pharisee and Saducee; the figure of Martha; the faces of St John and St Peter; the awestruck onlookers – they came and went until all that could be seen was the back of a fourteen-by-twenty-foot canvas marked by the grimy outlines of stretcher timbers that had supported it during its time at the National Gallery. It was left for an hour or so to 'settle' and adjust to the change in temperature, while the handling team, photographers and observers went for lunch.

That afternoon the activity of the morning was repeated, but in reverse. The edge of the canvas was stapled to the wooden roller and the picture re-rolled, as before, painted surface outwards, until again the staring face of Lazarus appeared at the end. Then, supported on cradles raised by wooden boxes to a height of about four feet, the edge of the canvas was flipped, over and under, so that it could be unrolled with its painted surface upwards. The same two men now lifted and rotated the roll at waist height as the line of blue-gloved handlers pulled the ninety-three square yards of thickly painted canvas back across the plastic sheeting until at last it lay, visible in its entirety, for the first time.

It was in far better condition than anyone had anticipated. It was also a far better painting than anyone had expected. The Tate's Director, Sir Nicholas Serota, came to see it the following day, spent some time pacing around it, studying it closely and speaking into his mobile phone. Later he sent an e-mail to colleagues, declaring himself 'very much in favour of action' regarding its restoration and display. 'It may not be the greatest work of art produced in the nineteenth century,' he concluded, 'but ambitious, fascinating as a link between Barry and Leighton and as an episode in the emergence of the artist as self-promoter and impresario . . . as well as a piece of high personal drama for Haydon.'[33]

It is hoped that money will soon be found to have the picture cleaned, repaired, stretched and framed, and that wall space will be found to hang it. *The Raising of Lazarus* might then obtain for its creator 'justice from the World'.

<div align="center">★</div>

Haydon's eldest son Frank rose in the Civil Service to the rank of Assistant Keeper at the Public Records Office, with special responsibility for patents. He married in 1858, but lost his wife within three years. She left him a daughter, two other children having been stillborn.

Ellen Mary Haydon noticed a change in her father's behaviour after November 1886, following the death of his brother. Frank had become increasingly emotional and violent in his behaviour. In August 1887 he suffered an attack of apoplexy and from that time on 'laboured under the delusion that he was being followed about, and that he was liable to be arrested for a criminal offence'.[34] He had possessed a revolver for several years and from an early age had an interest in shooting. He now declared that when 'they' came for him, they would not find him alive. On the evening of Friday 28 October 1887, a fortnight before the first anniversary of his brother's death, his daughter thought him calmer than usual, although he insisted on placing his revolver on a chest of drawers within easy reach while he slept. Alone in his room at quarter past two in the morning, Frank Haydon started up in bed as he heard the shadowy forces closing in on him, and was determined they should be cheated of their prey. The sound was his daughter's footfall on the landing outside his door. She heard a muffled

bang and ran into the room. Frank had learned from his father's botched suicide and had taken no chances. Gripping the butt with both hands for steadiness, he had pushed the barrel far back inside his mouth and pulled the trigger.

Illustrations

Integrated illustrations

P. viii 1846 Auction Catalogue (© Queen Mary College, University of London); **pp. 10–11** and **p. 34** *Royal Academy Great Room, Somerset House* (engraving by Thomas Rowlandson and A.C. Pugin, 1808); **p. 29** *Tables of the Skeleton and Muscles of the Human Body*, Bernard Siegfried Albinus, 1749; **p. 48** *Life Class of the Royal Academy, Somerset House* (engraving by Thomas Rowlandson and A.C. Pugin, 1809); **pp. 61–2** and **p. 75** *The Assassination of L.S. Dentatus*, engraving by William Harvey after Haydon (© The Royal Academy of Arts, London); **p. 68** *Theseus* drawings by Haydon from the Elgin Marbles (© *Lectures* I p. 75; *C&TTII* p. 171) and *Ilissos* drawing by Haydon from the Elgin Marbles (© British Museum); **p. 86** *The Parting*, engraving after Haydon (© The Royal Academy of Arts, London); **pp. 120–21** *The Judgement of Solomon*, drawing by Haydon (fMS Eng 1331 (6) by permission of the Houghton Library); **p. 152** *Portrait of Benjamin Robert Haydon*, drawing by David Wilkie (© National Portrait Gallery); **p. 159** *Mary Hyman*, drawing by Haydon (fMS Eng 1331 (10) by permission of the Houghton Library); **p. 191** *Egyptian Hall*; Anonymous aquatint, 1815; **p. 204** *Christ's Agony in the Garden*, engraving after Haydon published *London Magazine*, May 1821; **pp. 208–9** *The Raising of Lazarus*, engraving after Haydon, published The *Observer*, 30 March 1823; **p. 225** *The King's Bench Prison* (engraving by Thomas Rowlandson and A.C. Pugin, 1809); **p. 227** Rule of Court (fMS Eng 1331 (13) by permission of the Houghton Library); **p. 229** 1823 Auction Catalogue (Sale Catalogues of Libraries of Eminent Persons, vol. 9. p. 52); **p. 279** *The Death of Eucles*, engraving by S. Sangster after Haydon (© Royal Academy of Arts, London); **pp. 290–1** and pp. 416–17 *The Anti-Slavery*

Convention, engraving after Haydon (© National Portrait Gallery); **p. 324** *Portrait of Lord Brougham*, lithograph, published London: Thomas McLean, 25 June 1833; **pp. 336–7** *Reform Banquet, held in the Guildhall, City of London*, 11 July 1832, mixed mezzotint by John Charles Bromley after Haydon (© National Portrait Gallery); **p. 395** *The Hero and his Horse on the Field of Waterloo*, engraving by Thomas Lupton after Haydon (© National Museums Liverpool); **pp. 430–431**, *The Banishment of Aristides* engraving after Haydon, published *Illustrated London News*, 18 April 1843; **p. 448** *The Curse*, engraving after Haydon, published *Pictorial Times*, 20 April 1844 (© The Royal Academy of Arts, London); **p. 455** *Curtis leaping into the Gulf*, engraving after Haydon, published *Illustrated London News*, 8 April 1843 **p. 462** *The Cartoon Exhibition at Westminster Hall*, engraving published *Illustrated London News*, 8 July 1843; **p. 478** *Uriel and Satan*, engraving published *Illustrated London News*, 7 June 1845 (© The Royal Academy of Arts, London); **pp. 500–1** 'Post-Mortem Haydon death mask, lithograph published *The Zoist*, April 1854.

Plate section

Portrait of Benjamin Robert Haydon by Georgiana Zornlin (© National Portrait Gallery [NPG]); *Wordsworth on Helvellyn* (© NPG); *Leigh Hunt* (©NPG); *Portrait of Mary Russell Mitford* (©NPG); *The Judgement of Solomon* (© Plymouth City Art Gallery and Museum); *Christ's Triumphant Entry into Jerusalem* (© The Athenaeum of Ohio, Mount St. Mary's Seminary by Don Denney); *The Mock Election* (© Royal Collection); *Chairing the Members* (© Tate Britain); *Punch* (© Tate Britain); *Christ Blessing the Little Children* (© National Museums Liverpool); *Napoleon Bonaparte* (© NPG); *Arthur Wellesley, 1st Duke of Wellington* (© NPG); *Lazarus unrolled* (© Paul O'Keeffe).

Notes and References

Unless signalled by a superior number in the text, all quotations are taken from *The Diary of Benjamin Robert Haydon*, edited by Willard Bissell Pope and published in five volumes by Harvard University Press, 1960–1963 [*Diary* I–V], and from *The Autobiography and Memoirs of Benjamin Robert Haydon*, edited by Tom Taylor and republished, with an introduction by Aldous Huxley, in two volumes by Peter Davies, 1926 [*A&M*]. Page references to this material, too extensive to be included below, are to be posted on the internet.

Lot 343

1. Auction catalogue with MS. Annotations by William Newton, WFD/HA/69 (Queen Mary). • **2.** None of the contemporary newspaper accounts included this detail. It appeared in the summary of a report from Dr Elliotson and Mr Bryant, who first examined the body, published in the second edition of Tom Taylor's three-volume edition of *The Life of Benjamin Robert Haydon, Historical Painter from his Autobiography and Journals*, 1853 (see *A&M*, p.844). Another canvas, *Study for the Peasant Woman (Alfred) June 9 1846*, Lot 293, sold for £5 10s, was also said to be 'marked by his suicide'. See *Benjamin Robert Haydon*, cat. 179, Wordsworth Trust, 1996. • **3.** The address was given as 14 Burwood Place on the auction catalogue. The Post Office London Directory for 1840 gives 'Hayden [*sic*] Ben. R. historical paint. 4 Burwood pl. Edgw. Rd.' That for 1841 gives '14 Burwood place'. Further confusion regarding the address arises from the fact that, on 5 January 1824, BRH signed the lease on the property then identified as 58 Connaught Terrace, Edgware Road. Until

September 1827 Mary Russell Mitford addressed her letters to 'Connaught Terrace' and, from April 1828, to 4 Burwood Place. • **4**. Catalogue, Lot 135, p.10 • **5**. *The Times*, Coroner's Report, 25 June 1846 • **6**. Catalogue, Lots 151–188, pp.11–12 • **7**. *The Times*, 7 August 1846 • **8**. Catalogue, p.14 • **9**. *The Times*, op. cit. • **10**. Catalogue, Lots 262 and 256, p.15 • **11**. *The Times*, op. cit. • **12**. Catalogue, p.16 • **13**. *The Times*, op. cit.

1. No Stranger to the Muses: 1786–1807

1. fMS ENG 1331 (33), Genealogical Scrapbook, p.12 (Houghton) • **2**. ibid. • **3**. 'History of Plymouth, Plymouth Dock, and their Environs. Compiled from several scarce Manuscripts and Books of Authority, from the earliest Period to the Year 1801.' *Naval Chronicle*, Vol. VI, July–December 1881, and Vol. VII, January–July 1802. • **4**. Cyrus Redding, *Past Celebrities Whom I Have Known*, Vol. II, p.227, 1866; and *Fifty Years' Recollections, Literary and Personal with Observations on Men and Things*, Vol. I, p.119, 1853 • **5**. 'Obituary; with Anecdotes of remarkable Persons', *Gentleman's Magazine* LXXXIII, Part I, 1813 • **6**. Cadhay House still stands near Ottery St Mary, to the east of Exeter. • **7**. BRH's son, Frank Scott Haydon, pointed out this and other inconsistencies proving the Cadhay claim to be spurious. See *Diary* V, Appendix F. • **8**. Redding, *Fifty Years' Recollections*, Vol. I, p.120 • **9**. He was buried in the churchyard of St Ida's, Ide, near Exeter, 26 February 1770, the same church where he had married Joan Dey twenty-three years before (15 June 1747). The story of his death came from BRH (*A&M*, p.6), although elsewhere, in his *Diary*, he declares that his maternal grandfather, like Robert Haydon, died of 'ossification of the heart' (III, p.414). According to a letter from his Aunt Harriet to Frank Haydon, 26 September 1869, the Reverend Benjamin Cobley died on 14 February 1764, aged forty, 'from great excitement in preaching a charity sermon for the Benefit of his poor & schools belonging to his Parish – having suffered for some years previously organic disease of the heart'. • **10**. BRH gives them as Otschacoff and Ismailoff and describes an act of peculiar foolhardiness during the assault on the latter stronghold, by which his uncle won the admiration of his fellow officers: 'Close under the fortifications . . . was a very fine vine loaded with grapes. One day the officers of Cobley's mess in a joke said they should like some grapes for dessert . . . and away went my uncle with a ladder and basket. He soon reached the vine, planted the ladder against the wall and commenced picking the grapes. Some of the Turks, observing him, opened a rattling fire, but he filled his basket in spite of them and returned to his own lines without a scratch.' (*A&M*, pp.6–7.) • **11**. *Correspondence and Table Talk* I, p.3 • **12**. *London Chronicle*, 23 July 1788 • **13**. fMS ENG 1331 (31), Life

of BR Haydon (Vita) f5 (Houghton) • **14**. ibid., ff.3–4 • **15**. In *A&M*, p.8, BRH mentions going to school for the first time in 1792, but then, three paragraphs on: 'My father now sent me to the grammar-school.' Frederic Wordsworth Haydon conflates the two references and has his father attending the grammar school from 1792. See *C&TT* I, p.7. • **16**. fMS ENG 1331 (31), Life of BR Haydon (Vita) f6 (Houghton) • **17**. *The Panorama of Plymouth, or Tourist's Guide to the Principal Objects of Interest, in the Towns and Vicinity of Plymouth, Dock and Stonehouse*, Plymouth, 1821, p.21 • **18**. John Ruskin, 'Samuel Prout', *Art Journal* II, 1849 (Ruskin, *Works* XII, pp.306–307) • **19**. Haydon sketchbook among miscellaneous papers, National Art Library • **20**. William Hazlitt, 'Boswell Redivivus: A Fragment', *Works* XX, p.392 • **21**. Since Nelson did not return to England for over two years following his triumph at the Nile, the fleeting encounter could not have taken place earlier than January 1801, when Haydon had just turned fifteen. Although he failed to record that the man he saw lacked his right arm, lost in action off Santa Cruz, in 1797, his mention of a green eye shade is accurate. Nelson never wore a patch over the eye blinded on Corsica in 1794. Instead, the shade was sewn to the front of his hat – like the peak of a cap – and was worn not to conceal the blinded right eye, but in the hope of preserving the sight of the left. • **22**. *C&TT* I, pp.5–6 • **23**. ibid., footnote p.6 • **24**. *The Times*, 29 January 1796 • **25**. Ruskin, op. cit., pp.309–310 • **26**. Pope gives 1799 as the year BRH left Bidlake's school and 1800 as the year he left Plympton for accountancy training in Exeter. This contradicts Haydon's assertion that he spent the last three years of his education under the tutelage of Reverend Hayne, and that Hayne was headmaster at Honiton until moving to Plympton in 1800. • **27**. James Elmes, 'Memoirs of Benjamin Robert Haydon', *Annals of the Fine Arts* V, p.340 • **28**. ibid. • **29**. *Panorama of Plymouth*, p.282 • **30**. *The Diary of Joseph Farington*, 10 October 1809 • **31**. *C&TT* I, p.185 • **32**. Joshua Reynolds, *Discourses on the Fine Arts* I • **33**. Bernard Siegfried Albinus, *Tables of the Skeleton*, etc., commentary on the fourth table • **34**. From the Greek, to turn, being the second vertebra, which enables the head to turn. Modern anatomies call it the *axis*. John Bell, BRH's second anatomical authority, called it the *dentatus* because it bears a tooth-like process which fits through the ring of the *atlas*, or first vertebra, so called because it supports the head. • **35**. *C&TT* I, p.18. However, this diary entry from Haydon senior has not been preserved with the others in the 'Genealogical Scrapbook', fMS ENG 1331 (33), p.12 • **36**. Joseph Baretti, *A Guide through the Royal Academy*, London [1780], p.31. Quoted in *Art on the Line*, p.15 • **37**. Advertisement prefacing *The Exhibition of the Royal Academy*, London, 1780. Quoted in *Art on the Line*, p.20 • **38**. *The Times*, 28 April 1804 • **39**. Elsewhere there were fifty-two works in the Ante-Room, 147 in the Council Room, 152 in the Antique Academy, eighty-four in the Library and 156 in the Model Academy. The Catalogue for 1804 numbered 968 works in total. • **40**. By

William Owen • **41**. By Samuel William Reynolds • **42**. *The Times*, op. cit. • **43**. Cat. 115 by William Devis • **44**. *Discourses* IV • **45**. *The Times*, op. cit. • **46**. 'Rules and Orders relating to the School of Design.' Quoted Hutchinson, pp. 29–30 • **47**. James Elmes, 'Memoirs', *Annals* V, pp 335–378 • **48**. John Bell, *Anatomy of the Bones, Muscles and Joints*, note accompanying 'Muscles Plate I' • **49**. See A.N.L. Munby, 'The Bibliophile: BR Haydon's Anatomy Book', *Apollo* XXVI, December 1937 • **50**. BRH may have exaggerated the period of his father's promised support. The initial agreement, when he left Plymouth, was for two years. • **51**. The inflammation of brain and spine described in *Farington* VIII, pp.3002–3015, was probably meningitis. • **52**. Engraved by Charles Warre for Du Roveray's edition of *Paradise Lost*, 1802 • **53**. Haydon, *Lectures on Painting and Design* II, p.27 • **54**. Jackson to BRH, 30 May 1805, fMS ENG (6) v.IV f74 (Houghton) • **55**. First RA schools register, 1769–1830, ref. RAA/KEE/1/1/1: 9 March 1805, Haydon, B.R., 19, Painting • **56**. Jackson to BRH, op. cit. • **57**. ibid. • **58**. *Farington*, 9 May 1805 • **59**. Jackson to BRH, op. cit. • **60**. Haydon, *Lectures* II, p.51 • **61**. ibid., p.47 • **62**. Cunningham, *Life of Sir David Wilkie* I, p.74 • **63**. ibid. • **64**. Haydon, *Lectures*, op. cit. • **65**. Now Broadwick Street • **66**. Now Bolsover Street • **67**. See BRH's testimony: 'Minutes of the Select Committee on Arts and the Principles of Design, 1836', *Parliamentary Papers*. John Constable created his *Eve in the Garden of Eden* in 1831. The innovation, he claimed, 'was exceedingly liked; Old Etty congratulated me on it'. • **68**. *Farington*, 10 January 1805 • **69**. ibid., 29 November 1805 • **70**. RA 02/433 • **71**. RA 02/438 • **72**. *Farington*, 29 March 1804 • **73**. There is a letter from Nelson to Mr Dolland dated 11 September complaning that 'he has not yet received his Glasses', that his things are to leave London the following day and 'therefore if not sent to the Hotel Lord N begs that Mr Dolland will send them immediately to Portsmouth' [Monmouth: E179]. Colin White, *Nelson: The New Letters*, Woodbridge, 2005. • **74**. The tickets of John Hoppner, RA – one for admission to the funeral procession from the Admiralty to St Paul's, and the other, with a black wax seal, to the cathedral itself and signed by the Bishop of Lincoln, Dean of St Paul's – are in the National Maritime Museum, London. • **75**. Royal Academy, RA 02/339 and 02/340 • **76**. RA 02/337 • **77**. RA 02/342 • **78**. RA 02/279 • **79**. First published 1806, London • **80**. *Letters of Sir Charles Bell*, pp.64–65 • **81**. BRH's drawing (Royal Academy, RA 02/324) is dated 21 February 1806. • **82**. There is a chalk drawing of a foot by BRH in the British Museum (Album, No. 72) inscribed '1806 Before I began to paint'. • **83**. Later the 1st Duke of Sutherland • **84**. Wilkie to BRH, 7 September 1806, fMS Eng 1331 (6) v.IV f76 (Houghton) • **85**. 9 October 1806, Cunningham, *Wilkie* I, p.126 • **86**. 28 February 1807, fMS ENG 1331 (6) v.IV f77 (Houghton) • **87**. Wilkie to Beaumont, 7 February 1807, Cunningham, *Wilkie* I, p.137 • **88**. fMS ENG 1331 (6) v.IV. f77 (Houghton) op. cit. • **89**. fMS ENG 1331.1 (111) (Houghton), Miscellanea

removed from Genealogical Scrapbook. BRH writes: 'Copied from *The Times* news paper by my dear Mother 1807'. However, no such notice has been located in that source. • **90**. *Farington*, 4 May 1805 • **91**. *Review of Publications in the Fine Arts*, 1808, Vol. 2: 110–112 • **92**. fMS ENG 1331.1 (Houghton) op. cit. • **93**. fMS ENG 1331 (31) 'Vita' f42 (Houghton)

2. Struggles: 1807–14

1. Book II, 1757, Chapter 28, 1, p.337. *The Oxford Classical Dictionary* has the following: 'Siccius Dentatus, Lucius: A tradition which perhaps derives from Varro celebrates the numerous military campaigns, exploits, wounds and honours of this legendary "Roman Achilles." . . . Roman historians made him a mid-5th cent. Plebeian hero whose death was plotted unsuccessfully in 455 BC by the consul T. Romilius (whom Siccius prosecuted as a tribune in 454) and implemented by the Second Decemvirate in 450/449. These stories are obvious duplicates and neither is historical.' • **2**. 8 October 1807, fMS Eng 1331 (6) v.IV f82 (Houghton) • **3**. *Farington*, 6 June 1807 • **4**. ibid., 27 February 1808 • **5**. ibid., 30 March 1808 • **6**. Letter to Lord Elgin, reprinted in *Diary* II, Appendix C, p.518 • **7**. Cunningham, *Wilkie* I, p.173 • **8**. fMS ENG 1331 (1) v.I f3 • **9**. Dated 23 July, the entry headed 'Journals of my little Country Excursions. 1808' was written in the last fourteen pages of fMS ENG 1331 (3) v.A. • **10**. Cunningham, *Wilkie* I, Diary entry, 3 March 1809 • **11**. ibid., 2 April 1809 • **12**. *The Microcosm Of London*, 1808–1810 (reprinted 1985 as *A Portrait of Georgian London*, then as *Ackerman's Illustrated London*, whence this reference, p.116) • **13**. Charles Robert Leslie, *Autobiographical Recollections*, ed. Tom Taylor, vol. I, p.225 • **14**. The interloper was probably cat. 212: *Portrait of the daughter of the Hon. G. Villiers* by B. Burell. • **15**. *Farington*, 24 May 1809 • **16**. ibid., 13 June 1809 • **17**. ibid., 1 April 1809 • **18**. ibid., 20 April 1809 • **19**. This resolution was broken within the year. BRH saw, and was impressed by, a performance of *Hamlet* in September 1809. • **20**. Description in catalogue of the Liverpool Academy Exhibition of 1814 • **21**. Cunningham, *Wilkie* I, Diary entry, 20 May 1809 • **22**. fMS ENG 1331 (3) v.A, 'Journal of a jaunt into Devonshire with Wilkie in 1809' (Houghton). The material in square brackets was cancelled in the manuscript. • **23**. ibid. • **24**. Redding, *Past Celebrities* II p.235 • **25**. Cunningham, *Wilkie* I, Diary entry, 8 October 1809 • **26**. ibid., 30 October 1809 • **27**. *Farington*, 1 March and 7 March 1810 • **28**. BRH to Beaumont, 1 February 1810, fMS ENG 1331 (4) v.II f112v (Houghton) • **29**. Cunningham, *Wilkie* I, Diary entry, 6 January 1810 • **30**. ibid., 5 January 1810 • **31**. ibid., 7 January 1810 • **32**. ibid., 12 January 1810 • **33**. ibid., 15 January 1810 • **34**. ibid., 18 February 1810 • **35**. *Farington*, 7 May 1810 • **36**. BRH made no mention of

this in his journal until a passing reference seven years later, in May 1817.
• **37**. Variously entitled *The Wardrobe Ransacked*, *'No Fool like an Old Fool'* and *The Man in the Girl's Cap* • **38**. Farington, 7 May 1810 • **39**. Royal Academy candidate list RAA/GA/11/1 • **40**. 22 May 1810, fMS ENG 1331 (5) v.III ff39v–40 (Houghton) • **41**. *Farington*, 15 January 1811 • **42**. ibid., 26 February 1804 • **43**. ibid. • **44**. ibid., 18 September 1810 • **45**. Dawe later claimed to have 'been at considerable expense on this acct. Besides paying for His board He had given him money to the amount of Thirty two guineas' (*Farington*, 31 December 1810). • **46**. In 1809 Wilkie neglected this courtesy but was able to repair the damage. 'Several of the Academicians had expressed dissatisfaction at His not having called upon them. – In consequence He called upon all of them' (*Farington*, 28 February 1810). • **47**. *Farington*, 5 July 1810 • **48**. *Examiner*, 4 August 1811 • **49**. ibid., 11 August 1811 • **50**. ibid. • **51**. ibid., 8 September 1811 • **52**. It is fortunate that BRH left a description of its conception, because the painting has been lost since 1830 when it was sold at auction that year (see William Whitley, *Art in England 1821–1837*, p.202). • **53**. *Farington*, 17 January 1812 • **54**. 1 January 1812, fMS ENG 1331 (6) v.IV f102 (Houghton) • **55**. See Farington, 7 May 1810 • **56**. 10 January 1812, fMS ENG 1331.1 (152) (Houghton) • **57**. *Farington*, 10 January 1812 • **58**. *Edinburgh Review*, August 1810 • **59**. *Examiner*, 25 January 1812 • **60**. ibid., 2 February 1812 • **61**. Wilkie to BRH, 3 February 1812, fMS ENG 1331 (7) v.V f20 (Houghton) • **62**. Wilkie to BRH, 1812, fMS ENG 1331 (7) v.V f115v (Houghton) • **63**. *Examiner*, 9 February 1812 • **64**. *Farington*, 27 February 1812 • **65**. ibid., 30 March 1812 • **66**. Letter from Richter, dated 8 June 1812, read out at the meeting of directors held the following day and transcribed in British Institution minutes (National Art Library) • **67**. The Society of Painters in Water Colour had, since 1809, held its annual exhibitions in Spring Gardens, but its administrative head-quarters remained at 16 Old Bond Street, and it was here that Richter's oil painting was exhibited. Late in 1812 it was decided to change the name to the Society of Painters in Oils and Water Colour. • **68**. *Farington*, 7 June 1812 • **69**. British Institution minutes for meetings on 6 and 9 June 1812 (National Art Library) • **70**. *Examiner*, 9 February 1812 • **71**. *Farington*, 14 June 1812 • **72**. ibid., 18 June 1812 • **73**. ibid., 18 July 1812 • **74**. Recounted in a letter to Elizabeth Barrett, 25 April 1843 (*Invisible Friends*, p.87) • **75**. In the British Museum there is a rough sketch by BRH of a baby, inscribed 'body in oil' (*Album*, No. 72). • **76**. They were given to the Academy by the Duke of Bedford in 1800 and hung in the Great Room when it was not being used for the Exhibition. • **77**. 'Mrs Green, 20 [or 26] John Street, near Kings Bench, Borough', written on the inside front cover of fMS ENG 1331 (9) v. VIII (Houghton) • **78**. *The Times*, 1 December 1812 • **79**. ibid. • **80**. *The Times*, 10 December 1812 • **81**. *Examiner*, 22 March 1812 • **82**. Elizabeth Kent, author of *Flora Domestica* (1823) • **83**. Mary Lamb had stabbed her invalid mother to

death seventeen years previously and was to spend the rest of her life in the care of her brother, and subject to periodically recurring bouts of insanity. • **84**. It is not known who engaged the services of Adams in Haydon's case. Thomas Lawrence was a patient at this time. • **85**. *Bewick* I, p.287

3. Triumphs: 1814–21

1. *Farington*, 3 May 1814 • **2**. John Scott to BRH, 26 April 1814, fMS ENG 1331 (8) v. VI f106v (Houghton) • **3**. In his *Autobiography* BRH gave the asking price as 600 guineas. However, the balance sheet he made out in 1830 has £735 (700 guineas). 700 guineas was also the figure he mentioned to William Bewick in 1816 (see *Bewick* I, p.31). • **4**. *Farington*, 4 May 1814 • **5**. *Morning Chronicle*, 4 May 1814 (Hazlitt, *Works* XIX, pp.19–20) • **6**. Mitford to her mother, 18 June 1814 and to Sir William Elford, 5 July 1814, *Mitford* I pp. 278 and 287. • **7**. 5 May 1814, fMS ENG 1331 (6) v.IV f105v • **8**. BRH to John Scott, no date, fMS ENG 1331 (8) v. VI f17 (Houghton) • **9**. *The Journal of John Mayne During a Tour on the Continent upon its re-opening after the Fall of Napoleon, 1814*, ed. John Mayne Colles, London, 1909, pp.5–6. Mayne described the *cabriolet*: 'This machine is on two wheels, clumsy and ill-shaped . . . [but] the two wheels give it an easy motion; it is small, yet carries a vast quantity of luggage, and it admits a free circulation of air in hot weather . . .' It was driven and controlled by a single postilion who appeared to urge the horse on with the sound, rather than the sensation, of the lash. • **10**. Cunningham, *Wilkie*, I, p.402 • **11**. op. cit. • **12**. BRH to Leigh Hunt, 5 May 1814, *C&TT* I, p.271 • **13**. Haydon and Hazlitt, *Painting and the Fine Arts*, p.165 • **14**. Cunningham, *Wilkie* I, p.398 • **15**. 'L'Angleterre en forfeits trop souvent fut feconde.' The speech does not occur in Shakespeare. • **16**. Cunningham, *Wilkie* I, p.407 • **17**. *Farington*, 23 July 1814 • **18**. Henry Woolcombe to BRH, 26 September 1814, fMS ENG 1331 (8) v.VI f67 • **19**. Cunningham, *Wilkie*: Wilkie to Beaumont, 12 December 1816 • **20**. *Bewick* I, p.268 • **21**. August, October and November, that is. September had been spent at Bopeep. The account was written on the last page of fMS ENG 1331 (8) v. VI (Houghton): 'Expenses of Models for Christ entering Jerusalem'. • **22**. British Museum, *Album*, No. 67. See also *Journal of the Gypsy Lore Society*, July–October 1944, 3rd Series, 23: 69–71. • **23**. BRH to Elizabeth Barrett, 7 March 1843, *IF*, p.46 • **24**. Agreement between BRH and George Robertson, 1 January, 1820, fMS ENG 1331 (158) (Houghton) • **25**. Adapted by Elizabeth Inchbald from the French by Madame de Glenlis • **26**. Later Earl Fitzhardinge (1786–1857) • **27**. *Bleak House*, p.89 • **28**. 21 February 1816, BL. Add. 38108 f155 (British Library) • **29**. *Description of Mr Haydon's Picture of Christ's Triumphant Entry into Jerusalem*, 1820, p.10 • **30**. 31 December

1816, *C&TT* II, p.31 • **31**. 7 April 1817, ibid., p.31 • **32**. Southey to Wordsworth, 8 May 1817, *Southey Letters* II, p.157 • **33**. Undated, Spurzheim to BRH, *C&TT* I, p.300 • **34**. BRH to Mitford, 28 March 1825, *C&TT* II, p.93 • **35**. Advertisement, *The Times*, 11 May 1815 • **36**. *Catalogue Raisonee*, 1815, p.15 • **37**. ibid., p.18. The work referred to was cat. 9, *Portrait of Cornelis van der Geest* by Van Dyke, now in the National Gallery, London. • **38**. ibid., p.56. Cat. 125, *Daedalus and Icarus*, the property of J. Knight, Esq. • **39**. *Farington*, 9 June 1815 • **40**. ibid., 10 June 1815 • **41**. ibid., 24 November 1816 • **42**. ibid., 21 June 1815 • **43**. ibid., 9 June 1815 • **44**. ibid., 21 June 1815 • **45**. See *Diaries of a Lady of Quality*, ed. A. Hayward, QC, second edition, London, 1864, pp.167–169 • **46**. To BRH, 31 July 1815, fMS ENG 1331 (9) v. VII f92 (Houghton) • **47**. *Annals*, Vol. I, No. I, pp.91–2 [1 July 1816] • **48**. Philips to BRH, 19 August 1815, fMS ENG 1331 (9) v. VII f93 (Houghton) • **49**. Wordsworth to BRH, 8 October 1815, *Wordsworth Letters* III, p.250 • **50**. *Farington*, 5 December 1815 • **51**. Quoted William S. Clair, *Lord Elgin and the Marbles*, p.250 • **52**. ibid., p.254 • **53**. Reprinted *A&M*, p.233 • **54**. £18,000 was deducted from that sum in payment of a debt which a far-sighted creditor had managed to transfer to the Government. • **55**. See *Annals* III, p.165 • **56**. *Farington*, 10 April 1816 • **57**. *Annals* I, p.208 • **58**. *Catalogue Raisonee*, 1816, p.16 • **59**. ibid., pp.12–13 • **60**. *Farington*, 4 September 1816 • **61**. ibid., 3 September 1816 • **62**. ibid., 22 April 1817 • **63**. 3, 10 and 17 November 1816 • **64**. The review, occupying pp.189–209 of *Annals* I, No. 2, was unsigned, referred to 'Mr Haydon' in the third person, but was certainly written by him. • **65**. *Annals*, p.189 • **66**. ibid., p.201 • **67**. ibid., p.192 • **68**. Farington had dined there two years before with Benjamin West and Robert Smirke: 'Mr West had ordered [dinner] to be ready at 5 o'clock, but the House being full of Company . . . our dinner was not on the table till a quarter past 6 o'clock. – The dinner was but indifferent and bore no proportion to the charge for it' (*Farington*, 28 August 1814). • **69**. *Annals* III, No. 9, 1818 • **70**. *Bewick* quoted in a letter of 14 July 1816 to his brother • **71**. ibid., 17 September 1816 • **72**. Bewick senior's letter, dated 7 September 1816, is reprinted in *C&TT* I, p.304 • **73**. *Bewick* to his brother, 17 September 1816 • **74**. ibid., 30 March 1817 • **75**. *Annals* I, No. 3 • **76**. BRH to Reynolds, October 1816, *The Keats Circle* I, pp.5–6 • **77**. Letter dated 3 September 1816, quoted *Diary* II, footnote p.46. Printed in the *Examiner*, 20 October 1816. • **78**. 4 September 1816, BL Add. 38108 f169 (British Library) • **79**. Recounted in a letter dated 11 October 1817, *Mitford* II, p.15 • **80**. *Description of Mr Haydon's Picture of Christ's Triumphant Entry into Jerusalem*, 1820, p.7 • **81**. Bewick to CR Cromick, 31 March 1864, *Bewick* II p.227 • **82**. Keats to C.C. Clarke, 31 October 1816, *Letters* I, pp.114–115 • **83**. National Portrait Gallery, NPG 3250 • **84**. 20 November 1816, *Letters* I, p.117 • **85**. It opened fMS ENG 1331 (10) vol. VIII (Houghton) (*Diary* II, p.51) and was published in *Annals*, 1817. • **86**. 22 November 1816, fMS ENG 1331 (9) v. VII (Houghton) (*Diary* II,

p.75 footnote 4). It was published in the *Champion*, 24 November 1816.
• **87**. 12 December 1816, Cunningham, *Wilkie* I, p.453 • **88**. *Annals* III, No. 9, 1819, p.330 • **89**. To his brother, 30 March 1817, *Bewick*, p.39 • **90**. 7 August 1819, *C&TT* I, p.341 • **91**. *Farington*, 13 January 1818. However, the Christmas brothers copied one of the Raphael cartoons – *Elymas the Sorcerer* – jointly (see *Farington*, 22 May 1818). The *Annals* caricature of BRH's pupils copying the cartoons (published April 1818) identified Charles and Thomas Landseer, Bewick and one of the Christmas brothers. • **92**. Jones and Mayor paid Haydon £210 each for three years' tuition in 1820. See *A&M* II, Appendix II (for Major read Mayor). • **93**. 12 December 1816 Cunningham, *Wilkie* I, p.453 • **94**. Gittings, *John Keats*, p.171 • **95**. BRH's marginalia in his copy of Thomas Medwin's *Journal of the Conversations of Lord Byron* (1824). Duncan Gray and Violet W. Walker, 'Benjamin Robert Haydon on Byron and Others', *Keats-Shelley Memorial Bulletin* VII, 1956, p.23. • **96**. Act V, Scene V, 269–283 • **97**. Act I, Scene I, 138–146 • **98**. Act IV, Scene I, 194–199 • **99**. Act II, Scene II, 74–81 • **100**. *Keats-Shelley Memorial Bulletin*, p.24 • **101**. *The Times*, 25 January 1817 • **102**. 15 November 1817, *C&TT* II, pp.323–324 • **103**. 26 February 1817, *C&TT* II, p.60 • **104**. *Mitford* II, p.6 • **105**. 'Su le labbre un sospir, su gli occhi un pianto' [*sic*], Canto III, Verse 18 of *Gerusalemme Liberata (Jerusalem Delivered)*, an epic poem of the First Crusade, published 1580. Elsewhere on the drawing are the words: 'Dolcessa Patetica con estitzia [*sic*] mista' (Pathetic sweetness mixed with melancholy). • **106**. BRH wrote to thank her for the poem on 30 May. It was published in the *Annals*, dated '21 May 1817, Reading'. • **107**. *Mitford* II, pp.76–77. Haydn was born on 31 March 1709. Mitford's letter recounting the incident is dated November 1819. Hunt moved from Hampstead in April 1817, ten days after the anniversary of Haydn's birth. • **108**. *Annals* II, No. 4, p.120 • **109**. ibid., No. 5, p.285 • **110**. Also known as *The Conversion of the Proconsul* • **111**. *Annals* II, no. 6, pp.433–434 • **112**. *Annals* III, No. 8, pp.67–8 • **113**. *The Times*, 19 June 1817 • **114**. 3 June 1817, *C&TT* I, p.320. 'God bless your precious eyes, pray keep them till they have conferred immortality on your name . . . They are public property . . . Nurse them my jolly old Cock, till you are lynx eyed as Argus.' fMS ENG 1331 (10) v.VIII f101 (Houghton) • **115**. 15 August 1817, BL Add. 61677 f101 (British Library) • **116**. *Annals* I, No. 6, p.430 • **117**. Now Rossmore Road • **118**. Coutts to BRH, 6 December 1817, fMS ENG 1331 (10) vVIII f158v (Houghton) • **119**. Keats to George and Tom Keats, 13–19 January 1818, *Letters* I, p.205 • **120**. ibid. • **121**. BRH to Mitford, 12 February 1825, BL Add. 57976 (British Library). The anecdote appears in a fuller version in another letter, BRH to Edward Moxon, 29 November 1845, *Keats Circle* I, pp.143–145. • **122**. Keats had written something similar at the end of an article about Edmund Kean in the previous week's *Champion*: 'Cheer us a little in the failure of our days! For romance lives but in books. The goblin is driven from the hearth, and the rainbow is

robbed of its mystery.' • **123**. *Letters of Charles Lamb* IV, p.110 • **124**. BRH to Mitford, op. cit. • **125**. The programme would result in ninety-seven churches being built between 1818 and 1834. A second programme lasted until 1856 and produced over 500 more. See M.H. Port, *Six Hundred New Churches: The Church Building Commission 1818–1856*, London, 1961. • **126**. p.14 • **127**. *Farington*, 13 January 1819 • **128**. It was presumably done while visiting his parents, because the canvas identifies the animal as 'the property of Mr Greaves of Darlington, Durham'. • **129**. *Examiner*, 9 May 1819 • **130**. Quoted Olney, p.93, footnote 2 • **131**. BRH to M. Olenin, 8 July 1818, *C&TT* I, p.326; fMS ENG 1331 (ii) v.IX f49v (Houghton) • **132**. *Annals* III, No. 10, p.528 • **133**. *A&M*, pp.278–279. Two letters from Hamilton reprinted in *C&TT* I, pp.337–338, one undated, the other 28 October 1818. The journal contains no mention, at the time, of Hamilton's proposition. Entries for this period are confused and out of order. There are none dated between 13 August and 27 October 1818. • **134**. *The Times*, 10 December 1818 • **135**. It was drawn by J. Marks. The engraving, of course, shows the scene in reverse. No. 29 was actually on the east side of the street, opposite Brooks's Club. • **136**. *The Times*, 8 February 1819 • **137**. *Annals* IV, No. 12, pp.124–132 • **138**. ibid. I, No. 1, p.107 • **139**. ibid., no. 3, p.411 • **140**. ibid., No. 4, p.121 • **141**. ibid. III, No. 8, p.159 • **142**. ibid., No. 10, pp.523–524 and 528 • **143**. ibid. IV, No. 15, p.632 • **144**. It superseded Bullock's Liverpool Museum at 22 Piccadilly, the first London venue for his collection following his move from Liverpool in 1809. • **145**. *The Times*, advertisement, 10 May 1816 • **146**. ibid. • **147**. *The Times*, advertisement, 4 October 1819 • **148**. *Autobiographical Reminiscences of Charles Robert Leslie*, ed. Tom Taylor, p.221 • **149**. *Description of Mr Haydon's Picture of Christ's Triumphant Entry into Jerusalem*, p.10 • **150**. *Literary Gazette*, 1 April 1820 • **151**. *The Times*, 27 March 1820 • **152**. 'Farington's Life of Sir Joshua Reynolds', *Edinburgh Review*, August 1820 (reprinted *Hazlitt*, xvi) • **153**. £1,760 7s 6d to be precise, although after paying expenses of £462 5s he was left with a clear profit of £1,298 2s 6d • **154**. *The Times*, 16 June 1820 • **155**. Recounted by BRH, *Some Enquiry into the Causes which have Obstructed the Advance of Historical Painting, for the Last Seventy Years in England*, 1829, footnote p.28 • **156**. Mitford to Elford, 5 July 1820, *Mitford* II, p.101 • **157**. *C&TT* II, p.66 • **158**. *Blackwood's Magazine*, November 1820 • **159**. It is possible that *Blackwood's Magazine* originated this humorous application, of the ancient fabulous name, to London, home of the cockney. Earliest reference of this usage cited in the *Oxford English Dictionary* is 1824. • **160**. October and November 1817, July and August 1818, April and October 1819 • **161**. *Don Juan* XI, 1.60 • **162**. *Blackwood's Magazine*, April 1819 • **163**. ibid., August 1818 • **164**. ibid., November 1820 • **165**. *C&TT* II, p.67 • **166**. *Edinburgh Evening Courant*, 18 November 1820 • **167**. *The Times*, 20 November 1820 • **168**. *London Magazine*, May 1821

4. King's Bench, King's Patronage: 1821–30

1. Mitford had seen the sketch before 5 July 1820. The canvas was bought and the picture rubbed in before *Christ's Agony in the Garden* (4 April 1820–26 February 1821). Following completion of the smaller picture and after a long period of idleness, work had begun on the head of Christ on 31 May 1821. • **2**. *Description of Mr Haydon's Great Picture of Raising of Lazarus*, 1823, p.9 • **3**. *The Times*, 20 July 1821 • **4**. *Farington*, 20 July 1821 • **5**. *The Times*, op. cit. • **6**. Quoted Jane Robins, *Rebel Queen*, p.311 • **7**. ibid. • **8**. There were 2,934 spectators and those assembled for the procession to the Abbey numbered about 700. • **9**. Robert Huish *An Authentic History of the Coronation of His Majesty King George the Fourth*, 1821 (quoted Roy Strong, *Coronation*, p.390) • **10**. *Annual Register*, 1821 (quoted Cumming, 'Pantomime and Pageantry: The Coronation of George IV', *London – World City 1800–1840*, ed. Celina Fox, 1992, p.47 • **11**. *The Times*, op. cit. • **12**. Lockhart, *Memoirs*, p.455 (quoted Strong, *Coronation*, pp.413–414) • **13**. Huish, op. cit., p.414 • **14**. William Hazlitt, 'Mr Northcotes's Conversation: Conversation the Twelfth' (*Hazlitt* XI, p.253) • **15**. *Scotsman*, 24 November 1821. The picture is not listed in Pope's 'Chronological Checklist of Oil Paintings Begun by Haydon', *Diary* V, Appendix I. In the British Museum, amongst the collection of BRH's drawings, there is a tiny engraving of the picture, by W. Greatbach, illustrating a single page of a poem called 'Envoy', beginning: 'Spring breathes around us; the bright air is filled / With glistening life, and odours dewy sweet', from Watt's *Lyrics of the Heart and Other Poems*. • **16**. C.H. Reynell of Broad Street had printed BRH's *Descriptions* of his last two exhibited paintings. Most of the £3,000 made from admission charges to see *Jerusalem* in London, Edinburgh and Glasgow had been swallowed up in repayment of debts. But the exhibition of *Christ's Agony in the Garden* had been a failure. Only £120 of Reynell's bill had been paid and the painter was now arrested for the outstanding balance of sixty pounds. • **17**. Wilkie's diary entry for 21 November 1821 does not appear in Cunningham's *Wilkie*, but was published eight years after BRH's death in the *Illustrated London News*, 29 October 1853. • **18**. ibid. • **19**. Together with *Solomon, Romeo and Juliet, Dentatus, Cupid Cruising* and drawings from the Elgin Marbles. See *The Scotsman*, 24 November 1821. • **20**. *A&M* I, Appendix I, p.845 • **21**. The drawing is number 67 in BRH's *Album*, British Museum. It is reproduced in *A&M* I, p.320 • **22**. *The Times*, 5 March 1823 • **23**. *Observer*, 9 March 1823 • **24**. Sir George Beaumont had lent *Macbeth* for the exhibition and it was also seized by the Sheriff's Officers. Sir George had 'to pay again to redeem it from the law'. See *Diary* I, footnote 6, p.222 • **25**. 1 July 1823, quoted *Diary* II, footnote 8, p.415 • **26**. fMS ENG 1331 (31), Life of BR Haydon (Vita) f220v (Houghton) • **27**. BRH to Scott *Diary* II, op. cit.

• **28**. fMS ENG 1331 (31), Life of BR Haydon (Vita), op. cit. (Houghton) • **29**. BRH to Scott, op. cit. • **30**. Now the lower part of Borough High Street • **31**. A game involving the bowling of small iron balls at nine numbered holes in a frame. • **32**. It is tempting to suggest that from this monopoly of leisure resources in the King's Bench and other prison yards originated the modern terms associated with organised crime: 'racket', 'racketeer' and 'racketeering'. • **33**. *The Picture of London*, 1822, p.202 • **34**. fMS ENG 1331 (31), Life of BR Haydon (Vita), op. cit. (Houghton) • **35**. Mr Pickwick undergoes intense scrutiny by his turnkeys – 'Having your likeness taken, Sir' – on entering the Fleet Prison. *Pickwick Papers*, p.542. • **36**. 23 May 1823, Kearsey to Ashton, fMS ENG 1331 (13) v.X f209 • **37**. Quoted *A&M*, p.333 • **38**. The *Examiner*, 17 November 1811, p.745 • **39**. Sale catalogues of Libraries of Eminent persons, vol. 9, p.523 • **40**. See *Diary* IV, pp.398 and 398. It was bought at the 1846 sale of BRH's property following his death, for one guinea. • **41**. *The Times*, 12 June 1823 • **42**. BRH quoted this in his 1829 pamphlet *Some Enquiry into the Causes which have Obstructed the Advance of Historical Painting*. He implied that the author had connection or sympathy with the Royal Academy. • **43**. Printed in full in *A&M*, pp.334–336 • **44**. *The Times*, 26 June 1823 • **45**. *Pickwick Papers*, Chapter 42, pp.571–572 • **46**. See *C&TT* I, p.133. There are letters from Mitford, dated 24 August and October 1823, addressed to 8 Paddington Green. However, there are also letters to this address dated 11 July and 28 October 1824, after BRH's removal to Burwood Place. In *The Private Letter-Books of Sir Walter Scott*, ed. Wilfred Partington, 1930, p.170, there is a letter from BRH dated August 1823, with the address 8 Philpot Street, Edgware Road. No such address exists today. Much old property on the south side of Paddington Green has been obliterated by the Marylebone flyover. • **47**. fMS ENG 1331 (31), Life of BR Haydon (Vita) f224v and inside cover (Houghton) • **48**. 8 August 1823, fMS ENG 1331 (13) v.X f227v • **49**. The archaeologist Giovanni Baptista Belzoni (1778–1823) • **50**. 'Thursday night Feb 12 1824'. BL Add. 57976 (British Library) • **51**. *The Times*, 19 July 1830, gives £129, but in future dealings with his landlord the rent mentioned is £30 7s 9d per quarter, £121 11s per annum. • **52**. However, Mitford's letter of 9 February 1824, congratulating BRH upon the move, is addressed to 51 Sovereign Terrace, Connaught Place. See above, 'Lot 343' note 3, for further anomalies regarding this address. • **53**. *Mitford* II, p.175 • **54**. *The Times*, 16 February 1824 • **55**. His father exhibited him in England and France from 1812 until 1816. BRH met father and son in 1813 (see *Diary* I, pp.308–309). The chalk drawing is in the British Museum (1902-II-7-I). • **56**. *The Times*, 19 April 1824. Finally there was a painting called *Sleep* and sketches for *Jerusalem, Ariadne, Crucifixion*, and a couple of studies. • **57**. The picture (8½ x 7½ feet) hangs in Paisley Abbey. • **58**. George Borrow, *Lavengro*, p.224. The precise date that John Borrow and his brother visited is not known. However, on 3 May Haydon recorded that he had 'two

commissions, one for a Lord Mayor and another a family piece'. • **59**. BRH to Mitford, no date, *C&TT* II, p.90 • **60**. Kearsey to BRH, 25 October 1824, fMS ENG 1331 (14) v.XI f82 • **61**. Zornlin to BRH, 23 February 1825, fMS ENG 1331 (14) v.XI f25v • **62**. National Portrait Gallery Archives, quoted in Wordsworth Trust Catalogue, p.103 • **63**. See *A&M* II, Appendix II: 'received for Portrait £50 . . . Do. Portraits £614' • **64**. *Dr George Darling, Mayor Robert Hawkes – Mayor of Norwich, Mrs Robert Hawkes, Mary Russell Mitford, The Convalescent: a family picture*, three *Portraits of a Lady* and two *Portraits of a Gentleman*, one of whom was Mr John Hunter. • **65**. *The Times*, 28 March 1825 • **66**. ibid., 31 March 1825 • **67**. Borrow, op. cit., p.225 • **68**. *C&TT* I, p.185 • **69**. Borrow, op. cit. • **70**. Mitford to BRH, 18 July 1825, *Mitford II*, p.208 • **71**. Mitford to William Elford, 16 December 1828, *Mitford II*, pp.259–260 • **72**. *Examiner*, 9 May 1825 • **73**. Now lost • **74**. *The Times*, advertisement, 13 May 1825 • **75**. 16 April 1825, *C&TT* II, p.95 • **76**. *John Bull*, 15 May 1825 • **77**. ibid. • **78**. *The Times*, 19 July 1830 • **79**. Pope transcribes the name doubtfully as 'Mr John Church[?]' in *Diary* III, p.12, in the entry for 5 April 1825. The name is never mentioned again. However, BRH mentions John Hunter, 'East Indian Merchant who failed in the Panic', as the purchaser of the picture. See *Diary* II, footnote 2, p.20. • **80**. BRH to Mitford, 6 July 1825, *C&TT* II, pp.91–92 • **81**. BRH to Mitford, 29 December 1825, ibid., p.106 • **82**. *The Times*, 2 February 1826 • **83**. *The Times*, 29 April 1826 • **84**. BRH envied Carew, but twelve years later he reported having met the sculptor in Hyde Park, unprovided for by the late Lord Egremont's will, 'desponding, in debt, & harassed'. *Diary* IV, p.505. • **85**. *A&M* I, footnote p.385 • **86**. Shee to BRH, 5 January 1829, quoted *Diary* III, pp.330–331 • **87**. *The Times* and *Morning Post*, 5 May 1827 • **88**. More properly *Milon* • **89**. *The History of the Decline and Fall of the Roman Empire*, Chapter 12 • **90**. *The Times*, 15 June 1827 • **91**. 20 June 1827, *C&TT* II, p.116 • **92**. BRH to Newton, no date, WC/HA/2 (Queen Mary) • **93**. It features – as Solomon Jacob's 'lock up' – in Dickens's 'Passage in the Life of Mr Watkins Tottle', in the *Monthly Magazine*, January–February 1835, then in *Sketches by Boz*, pp.512–521. It is also mentioned by Thackeray in *Vanity Fair, The Newcomes* and *The Virginians*, and by Disraeli in *Henrietta Temple*. • **94**. *Sketches by Boz*, p.512 • **95**. ibid., p.519 • **96**. BRH to Newton, op. cit. • **97**. BRH to Editor, *Observer*, 20 July 1827 • **98**. See note in *Diary* III, p.152. Southampton Street runs north from the Strand to Henrietta Street, Covent Garden. • **99**. *Sketches by Boz*, p.517 • **100**. fMS ENG 1331 (17) v.XIV f33–34 (Houghton) • **101**. *Morning Chronicle*, 12 July 1827 • **102**. *The Times*, 16 April 1828 • **103**. ibid., 17 July 1827 • **104**. Charles Abbott, 1st Baron Tenterden, was the Lord Chief Justice of the Court of King's Bench. • **105**. *The Times*, op. cit. • **106**. *Diary* III, footnote 5 p.216 • **107**. ibid., footnote 9 p.218 • **108**. *Explanation of the Picture of the Mock Election*, 1828, pp.5–6 • **109**. *The Times*, op. cit. • **110**. ibid., 18 July 1827 • **111**. ibid., 17 July 1827 • **112**. ibid., 18 July

1827 • **113**. ibid. • **114**. *Explanation of the Picture of Chairing the Members*, 1828, p.4 • **115**. *The Times*, op. cit. • **116**. *The Times*, 19 July 1827 • **117**. ibid., 28 July 1827 • **118**. BRH to Editor, *Morning Chronicle*, 27 May 1830 • **119**. The ceremony took place at Paddington on 18 September 1840. Wilkie was the other godfather and BRH's sister, Mrs Haviland, godmother. As at Frank's baptism, proxies substituted for sponsors, 'as the real ones [were] scattered abroad' (*Diary* V, p.5). • **120**. *Explanation of . . . Mock Election*, p.13 • **121**. ibid., p.7 • **122**. *Examiner*, 13 January 1828 • **123**. *The Times*, 8 January 1828 • **124**. ibid., 11 January 1828 • **125**. ibid., 16 April 1828 • **126**. *Diary* III, footnote 2, p.215 • **127**. *The Times*, 6 October 1828 • **128**. 5 January 1829, fMS ENG 1331 (18) v.XV f172 (Houghton) • **129**. 7 January 1829, ibid., f171 (Houghton) • **130**. *The Times*, 13 April 1829 • **131**. ibid., 10 April 1829 • **132**. *Literary Gazette*, 11 April 1829 • **133**. *The Times*, 23 April 1829 • **134**. Cited by Philon for his *Phoenician History* • **135**. Now Gray's Inn Road • **136**. *The Times*, 5 March 1829 • **137**. ibid. • **138**. ibid., 6 October 1828 • **139**. Now Marylebone Road • **140**. A sketch, labelled 'St George's, Hanover Square, for the background of "Punch"', is reproduced by Pope in *Diary* III, p.401. However, the building is identifiable, as is the one used in the painting as St Mary's. • **141**. See letter to Mitford, 8 March 1830, *C&TT* II, pp.131–132. BRH mentions the catastrophe at the end of a long journal entry for 22 February. See *Diary* III, p.427. • **142**. Strutt was one of the benefactors who responded to BRH's letter to the *Morning Chronicle* on 12 July 1827. 'My dear Friend Strutt has again helped me effectually by taking all the remaining Shares of Eucles', he recorded on 31 July 1829 (*Diary* III, p.384). • **143**. See Whitley, *Art in England 1821–1837*, p.196. BRH refers to him as 'Neuman Smith', 23 May 1844 (*Diary* IV, p.365). • **144**. *The Times*, 6 April 1830 • **145**. ibid., 14 April 1830 • **146**. ibid. • **147**. See *C&TT* I, p.153 • **148**. Whitley, op. cit., pp.196–197 • **149**. King Street was demolished in the mid-1880s as Shaftesbury Avenue was cut through from New Oxford Street to Piccadilly Circus. • **150**. *The Times*, 21 May 1830 • **151**. ibid., 27 May 1830 • **152**. 20 May 1830, WFD/HA/7 (Queen Mary) • **153**. 24 May 1830, WFD/HA/8–9 (Queen Mary) • **154**. 29 May 1830, fMS ENG 1331 (20) v.XVII f19 (Houghton) • **155**. 21 June 1830 (Mulgrave Castle) • **156**. 16 April 1831, (Mulgrave Castle) • **157**. Auction catalogue, 1846, p.16

5. Campaigns: 1830–41

1. 7 November 1811, *C&TT* II, pp.216–217 • **2**. December 1828, *C&TT* II, p.219 • **3**. 12 December 1828, fMS Eng 1331 (20) v.XVII f99 (Houghton) • **4**. February 1829, *C&TT* II, p.219 • **5**. 4 February 1829, fMS ENG 1331 (20) f122 (Houghton) • **6**. 8 February, ibid., f124v (Houghton) • **7**. ibid., f43 (Houghton) • **8**. fMS

ENG 1331 (18) f118 (Houghton) • **9**. *The Times*, 5 June 1830 • **10**. BRH to his wife, 20 July 1830, fMS ENG 1331 (20) v.XVII f55v (Houghton) • **11**. *The Times*, 20 July 1830 • **12**. 2 September 1830, fMS ENG 1331 (20) v.XVII f68v (Houghton) • **13**. 12 October 1830, ibid., f78 (Houghton) • **14**. 14 October 1830, ibid., ff79v–80 (Houghton) • **15**. 18 October 1830, ibid., f82 (Houghton) • **16**. Quoted Edward Pearce, *Reform!*, p.60 • **17**. *The Times*, 16 November 1830 • **18**. *Kent Herald*, quoted in *The Times*, 30 October 1830 • **19**. Quoted in *The Times*, 14 October 1830 • **20**. ibid., 30 October 1830 • **21**. ibid., 14 October 1830 • **22**. 11 October 1830, fMS ENG 1331 (20) v.XVII f77 (Houghton) • **23**. BRH also wrote that, of the £75,000 spent buying pictures, he had benefited by only sixty pounds. The reference is puzzling because there is no record of the British Institution buying any work by Haydon, however cheaply. • **24**. *The Times*, 8 November 1830 • **25**. Alderman Key's letter was quoted in full in *The Times*, 9 November 1830 • **26**. 8 November 1830, fMS ENG 1331 (20) v.XVII f86 (Houghton) • **27**. 11 November 1830, ibid., f87 (Houghton) • **28**. 12 November 1830, ibid., f87v • **29**. Wellington had tendered his resignation to the King on the morning of 16 November and announced it in the Lords that afternoon. It was reported in *The Times* the following morning. • **30**. 23 November 1830, fMS ENG 1331 (20) v.XVII f89 (Houghton) • **31**. 27 November 1830, ibid., f90 (Houghton) • **32**. *The Mirror of Literature, Amusement, and Instruction*, Vol. 17, No. 486, 23 April 1831 • **33**. *The Times*, 5 April 1831 • **34**. No date, fMS ENG 1331 (20) v.XVII f118 (Houghton) • **35**. ibid., f125 (Houghton) • **36**. 27 April 1831, BRH to J.S. Dyer, fMS ENG 1331 (20) v.XVII f126 (Houghton) • **37**. *The Times*, 7 May 1831 • **38**. 27 May 1831, fMS ENG 1331 (20) v.XVII f126 (Houghton) • **39**. 'To B.R. Haydon, on Seeing his Picture of Napoleon Buonaparte on the Island of St Helena' • **40**. 22 June 1831, fMS ENG 1331 (20) v.XVII f150 (Houghton) • **41**. Undated, but written April 1835, fMS ENG 1331 (24) v.XXI f45 (Houghton) • **42**. Everett to BRH, 22 September 1831, fMS ENG 1331 (20) v.XVII f184 (Houghton) • **43**. 23 September 1831, fMS ENG 1331 (20) v.XVII f183v (Houghton) • **44**. cf: 'Attorney-General Sir John Holker: "The labour of two days is that for which you ask two hundred guineas?" Whistler: "No. I ask it for the knowledge I have gained in the work of a lifetime." (Applause)'. His Honour Judge Parry, 'Whistler versus Ruskin', *Cornhill Magazine*, January 1921, p.24. • **45**. *The Times*, 8 October 1831 • **46**. ibid., 20 October 1831 • **47**. *Haydon's Pictures of Xenophon, Mock Election &c. &c. &c.*, 1832, p.7 • **48**. Quoted Pearce, *Reform!*, p.206 • **49**. *Examiner*, 24 July 1820, quoted in *The Times*, 28 May 1821 • **50**. *The Times*, 19 November 1831 • **51**. The third letter from 'Radical, Junior' appeared on 31 March 1832. Pope appears to have confused this with one published on 27 March and signed 'Radical' (see *Diary* IV, footnote 6 p.27). However, BRH is unlikely to have been this correspondent, who wrote as one who had 'been in America'. • **52**. *Gentleman's Magazine*, March 1832 • **53**. Lot 52, Sotheby's London (Wednesday 10 April 1991), measured only

8x9½ feet. • **54**. *Gentleman's Magazine*, op. cit. • **55**. *Haydon's Pictures . . .* , p.8
• **56**. See Alexander Sommerville, *The Autobiography of a Working Man*, 1848
(Fitzroy edition, MacGibbon & Kee, 1967, p.163) • **57**. *The Times*, 18 May 1832.
The size and setting of the meeting were not entirely unprecedented. Just
six days before, 'a hundred thousand' had assembled in the same place, 'spon-
taneously . . . upon only 3 hours notice'. See Atwood to BRH, 12 May 1832,
fMS ENG 1331 (21) v.XVIII f69 (Houghton) • **58**. 24 May 1832, ibid., f66 • **59**.
From H. Wheatley, no date, ibid., f68 (Houghton) • **60**. 26 May 1832, ibid.,
f70 (Houghton) • **61**. 30 May 1832, ibid., f77 (Houghton) • **62**. 30 May 1832,
ibid., f69 (Houghton) • **63**. *Examiner*, 3 June 1832 • **64**. Inscribed by BRH on
his portrait drawing in the Birmingham Reference Library • **65**. fMS ENG
1331 (21) v.XVII f78v (Houghton) • **66**. *Examiner*, 24 June 1832 • **67**. Hutton to
BRH, 25 July 1832, fMS ENG 1331.1 (43) (Houghton) • **68**. *C&TT* II, p.369
• **69**. See B.J. Barlow's 'Benjamin Robert Haydon and the Radicals', *Burlington
Magazine*, September 1957 • **70**. *London*, Vol. V, ed. Charles Knight, London:
Henry Bohn, 1851, p.85 • **71**. *The Times*, 12 July 1832 • **72**. *Description of Haydon's
Picture of the Reform Banquet, painted for the Right Hon. Earl Grey*, 1834 • **73**. 13
July 1832, WC/HA/21 (Queen Mary) • **74**. 9 July 1832, fMS ENG 1331 (21)
v.XVIII f85 (Houghton) • **75**. BRH to Newton, op. cit. (Queen Mary) • **76**. The
sixth son of George III, brother to William IV • **77**. *Annual Register*, 1833, pp.314–319
• **78**. Peel was replying to Cobbett's resolution that the House 'present an
humble address to His Majesty to be graciously pleased to remove the right
hon. Sir Robert Peel from His Majesty's most hon. Privy Council, on account
of the proceeding of the said right hon. Baronet relative to the currency acts
of 1819, 1822 and 1826' (*The Times*, 17 May 1833). The not altogether serious reso-
lution had to do with Peel's navigation of bills abolishing paper currency and
returning the country to gold cash payments and the financial distress the meas-
ures had caused. • **79**. *The Times*, 21 May 1833 • **80**. ibid. • **81**. ibid., 31 May 1833
• **82**. According to BRH's journal for 28 June 1833, 'Dear Lady Seymour . . .
wished to be God-Mother to my dear little *just-born*. This is a great honor'
(*Diary* IV, p.105). A later reference, of 7 June 1835, has 'Lady Seymour & Mrs
Norton were God Mothers & Lord Seymour God Father' (*Diary* IV, p.289).
• **83**. *Diary* IV, footnote 3, p.109 • **84**. 3 July 1835, note by BRH, 'Mary Haydon's
Commonplace Book', fMS ENG 1331 (163) p.23 (Houghton) • **85**. *The Times*,
24 March 1834 • **86**. No date, fMS ENG 1331 (23) v.XX f33v (Houghton) • **87**. 24
April 1834, fMS ENG 1331 (23) v.XX f34 (Houghton) • **88**. *Fraser's Magazine for
Town and Country*, June 1834 • **89**. See Sutherland to BRH, 3 July 1834, fMS ENG
1331 (23) v.XX f59 (Houghton) • **90**. 'Mary Haydon's Commonplace Book', op.
cit., p.1 (Houghton) • **91**. ibid., pp.1–3 (Houghton)• **92**. Norton to BRH, no date,
fMS ENG 1331 (22) v.XIX f73 (Houghton) • **93**. Norton to BRH, 23 June 1834,
fMS ENG 1331 (22) v.XIX f56v (Houghton) • **94**. 'Mary Haydon's Commonplace
Book,' op. cit., p.3 (Houghton) • **95**. ibid., p.13 (Houghton) • **96**. BRH to Barrett,

7 March 1843, *IF*, p.45 • **97**. See *Diary* IV, p.221. The building was completed in 1829, demolished in 1913. • **98**. Broadsheet, *Dreadful Fire, And total destruction of both Houses of Parliament*, cat. 108, *Making History (Antiquaries in Britain 1707–2007*, London, 2007) • **99**. BRH to Peel, 25 February 1835, fMS ENG 1331 (24) v.XXI f31 (Houghton) • **100**. Apart from an oil sketch, now lost, with which he tried to gain a commission from Peel (see above). • **101**. Later he remembered it as 'Mrs Fox has put off her dinner' (see *Diary* IV, p.254) • **102**. Isaiah, Ch. XXXV, Verse 4 • **103**. fMS ENG 1331 (24) v.XXI ff6v (Houghton) • **104**. ibid., f7 (Houghton) • **105**. 22 January 1835, ibid., f8 (Houghton) • **106**. 11 February 1835, ibid., f19 (Houghton) • **107**. *The Times*, 4 March 1835 • **108**. ibid., 19 March 1835 • **109**. ibid., 26 March 1835 • **110**. *C&TT* I, p.192 • **111**. *Lectures* I, p.viii • **112**. ibid., p.1 • **113**. ibid., p.3 • **114**. ibid., p.13 • **115**. *The Times*, 10 September 1835. The phrase mentioned does not appear in the published version of the lecture. • **116**. *Lectures* I, pp.35–37 • **117**. *Works of Henry, Lord Brougham: A Discourse on Natural Theology*, 1856, p.69 • **118**. The inquest, reported in *The Times* of 4 November 1818, heard testimony that, having cut through his windpipe, Romilly was unable to speak, but made signs. Paper, pen and ink were given to him and he managed to write the barely legible words 'Sir, witness', but the 'remaining marks of the pen were feebly traced, and might be compared to those an infant would produce for its amusement'. • **119**. Three days later he wrote another version, altering the last line to 'But defy both the bowl & the Knife', and added a further three verses. He entitled it 'Haydon's 3 blessings', and dedicated it 'To his dearest Mary' (*Diary* IV, pp.322–323). • **120**. *Lectures* I, p.104 • **121**. 14 January 1836, fMS ENG 1331 (24) v.XXI f108 (Houghton) • **122**. 23 February 1836, fMS ENG 1331 (24) v.XXI f115 (Houghton) • **123**. 25 February 1836, ibid., (Houghton) • **124**. 26 February 1836 ibid. f115v (Houghton) • **125**. *The Times*, 30 January 1837 • **126**. *A&M*, footnote p.597 • **127**. Dickens, *Great Expectations* (Penguin edition, p.366) • **128**. 30 March 1836, fMS ENG 1331 (24) v.XXI f124 (Houghton) • **129**. 13 April 1836, WFD/HA/39 (Queen Mary) • **130**. 'Haydon's Lectures', anonymous newspaper cutting stuck into fMS ENG 1331 (24) v.XXI (Houghton) • **131**. *Lectures* I, p.330 • **132**. 'Haydon's Lectures', op. cit. (Houghton) • **133**. It is not known how much he was paid, but later in the year he gave a series of three more lectures at the Milton Theatre for which he received ten guineas. • **134**. *The Times*, 11 May 1836 • **135**. ibid. • **136**. ibid, 23 June 1836 • **137**. Quoted Norton to BRH, 7 August 1836, fMS ENG 1331 (24) v.XXI f159 (Houghton) • **138**. 6 August 1836, fMS ENG 1331 (24) v.XXI f157–8 (Houghton) • **139**. 22 August 1836, fMS ENG 1331 (24) v.XXI f159v (Houghton) • **140**. *The Times*, 18 July 1835 • **141**. House of Commons, 'Report on Arts and Manufactures', para. 1063, *Parliamentary Papers*, 1836, ix (568), I, session II • **142**. Holger Hoock, *The King's Artists*, pp.303–304 • **143**. *C&TT* I, p.196 • **144**. 16 September 1836, fMS ENG 1331 (24) v.XXI f173v (Houghton) • **145**. 26 October 1836, BL Add.

40422 f131 (British Library) • **146**. 16 September 1836, fMS ENG 1331 (24) v.XXI f172v (Houghton) • **147**. The controversial theory of Mary's genealogy was that of Annius of Viterbo in the late fifteenth century. See I. Howard Marshall, *The Gospel of Luke: A Commentary on the Greek Text*, 1978 • **148**. He was 'less in debt', he told Peel, 'than ever in my Life, yet being unable to meet in time the balance due, [he was] a Victim to that cursed law of Imprisonment'. BL Add. 40422 f131 (British Library). • **149**. *The Times*, 18 November 1836 • **150**. *Lectures* II, p.97 • **151**. ibid., p.99 • **152**. ibid., p.100 • **153**. 11 January 1837, *C&TT* II, p.233 • **154**. BRH to Charles Poulett Thomson, President of the Board of Trade. *C&TT* II, p.234, misdates this as 28 January 1837. According to BRH's journal (see *Diary* IV, p.463), the visit took place in February 1838. • **155**. 6 March 1837, fMS ENG 1331.1 (93) (Houghton) • **156**. *The Times*, advertisement, 13 January 1837 • **157**. ibid., 1 March 1837 • **158**. John Craig to BRH, 25 February 1837, WC/HA/42 (Queen Mary) • **159**. *Edinburgh Evening Courant*, 17 March 1837 • **160**. ibid., 30 April 1837 • **161**. An extensive but unidentified press report is attached to fMS ENG 1331 (24) v.XXI (Houghton). Thomas Murray wrote to BRH the day after the dinner: 'I do not think any of the reports so full as the Chronicle; though even there it cannot be given *ad longum*.' fMS ENG 1331 (24) v.XXI f5v (Houghton). • **162**. The following year this train would accomplish the journey in the opposite direction, at an average speed of forty-five miles per hour, in just forty-one minutes. • **163**. The 1828 Lawrence portrait currently hangs below *The Reform Banquet* in the west wing of Howick Hall. • **164**. Lowndes to BRH, 5 September 1837, includes a copy of committee meeting proceedings. fMS ENG 1331 (25) v.XXIA f31 (Houghton). • **165**. Nathaniel Sheldon, *A Journal of a Residence During Several Months in London*, 1830, p.28 • **166**. 'On the Effect of the Different Societies in Literature, Science, and Art, on the taste of the British Nobility and People' (first delivered 23 December 1836), *Lectures* II, p.115 • **167**. BRH to Wordsworth, 15 April 1817, *C&TT* II, p.34 • **168**. *Painting and the Fine Arts*, p.222 • **169**. ibid., p.122 • **170**. ibid., p.149 • **171**. ibid., p.148 • **172**. ibid., p.165 • **173**. ibid., p.155 • **174**. ibid., p.169 • **175**. ibid., p.206 • **176**. ibid., pp.219–220 • **177**. The lady's identity is not known. • **178**. Stanley to BRH, 31 December 1837, fMS ENG 1331 (68) (Houghton) • **179**. *Diary* IV, footnote 6, p.489 • **180**. Stanley to BRH, op. cit. (Houghton) • **181**. 16 January 1839, fMS ENG 1331 (26) v.XXII f119 (Houghton) • **182**. *Liverpool Mail*, 27 October 1838 • **183**. *Liverpool Journal*, 27 October 1838 • **184**. *Liverpool Mail*, 27 October 1838 • **185**. *Diary* IV, footnote 8, p.629 • **186**. *A&M*, p.601 • **187**. 4 February 1839, fMS ENG 1331 (26) v.XXII f125 (Houghton) • **188**. 21 December 1838, ibid., f113 (Houghton) • **189**. See fMS ENG 1331 (26) v.XXII ff140v–141 (Houghton) • **190**. 24 May 1839, ibid., f141v (Houghton) • **191**. The words were to have been inscribed on the pedestal of the statue inside the temple, but there is a drawing of the exterior in BRH's journal, in which it appears on the tympanum and frieze. *The Times*, 7 August 1846,

reported the inscription as 'A little man with a mighty heart' in BRH's oil sketch sold at auction after his death. • **192**. 11 May 1839 (Hornby Library, Liverpool) • **193**. Wellington to BRH, 17 May 1839, fMS ENG 1331 (26) v.XXII f137 (Houghton) • **194**. BRH to Wellington, 26 June 1839, fMS ENG 1331 (26) v.XXII f152 (Houghton) • **195**. 27 June 1839, ibid., f154 (Houghton) • **196**. See also: 'The rolling countryside . . . has been disfigured for its own glorification, robbed of its natural contours to make a funeral monument, so that history, put out of countenance, can no longer recognise herself. Returning to Waterloo two years later, Wellington exclaimed: "They have changed my battlefield!"' Victor Hugo *Les Miserables* 1862 (trans. Norman Denny, Penguin one-volume edition, 1982, p.297) • **197**. 9 October 1839, fMS ENG 1331 (26) v.XXII f177 (Houghton) • **198**. Possibly the six-year-old Arthur Edward Holland Grey, future 3rd Earl of Wilton Castle and 1st Baron Grey de Radcliffe. His parents were close friends of Wellington. • **199**. Publicity leaflet stuck into fMS ENG 1331 (26) v.XXII (Houghton) • **200**. The old Ashmolean was at this time, and until the mid-1840s, housed in the seventeenth-century building on Broad Street which now contains the city's Museum of History of Science. • **201**. BRH to Newton, 3 March 1840, WC/HA/49 (Queen Mary) • **202**. *The Diaries of John Ruskin*, ed. Evans and Whitehouse, Oxford, 1956, Vol. 1, p.74 • **203**. ibid., pp.75–76 • **204**. BRH to Newton, op. cit. (Queen Mary) • **205**. *Athenaeum*, 21 March 1840 • **206**. *The Times*, 18 March 1840 • **207**. *Diary* IV, footnote 4, p.622 • **208**. ibid., footnote 3, pp.621–622 • **209**. ibid., footnote 8, p.629 • **210**. ibid., footnote 9 • **211**. *Description of Haydon's Picture of the Greet Meetings of Delegates . . . for the Abolition of Slavery and the Slave Trade*, 1841, p.7 • **212**. *The Times*, 13 June 1840 • **213**. *Description*, op. cit., p.9 • **214**. *The Times*, 13 June 1840 • **215**. *Slavery and 'The Woman Question': Lucretia Mott's Diary of Her Visit to Great Britain to Attend the World's Anti-Slavery Convention of 1840*, ed. Frederick B. Tolles (Supplement No. 23 to the *Journal of the Friends' Historical Society*, Haverford, Pa., and London), 1952, p.29 • **216**. Lucretia Mott's reception at the 1840 London Convention was to have far-reaching consequences. It is said to have inspired her to establish, with Elizabeth Cady Stanton, the Seneca Falls Convention of 1848, the origin of the modern Movement for Women's Rights. Lucretia Mott's husband, James Mott, appears in BRH's picture at number 92. • **217**. BRH to Elizabeth Barrett, 8 April 1843, *IF*, p.74 • **218**. *Description* op. cit, p.10 • **219**. See ibid. (83), Edward Barrett, delegate for Western Baptist Union, Jamaica • **220**. ibid., p.10 • **221**. ibid., p.11 • **222**. Manuscript diaries of Henry Peak, Volume C, Chapter 12, p.210 (Surrey Historical Centre, Woking) • **223**. Charles Lear to his brother James, 30 April 1841 (found among uncatalogued papers in the Athenaeum, Liverpool) • **224**. *Description*, op. cit., p.12 • **225**. Lines 9–12 in the standard published text read: 'In his calm presence! Him the mighty deed / Elates not, brought far nearer the grave's

rest, / As shows that time-worn face, for he such seed / Has sown as yields, we trust, the fruit of fame' (Wordsworth, *The Poems* II, ed. John O. Hayden). • **226**. Made with hot water, sugar and spices. Dr Elliotson, in *The Zoist*, April 1854, wrote reprovingly that BRH's excitable nature was 'increased by drinking quantities of hot port-wine negus (and it was strongly sugared); and he really drank hard and was once intoxicated just before his death. An honest man in his straitened circumstances would not have spent a farthing in alcoholic drinks. Stimulants were poison to him. Even flesh was improper for such a man. Had he been a strict water-drinker, he would have been less passionate and impetuous, less unhappy, and possibly been still alive.' ('An account of the living and dead brain of the late Mr Benjamin Robert Haydon, Historical painter', James Straton, Esq. of Aberdeen, and some other gentlemen.) • **227**. Thomas Moor to BRH, 1 December 1840, *C&TT* I, p.242 • **228**. 25 December 1840, ibid., p.424 • **229**. 7 December 1840, WFD/HA/50/1 (Queen Mary) • **230**. Reverend Francis Augustus Cox (22), Samuel Bowley (20) and Reverend B. Godwin (69) • **231**. 19 March 1841, BL Add. 41267 A. f232 (British Library) • **232**. *The Times*, advertisement, 7 May 1841 • **233**. This clipping and that from the *Post* were stuck into BRH's journal and dated 10 May 1841 • **234**. *Morning Post*, 10 May 1841 • **235**. See *Diary* V, p.55 • **236**. *Morning Chronicle*, 9 June 1841 • **237**. Published 1829 • **238**. 18 June 1841, BL Add. 40429 f334 (British Library) • **239**. Quoted Clarke Olney, *Benjamin Robert Haydon, Historical Painter*, 1952, p.225 • **240**. Westminster Hall would never be decorated; the paintings on the theme 'The Building of England' in St Stephen's Hall would not be executed until the 1920s; Daniel Maclise would produce the two long friezes, *The Death of Nelson* and *The Meeting of Wellington and Blucher after the Battle of Waterloo*, in the Royal Gallery; the Queen's Robing Room would be adorned by frescoes on the theme of the Arthurian legends, by William Dyce; Sir Edward Poynter would be responsible for designing mosaics for the Central Lobby. • **241**. When the Committee enquired of Barry what subjects would be most appropriate, the witness replied that 'they should have reference to the object of the building, and as this building is for state purposes, the subjects most applicable would be those which refer to great events in English history'. Asked whether he 'would prefer historical paintings to allegorical, or anything of that kind', Barry replied: 'Most decidedly'. (*Report from the Select Committee on Fine Arts*, 1841 (423), Vol. VI, para 72–73.) • **242**. ibid., para 428 and 333 • **243**. ibid., para 168 and 277 • **244**. BRH to Peel, 10 August 1841, 'No man has given his evidence with more spirit, sense, and manliness than Sir Martin Shee' (*C&TT* II, p.236) • **245**. The 'old way in Fresco' that BRH had researched was that prescribed by Cennino di Drea Cennini da Colle of Valdelsa (b. 1370), mentioned by Vasari as author of the book *Trattato della Pittura*. Cennini's pedigree was unimpeachable so far as BRH was concerned: 'he was a pupil of Agnolo Gaddi, who was a pupil of the Greeks . . . his precepts were handed through this succession of the great masters to himself' (*Lectures* I, p.170). Instead of one

part sand to two parts lime, Cennini stipulated: 'due parti de sabbione, la terza parte calcina'. • **246**. *Lectures* II, p.162 • **247**. ibid., p.163 • **248**. *C&TT* I, pp.211–212 • **249**. BRH to Mitford, *C&TT* II, p.137 • **250**. *The Times*, 6 May 1845

6. Into the Gulf: 1842–46

1. James Newman, 24 Soho Square • **2**. *Annals of Ancient Rome* VII, 6 (trans. B.O. Foster) • **3**. *The Times*, 8 February 1842 • **4**. *Lectures* II, p.161 • **5**. Possibly the Duke of Sutherland, but BRH withheld the name. The letter is no longer attached to the journal. • **6**. Barrett to BRH, April 1842, *IF*, p.1 • **7**. 6 November 1842, ibid., p.11 • **8**. The Academy had moved from Somerset House in 1837 to occupy the eastern half of the National Gallery. It would move again to Burlington House in 1869. • **9**. 5 May 1842, fMS ENG 1331 (28) v.XXIV f50 (Houghton) • **10**. *Morning Post*, 25 April 1842 • **11**. 'The story that he reached the age of 99 is untrue, being based on Titian's false claims for the purpose of extracting money from the King of Spain', *Oxford Companion to Art* • **12**. See Robert Woof, 'Haydon, Writer, and the Friend of Writers', *Benjamin Robert Haydon* (Wordsworth Trust), 1996, p.51 • **13**. *The Times*, 27 May 1842 • **14**. BRH to Barrett, 16 August 1843, *IT*, p.140 • **15**. Conrad Loddiges & Sons • **16**. BRH consulted George Léopold Chrétien Frédéric Dagobert Cuvier's celebrated five-volume work, *Régne animal distribué d'après son organisation*, 1829–1830, and Patrick Russell's two-volume *Account of Indian Serpents Collected on the Coast of Coromondel* of 1796–1809. In the latter work he would have identified the snake that killed his stepson Simon, but nowhere among its elaborate illustrations is there anything that can have served as a source for the animal that featured in his cartoon. • **17**. Barrett to Mitford, 13 October 1842, *IF*, footnote 3 p.3 • **18**. Barrett to BRH, 13 October 1842, ibid., p.3 • **19**. Barrett to Mitford, op. cit. • **20**. Barrett to BRH, op. cit. • **21**. *Athenaeum*, 1 October 1842. Wordsworth had suggested the alteration: 'By a vision free / And noble, Haydon, is thine art release'. • **22**. BRH to his sister Harriet Haviland, 28 October 1842, *C&TT* I, p.429 • **23**. BRH to Barrett, 8 March 1843, *IF*, p.46 • **24**. *Morgenblatt für gebildete Leser*, 23 August 1842 • **25**. Translation by Waltraud Boxall and Axel Höptner • **26**. *Spectator*, 8 November 1842. Other letters appeared on 12 November and 2, 10 and 24 December. • **27**. Translation by Boxall and Höptner • **28**. See Diary V p.218 • **29**. Barrett to BRH, 8 December 1842, *IF*, pp.14–15 • **30**. Bell Scott, *Autobiographical Notes*, p.168 • **31**. ibid., p.167 • **32**. ibid., p.168 • **33**. *Poems*, 1854, p.171 • **34**. 31 January 1843, *IF*, p.28 • **35**. *Morning Chronicle*, 6 February 1843. 'This is decidedly the finest work on a large scale in the exhibition.' • **36**. John Kenyon, poet and philanthropist • **37**. Barrett to BRH, 7 February 1843, *IF*, p.29 • **38**. *Athenaeuem*, 25 February 1843 • **39**. *Spectator*, 11 February 1843 • **40**. *Athenaeum*,

op. cit. • **41**. *Illustrated London News*, 8 April 1843 • **42**. *Art Union*, March 1843 • **43**. *Illustrated London News*, 18 March 1843 • **44**. *Spectator*, op. cit. • **45**. 7 March 1843, IF, p.46 • **46**. ibid. • **47**. 9 February 1843, ibid., p.30 • **48**. 1 March 1843, fMS ENG 1331 (29) vXXV f6 • **49**. No date, fMS ENG 1331 (29) vXXV f7 • **50**. BRH to Barrett, 16 March 1843, IF, p.48 • **51**. BRH to Barrett, 19 March 1843, ibid., p.79 • **52**. BRH to Barrett, 22 April 1843, ibid., p.84 • **53**. BRH to Barrett, 19 June 1843, ibid., p.116 • **54**. BRH to Barrett, 11 May 1843, ibid., p.96 • **55**. Only Phillips, of the 1809 Committee of Arrangement, served on that of 1843, the others being Chalon and Jones. Shee, however, as President, could have exerted influence *ex officio*, as Benjamin West did in 1809. • **56**. BRH to Barrett, 16 May 1843, ibid., p.98 • **57**. Frith, *Autobiography and Reminiscences*, p.56 • **58**. 3:55, 57: 'I called upon thy name, O Lord, out of the low dungeon . . . Thou drewest near in the day that I called upon thee: thou saidst, "Fear not".' • **59**. 71:18: 'Now also when I am old and grey-headed, O God, forsake me not; until I have shewed thy strength unto this generation, and thy power to every one that is to come.' • **60**. Rogers to BRH, July 1842, fMS ENG 1331 (28) vXXIV f94 • **61**. June 1843, fMS ENG 1331 (29) vXXV f54 • **62**. BRH to Barrett, 27 June 1843, IF, p.118 • **63**. Barrett to BRH, 2 July 1843, ibid., p.120 • **64**. BRH to Barrett, 3 July 1843, ibid., p.121 • **65**. *Autobiographical Notes*, p.171 • **66**. Recounted by Frith, *Autobiography and Reminiscences*, p.225 • **67**. *Athenaeum*, 15 July 1843 • **68**. BRH to Barrett, 18 July 1843, IF, p.128 • **69**. Barrett to BRH, [19] July 1843, IF, p.130 • **70**. BRH to Barrett, 20 July 1843, IF, pp.132–133 • **71**. BRH to Barrett, 29 July 1843, IF, p.136 • **72**. BRH to Barrett, 8 August 1843, IF, pp.137–138 • **73**. *The Times*, 10 August 1843 • **74**. ibid., 10 August 1843, attached to fMS ENG 1331 (29) vXXV f72 (Houghton) • **75**. BRH to Barrett, 20 August 1843, IF, p.149 • **76**. BRH to Barrett, 9 November 1843, ibid., p.159 • **77**. BRH to Barrett, 29 November 1843, ibid., p.164 • **78**. BRH to Barrett, 19 December 1843, ibid., p.166 • **79**. BRH to Barrett, 21 January 1844, ibid., p.168 • **80**. BRH to Barrett, 6 February 1844, ibid., p.170 • **81**. Attached to fMS ENG 1331 (29) vXXV f125 (Houghton) • **82**. BRH to Barrett, 6 February 1844, IF, p.172 • **83**. *Pictorial Times*, 3 February 1844. An engraving of *The Curse* appeared in the same publication on 20 April 1844. • **84**. BRH to Barrett, 26 February 1844, IF, pp.172–3 • **85**. Not the present building (1914), or the one that preceded it (1876), but the one that preceded that (1826). • **86**. Attached to fMS ENG 1331 (29) vXXV f134 (Houghton) • **87**. *The Times*, advertisement, 4 April 1844 • **88**. op. cit. (Houghton) • **89**. BRH to his wife, 9 April 1844, C&TTI, pp.446–447 • **90**. BRH to Barrett, 9 April 1844, IF, p.174 • **91**. Announced in *The Times*, 15 July 1844 • **92**. *The Spirit of Religion, The Spirit of Justice, The Spirit of Chivalry, The Baptism of Ethelbert, Prince Henry Acknowledging the Authority of Justice Gascoigne* and *The Black Prince Receiving the Order of the Garter* • **93**. *The Times*, 16 July 1844. The six subjects for the Lords' Chamber were eventually executed by four of the original six painters: Cope, Dyce, Horsley and Maclise. • **94**. *The Times*, 6 May 1844 • **95**. 29 June 1844, fMS ENG

1331 (29) vXXV f163v (Houghton) • **96**. BRH to Barrett, 19 December 1843, *IF*, p.166 • **97**. '. . . *aged* 18, Aug. 22, 1804 – *Extract from a letter to a friend of his youth, Thomas Macdonald*' • **98**. *Quarterly Review*, December 1844 • **99**. *Art Union*, 1 January 1845 • **100**. *Description of Haydon's Two Pictures*, 1846, p.1 • **101**. BRH to Wood, 16 July 1845, fMS ENG 1331 (30) vXXVI f130v (Houghton) • **102**. *Illustrated London News*, 18 July 1846 • **103**. *The Times*, 6 May 1845 • **104**. *Fraser's Magazine*, 'Picture Gossip in a Letter from Michael Angelo Titmarsh', June 1845 • **105**. Dennys to BRH, 10 May 1845, fMS ENG 1331 (30) vXXVI f79 (Houghton) • **106**. Murray to BRH, 3 June 1841, fMS ENG 1331 (27) vXXIII f79 (Houghton) • **107**. BRH to Barrett, early January 1843, IF, p.20 • **108**. Barrett to BRH, 8 January 1843, ibid. • **109**. *Description*, op. cit. • **110**. *The Times*, 19 August 1845 • **111**. Agreement between BRH and David Nathan Fisher, 19 September 1845, fMS ENG 1331 (156) (Houghton) • **112**. Westmorland to BRH, 17 September 1845, fMS ENG 1331 (30) vXXVI f127v (Houghton) • **113**. BRH to Wood, 30 September 1845, ibid, ff131–132 (Houghton) • **114**. Reverend J.H. Earle to BRH, 15 October 1845, fMS ENG 1331 (33), 'Genealogical Scrapbook', p.14 (Houghton) • **115**. BRH to Peel, 3 November 1845, BL Add. 40577 f342 (British Library) • **116**. Young (for Peel) to BRH, 7 November 1845, fMS ENG 1331 (30) vXXVI f141 (Houghton) • **117**. *Lectures* I, p.64 • **118**. BRH made several mathematical errors in the statement made on 11 January 1846. The totals given here, calculated from his figures, are correct. • **119**. See Xenophon (Hell. p.2.3–4). There is only one reference to this subject in BRH's journal, below a rough compositional sketch. It reads: 'Satyrus seizing Theramenes in the midst of the 30 Tyrants'. He had presumably confused Critias, the author of a number of tragedies, with Satyrus, whose biographies of kings, statesmen, orators, philosophers and poets are known only from fragments and citations in the works of others. • **120**. Invitation card, inscribed thus, attached to fMS ENG 1331 (30) vXXVI (Houghton) • **121**. Lockhart to BRH, 4 April 1846, fMS ENG 1331 (30) vXXVI f183 (Houghton) • **122**. *The Times*, 6 April 1846 • **123**. *Morning Herald*, 6 April 1846 • **124**. *The Times*, advertisement, 11 and 13 April 1846 • **125**. Dickens to Thomas Chapman, 3 July 1846, *Letters* IV, p.576 • **126**. Bayard Taylor, quoted Alethea Hayter, *A Sultry Month*, p.22 • **127**. The clipping is attached between the journal entries for 26 and 27 May 1846, fMS ENG 1331 (30) vXXVI (Houghton) • **128**. BRH to Peel, 15 June 1846, BL Add. 40593 f309 (British Library) • **129**. See *Diary* V, p.556 • **130**. See Hayter, *A Sultry Month*, pp. 47–48 • **131**. *The Times*, 16 June 1846 • **132**. See *C&TT* I, p.233 • **133**. Frederic Scott Haydon to H. Buxton Forman, 7 January 1884, quoted *Diary* V, footnote 9, p.551 • **134**. Peel to BRH, 16 June 1846, BL Add. 40593 f311 (British Library) • **135**. *C&TT* I, p.236 • **136**. *The Times*, 14 August 1822 • **137**. BRH to Mitford, 7 July 1828, *C&TT* II, p.124 • **138**. BRH to Peel, 15 June 1846, BL Add. 40593 f309 (British Library) • **139**. *C&TT* I, p. 236 • **140**. In *The Times* report of the inquest, the barrel was described as being 'about two inches bore'. Clearly a mistake. • **141**. BRH to Peel, 22 June 1846, BL Add. 40593 f316 (British

Library) • **142**. *The Times*, 25 June 1846 • **143**. fMS ENG 1331.1 (32–33) (Houghton) • **144** ibid. (91) (Houghton)

Post-Mortem

1. *Bleak House* (Penguin edition), p.174 • **2**. Thomas Wakely (1795–1862). Born in Membury, Devon, and a practising surgeon in London from 1818, he was the founder and first editor of the *Lancet*, Member of Parliament for Finsbury (1835–1852) and coroner from 1839. • **3**. *The Times*, 25 June 1846 • **4**. *Diary* V, p.142 • **5**. *C&TT* I, p.237 • **6**. Peel to Coulton, 23 June 1846, fMS ENG 1331.1 (pp.138–139) (Houghton) • **7**. *The Zoist*, April 1854, pp. 72–73 • **8**. *The Times*, op. cit. • **9**. fMS 1331.1 (p.138–139) (Houghton) • **10**. Julia Peel to Mrs Haydon 27 June 1846, ibid. (137) (Houghton) • **11**. *Annual Register*, June 1846, p.96 • **12**. Royal Academy Council Minutes • **13**. Frith, *Autobiography and Reminiscences*, p.224 • **14**. cf. 'There mark what ills the scholar's life assail, / Toil, envy, want, the patron, and the jail.' *The Vanity of Human Wishes*, lines 158–159. • **15**. See *Diary* V, pp. 555–557 • **16**. The first volume contained BRH's autobiography and the remaining two, a masterly compression of the material covering the years 1821 to 1846 from the manuscript journal, together with letters and linking editorial matter. The manuscript of the autobiography was lost, but the journals were returned by Taylor to the Haydon family when he had completed his work. They were bought from the estate of Frank Scott Haydon's daughter in 1935, by M. Buxton Forman, and sold by him to Willard Bissell Pope in 1951. Pope published his edition of the *Diary* in five volumes in 1960–1963, afterwards presenting the collection – which today comprises thirty-seven leather-bound volumes and boxes – to the Houghton Library, Harvard University. It occupies five linear feet of shelf space. • **17**. *The Zoist*, op. cit., p.72 • **18**. ibid., p.70 • **19**. ibid., p.64 • **20**. ibid., p.46 • **21**. ibid., p.73 • **22**. ibid., pp. 73–74 • **23**. Foster & Son Sale Catalogue (National Art Library) • **24**. *C&TT* I, p.238 • **25**. Frank Scott Haydon to Dr Savage, 3 May 1886, pasted into 'Case Book Males 1884' (Bethlem Royal Hospital Museum) • **26**. BRH to Barrett, 31 August 1844, *IF*, p.177 • **27**. Quoted Paston, *BR Haydon and His Friends*, 1905, p.286 • **28**. Eric George, *The Life and Death of Benjamin Robert Haydon*, second edition, Appendix A, p.388 • **29**. Paston, op. cit., p.291 • **30**. *The Times*, 19 April 1958 • **31**. Paston, op. cit., pp. 285–286 • **32**. 'Case Book Males 1884' (Bethlem Royal Hospital Museum) • **33**. 30 November 2007, 13:52, To: Richard Humphreys, Cc: Stephen Deuchar; Robin Hamlyn, Subject: RE. Haydon unrolling. • **34**. *The Times*, 1 November 1887. Further details were given in an unidentified newspaper clipping, dated 'October 29th 1887', attached to Frederic Wordsworth Haydon's notes in 'Case Book Males 1884' (Bethlem Royal Hospital Museum).

Select Bibliography

Primary sources

Haydon, B.R., ed. Willard Bissell Pope, *The Diary of Benjamin Robert Haydon*, 5 vols, Cambridge, Mass., 1960–1963 [*Diary* I–V]

Haydon, B.R., ed. Tom Taylor, *The Autobiography and Memoirs of B.R. Haydon*, new edition with an introduction by Aldous Huxley, 2 vols, London, 1926 [*A&M*]

Haydon, B.R., ed. Frederic Wordsworth Haydon, *Correspondence and Table Talk*, 2 vols, London, 1876 [*C&TT* I–II]

Haydon, B.R., *Lectures on Painting and Design*, 2 vols, London, 1844 and 1846 [*Lectures* I–II]

Haydon and Barrett, ed. Willard Bissell Pope, *Invisible Friends: The Correspondence of Elizabeth Barrett and Benjamin Robert Haydon*, Cambridge, Mass., 1972 [*IF*]

Haydon and Hazlitt, *Painting and the Fine Arts, being the articles under those heads contributed to the seventh edition of the Encyclopaedia Britannica*, Edinburgh, 1838 [*Painting and the Fine Arts*]

Secondary sources

Annals of the Fine Arts, ed. John Elmes, 4 vols, London, 1816–1820

Bewick, William, *The Life and Letters of William Bewick (artist)*, ed. T. Landseer, 2 vols, London, 1871 [*Bewick*]

Brown, David Blayney, Woof, Robert and Hebron, Stephen, *Benjamin Robert Haydon: Painter and Writer, Friend of Wordsworth and Keats*, The Wordsworth Trust, 1996

Cunningham, Alan, *The Life of Sir David Wilkie*, 3 vols, 1843 [*Wilkie*]

Farington, Joseph, *The Diary of Joseph Farington*, ed. Garlick, Macintyre, Cave and Newby, 17 vols, 1978–1998 [*Farington*]

Frith, William Powell, *My Autobiography and Reminiscences*, London, 1892

George, Eric, *The Life and Death of Benjamin Robert Haydon*, 1948

Hayter, Alethea, *A Sultry Month: Scenes of Literary Life in 1846*, London, 1965

Hazlitt, William, *The Complete Works of William Hazlitt*, ed, P.P. Howe, 21 vols, 1930–1934 [*Works*]

Hoock, Holger, *The King's Artists: The Royal Academy of Arts and the Politics of British Culture 1760–1840*, Oxford, 2003

Hughes-Hallett, Penelope, *The Immortal Dinner: A Famous Evening of Genius & Laughter in Literary London, 1817*, London, 2000

Hutchison, Sidney C., *The History of the Royal Academy 1768–1986*, London, 1968, [Hutchinson]

Keats, John, *The Letters of John Keats 1814–1821*, ed. Hyder E. Rollins, 2 vols, Cambridge, 1958 [Letters]

Mitford, Mary Russell, *The Life of Mary Russell Mitford, Related in a Selection from her letters to her Friends*, ed. Rev. A.G. L'Estrange, 3 vols, London 1870 [Mitford]

Noon, Patrick et al., *Constable to Delacroix: British Art and the French Romantics*, London, 2003

Olney, Clarke, *Benjamin Robert Haydon, Historical Painter*, Athens, Ga., 1952

Park, Roy (ed.), *Sale Catalogues of Libraries of Eminent Persons*, vol. 9: Poets and Men of Letters, London, 1974

Pearce, Edward, *Reform! The Fight for the 1832 Reform Act*, London, 2003

Pidgley, Michael, *The Tragi-Comical History of B.R. Haydon's 'Marcus Curtius Leaping into the Gulf'*, Exeter, 1986

Reynolds, Sir Joshua, *Discourses on Art*, ed. Robert R. Wark, London, 1975

Robins, Jane, *Rebel Queen: The Trial of Caroline*, London, 2006

Roe, Nicholas, *Fiery Heart: The First Life of Leigh Hunt*, London, 2005

Rollins, Hyder Edward (ed.), *The Keats Circle: Letters and Papers 1816–1878*, 2 vols, London, 1848

St Clair, William, *Lord Elgin and the Marbles*, Oxford, new edition, 1983

Solkin, David H. (ed.) *Art on the Line: The Royal Academy Exhibitions at Somerset House 1780–1836*, 2001

Strong, Roy, Coronation: A History of Kingship and the British Monarchy, London, 2005

Whitley, William T., *Art in England 1800–1820*, Cambridge, 1928

Whitley, William T., *Art in England 1821–1837*, Cambridge, 1930

Wordsworth, Dorothy and William, *Letters of William and Dorothy Wordsworth*, ed. Ernest De Selincourt, revised Mary Moorman and Alan G. Hill, London, 1967–1993 [Wordsworth Letters]

Archives

Bethlem Royal Hospital Museum [Bethlem]
British Library [BL]
British Museum [BM]
Coutts Archive [Coutts]
Houghton Library, Harvard University, Cambridge, Mass. [Houghton]
National Art Library, Victoria and Albert Museum [NAL]
Royal Academy [RA]
Queen Mary College, University of London [Queen Mary]

Acknowledgements

Frank Milner suggested Haydon as a subject and other friends have contributed information: Malcolm Hicks, Edward Morris, Alan Munton, Joseph Sharples, John Vaughan, Phillip Ward-Jackson, Stephen Wildman, David Williams and Ian S. Wood. Thanks to Elpiniki Vavritsa for Greek translations, Waltraud Boxall and Axel Höptner for German; to Richard Williams for research in the Public Records Office; to Marjorie Williams and Roger Nicholas for the intriguing detail of Haydon's manacle collection; to Dr. Richard Cook for diagnoses of the fatal ailments of Haydon's children. David Blayney Brown read the entire manuscript and made astute suggestions for additions.

Thanks to conservators, handlers, photographers and observers who assembled at the Tate store to unroll *Lazarus*: Patricia Smithen, Rica Jones, Helen Brett, Kevin Miles, Jack Warans, Amy Simpson, Andrew Greenway, Terry Warren, Simon Hawkes, David Willett, Rebecca Hellen, David Lambert, Jared Schiller, Richard Humphreys, Lydia Hamlett. Thanks, also, to Sir Nicholas Serota.

Thanks to the staff of the Houghton Library, and to the Society of Authors for the grant that made my research there possible. Thanks also to the good people of Mount St. Mary's Seminary, Cincinnati, for hospitality and the opportunity to study *Jerusalem* at close quarters. At Plymouth City Art Gallery, Maureen Attrill showed me the Haydon paintings in store and arranged a viewing of *Solomon* in the Guildhall. At the Walker Art Gallery, Alex Kidson arranged a viewing of *Wellington*, while Christina O'Connor and Nathan Pendlebury provided illustrations. Thanks to Lord Howick of Glendale for showing me *The Reform Banquet* at Howick Hall, and to Di Spark for making the arrangements. Thanks also to Lord Normanby for allowing me to see *Dentatus* at Mulgrave Castle, and to Joy Moorhead for facilitating this. Sally Mewton-Hynds showed me around Walmer Castle. Thanks to the staff of the British Library, the British Museum, the National Art Library, and particularly to Colin Gale at the Bethlem Royal Hospital Museum; Tracey Earle the archivist at Coutts; Anselm Nye, librarian at Queen Mary College and, at the Royal Academy, Mark Pomeroy and Annette Wickham.

Thanks to my agent Bill Hamilton, to the copy-editor Mandy Greenfield; to Stephen Parker, Simon Rhodes and Neil Bradford for designing the book, and to Kay Peddle, for her beatific calm and kindness in overseeing its final stages. Thanks to Will Sulkin: a wiser, more sympathetic, more genuinely supportive editor, and friend, no author could hope for. Finally, Sian Hughes read everything, corrected, commented and questioned. For this and more is the book dedicated to her.

Index